ALFRED

ARTIST ON THE

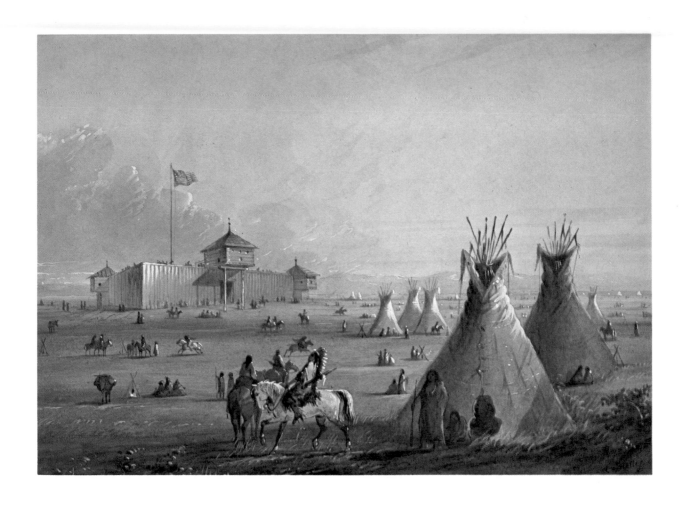

Laramie's Fort.

Watercolor on paper, 1858–1860. 8 1/2 x 11 3/4 in.
The Walters Art Gallery, Baltimore, Maryland 37.1940.49

Alfred Jacob Miller:

ARTIST ON THE OREGON TRAIL

Edited by Ron Tyler

with a Catalogue Raisonné by
Karen Dewees Reynolds and William R. Johnston

Amon Carter Museum: 1982

The Amon Carter Museum was established in 1961 under the will of the late Amon G. Carter for the study and documentation of westering North America. The program of the museum, expressed in permanent collections, exhibitions, publications, and special events, reflects many aspects of American culture, both historic and contemporary.

Alfred Jacob Miller: Artist on the Oregon Trail accompanies an exhibition by the same title at the Walters Art Gallery, Baltimore, October 16, 1981-January 10, 1982; the Amon Carter Museum, January 29-March 14, 1982; and the Buffalo Bill Historical Center, Cody, Wyoming, May 1-September 30, 1982.

The exhibition is partially funded by a grant from the National Endowment for the Arts, Washington, D.C. Presentation of the exhibition at the Walters Art Gallery is made possible by the generous support of Citibank/Citicorp.

Fᴇᴡ ᴀʀᴛɪsᴛs paint a picture that personifies their career as well as Alfred Jacob Miller's *The Lost Greenhorn* (plates 52, 53, and 54). Born in Baltimore and trained in Paris and Rome, Miller had spent only a few months in his New Orleans studio before being whisked away on a western adventure that he could hardly have dreamed of. He was, indeed, a greenhorn, completely at the mercy of his patron, Captain William Drummond Stewart. Fortunately, Stewart was a veteran of four previous trips to the American West and had experienced help from some of the most legendary trappers and hunters of the era. When Miller painted the expedition's cook, John, lost on the prairie, he might well have been painting his own portrait, for the title was an apt description of his only expedition to the Rocky Mountains.

That title also describes our initial efforts into Alfred Jacob Miller's career. We knew of Miller's delicate and compelling watercolors of the West, but Richard Randall, former director, and William R. Johnston, assistant director, of the Walters Art Gallery in Baltimore, had to acquaint us with his portraits and his Baltimore career in general. We could have gone little further without the help of lenders, scholars, friends, and the staffs of the participating museums. William R. Johnston; Peter H. Hassrick, director of the Buffalo Bill Historical Center; Robert Combs Warner, of the University of Wyoming; and Carol Clark, curator of paintings of the Amon Carter Museum served with me on a planning and advisory committee to help organize the exhibition and catalogue. William H. Goetzmann, of the University of Texas at Austin, shared his insight and understanding of the West and the fur trade throughout the project, and Jan Keene Muhlert, director of the Amon Carter Museum, has been supportive of our efforts and encouraging at every point.

Many people were generous with their time and their collections: Anthony R. Crawford of the Missouri Historical Society; David Hunt, Jan Trumm, and Berneal Anderson of the Joslyn Art Museum; Christine Knop of the Philbrook Art Center; Fred Myers and Anne Roden of the Thomas Gilcrease Institute of American History and Art; John Nelson of the Sheldon Memorial Art Gallery; Martin Kodner of St. Louis; Arthur J. Phelan of Chevy Chase, Maryland; and Earl Adams of Los Angeles were most helpful.

Mrs. Nelda C. Stark kindly permitted me to examine the fine collection of Miller paintings now in the Stark Museum of Art in Orange, Texas, and Sarah Boehm, curator, and Anna Jean Caffey, registrar, assisted in the study.

Kenneth M. Newman, of the Old Print Shop, and Rudolph Wunderlich, president of Kennedy Galleries, assisted in locating specific pictures and in the preparation of the catalogue raisonné, as did Frank E. Fowler, Irene Chapellier Little, James Maroney, Peter Rathbone, and Fred Rosenstock.

Donald Steuart Fothringham invited me to Murthly Castle for a visit and permitted the use of his family papers, now on deposit in the Scottish Record Office. Roy McGregor graciously showed me around the castle and the grounds. Michael Gill and Shiona Airlie of Edinburgh assisted in obtaining photographs of the two Miller paintings now hanging in Murthly Castle, and Betty Harington, who lives with her husband, Ray, in beautiful Tay View Cottage in Birnam/Dunkeld, assisted me with local information about Stewart.

Warder H. Cadbury, who has made a study of C. W. Webber's books and Miller's chromolithographs, contributed an essay on the subject. Mary Ellen Sigmond and Jean Jepson Page shared their information concerning Frank B. Mayer, one of Miller's students, and Stiles T. Colwill, of the Maryland Historical Society, made available the collections of the society as well as the results of his research on Miller. Barbara Spielman edited the manuscript.

The staffs of the participating institutions have helped throughout: Frederica Gore King Struse and David Gardiner of the Walters Art Gallery assisted with the cataloguing. At the Amon Carter Museum, Karen Dewees Reynolds assisted in every phase of the project, but especially worked with the catalogue raisonné. Sheila Smiddy and Becky Adamietz helped with the typing and organization; William Howze and Martha A. Sandweiss read the manuscripts and offered valuable suggestions; Nancy Graves Wynne, librarian, helped with materials while Milan Hughston, assistant librarian, prepared the bibliography and also read the manuscripts; and Carol Clark, in addition to contributing an essay, read the manuscript and offered valuable suggestions.

Of course, such an exhibition and publication would not be possible without the assistance and loans from many collections and institutions; they are acknowledged elsewhere in the book. Members of the Miller family, finally, were most helpful in permitting the use of material still in their collection.

<div align="right">
RON TYLER

Fort Worth, Texas
</div>

ALFRED JACOB MILLER:
ARTIST ON THE OREGON TRAIL

Introduction

Devoting himself to painting from his earliest youth, Mr. M[iller] has not only enjoyed the advantages of foreign study, with the works of the great Italian and other European masters for his models, but at a later period, and with the benefit of a matured judgment, he has travelled through remote sections of the "Far West" where he succeeded in giving views of the Rocky Mountains and other scenery that do him much honor.

SUCH WERE THE COMMENTS of the Baltimore *American* on July 17, 1838, when a young artist of that city, Alfred Jacob Miller, opened his first public exhibition of paintings. His work, according to the report, could be viewed that summer at his own studio or in a display presented at the shop of Messrs. Palmer and Company. For those who took advantage of this premier opportunity, there was cause for special notice in terms of the artist's technical accomplishment and of the unique western images he had preserved. Less than two weeks later another Baltimore newspaper responded with equal local pride that "we have no hesitation in saying that in him the country possesses an artist whose talents are calculated to reflect an enduring reputation in his native land."[1]

In May of the following year, Miller, with a collection of paintings bound for Scotland, exhibited his western scenes at the Apollo Gallery in New York City. Though somewhat skeptical of Miller's artistic maturity, critics continued to celebrate his originality of expression along with the "boldness and accuracy of drawing and perspective."[2] One New York reporter even shared the enthusiasm of Miller's hometown afficionados when he remarked that the artist's works were embued "with a lifelike force and reality that promise [him] . . . rich renown as a painter."[3]

Today, almost 150 years after Miller began his public career as a painter of the Far West, art historians and critics are beginning once again to echo these sentiments. He, along with John James Audubon, is now considered one of the truly distinguished talents in early nineteenth-century American art. However, this has not always been true. While both were singularly devoted to American themes—one to the natural world and one to the domain of men and history—neither achieved genuine recognition in his own day from the public or from his American peers. Despite Audubon's extraordinary enterprise in recording the birds of America, for example, he could find no support in his native land to publish his magnificent four-volume portfolio. And, in spite of Miller's initial acclaim as a painter of the alluring western scene and of its men and the prairies and mountains they sought to conquer, he was little known in his day beyond a small circle of friends and associates in Baltimore. In the case of Miller, this obscurity has persisted until very recent times.[4]

The reasons behind this lack of peer recognition and national exhibition stature are worth discussion here as it is the purpose of this book to look once again at Alfred Jacob Miller and apprise ourselves anew of the commanding place in America's artistic tradition that he deserves.

1. *American and Commercial Daily Advertiser*, July 23, 1838, p. 2, col. 1.
2. *New York Weekly Herald*, May 18, 1839.
3. *New-York Mirror*, May 25, 1839, p. 383, col. 2.
4. See Vernon Young, "The Emergence of American Painting," *Art International*, September 20, 1974, p. 14.

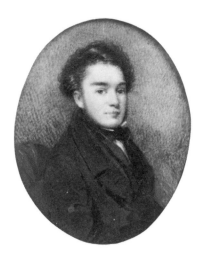

Alfred Jacob Miller, painted by an artist named Morgan, in New Orleans, probably in 1837. Courtesy Walter R. Abell, Sarasota, Florida

What happened to that bold and adventuresome young artist who, with little more than a second thought, embarked in 1837 on a summer-long odyssey across the Mississippi to the "Mountains of the Wind" and the trappers' rendezvous on the Green River?

Emboldened to confront the vast western wilderness and possessed of sufficient resources and energies to return east with over two hundred firsthand sketches, he was not apparently lacking the resolve or enterprise to proceed with a vigorous career. Nor was the American audience of the mid-nineteenth century without interest in the Far West as the eyes of the nation turned avidly toward Oregon and the promise of Manifest Destiny. And Miller, who lived a prosperous and long life with a number of esteemed and well-placed patrons, was by all accounts the most accomplished artist in nineteenth-century Baltimore, a city of no mean stature in America's cultural history. So what happened? Why and how could a painter with such a significant and timely artistic statement, one who held the promise of such "rich renown" and "an enduring reputation in his native land," slip into obscurity within his lifetime and linger in that obscurity until our own day?

The first answer must lie with Miller himself, his health, life-style, and personal motivations. As one of his contemporaries described him, "there could never have been a man in a popular profession who led a more retiring life than Mr. Miller."[5]

Among a close circle of intimate friends and family, Miller passed most of his life in the seclusion of a comfortable home that might, for lack of a better word, have been called a retreat. In his later years he suffered greatly from rheumatism, which, no doubt, turned his industry inward and limited his personal exposure. Under any circumstance, Miller did not share the entrepreneurial zeal of his colleagues George Catlin or John Mix Stanley, who traveled widely to tout their collections of Indian portraits and western scenes. To Miller, Catlin was a mere showman and a "humbug."[6] He did not share Catlin's celebrity, and, by all accounts, he was just as happy not to.

While Miller's retiring nature may have been a function of his personality and his health, it may also, as one recent observer commented, have been the result of not *realizing* his own significance.

5. Mrs. John D. Early [Maude G. Rieman], *Alfred J. Miller, Artist* (Baltimore, c. 1894), p. [5], collection of the Maryland Historical Society.

6. Letter from Miller to his brother Decatur, London, February 10, 1842, in the Macgill James File, Bernard DeVoto Papers, Stanford University Library, Palo Alto, California.

In Miller's case, his genuine gift was not recognized during his lifetime, yet it's fair to say that he didn't, himself, recognize it. Hired by a Scottish nobleman, Drummond [Stewart] who had inherited Dunsinane [Murthly Castle] . . . and wanted his walls to exhibit grandiose oil paintings of the scenery and inhabitants of the American West, Miller obliged. But it was the sketches for those epic pictures, or in others he jotted down for his own pleasure, where he revealed his flair for conveying movement and for capturing, as no one else was ever to do, the poetic essentials of Indian life before the mass invasions of the frontiers. With a sometimes slapdash economy of line he caught the precise cant of a man in the saddle as he counterweights the motion of his horse. Mountains and distant caravans are softly indeterminate. Indian man and beast are interfused, grass bends with the wind, wafted smoke and shadows are differentiated—the camp-fire vigils have sounds. . . . After completing Drummond's commission, Miller returned to Baltimore, resumed his portraiture of the local bourgeoisie and tossed his Western Sketches into a drawer. And there, although inherited by successive members of his family, they remained, unexclaimed over until their rediscovery—only about forty years ago.[7]

In addition, for Miller, there was no sense of driving personal quest or national mission as seen in the life work of Catlin or Stanley. Unlike Stanley's Indian portrait gallery, through which the artist hoped to "excite some desire that the memory, at least, of these [western] tribes may not become extinct,"[8] Miller's Indian paintings were simply intended to decorate the walls of Stewart's castle and certain Baltimore parlors. They were meant to serve personal enjoyment rather than attract national attention. While Catlin and Stanley caused a clamor of social and political excitement about the Indian and his fading way of life, Miller contented himself with having savored the taste of a rare holiday, an experience he would share guardedly with intimates and select patrons.

Miller also avoided, or was indifferent to, the potential scientific implications of his art. While Karl Bodmer rallied behind the Humboldtian dream of his patron, Maximilian, in the recordings of Indian life, Miller was sated by the thrill of being there. As James Flexner has noted, "The very strangeness of the experience to one of his temperament increased his sense of wonder. He thought his way into nothing, and his art abandoned thinking. In wandering through a pristine world, he served only the lust of the eye."[9]

Perhaps beyond these differences between him and his fellow artists, Miller lapsed into obscurity as a partial result of his being a member of no particular school of painting. Without the persuasions of science in documentation to influence him, Miller could not be counted among the artist-recorders, such as Bodmer, Catlin, Stanley, or Seth Eastman. And, although his landscapes of the prairies and Rocky Mountains are among the most sensitive and beautiful ever executed, art historians do not list him among the ranks of the later Hudson River School or its extension westward. In fact, Miller is a transitional figure caught between the two groups. And, without colleagues or competitors, he slipped comfortably into the solitude of a prosperous, long, but not especially involved life and career.

Miller's faint reputation, finally, may be a result of limited exposure through prints and illustrations in

7. Young, "Emergence of American Painting," p. 14.

8. J. M. Stanley, "Portraits of North American Indians, with Sketches of Scenery, etc., Painted by J. M. Stanley," in *Smithsonian Miscellaneous Collections*, II, [3].

9. James Thomas Flexner, *That Wilder Image*, p. 91.

contemporary literature. Only a handful of his works appeared in illustrations during his lifetime,[10] and he issued only one print of a painting. Most major painters of Indian life prior to 1850 published either portfolios of prints or volumes of writings illustrated by their own pictures or both. Miller contented himself making copies of his own work. Even his patron, Stewart, who wrote of own his western exploits in Byronic prose, failed to mention Miller.[11] Nor did the author illustrate any of the paintings he had commissioned during the 1837 trip to the Rockies.

Today, a generation of western afficionados is immediately familiar with Miller's work. Since the mid-1940s, his watercolors and oils have found profuse exposure as illustrations in all manner of books on America's frontier and the westward movement. He is proclaimed by historians as the master recorder of the mountain man and the fur trade era. His is considered a unique treasure as it is also the *only* pictorial record—since no other artist was privileged to witness the epochal exploit, Miller's paintings are a sole source.

This fact in itself has had an odd effect on appreciation of Miller's in modern times. For, while historians have increasingly celebrated Miller's role in contributing to posterity through his preserved images, they have seeded his cloud of obscurity by neglecting to celebrate his art. Miller's most esteemed protagonist, the distinguished historian Bernard DeVoto, stated this case perfectly in 1951 in a book review of Miller's only major illustrated biography, *The West of Alfred Jacob Miller*, by Marvin C. Ross: "Miller enables us to *see* the primitive West. To see as not Francis Parkman nor any one else who must use the medium of words could ever make us see the life of a strange, fascinating, violent time and place and breed of men. Certainly Miller was not a great painter but certainly too we owe him a great debt."[12]

DeVoto's historical perspective is beyond question, but his aesthetic commentary provides an unfortunate though time-honored critique that is both false and misleading. For Miller, despite his limited exposure and reclusive habits, his personal humility and historic significance, was, indeed, a great painter. Mr. DeVoto should have stuck by his own words, uttered only four years earlier, that his "esthetic opinions have no authority, and much work remains to be done before anyone can write critically about Miller."[13] That work is begun here. This book and the paintings assembled to grace its pages may cause us to reconsider Miller's *oeuvre* as something more than pictorial adjunct to historical event and to recognize it as an elemental part of America's artistic tradition in the nineteenth century.

10. The two books most heavily illustrated by Miller during his lifetime were both written by C. W. Webber: *The Hunter-Naturalist: Romance of Sporting; or, Wild Scenes and Wild Hunters* and *The Hunter-Naturalist: Wild Scenes and Song-Birds;* each contained five chromolithograph plates after Miller.

11. See Stewart's two accounts: *Altowan: or, Incidents of Life and Adventure in the Rocky Mountains by an Amateur Traveler*, ed. J. Watson Webb, and *Edward Warren*.

12. Bernard DeVoto, "The Only Man to Paint the Rocky Mountain Fur Trade," *New York Herald Tribune*, July 22, 1951.

13. Bernard DeVoto, *Across the Wide Missouri*, p. 455.

WILLIAM R. JOHNSTON

The Early Years in Baltimore and Abroad

INSIDE THE COVER of his "Journal," Alfred Jacob Miller inserted a newspaper clipping relating the history of the defense of Baltimore on September 12 and 13, 1814.[1] It was on this occasion, the most momentous in the early history of the city, that the Miller family came to the fore. George Washington Miller, the artist's father, served in the Water Battery of Fort McHenry and was rewarded by Colonel Armistead, the commander of the militia, with two unexploded British bombs as a memento of his service.[2] The senior Miller is otherwise known through the city directories. He is listed between 1803 and 1835, singly or in partnership with a brother, Howard, in a number of commercial endeavors ranging from innkeeper to sugar refiner and grocer,[3] invariably located near the old Market Space in the heart of the commercial district by the harbor. He was evidently successful in these enterprises, for at his death he left an estate that included a sugarhouse, a warehouse, and a farm on Hawkins Point complete with twenty-nine slaves in addition to the residence near the Market.[4] In 1809, G. W. Miller was married in Saint Margaret's Protestant Episcopal Parish, Anne Arundel County, to Harriet Jacob, whose family traced its roots in the country to the mid-seventeenth century.[5] The union resulted in nine offspring of whom Alfred Jacob was the first born.[6]

Information pertaining to the future artist's youth is limited. That he grew familiar with life on the Hawkins Point farm as well as with the bustling activities of Market Space may be gathered from the humorous anecdotal drawings he executed in later life recalling the 1820s. The Miller children were initially educated by tutors and then, at least in the instance of Alfred, enrolled in a fashionable academy on Fayette Street, which was operated by John D. Craig and which drew its following from the city's first families, "The Beltzells, Gill's, Welsh's, Carr's, Low's, McBlair's, etc." The master, a "narrow-minded ruffian" and "tyrant" of an Irishman, was given to thrashing his pupils with a hickory paddle until they could scarcely return to their desks, a mode of punishment "brought fresh from the first gem of the Sea," as well as to clouting them with their slates and hurling them across the room. Miller eluded such chastisements by duteously completing his homework although his drawings and caricatures were invariably burned by Craig, who never deigned to examine them.[7]

That Miller as a young man was already accustomed to mingling in society may be surmised from his visit to "Woodlawn" at Mount Vernon in the summer of 1832. His host, Major Lawrence, the nephew of George Washington, entertained him for two weeks showing him the family heirlooms and then arranged an introduction

1. The "Journal" is actually a collection of memoirs in a manuscript of 130 pages. Its leather cover is inscribed "A. J. Miller 1832." Minor errors in dating and a notation regarding the death of Sir W. D. Stewart in May 1871 indicate that the manuscript was written by the artist late in his life.

2. Journal, p. 113.

3. George Washington Miller (1777–1836) was listed in the city directories from 1803 to 1835, alone or together with his brother Howard (1776–1833), engaged in various occupations, including tailor (1803), grocer and tavern keeper (1804–1817 and 1819), sugar refiner (1833), and grocer (1822–23, 1824, 1827, 1829, and 1835).

4. George W. Miller: will, book 15, folio 483, and inventory book 45, folio 392, 401, at Baltimore City Hall.

5. Harriet Jacob (1780–1837) was a descendant of John Jacob, an indentured servant to Richard Warner listed in Anne Arundel County in 1665.

6. Included were four sisters: Harriet A. (1811–1905), Mary A. (1813–1896), Catherine S. (deceased 1873), and Elizabeth E. (1816–1899), and four brothers: George W. (dates unknown), Columbus A. (1818–1883), Decatur H. (1820–1890), and Theodore (1825–1900).

7. Journal, pp. 85–92.

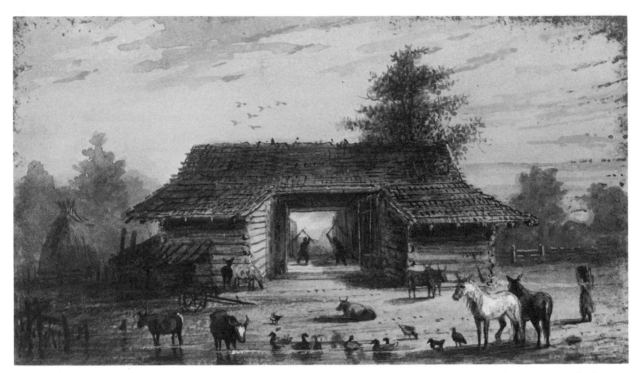

Barn Yard, Hawkins Point. Miller's father maintained a large farm on Hawkins' Point several miles southeast of the City. (Cat. 888–50). From Scrapbook, courtesy Mrs. L. Vernon Miller, Sr.

Jack C & the Market House Loafer, 1825. (cat. 893–33). Courtesy Walters Art Gallery. Gift of Mr. and Mrs. J. William Middendorf II

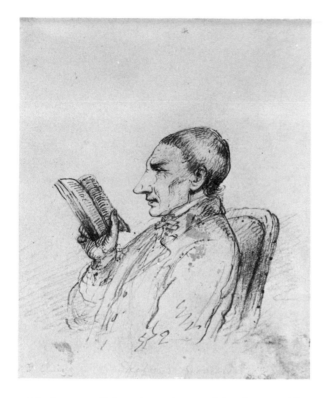

John D. Craig, Miller's Schoolmaster. In his "Journal" Miller wrote: "At the first glance of the head opposite, – most persons would say – 'that is the head of a narrow minded ruffian & tyrant' – & this was really the character of the man." Originally inscribed on bottom of page: *J Craigg [sic] Sketch from life.* This notation was erased when the drawing was pasted inside the "Journal." Below, the page is inscribed in ink *John D. Craig/my Schoolmaster/sketched from Life 1825.* (cat. 554). From the "Journal," courtesy Mrs. L. Vernon Miller, Sr.

with the son of the adopted son of the first president, G. W. P. Custis of "Arlington." Miller then stayed with Custis. The ostensible purpose of this visit—birdshooting—was quickly forgotten as the host became engrossed in relaying his reminiscences of Washington and in sharing his interest in painting. At "Arlington," Miller was able to see not only the "fine old paintings" of the Washington family but also Custis' own historical paintings of the Revolution.[8] Likely, he also attended the White House receptions for which President Andrew Jackson was noted.[9]

The extent of Miller's formal training in art has not been fully determined. His earliest biographer, Mrs. John D. Early, cited two divergent opinions: her husband's, that Miller was a pupil of Thomas Sully in 1831–32; and Emil Kett's, that he was entirely self-trained.[10] Though Sully, the prominent Philadelphia portraitist and pupil of Sir Thomas Lawrence, was never a resident of this city he did acquire an extensive clientele in Baltimore necessitating frequent visits, and in at least one instance, that of P. T. C. Tilyard twenty years earlier, he provided professional assistance to an aspiring, local artist.[11]

Another likely source of instruction was Peale's Baltimore Museum and Gallery of the Fine Arts opened by Rembrandt Peale in 1814 as an "elegant Rendezvous for taste, curiosity and leisure" and managed by his brother Rubens from 1822 until 1830.[12] This enterprise, which was modeled after C. W. Peale's Philadelphia museum, was situated on Holliday Street in proximity to the Miller family residence. It presented to the public, in addition to its displays of natural phenomena, paintings by the Peale family of artists, such large machines as

8. Ibid., pp. 3–6.
9. Ibid., pp. 27–28. Miller misleadingly discussed the receptions of President Jackson in a section of his journal otherwise devoted to Washington in the winters of 1841 and 1842.
10. Early, *Alfred J. Miller*, p. [1].
11. William Dunlap, *A History of the Rise and Progress of the Arts of Design in the United States*, II, 396.
12. Wilbur Harvey Hunter, Jr., *Rendezvous for Taste: Peale's Baltimore Museum, 1814–1830*, p. 3.

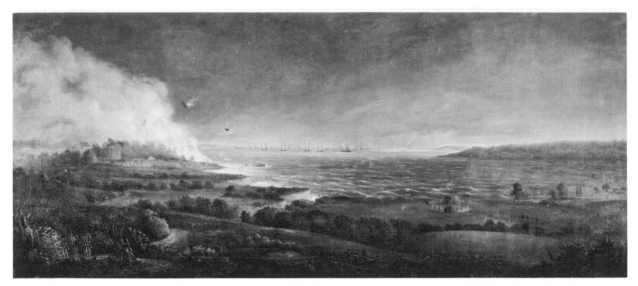

The Bombardment of Fort McHenry (about 1828). This view of the bombardment of the fort by the British on September 13th and 14th, 1814, is said to have been painted by Miller using sketches prepared under the guidance of his father, a participant in the event. The fort is seen from a hill on Whetstone Point. In the distance, down the Patapsco River, are the ships of the Royal Navy. This painting and the now lost *The Murder of Jane McCrea* were painted when Miller was about eighteen years of age. (cat. 38). Courtesy the Maryland Historical Society, Baltimore

John Vanderlyn's *Marius Amid the Ruins of Carthage* and *Ariadne Asleep on the Island of Naxos*[13] that were being circulated from city to city, as well as exhibitions of "master paintings of varying quality and degree of authenticity." Miller, later to be known as the "Lawrence of America," might well have had the opportunity to become familiar with his English namesake's work at Peale's Museum as early as 1823 when portraits of Robert Gilmor, Jr., the noted collector and secretary of the museum, Mrs. Robert Patterson, the Duke of Wellington, and W. Hoffman, Esq., were all exhibited.[14]

Recorded examples of Miller's earliest endeavors in painting are scarce but include historical scenes as well as portraits. Mrs. Early cited a large canvas with life-size figures, *The Murder of Jane McCrea*, executed by Miller at eighteen.[15] No trace of this work, his first Indian subject, has been uncovered. Perhaps it replicated John Vanderlyn's masterpiece of the same title, purported to have been exhibited at Peale's Museum. Another effort of the same period, also mentioned by the early biographer, *The Bombardment of Fort McHenry*, was painted under the supervision of Miller's father, who was accustomed to regaling his son with memoirs of the event.[16] This panoramic scene, which is equally ambitious in scale, measuring 3 1/2 x 8 feet, has survived and reveals Miller to have been a precocious if not already proficient painter. Also illustrating an episode from the same conflict is a dramatic oil sketch recalling analogous compositions by Francesco Bartolozzi, Benjamin West, and

13. *Federal Gazette and Baltimore Daily Advertiser*, February 16, 1820, p. 3.

14. Hunter, *Rendezvous for Taste*, p. 18.

15. Early, *Alfred J. Miller*, p. [1]. Jane McCrea (c. 1757–1777) was murdered by a band of Indians at Fort Edward, Washington County, New York, on the eve of her betrothal to David Jones, a loyalist in General Burgoyne's army. She was the subject of a popular ballad, and her death was portrayed by John Vanderlyn in *The Death of Jane McCrea* (1804, 32 1/2" x 26 1/2", in the Wadsworth Atheneum). W. H. Hunter, Jr., surmised that Miller copied Vanderlyn's painting, which he believes was exhibited at the Peale Museum. It should be noted that although the Vanderlyn picture circulated and was exhibited at the American Academy of Fine Arts, New York, in 1816, 1826, and 1827, there is no confirmed record that it was shown in Baltimore. If the figures in Miller's version were life-size, as claimed by Mrs. Early, then the copy was substantially larger than the original picture.

16. Maryland Historical Society, *The Bombardment of Fort McHenry, September 13-14, 1814*, canvas, 42" x 96".

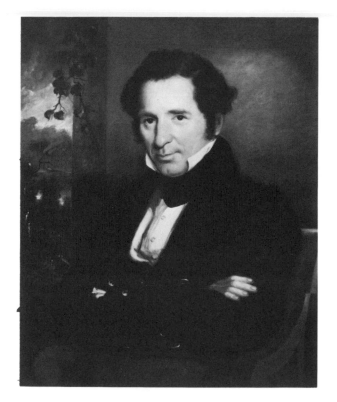

Portrait of Johns Hopkins (May 19, 1795 – December 27, 1873) 1832. Johns Hopkins, the son of Samuel and Hannah Hopkins was raised on a tobacco plantation, "Whitehall," on the Severn River in Anne Arundel County. He removed to Baltimore at the age of seventeen, to join his uncle, Gerard Hopkins, who ran a commission-merchant and grocery business. Following a dispute involving commerce in whiskey, young Hopkins broke his ties with his uncle, a strict Quaker, and established his own business, "Hopkins Brothers." This highly successful firm conducted business in the valleys of Virginia and North Carolina, transporting provisions by Conestoga wagons. Hopkins later diversified his holdings investing heavily in the Baltimore and Ohio Railroad and in Baltimore real estate. Six years prior to his death, he established two corporations which were charged with the responsibility of founding the university and hospital bearing his name, using the income from his estate. (cat. 647). Courtesy The Johns Hopkins University, Baltimore

John Trumbull. It shows Captain James Lawrence lying mortally wounded on the deck of the *Chesapeake*, surrounded by distraught seamen and issuing his celebrated rallying-cry for the navy, "Don't give up the ship."[17] In portraiture, a small sketch of himself at the age of seventeen, preserved in the Maryland Historical Society, affirms the artist's early commitment to the genre.[18] The portraits of Johns Hopkins, dated 1832, and of his mother, Mrs. Samuel Hopkins, are of greater historical interest in that they reveal Miller's degree of competency just prior to his departure for Europe.[19] In both, the figures are posed against the wall with an opening to the left revealing a rural scene, a device to which Miller occasionally resorted. The Hopkins portraits in their hardness of form, ruddiness of facial tones, and stridency of coloring correspond more closely to the realistic tradition of the Peales than to the more sophisticated portraiture of Thomas Sully.

An English barrister visiting Baltimore in 1831, Godfrey G. Vigne, commented concerning two painters at work locally, W. J. Hubard, the more experienced, and Mr. Miller, who was "still quite a boy." He prophesized that Miller, given an opportunity to study abroad, would become "an ornament to this native city."[20] Early in 1833 the occasion arose and Miller embarked for Europe with the backing of either his father or of Robert Gilmor, Jr.[21] Following a precedent set by Rembrandt Peale and John Vanderlyn, he chose to study in Paris rather then London, the more usual destination for the preceding generation of American painters.

Upon his arrival in the French capital, Miller naively established himself in the deluxe Hotel Montmorency on the Boulevard des Italiens,[22] where he took all his meals and engaged the services of a "valet" to guide him

17. Walters Art Gallery, *The Death of Lawrence*, oil on paper backed with canvas, 20 1/2" x 18", 37.2463.

18. Maryland Historical Society, *Self-Portrait*, oil on composition board, 11 5/8" x 10 1/2", 58.62.3.

19. The Johns Hopkins University, *Portrait of Johns Hopkins*, dated 1832, canvas, 30" x 25", and *Portrait of Mrs. Samuel Hopkins*, canvas, 30" x 25".

20. Godrey G. Vigne, *Six Months in America*, pp. 44–53.

21. Robert Combs Warner, *The Fort Laramie of Alfred Jacob Miller: A Catalogue of All the Known Illustrations of the First Fort Laramie*, p. 37, n. 2; Dunlap, *Arts of Design*, II, 472, stated that it was Miller's father who financed the trip.

22. Journal, p. 99.

about the city.[23] After a couple of weeks, he was rescued from further extravagances by a fellow Baltimorean, a Dr. McPhail, who found accommodations for him in the Hotel Corneille opposite the Odéon Théâtre on the Left Bank and introduced him to the restaurant Au Bon Diable on the Rue Saint Jacques, a student haunt that served five to eight hundred diners daily at moderate prices.[24]

Miller apparently spoke French, or learned it adequately, and was able to adapt to student life with little difficulty. With the intercession of the American consul, Mr. Warden, he was admitted without charge as an auditor to the École des Beaux-Arts, where, as the lone American, he joined his French fellow students each afternoon at four in the life classes sketching in crayon on carton paper, an experience that he later recalled as most beneficial.[25] At other times, he frequented the public collections studying and copying the Old Masters in the *musee des tableaux* of the Louvre and the foremost, modern paintings in the Musée Royal de Luxembourg. Dispersed throughout Miller's albums are studies of works that caught his attention. He was apparently cognizant of the renewed French interest in Dutch seventeenth-century art and shared, in particular, the romantics' admiration for the works of Rembrandt, in which the chiaroscuro and lighting were most dramatic. In one scrapbook are pastel studies of a number of Rembrandts in the Louvre, including *The Holy Family, The Angel Quitting Tobias, Christ and the Disciple of Emmaus,* two small interior scenes entitled *The Philosopher*—one of which is now attributed to S. Koninck—and several less readily identifiable portraits. Other seventeenth-century Dutch paintings that he drew are a Ruysdael riverscape, an interior he attributed to Nicolas Maes, and a reversed version of Rembrandt's *Good Samaritan* in the Wallace Collection, labeled by Miller as by Wouvermans, which may have been among the few Old Masters listed by Planta as still hanging in the Luxembourg.[26] He also drew a Salvator Rosa landscape, several interior scenes listed merely as "French School," an unidentified modern landscape, and the nude figure of the damned in the lower left corner of Delacroix's *La Barque de Dante,* then exhibited in the Luxembourg. Larger copies in oils that may date from his Paris sojourn include a detail of Veronese's *Jesus in the House of Simon* at Versailles and Titian's *Christ Crowned with Thorns* and *Allegory of Alfonso d'Avalos,* both in the Louvre.[27] Evidently, Miller became quite accomplished as a copyist, for he later let it be known that he had acquired, while in Paris, the sobriquet "The American Raphael."[28]

When not studying, Miller sought relaxation strolling in the Luxembourg Gardens, attending the theater, particularly the Opéra-Comique, which he later recalled with nostalgia,[29] and, on Sunday afternoons, attending the animal combats. These spectacles, a French substitute for the Spanish bullfights involving domestic and wild animals, were held in an amphitheater outside the city. Though he later condemned them for their brutality, he found them useful for his development at the time since they suggested "ideas of forcible action" that could only be caught from nature.[30]

Later, in 1833, Miller left Paris to continue his studies in Italy, briefly stopping en route in Lyons.[31] When he reached Rome, he found lodging with a fellow student from Virginia known as "Macoutra" (probably James

23. Edward Planta, *The Stranger's New Guide in Paris,* p. 33, mentions the practice of hiring valets as guides and cautions against it.

24. Journal, pp. 100–100a.

25. Miller's name does not appear in the registers of the École. It therefore must be assumed that he audited the courses.

26. Planta, *Stranger's New Guide,* pp. 495–496.

27. Private collection, *Jesus in the House of Simon the Pharisee,* oil on canvas, 13 3/4" x 9 3/4"; Parke-Bernet sale 4416M, New York, September 18, 1980, lot 107, *Christ Crowned with Thorns,* inscribed: *Sketch from Titian/Paris, 1833,* 14 1/4" x 11"; and George Durrett Collection, *Allegory of Alfonso d'Avalos,* oil on canvas, 45" x 42".

28. Early, *Alfred J. Miller,* p. [2].

29. Alfred J. Miller to Frank B. Mayer, July 20, 1865, in Frank B. Mayer Papers, Metropolitan Museum of Art, New York.

30. Journal, p. 29.

31. His sketchbook contains several drawings of scenes in Lyons.

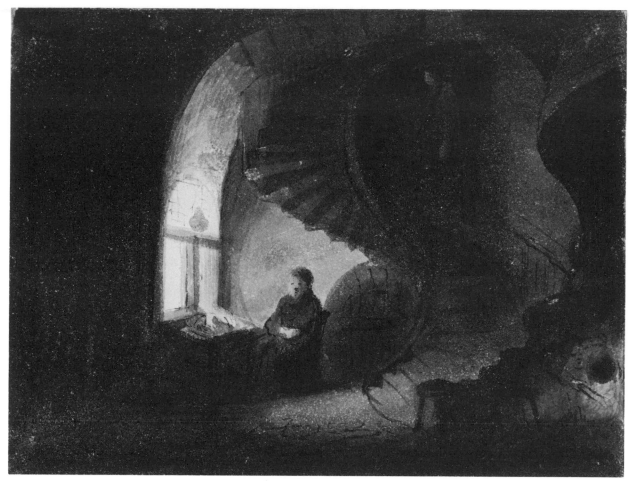

Study From Rembrandt. A copy by Miller of Rembrandt's *The Philosopher* or *Scholar in a Room with a Winding Staircase* (1632–1639) in the Louvre Museum, Paris. (cat. 889–20). Scrapbook, courtesy Mrs. L. Vernon Miller, Sr.

Macoughtry, active: 1828–1834). These accommodations were located facing the Capuchin church of S. Maria della Concezione on the Pincian Hill.[32] In recalling his activities in Rome, Miller referred to Thackeray's novel *The Newcomes,* in which the Roman sojourn of the amateur artist, Clive Newcome, is described. He remembered rising early in the morning, descending steps lined with Italian models picturesquely attired as brigands, *contadinos,* shepherds, and donnas to the Piazza de Spagna and having breakfast at the celebrated gathering point for artists of all nations, the Caffè Greco on the Via Condotti. Then, he and his colleagues would depart for the various palaces, Miller and "Macoutra" usually resorting to the Palazzo Borghese where they copied the Titians and Correggios. Several drawings in a sketchbook suggest that Miller was also drawn to the work of Caravaggio. At three o'clock, the hour the palaces closed, the young artists gathered at the Trattoria Lepre for dinner. After dining and drinking coffee and *mezzo-caldos,*[33] they continued to the Vatican galleries, which remained open. Here, apparently, Miller was particularly interested in the narrative cycle in the vaulting of the

32. Journal, p. 35. Miller recalled at length his experiences in Rome in his Journal, pp. 35–42.

33. The *"mezzo-caldo"* that he recalled in his journal, p. 38, as not a bad drink "consisted of a little rum, a slice of fresh citron, lots of pounded sugar and boiling water."

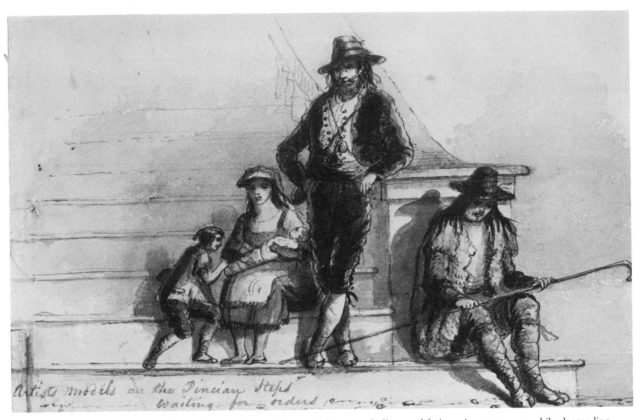

Artist's Models on the Pincian Steps/Waiting for Orders. Miller recalled passing Italian models in various costumes while descending the Pincian Steps each morning on his way to breakfast at the Café-Greco. (cat. 890–10). Sketchbook, courtesy Mrs. L. Vernon Miller, Sr.

Loggia de Raffaelo, outlining in pencil in his sketchbooks various compositions, including *The Fall of Jericho* and *Jacob's Dream.* Finally at night, he was admitted, as the sole American, to the English Life School, where models, varying in form from "the Apollo to the Hercules," illuminated by gas fixtures, posed for one-hour seances. He also had time to sketch out-of-doors, choosing such sites as the crest of the Pincian Hill, the entrance to the Borghese Gardens, the Ponte Rotto, and the surrounding Campagna.[34]

Outgoing in personality as a youth, Miller made a number of acquaintances while in Rome and was, shortly after his arrival, befriended by the great Danish neoclassical sculptor Bertel Thorvaldsen, who welcomed him on Sundays to his residence.[35] Miller remembered admiring the models of *Christ and Apostles* being prepared for the Church of Our Lady in Copenhagen and the marble tondos of *Night* and *Day* (1815). A full-length statue of Byron he found less pleasing. In addition, he was able to study the sculptor's noted collection of paintings by various northern European contemporaries. He was also cordially received by Thorvaldsen's pupil John Gibson, then the doyen of the English School in Rome.[36] Perhaps more pertinent to his development was a meeting with Horace Vernet, director of the French Academy from 1829 to 1835.[37] Upon presenting himself

34. These drawings are preserved in his sketchbook.
35. Journal, p. 31.
36. Ibid., p. 22.
37. Ibid., p. 34.

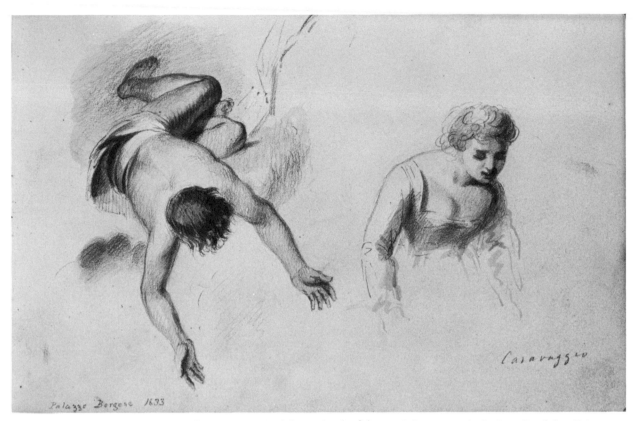

Sketches of Paintings in the Borghese Gallery, Rome. On the left is a sketch of the angel that appears in *St. Peter Freed from Prison*, a painting now attributed to Pier Francesco Mila (1612–1666). The figure of the Madonna at the right is taken from *The Madonna of the Palafrenieri* by Caravaggio (1573–1610). During his sojourn in Rome in 1834, Miller frequented the Borghese Gallery with his companion "Macoutra" sketching the "Old Masters." (Cats. 890–39A, 890–39B). Sketchbook courtesy Mrs. L. Vernon Miller, Sr.

as an American at the Villa Medici, Miller was immediately invited to the studio to examine an enormous battle painting then in progress. He was particularly impressed by the dexterity with which Vernet applied his pigments, slapping them on ad libitum with brushes ranging from one to one and a half inches in breadth. He also recalled admiring, in the villa's gardens, Vernet's eighteen-year-old daughter, who was later to become the wife and model of Paul Delaroche, the French *juste-milieu* painter.

Continuing his Italian journey, Miller accompanied N. Parker Willis, the journalist, dramatist, and poet from Portland, Maine, from Rome to Florence.[38] Willis, then in the midst of a five-year European odyssey, was corresponding with the *New-York Mirror*. His experience as a traveler soon proved of service, for when he and Miller reached the customs office at the border of the Papal States and the Duchy of Florence, the painter refused to pay a twenty-five-dollar tariff levied against his four-foot long case of copies as original works of art. Had not Willis intervened, persuading Miller to comply, the Baltimorean would have been forcibly detained and his paintings confiscated.[39]

In Florence, Miller sought out Horatio Greenough, with whom he had corresponded from Paris, at Robert Gilmor's instigation.[40] The sculptor was then commencing his colossal seated statue of Washington for the

38. Nathaniel P. Willis (1806–1867) published a collection of his letters in *Pencillings by the Way*. He made no reference to A. J. Miller but did refer to Miller's friend Brantz Mayer (I, 285).

39. Journal, p. 15.

40. Letter from Horatio Greenough to Robert Gilmor, Jr., October 18, 1834, published in Nathalia Wright (ed.), *Letters of Horatio Greenough, American Sculptor*, pp. 164–165.

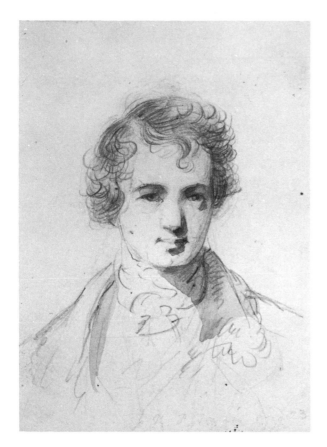

Portrait of Nathaniel P. Willis. (1806–1867). Miller accompanied N. P. Willis from Rome to Florence in 1834. In his day, the poet from Portland, Maine, was regarded abroad as America's most famous man of letters after Washington Irving and James Fenimore Cooper. An account of his travels was published as *Pencillings by the Way* in 1844. (Cat. 797). "Journal," courtesy Mrs. L. Vernon Miller, Sr.

U.S. Congress. As Miller anticipated at the time, Greenough's strict adherence to the tenets of neoclassicism in showing the president partially draped in a toga, rather than attired in the uniform of the Continental Army, was not about to be well received by his countrymen.[41] The young painter was more taken with the *Death of Medora,* a subject drawn from Lord Byron's "Corsair," commissioned by Gilmor. On Sundays in Florence, Miller joined Greenough in watching the traditional, local ball game, *pallone,* held in an amphitheater in the suburbs. This sport, in which the participants were flimsily dressed, provided the sculptor with "invaluable hints" in the study of movement and muscular development.[42]

The remainder of the European sojourn is sparsely documented by sketches and drawings in his albums, suggesting that Miller proceeded northward, stopping in Bologna and Venice, where he was particularly intrigued by the chimney-tops, and then continuing through the Lake District and the Alps. A view of the Wetterhorn in the Bernese Alps and another Alpine scene executed in gouache prefigured in their technique and style the later Rocky Mountain scenes.[43] Over thirty years later, writing to his pupil Frank B. Mayer, Miller admitted that his memories of Switzerland were "tinged with rainbow splendor" as he recalled the breakfasts of "fresh trout, directly from the lake, bacon and eggs, with honey of golden hue."[44] On the same occasion, he also recommended that Mayer try to visit Rome and Venice, not that he should study in either place, because the Louvre contained "all there is of excellence, in the greatest variety." The European trip, especially

41. Journal, p. 25.
42. Ibid.
43. Maryland Historical Society, nos. 56.24.2 and 14.
44. Letter from Miller to Mayer, October 12, 1866, in the Mayer papers, Metropolitan Museum of Art.

the stay in Paris, represented the happiest time of Miller's life. As he later concluded: "I had no cares, was in good health and a friendly set around me, that were willing to aid me to the extent of their power—what more could I ask or desire."[45]

In Baltimore on December 8, 1834, the following advertisement appeared:

ALFRED J. MILLER / ARTIST

Having recently returned from Europe where he has been assiduously engaged in studying the Art of Painting, respectfully informs his friends and the public generally, that he has taken room No. 153 Colonade Row, Baltimore Street, directly over Mr. George Willig's music store. Copies and sketches of celebrated pictures existing in the "Palazzo Borghese," Rome; "Accademia Reale," Florence; "Plazzo Ducale," Venice; and the "Louvre" of Paris, together with his original work, may be seen at his rooms—the public are invited to call and examine them.[46]

Although Miller's native city was beginning to burgeon economically in the 1830s, the arts were slower to develop. Peale's Museum, transferred in 1830 from its original building to another site on Calvert and Baltimore streets, continued to operate under various managements, experiencing a number of vicissitudes until acquired by P. T. Barnum in 1845. Among local portrait painters, Tilyard died in 1830 and Hubard moved to Virginia in 1833, leaving the field to Thomas Sully, who occasionally made visits from Philadelphia, and to Sarah Miriam Peale, the sole representative of her clan in the city, as well as a number of lesser figures, such as Michael Laty, James Wattles, and Thomas Cole Ruckle. In view-painting Nicolino Calyo was active in the mid-thirties, but in the copying of European masters, Miller was probably without rival, with the possible exception of Ruckle.[47] An attempt in 1838 to establish a Maryland Academy of Fine Arts proved premature and the organization disappeared without records.[48]

Miller's activities at this time are difficult to document. For his landlord, George Willig, Jr., he decorated in 1834 a couple of pages of sheet music.[49] He also submitted that year *The Destruction of Sodom* to the Boston Athenaeum exhibition, and the following year he sent to Boston *The Capture of Andre*.[50] A small portrait of Lieutenant William Chapman of St. Johns, Maryland, has been compared to the War of 1812 "Hero Portraits" once displayed by Rembrandt Peale in his museum and has been dated about 1835.[51] For the Baltimore Museum, as this institution was now known, Miller drew a lithographic frontispiece to a brochure, *Skeleton of the Mastadon forming a part of the Baltimore Museum*, published in 1836. Also that year, the museum announced the addition to its holdings of a "superior copy by Alfred J. Miller, Esq., and it is believed the only copy of Schidone's celebrated painting called 'Piety' or 'Charity,' the original of which is in the collection of Joseph Bonaparte."[52]

This decade was marred for the artist by a number of personal losses: his father died in 1836, followed by

45. Journal, p. 81.

46. *Baltimore American*, December 8, 1834, p. 3, col. 4.

47. See "Progress of the Arts in Baltimore," *Baltimore American*, July 17, 1838, p. 2, col. 1, and *Two Hundred and Fifty Years of Painting in Maryland.*

48. J. Thomas Scharf, *History of Baltimore City and County*, II, 764.

49. Mrs. Hermans' *The Warrior Crossed the Ocean's Foam* and *Troubadour Song* and John H. Hewitt's *Far O'er the Deep Blue Sea.* See Lester S. Levy, *Picture the Songs*, p. 40.

50. Robert F. Perkins, Jr., and William J. Gavin III, (comps. and eds.), *Boston Athenaeum Art Exhibition Index, 1827–1874*, p. 98.

51. Stiles T. Colwill, "Painter of Baltimore's Elite and the Raw West," (Master's thesis), pp. 3–4.

52. *Baltimore and Commercial Daily Advertiser*, November 7, 1836.

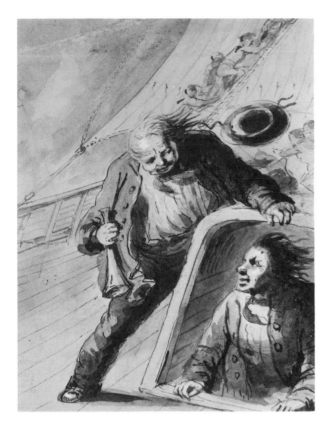

Incident of a Voyage to New Orleans off Cape Hatteras. Capt. (loqr.) "Mate? I say Mate!" /Mate – "Aye, aye Sir"/Capt. "Stand by, for a bit of dust." Miller is probably recalling his voyage to New Orleans in the autumn of 1836. He sailed on the *Platina* November 12th and arrived December 7th. The Cape, off the coast of North Carolina is known as the "Graveyard of the Atlantic" because of the frequent storms. (Cat. 893–29). Courtesy The Walters Art Gallery 37.2519. Gift of Mr. and Mrs. J. William Middendorf II

his mother, late in 1837. Since the senior Miller's brother and partner, Howard, had died several years earlier, the estate was liquidated, and the assets distributed among the surviving offspring.

Miller, burdened with "troubles of all kinds," left Baltimore late in 1836 on a merchant ship to seek his fortune in New Orleans.[53] Arriving with only thirty dollars in his pocket, he nevertheless engaged accommodations in a boardinghouse on Chartres Street and sought a studio. Fortunately, he met along the same street a Mr. L. Chittenden, a dealer in dry goods. Upon learning that the artist charged a hundred dollars for a 25 x 30 inch likeness, Chittenden agreed to accept a portrait of himself, despite his "d—d ugly countenance," in exchange for a room. He also volunteered to find additional subjects. As a result, Miller "made time pass profitably and very pleasantly" in New Orleans, receiving all the commissions that he could wish and being welcomed to Sunday dinner both in the city and at surrounding plantations. His work at this time included landscapes as well as portraits. It was while executing a large evening view of Baltimore, measuring 3 1/2 x 4 feet, based on a sketch previously drawn from Laudenslager's Hill, that Miller received the fateful visit of Captain William Drummond Stewart, who commissioned him to accompany an expedition to the Rocky Mountains.[54]

53. Journal, pp. 61–64; Miller recorded the date of his departure as September 1837. Actually, he arrived in New Orleans on the ship *Platina* on December 7, 1836.

54. Ibid., p. 53.

RON TYLER

Alfred Jacob Miller and Sir William Drummond Stewart

ALFRED JACOB MILLER'S account of how he came to find himself on the Missouri frontier in the spring of 1837 preparing for a trip to the Rocky Mountains was written years after the fact. In his journal, which in reality is a kind of memoir, he recalled having just established himself in his second-floor studio over L. Chittenden's dry goods store at 26 Chartres Street in New Orleans when a tall, erect gentleman with a hook nose (whom he mistakenly thought to be a Kentuckian because of his fashionable dress) entered the room and looked around.[1] He complimented Miller on a picture, a view of Baltimore from Laudenslager's Hill (cat. 820), but the artist thought no more of the incident until the gentleman returned a few days later, identified himself as Captain William Drummond Stewart, retired, of the British army, and invited Miller to accompany him on a trip to the Rocky Mountains as the expedition's artist.[2]

"I am . . . under engagement to proceed with Capt. W. Stewart (an affluent gentleman,) on an expedition to the Rocky Mountains, (professionally) the tour to occupy six months . . . ," Miller wrote to his friend Brantz Mayer in what is probably the only surviving letter that he wrote while on the expedition. It had not taken him long to decide to accompany the captain. Although he later recalled that he had to give up a rather comfortable life in New Orleans, this was his first major commission and would thrust him into the forefront of painters who depicted the American Indian. Miller had not seen the work of George Catlin and probably had never heard of Karl Bodmer, both of whom preceded him west, but few people had seen Catlin's paintings by 1837, and Bodmer was back in Paris at work on a handsomely engraved and colored set of pictures copied after the sketches that he had made while in America with Prince Maximilian of Wied-Neuwied. These would not be published for three more years.[3]

Miller was not driven by the fierce desire to document for posterity that motivated Catlin, but he would see more than both Catlin and Bodmer, for Stewart was en route to the annual rendezvous of fur trappers and traders, which he had attended for the past four seasons. The second son of a wealthy Scottish nobleman, Sir George Stewart, Captain Stewart was a bored veteran of Wellington's Peninsular campaigns and of the victory at Waterloo. Trapped in an unhappy marriage to a farm girl and retired on half-pay, he had come to America in 1832 after a furious fight with his older brother, John, who had inherited the family title and estates. Having sworn never again to sleep under the roof of Murthly Castle, the family home in Perthshire, the captain had come to America "for the sole purpose of penetrating the great wilderness of the West," something that had

1. Miller probably arrived in New Orleans in December 1836 on the *Platina*, which sailed from Baltimore to the Crescent City, arriving on December 6. The *Bee*, December 7, 1836, p. 2, col. 5, lists the ship's arrival as well as a "J A Miller" in steerage. Miller says in his Journal that he took a room with Mr. L. Chittenden at 132 Chartres, but *Gibson's Guide and Directory of the State of Louisiana, and the Cities of New Orleans & Lafayette*, pp. 42, 146, lists both Mr. Chittenden and an "A F" Miller, a painter, at 26 Chartres Street.

2. Miller's Journal, which is a series of memoirs written late in his life, contains newspaper clippings, sketches, and his accounts of various incidents in his life, including his meeting with Captain Stewart in New Orleans (p. 35). No date is given. The Journal is still in the family and was made available to me while it was on loan to the Walters Art Gallery, Baltimore.

3. The quote is in Miller to Mayer, St. Louis, April 23, 1837, in Warner, *Fort Laramie*, p. 144. Perhaps Stewart got the idea of an expedition artist from Prince Maximilian when he met Bodmer and Maximilian in St. Louis in 1833. It surely was not unusual to have an artist along on such a trip, however. Miller had not seen any of Catlin's work (see his letter to Mayer, cited above), but he certainly knew of it and would have the chance to hear Catlin lecture upon his return to New Orleans (*Bee*, October 14, p. 2, col. 3, November 16, 1837, p. 2, col. 3).

This *Distant View of Baltimore* may be similar to the view of Laudenslager's Hill that Stewart saw, at least in the mistiness that he liked in Miller's painting. (Cat. 821). Courtesy L. Vernon Miller family.

become fashionable among European nobility anxious for the thrill of a western hunt. Writing in 1832, John had asked him for an account of the "scenery at Niagara" and commended his decision to move to New Orleans for the winter. "I think you are quite right to see America thoroughly now that you are there," he concluded.[4]

It was probably in New Orleans that Stewart learned of the annual caravan to the rendezvous, which was one of the true spectacles that the West had to offer in 1833. It was also there, four years later, that he employed Miller to make his historic trip to the Rockies, perhaps because of his chance encounter with Prince Maximilian and Bodmer in St. Louis during the captain's first western trip. Maximilian had employed Bodmer to document his trip and to produce finished engravings to illustrate the books that he intended to publish on his return to Europe.[5]

Prepared by the salons and plein-air classrooms of Paris and Rome, Miller had little idea of what to expect as he set out for St. Louis in April 1837. A refined and somewhat bashful young man, he found the city to be a "thriving little place," but even his student days in France and Italy did nothing to prepare him for the city's

4. Quote in Stewart, *Altowan*, p. viii; quote in John Stewart to William Stewart, Perth, Scotland, September 25, 1832, Bundle 21, Box 101, Murthly Muniments, G.D. 121, Scottish Record Office, Edinburgh; Mae Reed Porter and Odessa Davenport, *Scotsman in Buckskin: Sir William Drummond Stewart and the Rocky Mountain Fur Trade*, pp. 18–19. See also Marshall Sprague, *A Gallery of Dudes*, pp. 2–32, for a summary of Stewart's American experience.

5. There was even some discussion of trying to combine Stewart's and Maximilian's parties, but the objectives were so different that they finally gave up the idea. Maximilian was on a scientific quest; Stewart was primarily interested in hunting and adventure. See Davis Thomas and Karin Ronnefeldt (eds.), *People of the First Man: Life among the Plains Indians in Their Final Days of Glory. The Firsthand Account of Prince Maximilian's Expedition up the Missouri River, 1833-34*, p. 18. See also Porter and Davenport, *Scotsman in Buckskin*, pp. 28–29; John E. Sunder, *Bill Sublette: Mountain Man*, pp. 123, 125.

hotels, which he pronounced "abominable." Situated a few miles south of the confluence of the Mississippi and Missouri rivers, St. Louis had a "motley population" of perhaps sixteen thousand persons, whom Washington Irving described as a compound of "creole descendants of the original French colonists," "keen traders from the Atlantic states," "backwood[s]men of Kentucky and Tennessee," "Indians and half-breeds of the prairies," and that "singular aquatic race," the "boatmen of the Mississippi."[6]

Miller's days there were filled with meeting new people and preparing for the trip. Stewart introduced him to the merchants and mountain men alike, acquaintances of his previous trips. William Sublette and Robert Campbell, the mountain men with whom Stewart had first gone to the rendezvous of 1833 and two of the better known carriers and outfitters, had now settled down in St. Louis to become merchants and bankers. "Almost the first thing [Sublette] . . . did," Miller wrote, "was to hand us a piece of . . . prepared meat [jerky] to give us a foretaste of mountain life. He told us that every season he caused a bale of meat to be brought down to him which lasted six or eight months."

Stewart and Miller also called on Governor William Clark, the prominent landowner, superintendent of Indian affairs in St. Louis, and, of course, widely known explorer who had helped open up the West with his 1804-1806 reconnaissance with Meriwether Lewis. The governor probably knew more about the West than any living American and frequently entertained travelers on their way to the Rockies or the Oregon Country. Miller found him seated in an enormous chair that was "covered with a very large Grizzly bear robe." He had a "fine head," recalled the artist, "surrounded with a mass of hair falling over his shoulders" with "quick vigorous eyes and expressive features." Governor Clark rehearsed all his western adventures for his visitors, but to Miller the most appealing aspect of the visit was the governor's museum, which contained "many trophies . . . , Indian implements, dresses, war clubs, pipes, etc. This visit to us was replete with deepest interest," wrote the young painter, who now had a preview of what he would see in the mountains. "We had almost daily intercourse with . . . Gov. Clark before we started."[7]

After a few days in St. Louis, Miller moved on to Westport (today, surrounded by Kansas City), where the outfitting was completed. Founded in 1831 by Baptist missionaries, the village now teemed with traders and merchants, adventurers, and Indians as the time of departure—when the grass began to turn green—approached. All sorts of gear and supplies, including horses and mules, were available as Stewart completed his preparation for the trip. "I expect to depart . . . on Tuesday next 25inst and join Capt S above fort Independence," Miller wrote to Mayer.[8]

The forty-five men and twenty carts departed for the Green River country shortly after Miller arrived. Had they been dependent upon a map to find their way, they would have been unfortunate, indeed, for even the most recent, including David H. Burr's *Universal Atlas*, published only the year before, were inadequate when

6. Washington Irving, *Astoria, or, Anecdotes of an Enterprise beyond the Rocky Mountains*, I, 144; see also Miller to Mayer, St. Louis, April 23, 1837, in Warner, *Fort Laramie*, p. 144.

7. Marvin C. Ross (ed.), *The West of Alfred Jacob Miller* (rev. ed.), pl. 150. This book contains reproductions of the set of sketches that Miller prepared for William T. Walters between 1858 and 1860, as well as the notes that Miller supplied for each picture. Most of the notes, in essence, are contained in an earlier form in Alfred Jacob Miller, "Rough Draughts for Notes to Indian Sketches" (MS in Library, Thomas Gilcrease Institute of American History and Art, Tulsa, Oklahoma), see preface and entry No. 146 for quotes; Stewart, *Edward Warren*, pp. 75–76; see also John C. Ewers, "William Clark's Indian Museum in St. Louis, 1816–1838," in *A Cabinet of Curiosities: Five Episodes in the Evolution of American Museums*, ed. Whitfield J. Bell et al, pp. 49–72.

8. For information on Westport, see Merrill J. Mattes, "The Jumping-Off Places on the Overland Trail," in *The Frontier Re-examined*, ed. John Francis McDermott, pp. 28–30, and Merrill J. Mattes, *The Great Platte River Road*, pp. 108–109; quote in Miller to Mayer, St. Louis, April 23, 1837, in Warner, *Fort Laramie*, p. 146. The outfitting probably cost Stewart more than $20,000, according to Miller, and was completed over a period of weeks.

it came to the Rocky Mountains. The map that Miller and Stewart used was in the head of Stewart's old friend Thomas Fitzpatrick, a thirty-eight-year-old Irish-American who had been with William H. Ashley at the first rendezvous in 1825 and probably had attended every one since. Sublette and Campbell might have retired to the city, but "Broken Hand," as the Indians called Fitzpatrick because of an injury he had received when a rifle barrel burst, still relished the venture. A pioneer of the Platte River trail, Fitzpatrick was with Jedediah Smith when they rediscovered South Pass, which effectively opened California and Oregon to overland transportation via the Platte, the North Platte, and the Sweetwater rivers. He knew the mountains as well as any man.[9]

Captain Stewart (pls. 28, 42, cat. 101) was Fitzpatrick's assistant. Forty-one years old and proud of his military background, Stewart was a familiar figure at the rendezvous. His family had become accustomed to his annual adventure, his younger brother, Archibald, writing him in 1836, "I heard that it was no use writing to you till October as you intended going to the wild parts of America." Stewart called on his experience with Wellington to enforce strict discipline on the free spirits who made up the caravan. He carried himself with dignity and felt the others should too: the captain was "somewhat of a martinet . . . [who] would not tolerate for a moment any neglect of orders," noted Miller, whose tenure on the Left Bank probably rendered him unprepared for such rigor. "The government of [our] . . . band . . . is somewhat despotic."[10]

Stewart's distinctive features made him easily recognizable among the motley band of trappers and traders in Miller's paintings. He dressed in white buckskin and rode a white horse (pl. 42, cat. 101). That alone made him stand out, but his physical features marked him further: a moustache and a hook nose so apparent that one of the Crow Indians imitated him by crooking his finger and putting it to his nose. He "seemed to be composed of the same iron that formed the 'Great Duke' himself," Miller wrote. On one occasion they approached a raging stream. Miller, who confessed that he could not swim, saw "not the slightest necessity" to cross the stream, but the captain plunged in, with Miller paddling along after him, because the "river looked a little in opposition." Only after they were on the other bank did Stewart also admit that he could not swim.[11]

Miller, used to working at his own rate and, perhaps, somewhat carefree, quickly felt the sting of Stewart's discipline (cat. 92, verso). He was relieved of guard duty and was permitted to employ someone to put up and take down his tent, but he had to combine his drawing with retrieving and picketing his horse and other trail duties. Dissatisfied with these chores because they occurred when the camp was most active and object of Stewart's complaints that he was not getting enough pictures, Miller erupted: "If I had half a dozen pair of hands, it should have been done!"[12]

The young artist might not have been so quick to talk back had he known of the captain's dreadful temper. He saw it firsthand one afternoon as Stewart, Miller, and Stewart's hunter, Antoine Clement, son of a Canadian and a half-breed Cree, rode out on a hunt (pl. 30, cat. 52A). Stewart and Antoine became engaged in an argument that was resolved only when a herd of buffalo came along, permitting the hunters to divert their attention. Miller later heard of an even more disastrous incident in which Stewart's anger led him to make a rash promise. There are several versions of the story, including Stewart's account in his autobiographical novel, *Edward Warren*. The tale concerns the trapper Mark Head and Stewart's half-breed employee Marshall, who,

9. LeRoy R. and Ann W. Hafen, "Thomas Fitzpatrick," in *The Mountain Men and the Fur Trade of the Far West*, ed. LeRoy R. Hafen, VII, 87–88, 92–93, 96. See also LeRoy R. Hafen, *Broken Hand: The Life of Thomas Fitzpatrick, Mountain Man, Guide and Indian Agent*. Also see David H. Burr, *A New Universal Atlas*.

10. Ross, *Miller*, pls. 37 (quote), 51; A. D. Stewart to William Stewart, London, August 5, 1836, Bundle 21, Box 101, Murthly Muniments.

11. Ross, *Miller*, pls. 43, 120.

12. Ibid., pl. 139.

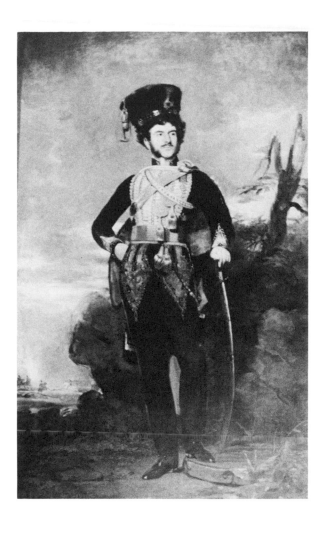

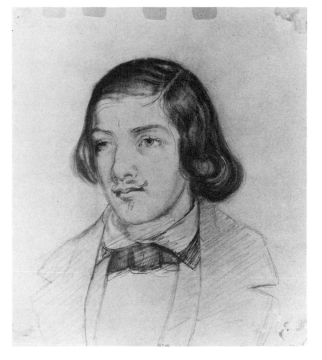

Captain William Drummond Stewart in dress uniform. The painting was found in an old, abandoned chapel and brought to Murthly Castle, where it now hangs. Courtesy Donald Steuart Fothringham

Alfred Jacob Miller was a twenty-seven year old young man when Stewart invited him to accompany the caravan to the Rocky Mountains. This self-portrait probably was drawn while on the expedition. (Cat. 92, verso). Joslyn Art Museum, Omaha; InterNorth Art Foundation Collection

threatened by dismissal, stole Stewart's rifle and his favorite running horse and fled. Enraged at the theft, Stewart thoughtlessly promised a $500 reward for Marshall's scalp. Head took him at his word. He caught Marshall and shot him, then returned to camp with the scalp at the end of his rifle. The stunned Stewart admitted that "this was a little more than I looked for" (as he wrote in Edward Warren), but, according to the account, he paid the bounty.[13]

For all his strong-headedness, Stewart had earned the respect of the men. They had all heard stories of his courage and honesty. Kit Carson's remark that Stewart would be "forever remembered for his liberality and his many good qualities" is, perhaps, characteristic. The trappers admitted that Stewart had the "h'ar . . . of the Grizzly in him," meaning that he was a brave man.[14] Miller, as an educated man and Continental traveler, had the perspective to view Stewart's behavior in relation to the mountain men, and he admitted that the Scotsman was extraordinary. He could be determined, as in his disagreement with Antoine, and he could be generous, as he was with two trappers encountered near Independence Rock. Abandoned with no equipment or animals, the men were near starvation when the caravan came along (cat. 164). Stewart outfitted them and sent them on their way, probably with better equipment than they had originally possessed. The artist also received a lesson in Old World aplomb as they neared St. Louis on the return trip. Miller commented that the captain's fine horses would bring a good price in St. Louis. Stewart replied, "Mr. Miller, have you never been informed that I never sell anything?" Miller answered no, and Stewart continued: "Then, Sir, you will now understand that I never do." Miller concluded that the horses were given away at the end of the trip.[15]

Although little is known about Stewart personally, he comes alive in Miller's notes and pictures. When the captain learned that two of the cartmen had been fighting, he called in the loser and observed that he had been fairly beaten. Then he called in the winner and warned that if he ever boasted of the victory, he would be forced to give up his horse and walk for a week. Miller said that was the end of the fighting in the caravan. On another occasion, when an Indian made off with Stewart's favorite pipe and tomahawk, Stewart recalled that the Crow had first offered to trade for it, then, when the captain refused, had warned that he would steal it. "Although the tomahawk was a favorite," Miller recorded, "he said the Indian had given him fair warning, and made no effort to recover it."[16]

Stewart was also well known in the mountains for his generosity. With delicacies brought from St. Louis and New Orleans in his camp, he was sure to be popular. When he opened a tin of sardines as an hors d'oeuvre at breakfast one morning, one of the trappers dumped the whole can in his plate. Seeing the enthusiasm, Stewart ordered that the entire stock be brought out. It was a "rather dear breakfast," Miller admitted, but Stewart now had a "prime after dinner story for England."[17]

Miller is even more of an enigma than Stewart. Only one letter written while he was on the trip is known, and that from St. Louis. Both his journal and the captions for his pictures were written years after his return— based on his original notes, to be sure, but edited, augmented, and constantly rewritten. He also left out vital information, such as dates and places, so that, while his pictures form the most complete record of the 1837 caravan and rendezvous, the effort to sort them out in any meaningful sequence is like assembling a giant jigsaw puzzle.

13. Ibid., pls. 37, 159; Stewart, *Edward Warren*, pp. 6 n., 288–289 n.; David L. Brown, *Three Years in the Rocky Mountains*, pp. 13–14; DeVoto, *Across the Wide Missouri*, pp. 193–194; Hafen, "Mark Head," in Hafen (ed.), *Mountain Men*, I, 187–193.

14. Milo Milton Quaife (ed.), *Kit Carson's Autobiography*, pp. 52–53; Ross, *Miller*, pl. 36 (quote).

15. Ross, *Miller*, pl. 163; *Morning Herald*, October 2, 1839, p. 2, col. 5.

16. Ross, *Miller*, pls. 51, 63.

17. Ibid., pl. 52.

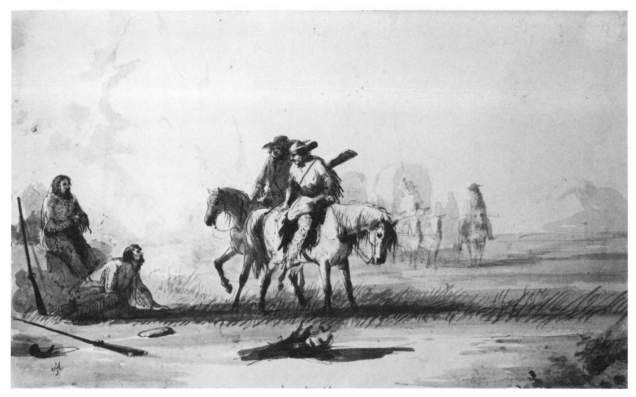

Starving Trappers near Independence Rock. (Cat. 164). Private
Collection, Rochester, New York

Miller must have been elated as the caravan pulled out of Westport. He surely glimpsed the opportunity that would be his: the first painter to see the Rocky Mountain trappers, many of whom already had become legends; the first to paint the scenery along the Platte and in the mountains; and the first to document the rendezvous and the westernmost Plains and Mountain Indians. Miller's notes conceal his almost certain excitement as the party reached the Plains, but his diligence and superb sketches betray his enthusiasm.

Quickly establishing his working routine on the trail, Miller realized that the most dramatic scenes occurred at sunup and sundown. He often left with the hunters, sketching until almost dark. Perched on a rock quietly sketching a scene early in the trip, he suddenly felt the steel grip of someone holding his head and neck. He could not move. He thought it was an Indian and that each breath would be his last. After approximately five minutes of silence, Stewart finally released him with the admonition that he not become so involved in his sketching that he neglected to look for Indians.[18]

Miller applied to Stewart for assistance at times of peak activity, asking on one occasion to be relieved of retrieving and picketing his horse. Mindful of the group's discipline, Stewart refused. "Reasons were as plentiful as blackberries why it should not be done," a disappointed Miller recalled.[19] On another occasion, Stewart was able to help. He dispatched Antoine to aid the artist in getting close enough to a buffalo to sketch him. Antoine did it in his "own peculiar fashion," Miller recalled. An expert marksman, Antoine wounded a buffalo in the flank, causing him to stand still. Miller crept as near as he dared, "holding the sketch book in one hand and

18. Ibid., p. xxi.
19. Ibid., pls. 155, 178.

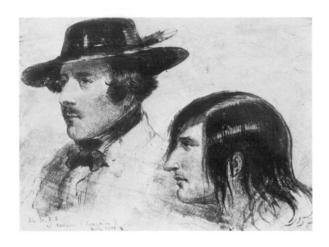

Sir William Drummond Stewart and Antoine. (Cat. 378).
Courtesy Thomas Gilcrease Institute of American History and
Art, Tulsa

the pencil in the other." Then the animal charged, sending Miller into a "double-quick" retreat, "pencil and paper flying." Later, Miller watched in awe as Antoine grabbed the tail of a wounded buffalo and held on: "The astounded brute . . . turned first one way & then another, swinging A. about as if he was a feather, and lifting him completely from the ground." The hunter held on until the buffalo, completely exhausted, fell to the ground and died.[20]

A romantic artist whose mood could change from exhilaration to depression in a matter of moments, Miller had days when the seemingly endless rain soaked him to the skin and depressed him to the point that he was unable to sketch with his watercolors, which would run and fade when wet (pl. 60, cat. 167A). No doubt the hardships of the trail wore him down; he developed a severe rheumatism, which he later credited to his mountain sojourn, and, to make matters worse, Stewart would "banter" with him about his emotions, saying that his "early training . . . has been faulty."[21]

Miller trod a path that Samuel Seymour (artist for the Stephen H. Long expedition of 1819), George Catlin, and Karl Bodmer had partially trod before him. From St. Louis he headed westward along the Missouri River to Independence and Westport, where the expedition was fitted out. While Catlin and Bodmer then turned up the Missouri, Miller more likely followed the trail that would soon become known as the Oregon Trail: he rode approximately forty miles down the Santa Fe Trail from Westport, then veered westward to follow the Kansas River for approximately sixty miles to the Little Blue River, which he probably paralleled until reaching the Platte in the vicinity of Grand Island. The caravan marched along the south bank of the Platte and the North Fork of the Platte, bypassing the South Fork, which Samuel Seymour, traveling with Long's expedition in 1819–20, had taken to Colorado.

Miller moved through Indian country that, while safe in large groups, could be extremely dangerous for small parties. The Pawnees were particularly troublesome as petty thieves, and Fitzpatrick ordered a double guard on the horses until they were safely out of Pawnee country. Thus prepared for ambush, Miller was easily frightened when a hunter came running into camp yelling, "Injins all about—thar will be some raising of h'ar,—as sure as shootin'." Miller was as conscious of his scalp at that moment "as a Chinese [is] concerning his pig-tail que[ue]." No fight occurred because the traders offered "extensive" bribes (pl. 59, cat. 155).[22]

The first real variety in the topography came almost 150 miles past the South Fork of the Platte as the caravan approached the prominent sand hills known as Scott's Bluffs (pl. 41, cat. 100B). The bluffs were no comparison to the scenery that Miller would see later on, but, combined with the dramatic, isolated spire of

20. Ibid., pl. 155.
21. Ibid., pl. 147.
22. Ibid., pls. 44, 68, 76.

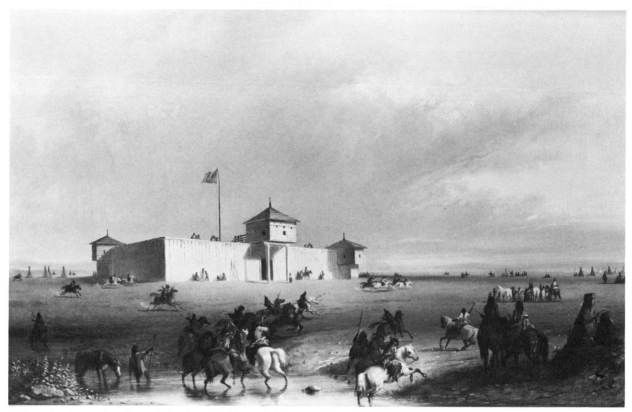

Miller painted several versions of Fort Laramie. (Cat. 160B) Courtesy Thomas Gilcrease Institute of American History and Art, Tulsa

Chimney Rock (pl. 40, cat. 99B), which they had just passed, Scott's Bluffs constituted a major landmark. Captain Benjamin Bonneville believed it "scarcely possible" that castles, churches, and fortified cities were not among these "fantastic freaks of nature" near his 1832 campsite. Dr. Adolf Wislizenus noted in 1839 the "obvious resemblance" of the bluffs to "several places in Switzerland," while six years later Lieutenant Colonel Philip St. George Cooke called them a "Nebraska Gibraltar." Miller's watercolor sketches are the earliest known pictures of the bluffs, which were named for an early day fur trader who was abandoned by his companions and died nearby. (There are dozens of accounts of the tragedy, including at least one which concludes that Scott did not die but merely chose to live out his life in a scenic area.)[23]

About a month out of Westport—perhaps five weeks—the expedition approached Fort Laramie, an oasis in the desert in more ways than one (pl. 56, cat. 159B). The newcomers brought news from St. Louis; they would be able to sit down to a table supplied with a cool crock of fresh milk. As they approached the fort, Stewart told Auguste, a French Canadian, to go to the fort and get the blooded stallion that Stewart had left the year before with strict instructions that no one ride him. Miller described Auguste as he emerged from the "great gate" of the fort, "coming toward us at top speed . . . yelling like an Indian, and the horse frightened out of his wits." As he drew within a hundred yards of the caravan, the horse shied at something, dumping his rider on the ground. Miller sketched a humorous view of Auguste plunging over the stallion's head (cat. 158). He

23. Mattes, *Great Platte River Road*, pp. 422–425; Ross, *Miller*, pl. 65. Of particular interest in discussing the condition of the Oregon Trail today is Gregory M. Franzwa, *The Oregon Trail Revisited*.

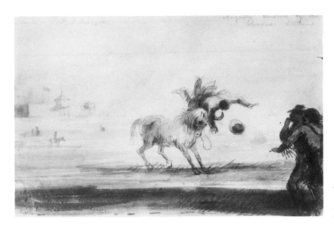

Auguste Thrown by the Blooded Stallion—Fort Laramie. (Cat. 158). Courtesy Western Americana Collection, Beinecke Rare Book and Manuscript Library, Yale University

was kinder in another picture, showing Auguste watering the horse, a picture later used as the study for his large oil *Antoine Watering Stewart's Horse* (pl. 55, cat. 157) which hung in Murthly Castle for years.[24]

Fort Laramie was a high point on the trip west. Founded by William Sublette and Robert Campbell in 1834, it lay at the crossroads of an old north-south Indian trail and what became known as the Oregon Trail. It was christened Fort William—supposedly after William Sublette and William Marshall Anderson, a greenhorn along with Sublette—but was known as Fort Laramie virtually from its construction because of the nearby Laramie Mountains (called the Black Hills) and Laramie's Fork, which flowed into the North Platte River. Miller described the post as being approximately 150 feet square with bastions at the diagonal corners and a cannon in the blockhouse above the door (pl. 57, cat. 161B). Clearly situated at a point to take advantage of the mountain trade, Fort Laramie was commanded by a civilized gentleman, Lucien B. Fontenelle, who decorated his rooms with what Miller called "large first-class engravings." Miller's pictures of the fort are the only known ones, because the original wooden stockade was rebuilt of adobe in 1841 before any other artist had the chance to see it.[25]

Approximately 150 miles west of Fort Laramie, on the Sweetwater River, Miller had his first view of Independence Rock, that "register of the desert" on which so many of the pioneers of the Oregon Trail carved their names (cat. 162). Miller conceded that, "the temptation was too strong not to add our own." Upriver from Independence Rock, the Sweetwater River runs through a rocky ridge some five hundred feet high to create the Devil's Gate, a "singular scene" that later emigrants would recognize, along with Independence Rock, as a landmark along the way to Oregon (cat. 165B). The river completely filled the passage, which was only about thirty feet wide at the bottom, so that one had to be a swimmer or a mountain climber to get through.[26]

Past the Devil's Gate, the nature of the territory changes dramatically, signaling the approach to the Rocky Mountains. Split Rock, which Miller called the "Cut Rocks" (cat. 172), was in view for the better part of two days as they approached the South Pass, on the Continental Divide (pl. 61, cat. 149A), some eighty-five miles beyond Devil's Gate. First discovered in 1812, the pass remained unknown to Anglo-Americans until a party of Crow Indians told Smith and Fitzpatrick about the broad, high plain that actually forms a saddle between the southern tip of the Wind River Range and the Antelope Hills to the south. It rises almost imperceptibly from the plains to a height of 7,550 feet above sea level, leading one early Oregon traveler to remark that, "if you dident now it was the mountain you wouldent now it from any other plane." The early travelers, in fact,

24. Ross, *Miller*, pl. 10.

25. Ibid., pls. 49, 150. For further information on Fort Laramie, see LeRoy R. Hafen and Francis Young, *Fort Laramie and the Pageant of the West, 1834-1890*, and Warner, *Fort Laramie*, pp. 1–24.

26. Ross, *Miller*, pls. 69, 164.

One of the eighteen paintings exhibited at the Apollo Gallery in New York in 1839, this large canvas of *Hell's Gate—Sweet Water River* later hung in Murthly Castle. (Cat. 165B). Courtesy Leo Heaps, Toronto

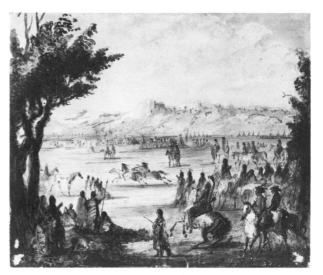

The rendezvous of 1837 was a virtual carnival, with races, gambling, feasts, and trading. (Cat. 183). Courtesy Western Americana Collection, Beinecke Rare Book and Manuscript Library, Yale University

did not realize that they had crossed the Continental Divide until they reached Pacific Spring and saw the water flowing westward. Fitzpatrick and Smith were the effective discoverers of the pass; Miller was the first artist to paint it.[27]

The party then turned northwestward and paralleled the Wind River Mountains as far as Horse Creek, a tributary of the Green River and the site of the 1837 rendezvous. As they neared the beautiful valley, the men heard a "tremendous Indian yell of a large body of men" and thought that they were under attack, recalled David L. Brown, who was a member of the expedition. But Stewart, a veteran of four previous rendezvous, recognized this as the welcoming party (pl. 62, cat. 169). Those already at the rendezvous had been waiting several days for the caravan and were anxious to get both the supplies and the latest news. After a "tremendous shaking of hands, firing off of guns, and asking of questions," the riders got back in their saddles and rode along conversing "upon such subjects as were uppermost in our respective minds . . . ," Brown continued. "We came suddenly upon a long line of beautiful Indian tents ranging in regular order, and stretching away for at least two miles in perspective, and terminating in a wide and circular array of the same romantic and fairy-looking dwellings" (cat. 183). It was an idyllic scene, and Miller climbed a low hill nearby and painted it for Stewart (pls. 63, 64, cats. 170, 171A).[28] The area near Horse Creek is still a gorgeous setting with the Wind

27. Ibid., pls. 9, 132; quote in Howard R. Lamar, "South Pass," in *The Reader's Encyclopedia of the American West*, p. 1132.

28. Brown, *Three Years in the Rocky Mountains*, p. 10; Ross, *Miller*, pl. 133, is one version of the painting of the welcome. Another is the watercolor version at the Buffalo Bill Historical Center, Cody, Wyoming. Plate 159 in Ross may represent the rendezvous scene that Brown describes.

River Mountains to the east, the Bear River Range to the west, and the floor of the valley interspersed with perfect beaver streams and broad, horse-racing plains.

The rendezvous was a grand affair, reminding Brown of the "storied wonders of my childhood and early youth . . . pouring over the delightful pages of Scott and Froissart." It was an affair that had originated in the mid 1820s when William H. Ashley, a St. Louis politician and businessman, confronted the difficulty of sending trappers out each year. Much of the time was lost in transit. He solved the problem by advertising for one hundred "Enterprising Young Men" who would remain in the mountains for two or three years. This brigade would split into several groups and trap all season, which ended as summer approached and the quality of the pelts diminished. They would meet at a prearranged spot in June or July to await the caravan from St. Louis, which would bring supplies and take their furs back to the market. Ashley did not invent the rendezvous, as this annual exchange became known, for the North West Company of Canada had sponsored a "general rendezvous" as early as 1808, but he did change it to suit his purposes.[29]

Company men and free trappers (who worked for themselves and sold for the highest price), Indians, traders, and hangers-on gathered there. Business was conducted, but, as Miller found out, the rendezvous was more. It was the highlight of the year in the mountains, "one continued scene of drunkenness, gambling, and brawling and fighting, as long as the money and the credit of the trappers last[ed]," wrote George Frederick Ruxton. "The trappers drop in singly and in small bands, bringing their packs of beaver to this mountain market, not unfrequently to the value of a thousand dollars each, the produce of one hunt. . . . The goods brought by the traders, although of the most inferior quality, are sold at enormous prices." When the trappers and Indians were not trading, they were racing horses, wrestling, matching marksmanship, or chasing buffaloes.[30]

Everyone was particularly glad to see Stewart at the rendezvous of 1837. The fur trade was on the decline. Beaver hats and heavy winter coats were going out of style, and the cutthroat competition reached all the way from the mountains to St. Louis and New York. Bonneville, who had established a post north of the rendezvous site and had tried to get into the fur business, had given up and returned to St. Louis the previous year. The Rocky Mountain Fur Company had recently sold out to the American Fur Company, which struggled for control of the remaining trade. Meanwhile, in the mountains the trappers were in a "bad fix," recalled Isaac P. Rose, who had stayed there all winter. "Their blankets were worn out, and their ammunition was gettin low." But "the caravan from St. Louis made its appearance at about the usual time," he said, "and laughter, fun and frolic were once more the order of the day."[31]

Stewart, now among old friends, organized a party on the second night. It was his fifth trip to the mountains, and he brought tall tales of Wellington and the Napoleonic wars as well as food, drink, and valuable presents. His guests were legends sufficient to awe any western afficionado today: James Bridger, tough and lean, an acknowledged leader among independent sorts for whom Stewart had brought a facsimile of the suit of armor worn by the English Life Guards (cat. 269); Bill Williams, the best trapper in the mountains, a man devoted to excesses, whether swearing and drinking or horse racing; Joe Meek, a character whose real adventures would

29. Carl P. Russell, "Wilderness Rendezvous Period of the American Fur Trade," *Oregon Historical Quarterly* 42 (March 1941): 1–2; see also Hafen (ed.), *Mountain Men* I, 73–157; Richard M. Clokey, *William H. Ashley: Enterprise and Politics in the Trans-Mississippi West*, p. 67.

30. George Frederick Ruxton, *Ruxton of the Rockies: Autobiographical Writings by the Author of Adventures in Mexico and the Rocky Mountains and Life in the Far West*, coll. Clyde and Mae Reed Porter, ed. LeRoy R. Hafen, p. 230; Gordon B. Dodds, "Fur Trade in the United States," in Lamar (ed.), *Reader's Encyclopedia of the American West*, p. 425.

31. James B. Marsh, *Four Years in the Rockies: or, The Adventures of Isaac P. Rose, of Shenango Township*, p. 206; Brown, *Three Years in the Rocky Mountains*, p. 10.

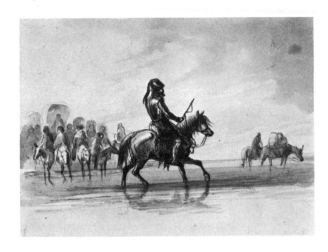

Jim Bridger was a "great favorite of Sir Wm. Stewart," Miller wrote, and Stewart "imported a full suit of English Armor & presented it to Bridger, who donned it on all special occasions, & rode so accoutered at the head of his men." (Cat. 269). Joslyn Art Museum, Omaha; InterNorth Art Foundation Collection

not be believed, according to Brown (but whose public had its chance, for Meek's story was written up by Mrs. Frances Fuller Victor); and Mark Head, about whom Brown said, ". . . it would take a stronger pencil than the author" to "embody the dark depths and shadows that alone could make up a true picture of this ruthless and remorseless original."[32]

Stewart entertained lavishly, bringing out good whiskey and porter that he had carted all the way from St. Louis. "The first few days after our arrival were one continued scene of wild revelry and excitement," says Brown. Bridger "created a sensation" wherever he went in his "full suit of steel armor." In the midst of the drinking, racing, marksmanship, and other forms of competition, Isaac Rose finally got some crackers and water, a "great delicacy" that he had not tasted since his arrival in the mountains. Frequently everyone had to stop to watch an Indian parade or dance. During all the excitement, trades actually were made, so that all the pelts eventually wound up in the merchants' hands and the cheap cloth, vermillion, traps, and other trade goods in the trappers' and Indians' possession to outfit them for the coming winter. And Miller painted it all, little knowing that neither he nor any other artist would have a second chance (pl. 65, cat. 174).[33]

The highlight was the arrival of the Snake Indians, regular guests at the rendezvous, who staged a grand entry—or "cavalcade," as Miller termed it—in Stewart's honor (pl. 66, cat. 178B). Led by Chief Ma-wo-ma (pl. 85, cat. 294B), a respected and somewhat loquacious man, several hundred (or thousand, depending on whom you believe) Snake Indians paraded around the rendezvous grounds in their best dress, decorated with lavish amounts of vermillion, which Miller pointed out was "worth four dollars per oz." in the mountains. William H. Gray, a lay missionary on his way back to the States, was a disgusted witness to the scene—"singing, yelling, and firing their arms, some naked, some dressed in various ways to suit their fancy"—although he had camped some distance from the rendezvous to avoid the drunkenness and debauchery. "Today I was told . . . that Indian women are a lawful commerce among the men that resort to these mountains . . . ," he recorded in his journal,"thus setting at defiance every principle of right, justice and humanity, and law of God and man."[34] Obviously there was some truth in Gray's charge that the Indian women were bought and sold. Miller

32. Brown, *Three Years in the Rocky Mountains*, pp. 11–13; Marsh, *Isaac P. Rose*, pp. 206–207; Frances Fuller Victor, *The River of the West: Life and Adventure in the Rocky Mountains and Oregon*, pp. 233–236; Stewart, *Edward Warren*, pp. 241–245; Ross, *Miller*, pl. 159; DeVoto, *Across the Wide Missouri*, pp. 193–194.

33. [Osborne Russell], *Osborne Russell's Journal of a Trapper*, ed. Aubrey L. Haines, pp. 58–61; Brown, *Three Years in the Rocky Mountains*, p. 15; William H. Gray, "Unpublished Journal of William H. Gray, from December, 1836, to October, 1837," *Whitman College Quarterly* 16, no. 2 (June 1913): 56–57; Ross, *Miller*, pl. 159.

34. Ross, *Miller*, pls. 35, 199; Gray, "Unpublished Journal," pp. 56, 61.

reported that in one instance the price of the girl (paid to her father) was $600 in guns, blankets, red flannel, alcohol, tobacco, and beads. He also recounted the story of his young friend, L. Phillipson, who ardently tried to win the heart of a Flathead maiden. Apparently something of a ladies' man at home, Phillipson was stunned when the Indian girl encouraged him, then left camp with a Canadian trapper. Miller painted a small portrait of this maiden (pl. 90, cat. 300A), and the incident might also have inspired his painting entitled *The Trapper's Bride* (pl. 67, cat. 191F).[35]

Although Miller made dozens of sketches at the rendezvous, he seemed to withdraw, perhaps a bit fatigued by the roughhouse games and hard drinking, preferring instead the more civilized company of Gray, whom everyone else found self-righteous. Miller considered Gray "a thriving well-to-do man" and shared tea with him on at least two occasions. By contrast, Miller also accepted the invitation of an Indian and visited his teepee for dinner. Fearing that he would have to eat dog meat, Miller took the precaution of hiring one of the trappers to go with him to eat (a socially acceptable practice among the Indians), while he engaged in awkward conversation of a few words and signs with his hosts. At the feast, Miller sat by the trapper, "who . . . seemed to enjoy it." Miller did a sketch of the dinner, showing the trapper entertaining his hosts with a yarn (pl. 106, cat. 417A).[36]

Another of the famous personalities that Miller met—and painted—was Joseph Reddeford Walker, a trapper and explorer who probably was leader of the first American party to see Yosemite Valley. Miller did a small watercolor of "Bourgeois" Walker (pl. 81, cat. 268), as he was called (mountain terminology for one who commanded a group of twelve or more trappers) and a finished portrait (pl. 80, cat. 267). Walker had pioneered an overland route to California, but Miller noted only the campfire gossip concerning the "exquisite revenge" perpetrated on Walker by a group of Digger Indians after a battle. "The Indians . . . proposed to bury the tomahawk and invited him to a feast and pipe smoking," recalled Miller. The feast was generous, and Walker did "full justice to their hospitality." After a hearty smoke, he returned to his camp only to discover that he had partaken of a meal composed of his own men who had fallen in battle. Miller had wanted to ask about the incident, but "prudence forbade."[37]

Stewart was the honored guest at the rendezvous, with Indians and trappers alike paying him courtesy calls, and he entertained in a regal style in front of his striped tent with Persian rugs spread on the ground (cat. 170A). He held forth around the camp fire with stories of foreign lands, "curious cities, and monuments of antiquity," said Miller, "all the while maintaining a gravity that was most amusing." Toward the end of the rendezvous, Stewart presented gifts to Indians who had rendered some service to the trappers, or who had performed some great deed (pl. 68, cat. 192B). Miller suggested that the bright cloths, feathers, and Bowie knives were a diplomatic effort to keep the Indians friendly, because a hostile group of Blackfeet was rumored to be in the vicinity. The Indians enjoyed the presentations, nonetheless, and "attached great importance to the matter," said Miller, "as it gives them a certain status with their people."[38]

As the rendezvous, a three-week extravaganza, wound down, Stewart took a few friends and headed toward his favorite hunting spot in the Wind River Mountains near the headwaters of New Fork River. It was a sportsman's paradise, with abundant wildlife available for amateur hunting during the day and Stewart's store of delicacies—various kinds of food and drink that the trappers would not have seen since the last rendezvous— for the campfire at night. Miller helped despatch the "two ankers of Brandy and Port Wine" himself and fell

35. Ross, *Miller*, pl. 12.
36. Ibid., pls. 143, 185.
37. Ibid., pl. 78. For information on Walker, see Ardis M. Walker, "Joseph R. Walker," in Hafen (ed.), *Mountain Men*, V, 361–380.
38. Ross, *Miller*, pl. 13.

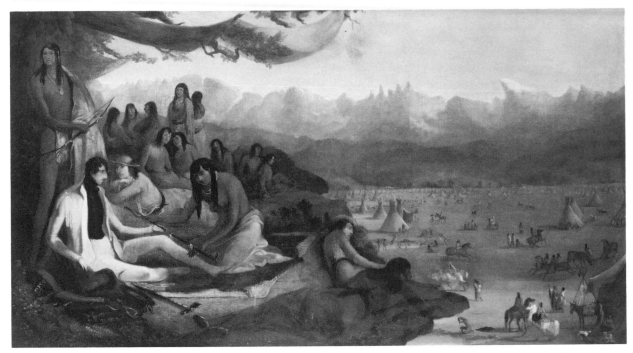

"This is a most splendid painting," wrote the critic for the New York *Weekly Herald*. "The waving blue mountains in the back ground, and the bustle and animation in the foreground, are beautiful. The Alps are nothing to these cold, blue Mountains of the Wind." Captain Stewart is shown in the foreground, reclining "quite en famille." (Cat. 170A). Courtesy Stark Museum of Art, Orange, Texas

among those who "went to bed without candles" that night. Their sportsman's urge was satisfied, too, when they caught "noble trout" from ledges surrounding crystal lakes, "unsophisticated" fish that they caught on common wire and large pins after they had lost all their fishhooks.[39]

The party was somewhat concerned that a large group of Indians who bore a grudge against one of Stewart's engagés would attack. Although they did not, their threat might have been the source of several Miller paintings which depict hostilities that he never saw, according to his own records, but which must have been the subject of frequent campfire conversations. One shows a group of young warriors with spears and war clubs at the ready (cat. 377). Another shows Blackfoot warriors chasing Black Harris and a fellow trapper, which Miller clearly had learned of around the campfire (pl. 58, cat. 150A), and a third depicts an incident that did happen, a threat by a large group of Sioux Indians that went unfulfilled (pl. 59, cat. 155). But this is as close to warfare as Miller came, for, in fact, they were relatively safe traveling in such a large group. William H. Gray, the missionary whom Miller had met at the rendezvous, was not so fortunate. Taking a small group of Flathead Indians with him, he set out against all advice for St. Louis before the rendezvous was over. He was attacked by a Sioux war party between Fort Laramie and Council Bluffs. He was permitted to continue, but his Indian companions were brutally murdered, leading many of the trappers to conclude that Gray had traded the lives of his Indians for his own.[40]

It was on this trip into the Wind River Mountains that Miller saw the most spectacular landscapes of the whole journey (pl. 69, cat. 224B). He realized that he lacked the ability to capture them, either in paint or in

39. Ibid., pl. 116.
40. Ibid., pls. 61, 67, 76; Gray, "Unpublished Journal," pp. 67-71; DeVoto, *Across the Wide Missouri,* pp. 330–333.

Wind River Country, a superb watercolor in which Miller succeeds in portraying the grandiose Wind River Mountains in a more believable manner than in most of his relatively small and cramped pictures. (Cat. 276). Courtesy Buffalo Bill Historical Center, Cody, Wyoming

words, but his eyes took in the "deep purple masses," "the salmon-coloured granite rock," and the "immense sheets of clear water" as he dabbed his watercolor brush on the sketching paper. Europe, Greece, Egypt—their wonders have been " 'done' to death," he said, but "here is a new field for . . . the enterprising traveller. . . . These mountain Lakes have been waiting for him for thousands of years, and could afford to wait thousands of years longer, for they are now as fresh and beautiful as if just from the hands of the Creator." Looking at those peaks, Miller felt the exhilaration of an explorer: "In all probability, when we saw them not 20 white men had ever stood on their borders. . . . Here are mountains and lakes reaching from Tehauntepec to the Frozen Ocean in the North . . . nearly one seventh part of the globe—ample room and verge enough, one would think, for a legion of tourists." He remained proud of his pioneering trip, noting in a preface to his "Rough Draughts" that he had preceded Captain John C. Frémont into the mountains by some four years.[41]

Miller lacked the scientific and geological understanding of the landscape to produce pictures the equal of Thomas Moran and others who talked with scientists about their work, admitting that one "scene in reality was charming, but would have required the pencil of a Stanfield, Turner, or Church in giving it due effect and rendering it complete justice." He did paint a convincing mountain range on occasion, one with the feeling of space and freshness characteristic of the spectacular country he saw (cat. 276).[42] Most of his landscapes are small and pinched, embodying none of the majesty of the West but characteristic of the training that Miller had received, training that emphasized figure painting and historical scenes over drawing from nature (pl. 72, cat. 225A). Thus he, as his European predecessors had done, searched for the noble savage, hoping to document a race that they feared would soon be extinct.

Miller saw everything through the romantic's eyes—he was a romantic, both in terms of painting and in what he read and how he saw. When he met the Sioux Indians, he reacted as Benjamin West had when he first saw the Apollo Belvedere: "By God, a Mohawk." Miller believed the Sioux to be an ideal sculptural specimen and lamented that sculptors had not come west to see them and model after them. Some of his portraits reflect this feeling, but the same thing happened to Miller that had previously happened to Catlin: the other Indians objected to Miller painting a particular man whom he had selected because "he was . . . a good specimen of the tribe, intelligent head, fine form, and was upwards of 6 feet high," because he had not distinguished himself in battle and "held no rank either as chief or brave."[43]

Another example of Miller's romanticism was his reaction to a wild horse herd they encountered. The horses

41. Ross, *Miller*, preface and pls. 59, 81, 116, 130; Miller, "Rough Draughts," preface.
42. Ibid., pls. 130, 183. See also Carol Clark, *Thomas Moran: Watercolors of the American West*, p. 30, for a discussion of Moran's concern for the geological accuracy of his pictures.
43. Ross, *Miller*, pls. 6, 23 (quote), 39.

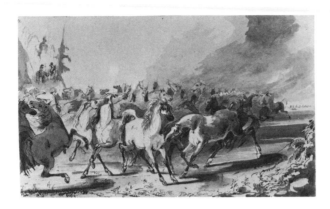

Wild Horses. (Cat. 449A). Courtesy Buffalo Bill Historical Center, Cody, Wyoming

probably were the "runty . . . broomtails" of the Plains that Bernard DeVoto describes, but Miller painted them as if they were the handsome Arabians that Delacroix had seen during his African sojourn (cat. 449A).[44]

"Everything must have an end," Miller finally lamented, "time elapsed, we were in our saddles, and the enchanting scene left as solitary as ever." Miller had painted some of the most spectacular scenery the West has to offer. The rendezvous grounds south of Horse Creek are still as inviting as ever, while the lakes of the Wind River Mountains remain remote and enchanting. He probably did not get as far into the mountains as Green Lake, the source of the Green River, but it is difficult to tell from his picture captions precisely where he went. He had camped within a few miles of the site of Captain Bonneville's abandoned fort, four or five miles above Horse Creek and only a few hundred yards from the Green River. It had, indeed, been the chance of a lifetime, and Miller, with winter fast approaching, packed his sketchbooks in his saddlebags, sure in the knowledge that he had thoroughly documented one of the West's greatest adventures. He and Stewart returned to St. Louis, Stewart remaining there for a while, Miller continuing to New Orleans to start work on his finished pictures.[45]

Stewart quickly set about trying to get his finances in order. He had not received the interest from Scotland that had been left him by his aunt and had hired an attorney to try to force his brother John to pay the money. He was involved in a business deal with John Crawford, the British consul in New Orleans, and a man named Theodore Vernunfft to sell southern cotton to English mills. Judging from the rather breathless letters that Crawford sent Stewart, the joint enterprise was losing money—Stewart's money—but the consul hoped that the captain would do nothing hasty. The last that has been learned of Stewart in 1837 is that he went down to the St. Louis Cathedral, near the Mississippi River, and reconciled himself to the Catholic Church. He knew that his brother John was sick and in Paris for treatment; perhaps he was preparing himself emotionally to become the head of his family.[46]

Miller, meanwhile, had reached New Orleans and set to work turning out a set of washes and several finished oils. Consul Crawford wrote Stewart on November 18, 1837, "I was agreeably surprised to see our friend Mr. Miller, who seems all the better for his travels in the Mountains."[47]

While Stewart was attending the 1838 rendezvous in the Rockies, Miller began moving back to Baltimore, arriving in July 1838. He soon had a number of his oil paintings on exhibit at the same time that George Catlin

44. DeVoto, *Across the Wide Missouri,* p. 315.

45. For information on Bonneville's fort, see Washington Irving, *The Adventures of Captain Bonneville, U.S.A., in the Rocky Mountains and the Far West,* ed. Edgeley W. Todd, pp. 49–50, n. 10.

46. Crawford to Stewart, New Orleans, May 2, 1838, and Archibald Stewart, London, August 5, 1836, Bundle 21, Box 101, Murthly Muniments. Archibald says that John is "better but still weak."

47. Crawford to Stewart, New Orleans, November 18, 1837, in the William Sublette Papers, Missouri Historical Society, St. Louis.

was in the city. One reporter noted that the pictures did Miller "much honor," while another perceived "more of the painter than the artist. The true artist, would have endeavoured . . . [to] give us nature in her dress of glorious green, bathing her mountains and her vallies in the light of heaven . . . ," he claimed, but, on the whole, Miller's hometown critics liked what they saw: "Judging from the production of Mr. Miller's pencil that have come under our notice, we have no hesitation in saying that in him the country possesses an artist whose talents are calculated to reflect an enduring reputation in his native land."[48]

Miller returned to New Orleans in the fall of 1838, for he had not completely closed his studio there. "Mr. Miller is expected here soon," Consul Crawford wrote Stewart, who was just returning from the mountains. "I think he got your letter, his pictures &c. are here at his old quarters in Chartes Street, what progress he has made I cannot say, but fear not much—he seems rather lazy." The conclusion was premature, for Miller was working ahead, both on oils and on the series of wash sketches that would summarize his western experience.[49]

Stewart, meanwhile, had other things on his mind. He had just received the news in St. Louis that his brother John had died in Paris and that he had inherited the title and estates of Murthly, Grandtully, and Logiealmond. He did not let himself be convinced of the news until he received the further news that John's wife was not pregnant with a possible heir; he then began to make arrangements to return to Scotland. He also made plans to take a little bit of the American West with him, shipping various native plants and animals for the Murthly grounds. Sublette and Campbell, Stewart's good friends who had helped him arrange all his western trips, spent a great deal of time and effort securing stock for the estate, and even Miller got into the act when Stewart's two buffaloes and a grizzly bear came through New Orleans en route to Scotland. "The male [bison is] . . . giving already an assurance of a goodly sized hump rib & proportionate body," Miller wrote. "The Bear is a most noble fellow."[50]

With news that Stewart was now the lord of Murthly Castle, an elegant old Scottish country house on the River Tay just a few miles north of Perth, the paintings that Miller labored to finish assumed greater importance, for they would surely occupy prominent spaces there. By the spring of 1839, Miller had finished eighteen pictures, which J. Watson Webb, a good friend of Stewart, arranged to have exhibited at the Apollo Gallery in New York before they were shipped to Scotland. Miller wrote Stewart from New Orleans in March that he had just completed packing the pictures and was shipping them via the New York packet *Vicksburg*, which sailed on March 28. Miller probably had also completed arrangements for his return to Baltimore, for he informed Stewart that any further correspondence should be directed there.[51]

Miller's paintings of Indians, landscapes, and camp and hunting scenes created quite a sensation in the city that had only two years before seen Catlin's pictures of the Indians along the upper Missouri River. Miller exhibited eighteen paintings, from the portrait of a seventeen-year-old Arikara squaw to huge views of Stewart's camp at the rendezvous (cat. 170A), to buffalo hunts (pls. 44, 45; cats. 114, 113), to Devil's Gate on the

48. *American and Commercial Daily Advertiser*, July 17, 1838, p. 2, col. 1; Ross, Miller, p. xxii.

49. Crawford to Stewart, New Orleans, October 11, 1838, in Sublette Papers.

50. Lord Breadalbane to Stewart, London, May 25; George Stewart to William Stewart, Murthly, May 30, 1838, both in Bundle 21, Box 101, Murthly Muniments; Ross, *Miller*, pl. 51. "I remain here some time longer in hopes these *Canny* Scots may favor me with some communication which I trust you will forward in case it should [not] arrive until the month of February is past," Stewart wrote Sublette from New Orleans, December 7, 1838, in Sublette Papers. For information on the shipment of plants and animals to Murthly, see Miller to Stewart, New Orleans, March 27, 1839, in Warner, *Fort Laramie*, pp. 147–148; see also Robert Campbell to Stewart, St. Louis, August 29, 1839, Bundle 21, Box 101, Murthly Muniments; and Stewart to Sublette, New Orleans, December 7, 1838, in Sublette Papers. The animals arrived before Stewart did, with the local newspaper noting their passage en route to Murthly through Perth (*Perthshire Courier* [Perth], July 4, 1839, p. 2, col. 6).

51. Miller to Stewart, New Orleans, March 27, 1839, Bundle 21, Box 101, Murthly Muniments.

Sweetwater River (cat. 165B). Miller, of course, was a better trained painter than Catlin, but that hardly explains the reception that the sophisticated public, more used to the studied landscapes of painters like Thomas Cole, accorded him.

The New York *Morning Herald* first noted that the exhibition was popular and "is much frequented at present. The beautiful landscapes of Miller, illustrative of the scenery, sports and Indian society, near the Rocky Mountains . . . are well worth a couple of hours inspection." There was more to come. The *Herald* followed up a week later with the report that "for several days and evenings the town has been delighted with the Pictures painted by Alfred J. Miller." The reporter went on to list and describe the eighteen pictures, commenting that the "principal merit of these works is their originality—boldness and accuracy of drawing and perspective." That seems to be the key to Miller's reception. These pictures represented the first scenes of the Rocky Mountains seen in New York at a time when the nation was becoming interested in the West. The critics were not aesthetically overwhelmed. The *Herald* reporter noted the "slight rawness in the coloring" but concluded that this was "nothing to mar the general effect of the whole."[52]

A look at these paintings today shows that, even when compared to Miller's later work, they are sketchy and sometimes awkwardly composed. Miller, after all, had produced eighteen finished oils and eighty-seven washes, all intended for Stewart, in less than two years. Such a large task might explain some of the difficulty he had with pictures, such as Stewart's camp (cat. 170A) and the *Trapper's Camp* (cat. 120); also Miller was a young artist with little experience in producing such huge paintings. That, plus the subject matter, no doubt explains the excellent reviews. The writer for the *Mirror* called attention to Miller's "life-like force and reality" that promised "rich renown as a painter."[53]

The Apollo executive committee was clearly impressed. The day after the *Herald* review appeared, Augustus Greele, chairman of the committee, wrote Stewart "that the paintings . . . have so far attracted the attention and favor of the public and the public press, that the receipts of the exhibition had more than doubled the amount of any former week since the formation of the Association, and that the attraction continues to

52. *Morning Herald* (New York), May 11, 1839, p. 2, col. 1, and May 16, 1839, p. 2, col. 3. The eighteen pictures exhibited were:
 1. "Camp of the Indians at the rendezvous of the whites, near the Mountains of the Winds." (Cat. 170A)
 2 and 3. "Hunting the Buffalo." (Cats. 113 and 114)
 4. "Approaching a herd of Buffalo, crossing the Platte River." (Cat. 67)
 5. "Baiting a wounded Buffalo." (Cat. 362)
 6. "Hell-Gate-Sweet Water River–Mountains of the Winds." (Cat. 165B)
 7. "Hunting the Grisly Bear." (Cat. 143)
 8. "Butchering a Buffalo." (Cat. 118)
 9. "Portrait of an Arickara Squaw, 17 years of age." (Cat. 301A)
 10. "Portrait of the Big Bowl, principal Chief of the Crow Indians." (Cat. 303A)
 11. "Portrait of a Chief of the Snake nation." (Cat. 294A)
 12. "Greeting of the Snake Indians and the whites, under the Mountains of the Winds." (Cat. 169A)
 13. "Hunting the Argoli, at Big Horn, on Sweet Water River." (Cat. 138B)
 14. "General View of the Indian Camp under the Mountains of the Winds." (Cat. 173)
 15. "One of the Sources of the Colorado of the West." (Cat. 266B)
 16. "Fishing on Grand River." (Cat. 265)
 17. "Trappers' Camp." (Cat. 120)
 18. "One of the Sources of the Colorado." (Cat. 266A)
53. Ibid., May 25, 1839, p. 2, col. 1; *New-York Mirror*, May 25, 1839.

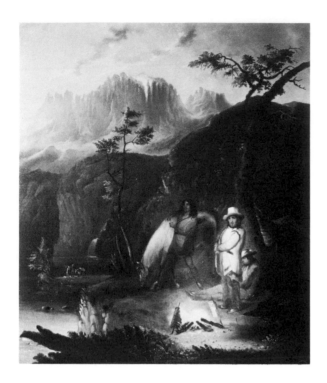

This painting was one of the eighteen exhibited at the Apollo Gallery in the summer of 1839 under the title of *Trapper's Camp*. It appeared "dark but soft" to the reviewer for the *Weekly Herald*. (Cat. 120). Courtesy The Warner Collection of Gulf States Paper Corporation, Tuscaloosa, Alabama

increase." The committee then requested that Stewart permit the exhibition to continue until the close of the season in July. Granting permission, Stewart boarded the *Sheridan* and headed for Liverpool and home.[54]

Miller, finally back in Baltimore and basking in his new-found notoriety, was now at work on a huge canvas for Stewart to be called "The Indian Procession," or "Cavalcade" (cat. 178A). A correspondent for the *Herald* visited Miller's studio and described it: "The scene is . . . one of those waste plains which lie at the foot of the Mountains of the Winds. The tents of the Indians are scattered over a large tract. Around this extensive encampment winds an Indian procession. . . ." This was the arrival of the Snake Indians at the rendezvous, led by Chief Ma-wo-ma. Miller recalled the scene as one of the high points of the summer. "This picture is a work of immense labor," the reporter concluded, "and displays the talents of the artist more to advantage, than any of those you saw at the Apollo in the spring." The picture is 69 x 96 inches and is one of the grandest oils that Miller completed.[55]

Exhibited in what one critic called the "best exhibition of American painting ever presented to the public," Miller's "Rocky Mountain scene" was singled out from among paintings by Thomas Doughty, John Woodhouse Audubon, Henry Inman, Seth Eastman, Thomas Cole, John Quidor, Emanuel Leutze, and other well-known artists as being a "truly remarkable production." The following week the *Mirror* critic urged his readers to see the picture quickly, for it was on its way to the Scotland home of Sir William Drummond Stewart: because of "the novelty of the subject and the skillful execution; its evident truth to nature, and the mastery of its

54. Augustus Greele to William Stewart, New York, May 17, 1839, Bundle 21, Box 101, Murthly Muniments. Stewart left New York on board the *Sheridan* May 25, 1839 (see the *Morning Herald*, May 25, 1839, p. 2, col. 1), arriving at Liverpool after a lengthy trip on June 19. He arrived in Perthshire in late July and immediately took charge of his estates, dining with the villagers and tenants and announcing plans for the construction of another village, Birnam, up the Tay from Murthly. See *Morning Herald*, May 25, 1839, p. 2, col. 1; *Standard*, June 20, 1839, p. 3, col. 3; *Perthshire Courier*, August 1, p. 3, col. 2, August 8, p. 3, col. 3, and August 13, 1839, p. 3, col. 3; and *Jeffersonian Republican*, October 5, 1839, p. 1.

55. *Morning Herald*, October 2, 1839, p. 2, col. 5; for Gray's description, see "Unpublished Journal," p. 61.

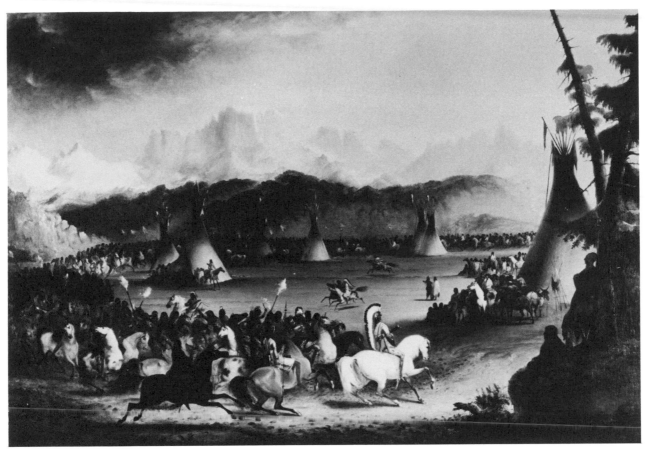

Miller painted the *Cavalcade* after he returned to Baltimore in 1839. It, too, was exhibited at the Apollo before being shipped to Murthly Castle. 69 x 99 inches, it is one of Miller's largest and most successful oil paintings. (Cat. 178A). Courtesy State Museum, Oklahoma Historical Society

difficulties; we fully agree with the uniform opinion expressed by the artists and amateurs who daily congregate around it, that it will attract great attention abroad, and make a favourable impression there of the progress of American art." Another critic agreed: "Perhaps the most striking performance [in the exhibit] is the large painting by ALFRED J. MILLER, the artist who accompanied Sir William Drummond Stewart on his expedition among the American Indians. . . . It is, we presume, beyond all question, the finest painting ever executed of an Indian subject." The picture was soon taken down and shipped, according to Stewart's instructions, to his home at Murthly Castle.[56]

Miller hoped to follow his paintings to Scotland. In his March 27 letter to Stewart he had admitted that "the recollections of our wanderings in the West is growing clear unto me and superseeding [*sic*] others which I thought more indelibly fixed on my imagination," and to the *Herald* correspondent in September he confided that it was probable that he would be invited to Scotland to continue working on his canvases. "He intimated that he might want me," Miller said of Stewart, "and . . . if he were to write to me to lay aside everything here,

56. *New-York Mirror*, November 9, 1839, p. 159, and November 16, 1839, p. 166, col. 1; undated, unidentified newspaper clipping in Miller's journal, in possession of the Miller family, Baltimore; "The large painting by Alfred J. Miller, not upon the walls on account of the short period it can remain in this city" (quoted in *Catalogue of Paintings and Sculpture, by Living Artists in the Fall Exhibition of the "Apollo Association for the Promotion of the Fine Arts in the United States," at the Apollo Gallery, No. 410 Broadway, New-York. October, 1839* ([New York:] Scatchered & Adams, Printers, [1839]), cited in Mary Bartlett Cowdrey, *American Academy of Fine Arts and American Art-Union*, I, 270-271, II, 11, 81, 112, 125, 292, 202, 230).

Murthly Castle was the home of the Stewarts. It is located only a few hundred yards south of the River Tay in Perthshire. Miller lived and painted there from mid-1840 until his departure in 1842. Photograph by Ron Tyler

and join him immediately, I would do so." The invitation was not long in coming. Miller sailed for Scotland in the summer of 1840, and by October 16 was writing his brother Decatur that he was safely ensconced in Murthly Castle (pl. 27, cat. 880) and had already finished two pictures.[57]

Miller apparently arrived about the same time as his pictures, which were shipped from New York in the late summer or fall of 1839. "They have been long enough on the journey to have made a trip to Kamskatca [*sic*]," he wrote his brother. "They are however in good order and have given utmost satisfaction to my friend. Already have frames been ordered for them and as soon as finished they will be suspended in the Library." Stewart was also pleased with the large group of sketches that Miller had prepared in New Orleans immediately after his return from the mountains. They are a fresh and lively group of pen, wash, and watercolor sketches

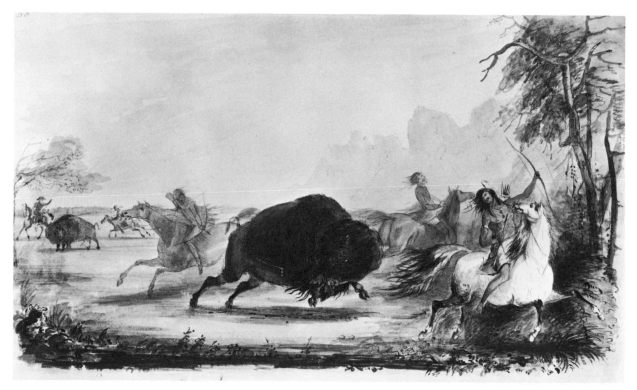

Indians Tantalizing a Wounded Buffalo, one of the watercolor washes from the drawing room portfolio. (Cat. 360). Courtesy Amon Carter Museum, Fort Worth

57. Miller to Stewart, New Orleans, March 27, 1839, Bundle 21, Box 101, Murthly Muniments; *Morning Herald*, October 2, 1839, p. 2, col. 5; Miller to Decatur H. Miller, Murthly Castle, October 16, 1840, in Warner, *Fort Laramie*, p. 154.

Miller painted the *Attack of the Crow Indians* after he arrived at Murthly. It represents a scene that he did not see, one that occurred during the captain's 1833 trip to the mountains. It still hangs in Murthly Castle. (Cat. 377A). Courtesy Donald Steuart Fothringham

This lithographic copy of the *Attack of the Crow Indians* was published in *The Red Book of Grandtully*, a history of the Stewart family, commissioned by Sir William. Miller received no credit for the painting. (Cat. 899). Courtesy National Library of Scotland, Edinburgh

that Stewart kept in a "richly bound portfolio" in the drawing room (cat. 360). They were "one of the Chief Attractions . . . to . . . distinguished visitors who are profuse in their compliments to me," Miller wrote his brother.[58]

After finishing two smaller pictures, Miller began work on a large canvas that would be a companion to *The Cavalcade*, which he had painted in Baltimore in the summer and fall of 1839. Stewart liked the large format and had plenty of walls at Murthly that would hold another large picture. He chose as the subject for this picture an incident that Miller had not seen but that had apparently been described to him in detail, for he also did several watercolors of it: "Crows Trying to Provoke the Whites to an Act of Hostility," or "Threat by Crows," as Miller called the picture—the *Attack by the Crows*, as it is known today (cat. 377A). The incident occurred during Stewart's 1833 trip to the Rockies. According to the story that Miller heard, a large number of Crows confronted Stewart's greatly outnumbered party. They had been told by their medicine man that they would not be victorious if they struck the first blow, so they surrounded Stewart's party and began to taunt them, hoping to goad them into a battle. But the white men held their temper and did not strike. In reality,

58. Miller to Miller, Murthly Castle, May 19, 1841, in Warner, *Fort Laramie*, p. 154; see also Parke-Bernet Galleries, Inc., *A Series of Watercolour Drawings by Alfred Jacob Miller, of Baltimore: Artist to Captain Stewart's Expedition to the Rockies in 1837.* Originally there were eighty-seven paintings; Nos. 35, 37, 64, and 77 were missing and presumed lost at the time of the auction. See p. 9 of the catalogue. Robert Combs Warner indicates that one of the four is still in England.

the Indians overawed Stewart and took several items from his camp. Miller predicted that this picture and the other sketches selected to be made into oil paintings would keep him occupied all winter.[59]

Stewart decorated his lodge, which is located at the corner of the garden south of the castle, to remind him of the mountains. (The story uncovered by Mrs. Mae Reed Porter, during her research on Stewart, explains that he slept in the lodge because of his vow never to spend another night under the Murthly roof. He later moved into the castle but satisfied his conscience by adding new rooms to the castle and reasoning that this was not the same cursed roof.) He spread magnificent buffalo robes over a damask sofa and kept his tomahawk on a small table nearby. A number of Miller's paintings, including *The Death of the Panther* (cat. 146), *Return from Hunting,* (cat. 119A), *Indian Belle Reclining* (cat. 463B), *Auguste* (cat. 53), *Roasting the Hump-rib* (cat. 120), *Porte d'Enfer* (cat. 165B), were suspended from brass rods along the ceiling. Indian pipes mingled with Turkish chibouks and meerschaumes in another part of the room. Miller probably spoke for himself as well when he wrote his brother that "these recollections must be to him grateful and pleasant for our remembrance of pleasure is always more vivid than the reality."[60]

Miller was accepted as a member of the household, along with Antoine, whom Stewart had brought back with him and dressed "in a full suit of black" to wait on the table as a Scottish valet. Stewart also presented Antoine with a Highland suit (the cost of which Miller estimated at £50) so that he could attend the local parties in style. Miller himself apparently spent most of his time at the castle. Stewart was away much of the time, and when his son, George, also was away, Miller sometimes played host.[61]

Miller obviously liked the situation at Murthly. He had a "delicious little painting room which looks out upon the garden & when I raise the window in the morning—the birds pour in a perfect flood of song." When he wanted to take a break he went into the library, which, "most especially on a rainy day, is sure to tempt me." Composed of a wide variety of "choicest authors on almost every subject," the library, particularly the "large velvet lounges near the fire," was a favorite haunt of the artist. For exercise, Miller took walks around the castle each day, going through the garden (pl. 27, cat. 880) or to the chapel near the River Tay, which flows within half a mile of the castle. On one occasion he went up the river a few miles to Birnam, past the only two surviving trees of the wood that Shakespeare made famous. On another, he walked the several miles to where Stewart was supervising the construction of a hunting lodge at Rohallion. But mostly he stayed near the castle, because he apparently suffered from rheumatism, which either began or worsened during his trip to the Rockies, and he got little relief, either from the Edinburgh doctor that Stewart recommended or from the dozen bottles of "celebrated Strathpeffer water" that he ordered from Inverness.[62]

Still, Miller was healthy enough to undertake another huge canvas. After he finished the *Attack by the Crows* in May 1841, Stewart requested an oversized *Trapper's Bride* (cat. 191A; see pl. 67 for another example of the painting). Miller ordered a 10 x 8 foot canvas from London and set to work. "The foreground figures [will be] full the size of life," he wrote his brother. "There is no joke in painting such a picture," he wrote the following

59. This huge and superbly painted 60 x 108 inch canvas still hangs in Murthly Castle, but its life has been somewhat hectic, for it was sold at auction in Edinburgh in 1871 and later bought back by the family. Stewart chose this picture—and this is the only picture by Miller included—for illustration in *The Red Book of Grandtully,* which he commissioned as a history of his family in 1868 (p. 41, cat. 899). Miller is given no credit as the artist; see Miller to Miller, May 19, 1841, in Warner, *Fort Laramie,* pp. 174–175. See also Ross, *Miller,* pl. 179; Sir William Fraser, *The Red Book of Grandtully,* opp. p. ccxlii; and the Reverend William Anderson, "Sir William Drummond Stewart and the Chapel of St. Anthony the Eremite, Murthly," *The Innes Review: Scottish Catholic Historical Studies,* 15 (1964): 158.

60. Miller to Miller, Murthly Castle, December 25, 1840, in Warner, *Fort Laramie,* pp. 168–169; Porter and Davenport, *Scotsman in Buckskin,* pp. 18–19.

61. Miller to Miller, Murthly Castle, October 31, 1840, in Warner, *Fort Laramie,* pp. 162–163.

62. Miller to Mayer, Murthly Castle, October 18, 1840; Miller to Miller, Murthly Castle, December 3, 1840; and Miller to Harriet Miller, Murthly Castle, March 22, 1841, in Warner, *Fort Laramie,* pp. 157, 165, 172, 183.

month. "If you should hear of my having broken my neck, you need not be surprised, as the canvas is 10½ feet in height." In July he wrote, "The picture of the Trapper's Bride is progressing rapidly and seems to give much satisfaction to Sir Wm Stewart, who visits the painting room almost every day after luncheon to examine and perhaps to offer a criticism on any point wherein he thinks I may be wrong . . ." Again, in September, he reported, "My large picture progresseth right speedily The Indian girl hath a pensive, dreamy expression and the 'womankind' say beautiful exceedingly. Indeed I do most marvellously lack judgment if this prove not to be one of my best pictures and am hugely pleased that it savoureth not of paralysis like the archbishop of Grenada's homilies." He predicted that he would be finished with it in a month and joyfully reported on November 1 that he had just completed "my large picture of the 'Trapper's Bride' which has occupied my time longer than I expected, but am amply repaid for the trouble by the admiration it excites."[63]

The artist's task at Murthly was rapidly drawing to a close, but he had one more commission to complete before he returned home. Sir William asked him to do a religious picture for the chapel, which he was in the process of renovating, and gave him the choice of painting the picture in Edinburgh or London. Miller chose London and left Murthly on November 11, headed for Dundee, where he caught a steamer for London.[64] Taking a room on Berrand Street near the National Gallery, Miller set to work on a religious subject, which, he warned Sir William, would be "entirely new to me." He sent him two sketches, one "The woman anointing Christ's feet and wiping them with her hair, in Simon the Pharisee's house," the other "Christ raising from the death of Jarius' daughter." He asked Stewart's advice and preference, declaring that he would "make every effort to give you a respectable picture." To his brother, Miller confided even more doubt: ". . . am about to paint . . . a religious subject. I do not know how I shall succeed with it."

The record is not clear, but Stewart apparently told Miller to proceed with both pictures, for some time later Miller wrote the baronet asking if he might be able to pay a little more for the two pictures completed while he was in London, stating that previous payment only covered expenses. Miller began painting "Mary Magdalen anointing the feet of our Saviour, and wiping them with the hair of her head" in December. Again it was a large composition, including twelve life-size figures. He continued into February 1842, writing his brother that there were then fourteen life-size figures "besides accessories." "I am delving away at my picture as fast as 'London fogs' and my present state of health will permit for I expect that Sir Wm. will be here about the latter end of this month, and I wish to have it in a state of readiness for his criticism and censorship." "I am steadily working," he wrote Sir William, "whenever there is light at all."[65]

Stewart must have liked Miller's religious pictures, for he continued to commission them. When Stewart returned to the United States in 1842 for a last trip to the Rocky Mountains, he visited Miller in Baltimore. As a result of that meeting, Miller prepared several sketches for Stewart's approval: "Paul's defence before Agrippa," "Ruth, Boaz and the gleaners," "The Prodigal Son," "David and Abigail," "The Good Samaritan," "Sacrifice of Abraham," and "Christ disputing with the Doctors."[66]

At least one of these pictures was completed, for Miller wrote Stewart in August 1845, thanking him for the payment and noting that he was beginning yet another religious picture, *Christ's Charge to Peter.* He made three sketches of the picture, then chose his favorite. He pointed out that he would "take care to procure models and execute as much of the picture from nature as I can."[67]

63. Miller to Miller, Murthly Castle, May 29, June 24, November 1, 1841, in Warner, *Fort Laramie,* pp. 174, 176, 183.

64. James W. Shay to Stewart, Murthly Castle, November 12, 1841, Bundle 22, Box 101, Murthly Muniments.

65. Miller to Miller, London, November 22, and Christmas Day, 1841, and February 10, 1842, in Warner, *Fort Laramie,* pp. 185–192; Miller to Stewart, London, February 25, 1842, and Baltimore, November 20, 1843, in Bundle 22, Box 101, Murthly Muniments.

66. Miller to Stewart, Baltimore, March 16, 1844, Bundle 22, Box 101, Murthly Muniments.

67. Miller to Stewart, Baltimore, August 23, 1845, Bundle 22, Box 101, Murthly Muniments. When J. Watson Webb of New York visited Murthly in 1844, he found Stewart "surrounded . . . by galleries of magnificent paintings, executed by our countryman MILLER . . ." (see Stewart, *Altowan,* p. x).

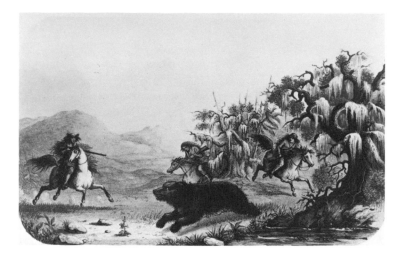

A figure on the left that could represent Stewart is shown chasing a grizzly bear from the bushes. This chromolithograph was produced by L. Rosenthal of Philadelphia for use in C. W. Webber's *The Hunter Naturalist. Romance of Sporting*, published in 1851. (Cat. 902). Courtesy Amon Carter Museum, Fort Worth

Stewart also had another project in mind for Miller, a set of lithographs, probably of his western pictures. Aware of Karl Bodmer's trip to the West with Prince Maximilian, since he had met them in St. Louis in 1833, Stewart probably also was aware that both Bodmer and Catlin were publishing handsome portfolios of colored prints of their western pictures and raised the possibility of a set of prints with Miller in February 1842. "I received your esteemed favor of the 20th and must ask your kind indulgence until I reach home before I attempt the lithographs," Miller responded. "I am sure I should not like to offer any things of the kind without having bestowed some labour on them and I feel that this would be impossible at the present as I am sick both in body and mind—a depression and anxiety hangs over me that I cannot throw off. I shall think myself fortunate in being able to finish the present picture at which I am steadily working," he concluded.[68]

Miller did try his hand at several prints once he returned home, but never in the lavish format that Bodmer, and later Catlin, achieved. He first permitted a series of chromolithographs (colored lithographs printed completely from three or more stones, see pl. 119, cat. 901) to be made for Charles Wilkins Webber's two books, *The Hunter-Naturalist: Romance of Sporting* and *The Hunter-Naturalist: Wild Scenes and Song-Birds* (see Appendix I). At least one separately issued chromolithograph is known, a large-format print entitled *Lost on the Prairie* (pl. 54, cat. 898). Any further projects that Miller might have planned were preempted when Bodmer's, Catlin's, and Thomas McKenney's and James Hall's superb portfolios appeared in the 1840s. There would have been trouble financing such an undertaking, and, with the appearance of these other portfolios, there would have been a genuine question about the possible market. Further, Miller earned much of his income from copying his sketches for clients like William T. Walters, an idea he might have gotten when he saw how many copies of his paintings that Catlin was selling in Europe, and a print portfolio might have detracted from this income.[69]

Miller kept up his contact with Stewart, and Stewart visited the artist in Baltimore when he was in the United States for his final trip to the mountains in 1842-43. There might have even been an invitation to accompany

68. Miller to Stewart, London, February 25, 1842, Bundle 22, Box 101, Murthly Muniments. Bodmer's engravings were published in 1840 in Paris: Maximilian, Prince of Wied-Neuwied, *Voyage dans l'intérieur de l'Amérique du Nord . . .* ; Catlin's lithographs were published in London: *Catlin's North American Indian Portfolio; Hunting Scenes and Amusements*

69. Miller to Stewart, London, February 25, 1842, Bundle 22, Box 101, Murthly Muniments. All the known Miller prints have been listed in the Catalogue Raisonné. See Thomas L. McKenney and James Hall, *History of the Indian Tribes of North America, with Biographical Sketches and Anecdotes of the Principal Chiefs.*

him again, but Miller would have refused because of his poor health. It was just as well, for Miller had already created an unparalleled pictorial record. For one who wrote about his 1837 adventure to the Rocky Mountains in such stiff and lifeless prose, Miller painted it freely and spontaneously. Perhaps words failed him because he waited until his return to civilization to compose them—they were couched in Miller's Baltimorean formality—but his washes and watercolors, sketched on the spot and vibrant in their color and composition, embody the enthusiasm that he must have felt as he began his great adventure—"a new and wider field both for the poet & painter," as he wrote his friend Brantz Mayer. In addition, they form a unique document of the West before it was settled and "civilized." The mountain men were America's vanguard on the frontier, and Miller was the only artist to see them in their element while the fur trade was at its height.[70]

70. Miller to Robert Gilmor, Franklin, October 13, 1842, in the Dreer Collection (Paintings & Engravings, Historical Society of Pennsylvania, Archives of American Art Microfilm, Roll P20, frame 522), asking Gilmor to receive Stewart while he is in Baltimore. Miller probably did a total of twenty to thirty oils for Stewart. When Stewart died in 1871 (see the *Glasgow Herald*, April 29, 1871, p. 4, col. 4), he left all the movable items in Murthly to his adopted son, a Texan named Frank Nichols Stewart: (He had wanted to leave everything to Frank, for his only son, George, had died in October 1868, but he could not because the estates were entailed.) Frank Nichols Stewart promptly took all the paintings, tapestries, furniture, books, and jewelry in Murthly to Edinburgh and auctioned them off at Chapman's on Hanover Street. (See the *Glasgow Herald*, May 11, p. 4, col. 3, and May 20, 1871, p. 5, col. 5, for the dispute over the inheritance and its resolution. See the *Scotsman*, June 1, p. 8, col. 2, June 17, p. 2, cols. 3 and 4, and June 19, 1871, p. 2, cols. 4 and 5, for an account of the sales.) Most of the Miller paintings, including the sketches that were kept in the drawing room, have now made their way back to the United States. Only two paintings remain at Murthly: *Death of the Panther* (cat. 146) and *Attack by the Crows* (cat. 377A). Several, including *The Trapper's Bride*, remain lost. See also Porter and Davenport, *Scotsman in Buckskin*, pp. 272–274. For quote, see Miller to Mayer, St. Louis, April 23, 1837, in Warner, *Fort Laramie*, p. 144.

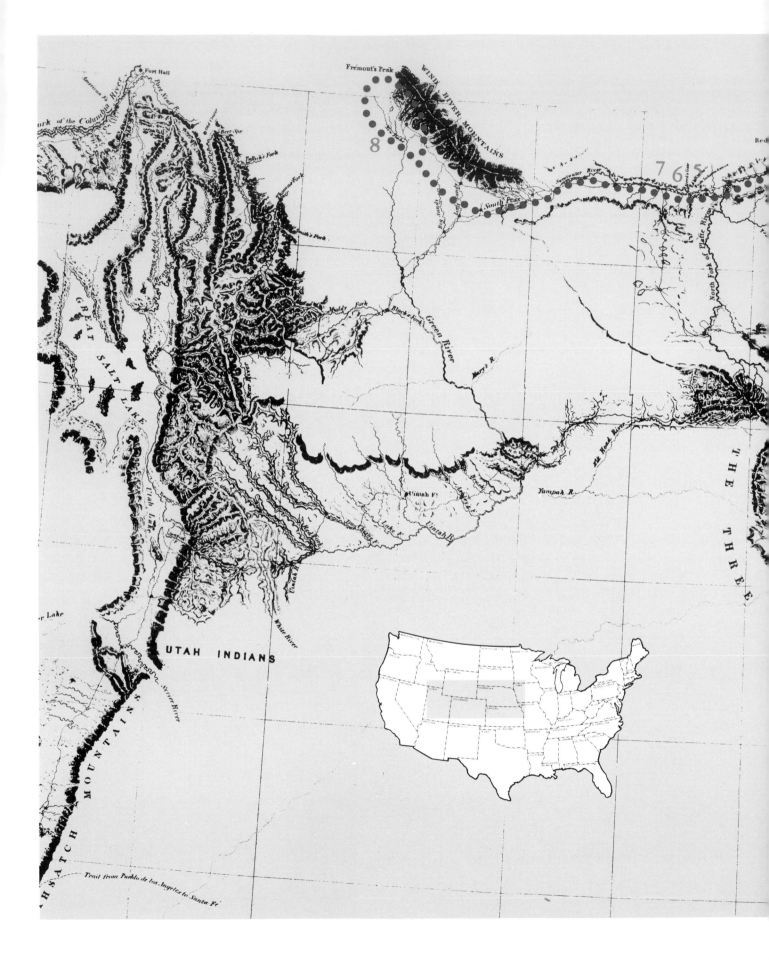

CAROL CLARK

A Romantic Painter in the American West

"Sure you're romantic about American history . . . it is the most
romantic of all histories. It began in myth and has developed through
three centuries of fairy stories."

—Bernard DeVoto to Catherine Drinker Bowen[1]

During the 1830s three artists, two Americans and one Swiss, traversed the West in search of imagery to satisfy their own thirst for adventure and to respond to the public's growing curiosity about the farthest reaches of the American wilderness. These artists, George Catlin, Karl Bodmer, and Alfred Jacob Miller, were part of a tradition, inspired by the European Enlightenment, of inquiry into America. They came to the West encumbered with mythical baggage from the Enlightenment ideal of the noble savage and America as hope for the Old World's redemption. The remarkable natural setting, people, and wildlife that they found so interesting had fascinated Europeans from the first hint of the existence of a continent between Europe and the Orient.

Catlin, Bodmer, and Miller crossed the Mississippi on the verge of the West's settlement and civilization (or corruption in the terms of the Enlightenment). That Miller and the others discovered the West at such an important era of transition necessarily colored their vision, for they saw the land and its inhabitants through nostalgic eyes—either as scientists ready to record that which would soon pass or as romantics wanting to evoke the beauty and terror of a vanishing landscape and people.

It is only surprising that it took the American public so long to embrace western imagery and to recognize the contributions of exploration artists. During the 1830s, European interest in the American West was strong, and European usually preceded native attention to western painting. Catlin was proud of the reception and critical acclaim given his "Indian Gallery" as the paintings toured American cities between 1837 and 1839, but in 1840 he took the exhibition abroad in search of greater financial success. Karl Bodmer was Swiss-born and part of a German prince's exploration party, and Alfred Jacob Miller's patron was Scottish. Although Miller earned a reputation in America, European training and patronage shaped his vision. American artists also longed for success abroad. Western imagery might garner attention in London or Paris and, in turn, appeal to the American public precisely because of its European acceptance. As late as 1867, Henry T. Tuckerman, eminent biographer of American artists, was just beginning to recognize the West's potential and, with no apparent knowledge of Bodmer or Miller and scant information on Catlin, found it "somewhat remarkable that a field so peculiar to our country has not been more ardently explored by native artists and authors." Tuckerman recommended that artists "seize upon themes essentially American," in order to "earn trophies abroad," and patrons at home.[2]

European romanticism rather than a strictly nationalistic westering experience holds keys to the spiritual and artistic sources for western art of the 1830s and 1840s. The American land, unencumbered by ancient ruins and untrampled by generations, impressed foreign travelers. In the first decades of the nineteenth century, American artists, such as British-born Thomas Cole, discovered an audience for a style and subject matter that united

1. Undated letter in Wallace Stegner, *The Letters of Bernard DeVoto*, p. 285.
2. Henry T. Tuckerman, *Book of the Artists*, pp. 424–425.

European romanticism and national themes. The American land provided its own natural history for those who chose to read and interpret it as Cole did. Yet Cole's wilderness was still eastern, and adventure beyond New England and the Atlantic states held little appeal for him. European precedents firmly held him, and he clung to the ideal of arcadian Italy. The imaginative veil of memory, Cole believed, was as important as the American scene that inspired the reverie and ultimately produced a picture. His patrons had to exort him to cease painting "fancy" pictures and to devote his energies to American subjects.

In his published writings as well as his paintings Cole expressed fears that the American wilderness was disappearing and he longed to stop the progressive and seemingly inevitable advance of civilization. In his 1835 *Essay on American Scenery,* he wrote passionately of his "sorrow that the beauty of such landscapes are quickly passing away—the ravages of the axe are daily increasing—the most noble scenes are made desolate, and oftentimes with a wantonness and barbarism scarcely credible in a civilized nation."[3]

Miller shared Cole's concern, and, while not as eloquent, he recognized that he was painting an evanescent West, with Indians "melting away like snowflakes in the sun."[4] Miller looked on the West as preserved antiquity which was ready for discovery by the ardent traveler for whom "these mountain Lakes have been waiting . . . thousands of years . . . for they are now as fresh and beautiful as if just from the hands of the Creator."[5]

To us who are used to travel by train and plane, who can fly over the Wind River range by day and camp in Yellowstone that night, and who know the West through film and color photographs, it may be difficult to imagine the strangeness of the land to those first artists who dared to paint it. Why during the 1830s were they so ready to explore, discover, and paint these uncharted territories and to risk the dangers of hazardous travel, Indian attack, and the peril of wild animals to do so? It was because the romantic spirit was abroad in America fresh from triumphant conquests in Europe.

Miller had ample opportunity to study English romantic portraiture while a young artist in Baltimore. Although he painted historical and genre scenes, Miller committed himself early to portrait painting through which he hoped to earn a reputation and a living. We may think of more daring and exotic subjects as typical of European and American romantic painting, yet the romantic artist's intense interest in people and individual expression contributed to the success of portraiture through the era of the daguerreotype. Even Miller's Indian portraits, so expressive of character, costume, and mores, were an extension of his romantic as well as practical commitment to the profession of portrait painter.

Sir Thomas Lawrence was an important model for the young Miller, and although Miller would later boast of the epithet the "American Raphael," he was also known somewhat more modestly as the "Lawrence of America." Miller's portraits, however, never reached the height of Lawrence's, and it seems unlikely, as has been claimed, that he was ever a student of Lawrence's American pupil, Thomas Sully. Nevertheless, Miller enjoyed some success as a portrait painter prior to his European sojourn, benefiting from the patronage of Robert Gilmor and the Hopkinses, among other prominent Baltimore families. In light of this and his extensive European experience, it seems strange that Miller would have abandoned a career in Baltimore and set out for New Orleans as he did in 1836. Perhaps it was personal losses coupled with unfulfilled high expectations upon returning from the heady experience of a young painter among the lights of old master and contemporary European artists. It is significant for Miller's career, particularly the western portion of it, that he fled to a city known for its foreign visitors and as a starting place for travel up the Mississippi and into the American western

3. Thomas Cole, "Essay on American Scenery," reprinted in John W. McCoubrey, *American Art, 1700-1960: Sources and Documents,* p. 109.
4. Miller, *Rough Draughts,* no. 35.
5. Ross, *Miller,* pl. 59.

territories. On this western journey Miller brought with him artistic experiences gained from his travel and training in Paris and Rome.

Before he had thought of New Orleans or the West, Miller recognized the importance of European study. He took advantage of offered financial support and chose the newly popular French capital rather than the London schools selected by his predecessors. He studied at the École des Beaux Arts in Paris, but equally instructive and inspiring were his experiences observing and sketching at the Louvre and the Luxembourg Gallery as well as his acquaintance with other young romantic artists. He copied Giorgione, Rembrandt, Jacob Ruysdael, and Salvator Rosa, artists admired by other nineteenth-century romantics. Although these Renaissance and Baroque artists influenced Miller's work only in a general way, the American artist probably chose them because he had lofty goals to be a painter of historical, religious, and literary scenes. He also copied two more contemporary models, the English romantic, J. M. W. Turner, and the French romantic, Eugène Delacroix, whose influence is most important for Miller's subsequent pictures.

Delacroix's presence in the Parisian art scene must have seemed powerful to the American artist. In Miller's Parisian sketchbook, still in the possession of the Miller family, are sketches after elements of Delacroix's *La Barque de Dante* undertaken in the Luxembourg and dated 1833. Study of this painting, in which Delacroix experimented with color, may have prompted Miller to copy or devise color wheels of his own which he drew in the front of this same sketchbook. Miller made no notes on either the primary or tertiary color charts of the visual or emotional effects he hoped to achieve from such studies.[6] Yet attention to Delacroix's paintings and to the theoretical basis of color effects popular in Paris give adequate support for Miller's conscious balancing of the compositional and emotional results of color in his western watercolors and oils.

Although they appear not to have met, it is likely that Miller knew of Delacroix's journey to Morocco and Algiers, undertaken just months before the American's arrival in Paris. Paralleling Miller's later experience with William Drummond Stewart, Delacroix was taken to Morocco by Comte de Mornay, the young diplomat who wanted an artist to accompany him and record the events of his exotic journey. Like Miller just five years later, Delacroix was along to paint a fabulous holiday, afforded by the king of France's desire to establish good relations with the newly acquired Algiers.

Miller's first touch with the American West was an accidental meeting with Stewart in New Orleans, while for Delacroix this journey was the fulfillment of a long-held wish to travel within an oriental culture. Their sponsors, Mornay and Stewart, enabled each artist to penetrate parts of exotic cultures which would have been closed to them as independent artist-travelers: for Delacroix this was the sultan's residence; for Miller, events of the rendezvous. Miller intended later to develop his watercolor field sketches into monumental oils for his Scottish patron, but, even if Delacroix had similar plans, he only finished a handful of the watercolors from the seven notebooks with which he returned. This problem was common in the nineteenth century, as fewer grand spaces for monumental paintings were available to a bourgeois society.[7] Although the huge walls of Stewart's Murthly castle were certainly sufficient for Miller's oils of the late 1830s, the artist's field and commissioned watercolors and smaller oils were more appropriate to their period.

The brilliant light and color of Morocco and Algiers brought new vigor to Delacroix's palette, and his first-hand experience with an exotic culture introduced him to new canons of beauty. Admiration of exotic types was typical of the romantic spirit in art, which found the American Indian either a noble remnant of a once strong culture or a vicious savage preventing the spread of civilization. Paralleling Delacroix's experience, Alfred

6. My thanks to Charles Parkhurst, who explained Miller's color wheels and their precedents to me.
7. Walter Friedlaender, *David to Delacroix*, p. 129.

Jacob Miller relished the opportunity to observe Indian tribes and to experience a different culture as he traveled west with Stewart.

To the romantic mind the animal world was an important link to primitive people.[8] Miller's interest in painting horses, in particular, was part of a broader nineteenth-century fascination. The horses in Morocco held Delacroix's attention, and among his favorite subjects were the wild events of horsemanship displayed by the Africans. Wild animals at the zoo outside Paris impressed Delacroix and Théodore Géricault, who also painted wild horses in the streets of Rome. Miller frequented the animal fights conducted outside Paris, finding in this natural study action he could not see in the studio.

In his notebooks Miller scattered nature studies among his sketches after paintings, including one in pen and ink and watercolor of a weary horse standing in water. In order to paint the idealized horses he included in many of his works, Miller needed to know the anatomy and expressions of actual horses, for he observed and painted them faithfully.

Perhaps even more significant is Miller's attention to the most famous group of horses from antiquity, those represented in the Elgin marbles, carried from Athens by Lord Elgin, that Miller studied and sketched in London. Miller's observations of the Elgin marbles, particularly the mounted horsemen, are sensitive and fluid and are interspersed with studies of horses "after nature." Miller's European drawings and watercolors are more than surface studies to perfect his execution. He also made phrenological sketches suggesting that the surface of man (or beast) held clues to his inner nature, and that the artist could penetrate such meaning through his study of expression.

Miller's European experience was influential throughout his career. Some of his earliest critics recognized French parallels to Miller's work and expressed hope that this would win him appreciation abroad. In a review of the Apollo Gallery exhibition in the *New-York Mirror* for November 16, 1839, a reporter noted that *The Indian Procession,* or *Cavalcade* (cat. 178A), "is a work which would not discredit Horace Vernet himself, if he had painted it, and by the novelty of the subject and the skillful execution; its evident truth to nature, and the mastery of its difficulties, we fully agree with the uniform opinion expressed by the artists and amateurs who daily congregate around it, that it will attract attention abroad, and make a favorable impression there of the progress of American Art."[9] Important, of course, is the overt reference to the French romantic painter, Horace Vernet, director of the French Academy in Rome and an acquaintance of Miller, as well as praise of the romantic attributes of "novelty" and "truth to nature." Equally significant is the critic's insistence that Miller's painting will inhance the fame of American art abroad, since it was soon to be shipped to Miller's Scottish patron, Sir William Drummond Stewart. Almost a century later, critics turning again to Miller's works still acknowledged the artist's European orientation, from study and artistic influence to patronage. Macgill James observed that Miller "paints the noble red men resplendent in their glory. What matter if a buffalo hunt is slightly à la Delacroix, and the braves are mounted upon fiery steeds which might have come from the studies of the French romantics?"[10]

We only assume Miller's first reaction to the West from secondary sources and from the artist's recollections. He kept no journal of his season in the Rockies, but he brought with him firm preconceptions about the role of an artist. These romantic attitudes lured Miller west much more than could any purely American urge for exploration. As a nineteenth-century romantic, Miller might have elected to follow Delacroix to Morocco, to

8. Hugh Honour, *Romanticism,* p. 311.
9. "The Fine Arts, The Apollo Gallery,"*New-York Mirror,* November 16, 1839, p. 166.
10. Macgill James, "Noted Baltimore Artist Represented in Exhibit," *Sun,* December 3, 1933.

Greece, or even farther east. Yet, as an American artist he chose to take advantage of that which was exotic within his own country—the Indian, the mountain man, and the western landscape.

Until his meeting with Captain Stewart in New Orleans, Miller's specific interest in Indians had gone no further than an 1828 painting, *The Murder of Jane McCrea*, now lost but undoubtedly part of the romantic revival of interest in this event from the War of Independence, which was popularized in an early nineteenth-century poem about British-inspired Indian atrocities.[11]

The anticipation of pure adventure rather than a special zeal for Indians attracted Miller to Stewart's expedition to the Rocky Mountains. The artist's experiences in Europe, Baltimore, and New Orleans had trained him as a good observer, and he could easily apply his skills as portrait painter to the many tribes of Indians he would see along the way and at the rendezvous. He knew of George Catlin's excursions although he had not seen his predecessor's portraits or landscapes, which had briefly toured Pittsburgh and Cincinnati in 1833.

If the Indian did not inspire Miller's journey as he had Catlin's wanderings, the Baltimore artist at least pleasurably anticipated his western trip, because it would provide "a new and wider field both for the poet & painter," as he wrote to Brantz Mayer from St. Louis in 1837. Still he relished the chance to paint Indians, "for if you can weave such beautiful garlands with the simplest flowers of Nature—what a subject her wild sons of the West present, intermixed with their legendary history."[12] Several years after his western trip Miller expressed appreciation of his first-hand knowledge of the Indians and realized that he was one of the few who possessed the visual experience to challange his rival Catlin. "There is in truth . . . a great deal of humbug about Mr. George Catlin," he wrote his brother from London in 1842. "He has published a book containing extraordinary stories and luckily for him there are but few persons who travelled over the same ground."[13]

In "travelling over the same ground" William Drummond Stewart, actually and spiritually, led Miller to an appreciation of the noble savage. As a romantic European who had fought at Waterloo, Stewart subscribed to the mid-nineteenth-century view of the American Indian as a mysterious creature, wild and unpredictable, yet noble in his freedom from civilization's constraints. Stewart brought Indians back to his family home, Murthly Castle in Scotland, which in turn he adorned with Miller's huge Indian paintings. The Scotsman impressed Miller with his views of the Indian and dictated Miller's artistic interpretation. While engaged in painting the *Trapper's Bride* (cat. 191A) at Murthly, Miller wrote to his brother that Stewart "visits the painting room almost every day after luncheon to examine and perhaps to offer a criticism on any point wherein he thinks I may be wrong and woe to the Indian who has not sufficient dignity in expression and carriage, for *out* he must come."[14]

As much as Stewart wanted a record of the 1837 journey, his needs were much more personal and interpretive than those of other contemporary European travelers, such as Prince Maximilian. Stewart's trip was a nobleman's adventure full of Indian maidens, buffalo hunts, long evenings of western tales, and feats of horsemanship by Europeans and Indians alike. Since Stewart wanted imagery consonant with his viewpoint, Miller's field sketches are not scientific and focus only on the broadest view of the landscape. Miller recorded some of the more dramatic sites along the way, and these are easily identified. Yet the haze of memory clouds each, and the landscapes are as idealistic as they are real. Stewart and his chosen artist, Miller, were not interested in the literal view of the West—they did not intend to make maps or to engrave prints of the flora and fauna. Nor

11. Jane McCrea's story was given national attention in 1822 at the time of her reinterment at Fort Edward. See Samuel Y. Edgerton, Jr., "The Death of Jane McCrea: The Tragedy of an American *Tableau d'Histoire*," *Art Bulletin* 47, no. 4 (December 1965): 481–492. William Johnston kindly pointed out to me that there is no proof, as has been claimed, that Vanderlyn's *The Death of Jane McCrea* was exhibited in Baltimore.

12. Miller to Mayer, St. Louis, April 23, 1837, in Warner, *Fort Laramie*, p. 144.

13. Miller to Miller, London, February 10, 1842, in ibid., pp. 191–192.

14. Miller to Miller, Murthly Castle, July 26, 1841, in ibid., p. 180.

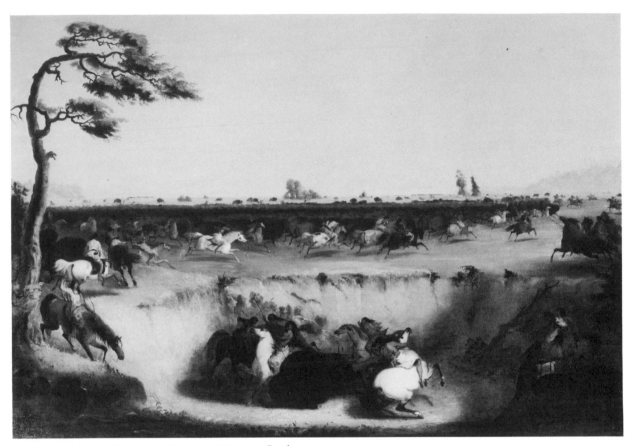

The Surround. (Cat. 353). Courtesy Joslyn Art Museum, Omaha

did they have to convince anyone to settle in the West or to choose a certain site for a railroad. These were pictures for a Scotsman's personal pleasure and, for Miller, the raw material of future commissions. In his letter to Brantz Mayer from St. Louis, Miller expressed his attitude about interpretation of his forthcoming western adventure. "It's best, never to be too explicit (I have found in painting that whenever I left anything for the imagination to fill up, that it invariably did me more than justice)."[15] Miller wrote as an American romantic, aware of his viewer's participation and of the dangers of too literal an interpretation.

Stewart, whose imagination would expand Miller's western art, was the viewer the artist most wanted to impress; Miller recognized that the imaginative potential of his paintings appealed to his patrons. Later, recalling his meeting with Stewart, he recounted that the Scotsman had admired the *View of Baltimore from Laudenslager's Hill* (cat. 820) on his easel, in which the sun was "throwing a mysterious haze over every object," and where "a general mist rested over everything." Miller went on to conclude that "this mistiness was pleasing to the observer [Stewart] because it leaves his imagination full play."[16]

Miller's western landscapes fall within the tradition of the early "Hudson River School," an unaffiliated group of artists who took pleasure in painting scenery near the Hudson and in New England. Miller's works are simply composed and pleasingly framed by rocks and blasted trees. The artist provides the viewer access to the

15. Miller to Mayer, St. Louis, April 23, 1837, in ibid., p. 144.
16. Miller's Journal, Miller family, Baltimore, quoted in Ross, *Miller,* p. xvii.

middle and background by means of a few mounted or standing Indians who gaze in awe at a lake and mountains or who gallop furiously into the distance. The small figures and seemingly insignificant incidents (of trappers building campfires or fording streams) are actually very important in order to understand Miller as a landscape painter. He painted events of the journey rather than pure landscapes and described the scenes in great detail in the narrative that accompanies the Walters watercolors. Even when he located a scene no more specifically than "a gorge in the vicinity of the Rocky Mountains," he elaborated upon the precise events painted in the foreground.[17]

Although Miller was not trained or particularly adept as a landscape painter and often had difficulties with the perspective of distant mountains, his western landscapes attracted a good deal of attention when he exhibited them at the Apollo Gallery, New York, in the spring of 1839. The *Morning Herald* reported that "the beautiful landscapes of Miller . . . are well worth a couple of hours inspection."[18] Referring to a painting of the Wind River Mountains, the critic evaluated the scenery as "of the most superb and romantic character,"[19] and certainly worthy of artistic attention.

Comparison of the American West to romantic European mountain scenery was common throughout the nineteenth century. Miller's critics found his American imagery far superior to that which he could have painted in the Old World. "The Alps are nothing to these cold, blue Mountains of the Wind," wrote the *Morning Herald* critic of *Camp of the Indians at the Rendezvous* (cat. 170A).[20] Artists sought legitimacy for American landscape, however, by favorable comparison to Old World monuments rather than to European scenery. America's history was a natural history, and if her land lacked the historical associations of an older civilization, she more than made up for it in natural "monuments." Miller was conscious of this attitude, as he showed in the narratives written to accompany his watercolor sets. "The tourist who journeys to Europe in search of a new sensation, must by this time find that his vocation is nearly gone. . . . Well, here is a new field for him. These mountain Lakes have been waiting for him thousands of years. . . ."[21]

Western American rock formations may resemble European romantic ruins, yet they were created naturally,

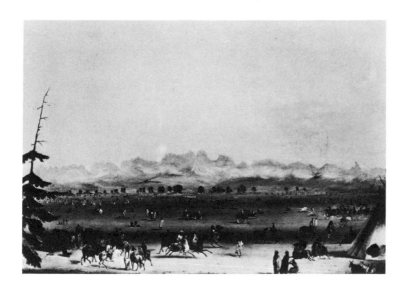

Rendezvous near Green River. (Cat. 173). Courtesy University of Wyoming, Laramie

17. See Ross, *Miller*, pl. 112.
18. *Morning Herald*, May 11, 1839, p. 2.
19. Ibid., May 16, 1839, p. 2.
20. Ibid.
21. Ross, *Miller*, pl. 59.

which made them even more romantic specimens. "At a distance as we approached [Scott's Bluffs]," Miller wrote, "the appearance was that of an immense fortification with bastions, towers, battlements, and embrazures. As we neared it, however, we found this appearance caused by strata of rock, running in veins through the earth and broken into these eccentric forms by the action of the elements."[22] If the age of America's natural "ruins" was impressive, even more so was their relative permanence. Here was an unmatched romantic continuum which could only heighten American national consciousness and win European appreciation. The formations of rock "will be as they are now when the great pyramids of Egypt are forgotten."[23]

Another typical romantic tenet to which Miller subscribed was the potential of human or animal characteristics within the inanimate world. Miller's trees are emotionally expressive, as are Thomas Cole's, and his horses often mirror the spirits of their riders. Miller found the landscape formations which the party saw as they crossed the great plains suggestive of animal forms. "On approaching [the Rock of Independence] . . . we were struck with its resemblance to a huge tortoise sprawling on the prairie."[24]

Miller's delicate, almost soft and feathery touch was well suited to his landscape subjects, which even today suggest that the viewer is the first white man to see such sights. Miller's landscapes in watercolor and oil are usually small and very personal works of art. Those he painted on the trail and in camp during the 1837 journey are simple and expressive notations which he undoubtedly intended to supplement with imaginary and remembered images when he returned to the studio. He painted few large landscapes; rather, he used his developed skills as background for the events of overland travel and the rendezvous. His watercolors and their accompanying narratives are more specific than the landscape settings of the oil paintings, which often appear to be fantastic mountain sets for an unfolding drama of Indians meeting mountain men and travelers, such as in the huge *Cavalcade* painted for Stewart's Murthly Castle.

For Miller and other romantics the spirit of the Indian enveloped all the West. Rather than a lawless area in need of civilization, the West to Miller and Stewart was hallowed ground which supported a natural life and fostered the Indian's freedom. "When we first came in view of the Rock [of Independence], Buffalo were feeding under its shadow, and the swift-footed Antelope bounding along so fleetly and so phantom like that we almost imagined them to embody the spirit of departed Indians, again visiting their beautiful hunting grounds and scenes of former exploits."[25]

The Indians highlighted Miller's journey, and this fascination encompassed their land, their customs, and, especially, their image. Indian portraits form a large and important part of Miller's watercolors. Some he completed in the West in 1837, but the majority he painted in his studio from sketches and memory. Miller chose the profession of portrait painter, and he well applied his training and experience to the task of recording individual Indians. In addition to his early experience as a portraitist in Baltimore, Miller copied two of the most important artists of that genre, Rembrandt and Sir Joshua Reynolds, when he was a student in Paris and London. Europeans had long sought individual portraits of Indians, most of which were done either in Europe or in eastern American cities until George Catlin set out to the West during the 1830s.

Catlin established the tradition of an Indian portrait "gallery." Although he painted many fewer portraits, Miller followed Catlin's lead in creating a significant body of Indian images, most of them bust or half-length format. Catlin carried rolled canvases on his journeys, sketching in the whole figure and completing in detail

22. Ibid., pl. 65.
23. Ibid., pl. 87.
24. Ibid., pl. 69.
25. Ibid.

the face and some accessories, leaving most of the costume and figure to finish in his studio during the winter.[26] Miller followed the British and more common American practice of sketching in pencil and watercolor in the field. Very small in scale (often only about 5 x 4 inches or 6 x 5 inches), most of his portrait field sketches remained in the Miller family and are now preserved at the Gilcrease Institute of American History and Art in Tulsa, Oklahoma; in the InterNorth Collection at the Joslyn Art Museum, Omaha, Nebraska; and at the Beinecke Rare Book and Manuscript Library, Yale University, New Haven, Connecticut. Miller only sketched broadly the figures and costumes of these Indians whom he presented in bust format. Occasionally, he would paint in detail a headdress or an accessory, such as the bear-claw necklace worn by a Kansas Indian (cat. 310). Miller elaborated such details and sometimes expanded the figure to half length or standing in his later studio watercolors, many of which are now at the Walters Art Gallery and the Public Archives of Canada as well as the Gilcrease Institute and the Joslyn. The portraits are usually full or three-quarters face with just a few pure profile. Although most are in rectangular format, some are oval or round, which are common alternatives for portraits of this period. Miller chose not to elaborate his finished portraits with background setting and he followed quite closely the pose and general countenance of his 1837 field sketches. Although he intended these sketches for his own use, he did monogram and inscribe some of them "after Nature," quite possibly at a later date.

Miller chose his subjects because of their beauty or character. About one Sioux he wrote: "We selected this Indian not because he was a great warrior chief or brave, in that he was neither, but for the reason that his face pleased our fancy and bore an agreeable expression."[27] Miller did not always approve of or even understand

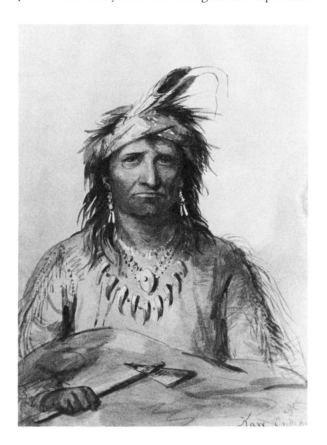

Kaw Man. (Cat. 310). Courtesy Thomas Gilcrease Institute of American History and Art, Tulsa

26. William H. Truettner, *The Natural Man Observed: A Study of Catlin's Indian Gallery,* p. 105.
27. Miller, "Rough Draughts," no. 58.

Indian customs, particularly when these were violent. "How little they are fitted for civilization and its artificial habits . . . ," he wrote. "We looked upon [In-ca-t'ash-a-pa] as a bloody minded fool. A man can however only act according to the light shown him and the misfortune was that we looked at the matter from entirely different standpoints."[28] This is a tolerant view of Indian life from an artist who was ambivalent toward the exotic culture.

Miller especially admired the Indians whose appearance reminded him of antique sculpture. The artist selected one Sioux for a profile portrait because he bore a "strong resemblance to an antique bronze."[29] Catlin, too, borrowed classical poses for his Indian portraits, and it is very possible that Miller knew this as he painted his own studio Indian busts. In his *Letters and Notes,* Catlin wrote that "the wilderness of our country afforded models equal to those from which the Grecian sculptors transferred to the marble such inimitable grace and beauty."[30] Charles Baudelaire, who admired Catlin's paintings exhibited in Paris in 1846, singled out two Indian portraits in particular: "with their fine attitudes and their ease of movement, these savages make antique sculpture comprehensible."[31]

Miller's Indian braves, especially those who are mounted, relate closely to classical sources and suggest Roman orators and antique and Renaissance equestrian monuments, much as does Catlin's *He Who Jumps Over Everyone* (collection of Mr. and Mrs. Paul Mellon, Upperville, Virginia). Miller recognized parallels between the Greek ideal and the American Indian and he even found the Indian a superior model: "American sculptors travel thousands of miles to study Greek statues in the Vatican at Rome, seemingly unaware that in their own country there exists a race of men equal in form and grace (if not superior) to the finest beau ideal ever dreamed of by the Greeks."[32] The antique provided convenient conventions and each artist found confirmation of the Indian's nobility by association with ancient prototypes.

Although Miller was able to take a few profile portraits, some Indians objected because the "taken" side of the face might be more susceptible to injury in future battles, due to the artist's presumed magical powers. Many of the Indians were pleased with their portraits, and each tribe wanted their bravest warriors as subjects for the artist's brush. Miller recorded that Big Bowl, an Indian chief, upon seeing his portrait sketch, "expressed his gratification by the exclamation 'Howgh, Howgh,' pronounced rapidly; he was told it would be carried a long way towards sunrise and shown to a 'heap' of 'palefaces,'—which seemed to gratify him exceedingly."[33] Others, however, regarded Miller's portraits as too close to life. Ma-wo-ma, a Snake chief and an artist whose works Miller found to suffer "from a want of knowledge of perspective,"[34] objected to Miller's portrait because "it was too like . . . a vulgar and familiar species of art, such as . . . could be made by his looking glass."[35]

The Indian portraits of Karl Bodmer differ from both Catlin's and Miller's. Bodmer was by far the most accomplished artist, and his ability with anatomy and expression and his use of color far exceed that of the other two. In keeping with the scientific concerns of his sponsor, Prince Maximilian, Bodmer's portraits are ethnographic specimens which transcend that genre to become works of art. Bodmer concentrated on the varied and often remarkable physiognomy and on the colorful and elaborate accessories of the Indians he

28. Ibid., no. 88.

29. Ibid., no. 153.

30. George Catlin, *Letters and Notes on the Manners, Customs, and Condition of the North American Indians,* I, 15. See also Truettner, *Catlin,* p. 73.

31. Charles Baudelaire, *Art in Paris, 1845–1862: Salons and Other Exhibitions,* trans. and ed. by Jonathan Mayne, p. 71.

32. Ross, *Miller,* pl. 64.

33. Ibid, pl. 15.

34. Ibid., pl. 35.

35. Stewart, *Edward Warren,* p. 381.

encountered along the upper Missouri. Although Catlin's Indian Gallery was much larger, we can learn as much about the specific characteristics and dress of the Indians from Bodmer's portraits. Like Bodmer, Miller was not on a crusade to preserve the Indian in his natural habitat and he could be more objective in his approach.

Stylistically, the portraits of each artist vary greatly. Bodmer's works are crisp and detailed, with definitive line even when they are not complete. His chosen colors are naturalistic and brilliant when an Indian's paint or costume called for it. Bodmer's European training served him well in his capacity as artist-illustrator for a German prince. Catlin's portraits are at another extreme. At best they are noble images of a vanishing people, but sometimes they fail in their awkwardness, the result of limited artistic experience. Catlin's portraits are outstanding, however, in the dramatic palette he discovered to be perfect for tribal imagery.[36] In analyzing Catlin's portraits, Baudelaire stressed color and its power to convey emotions,[37] and he wrote, "turning to his colour, I find in it an element of mystery which delights me more than I can say."[38] Catlin had a deep emotional attachment to the Indian, an obsession that Baudelaire recognized and to which he responded positively. It is as if Catlin's bold colors and primitive style suited his primitive subjects.

Miller's portraits are by far the most romantic of those of the three artists. His Indians lived in an arcadian wilderness, especially when he painted them in a vague, almost cloud-filled setting. Their expressions are serene and they often look dreamily beyond the viewer. Miller softened the craggy features of older Indians and made the most ferocious brave seem mild and approachable even when he held a tomahawk. They are charming rather than noble or curious. Miller represented their costumes and jewelry but these, as well as their facial characteristics, yield to the overall effect of the portrait—that of a member of a romantic race existing within reach of the adventurous, such as Captain Stewart and his party.

Painting portraits of Indian women appealed to Miller, possibly in proportion to the appeal they had to William Drummond Stewart. He often showed women with their children or at daily chores, demure and helpful. Many of the women, Miller noted, were not beautiful, which he "attributed to exposure and the precarious life they lead."[39] Among Miller's best-known, and, to judge by his account books, most popular,[40] compositions was *The Trapper's Bride* in which a trapper receives an Indian woman he has just purchased from one of the onlookers. Miller portrayed this commercial exchange as something sweetly romantic as the young woman shyly places her hand in that of the grateful-looking trapper. This may be Miller's version of the reconciliation of two cultures,[41] with the trapper symbolic of one who lived between the two. Miller's paintings of Indian women were prominent at the American Art-Union sale of 1852, with the exhibition of *Indian Girls Watering Horses* (cat. 439B) and *Indian Girl Giving a Drink to a Trapper [The Thirsty Trapper* or *The Halt]* (cat. 459B). Such attention to the imagery of Indian women was not unusual for a culture in which the Indian princess was still regarded as a symbol of America.[42]

Imagery of Indians, male and female, long had been associated with America's natural wonders, especially

36. Truettner, *Catlin*, p. 105.

37. See Robert N. Beetem, "George Catlin in France: His Relationship to Delacroix and Baudelaire," *Art Quarterly* 24, no. 2 (Summer 1961): 139.

38. Baudelaire, *Art in Paris*, p. 71.

39. Ross, *Miller*, pl. 19.

40. Randall, "A Gallery for Alfred Jacob Miller," p. 840.

41. Dawn Glanz, "The Iconography of Westward Expansion in American Art, 1820 to 1870: Selected Topics" (Ph.D. dissertation), p. 78.

42. See E. McClung Fleming, "The American Image as Indian Princess, 1765-1783," *Winterthur Portfolio* 2 (1965): 65–81.

Niagara Falls.[43] Indians were usually staffage elements in these paintings, added as spectators of America's scenic beauty. We have seen that Indians played a similar role in Miller's landscape paintings, but they emerge as primary elements in his Indian genre works, such as the many versions of *The Trapper's Bride*. Miller's genre subjects, by far the largest portion of his Indian paintings, fall into several categories: heraldic Indians; Indians at play; Indians interracting with trappers and other visitors during the rendezvous (with a special group featuring Stewart); domestic life; hunting; and imaginary scenes.

Women and domestic life form a large subject group of Miller's watercolors, for to him these women represented the idyllic side of Indian life. Of one scene he wrote that it "may be said to represent a small slice of an Indian paradise;—Indian women, horses, a stream of water, shade trees, and the broad prairie to the right, on which at times may be seen countless herds of Buffalo, Elk, and deer."[44]

The artist was impressed by the Indian woman's strength, especially her ability to bear and raise children in the wilderness. Miller painted women raising cradle boards proudly to display their offspring for the visitors, as in *Indian Hospitality—Conversing by Signs* (pl. 106, cat. 417A), and *Dakota Squaw and Papoose* (cat. 466B). Amusements of Indian women were especially popular sights to the easterners, and Miller painted women playing with dogs, riding horses, and swimming. Since only exotic subjects, such as captive slaves, Greek goddesses, and Indian maidens, offered romantic artists opportunities to paint the nude, Miller must have welcomed his chance to observe Indian women swimming or swinging over the water. The artist reported that the Indian women were unashamed and gladly admitted outsiders to their swimming and diving amusements; Miller painted several versions of their sport. His interpretations of Indian women parallel classical sources and suggest that Miller knew John Vanderlyn's famous nude, *Ariadne Asleep on the Island of Naxos* (Pennsylvania Academy of the Fine Arts) when he painted the romantically idyllic if anatomically awkward *Indian Girl Reposing* (cat. 463C).

Miller found Indians a complex and emotional people. He painted several images of mourning which are contemplative, serene, and deeply moving, such as *Sioux Indian at a Grave* (cat. 446). In these romantic scenes he followed early nineteenth-century involvement in Indian mourning ritual, typified by Chateaubriand's novel *Atala*.

Romantic preoccupation with animals placed them among the nineteenth century's most popular subjects. Miller discovered an ideal setting for his own interest in horses within the Indian culture in which the horse played a crucial role. Some of Miller's work, in particular his field sketches, exhibit a close study of nature, as in the charming *Reaching Camp, Removing the Saddles* (cat. 77), a lightly washed pencil field sketch showing the unburdened animals romping in freedom and rolling on their backs in the grass.

The Indians' wild horse races which Stewart so enjoyed afforded Miller a chance to sketch and later paint horses in frantic action as opposed to the more heraldic equestrian images of greeting visitors and returning from the hunt. The artist's European study aided him in this, and his horse races are reminiscent of Delacroix's and Géricault's. Miller regarded horses much as he did Indians—wild and unpredictable. They would huddle together, feeding, and "take alarm at the slightest movement,—so that when they start a general stampede takes place, and in a very few minutes the prairie is bare and not one of them is to be seen."[45]

Belief that animal actions mirrored human emotions pervaded nineteenth-century painting.[46] Miller's horses

43. Ellwood Parry, *The Image of the Indian and the Black Man in American Art, 1590-1900*, pp. 53-55.

44. Ross, *Miller*, pl. 20.

45. Ibid., pl. 176.

46. For an interesting discussion of this subject, see David Huntington, *Art and the Excited Spirit: America in the Romantic Period*, pp. 21-23.

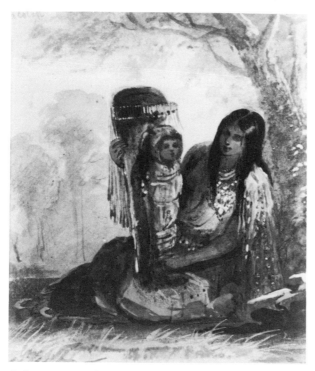

Dakota Squaw and Papoose. (Cat. 466B). Courtesy Western Americana Collection, Beinecke Rare Book and Manuscript Library, Yale University, New Haven

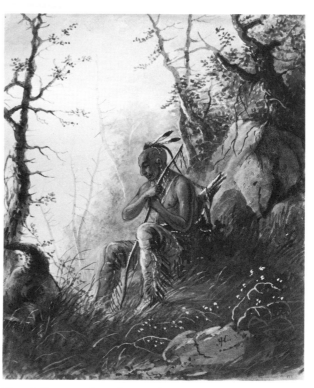

Sioux Indian at a Grave. (Cat. 446). Courtesy Walters Art Gallery, Baltimore

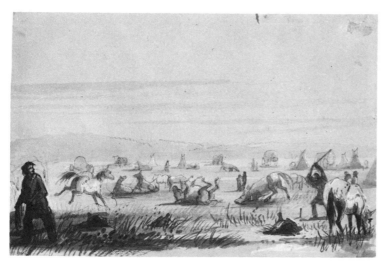

Reaching Camp, Removing the Saddles. (Cat. 77). Courtesy Joslyn Art Museum, Omaha; InterNorth Art Foundation Collection

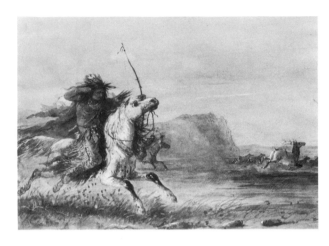

Pawnee Indians Hunting Elk. (Cat. 375). Courtesy Thomas Gilcrease Institute of American History and Art, Tulsa

often echo their riders' expressions, as in the fear of *War Ground* (pl. 102, cat. 379F), the defiance of *Pawnee Indians Hunting Elk* (cat. 375), or the coy conversation of *Conversing by Signs* (cat. 86B). Miller's horses are not the stout Indian ponies that Bodmer so accurately sketched but rather romantic Arabian stallions that would have appealed to Delacroix. Like his other western genre pictures, those including horses are a combination of romantic generalities and precise observation of Indian accessories and activities.

Miller's sympathies lay with the animals he painted, and *A Trapper in His Solitary Camp* (cat. 277) is as much a "portrait" of an overburdened and friendly mule as of a trapper roasting meat at a campfire. Miller anthropomorphized the buffalo whose "portrait," *Buffalo Head* (cat. 106), compares to the artist's many Indian portraits. Like David Brown, who traveled with the American Fur Company, Miller showed compassion for the fallen buffalo, the object of the many hunts he observed and in which he participated with Stewart. Although he enjoyed the sights of the sport and the taste of the choice hump meat, Miller's portraits of the buffalo are not far from Brown's description of an animal "needlessly deprived of life. The enormous creature lay prostrate on the ground, with its head twisted partly under its bulk, its only visible eye white and glazed."[47]

The rendezvous, focus of the trip, provided by far the most exciting moment of the journey. Accompanying the American Fur Company's party, Miller saw this meeting and exchange of furs for trade goods just before the decline of the fur trade. Among the most romantic characters of the West were the fur trappers, or mountain men, whose exotic costumes and wild manners made the rendezvous a colorful and raucous event.

Miller's bright palette, in which he often played off reds and blues of Indians' and trappers' costumes against the dreary browns of the plains, was well suited to depict the colorful rendezvous. In his watercolors Miller used a light touch to great advantage to convey the speed of the Indians' ponies with their costumes streaming behind. Settings for the genre pictures are usually quite generalized and highly romantic, with scenes framed by expressive trees and backed by blue mountains and skies pink with sunset. Night scenes allowed Miller to exploit the use of internal light sources as campfires illuminate the faces of raconteurs and warm a small area made safe from the perils of the wilderness.

His field sketches are watercolor over pencil drawings, often with gouache added. Miller worked on these watercolors consistently throughout his summer in the West, and they formed the core of his studies for the highly finished works he painted in New Orleans, Baltimore, and Scotland. The field sketches are spontaneous, loosely painted, and delightful. He exhorted himself to improve certain aspects of the works later in the studio. On *A Surround* (pl. 92, cat. 352) he wrote, just above the horizon, "more space" and "dust," changes and

47. Brown, *Three Years in the Rocky Mountains*, p. 6.

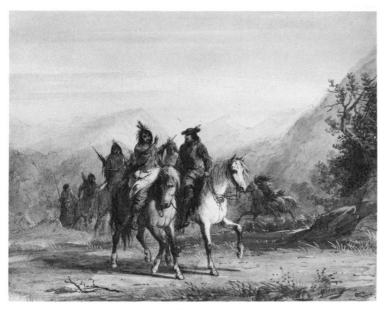

Conversing by Signs. (Cat. 86B). Courtesy Walters Art Gallery, Baltimore

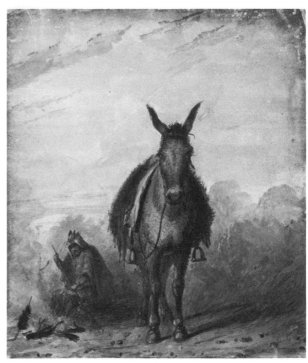

A Trapper in His Solitary Camp. (Cat. 277). Courtesy Joslyn Art Museum, Omaha; InterNorth Art Foundation Collection

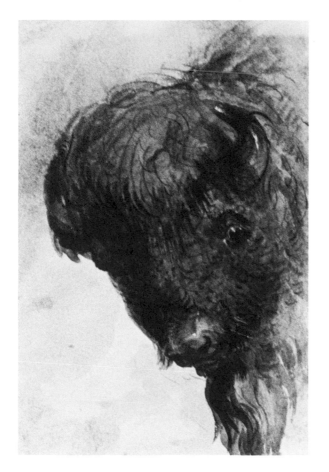

Buffalo Head. (Cat. 106). Courtesy Thomas Gilcrease Institute of American History and Art, Tulsa

additions he accomplished in the later studio watercolor, now at the New-York Historical Society (pl. 93, cat. 352A). He wrote, "Indian longer in body" on *Crow Indian on Lookout* (cat. 395). Possibly an *aide-mémoire* to remind him that an Indian actually was taller, this notation also may have been part of Miller's overall attempt to make the Indian appear grander and more noble according to Stewart's taste. Miller continued to use the light, nervous line of his sketches in the more highly finished watercolors, which gain in rich coloration and elaboration of detail even if they lose the freshness of the artist's first inspiration before the actual scenes.

Miller's western oils are furthest from the spontaneous sketch, and some may suffer from having been quite hurriedly finished for his Scottish patron, who impatiently awaited them as adornment for Murthly Castle. Miller was not at his best in these huge oils for which few American artists had experience or commissions.

Miller's experience with patronage contrasts sharply with that of his contemporary, Catlin, for whom the Indian was an obsession and became his life's devotion. The artist from Baltimore went west because of his patron's interest, and Stewart helped form Miller's romantic view of the Indian. Miller had no one to persuade, only someone to please. His success at that suggests that he fully adopted a romantic view of the noble savage. Neither did Miller try to attract official government patronage (as did Catlin so unsuccessfully) or a potentially broader audience by issuing prints after his works (as did Catlin and Bodmer through his patron, Prince Maximilian). The press of Miller's native Baltimore reported a fine reception for the exhibition of Catlin's "Gallery of Indian Portraits" and accompanying lectures. Miller might even have been in the audience or have read the *Sun*'s review for July 10, 1838: "His lectures and explanations have all the charms of romance; and the spectator, as he gazes upon the speaking canvass, and listens to the eloquent exhibiter, almost imagines himself transported to the western wilds, and seated at the council fires of the lord of the forest."[48]

Western painting, most especially Indian subjects, formed a significant part of Miller's middle career, and patrons continued to seek him out for such subjects throughout his later life in Baltimore, notably for sets of watercolors like those he prepared for William T. Walters and Alexander Brown.

Unlike Catlin, who wandered in the West over a period of six years, Miller never seems to have been tempted by another trip west, despite the probability that Sir William Drummond Stewart invited him again. This may have been due to Miller's poor health, which stemmed at least in part from the rheumatism he developed in the West in 1837. Miller complained of the limitations of his "indifferent health," and in 1854, his friend Brantz Mayer described the results of his journey: "In consequence of exposure during this campaign he contracted chronic rheumatism which has resulted in lameness and proved a detriment to his artistic progress, by restricting his movements and exercise and producing a morbid nervous condition."[49] We do not know the nature of Miller's "morbid nervous condition," but it did not prevent him from painting quite prolifically until just a few years before his death in 1874, although he remained close to his native Baltimore after his return from Europe in 1842. As early as 1844, Miller wrote to Stewart that "my health although not good permits me to pursue my profession."[50]

In some ways his profession parallels that of Karl Bodmer as each artist traveled only once in the American West. The intended result of the expedition that Bodmer accompanied was publication of Prince Maximilian's

48. Catlin's show was reviewed in the Baltimore *Sun*, July 10, 1838. It is possible that Miller was in Baltimore for his own exhibition, which was reviewed in the *American and Commercial Daily Advertiser*, July 17, 1838, p. 2, col. 1. It is not known definitely that Miller was in Baltimore for the exhibition, but the British consul in New Orleans, John Crawford, wrote Stewart on October 11, 1838, that "Mr. Miller is expected here soon," so he had been away from New Orleans and quite possibly in Baltimore. Crawford's letter is in the Sublette Papers, Missouri Historical Society. My thanks to Ron Tyler for this insight.

49. Brantz Mayer's Journal, February 17, 1854, in Warner, *Fort Laramie*, pp. 195–196.

50. Miller to Stewart, Baltimore, March 16, 1844, in ibid., p. 194.

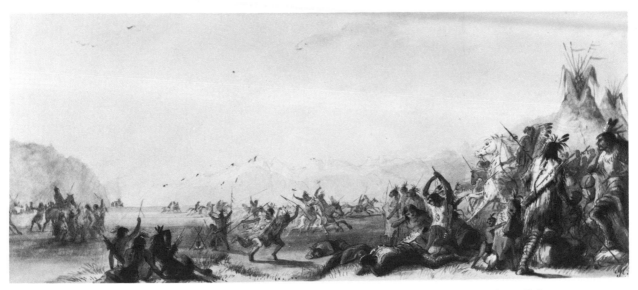

Advent of the Locomotive in Oregon. (Cat. 40). Courtesy Thomas Gilcrease Institute of American History and Art, Tulsa

scientific discoveries with the artist's watercolors engraved as accompanying illustrations. After the journey Bodmer quickly lost interest in America and became a minor French Barbizon artist. In contrast, the body of work which Miller left—oil paintings, watercolors, and writings—narrates continued involvement with a romantic tale of great adventure in the West.

Miller was especially involved with the Indian, and his opinion of native life ranged from great admiration to disgust at their lawlessness. "It is only in savage life that real and absolute liberty exists,"[51] he wrote. Yet he also observed that the Indian's "great difficulty is that he has too much freedom for his own good."[52] Indian life was unpredictable and could pass too quickly from pastoral to bellicose. An evening campfire scene "would appear almost Arcadian, if we did not know that a sudden war whoop would rouse instantly the demon within them."[53] Whatever the pleasures and terrors of the Indian life that Miller painted, he recognized that it was "rapidly passing away."[54]

Symbolic of that passing was Stewart's and Miller's presence in the West following the mountain man into the wilderness. Soon afterward, civilization would move over the plains to the Rocky Mountains and permanently destroy that way of life. Miller painted this symbolically in *Advent of the Locomotive in Oregon* (cat. 40) in which Indians observe a tiny train on the horizon. Many exhibit great distress by putting their ears to the ground or fleeing in panic. Others seem resigned, and one Indian sits poignantly with head in hands. Miller did not share Catlin's missionary zeal or Bodmer's scientific skills, yet his art better expresses the spirit of the nineteenth-century's romantic preoccupation with Indians and the American wilderness. Although there is certainly not one style of romantic painting, Miller's free, colorfully expressive approach and his choice of nationalistic yet exotic subject matter clearly identify him as an American romantic artist. On one brief trip to the mountains in a holiday atmosphere, Miller experienced and sketched the essence of that fascination with the American West which would occupy him for the rest of his life.

51. Ross, *Miller*, pl. 40.
52. Ibid.
53. Ibid., pl. 34.
54. Ibid., pl. 64.

Back to Baltimore

Alfred Jacob Miller returned to Baltimore in the spring of 1842. The city, now the hub of a vast transportation system of railroads, canals, and shipping, was experiencing rapid growth. With the advent of prosperity, cultural life began to develop, albeit erratically. The Maryland Art Association, started in 1847, proved abortive and disappeared shortly thereafter.[1] Though equally ephemeral, the Artists' Association of Baltimore, founded in 1855 for the mutual encouragement of the profession and the establishment of a permanent gallery for American art, included in its membership over twenty-seven local artists. Only a few, admittedly, such as Miller and Hugh Newell, had received formal training, whereas others were of lesser talent and are now forgotten.[2] In the meantime, the Maryland Historical Society, established in 1844, began, three years later, to sponsor annual exhibitions that afforded local artists and collectors the opportunity to display paintings. Although Robert Gilmor, Jr., Baltimore's preeminent connoisseur of the arts in the early nineteenth century, died in 1848, other collectors, equally zealous, succeeded him, most notably Dr. Thomas Edmondson, a horticulturist and proprietor of an impressive "Harlem," an estate in the western suburb of the city. Edmondson, a generous supporter of a number of local artists, was among the first to patronize Miller.[3] Other collectors included Owen Gill, Z. Collins Lee, O. C. Tiffany, and, eventually, W. T. Walters, who, in the years just prior to the outbreak of the Civil War, amassed one of the most extensive holdings of contemporary American painting.[4]

For almost three decades following his return to his native city, Miller pursued the role of regional painter. His career in Baltimore, marked by industry and relative tranquility, drew scant attention from contemporary writers or subsequent historians. Nevertheless, by citing his works and consulting his studio account book, various exhibition records, and surviving correspondence, it is possible to follow his progress. At first Miller did not fully engross himself in work. Instead, presumably with earnings derived from Sir William Drummond Stewart's commissions, he purchased a 165-acre farm known as "Lorraine" on the Franklin Turnpike five miles west of the city.[5] There he resided in an English cottage-style house, tended by two sisters, Harriet and Lizzie. He apparently never considered marriage. His "Journal," in fact, abounds with aspersions on the institution by such notable predecessors as Michelangelo and Sir Joshua Reynolds.[6]

Soon after returning to Baltimore, Miller began to visit Washington, where he befriended two artists with kindred interests, Charles Bird King, a portraitist who specialized in Indian subjects, and John Gadsby Chapman, who had recently completed an enormous *Baptism of Pocahontas* for the Rotunda of the Capitol. At this time he also discovered in the Library of Congress folios of engravings of "old master works" which he considered a "great boon."[7]

1. Scharf, *History of Baltimore*, p. 674.
2. Note in the "J. Hall Pleasants Studies in Maryland Painting" file in the Maryland Historical Society.
3. Twelve works by Miller were lent to the Maryland Historical Society exhibitions by Dr. Edmondson or his estate between 1848 and 1858.
4. William R. Johnston, "American Paintings in the Walters Art Gallery," *Antiques* 106, no.5 (November 1974): 853–861.
5. Deed from Elizabeth Myers to Alfred J. Miller, Land Records of Baltimore County, Liber TK No. 323, folio 66, copy in Archives of the Maryland Historical Society, Baltimore. Miller listed the farm for sale in the Baltimore *Sun* on October 5, 1847.
6. Unidentified newspaper clipping pasted inside cover of Journal: "Michael Angelo the painter was asked why he did not marry. He replied: 'I have espoused my art, and it occasions me sufficient domestic cares, for my works shall be my children.' A young artist who had just married told Sir Joshua Reynolds that he was preparing to pursue his studies in Italy. The great painter replied: 'Married then you are ruined as an artist.' "
7. Journal, pp. 27–28.

By October 1843, Miller had engaged a painting room in Baltimore, and six months later he reported to his patron, Stewart, that he was leading the life of a hermit, working eight hours a day, endeavoring through toil to "throw off some of the difficulties" that surrounded him.[8] These problems may have included inflammatory rheumatism contracted during the western expedition, which continued to afflict him.

Though the extent of his oeuvre in the early forties remains obscure, it is fortunate that he began to maintain a studio account book in January 1846. He continued to meticulously record his transactions until October 1871. This document not only serves as an invaluable record of his career during this period but also provides a probable *terminus ad quem* for works not listed.[9] In the course of this twenty-three-year span, Miller listed earnings totaling $23,472. Almost half of this amount was derived from commissions for 272 portraits, approximately a third from western scenes, and the remainder from replicas, religious paintings, and miscellaneous subjects. The most lucrative orders were Stewart's commissions for two religious works, *Christ's Charge to Peter* recorded in 1846 and *Jepthah's Vow* in 1847, for which he was paid $800 and $968, respectively. In addition, Miller, at various times, listed earnings as a teacher, copyist, and restorer of paintings.

Once, when asked what kind of portrait he painted, Miller replied that he produced a "strong likeness."[10] He was obviously more concerned with recording external appearances rather then conveying the character of his subjects although occasionally, particularly in his likenesses of men, he imparted them with a sense of dignity through selection of pose and background.

Despite the length of Miller's career, a number of stylistic traits and technical features remained constant in his portraiture. His manner was fluid. Working on finely woven, preprimed canvases, often oval in format, he applied his pigments thinly, carefully blending the brushstrokes. Occasionally, the paint film was so translucent that pentimenti became evident. Many of his portraits are warm in tonality; the complexions of the sitters are marked by ruddy hues and the backgrounds are frequently adorned with crimson draperies. Cream-colored silk shawls with embroidered patterns rendered in impasto are often worn by his subjects or used as table coverings.

In the backgrounds of early portraits, Miller often relied on the convention of a billowing curtain and a column, a practice that may have earned him the appellation "the Lawrence of Baltimore."[11] A vertical division, with a wall on the right and a landscape vista on the left, is also encountered in his early work. Later in his career he employed more neutral backgrounds. His likenesses of children, which formed a major portion of his oeuvre and one that apparently intrigued him, judging from the number of preparatory sketches that have survived, differ in that the subjects are usually shown in exterior settings. Frequently, the children are casually posed, often playing with hoops, though they are occasionally shown in somewhat contrived positions.

In his account book Miller listed his portraits by size, and varied his prices accordingly. Early entries alluded to group portraits at $250; full-length representations at $100; "kit-cats" at $75 or $80; standard portraits, presumably half-lengths, at $60 to $100; and cabinet-size works showing entire figure or the head and shoulders at $40. Later, he tended to record the actual measurements, listing full-length portraits for as much as $150,

8. See A. J. Miller to Sir William Drummond Stewart, Baltimore, March 16, 1844, in Warner, *Fort Laramie*, pp. 193–194. Baltimore city directories give the following addresses for A. J. Miller: corner of Frederick and Baltimore streets (1833); corner of Baltimore and Charles streets (1840); Law Building (1845) (he advertised his removal from Law Building to rooms over George Willig's music store–151 Baltimore Street, on September 27, 1844); over 207½ Baltimore Street (1849–50); October 5, 1847, Miller advertised move to 65 Fayette Street; 120 West Fayette Street (1851); 3 Carroll Hall and 264 West Fayette Street (1855–59); 264 West Fayette Street (1864–74).

9. The studio "Account Book" is a manuscript preserved in the Walters Art Gallery.

10. Journal, p. 62.

11. Even *Appleton's Cyclopedia of American Biography*, IV, 324-325, listed Miller as belonging to the "School of Sir Thomas Lawrence" in portraiture.

standard portraits measuring twenty-five by thirty inches for $100; "vignettes," twenty by twenty-four inches, for $60; still smaller "cabinet" pictures ranged from $40 to $70. Whether one or both of the sitter's hands were portrayed was also noted as a factor determining the fee.

At the peak of his production in the late 1840s and early 1850s, Miller averaged about twenty portraits a year. Four months usually transpired between the dates of commission and payment. Apparently satisfied with his endeavors, his clients seldom failed to reimburse him and frequently commissioned additional likenesses of other family members. It should be noted that some of the more discerning collectors in Baltimore, such as Dr. Edmondson, Brantz Mayer, T. Stricker Jenkins, and W. T. Walters, who acquired Miller's paintings in other genres, did not necessarily patronize him as a portraitist. For more elegant, flattering images at higher prices, they turned elsewhere, often to Thomas Sully of Philadelphia. Miller's patrons, however, included many of the most prominent members of the community, among them the Blacks, Cockeys, Defords, Dorseys, Ellicotts, Jenkins, Shepherds, and Stumps, families that are still extant or have left their mark in the nomenclature of local topography. In addition, the artist drew patrons from further afield. His account book lists clients from Hagerstown, Maryland; Lynchburg and Petersburg, Virginia; Lexington and Versailles, Kentucky; and New Orleans.

Additional insight into Miller's activities is provided by exhibition records. In 1848 he was represented in the first annual exhibition of the Maryland Historical Society by four portraits, three Indian subjects, and two literary genre scenes.[12] Thereafter, until 1856, various examples of his work were shown in the society's exhibitions submitted either by himself or by clients. In 1858, no less than eleven of his paintings, drawn principally from the estate of Dr. Edmondson, appeared at the society's annual exhibition.

Although Miller has been described as a provincial painter concerned with the artistic needs of his native Baltimore, he intermittently sought recognition and patronage elsewhere. In 1844, at the National Academy of Design in New York, he exhibited two portraits and an Indian scene, which were followed in the succeeding year by *Olivia and Sophia Consulting the Gypsy Fortune Teller*, a subject from Goldsmith, and *Boaz and Ruth*, a biblical theme.[13] At the Pennsylvania Academy of Fine Arts, he was represented in 1847 by a Correggio copy; in 1852, he showed *The Trapper's Bride*, a *Lost "Greenhorn" on the Prairie*, and a *Wind River Mountain, Oregon* and, in 1861, *An Election Scene*.[14] He also participated in the sales of the Art-Union in New York, the successor to the Apollo Gallery, where he had first drawn national attention in 1839. In 1851 Miller received $230 from the Art-Union, a respectable fee for the time, for three pictures, *Drink to Trapper*, *Watering Horses*, and *Fort Laramie Indian Camp*. Two years later he fared less well, realizing a total of only $120 for a *View on Shenandoah* and two genre scenes.[15] His paintings did not appear again in New York until January 1865, when he tested the art market once more by submitting three pictures, *An Indian "Shooting" a Cougar*, *Racing at Fort Laramie*, and *Charity* to Samuel Putnam Avery, who was opening an art agency with the backing of Miller's patron, W. T. Walters.[16] Miller also attempted to retain his ties with New Orleans, where he had resided in 1837. Twenty-one years later, he tried to sell a view of Niagara Falls in the southern city, an endeavor that failed.[17]

12. No. 32, *Trappers Bride*; No. 78, *Portrait*; No. 103, *Portrait*; No. 113, *Portrait*; No. 133, *The Buffalo Hunt on the Prairie known in the West as "A Surround"*; No. 187, *Dr. Primrose Overturning the Cosmetic*; No. 290, *Indian Caressing his horse*; No. 292, *Cobbler reading the President's Message*.

13. *National Academy of Design Exhibition Record, 1826-1860*, II, 24.

14. Anna Wells Rutledge (comp.), *Cumulative Record of Exhibition Catalogues: The Pennsylvania Academy of the Fine Arts, 1807-1870; The Society of Artists, 1800-1814; The Artists' Fund Society, 1835-1845*, p. 142.

15. Cowdrey, *American Academy of Fine Arts*, I, 236.

16. "Letters from Americans [to] R. S. P. Avery," bound volume, Metropolitan Museum of Art, New York, Liber no. 97.

17. B. M. Norman to B. Mayer dated April 17, 1858, in the Archives of the Maryland Historical Society. Norman tried without success to sell the picture himself, and then he placed it in the private gallery of Galvani in New Orleans. It was probably the picture that was listed in the account book as having been sold to B. Mayer in 1860. In a letter dated October 1, 1857, Miller mentions returning to B. Mayer an ambrotype of the Falls.

The artist's Saint Bernard, "Bronte." Inscribed: *Sketched at Lorraine. – AJM. Bronte/My: St. Bernard.* (Cat. 889–97). From Scrapbook, courtesy Mrs. L. Vernon Miller, Sr.

MOUNT DE SALES. The convent-school was located in Catonsville, not far from Miller's farm, Lorraine. (Cat. 889–100). Scrapbook, courtesy Mrs. L. Vernon Miller, Sr.

Miller was an inveterate sketcher, producing hundreds of drawings, which he compiled in scrapbooks for his own enjoyment and that of his friends. The inventory of his estate listed fourteen scrapbooks valued at fifty cents each and one loose lot of drawings at two dollars each. Only two of the books, still in the possession of the Miller family, have remained intact. About 120 drawings have been tipped into each. The subjects were usually identified by labels inscribed in ink, either on the drawings themselves or, more frequently, on separate scraps of paper glued below or beside, and occasionally by brief pencil notations. No particular sequence is followed in mounting the works, which range from copies of paintings in the Louvre, drawn while Miller was a student in Paris, to Baltimore scenes dating from the 1860s. The media varied: brown and black inks applied with pen and brush or used as washes, often heightened with white; pencil, crayons, and, occasionally, oils were employed.

Similar diversity is encountered in a collection of sketches from two recently dismembered albums presented to the Maryland Historical Society by a descendant of the artist, Lloyd O. Miller. More homogeneity in both technique and subject is seen in yet another series of drawings removed from a couple of scrapbooks and presented to the Walters Art Gallery by J. William Middendorf II.[18] The latter, which illustrate Miller's recollections of his youth in Baltimore as well as scenes of literary and dramatic interest, were rendered in pencil and inks highlighted with white. Also in the Walters Art Gallery is a collection of drawings from a scrapbook showing single figures of actors, chiefly members of the Ravel pantomime troupe, interspersed with several of his more characteristic sketches.[19] Though it is more precisely a sketchbook, a small album of drawings dating from the artist's first European sojourn may also have been included among the scrapbooks in the estate inventory. Even in this book, still in the possession of the Miller family, the artist has inserted several later sketches, including a copy in gouache of a lithograph after A. G. Decamps' *Le Passage du Gué*, not painted until 1849.

The extensive corpus of drawings provides an invaluable insight into Miller's activities and interests. A series of sketches alludes to his farm, "Lorraine." There, the animal life numbered a Saint Bernard dog, "Bronte," a cat, "Pill," and some livestock, including a young bull, "Ranney," and a calf "Percy," all of which served as subjects for the artist. To assist him as a laborer, Miller employed a German orphan, Heinrich, retrieved from a nearby almshouse, who enjoyed fishing and was prone to fighting with the local youngsters.[20]

Miller's sketching forays in Baltimore and its environs were chiefly in the vicinity of Catonsville in the west, and along the Jones Falls Road, a route that he must have traveled regularly to visit his brother Decatur, whose country residence lay north of the city. Miller was particularly drawn to the mills and waterfalls along the road and to the Hampden Reservoir. Other sites that attracted his attention were that of Mount Hope, a hospital built on the crest of a hill overlooking Reisterstown Road northwest of Baltimore, and of Swann Lake (Lake Roland), Druid Hill Park Lake, and the Baltimore Cemetery with its crenelated portals.

Farther afield, Miller painted in wash and watercolor a number of landscape studies of Harper's Ferry in West Virginia; stretches along the Susquehanna River; the Cumberland Gap in western Maryland, and the Blue Ridge Mountains in Virginia. A humorous drawing of a couple of figures seated on a bench, swatting flies,

18. The drawings were presented to the gallery between 1970 and 1977. see Richard H. Randall, Jr., "A Gallery for Alfred Jacob Miller," *Antiques* 106, no. 5, (November 1974): 836–843.
19. William R. Johnston, "Sketches by Alfred Jacob Miller," *Bulletin of the Walters Art Gallery* 21, no. 7 (April 1969): 3–4.
20. Journal, pp. 128–131, with drawing "Our Heinrich/Fishing from the Life."

entitled *Beach at Cape May* and a watercolor of Smith's Island opposite Philadelphia suggest that he occasionally traveled northward. The only indication that he ever visited New York is a drawing of urchins crouched over a grate labeled *Newsboys in Winter—New York*. Several views at Niagara Falls were probably taken from photographs, as was the painting of the site sold to Brantz Mayer in 1860.

In many sketches, particularly those illustrating scenes recalled from childhood, Miller's humor is revealed as being robust rather than sophisticated. Seldom are the subjects abstruse. Stock characters are depicted, stereotyped by race, age, and wealth or its lack. The juxtaposition of youth with old age is a common theme. In the labels, dialects, generally those of German immigrants or of blacks, are liberally utilized. Miller restricted this propensity for humor almost solely to his scrapbook sketches, his only important genre painting being *An Election Scene,* exhibited at the Pennsylvania Academy of the Fine Arts in 1861 and later sold to his brother Columbus A. Miller.[21]

Literary and theatrical subjects abound in the artist's oeuvre.[22] Though his library was limited to eighty-six volumes, Miller was fully conversant with the popular literature of the time. Usually, he drew from eighteenth- and nineteenth-century English authors, whose writings would have been familiar to all his contemporaries. James Boswell's *Life of Samuel Johnson* proved to be a singularly fecund source of subjects. Other eighteenth-century literature upon which he relied included Thomas Gray's *Elegy in a Country Churchyard,* Oliver Goldsmith's *The Vicar of Wakefield,* and Laurence Sterne's *Tristram Shandy* and *A Sentimental Journey.* A particularly witty drawing showing from the back an eighteenth century periwigged gentleman is facetiously entitled *Full Length Likeness of the Author of "Junius,"* the writer of the Junius Letters, published anonymously in London between 1768 and 1772, never having been identified. Two nineteenth-century English authors who provided subjects for Miller's pen were Sir Walter Scott and Charles Dickens. Readily identifiable are scenes from the former's novels *Old Mortality, St. Ronan's Well, Legend of Montrose,* and *The Pirate* and the latter's *Barnaby Rudge, The Old Curiosity Shop, Martin Chuzzlewit,* and *Little Dorrit.* Somewhat more obscure are a drawing of a suicide scene from Thomas Hood's poem *The Bridge of Sighs* and a watercolor illustrating *The Friars of Dijon,* a poem by Scotsman Thomas Campbell.

The sole American writer to figure in the scrapbooks is Washington Irving. Miller illustrated several scenes from *Rip Van Winkle* and, at least twice, he depicted the meeting of George Washington and his namesake, the future author, an incident alleged to have occurred on Broadway in New York late in the eighteenth century.[23]

Scenes from Victor Hugo's *Les Misérables* and Cervantes' *Don Quixote of La Mancha,* works he probably knew through translation, are the only references to foreign authors, and the sole allusions to classical literature are two rather conventional subjects, *Sappho Falling into the Sea* and *Diogenes and His Lamp.*

Miller appears to have been, especially in his younger days, a devotee of the stage. Late in life he recalled having heard Adelaide Kemble sing in the opera *Norma* at the Drury Lane Theater.[24] He also remembered seeing, many years earlier, such eminent actors as William Warren, W. B. Wood, Joseph Jefferson, Sr., John

21. *Election Scene Catonsville, Baltimore County,* oil on academy board, 11 1/4" x 15 1/2", the Corcoran Gallery of Art, Washington, D.C. Miller listed the painting as being sold to Columbus A. Miller, 1869.

22. William R. Johnston, "Alfred Jacob Miller–Would-be Illustrator," *Bulletin of the Walters Art Gallery* 30, no. 3 (December 1977): [2–3].

23. George S. Helman, *Washington Irving Esquire, Ambassador at Large from the New World to the Old,* discusses the incident. In a drawing in a scrapbook and in a small oil painting, *George Washington and Washington Irving,* canvas, 7" x 5", formerly in the Museum Art Exchange, Inc., Boston, Miller showed the maid "Lizzie" presenting Irving to the President, who lays his hand on the child's head.

24. Journal, p. 72.

Newsboys in New York/Winter 3 o'clock. "Jack, these printing offices keep up the steam all night through the grates, so all I have to do is to curl myself up & go to sleep snug & warm." This drawing is the only evidence that Miller was familiar with New York, where he occasionally exhibited his paintings. (Cat. 888-3). Scrapbook, courtesy Mrs. L. Vernon Miller, Sr.

Fritz' Honeymoon. Fritz (loqr) "I'd vas youst so easy/as a needle cood valk out mit/a camel's eye – as to get der behindst voud mit a voorman's" Signed *AJM.* (Cat. 888-31). Sketchbook, courtesy Mrs. L. Vernon Miller, Sr.

Portrait of the Author of "The Junius Letters." The identity of the writer of a series of letters directed against the Duke of Grafton, which was published in London in the *Public Advertiser* between November, 1768, and January, 1772, has yet to be ascertained. Inscribed: *Full length "likeness" of the author/ of Junius.* Signed: AJM. (Cat. 888-54). Scrapbook, courtesy Mrs. L. Vernon Miller, Sr.

Giles da Passemonte Stealing Sancho's Mule. The galley-slave freed by Don Quixote in Cervantes's *Don Quixote* is stealing the mule from under the sleeping Sancho. Inscribed: *Giles Passemonte stealing/Sancho's Mule.* (Cat. 889-105). Scrapbook, courtesy Mrs. L. Vernon Miller, Sr.

Duff, and Charles Burke perform at the Holliday Street Theater in Baltimore.[25] Because of its position on the railroad lines, the city was an important center for touring companies that stopped at either the Holliday or Front Street theaters.

The artist's tastes in theater ranged from serious drama to light divertissements. An abiding interest in Shakespeare was manifested during his 1840 sojourn at Murthly Castle by his obvious enthusiasm at visiting Birnam Wood, the site of the march on Dunsinane in *Macbeth*.[26] In illustrating Shakespeare, Miller was drawn to the comedies as well as to the tragedies: his scrapbooks containing scenes from *As You Like It* and *Love's Labor's Lost* as well as *Macbeth* and *Hamlet*. In these illustrations, he depicted the scenes either as staged presentations, as in the four subjects from *Hamlet* mounted together in one book, or, more usually, as historical events in actual settings.

Writing in 1865, Miller recalled as being among the happiest moments of his youthful stay in Paris, his visits to the Opéra Comique, where he was bewitched by the singing and acting of the pretty soubrettes.[27] Similar dramatic fare, borrowed from the traditions of the theaters of Boulevard du Temple, the Gaite, and the Ambigu-Comique in Paris, was presented to American viewers for three decades by a family theatrical troupe, the Ravels, who made their New York debut in 1832.[28] On three occasions, this troupe appeared in Baltimore, offering a varied program of short comedies, dances, vaudeville productions, *tableaux vivants,* and feats of strength and tightrope walking. It was probably during their last visit to Baltimore in 1862 that Miller executed a series of forty-four drawings in watercolor, pencil, and ink of the individual members of the troupe in characteristic poses.

Although Miller's account book contains no explicit references to such works, he occasionally developed his literary and dramatic subjects into oil paintings. The most notable examples are *Olivia and Sophia Consulting the Gypsy Fortune Teller*[29] and *Dr. Primrose Overturning the Cosmetic,*[30] both from Goldsmith's *The Vicar of Wakefield,* and a cabinet-size painting of the little servant girl, known as "The Marchioness," peeping through the keyhole, from Dickens' *The Old Curiosity Shop* (pl. 18, cat. 44).[31] Two pictures, a sketch and a large oil, show James Hackett as Falstaff at the Battle of Shrewsbury in Shakespeare's *Henry IV—Part One* (pl. 17, cats. 43, 43A).[32] The lack of records of any such works, despite the obvious pleasure he derived from depicting literary and dramatic scenes in his sketches, would suggest that, though Miller's personal inclinations may have lain in such directions, the dictates of his Baltimore clientele drew him to the more lucrative fields of portraiture and western views.

An assessment of Miller's contribution to the development of painting in Baltimore would not be complete without reference to his role as teacher. Two pupils, Frank B. Mayer and A. J. H. Way, emerged locally as artists of note in the second half of the century. The former, the nephew of Brantz Mayer, an amateur artist and long-time associate of Miller, was a pupil in 1845. For Mayer, his teacher was incontrovertibly the painter of the West. Twenty years later, in a letter to his former instructor, Mayer wrote: "I have no higher ambition

25. Ibid., p. 24.

26. A. J. Miller to Decatur H. Miller, Murthly Castle, October 16, 1840, in Warner, *Fort Laramie,* pp. 154–156.

27. A. J. Miller to F. B. Mayer, July 20, 1865, in the Mayer papers.

28. Mary Grace Swift, *Belles and Beaux on Their Toes: Dancing Stars in Young America,* and William R. Johnston, "Drawings of the Ravels by A. J. Miller in the Walters Art Gallery" (typescript in possession of the author). The Ravels visited Baltimore in 1833, 1853, and 1862. Miller was in Paris in 1833, and Antoine Ravel, whose image appears among the drawings, did not participate in the 1853 tour.

29. National Academy of Design Exhibition, 1845, No. 92.

30. Maryland Historical Society Exhibition, 1848, No. 187.

31. Walters Art Gallery, 37.2538.

32. The sketch belongs to S. T. Colwill of Baltimore and the painting to George Arden of New York.

Playbill for the Ravels' Volauvent. On July 16, 1832, the Ravels made their American debut at Park Street Theater in New York with a spectacle composed of rope-dancing, herculean feats, and pantomime ballets. Presenting such varied fare, the troupe flourished in this country as master entertainers for over three decades. Though the troupe varied in size, its four principal members remained the brothers Gabriel, Antoine, Jerome, and Francois. One of their most popular productions was a comic pantomime known initially as *Monsieur Moulinet* and later as *Vol-au-Vent and the Millers; or, a Night's Adventures* that featured a performance by Gabriel Ravel on the *Barre cerrique,* fifteen feet high. Miller compiled a sketchbook of forty-seven "costume studies" of the Ravels.

than to place my name near yours as a painter of Indians, for I think that your Indian pictures are the best things of the kind yet produced."[33] Though remembered locally for his scenes of colonial Maryland, Mayer was also a painter of the West. In 1851 he traveled through Minnesota recording life among the Indians, and shortly before his death in 1899 he executed, for Henry Walters, a series of watercolors based on recollections of this trip, much as his mentor had done for Henry's father, William Walters, forty years earlier.[34]

Way, who received lessons from Miller in 1848, began his career as a portraitist but later devoted himself to still-life painting, a genre of which he was then the sole exponent in Baltimore. He remained a close friend of Miller, and eventually became a leader of the local artistic community.

Other pupils of Miller were James Craig Jones, who received lessons in 1846 and exhibited *Washington's Headquarters, Cumberland, Maryland,* and *The Glades, Western Maryland* at the Maryland Historical Society in 1849; Edward G. McDowell, a landscape painter who participated in the society's 1858 exhibition; Osmond Tiffany; William M. Alexander of Cumberland, Maryland; Alfred Bujac; and, possibly, W. S. G. Baker.[35]

The scope of Miller's instructions has not been recorded. That he owned a collection of plaster casts[36] and was given to reproducing color scales in his sketchbook[37] would suggest that he at least taught the rudiments of drawing and color theory. More important than the actual lessons may have been his willingness to share with his pupils the benefits of his experience and knowledge of contemporary art. His two principal pupils, Mayer and Way, followed his precedent in continuing their training abroad. Through an exchange of letters, Miller continued to follow their progress and to offer advice, recommending to Mayer that he seek out the works of Edouard Frere, the then popular genre painter of Ecouen, France, as well as those of the eighteenth-century painter Watteau. On one occasion he warmly recalled how they had read together Mrs. H. L. Grote's *Memoir of the Life of Ary Scheffer,* first published in London in 1860.[38]

The outbreak of the Civil War disrupted every facet of life in Baltimore, a city of sharply divided loyalties. For Miller the war meant the dispersal of clientele and colleagues. On November 7, 1864, he wrote to Mayer that "Art and War seem to have as little affinity as oil and water, the former is quite neglected;—as for the artists themselves that were here, like mosquitos [*sic*] in a north-western, they have 'vamosed the rancho'—two of the tribe yet remain, Harley [James Kimball Harley] and myself. We try to get over-*neverminding*."[39]

33. F. B. Mayer to A. J. Miller, March 5, 1865, in Marvin C. Ross (ed.), "Artists' letters to Alfred Jacob Miller" (Baltimore, 1951, typescript in the Library, Walters Art Gallery, Baltimore).

34. [Francis B. Mayer], *With Pen and Pencil on the Frontier in 1851,* ed. Bertha L. Heilbron, pp. 21–22.

35. In his account book, Miller listed his receipts from tuitions as follows:

 1846 April 21, Jas C. Jones, $250.00

 April 28, Osmond Tiffany, $50.00

 December 2, William Alexander, $200.00

 1848 March 25, A. J. Way, $75.00

 March 25, Bujac, $50.00

 1852 August 20, Ed. McDowell (12 lessons), $24.00

Mrs. John D. Early listed William Alexander among the pupils of Miller. A portrait sketch by Miller of J. C. Jones is preserved among the Mayer papers of the Baltimore Museum of Art.

36. Eighteen plaster casts were listed in the inventory of his estate.

37. The color charts are among the first leaves of the sketchbook inscribed "Paris, 1833" in the possession of the Miller family.

38. These suggestions and recollections occur in a letter from Miller to F. B. Mayer, December 23, 1865, preserved in the Mayer papers of the Metropolitan Museum of Art.

39. A. J. Miller to F. B. Mayer, November 7, 1864, preserved in the Mayer papers of the Metropolitan Museum of Art.

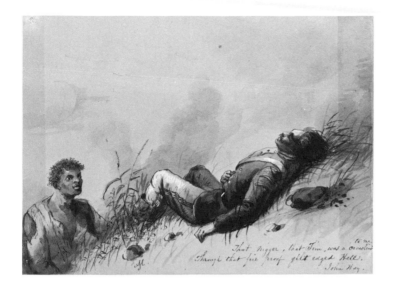

"Banty Tim." Miller, during the Civil War, was an abolitionist and supporter of the Union. In this drawing he commemorates the loyalty and courage of a black retainer who rescues a Union soldier wounded at the Battle of Vicksburg Heights. The subject is taken from a ballad by John Hay. (Cat. 888–60). Scrapbook, courtesy Mrs. L. Vernon Miller, Sr.

Miller had long since repented of his callow advocacy of slavery[40] and was indisputably an adherent of the Union. His sketches, however, remained noncommittal and were, for the most part, limited to such subjects as the fortifications of Federal Hill overlooking Baltimore Harbor, lonely sentries on watch in winter landscapes, children awaiting the return of their father, and a southern lady reading a letter from her beloved. His most explicit reference to the conflict was an illustration to the ballad *Banty Tim,* written by Lincoln's assistant secretary, John M. Hay, that celebrated the courage and loyalty of a black retainer who crossed the battlefield of Vicksburg Heights to rescue a Union soldier.

In the postwar years, Miller's productivity began to decline. Though he was still receiving orders for western views, most notably the commission for forty watercolors from Alexander Brown, the requests for other works were decreasing. In 1869, obviously a lean year, the account book listed only four orders: for the retouching of a portrait, the painting of a cabinet-size portrait, and two genre subjects. The last entries occurred in 1871.

Several factors may have contributed to the waning of Miller's endeavors. Photography was undoubtedly making inroads into the field of portraiture, particularly at the level practiced by Miller. In addition, many local collectors, following an example set by W. T. Walters, were turning from American to European art. The painter's declining health may also have affected his efforts. His chronic inflammatory rheumatism had resulted in a debilitating "morbid nervous condition." In a letter to the artist dated January 30, 1872, Kate Breckenridge expressed on behalf of herself, her husband, and her friends, the Warfields, their regrets to learn that Miller had been compelled to abandon his profession.[41] Finally, a lack of financial incentives may have led to his retirement. Miller was now relatively wealthy. Perhaps with the advice of his brother Decatur, a leader in the business

40. In his Journal, pp. 7-13, Miller related how he and "Macoutra," his companion from Virginia, had become involved in an argument with two English students also working in the Borghese Gallery. Miller claimed that the English students' opposition to slavery was invalid on the grounds that their views were colored by the writings of Captain Basil Hall and Mrs. Trollope. Since Hall had been taken off a Mississippi steamer for acts of impudence (he had entered a "Ladies' Cabin" without accompanying a lady), his opinions, Miller continued, were unworthy of consideration. Ironically, Hall, the author of *Fragments of Voyages and Travels* (London: Whittaker, 1831), happened to be standing in the gallery at the time. A reconciliation between the artist and the writer was effected by an Irish artist also present, Richard Rothwell (1800–1868).

41. Letter belonging to the L. Vernon Miller family.

community, he had invested astutely in the stocks and bonds of a number of railroads and insurance companies, and, by the time of his death in 1874, he had assembled an estate valued at approximately $119,000.[42]

In his later years Miller retired almost entirely from public life. The announcement of his death on June 26, 1874, identified him simply as the brother of Decatur H. Miller and as an artist who had passed much of his time in Rome.[43]

Though his paintings were no longer on public view, writers, in surveying Baltimore's cultural past, cited him as a luminary of the city's artistic heritage.[44] However, not until Mrs. John D. Early prepared a paper treating the artist for her Woman's Literary Club in June 1894, was there an attempt to record his biography. Drawing from the memories of his still-living associates and from old newspapers, she was able to convey to her audience a warm, appealing image of the artist, which concluded with the following passage: "If I could but show the picture that hangs on memory's wall of Mr. Miller in his quiet home, on a secluded grass-grown city street in Baltimore, with his violin near him, and his paintings on the easels, and his very handsome, bright face and charming manner, and hear him talk of his wild Indian life and its adventures, and then of his love for his native city and now hackneyed subject the 'beauty of its women,' I would have shown a picture of old Baltimore as interesting as he ever painted."[45]

42. More remarkable is that between July 9, 1874, and May 3, 1875, $10,794.64 accrued in income from the stocks and bonds in his estate. In a letter to his sister Harriet, January 3, 1874, Miller instructed her to have her own will drawn bequeathing the house and stocks and bonds to their sisters. He advised her to consult with their brother Decatur in this regard. He also requested that Harriet give to W. T. Walters his "proof-impression (before letters)" of a portrait of Pius VII after Sir Thomas Lawrence; to Owen Gill, a cabinet picture of *A Boy Selling the "Sun Extra"*; and to Brantz Mayer, his sketch in color drawn from Veronese's *Europa and the White Bull*. Gill and Mayer, he observed, were his friends for over forty years.

43. *Sun*, June 27, 1874.

44. "Art and Artists in Baltimore," *Sun*, "Supplement," November 5, 1881, cols. 4–5, and "Artists of Baltimore," *Sun*, March 10, 1889. Miss Harriet Miller occasionally showed portfolios of her brother's sketches to individuals or groups. In an undated letter (collection of L. Vernon Miller family) to Miss Miller, John W. Garrett thanked her for lending him sketches, which he showed to mutual friends. Mrs. Early also borrowed some sketches to illustrate the talk that she gave to the Woman's Literary Club on February 13, 1894 (see letter, February 1894, from Mrs. Early to Miss Harriet Miller, in the L. Vernon Miller family collection).

45. Early, *Alfred J. Miller*, p. [6].

CATALOGUE OF THE EXHIBITION

All quotations not otherwise credited come either from Miller's "Rough Draughts for Notes to Indian Sketches," now in the Library of the Thomas Gilcrease Institute of American History and Art, or from the notes accompanying his watercolors at the Walters Art Gallery in Baltimore, published in Marvin C. Ross (ed.), The West of Alfred Jacob Miller.

**Picture exhibited in Baltimore and Fort Worth only.*
†Picture exhibited in Fort Worth only.

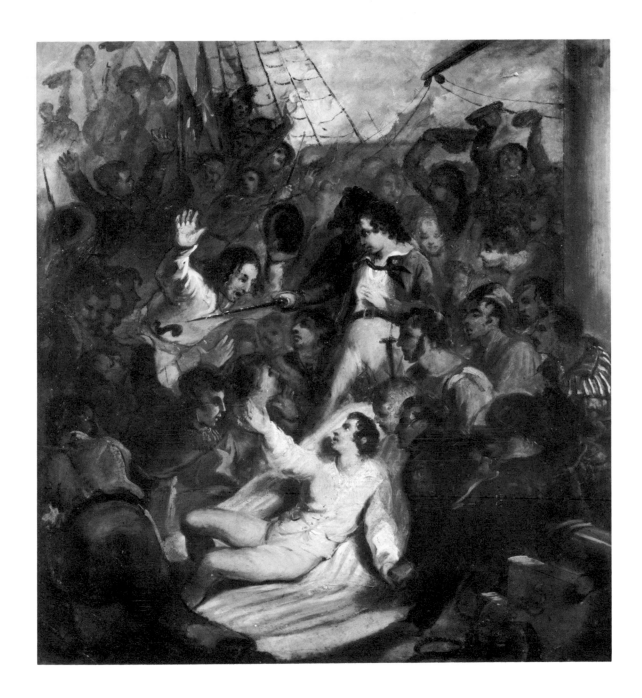

1. *Don't Give up the Ship*
 Oil on paper, backed with canvas. 20 x 18 in.
 Walters Art Gallery, Baltimore, Maryland 37.2463
 Catalogue number 42

Captain James Lawrence (1781–1813) was mortally wounded on May 6, 1813, in an engagement between his ship, the *Chesapeake,* and the frigate *H.M.S. Shannon.* While being moved below deck, Lawrence is said to have uttered his last command, "Don't give up the ship," which became a popular rallying cry of the navy.

Miller was interested in the history of his country and frequently depicted its heroes and their military exploits. In this early painting he worked in a tradition of heroic death scenes established by Benjamin West, John Trumbull, and Francesco Bartolozzi. WRJ

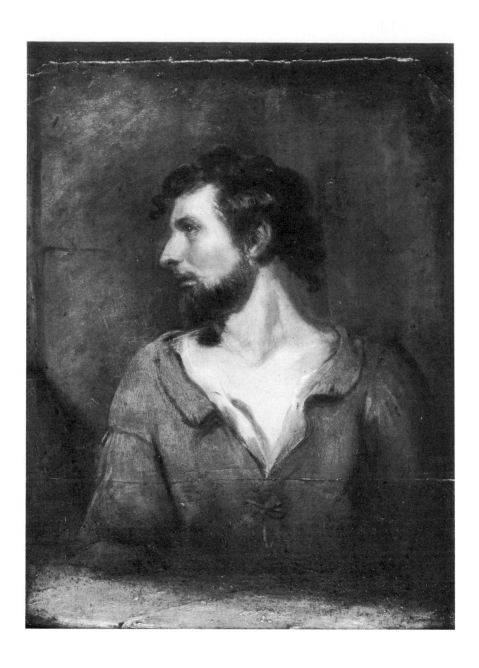

2. *Study in the Life School, Rome*
 Oil on paper, mounted on cardboard, 1834. 12 7/8 x 9 in.
 Mr. Norton Asner, Baltimore, Maryland
 Catalogue number 1

In his Journal, p. 39, Miller wrote: "Shortly after reaching Rome, I was admitted into the English Life School being the only American; the posing of models took place at night. Surmounting a platform a pedestal 4 ft. square was placed,—on this the model took his position & stood for one hour without scarcely moving a muscle,—a large maroon colored curtain fell in graceful folds behind him & a brilliant lamp with a shield 3 ft. in diameter threw a blaze of light over him—bringing the figure out in a wonderful relief." WRJ

3. Copy of Titian's *Allegory of Alfonso d'Avalos,*
 Marchese del Vasto in the Louvre, Paris
 Oil on canvas, c. 1833. 45 x 42 in.
 Mr. George Durrett, Baltimore, Maryland
 Catalogue number 856

Miller, in his Journal, recorded receiving permission to copy the "Old Master" paintings in the Louvre in 1833.
Here, he has copied with precision an allegorical painting by Titian, traditionally thought to represent Alfonso
d'Avalos and his wife, Mary of Aragon (canvas, 47 5/8 x 42 1/4 in.). WRJ

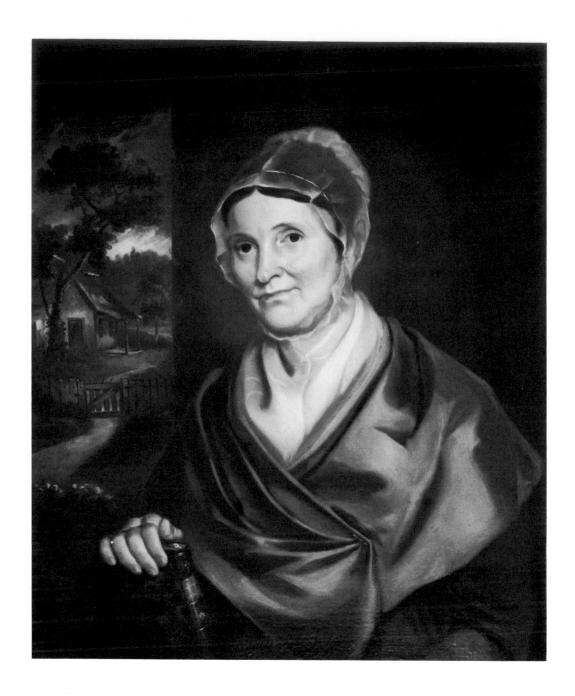

4. *Portrait of Mrs. Samuel Hopkins*
 Oil on canvas, 1832. 30 x 25 in.
 The Johns Hopkins University, Baltimore, Maryland 26366; gift of Mrs. Francis White
 Catalogue number 648

Mrs. Hopkins, née Hannah Janney, was the daughter of Joseph Janney of Loudon County, Virginia, and of Hannah Jones. In 1792, she married Samuel Hopkins of "Whitehall" near Millersville, Anne Arundel County, Maryland. The decision of Mr. and Mrs. Hopkins, both Quakers, to manumit their slaves involved considerable sacrifice for themselves and their twelve children, who assumed the burden of working the family tobacco plantation. After her husband's death in 1814, Mrs. Hopkins joined her son Johns Hopkins in Baltimore city.

WRJ

5. *The Savoyard*
 Oil on cardboard. 8 3/16 x 6 3/8 in.
 Walters Art Gallery, Baltimore, Maryland 37.1584
 Catalogue number 4

Natives from Savoy emigrated to Paris, where they frequently eked out a living as chimney sweeps or as itinerant musicians. Miller executed a preliminary drawing of this subject in Paris in 1834, which he preserved in a scrapbook. He presented this oil sketch to Jennie Walters (1853–1922), the daughter of his patron, William T. Walters. The syntax in Jennie's letter of acknowledgment suggests that the gift was made after the Walters' return from Europe following the Civil War. Miller repeated this theme in another sketch, also in a family scrapbook, showing Jean Valjean and a young Savoyard with a hurdy-gurdy, characters taken from Victor Hugo's *Les Misérables* of 1862. WRJ

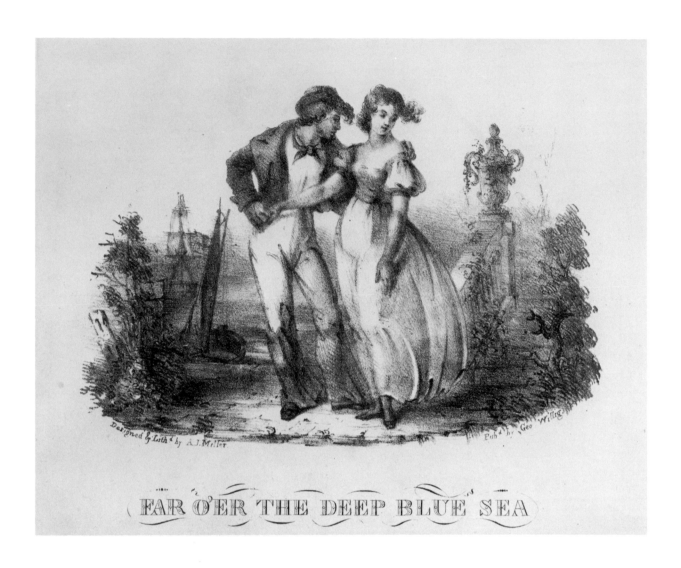

FAR O'ER THE DEEP BLUE SEA

6. *Far O'er the Deep Blue Sea*
 Lithographed sheet music cover, 1834. 7 1/2 x 9 1/2 in.
 Mr. George Durrett, Baltimore, Maryland
 Catalogue number 895

In 1834, Miller experimented with lithography, producing two song covers for the Baltimore music publisher George Willig, Jr., from whom he was renting a room. This cover illustrates a song by lyricist R. H. Pratt with music by John H. Hewitt. Miller produced at least one other sheet music cover. WRJ

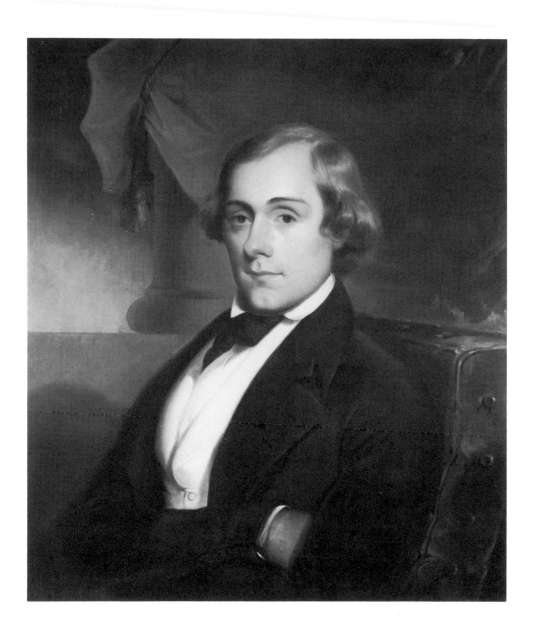

7. *Portrait of William Henry Heald*
 Oil on canvas, c. 1844. 30 x 25 in.
 Walters Art Gallery, Baltimore, Maryland 37.2509; gift of Mrs. William Newland Day, 1973
 Catalogue number 633

Heald, as a young man, was a member of the firm of John H. Heald and Co., tanners, at North and Madison streets, Baltimore. He married Sarah Malvina Allen (September 15, 1824–December 16, 1854) in 1844, by whom he had three children, Mary Elizabeth (1851–1935), Emma Eliza (1845–1920), and James Allen (1849–1889). As a companion piece, Miller painted a portrait of Mrs. Heald (Walters Art Gallery 37.2511). The children were subsequently portrayed by another local artist, Henry Bebie. Following the death of Sarah Malvina, Heald remarried. Though he retired from the business at an early age, he took an active interest in a number of ventures, including the construction of the Mount Vernon Methodist Church. Probably as a result of the business ties between his brothers Decatur and Columbus and the Healds, Miller executed a number of portraits of members of the Heald family. WRJ

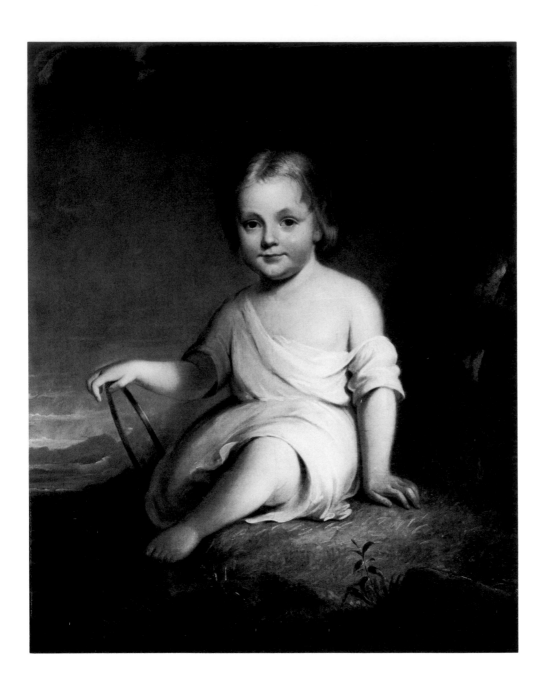

8. *Portrait of Master Francis Mankin Jenks*
 Oil on canvas, c. 1848. 36 x 29 in.
 Francis H. Jencks, Baltimore, Maryland
 Catalogue number 658

The subject, a two-year-old, was the son of Francis Haynes Jenks from Maine and Mary Gardner Mankin of Baltimore. As an adult, he practiced law in New York until 1890, the year he retired to Baltimore.

Miller appears to have enjoyed portraying children, judging from the many sketches of them in his scrap-books. Invariably, he showed them in out-of-doors settings.

F. H. Jenks commissioned this portrait, together with a portrait of his wife, in November 1848. WRJ

9. *Portrait of Henry Mankin and Daughters,*
 Alice Gardner Mankin and Sarah A. Mankin
 Oil on canvas (oval), 1848–1849. 36 7/8 x 48 1/8 in.
 The Baltimore Museum of Art, Baltimore, Maryland 16.1.1; gift of the Misses Mankin, 1916
 Catalogue number 681

Henry Mankin (1804–1876), a wealthy shipping merchant and land developer, is shown seated on a rustic chair in an exterior setting, reading a book to his daughters, Alice Gardner (1840–1907) and Sarah A. (1842–1918). The painting was commissioned on May 20, 1848, for $250.00 and payment was made on August 20 the following year. This work is a companion to a portrait of Mrs. Mankin (Sarah Anne Foard) and her infant daughter, Maria Theresa, painted the preceding year.

These portraits are among the artist's most ambitious works in this genre. In their smooth, glazed surfaces, luminous flesh tones, and somewhat mannered poses of the subjects, they recall the portraiture of Thomas Sully.

Other Mankin family portraits produced by Miller include a cabinet-size portrait of Mr. Mankin, commissioned in 1849, and three pictures ordered by Isaiah Mankin, Henry's father: one of the elder Mrs. Mankin (May 17, 1847), another of Dr. Clendinen Mankin (February 15, 1849), and the third, Mary Clendinen (March 26, 1851). WRJ

10. *Crabbing for Soft Crabs at Hawkins Point*
 Watercolor, gouache, and ink on paper. 5 5/8 x 7 1/2 in.
 The L. Vernon Miller family
 Catalogue number 888–52

In this picture, Miller recalls his youth on his father's farm on Hawkins Point below Baltimore on the
Patapsco River.

<div align="right">WRJ</div>

11. *Beach at Cape May*
 Black and brown ink on beige paper. 4 5/8 x 6 in.
 The L. Vernon Miller family
 Catalogue number 888–32

For his own amusement, Miller compiled in scrapbooks his humorous drawings, often identifying scenes with labels inscribed on separate scraps of paper. Here, he shows a scene at Cape May, a popular beach resort in nearby New Jersey.

WRJ

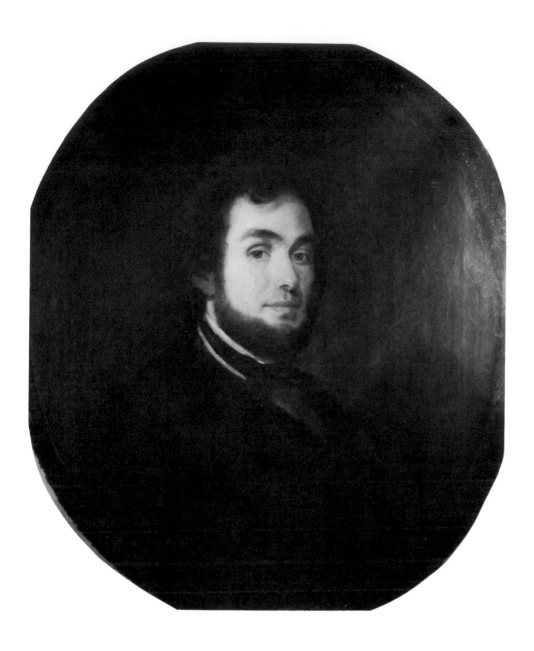

12. *Self-Portrait*
 Oil on canvas (oval), c. 1850. 30 x 25 in.
 Walters Art Gallery, Baltimore, Maryland 37.2556; gift of Mrs. L. Vernon Miller, Sr., 1978
 Catalogue number 693

The artist has portrayed himself at about the age of forty. He has chosen an oval format and has applied the pigments extremely thinly in smooth brush strokes, as was characteristic of many of his mature works. Other self-portraits include a small oil sketch on academy board painted about 1827 (cat. 692), a pencil sketch probably made during his western trip in 1837 (cat. 92), and a later work showing him as a bearded individual (cat. 694).

WRJ

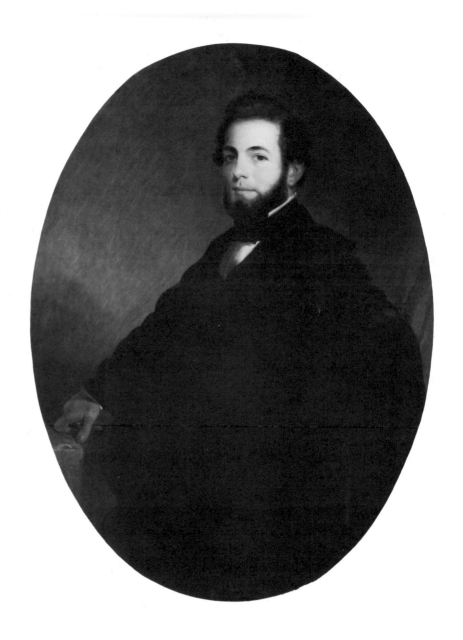

13. *Portrait of Decatur Howard Miller*
Oil on canvas (oval), c. 1850. 48 x 36 1/2 in.
Walters Art Gallery, Baltimore, Maryland 37.2558; gift of Mrs. L. Vernon Miller, Sr., 1978
Catalogue number 697

The artist's younger brother Decatur Howard Miller distinguished himself as a leader of the Baltimore business community. As a young man, he entered the tobacco business of Jacob Heald and eventually succeeded his employer as head of the firm. He continued to direct the business in his own name until 1880. Miller also served as director of the Baltimore and Ohio Railroad, the Baltimore Dry Dock Company, the Consolidation Coal Company, and the Merchants and Miners Transportation Company, which operated ships along the northeastern Atlantic coast. He was at one point a member of the city council and vice-president of the Board of Trade (1875–1876).

D. H. Miller appears to have assumed responsibility for the financial affairs of his brothers and sisters, and it was probably his astuteness as an investor that led to the artist's financial independence. WRJ

14. *Portrait of Mrs. Decatur Howard Miller (Eliza Credilla Hare)*
Oil on canvas (oval), c. 1850. 47 3/4 x 36 3/4 in.
Walters Art Gallery, Baltimore, Maryland 37.2557; gift of Mrs. L. Vernon Miller, Sr., 1978
Catalogue number 699

In this elegant, colorful portrait, a companion to the preceding work, Miller excels as a portraitist. He shows his sister-in-law standing with her back to a mirror, which, in turn, reflects her bare neck and shoulders. Hanging from her right shoulder is a red velvet drapery with a green lining. Beside her on a table is a bowl containing a large goldfish.

Mrs. Decatur H. Miller, née Eliza Credilla Hare, was the daughter of Jesse Hare of Lynchburg, Virginia, and Baltimore, and of Catherine Welch. Her father was an extremely wealthy tobacco manufacturer who introduced the use of licorice in the manufacture of chewing tobacco. Eliza was married to D. H. Miller on October 14, 1847.

WRJ

15. *Newspaper Boy*
Watercolor, ink, and pencil on paper. 5 5/8 x 3 5/8 in.
The L. Vernon Miller family
Catalogue number 888–34

Newspaper boys were a popular subject for mid-century genre painters. Miller left to his friend Owen Gill a cabinet painting entitled *A Boy Selling the "Sun Extra."* WRJ

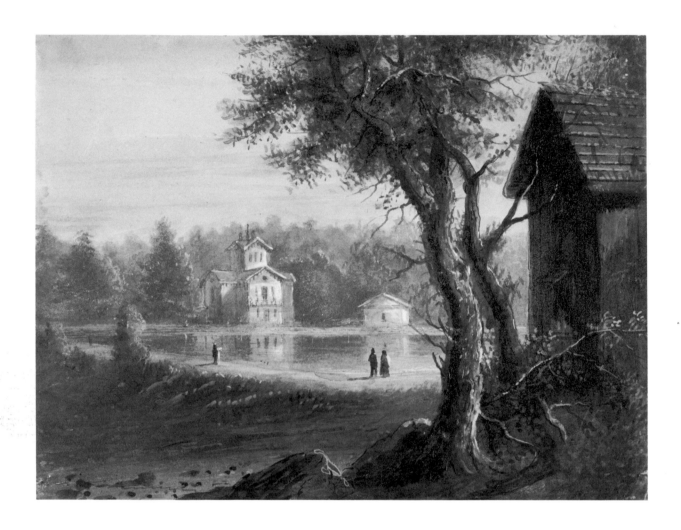

16. *Hampden Reservoir*
 Watercolor on paper. 6 1/2 x 8 5/8 in.
 The L. Vernon Miller family
 Catalogue number 888–73

Miller, traveling north on the Jones Falls Road, would pass the Hampden Reservoir on the outskirts of the city.

WRJ

17. *Falstaff on the Battlefield* [in Shakespeare's *Henry IV, Part One*]
Oil on canvas. 20 x 24 in.
From the Collection of George J. and Patricia Arden
Catalogue number 43A

The American actor James Hackett (1800–1871) is shown in one of his most celebrated roles, that of Falstaff in Shakespeare's *Henry IV*. He is portrayed seated on a mound at the Battle of Shrewsbury in a position strongly recalling that of David Garrick as Richard III in William Hogarth's painting in the Walker Art Gallery, Liverpool. Miller painted a smaller version of this scene, now in a private collection in Baltimore (cat. 43). WRJ

18. *The Marchioness* [illustration from Dickens' *The Old Curiosity Shop*]
Oil on panel. 11 3/4 x 10 3/8 in.
Walters Art Gallery, Baltimore, Maryland 37.2538; gift of Miss Margaret Hodges
Catalogue number 44

The servant girl who took "a limited view of society, through the keyholes of doors," in Charles Dickens' *The Old Curiosity Shop* (1841) is shown in her distinctive role, carrying a broom. A sketch from a scrapbook shows the same subject with a less detailed setting. Miller, in his sketches, expressed an abiding interest in popular literature, particularly in the works of Dickens. Seldom, however, did he transpose this interest to his oil paintings.

WRJ

19. *The Marchioness* [illustration from Dickens' *The Old Curiosity Shop*]
Ink, wash, and white watercolor on paper. 8 1/8 x 5 3/8 in.
Walters Art Gallery, Baltimore, Maryland 37.2468.3; gift of Mr. and Mrs. J. William Middendorf II
Catalogue number 893–41

The nameless little servant girl was invited by Dick Swiveller to play cribbages in his room in Dickens' *The Old Curiosity Shop* (1841). After she nursed him through a serious illness, Mr. Swiveller married his "Marchioness." Miller was particularly drawn to the works of Dickens and drew illustrations to *Barnaby Rudge, Martin Chuzzlewit,* and *Little Dorrit,* as well as *The Old Curiosity Shop.* WRJ

20. *Serenaders under the Wrong Window*
Ink and wash. 13 7/8 x 16 1/4 in.
Walters Art Gallery, Baltimore, Maryland 37.2519.8; gift of Mr. and Mrs. J. William Middendorf II
Catalogue number 893–66

Inscribed: Serenaders *under the wrong window!* Quaker Gent—"My friends,—I think in thy song, I heard the expressions of 'Home Sweet Home' & that there was *no* place like *Home*." "Truly—Friends I agree with Thee & now advise Thee to go home."

WRJ

21. *A Disposition to "Pick-Foul"*
Pencil and white watercolor on paper. 9 1/4 x 8 3/8 in.
Walters Art Gallery, Baltimore, Maryland 37.2468.28; gift of Mr. and Mrs. J. William Middendorf II
Catalogue number 893–15

Young boys are shown tapping eggs together to determine the winner—the one whose egg remains intact at both ends. "Pickin' eggs" was a popular springtime pastime in east coast American cities until a generation ago.

WRJ

unsophisticated youth (loqr). – Frank – while I have tickled almost to death with the farce, – I notice that these fiddlers never move a muscle, – but look as if they are to be hung immediately – if not sooner.!

22. *Unsophisticated Youth*

Pen and wash on paper. 13 3/8 x 15 7/16 in.
Walters Art Gallery, Baltimore, Maryland 37.2519.9; gift of Mr. and Mrs. J. William Middendorf II
Catalogue number 893–73

"Unsophisticated youth [loqʳ]—Frank while I have been tickled to death with the farce, I notice that these fiddlers never move a muscle, but look as if they are to be hung immediately if not sooner."

Miller, especially in his younger days, was a devotee of the stage. In Baltimore he had the opportunity to enjoy the widely varied fare presented at the city's two principal theaters, the Holliday, one of the nation's most venerable houses dating from 1792, and the Front, built in 1829. WRJ

23. *Burning of the Stieff Factory*
Watercolor and gouache on paper, c. 1859. 4 x 7 15/16 in.
The L. Vernon Miller family
Catalogue number 888–66

Mat inscribed: "Sketches at night Burning of Stieffs Factory Baltimore December 10th/59"

Miller has depicted a conflagration that erupted on the evening of December 10, 1859, in the heart of Baltimore. The fire destroyed the piano factory of C. M. Stieff at 408 W. Baltimore Street and spread to several adjoining buildings before being brought under control. WRJ

Dr. Johnson, Boswell & Hodge, the C...

24. *Dr. Johnson, Boswell and Hodge, the Cat*
 [illustration from Boswell's *Life of Samuel Johnson*]
 Pencil, pen and ink, and white watercolor on beige paper. 7 1/2 x 6 3/4 in.
 The L. Vernon Miller family
 Catalogue number 888–92

James Boswell's biography provided a particularly rich source of subject matter for the artist's pen. Here the doctor is shown with his biographer and cat.

WRJ

Gabrial Ravel as Godenski.

25. *Gabriel Ravel as Godenski*
 Watercolor on blotting paper. 10 13/16 x 8 1/2 in.
 Walters Art Gallery, Baltimore, Maryland 37.2453.1; gift of Mr. and Mrs. D. Luke Hopkins
 Catalogue number 894–1

Among the Ravels' most long-standing successes was a two-act pantomime set in Russia, *Godenski, or the Skaters of Wilnau,* in which the tribulations of the young lovers, Ludoviski and Ludoviska, follow the lines of the traditional harlequinade. The comic suitor, Godenski, is rescued in a skating scene in which roller skates were used for the first time in America. WRJ

Francois Ravel as Vol-au-vent.

26. *François Ravel as Vol-au-vent*

Watercolor on cream-colored paper. 10 1/2 x 8 1/2 in.
Walters Art Gallery, Baltimore, Maryland 37.2453.31
Catalogue number 894–31

Vol-au-vent was a character in the comic pantomime of the same name. WRJ

27† *View from Garden, Murthly Castle*
Watercolor on paper. 5 x 7 5/8 in.
Maryland Historical Society, Baltimore, Maryland 54.151.4; gift of Mrs. Laurence R. Carton
Catalogue number 880

Murthly Castle was the ancestral home of the Stewarts, the seventeenth-century house to which Sir William Drummond Stewart returned after his brother's death and his inheritance of the estates and title. It is located a few miles north of Perth, Scotland, near the River Tay. From its upstairs windows one can see the remaining two trees in Shakespeare's Birnam Wood, made famous in *Macbeth*.

Upon completing his original commission, Miller accepted an 1839 invitation from Stewart to live at Murthly and work others of his sketches into finished oil paintings for Murthly. "The old castle of Murthly . . . presents at every turn fine scenes for the pencil of the artist At the end of the Terrace is the Moss Cottage fitted up with rustic seats,—this is my favorite haunt,—here of an afternoon I sit me down to breath[e] the invigorating air and to enjoy the tranquil scene." This small watercolor is one of the sketches that Miller made, probably to show his family in Baltimore something of what Murthly looked like. Miller returned to Baltimore in 1842.

RT

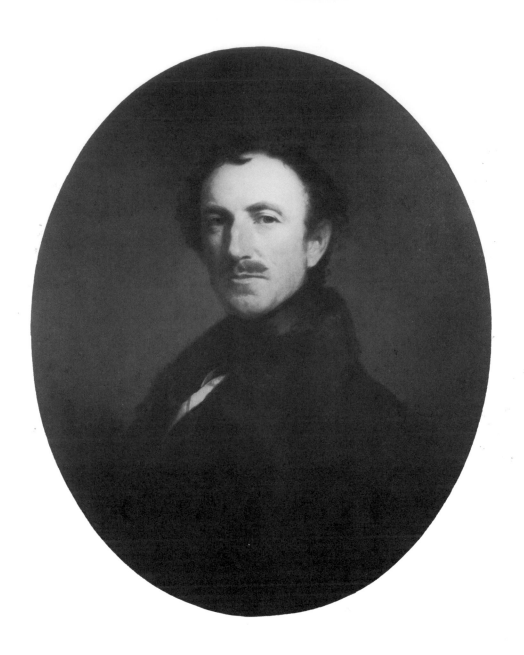

28. Henry Inman. *Portrait of Sir William Drummond Stewart*
Oil on canvas (oval), 1844. 29 x 25 in.
Joslyn Art Museum, Omaha, Nebraska 1963.617

William Drummond Stewart, the second son of a wealthy Scottish nobleman, was a retired veteran from the British army who had come to America to recover from a violent quarrel with his older brother and an unwanted marriage to a lovely farm girl. He first went west in 1833 and so enjoyed the rendezvous that he returned every year thereafter until the fall of 1838, when he learned that his brother had died and that he had succeeded to the family estates and title.

This portrait was the result of a visit by Henry Inman, well-known American portrait painter, to Murthly Castle in 1844. There Stewart commissioned Inman to paint his portrait, intending the picture as a gift for J. Watson Webb, a New Yorker and good friend of Stewart who had brought Inman to Murthly. Famous for his hundreds of Indian portraits (largely copies of Charles Bird King's work), Inman rendered an excellent likeness of Stewart, clad in a navy blue coat with a beaver collar, perhaps a reference to the baronet's many western trips. RT

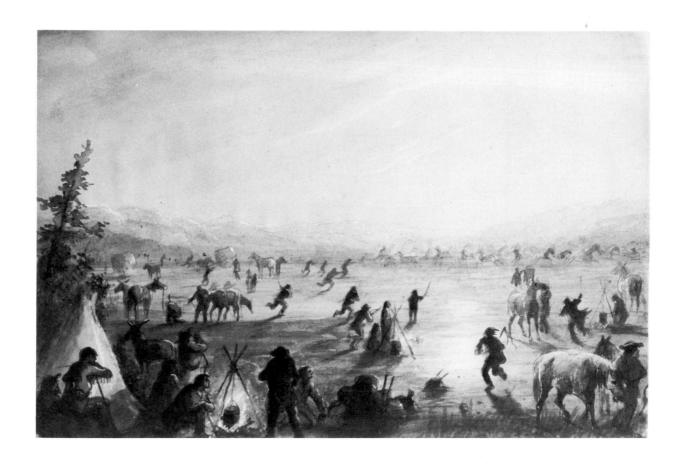

29† *Attrapez des Chevaux*
Watercolor on paper. 8 x 12 1/4 in.
Boatmen's National Bank, St. Louis, Missouri
Catalogue number 59

The morning starts briskly as the men finish breakfast and go out to catch their semiwild horses. This delightful sketch captures some of the freshness and vigor that Miller associated with wild horses whenever he saw them. Their "hot and fiery blood" fueled his imagination as he permitted them to represent the spirit of the West in both his pictures and his words. Historians have since noted that Miller's highly romantic view of the West caused him to picture the scrawny Indian ponies as beautiful Arabians. RT

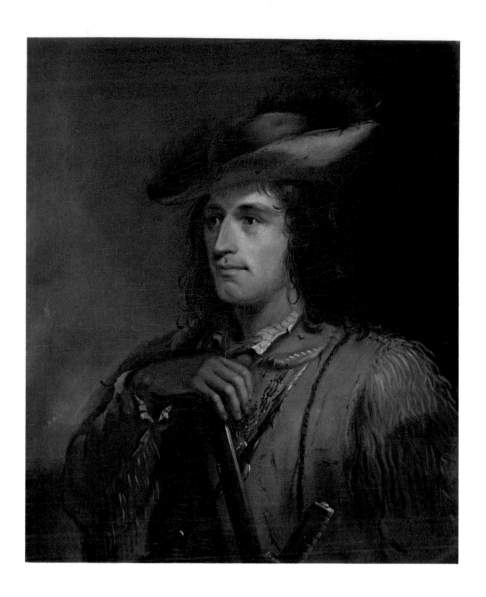

30. *Portrait of Antoine*
Oil on canvas, c. 1840. 30 1/8 x 25 in.
Walters Art Gallery, Baltimore, Maryland 37.2573;
gift of the Moser family in memory of Rebecca Ulman Weil
Catalogue number 52A

Antoine Clement was Stewart's hunter, a man of supreme ability and mountain skills. A French Canadian, he had a temper violent enough to match Stewart's determination and returned with Stewart to Scotland in 1839, where he lived a rather unhappy life serving as backdrop for Stewart's stories and, on occasion, as butler.

Antoine's marksmanship was legendary. He was "our best man and killed single handed about 120 buffalo for us on the outward journey," Miller wrote. Antoine was a true son of the West and was unhappy in Scotland or St. Louis. When Sir William returned home after his 1843 trip to the mountains, Antoine remained in St. Louis. RT

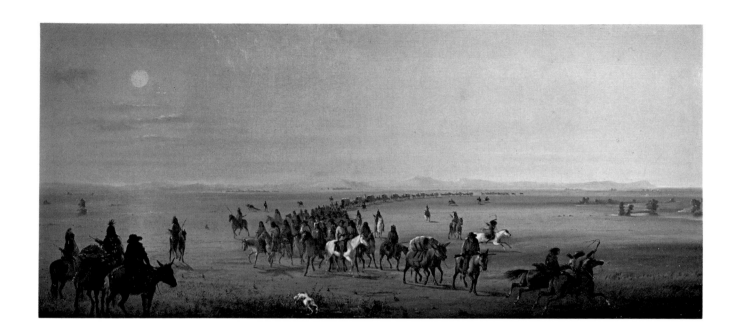

31[†] *Caravan en Route*
Oil on canvas. 21 x 47 in.
Boatmen's National Bank, St. Louis, Missouri
Catalogue number 60G

Thomas Fitzpatrick was the leader of the American Fur Company caravan as it left Westport and headed across the prairie with perhaps forty-five men and twenty carts and wagons full of supplies for the Indians and trappers waiting in the mountains. But the dominant figure in this "heterogeneous mass of people" is Captain Stewart, mounted on the white horse. A veteran of these westward treks as well as Wellington's campaigns against Napoleon, Stewart, whom Fitzpatrick named as his assistant, was in charge of disciplining the "unruly spirits."

This is one of the few oil paintings that Miller finished of the prairie scenes. RT

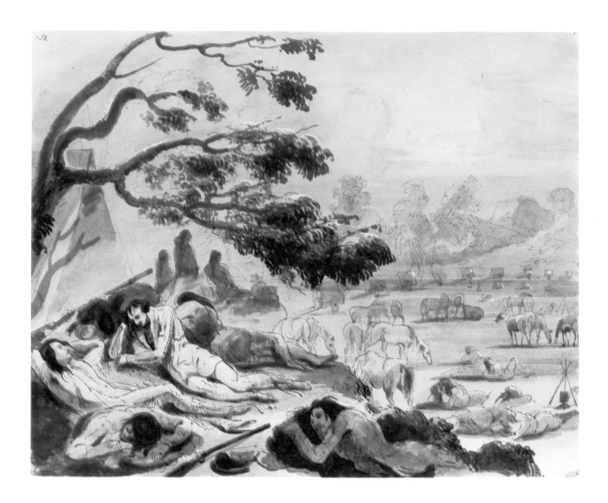

32. *Repose at Mid-day*
 Pencil and pen and ink with brown wash, heightened with white, on gray card, c. 1837. 8 7/8 x 11 in.
 Amon Carter Museum, Fort Worth, Texas 22.66
 Catalogue number 61A

The noon rest was a busy time for Miller, who occupied himself sketching as the horses fed and the men napped. It was also the time during which Stewart and Miller developed the working relationship that carried them through the summer. Thinking, no doubt, of the images that he wanted to remember the trip by, Stewart prodded Miller, asking why he did not "sketch this and that thing." Miller replied somewhat sharply that he would if he "had half a dozen pair of hands . . ." Recovering his mastery of the situation, Stewart smilingly observed, "That would be a great misfortune." Miller should have left the discussion, but he could not: "Why?" he asked. "It would be very expensive in the matter of kid gloves," Stewart answered. Miller confided in his private Journal—not in the captions prepared for his pictures—that he had a reply to this remark in fifteen minutes, but *"too late."*

This sketch is one of a group that Miller did upon returning to New Orleans in the fall of 1837. The entire series, bound together in a leather-covered album, was kept in the drawing room at Murthly where, Miller noted with pride, Stewart frequently showed them. When Stewart's pictures were auctioned in 1871, these sketches were, no doubt, among the items to be sold. Fortunately, they fell into the hands of Bonamy Mansell Power, who had served Stewart's son as a tutor and probably recognized their significance. They remained in Power's family until their sale in the United States in 1966. Whereas Miller's normal sketches are quite colorful, these sketches are notable for the absence of bright colors. They usually are delicate washes, such as this one, or have pale colors applied. RT

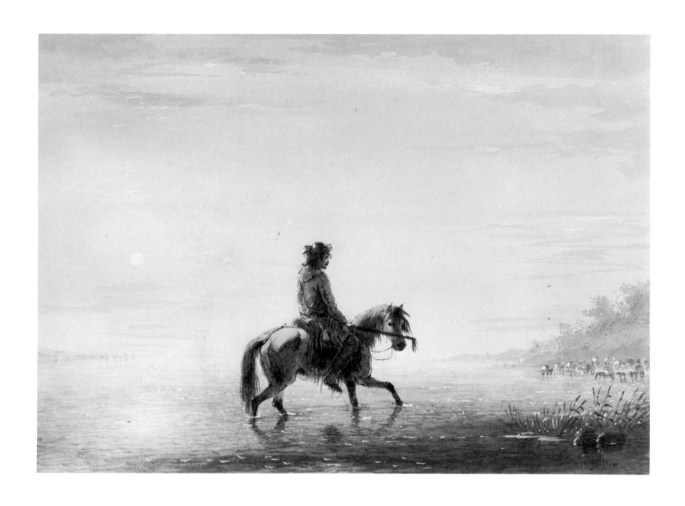

33. *Crossing the River—Trapper Trying Its Depth, &c.*
Watercolor on paper, 1858–1860. 8 3/4 x 12 5/16 in.
Walters Art Gallery, Baltimore, Maryland 37.1940.119
Catalogue number 62

When the caravan approached a river, "a trusty and experienced man is . . . selected whose business it is to cross the river and try its depths, and then return by a different route, looking out [for] the shallowest parts and marking them in his mind's eye as a trail for the company." If the river was not shallow enough for the wagons to cross, everything had to be unloaded and bull boats—the wagon beds covered with buffalo hides—had to be constructed and all the caravan's goods floated across. RT

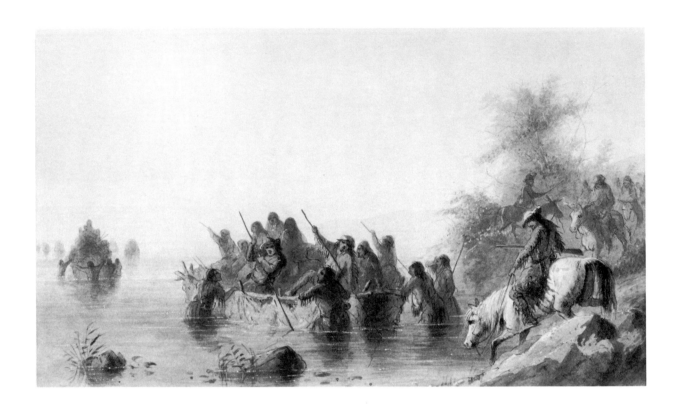

34. *Bull Boating*
Watercolor on paper, 1858–1860. 8 1/2 x 14 7/8 in.
Walters Art Gallery, Baltimore, Maryland 37.1940.180
Catalogue number 73A

When the river was too deep to permit the wagons to cross, the Conestoga wagons were stripped and buffalo hides were wrapped around them. All the goods and equipment were loaded into them, beginning with the ten-gallon barrels of alcohol (which had been slipped by the authorities, it being illegal to take alcohol to the Indians), and floated across the river. The carts were emptied and floated across on their own. This was a time-consuming process to be avoided if at all possible. RT

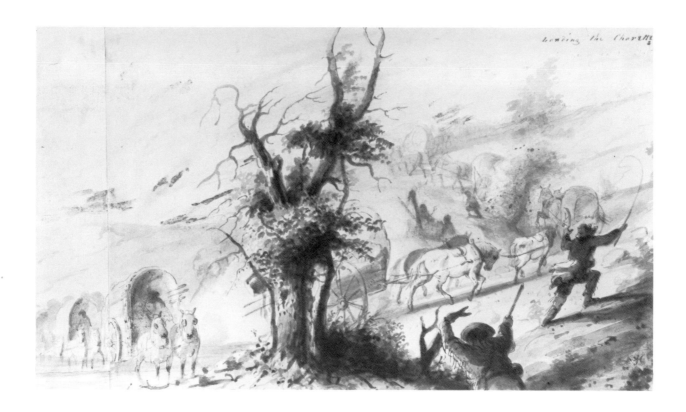

35. *Landing the Charettes*
Brown wash on paper, c. 1837. 9 1/4 x 15 1/4 in.
Joslyn Art Museum, Omaha, Nebraska; InterNorth Art Foundation Collection 728
Catalogue number 75

Crossing a river was one of the most difficult tasks in the westward march. Even if the stream were shallow enough to permit the wagons to roll across, as illustrated here, the opposite bank might be so steep that the horses and mules could not pull the carts and wagons up. In this instance, the teamsters were able to combine the horses into teams and pull the wagons up, something that might not be possible on steeper banks.

Miller notes with some curiosity that the Indians always stood by, declining "presents and all reasonable inducements" to help. RT

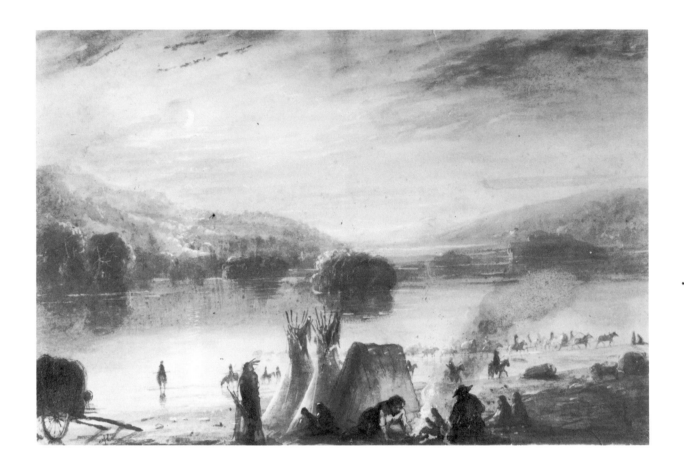

36. *Crossing the River by Moonlight—Making Camp*
Watercolor on paper, c. 1837. 8 3/4 x 12 7/8 in.
Joslyn Art Museum, Omaha, Nebraska; InterNorth Art Foundation Collection 717
Catalogue number 72

This sketch depicts the camp of tired men who, having marched all day, then crossed the river before making camp. The cooks are at work on the evening meal, while everyone else is completing the day's work. The Canadians "may get up for a dance," noted Miller, while each trapper is "stretched out with 'his back to the earth, his feet to the fire.'" RT

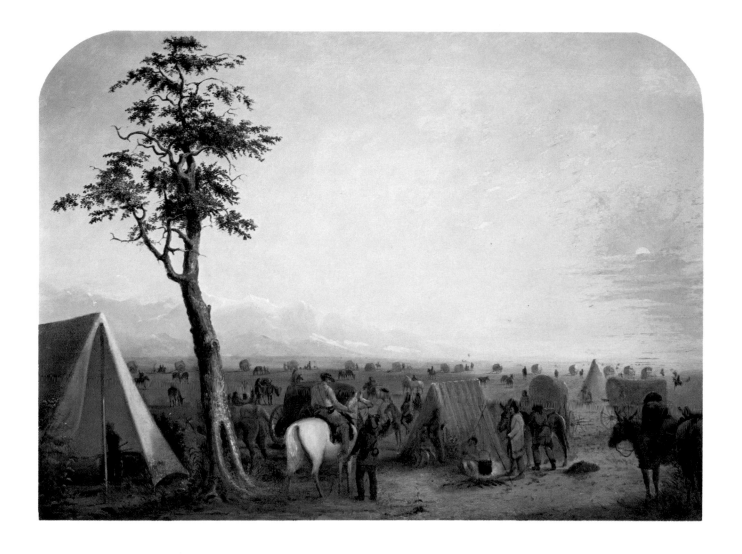

37. *Our Camp*
 Oil on canvas. 26 3/8 x 36 in.
 Whitney Gallery of Western Art, Buffalo Bill Historical Center, Cody, Wyoming 11.70
 Catalogue number 76C

Selecting camp each day was the duty of scouts sent out in front of the caravan. The carts and wagons would form a circle with a circumference of five or six hundred feet; the animals would be loosened to feed in the middle, and the teamsters slept under their wagons. Stewart's camp is shown in the foreground. RT

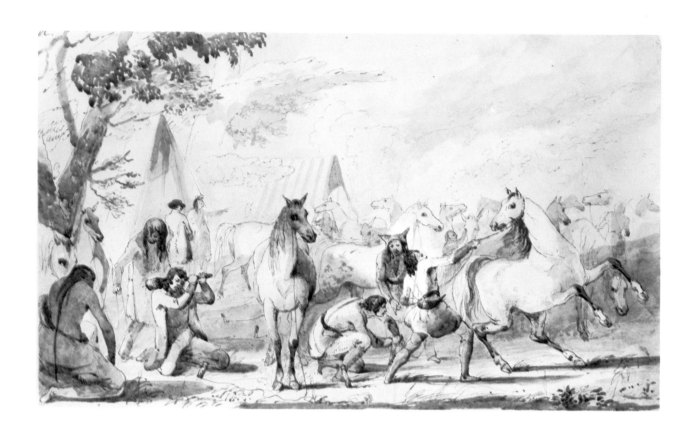

38. *Picketing the Horses—At Evening*
Pen and ink with gray and brown washes on paper, c. 1837. 7 5/8 x 12 1/8 in.
Amon Carter Museum, Fort Worth, Texas 24.66
Catalogue number 78A

As they made camp each day, each man had to picket his horse in a good bed of grass. Miller, acknowledging the necessity of this duty, nevertheless asked to be excused from it so that he could devote those hours to sketching the camp activities. Stewart said no: "In short, the reasons were as plentiful as blackberries why it should not be done," Miller wrote.

RT

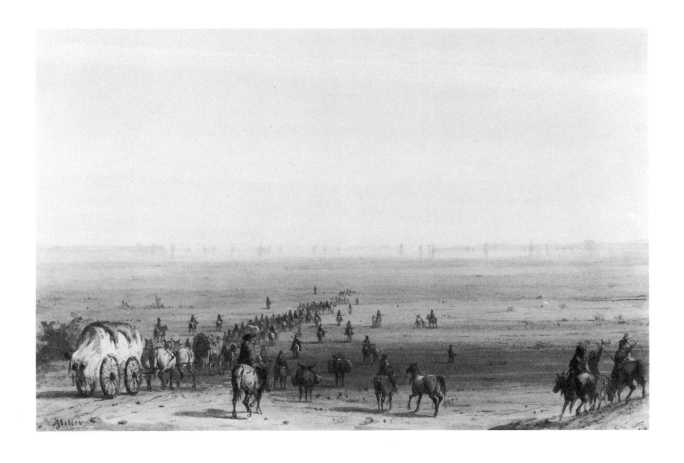

39. *Prairie Scene: Mirage*
 Watercolor on paper, 1858-1860. 8 13/16 x 13 3/16 in.
 Walters Art Gallery, Baltimore, Maryland 37.1940.149
 Catalogue number 79B

The men were tormented by thirst several times while crossing the prairie. It was not unusual in such a situation to see a delightful lake looming on the horizon. When the horses did not "quicken their motion, or snort," Miller knew that he was seeing a mirage. Although Miller is noted for the first pictures of the Rocky Mountain fur trade, he also painted some of the freshest and most candid prairie scenes to come out of the overland trail.

RT

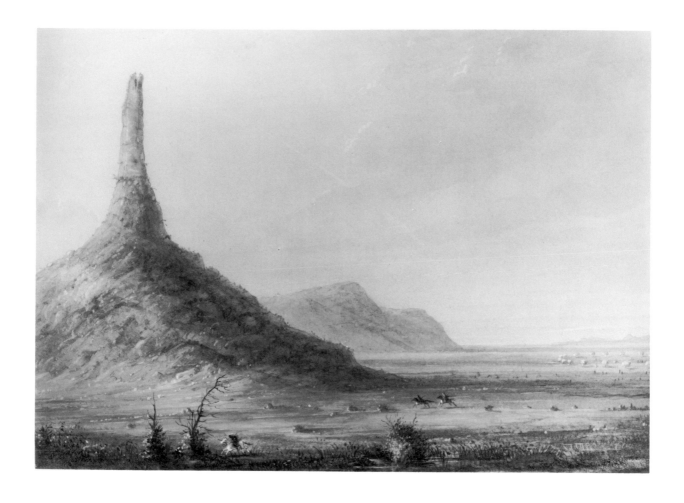

40. *Chimney Rock*
Watercolor on paper, 1858–1860. 10 1/4 x 14 1/4 in.
Walters Art Gallery, Baltimore, Maryland 37.1940.54
Catalogue number 99B

Chimney Rock, along the Platte River, is one of the first unusual formations that Miller saw. A remarkable column approximately 150 feet high when he saw it, the rock is made of clay with strata of rock running through it. In his novel *Edward Warren* (pp.155–156), Stewart commented that the rock, "seen in the mists occasioned by the evaporation of a wet region around, represents Parthenons and Acropolises, fortifications or cathedrals . . ."

The column has deteriorated today but is still a prominent landmark, a recognizable remnant of an earlier era.

RT

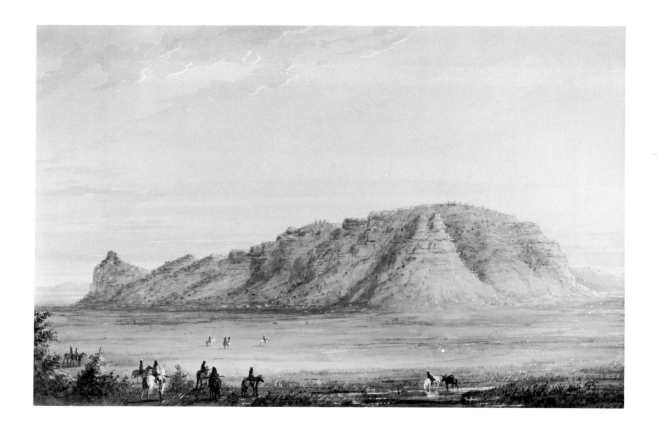

41. *Scott's Bluffs*
 Watercolor on paper, 1858–1860. 9 1/16 x 14 1/4 in.
 Walters Art Gallery, Baltimore, Maryland 37.1940.65
 Catalogue number 100B

Soon after passing Chimney Rock, the traveler saw Scott's Bluffs, a mound with the appearance of an "immense fortification with bastions, towers, battlements, and embrazures" to Miller. Stewart (*Edward Warren*, p. 156) called it "an obstacle to be surmounted." The name originated, Miller noted, when a man named Scott became sick and had to be abandoned near the bluffs, but there are many other versions of the story. RT

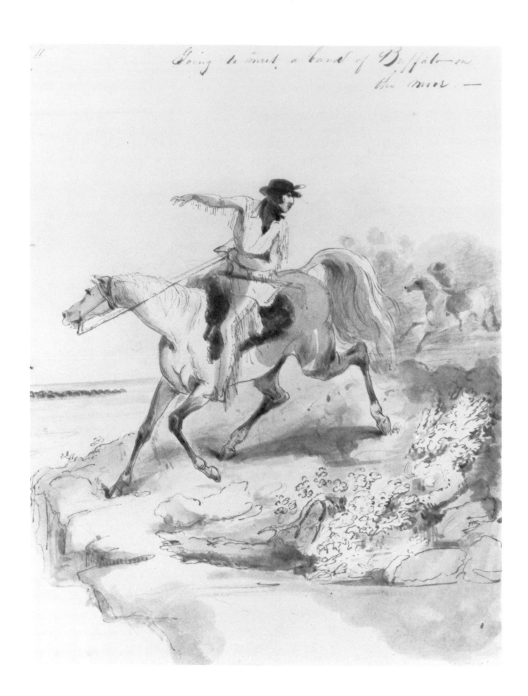

Going to meet a band of Buffalo on the move. —

42. *Going to Meet a Band of Buffalo on the Move*
Pencil and pen and ink with gray and yellow washes on paper, c. 1837. 8 1/2 x 6 5/8 in.
Amon Carter Museum, Fort Worth, Texas 25.66
Catalogue number 101

The set of sketches that Miller prepared for Stewart (known as the Power sketches) contain more pictures of Stewart than do the other watercolor sets at the Joslyn Art Museum (InterNorth Collection) and the Gilcrease Institute. This one was probably prepared especially for Stewart and it might well have been inspired by a remark that Stewart made when he approached a raging river. "Yes," Stewart said, he intended to cross the river, although Miller believed that "not the slightest necessity existed for this, except that [the] river looked a little in opposition."

RT

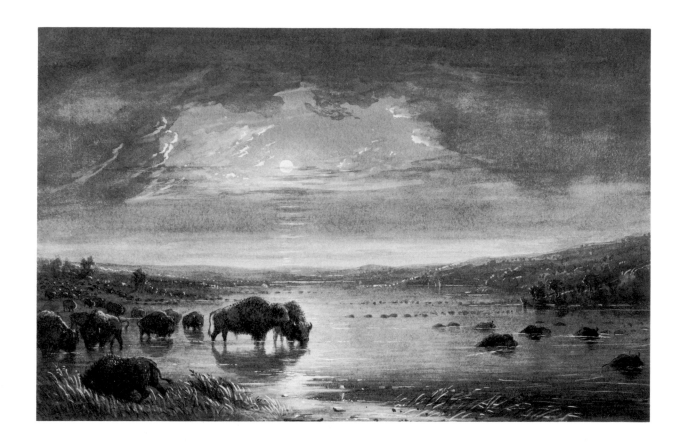

43. *Buffaloes Drinking and Bathing at Night*
 Watercolor on paper, 1858–1860. 8 11/16 x 13 7/16 in.
 Walters Art Gallery, Baltimore, Maryland 37.1940.100
 Catalogue number 112A

"The scene of the sketch is on the Platte," wrote Miller, "at night the Buffalo come to the River banks in legions, to quench thirst and refresh themselves by swimming." Miller, like all other artists to visit the West, was amazed at the buffaloes and recorded many details of their activities: "Two things are essential to the well-being and comfort of this animal—he must have his water bath, which he usually takes at night, and his earth bath, with which he solaces himself during the day." RT

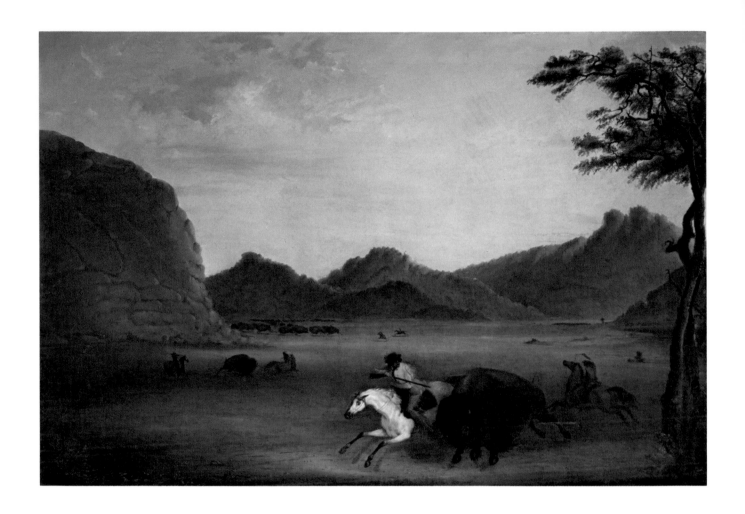

44. *The Buffalo Hunt*

Oil on canvas, c. 1839. 38 1/2 x 56 1/2 in.

Lent by Philbrook Art Center, Tulsa, Oklahoma; gift of Lydie Marland to honor George Marland and Governor E. W. Marland, 1961

Catalogue number 114

Although the hunt was a great sport, it was also a necessity. When they left Westport, Miller noted in the preface to his "Rough Draughts," they left bread and salt behind. They subsisted solely on meat while on the trail, meat that the hunters brought in each day. "The hunter for the camp must be a prime marksman of indomitable perseverance and unflinching courage," Miller later wrote. "Where 150 men are to be provided for daily, with capital appetites, no excuses for failure will do."

This large painting is one of the original eighteen commissioned by Stewart for Murthly Castle and was among those exhibited at the Apollo Gallery in New York in 1839. RT

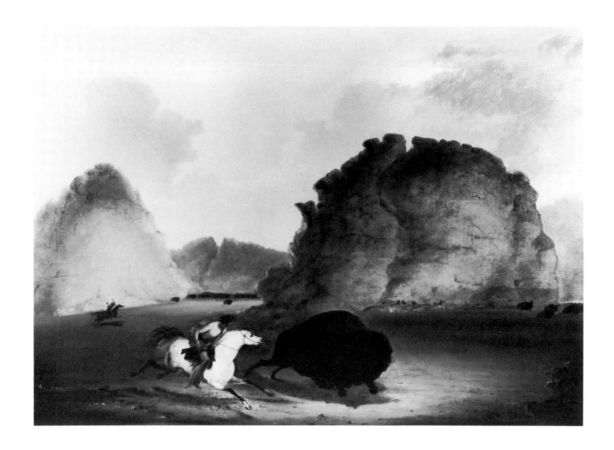

45. *Buffalo Hunt*
Oil on canvas, c. 1839. 38 x 57 in.
U.S. Army Field Artillery and Fort Sill Museum, Fort Sill, Oklahoma; gift of General Henry W. Butner, 1936
Catalogue number 113

Miller returned from the West in October 1837 and set to work painting finished oils for Stewart. By May 1839, when the eighteen oil paintings went on display at the Apollo Gallery in New York City, he also had produced eighty-seven wash drawings and watercolors for Stewart, a tremendous output in the approximately eighteen months that he had to work. The number of pictures that Miller painted, plus the size of many of the canvases, necessarily meant that some of them would not be as well composed or as finished as others. A good example is this *Buffalo Hunt,* in which Miller has virtually transferred the style and feeling of his small sketches to a large canvas, where shortcomings of the composition are magnified. The hunched figure of Stewart on horseback is characteristic of the sketches, as are the fluid mountains in the background. After he reached Murthly Castle and had more time to spend on each painting, Miller's works show a better sense of composition and painterly technique. RT

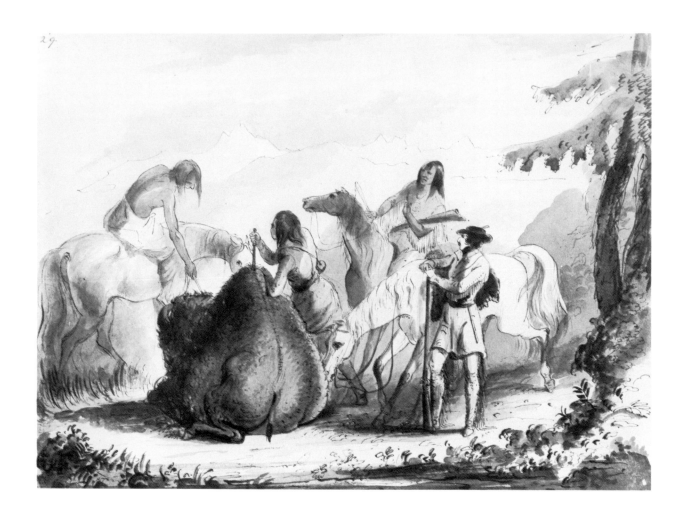

46. *Taking the Hump Rib*
 Pen and ink with gray wash on gray card, c. 1837. 8 1/8 x 10 7/8 in.
 Amon Carter Museum, Fort Worth, Texas 28.66
 Catalogue number 117A

Here Stewart strikes the pose of the successful hunter, while the Indians prepare to take that "most glorious of all mountain morsels," the hump rib. "A cut is made longitudinally with a knife, the skin on each side flapped down on the shoulder," wrote Miller. The rib is then cut away and turned over to the camp cook, whose preparation left nothing to be desired. "We suppose that no traveller who makes the journey to Oregon ever forgets afterwards the delicious flavor of the Bos or Hump rib,—it is probably superior to all meats whatsoever, and the preparation for securing it is the subject of our present sketch." Only the choicest pieces— the hump rib, the side ribs, the fleeces, and the tongue—were kept for the camp; all the rest, including the hide, was left for the nearby wolves.

 This painting, like the other early sketches, has a fresher, freer composition than Miller's later, more finished watercolors. This quality, plus the fact that most are washes instead of finished watercolors, distinguishes the set that Miller made immediately upon returning from the mountains. RT

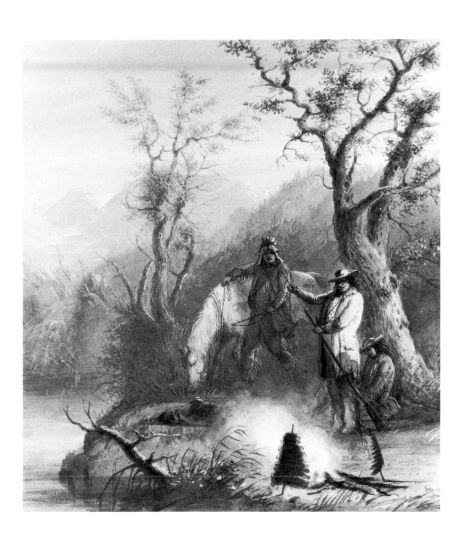

47. *Roasting the Hump Rib*

Watercolor, heightened with white, on paper, 1858–1860. 11 1/2 x 10 in.
Walters Art Gallery, Baltimore, Maryland 37.1940.36
Catalogue number 120B

Once the meat is in camp, it is turned over to John, the cook, and his preparation, wrote Miller, "although simple, in the extreme, is perfection in itself. With a stick sharpened at one end he skewers it lengthwise leaving about sixteen inches of the stick bare. This part he plants in the ground near the fire, inclining the meat inwardly at the top. Gradually a crisp surface forms over the fat and as the roasting process goes on it is thus driven back into the meat without need of any basting. When done it is a dish for an Emperor, exceeding the flavor, richness and juiciness [of] all other beef preparations."

But John was not the only one who knew how to prepare the hump rib, as Miller shows here. The hunters LaJeunesse, Burrows, and François have prepared that most delicate of treats and are roasting it around a smoldering fire. After the meal, the trappers would settle down for an evening of exchanging accounts of impossible deeds, and Stewart would entrance them all with stories of his Napoleonic battles or of exotic and undreamed-of places.

This small watercolor, prepared for William T. Walters, is similar in composition to the large oil painting that Miller made for Stewart, although some of the individuals pictured are different. In the large oil, Antoine Clement is shown instead of LaJeunesse, Pierre instead of François, and Stewart is shown in the distance. RT

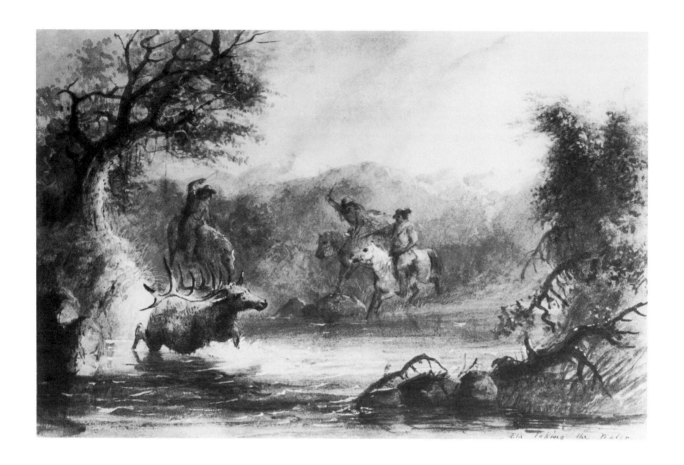

48.† *Elk Taking the Water*
 Watercolor on paper. 7 5/8 x 11 3/4 in.
 Boatmen's National Bank, St. Louis, Missouri
 Catalogue number 128C

One of Stewart's favorite pastimes during the trip was hunting, whether buffalo, bears, or elk, as shown here. Miller noted that, even though beaten, the animal has a "most noble presence, often carrying ten antlers on his head, and is extremely graceful." RT

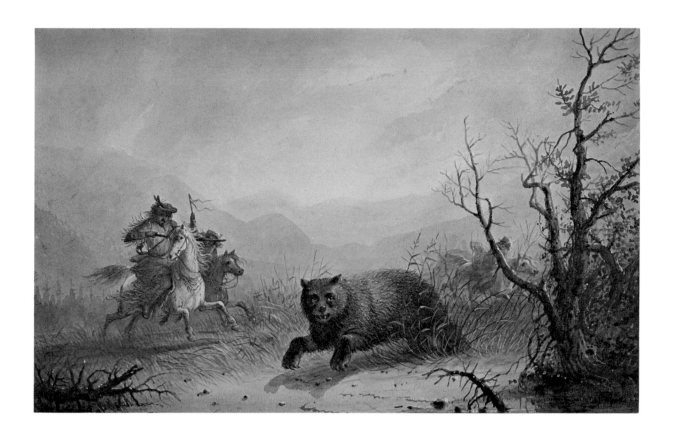

49. *The Grizzly Bear*
Watercolor, 1867. 7 13/16 x 12 3/8 in.
Public Archives of Canada, Ottawa, Ontario 1946–128
Catalogue number 143B

The hunters have just driven this grizzly bear from the wild cherry bushes, a fruit for which the bear has a great weakness. Giving him a wide berth, they are preparing to run him to exhaustion, realizing that they may not be able to kill him any other way: sometimes an arrow would not pierce him because of his thick, matted hair. Miller called this "dangerous sport" and the "greatest charm to the reckless trapper and Indian." RT

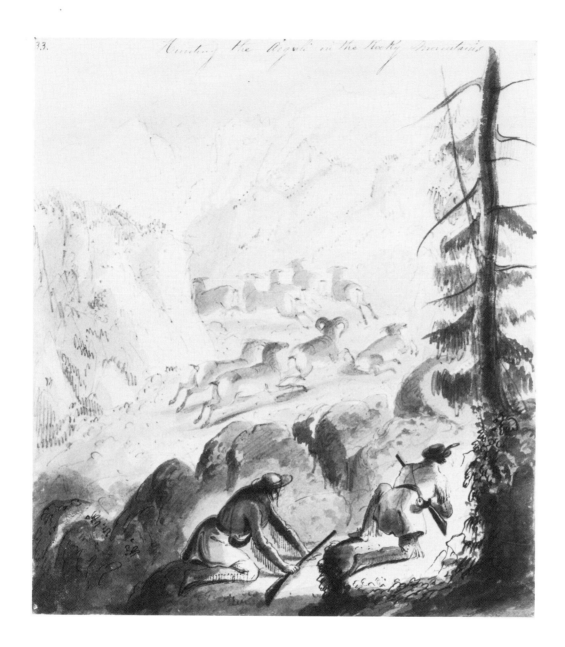

50. *Hunting the Argali in the Rocky Mountains*
Pencil and pen and ink with gray and brown washes on white card, c. 1837. 8 7/16 x 7 1/4 in.
Biltmore Galleries, Los Angeles, California
Catalogue number 138A

The argali—mountain sheep—reside in the "wildest and most secluded haunts of the mountains, on high rocky peaks," wrote Miller. They were favorites of the hunters, for their meat is tasty and the hunt is exhilarating.

Miller was victimized by one of the mountaineers' favorite jokes when he believed that the loser in the argali's famous head-to-head fights always took care to fall on his horns, which, Miller believed, were strong enough to sustain a fall over a cliff. Some of the misinformation fed him by the trappers he discovered by the time he made the set of notes for the Walters pictures in 1858, but this story is in the Walters notes as well as Miller's personal notes, "Rough Draughts," which he kept and revised throughout his life. RT

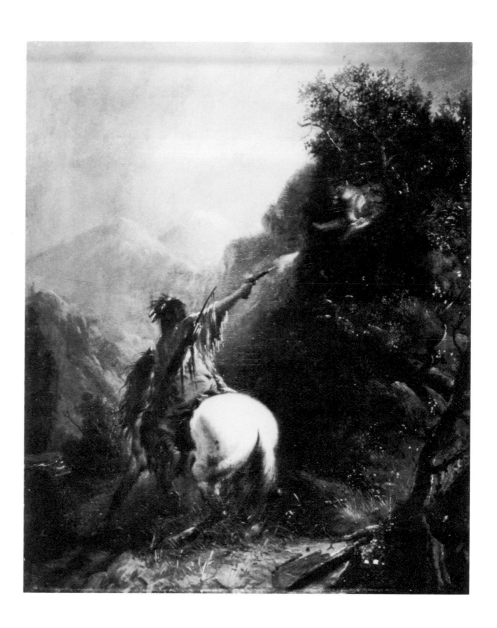

51. *Indian Shooting a Cougar*
 Oil on canvas. 24 x 19 15/16 in.
 Private collection
 Catalogue number 146C

It was lucky for the westerners, Miller said, that cougars did not appear in large numbers, for this picture represented Miller's conception of the "stealthy attack" on his victim. Miller continued on to say that the Indians highly valued the beautiful hide and had a superstition regarding the great "medicine" associated with it.

The original of this painting, still at Murthly Castle, shows Stewart, rather than an Indian, shooting the cougar. "The tree was on my right hand, and I had not time to turn my rifle," Stewart wrote in his autobiographical novel, *Edward Warren* (p. 262). "There was not a second for thought, but a branch had laid back the blanket from my pistols, and getting one out, I covered the breast of the cougar, just as he sprang—the animal fell short, and writhed out his last at my horse's feet."

The picture was also reproduced as a black-and-white etching in Webber's *The Hunter-Naturalist: Romance of Sporting* (1851), p. 403. RT

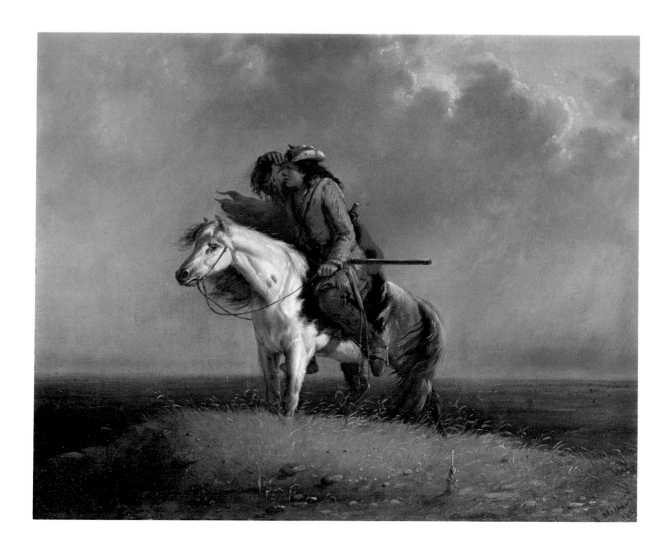

52. *The Lost Greenhorn*
Oil on canvas, 1851. 16 x 20 in.
The Warner Collection of Gulf States Paper Corporation, Tuscaloosa, Alabama
Catalogue number 147A

This picture had its origin in the fact that John, the English cook on the expedition, boasted of what he could accomplish on a buffalo hunt. "When anyone boasted," Miller said, "our captain . . . put them to the test." John was given the day off to prove his statements. He did not return to camp at the end of the day. When he was missing for a second day, Fitzpatrick, the caravan commander, sent the hunters out in different directions to try to find him. They brought back a crestfallen cook who told of being near death as he found himself in the path of a stampeding herd of buffaloes. He had lost his way and was nearly starved to death by the time the hunters found him.

This proved to be one of Miller's most popular pictures and was copied several times for clients who requested it. Miller also permitted it to be chromolithographed. RT

53. *The Lost Greenhorn*
 Watercolor on paper, 1858-1860. 9 7/16 x 12 5/16 in.
 Walters Art Gallery, Baltimore, Maryland 37.1940.141
 Catalogue number 147B

Miller made this version for William T. Walters when he commissioned two hundred watercolors in 1858.

RT

54. *Lost on the Prairie*
 Chromolithograph, c. 1851. 17 3/4 x 22 1/2 in.
 Joslyn Art Museum, Omaha, Nebraska 1955.12
 Catalogue number 898

This print was made for distribution by H. Ward, Jr., in New York City. Miller permitted several of his paintings to be reproduced by chromolithography, the relatively new method of making color pictures from several lithographic stones. RT

55. *Antoine Watering Stewart's Horse*
 Oil on canvas, c. 1840. 36 x 30 in.
 American Heritage Center, University of Wyoming, Laramie; Everett D. Graff Family Collection
 Catalogue number 157

On a previous trip to the Rockies in 1836, Stewart had left his good riding horse at Fort Laramie. As the caravan approached the fort in the summer of 1837, Stewart told a French Canadian, Auguste, to ride to the fort and get his horse. "In a short time both emerged from the great gate, coming toward us at top speed," Miller recorded, "Auguste yelling like an Indian, and the horse frightened out of his wits." The incident had a humorous climax when the horse shied and dumped Auguste on the ground in front of the entire party.

 Miller painted several versions of Auguste watering Stewart's horse, then, while at Murthly Castle, produced this slightly different version, replacing Auguste with Antoine. RT

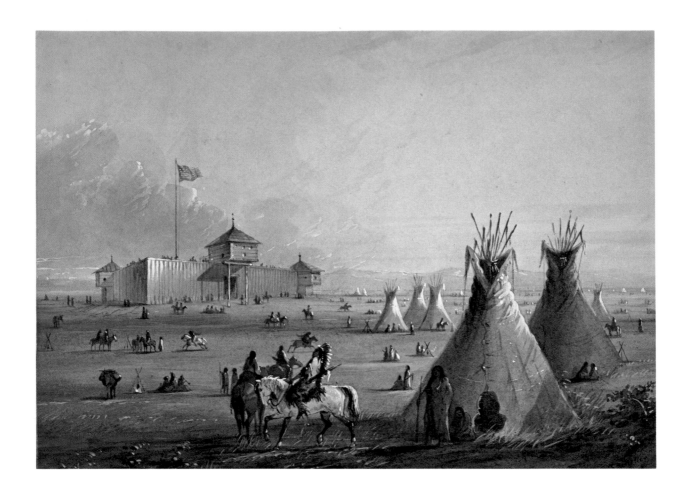

56. *Laramie's Fort*
Watercolor on paper, 1858–1860. 8 1/2 x 11 3/4 in.
Walters Art Gallery, Baltimore, Maryland 37.1940.49
Catalogue number 159B

Founded by William Sublette and Robert Campbell, Fort Laramie lay at the crossroads of an old north-south Indian trail and what became known as the Oregon Trail. Called Fort Laramie because of the nearby Laramie Mountains and the Laramie Fork of the North Platte River, the post was approximately 150 feet square, according to Miller, with bastions at the diagonal corners. Miller's paintings are the only known visual records of the fort, because the original fort was torn down in 1840 before any other artist had traveled the Oregon Trail; it was replaced with another structure, located perhaps on the same site in 1841. RT

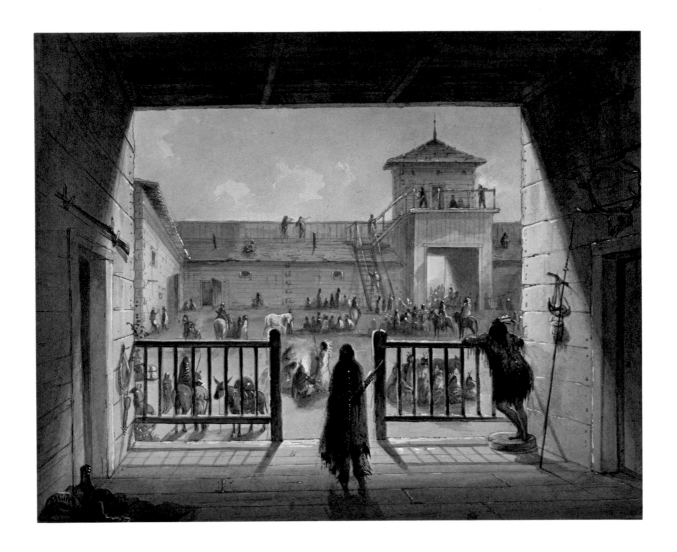

57. *Interior of Fort Laramie*
 Watercolor, heightened with white, on paper, 1858–1860. 11 5/8 x 14 1/8 in.
 Walters Art Gallery, Baltimore, Maryland 37.1940.150
 Catalogue number 161B

Miller's pictures of the fort form a unique, visual document of life at the fort as well as the fort itself. From the "great entrance" to the fort, Miller saw the Plains and Mountain Indians as they engaged in trade with the trappers and traders. "They gather here from all quarters," he reported, "from the Gila at the South, the Red River at the North, and the Columbia River West."

 As the overland migration began in later years, Fort Laramie became even more important as an oasis for the immigrants. The fort was sold to the government in 1849 and was finally abandoned in 1890. It is now a national monument. RT

58. *Escaping from a War Party*
Pen and ink with brown wash on paper, c. 1837. 6 3/16 x 9 1/4 in.
Walters Art Gallery, Baltimore, Maryland 37.2437
Catalogue number 150A

Another of the early sketches prepared for Stewart, this picture has its origin in a drawing that Miller did of Black Harris, one of the trappers, and his brother escaping from the Blackfeet. Miller noted that Harris "always created a sensation at the camp fire" with his dramatic story of the escape, and it was easy for Miller to make the transition and depict Stewart in Harris' place. As Miller noted of another instance, it made a "prime after dinner story for England."

RT

59. *Approach of a Band of Sioux*
Pen and ink with gray wash on paper, c. 1837. 9 1/4 x 14 1/4 in.
Brannin Collection
Catalogue number 155

The scouts rode into camp one morning, shouting, "Injins all about—thar will be some raising of h'ar—as sure as shootin." Although the Indians were less a problem in recent years than in the beginning of the fur trade, there were notable examples of small groups of white men being overcome by larger bands of Indians. Fitzpatrick and Stewart had to exercise the greatest caution.

"We were not kept long in suspense," Miller recalled. "A cloud of dust soon divulging a piratical horde of wretches, painted without regard to harmony of color, coming down on us at top speed,—armed to the teeth, and when they reached us, they commenced riding around in a menacing manner."

The leaders sat down to talk, the result being "that we had to blackmail [or bribe] them extensively.—cloth, blankets, guns, tobacco and knives . . ." But the party survived unhurt to proceed. RT

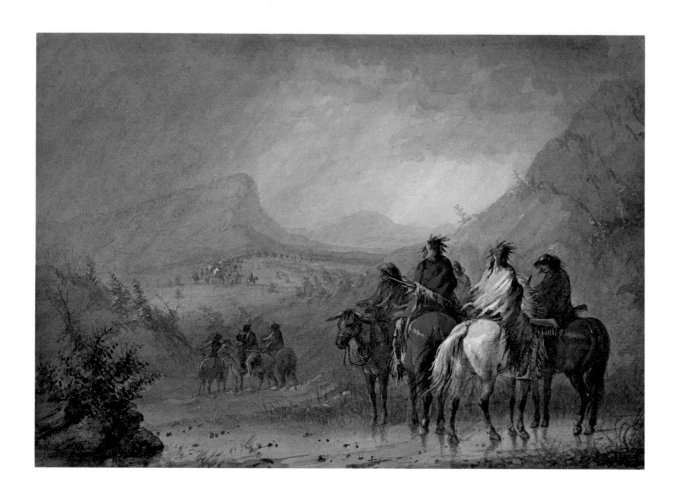

60. *Storm: Waiting for the Caravan*
Watercolor on paper, 1858–1860. 9 5/16 x 12 15/16 in.
Walters Art Gallery, Baltimore, Maryland 37.1940.147
Catalogue number 167A

One of Miller's most beautifully painted and atmospheric pictures, *Storm* shows those who have gone ahead in a driving rainstorm and are waiting for the rest of the train to catch up. Miller said that after two or three days of rain he would become depressed, causing the captain to suggest that his "early training" had been "faulty."

<div align="right">RT</div>

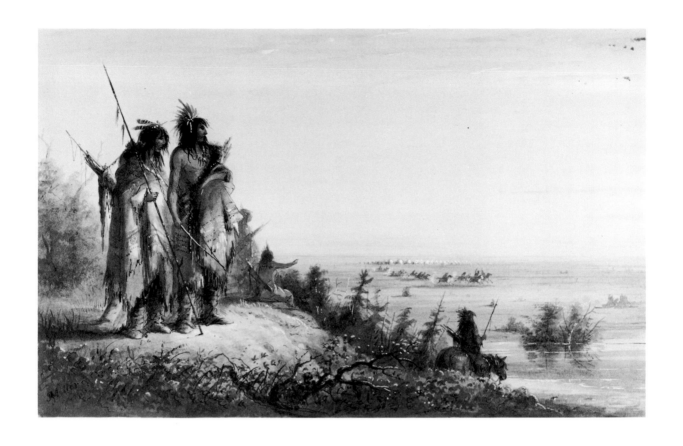

61. *Crossing the Divide*
 Watercolor on paper, 1858–1860. 9 x 14 13/16 in.
 Walters Art Gallery, Baltimore, Maryland 37.1940.132
 Catalogue number 149A

South Pass, or the Continental Divide, was the gateway to Oregon and California. The southwestern desert was not yet as fully explored as the Midwest, and so the trail along the Platte became the favored route. Discovered in 1812, the pass remained unknown to Anglo-Americans until a group of Crow Indians told Jedediah Smith and Thomas Fitzpatrick about it in 1824. After William H. Ashley started the rendezvous system in 1825, Fitzpatrick and others used South Pass as the entrance to the best beaver country in the mountains.

Here Miller pictures the frenzy that possessed the men as they neared the fresh water. The Indians, watching in contempt, Miller suggested, had much the same attitude as did Captain Stewart, who would not run his horse for the water but walked casually along as if he did not feel the same thirst that possessed the men. RT

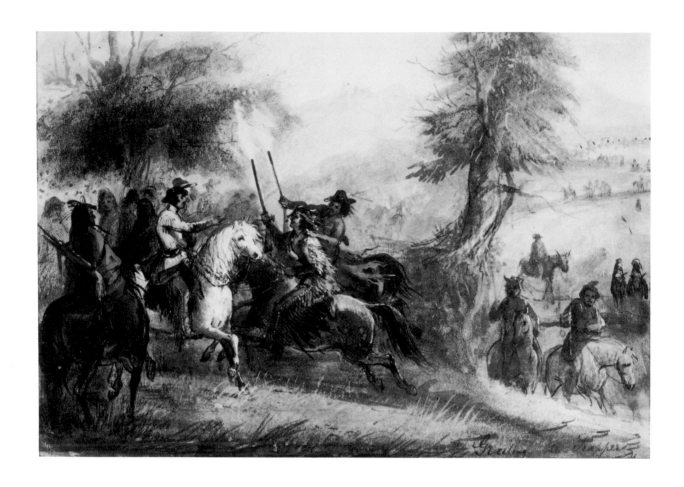

62. *Greeting the Trappers*
Watercolor on paper. 6 1/2 x 9 1/2 in.
Whitney Gallery of Western Art, Buffalo Bill Historical Center, Cody, Wyoming 8.70
Catalogue number 169

As the caravan approached the rendezvous site, trappers rode out to meet it, firing cartridges into the air—Miller said they were blank, but that is doubtful—and shouting like Indians. David L. Brown says, in fact, that some of the men in the caravan initially thought they were under attack. But the riders were old friends. They renewed acquaintances, exchanged news of the previous year, and settled down for a "grand Carouse" of hump ribs, buffalo tongues, and mountain sheep, supreme delicacies of the mountains. They all drank metheglin, an alcoholic concoction of honey and alcohol that Miller described as "potent and fiery," and "one after another toppled over" in "overpowering sleep." RT

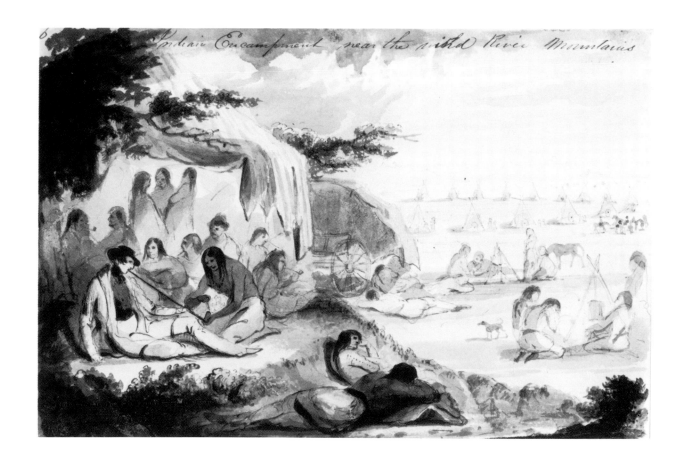

63. *Indian Encampment near the Wind River Mountains*
Pencil with black and gray washes on paper, c. 1837. 6 3/8 x 9 1/2 in.
Whitney Gallery of Western Art, Buffalo Bill Historical Center, Cody, Wyoming 15.80
Catalogue number 170

Stewart's familiar striped tent served as a gathering place throughout the rendezvous. This picture of Stewart's camp shows the captain, dressed in his distinctive white buckskin, with an Indian woman preparing his pipe, in the beautiful valley between the Wind River Mountains and the Bear River Range, south of Horse Creek, a tributary of the Green River, the rendezvous site. It was one of the wash drawings kept in the drawing room at Murthly Castle. This camp scene was also the subject of a much larger oil painting, which was exhibited at the Apollo Gallery in New York City and finally hung in Murthly Castle, Stewart's home in Perthshire. It is now in the collection of the Stark Museum of Art in Orange, Texas (cat. 170A). RT

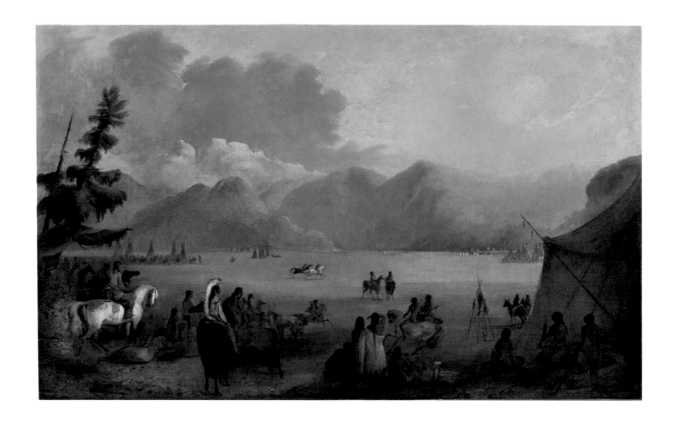

64. *Indian Village*

Oil on canvas, c. 1850. 30 1/4 x 48 1/4 in.
Amon Carter Museum, Fort Worth, Texas 20.66
Catalogue number 171A

The main purpose of the rendezvous was to trade pelts for supplies and to refit the trappers for the coming year, but the days were first filled with contests, gambling, and visiting, as can be seen in this painting, done several years after Miller returned from the Rockies and based on his observations and on-the-spot sketches.

The activities even included orations, as Miller learned when he attended one of the Indians' council meetings. "The speeches delivered were generally a prelude to some contemplated foray on the neighboring tribes," he noted. "As they were translated to us they seemed short, pithy, apothegms, intermingled with an inordinate quantum of boasting." RT

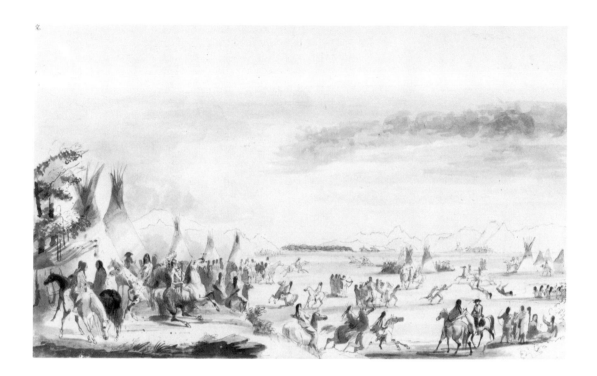

65. *Indian Encampment*

Pen and ink with gray wash on pink card, c. 1837. 8 3/8 x 13 1/2 in.
The Dentzel Collection 1731
Catalogue number 174

The rendezvous was the "ultima thule, our final destination," wrote Miller: "Here we rested for a month under the shadows of the great spurs of Wind River Mountains, encamping among 3000 Snake and other Indians who had all assembled at this place for a special purpose, viz. to trade buffalo robes and peltries for dry goods, ammunition, tobacco, etc. It truly was an imposing, animated and unique sight. The white lodges of the Indians stretching out in vast perspective, the busy throng of savages on spirited horses moving in all directions, some of them dressed in barbaric magnificence." This picture, which shows Captain Stewart in the lower left-hand corner conversing with an Indian, was the model for several later sketches, including two watercolors in the Walters Art Gallery collection, *Rendezvous* and *Scene at "Rendezvous."* RT

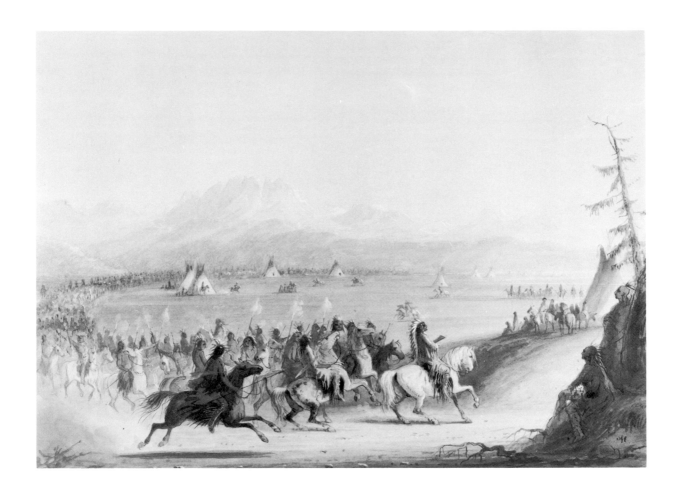

66. *Cavalcade*
 Watercolor on paper, 1858–1860. 10 7/8 x 15 in.
 Walters Art Gallery, Baltimore, Maryland 37.1940.199
 Catalogue number 178B

After everyone had arrived at the rendezvous, the Snake Indians, led by Chief Ma-wo-ma, staged a grand entry in honor of Captain Stewart. "Some of the dresses were magnificent," Miller wrote as he recalled the parade, "and although vermillion was worth four dollars per oz., a lavish use of that article was exhibited on their bodies and faces." Miller's friend, the missionary William H. Gray, was otherwise impressed, noting that some of the marchers were naked or hardly clothed at all.

Miller worked his sketches into a large oil version of this scene (now in the collection of the Oklahoma Historical Society) after he returned to Baltimore in 1839. He shipped it to New York for exhibition and transport to Liverpool. It was shown at the Apollo Gallery as a sequel to his spring and summer exhibition that had already been shipped to Murthly. This small watercolor was a part of the commission that Miller received from William T. Walters. RT

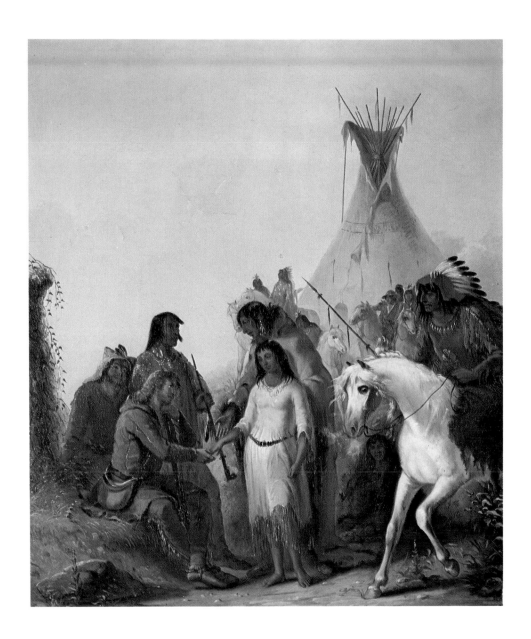

67. *The Trapper's Bride*
 Oil on canvas, 1850. 30 x 25 in.
 Joslyn Art Museum, Omaha, Nebraska 1963.612
 Catalogue number 191F

Miller says that this scene occurred at the rendezvous when the half-breed trapper François purchased an Indian woman for his wife. The price, paid to the bride's father, was $600 in guns ($100 each), horse blankets ($50 each), red flannels ($20 per yard), alcohol ($64 per gallon), and sugar, tobacco, beads, and other trade goods at descending rates.

Some weddings were even more expensive, according to Miller, who told of another trapper who fell in love with an Aricara woman and "pledged himself and his services for three years to the American Fur Company to secure the debt incurred by his liberality, gallantry, and recklessness."

After Miller arrived at Murthly Castle, Stewart selected this picture to be worked into a ten-and-one-half-foot-high canvas. One of Miller's largest paintings and proudest accomplishments, it was among the items auctioned in 1871 at Chapman's in Edinburgh and has not been located since. RT

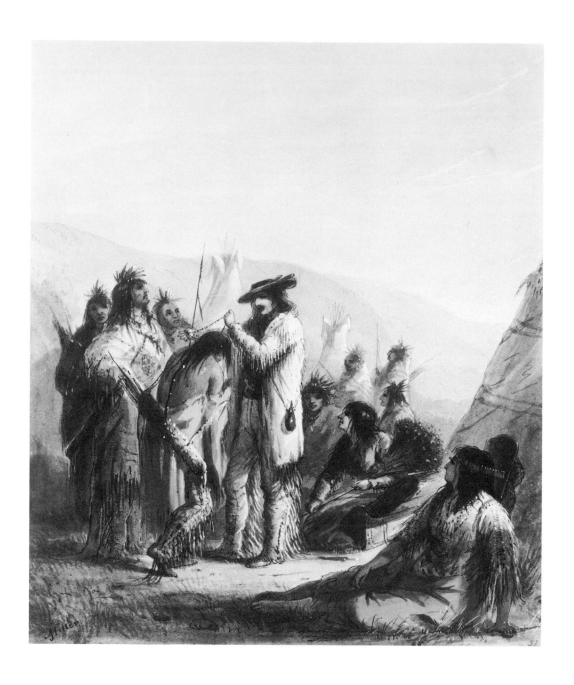

68. *Presents to Indians*
Watercolor, heightened with white, on paper, 1858–1860. 11 1/4 x 9 7/16 in.
Walters Art Gallery, Baltimore, Maryland 37.1940.13
Catalogue number 192B

Toward the end of the rendezvous, Captain Stewart, amid great ceremony, presented gifts to various chiefs, braves, and warriors who had performed some meritorious action or who had rendered personal services to Stewart or his group. These were "the 'elite,' the 'creme de la creme,' " said Miller. "They attached great importance to the matter, as it gives them a certain status with their people."

Antoine, behind Stewart, is selecting the Bowie knives and other gifts, which were also intended to ensure the friendship of a large group of Indians, because a hostile group of Blackfeet was rumored to be nearby. RT

69. *Avalanche Lake*
Oil on canvas. 10 x 12 1/4 in.
Private collection
Catalogue number 224B

Miller had little experience painting landscapes, which were among the scenes most relished by his eastern audiences. However, unlike any artist before him, Miller had seen the majestic Rockies and seemed qualified to paint from nature. Many of Miller's landscapes lack the grandeur now associated with the Rockies, and he recognized his shortcomings, noting that one particular lake "would have required the pencil of a Stanfield, Turner, or Church in giving it due effect and rendering it complete justice." CC

70. *Lake Scene—Rocky Mts.*
Watercolor on paper, 1858–1860. 9 1/8 x 13 1/2 in.
Walters Art Gallery, Baltimore, Maryland 37.1940.161
Catalogue number 273A

Easterners first experienced the Rocky Mountains through Miller's landscape paintings. Finding it difficult to convey the scenery's vastness, Miller strove to live up to his own descriptions: ". . . huge masses of rock are piled one upon another lifting themselves skyward," he wrote. "At the base in the water lies a monstrous boulder, brought down (no doubt) centuries past, in one of [nature's] . . . convulsive fits; beyond this a bluff covered with stunted vegetation pushes boldly out of the lake . . . farther off the mountains continue to rise until they reach the region of eternal snow." CC

71. *Lake Scene*
 Watercolor on paper, 1858–1860. 9 3/16 x 12 5/16 in.
 Walters Art Gallery, Baltimore, Maryland 37.1940.77
 Catalogue number 202A

Proud of being one of the few artists to see the Rocky Mountains before the Oregon Trail was fully initiated, Miller read the accounts of explorers like John C. Frémont and revised the captions for his pictures in the light of their findings. When he encountered George Catlin in London, he commented to his brother that there was a great deal of "humbug" about Catlin and that Catlin was lucky there were so few people who had seen the West and who could discredit him. Miller, of course, considered himself one of the few.

 Marshall Sprague, author of an essay about Miller and Stewart, has suggested that this is Frémont Lake. RT

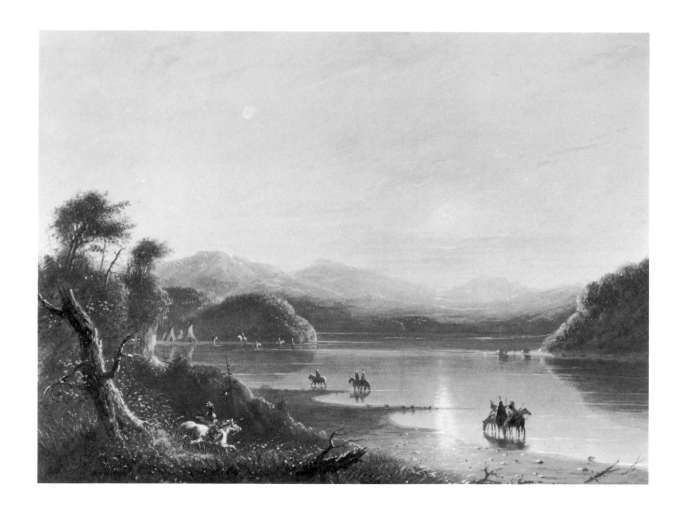

72. *Green River (Oregon)*
 Watercolor on paper, 1858–1860. 9 1/16 x 12 1/4 in.
 Walters Art Gallery, Baltimore, Maryland 37.1940.82
 Catalogue number 225A

The Green River of Wyoming (Oregon Territory to Miller) winds through spectacular mountains to join the Colorado River. Miller trekked through the Rockies for one season and noted many difficulties, especially for those who tried to climb the highest peaks, only to experience "giddiness and headache, attended with vomiting," and turn back.

He has included a camp of Indians en route to the rendezvous near the shore of what might well be Frémont Lake, a romantic touch emphasizing the harmony between unspoiled nature and natural man. RT

73. *Rocky Mountain Scene, Wind River Mountains*
Oil on canvas, 1853. 18 x 24 in.
J. N. Bartfield Art Galleries, New York
Catalogue number 259

One of several small landscapes painted for Baltimore clients, this picture probably was commissioned by William C. Wilson, as shown in Miller's account book for June 25, 1853. Miller thought the Rocky Mountain lakes that he visited with Stewart after the rendezvous were among the most striking he had ever seen, giving an idea of the "sublimity and beauty" of the region. Miller did not identify the specific lakes that he painted, although among them surely were Boulder, Frémont, Willow, and New Forks lakes, all within Bridger National Forest today.

RT

74. *Lake in Wind River Country*
Oil on canvas, 1854. 18 x 24 in.
William J. Williams Family Collection
Catalogue number 260

"'No primrose road of dalliance' met our eyes," Miller recalled in his notes. "We scrambled over rocks, through briars and brushwood, crossed rapid streams and ascended steep acclivities. We at last found ourselves on the borders of these beautiful Lakes, and were richly repaid for all our difficulties." More than the sportsman's wish to reach the peak, Miller shared the desire of many other nineteenth-century artists to experience nature, observe it carefully, and interpret it artistically.

 This painting, one of the few that Miller signed and dated, might well be the one referred to in his account book as being sold in December 1854 to Melville Wilson for $60. RT

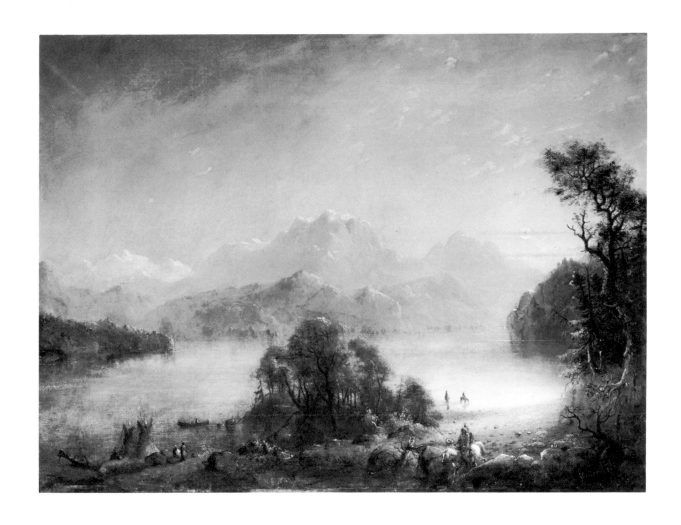

75. *Indian Encampment*
 Oil on canvas. 17 1/2 x 24 1/2 in.
 The Dentzel Collection 2672
 Catalogue number 258

Artistic interest in America's natural beauty was keen during the 1830s, and Miller's 1837 trip west coincided with growing artistic curiosity about the unusual mountainous regions called the Rockies. To easterners, the Indian's presence, often merely suggested in Miller's landscapes, only added to the area's mystery. CC

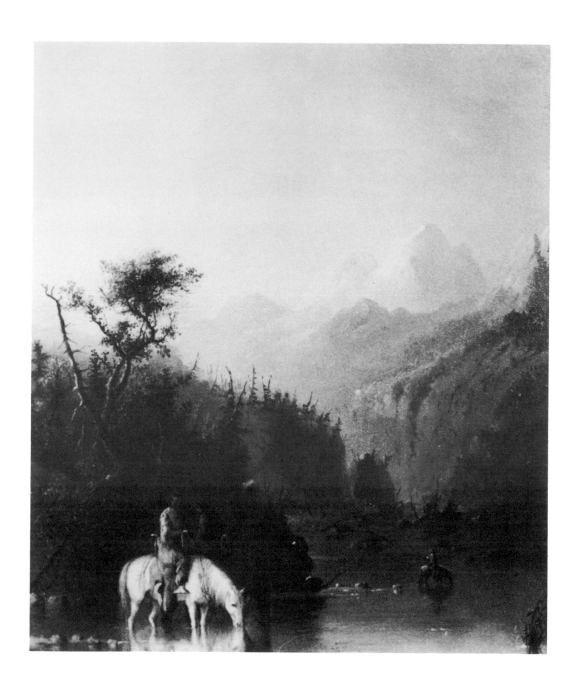

76. *Indians Watering Their Horses*
Oil on wood panel. 12 x 9 7/8 in.
Lent by Philbrook Art Center, Tulsa, Oklahoma 60.11.4; gift of Mr. and Mrs. Bailie W. Vinson, Tulsa, 1960
Catalogue number 437B

The site of Miller's sketch of watering horses is Horse Creek, or, as Miller called it, Horse Shoe Creek, near the rendezvous grounds (cat. 435, 435A, and 437A). Perhaps this later painting is an adaptation of that sketch, with a slightly changed figural group and the addition of mountain scenery. RT

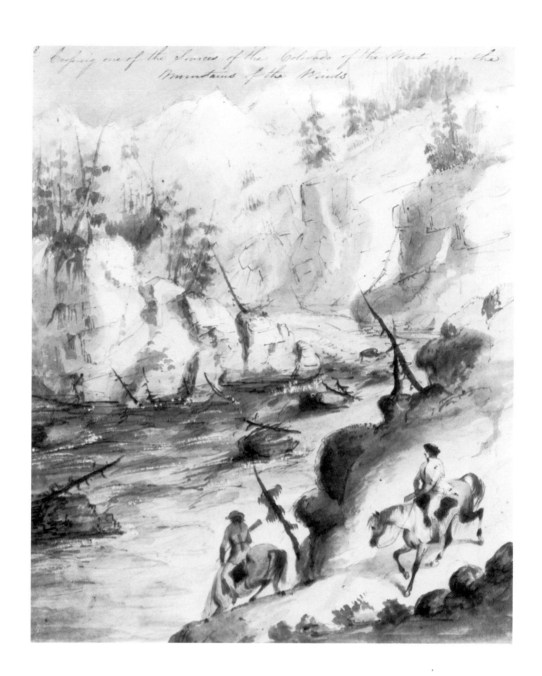

Crossing one of the Sources of the Colorado of the West, in the Mountains of the Winds

77. *Crossing One of the Sources of the Colorado of the West, in the Mountains of the Winds*
Pencil with gray wash on paper, c. 1837. 9 3/4 x 7 1/8 in.
Whitney Gallery of Western Art, Buffalo Bill Historical Center, Cody, Wyoming 10.80
Catalogue number 266

On their hunting trip after the rendezvous, Stewart and his party saw more spectacular and rugged country than Miller was capable of adequately painting. Here, however, Miller has captured the feeling of danger and adventure in crossing the Green River or a tributary that has evidently been on a rampage, judging from the trees and branches in the water. RT

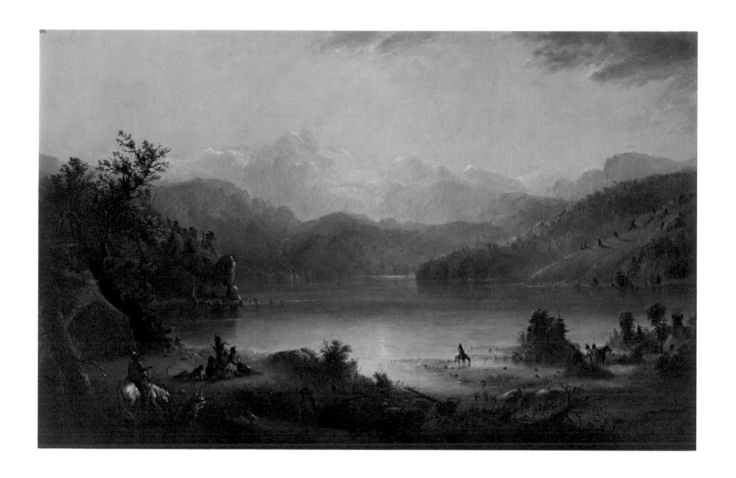

78. *Stewart's Camp, Wind River Range, Western Wyoming*
Oil on canvas, c. 1865. 31 x 48 in.
The Peale Museum, Baltimore, Maryland; gift of the Maryland National Bank
Catalogue number 262

This painting, probably done during the 1860s, is larger and more finished than most of Miller's work. It probably shows New Forks Lake, 7,800 feet high in the Wind River Mountains, during the autumn, the last season that Stewart's group could travel with ease in the mountains.

In the left foreground the hunters are relaxing, smoking the calumet, the Indian ceremonial pipe. Stewart and Antoine are clearly recognizable in the group, Antoine gazing intently at the captain.

Several sketches were used in the composition of this superb painting, including *Group of Trappers and Indians* (cat. 93), *Captain Stewart, Antoine, Pierre, and Indians at Campfire* (cat. 93B), and *Interior of an Indian Lodge* (cat. 93A). RT

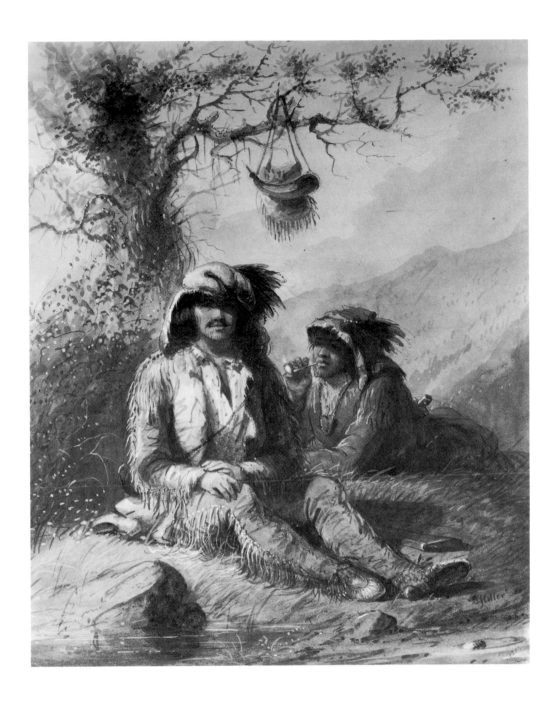

79. *Trappers*
 Watercolor and gouache on paper, 1858–1860. 11 15/16 x 9 7/16 in.
 Walters Art Gallery, Baltimore, Maryland 37.1940.29
 Catalogue number 288A

Miller was the only painter to portray during their heyday the men who "may be said to lead the van in the march of civilization,—from the Canadas in the North to California in the South;—from the Mississippi East to the Pacific West; every river and mountain stream, in all probability, have [*sic*] been at one time or another visited and inspected by them." Perhaps they numbered no more than a thousand, but their impact was incalculable.

 Here Miller has pictured two of that company, one of them probably Black Harris. RT

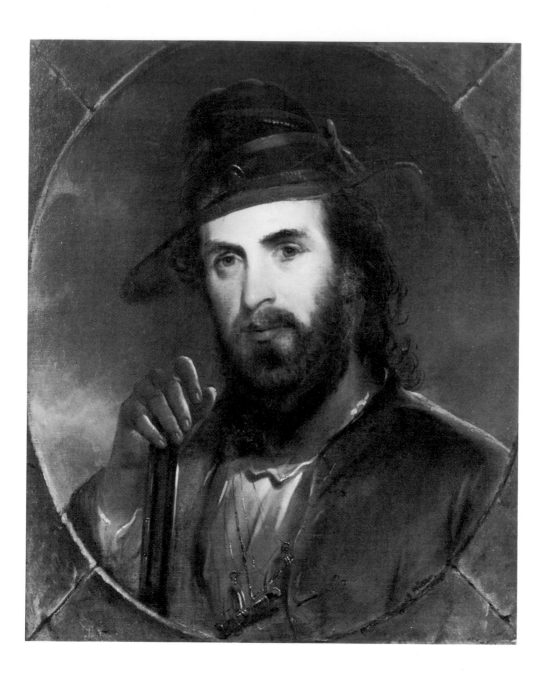

80. *Captain Joseph Reddeford Walker*
Oil on canvas. 23 3/8 x 19 1/2 in.
Joslyn Art Museum, Omaha, Nebraska 1963.610
Catalogue number 267

Joseph R. Walker was one of the most famous of the mountain men because of his demonstrated ability as well as, perhaps, because of what Miller called the "exquisite revenge" a group of Indians pulled on him. After a battle in which Walker and his men had defeated an entire tribe, the Indians sued for peace and arranged a feast and pipe smoking. "The feast was plentiful, and our Capt. always with a good appetite enjoyed it, doing full justice to their hospitality, & after a hearty smoke, returned to his men,—but horror of horrors! in as short time they had let him know that he had partaken of a meal composed of his own men!" "We thought of asking him the particulars of this matter," Miller noted, "but prudence forbade."

Walker is better known to history as probably the first American to see Yosemite Valley. RT

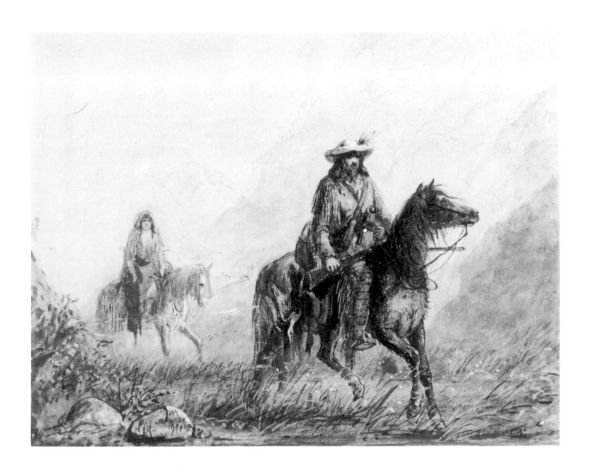

81. *Captain Walker (Joseph Reddeford Walker)*
Watercolor on paper, c. 1837. 7 x 9 1/4 in.
Joslyn Art Museum, Omaha, Nebraska; InterNorth Art Foundation Collection 734
Catalogue number 268

Captain Walker was one of the few mountain men to attain the title "Bourgeois," which meant that he commanded a group of twelve or more trappers. Walker's squaw, shown here traveling behind him as custom demanded, made a dozen pair of moccasins, "richly embroidered on the instep with colored porcupine quills," for Miller. Walker had some Indian dances performed so that Miller could see them. RT

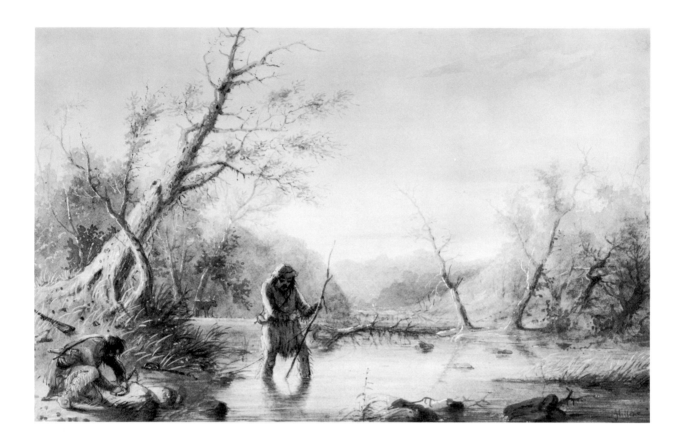

82. *Trapping Beaver*
 Watercolor on paper, 1858–1860. 8 7/8 x 13 3/4 in.
 Walters Art Gallery, Baltimore, Maryland 37.1940.111
 Catalogue number 290A

Having searched around the stream for "sign" of beavers—such as footprints in the mud or sand, these trappers are in the process of setting their five pound traps in beds they had dug with their knives. Each trap was tied firmly to a tree or a pole as well as a float stick that was hammered into the mud so the beaver could not carry off the trap.

The trappers travel in pairs because of the continual threat of Indian attack. RT

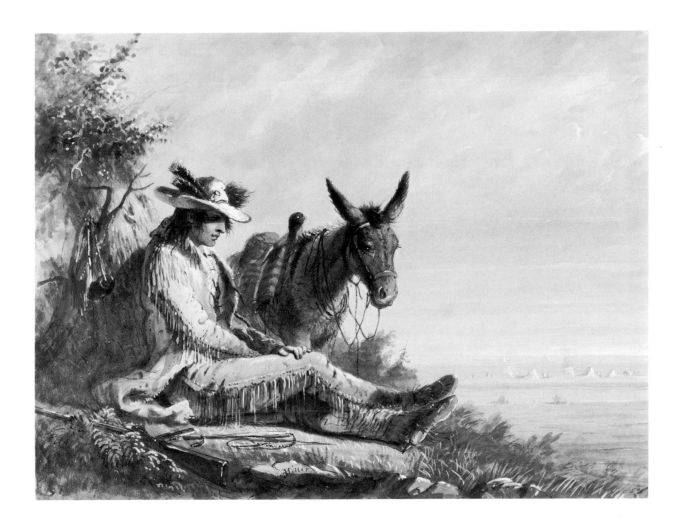

83. *Pierre*
 Watercolor on paper, 1858–1860. 9 5/16 x 12 3/16 in.
 Walters Art Gallery, Baltimore, Maryland 37.1940.53
 Catalogue number 291B

By the time Miller saw the fur trade, several famous personalities were involved, such as Jim Bridger, "Bourgeois" Walker, and Kit Carson. Of that group, it is interesting to note, Miller painted a portrait only of Walker. There are various other portraits of members of Stewart's group, such as Pierre, a seventeen-year-old French Canadian and one of Miller's favorites. Dressed here in his buckskin shirt, his hat decorated with turkey feathers and a fox-tail brush, and holding his treasured pipe, Pierre is apparently deep in thought. RT

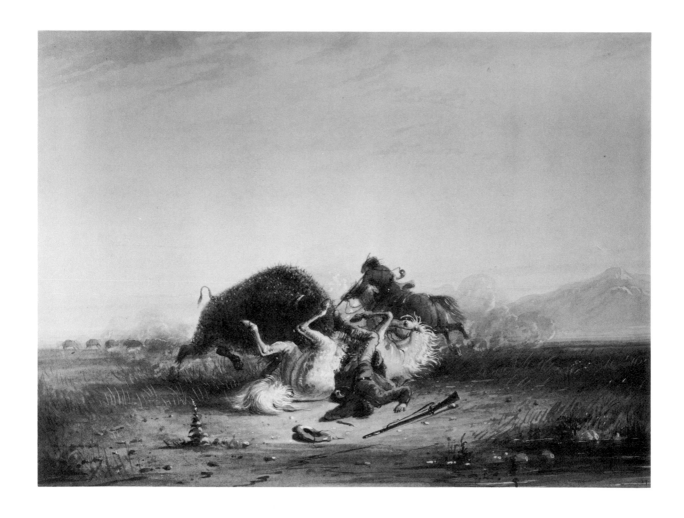

84. *Pierre and the Buffalo*
Watercolor on paper, 1858–1860. 10 3/8 x 14 in.
Walters Art Gallery, Baltimore, Maryland 37.1940.58
Catalogue number 293A

Pierre had several hazardous encounters on the trail—almost drowning, his horse being gored by a buffalo—before he was killed by a wounded buffalo. The incident depicted did not cost Pierre his life but was one in which he could have easily been killed. Miller painted several versions of this scene, including one from another angle (cat. 292).

RT

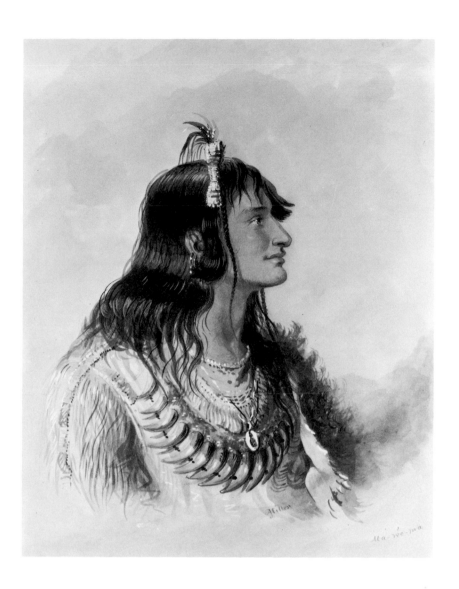

85. *Ma-wo-ma*

Watercolor and gouache on tan paper, 1858–1860. 12 1/4 x 9 1/2 in.
Walters Art Gallery, Baltimore, Maryland 37.1940.35
Catalogue number 294B

Ma-wo-ma, whose name was somewhat misleading because it translates "Little Chief," was leader of the approximately three thousand Snake Indians, many of whom came to the rendezvous. He was "decidedly in every sense superior to any Indian that we had met," Miller declared. "He was a man of high principle, in whom you could place confidence."

Miller and Ma-wo-ma were both artists, neither terribly appreciative of the other's work: "I noticed that all four of the legs of the horses were on one side," Miller observed of one of Ma-wo-ma's paintings. "This arose from a want of knowledge of perspective. He also colored them with the stick end of a brush instead of the hair end,—not probably having seen before an article of this kind. . . . A running commentary was kept up while he proceeded with the drawing. There was a little more of the 'ego' than good taste might have dictated but it sat with exceeding grace on our excellent friend Ma-Wo-Ma. And the interpreter so far from softening no doubt exaggerated—as such gentry are wont to do." Ma-wo-ma criticized Miller's work for being too much like the "vulgar and familiar species of art" that he could see in his "looking glass." RT

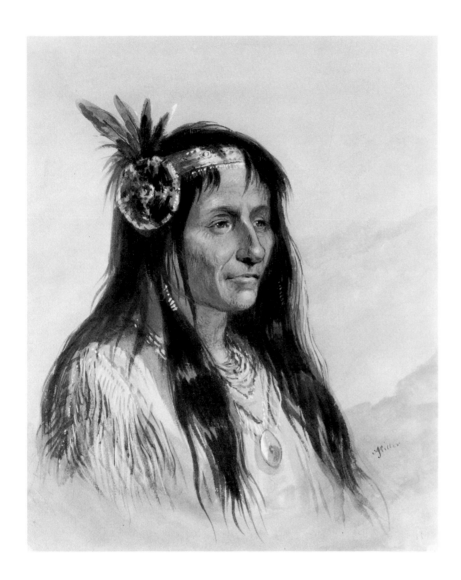

86. *In-ca-tash-a-pa*
 Watercolor, heightened with white, on paper, 1858–1860. 11 5/8 x 9 1/16 in.
 Walters Art Gallery, Baltimore, Maryland 37.1940.31
 Catalogue number 296

Red Elk, as In-ca-tash-a-pa's name was translated, was a distinguished Snake warrior. Miller has painted him with an ornamented bandeau set off by a rosette with feathers. Wampum beads encircle his neck, along with a kind of flat shell.

While not as detailed in terms of costume and decoration as Catlin's and Bodmer's Indian portraits, Miller's are more romantic in their conception and presentation. Both Bodmer and Catlin strove for accuracy in detail, while Miller was interested in showing the Indians as the noble savages in the wilderness. RT

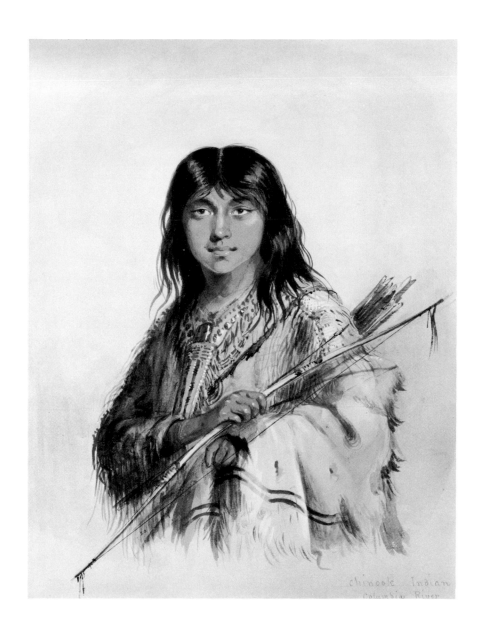

87. *Chinook Indian:—Columbia River*
 Watercolor on paper, 1858–1860. 12 7/16 x 9 1/2 in.
 Walters Art Gallery, Baltimore, Maryland 37.1940.7
 Catalogue number 297

It was probably the "Asiatic type, the eyes being almond shaped and slightly turned up at the corners," that attracted Miller to paint this Chinook Indian portrait. He was a "favorable specimen, about 22 years of age," and holding a remarkable bow made of elk-horn with a sinew string, which Miller also drew. RT

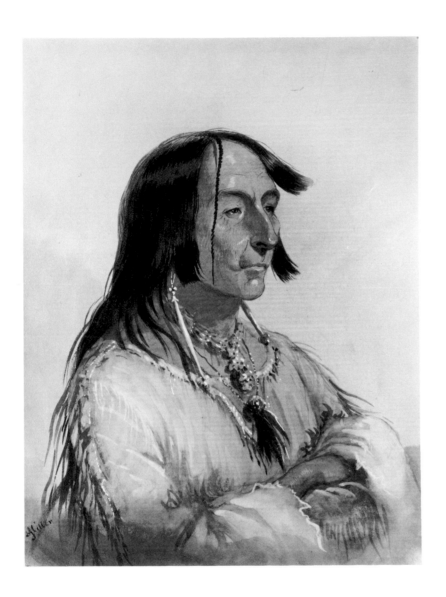

88. *Shim-a-co-che, Crow Chief*
Watercolor and gouache on paper, 1858–1860. 12 9/16 x 9 7/16 in.
Walters Art Gallery, Baltimore, Maryland 37.1940.39
Catalogue number 299A

Miller was impressed with Shim-a-co-che, the Crow chief, a distinguished man, "full of dignity, and such as you might look for in a well-bred civilized gentleman." Miller noted his "grave look," the "well-cut Roman nose," and the "forehead [that] retreats overmuch . . . ," and recalled that Shim-a-co-che had protested that some of the other sitters for Miller's portraits were common Indians who had counted no coups and did not deserve to be painted.
 RT

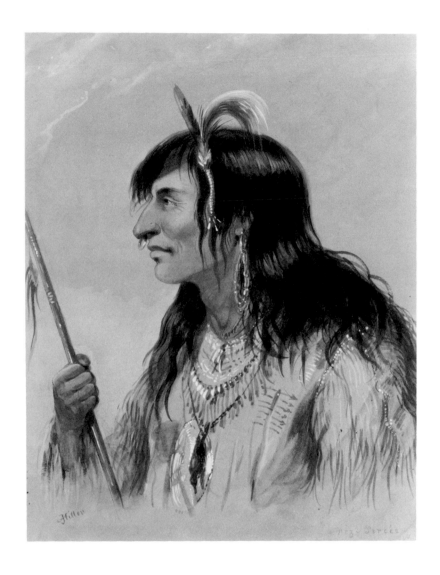

89. *Nez Percés Indian*
 Watercolor, heightened with white, on brown paper, 1858–1860. 12 9/16 x 9 7/16 in.
 Walters Art Gallery, Baltimore, Maryland 37.1940.33
 Catalogue number 298A

"These Indians," wrote Miller, "are anti-belligerent, and have some other qualities that are rare and commendable; they are said to be religious, and honest and truthful in their intercourse with the whites. Their observance of religious ceremonies and rites are uniform and remarkable."

Many Indians from the middle Columbia River area pierced their noses and wore rings or thin dentalium shells in their septums. That is the trait for which the Nez Perces are historically named, and this Miller portrait is one of the earlier documents that shows a ring "thrust through" the brave's nose. RT

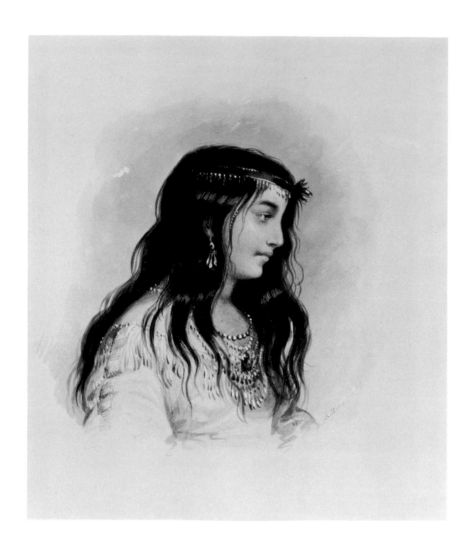

90. *A Young Woman of the Flat Head Tribe*
 Watercolor, heightened with white, on paper, 1858–1860. 11 1/16 x 9 7/16 in.
 Walters Art Gallery, Baltimore, Maryland 37.1940.11
 Catalogue number 300A

One of the social highlights of the rendezvous occurred when this young woman ("quite a belle," Miller thought) ran off with a "stalwart Canadian trapper." Not knowing that the trapper had already begun paying court to the girl, one of Miller's friends, a young man from St. Louis named Phillipson, decided that she would be his. His presents and attentions were "kindly received," Miller noted, encouraging the young man. Phillipson felt embarrassed before the whole camp when the "simple Indian girl," realizing that her future was with the trapper, stole off quietly.

Phillipson initially was "crest-fallen and melancholy," Miller recorded, but later regained his serenity.

RT

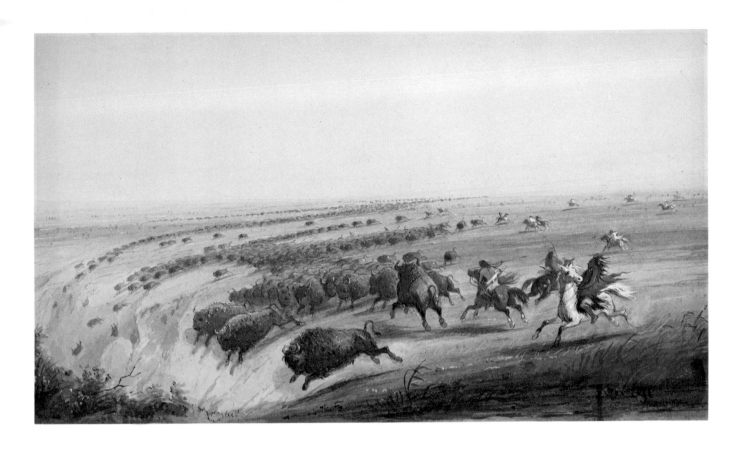

91. *Hunting Buffalo*
Watercolor on paper, 1858–1860. 8 5/16 x 14 1/8 in.
Walters Art Gallery, Baltimore, Maryland 37.1940.190
Catalogue number 351B

It is true that various Plains Indians would occasionally chase buffalo over a small cliff, but Miller probably never saw this scene and therefore exaggerated it a bit. The Indians, when they found a suitable bluff, would conceal themselves behind the rocks with hides. When the herd would start to move toward the bluff, the Indians would jump up from behind their rocks, shouting and waving the hides, keeping the buffalo moving toward the cliff. In later versions of this picture, Miller exaggerated the cliff even more. Had the Indians driven buffalo over such precipices, the meat would have been too badly smashed to eat and the bones would have been broken. RT

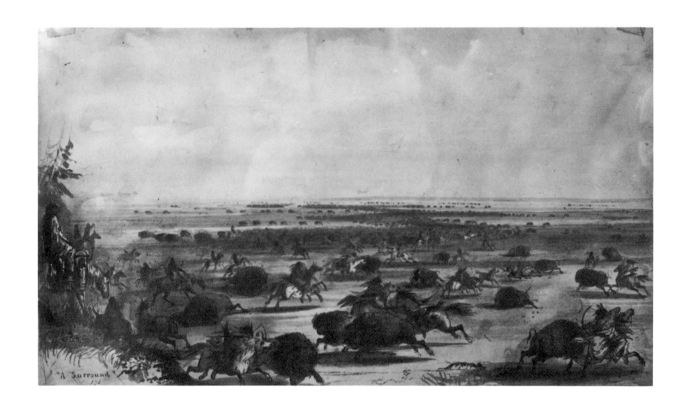

92. *A Surround*
Wash on paper, c. 1837. 10 1/4 x 17 1/4 in.
Joslyn Art Museum, Omaha, Nebraska; InterNorth Art Foundation Collection 723
Catalogue number 352

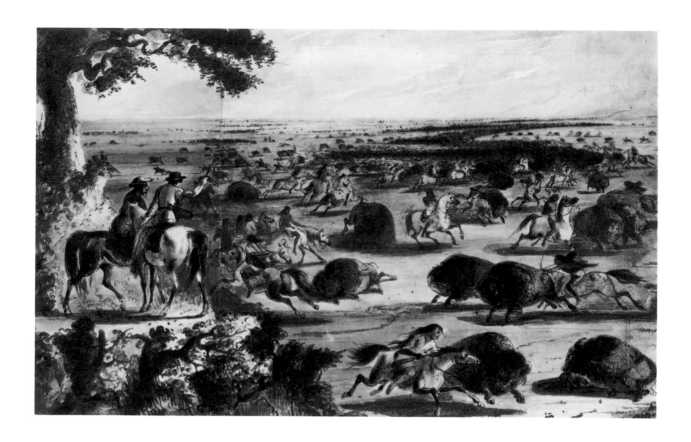

93. *A Buffalo Surround in the Pawnee Country, 1837*
Sepia wash, heightened with white, on paper, 1840. 6 1/2 x 9 15/16 in.
Courtesy, The New-York Historical Society, New York 1949.273
Catalogue number 352A

In this sketch (92) Miller's notes can be seen: "more space," "dust," suggestions as to how the picture should be rendered in its final form. The revised sketch in the collection of the New-York Historical Society (93) shows how he pasted paper together to enlarge the composition.

The subject is a surround of buffalo by the Indians. When a large herd was sighted, the Indians would send their fleetest riders to race around the herd, yelling all the while. They would run in a circle, continually drawing it tighter. When the whole body was pushed close together, the firing began. "The dexterity and grace of the Indians and the thousands upon thousands of Buffalo moving in every direction over an illimitable prairie form a scene altogether, that in the whole world beside, cannot be matched," Miller claimed. RT

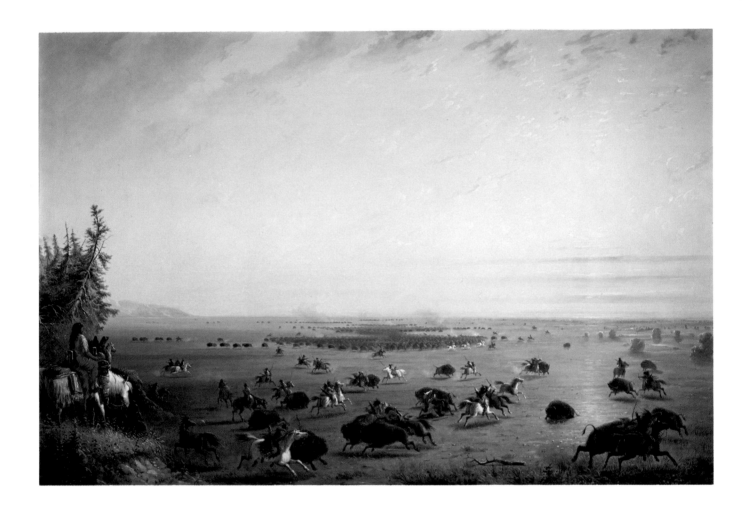

94. *A Surround of Buffalo by Indians*
Oil on canvas. 30 3/8 x 44 1/8 in.
Whitney Gallery of Western Art, Buffalo Bill Historical Center, Cody, Wyoming 2.76
Catalogue number 352B

"The distant plain was literally black with buffalo," Miller recalled, as the "surround" began. "On reaching a proper distance, a signal is given and they all start at once with frightful yells, & commence racing around the herd, drawing their circle closer and closer, until the whole body is huddled together in confusion. Now they begin firing, and as this throws them into a headlong panic and furious rage, each man selects his animal."

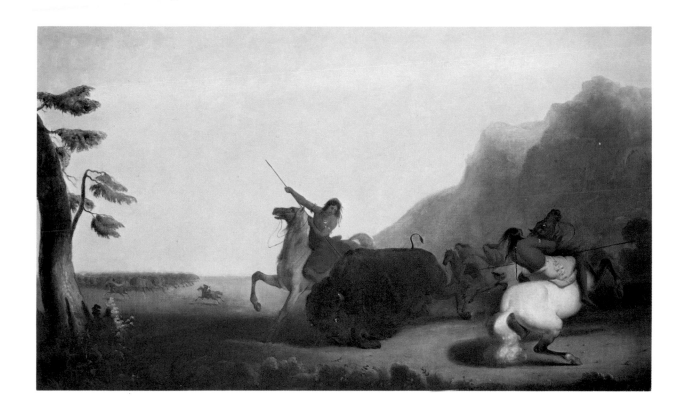

95. *Buffalo Hunt*
 Oil on canvas, c. 1850. 30 1/4 x 50 1/8 in.
 Amon Carter Museum, Fort Worth, Texas 21.66
 Catalogue number 367B

Probaby the most exciting part of the hunt was when the rider managed to isolate his prey and moved in for the final confrontation. "The chase of the Bison is attended with danger," Miller reported, "for although in general shy, and flying from the face of man, yet when wounded they become furious, and make fight to the last." In this picture the buffalo has fallen to his knees in exhaustion from loss of blood. "The Indian's horse to the right has become restive & refuses to approach, while the horseman to the left, with a javelin or lance is about to give the *coup de grace*." RT

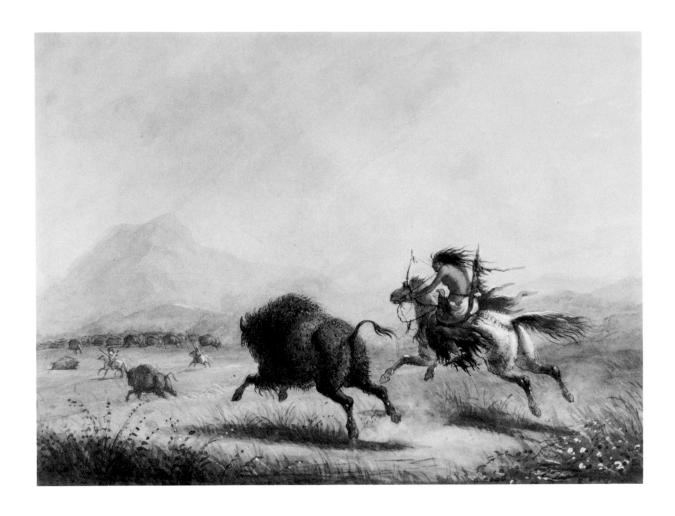

96. *Buffalo Chase—by a Female*
 Watercolor on paper, 1858–1860. 8 7/8 x 12 1/4 in.
 Walters Art Gallery, Baltimore, Maryland 37.1940.90
 Catalogue number 350A

One of the greatest events in the Plains Indians' life was the buffalo hunt. Few Indian women tried to conquer all the skills necessary for the buffalo hunt, and no wonder. Fascinated with buffalo, as were all artists who went west, Miller enumerated them all: "No sooner does she reach the animal than she must watch his every movement,—keep an eye to her horse and guide him,—must look out for rifts and Buffalo wallows on the prairie,—guard against the animal's forming an angle and goring,—manage bow and arrows, or lance—and while both are at full speed to wound him in a vital part;—To do all this requires great presence of mind, dexterity, and courage,—and few women are found amongst them willing to undertake or capable of performing it." RT

97. *Approaching Buffalo under the Disguise of a Wolf*
Pen and ink and watercolor on pink card, c. 1837. 6 1/8 x 8 1/2 in.
Amon Carter Museum, Fort Worth, Texas 26.66
Catalogue number 371A

The hunters are able to approach so closely to the buffalo because the beast's shaggy hair so obscures its vision that the clumsy disguise—a cap with two ears and a flap reaching to the shoulders—is effective. The buffaloes think that the Indians are wolves and permit them to approach.

There are several versions of this picture. This one shows Stewart (on the right) with a trapper. Later versions show a trapper with an Indian (cat. 371B). This picture was one of the washes bound in leather and placed in the drawing room at Murthly, thus many of this series have portraits of Stewart. Miller replaced Stewart in later pictures. RT

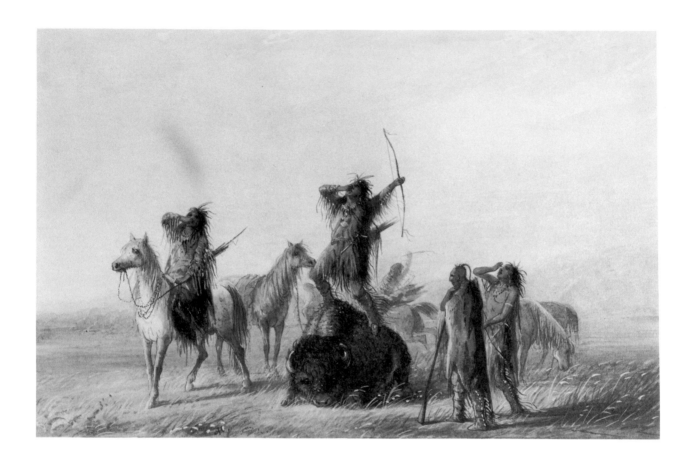

98. *Yell of Triumph*
Watercolor on paper, 1858–1860. 8 1/8 x 12 7/16 in.
Walters Art Gallery, Baltimore, Maryland 37.1940.151
Catalogue number 372A

The hunters have brought down the buffalo, Miller noted, "and one has mounted the back of the animal to join in an Indian yell and song;—partly as a species of requiem to the Buffalo for the game quality he has exhibited, but mainly as an act of self glorification for giving the *Coup de grace* to the bull.

"The Indian hunters in selecting a buffalo from the herd for themselves are generally much more influenced by the luxuriant coat of hair he wears, in reference to making a robe, than tenderness of beef for roasting purposes. The party here have secured an animal whose hide will make a first class robe. Placing him on his haunches in an upright position the conquerer is mounting the animal in full war dress and in his exultation sounds the key note for a 'Yell of Triumph' in which all join. No description can give an idea of this wild ear piercing manifestation, it is something unearthly serving at the same time as a boast for the visitors and requiem for the buffalo.

"After tanning one side of the robe in which they are experts they often paint on it reminiscences of battle scenes in most brilliant colors, thereby commanding a premium at the agency of the Fur Company. . . . In fact is is indispensable in many domestic purposes among themselves, clothing them in winter and forming the most comfortable couches for repose."

RT

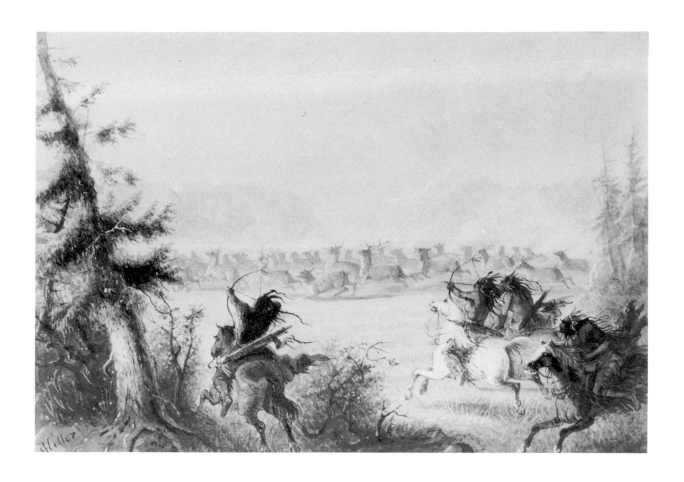

99. *Herd of Elk*
Watercolor on paper, 1867. 8 1/8 x 11 11/16 in.
Public Archives of Canada, Ottawa, Ontario 1946-132
Catalogue number 373B

The hunt was, perhaps, the reason for Stewart's continued visits to the mountains, whether buffalo, grizzly bears, or elk, as shown here. "The Elk are desirable game to the Indians on account of their size and weight," said Miller, although "their meat is coarser, and the flavor inferior to deer." In this picture, Miller has illustrated the hunters just as they encounter a large herd of elk and are charging out in ambush.　　　RT

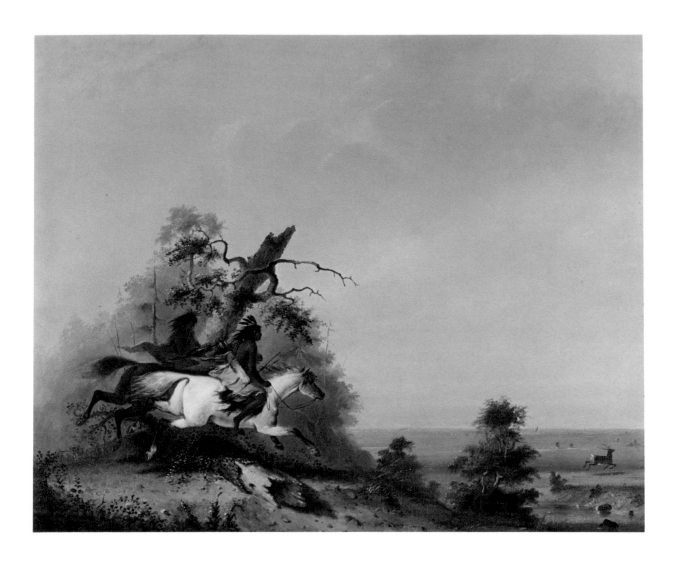

100. *Elk Swimming the Platte*
Oil on canvas. 21 3/4 x 37 in.
Gerald Peters
Catalogue number 374G

After chasing the elk across the prairies, the hunters finally have him pinned against the river, but "in his extremity [the elk] has plunged into the Platte River." The hunters know that he is a "dangerous customer" in the water, for he could hook them with his antlers, and that, if he reaches the other side, they have scant hope of ever catching him.

Miller also noted that the "Pie-bald horse [ridden by the Indian nearest the viewer] is held in great esteem,— the manner in which the Trappers describe their breeding was similar to that used by Jacob of old among Laban's flocks of cattle." RT

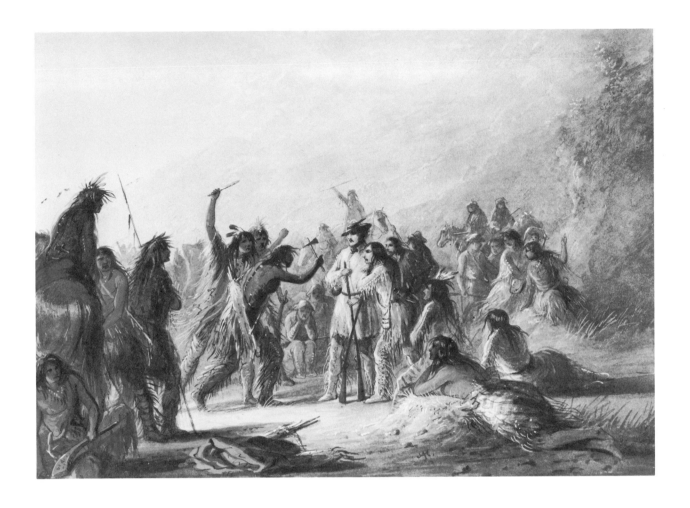

101. *Attack by Crow Indians*
 Watercolor on paper, 1858–1860. 9 7/8 x 13 5/8 in.
 Walters Art Gallery, Baltimore, Maryland 37.1940.179
 Catalogue number 377B

Miller did not see this scene, which occurred during one of Captain Stewart's earlier trips to the mountains, but it was explained to him in detail and he painted several versions of it, including a large painting approximately 5 x 9 feet for Murthly Castle and this fine watercolor.

 According to LeRoy R. Hafen's account of the incident (*Broken Hand,* p. 134), a band of young Crows invaded the camp while Fitzpatrick was away and Stewart was in charge. They carried off stock, pelts, and other property. They encountered Fitzpatrick on their return and stripped him of everything of value as well. As Stewart described the incident, the Crow medicine man had told the braves that, if they struck the first blow, they could not win. Thus, they had to provoke Stewart or someone in his party into striking the first blow. Stewart stood firm, refusing to strike. The Crows left, and the captain survived a situation in which he would have surely lost the battle. Fitzpatrick managed to talk the Crows into returning most of what they had taken. RT

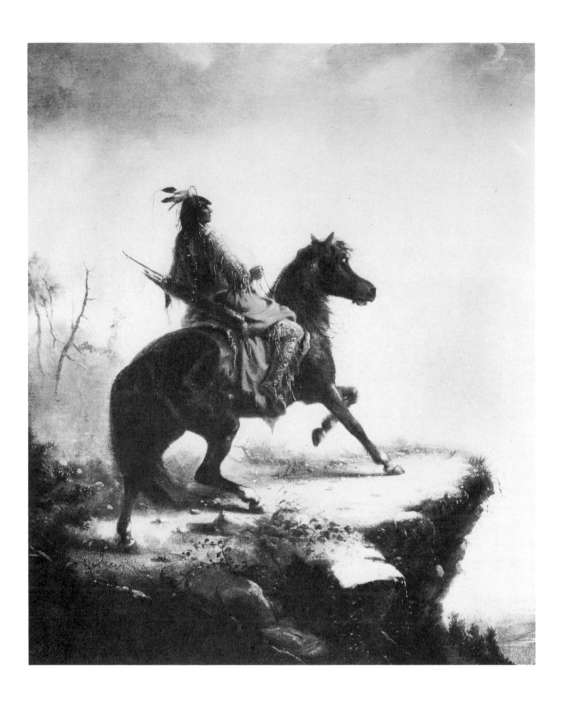

102. *Crow Indian on the Lookout*
Oil on canvas. 30 x 25 in.
Private collection
Catalogue number 395J

The bluffs formed an observatory for the "vigilant Indian," wrote Miller. "His cunning eye sweeps the horizon in all directions and from long practice he discerns an object (like the sailor on the ocean) much sooner than an ordinary observer.

"From these bluffs they observe in which direction game is to be had and notify their hunters, the direction of rivers and land marks, the approach of an enemy or a caravan of 'pale faces,' and make their preparations accordingly."

This composition proved to be one of Miller's more popular, as he did several versions of it for later commissions.

RT

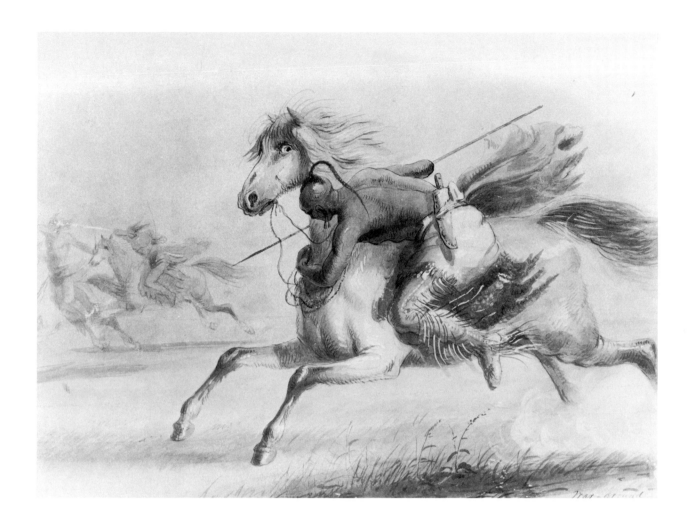

103† *War Ground*
 Ink and wash on paper. 13 1/2 x 18 in.
 The Rockwell Museum, Corning, New York
 Catalogue number 379F

Although Miller saw no actual combat, he did compose several war scenes, perhaps based on accounts of incidents that he heard. This ink-and-wash drawing was probably used as a study for oil paintings of the same title that he completed on commission in 1863 and 1865. RT

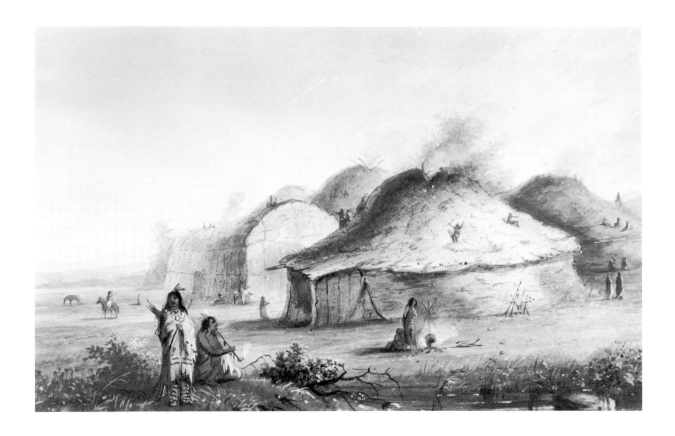

104. *Indian Lodges*
 Watercolor on paper, 1858–1860. 9 x 14 5/16 in.
 Walters Art Gallery, Baltimore, Maryland 37.1940.94
 Catalogue number 414A

The principal lodge, says Miller, is sixty to seventy feet in diameter with a domelike roof perhaps forty feet high in the center. The only light comes through a six-foot aperture at the top, which also permits the smoke to escape. Miller compared the whole effect to the Pantheon at Rome. RT

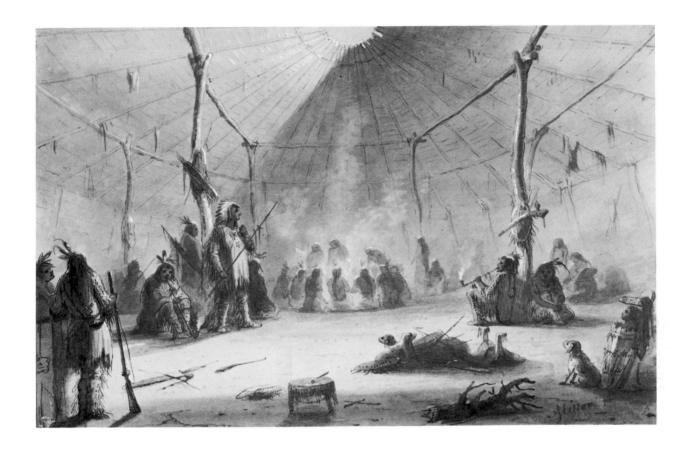

105. *Indian Lodge*
 Watercolor on paper, 1867. 7 3/4 x 11 7/8 in.
 Public Archives of Canada, Ottawa, Ontario 1946–130
 Catalogue number 416B

The roof is composed of poles, supported by upright beams, covered with adobe, and is so strong that the Indians can sit on it while they make arrows or other implements. In this sketch, the Indians in the center distance are playing the game of "hand," which Miller says is similar to "hunt the slipper." RT

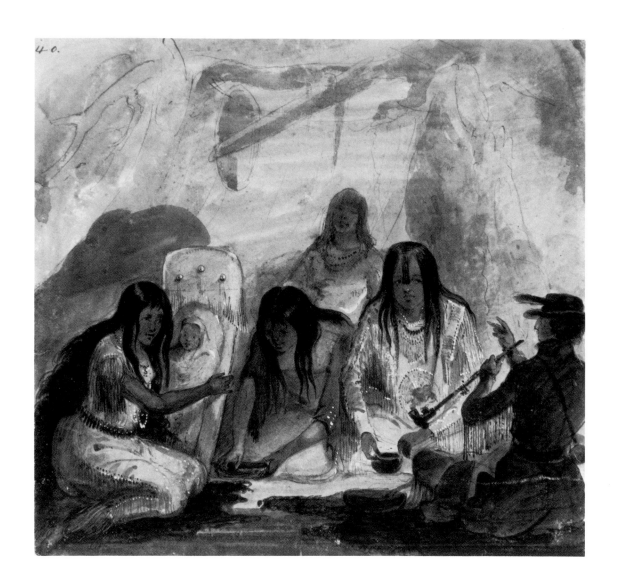

106. *Indian Hospitality—Conversing by Signs*
Pencil with brown, gray, and yellow washes, heightened with white, on paper, c. 1837. 7 1/2 x 8 in.
The Dentzel Collection 1732
Catalogue number 417A

This sketch, which represents a Snake Indian family entertaining a trapper in their lodge, might be a self-portrait of a kind, since Miller, too, was included in such an entertainment. Confronted with the necessity of eating dog meat or being unkind to his hosts, Miller resorted to employing a trapper to accompany him to eat for him. "We sat by the trapper at the feast who eat [*sic*] our share, seemed to enjoy it," said Miller, "and the etiquette appeared satisfactory to our hosts, in every respect." RT

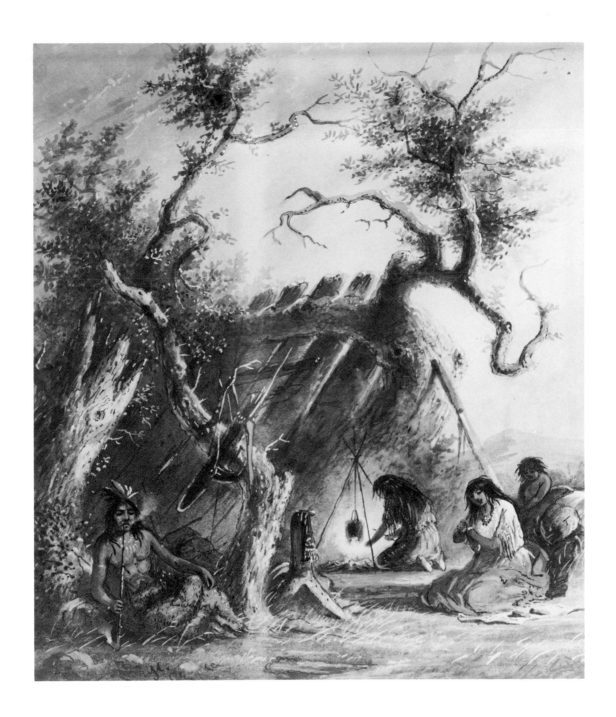

107. *Indian Lodge*
Watercolor on paper, 1858–1860. 11 1/8 x 9 3/8 in.
Walters Art Gallery, Baltimore, Maryland 37.1940.174
Catalogue number 418A

Along the waters of the upper Platte River, Miller encountered this Indian who had taken advantage of a peculiarly bent tree to put up planks to form a "very tolerable Lodge for his progeny."

To the right a female is seated, making moccasins. The head of the household is seated to the left, smoking his calumet, "not trying to solve the difficult problem, the squaring of the circle," Miller supposed. RT

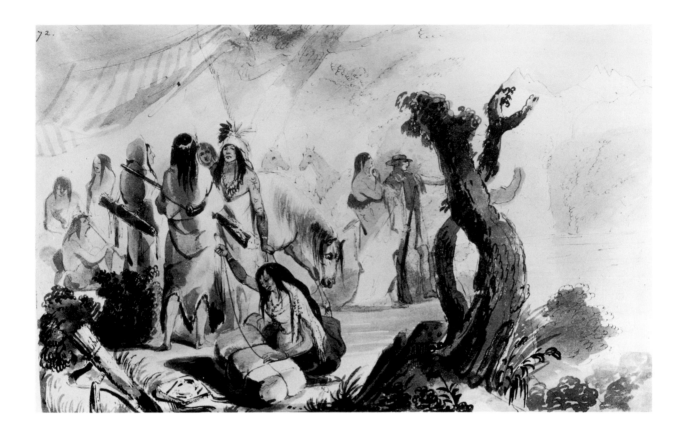

108. *Visit to an Indian Encampment*
Pen and ink with gray wash on paper, c. 1837. 7 3/4 x 11 7/8 in.
Private collection
Catalogue number 419

"It is not wonderful that Trappers and travellers soon begin to have sympathy and fondness for [the Indians'] . . . mode of life," wrote Miller. "They are perfectly free from care and responsibilities of all kinds."

Many trappers found a home among the Indians, including James Beckwourth, whom Miller met. Beckwourth had become a chief among the Crow Indians, "presiding at their Council, leading them to battle, and inter-marrying with an Indian girl."

Miller, too, found the Indians striking: "The Sculptor and Historical painter will in vain look for finer models, or greater variety of costume and equipments, their bronzed complexions, too, forming the most admirable contrasts with the white man." RT

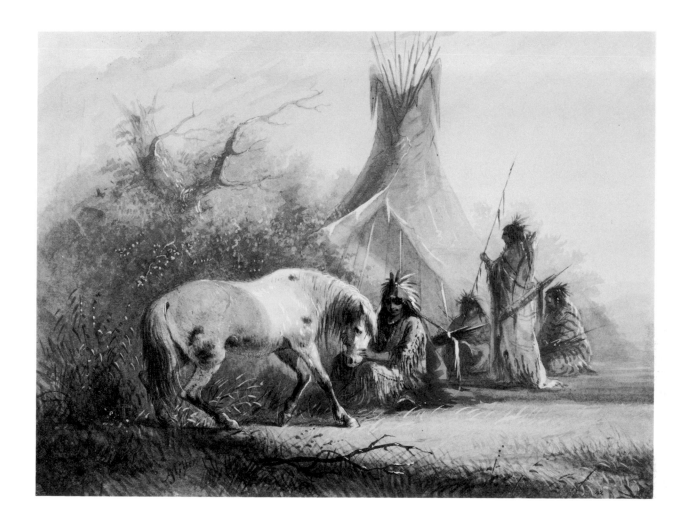

109. *Shoshone Indian and His Pet Horse*
Watercolor on paper, 1858–1860. 9 1/16 x 12 in.
Walters Art Gallery, Baltimore, Maryland 37.1940.62
Catalogue number 420B

The scene is a normal day in an Indian village, with the teepee thrown open to admit the fresh air while the Indians in front are making bows, arrows, and so on. In the foreground, a warrior is petting his horse. Miller, perhaps in anticipation of the old cowboy-and-horse story, suggested that, if the Indian had to choose between his horse and his bride, "we opine that the horse would be the first choice." RT

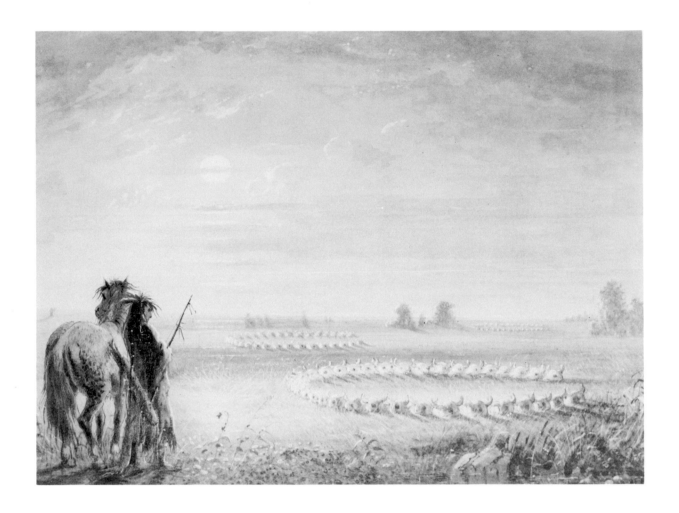

110. *Medicine Circles*
 Watercolor on paper, 1867. 8 13/16 x 11 15/16 in.
 Public Archives of Canada, Ottawa, Ontario 1946–123
 Catalogue number 440C

Miller's painting of this medicine circle, found along the upper Platte, is slightly different from Catlin's and Bodmer's versions, found among the Mandan Indians on the upper Missouri. The skulls related to the Sun Dance, which was the most significant annual event among most of the Plains Indians, occurring, usually, in the spring before the summer buffalo hunts. The skulls marked a sort of sacred altar. Special offerings were placed on a pole in the center of the circle. A torture ceremony ensued, after which the young braves who survived were considered worthy of any mission. Miller noted that he had heard that some circles in other parts of the country were made entirely of human skulls, but he could learn nothing more of the ritual. Both Bodmer and Catlin include human skulls in some of their drawings and paintings of Mandan circles. RT

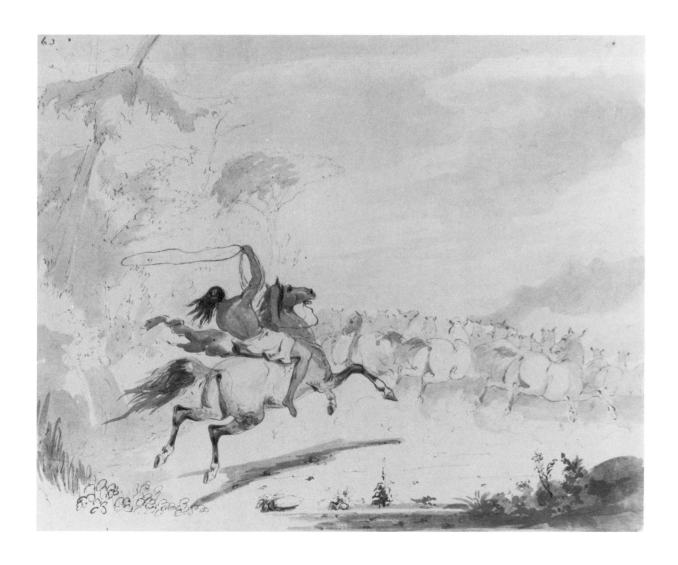

111. *Throwing the Lasso*
 Pen and ink with gray wash on gray card, c. 1837. 8 3/4 x 10 3/4 in.
 Joslyn Art Museum, Omaha, Nebraska; InterNorth Art Foundation Collection 782
 Catalogue number 442A

Miller found the Indians to be extremely good athletes, particularly when it came to horseback riding. "On approaching the band, his body swaying to and fro," Miller wrote, "the noose part is flourished above the head, and as opportunity offers, is flung with great precision and dexterity, around the neck or leg, whichever appears most feasible to the Indian." The rope used in this instance is made of plaited bull hide and is "remarkably strong, pliable, and of sufficient weight for throwing well, about 25 feet long, one end generally secured to the rider's horse." RT

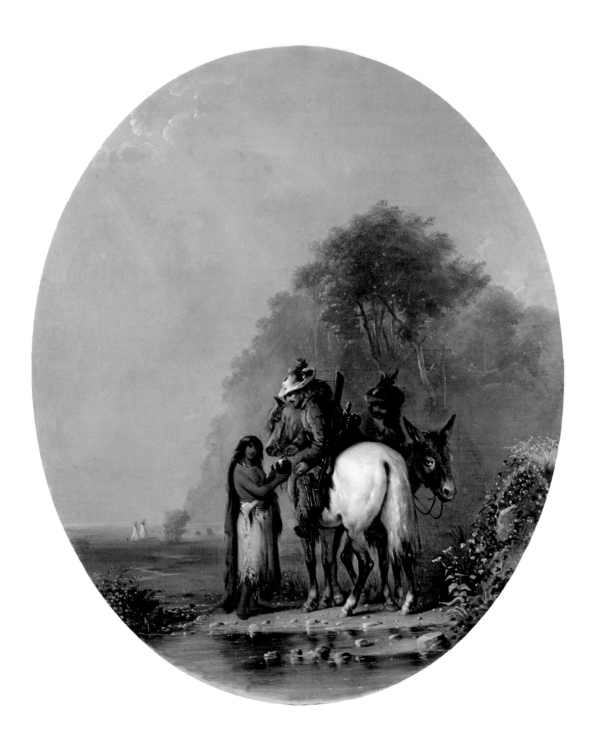

112. *The Halt*

Oil on canvas (oval). 24 x 20 in.
Sheldon Memorial Art Gallery, University of Nebraska, Lincoln U-372; University Collection, gift of
Norman Hirschl
Catalogue number 459G

There are several versions of this picture, variously titled *The Thirsty Trapper* (cat. 459B), *Receiving a Draught of Water from an Indian Girl* (cat. 459A), and *The Halt*. Miller discusses in several instances the great thirst that befell the trappers, suggesting that "one must absolutely go through the ordeal" in order to appreciate the feeling. The pipe was the "universal resort," he said, but a drink of water was the only real cure.

In this picture, Stewart appears to be more interested in the girl than in the water. Perhaps this is the young woman who provided the inspiration for his highly romanticized novel about his Rocky Mountain experiences, *Altowan:* she was "a wild creature . . . with well-formed limbs and a roguish eye," he wrote. RT

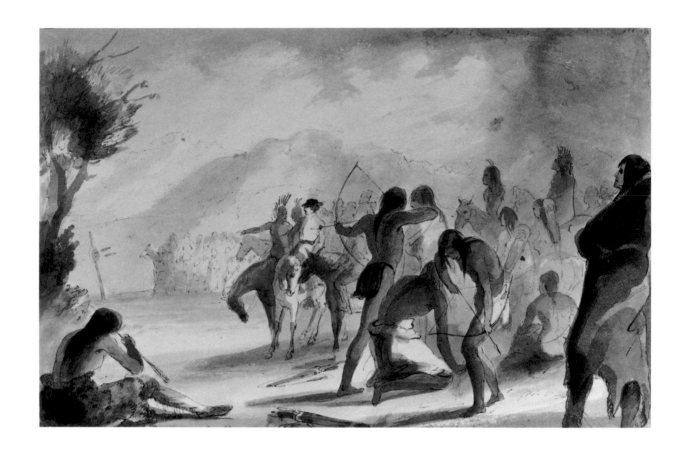

113. *Trial of Skill—with the Bow and Arrow*
Pen and ink with gray and yellow washes on paper, c. 1837. 7 3/8 x 10 1/4 in.
Walters Art Gallery, Baltimore, Maryland 37.2438
Catalogue number 455A

While at the rendezvous, Miller had frequent opportunities to observe "trials of skill," one of the Indians' chief amusements. Of course, they bet on the results—beaver pelts against blankets, beads against wampum, pipes against tobacco. "This proceeds," Miller wrote, "until at last the very dresses they have on are placed in the scale of chances, sometimes reducing the poor devils almost to the condition of Adam, gambling being one of their strong passions."

The contests themselves—marksmanship with the elk-horn bow—were usually conducted on a calm day over a distance of thirty to forty yards. The arrows, shown being made by the figure at the left, were tipped with flint or iron, with a neat and balanced feather on the end. With the elk-horn bow they could "drive an arrow completely through a buffalo," Miller claimed. The targets shown in this sketch were circles two or three inches in circumference. RT

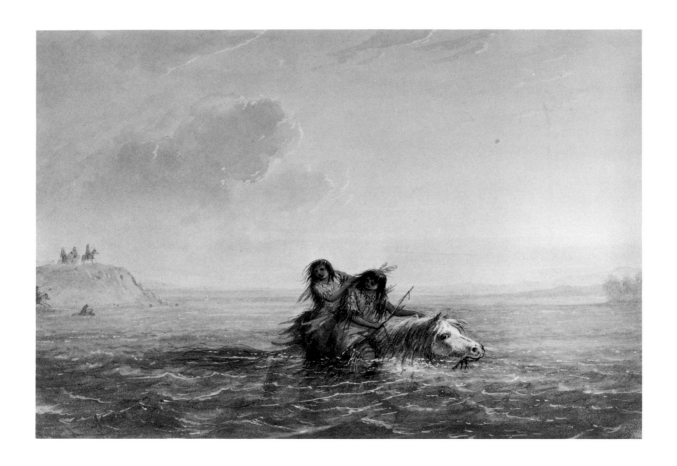

114. *Indian Elopement*
Watercolor on paper, 1858–1860. 8 7/16 x 12 5/16 in.
Walters Art Gallery, Baltimore, Maryland 37.1940.86
Catalogue number 479B

The Indian custom, of course, called for the young man to pay the family of the girl he chose for his wife. But in this case, Miller says, the brave has only his horse and he does not want to give it up. So he slipped into the village when the other men were away hunting and persuaded the maiden to go with him. The old men mounted their horses and pursued the couple to the river but could not catch them. RT

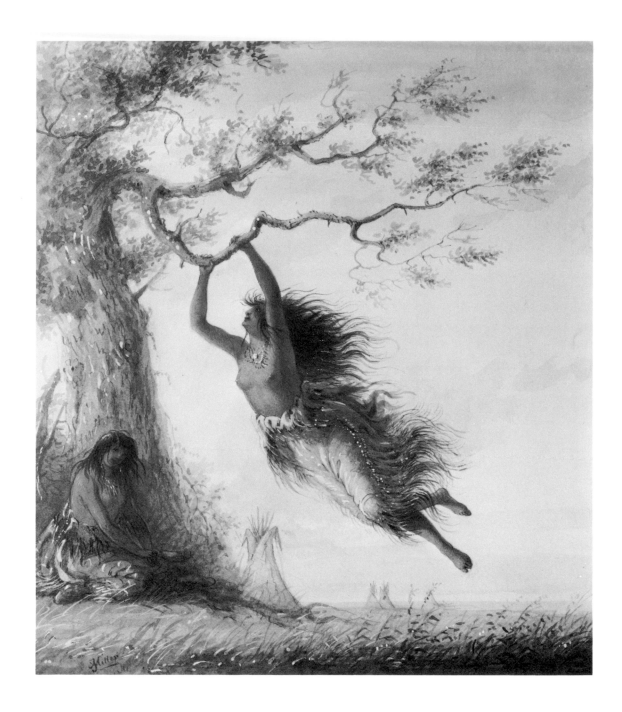

115. *Indian Girls Swinging*
Watercolor, heightened with white, on paper, 1858–1860. 10 15/16 x 9 1/2 in.
Walters Art Gallery, Baltimore, Maryland 37.1940.47
Catalogue number 470A

This "single incident that arrested the Artist's eye" proved to be a popular picture that, perhaps as much as any other image, seemed to show the Indians to be a carefree, romantic lot. Miller later permitted it to be copied as a chromolithograph for C. W. Webber's book entitled *The Hunter-Naturalist: Wild Scenes and Song-Birds* (1854). As might be anticipated, later editions of the work had the girl fully clothed, despite Miller's note that "she had in truth, almost 'nothing to wear.' "

RT

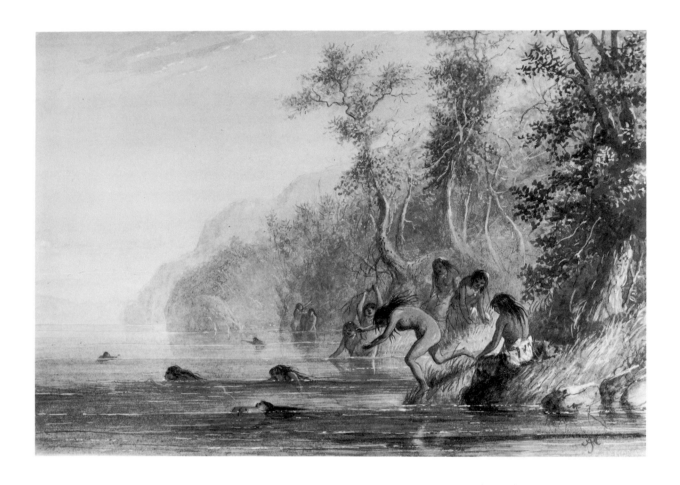

116. *Indian Women: Swimming*
Watercolor on paper, 1858–1860. 8 1/8 x 11 15/16 in.
Walters Art Gallery, Baltimore, Maryland 37.1940.194
Catalogue number 474A

One relaxation available to the Indian women was swimming, which, Miller said, they resorted to at every opportunity. They took great pleasure in diving, swimming underwater, and swimming for distance and did not seem in the least disturbed by Miller's approach. RT

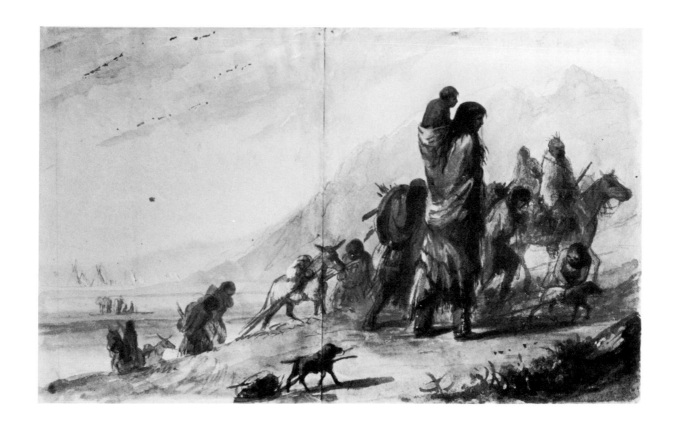

117† *Migration of the Pawnees*
 Watercolor on paper. 5 3/4 x 9 3/8 in.
 Boatmen's National Bank, St. Louis, Missouri
 Catalogue number 481B

"When the grass in camp is eaten up by the animals, & the Buffalo all driven off by repeated forays amongst them, the Indian must then per force break up his encampment," wrote Miller. In this sketch he has pictured a group of Pawnees moving. "Everything now is brought into requisition, even to the dogs," he continued. The women had a particularly heavy load to bear. As anthropologist John C. Ewers has noted, the horse was a boon to Indian women. RT

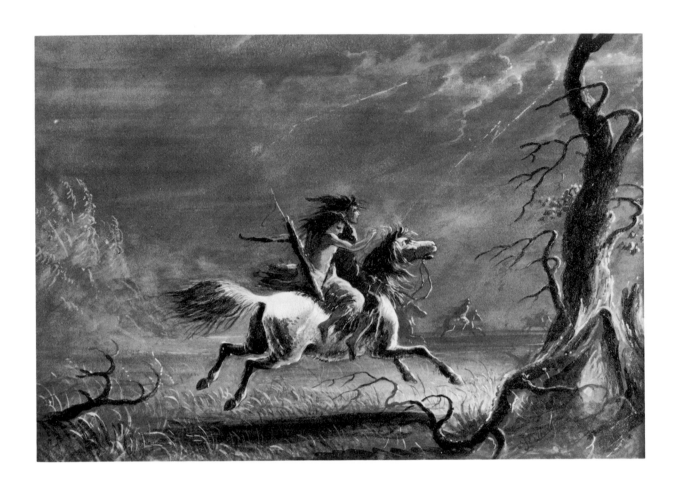

118. *Indians in a Storm: Night Scene*
Watercolor on paper, 1858–1860. 8 5/8 x 12 3/16 in.
Walters Art Gallery, Baltimore, Maryland 37.1940.83
Catalogue number 461A

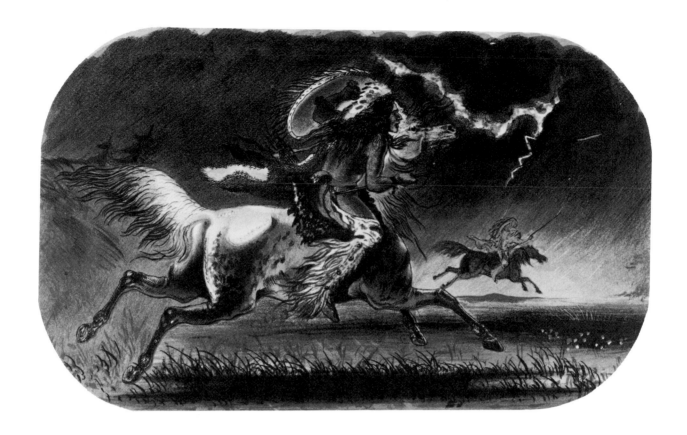

119. Untitled [Indians in a storm].
Chromolithograph published in Charles Wilkins Webber, *The Hunter-Naturalist:*
Romance of Sporting; or Wild Scenes and Wild Hunters
(Philadelphia: J. W. Bradley, 1851).
4 7/8 x 7 1/2 in.
Amon Carter Museum, Fort Worth, Texas
Catalogue number 901

The Indians saw the "Anger of a Great Spirit" in thunderstorms, Miller observed, because they knew "nothing of positive or negative clouds approaching each other and discharging a surplus of electricity." In a storm, "they become frightened, hang their heads, and deprecate his wrath;—their resolution for the moment is to do better."

This night scene, one of Miller's more dramatic watercolors, was also produced as a chromolithograph by L. N. Rosenthal in Philadelphia. Some changes in the picture have been made: for example, the watercolor version shows a female riding behind the warrior; also, the warrior has no shield and there is a tree on the right that does not appear in the chromolithograph. RT

CATALOGUE RAISONNÉ

The pictures listed in the catalogue raisonné have been grouped thematically and roughly organized to follow the chronological sequence of Miller's career: genre scenes (including Miller's earliest known paintings), western scenes, portraits (the majority of which were painted after Miller's return to Baltimore), portrait effigies, landscapes, copies, religious pictures, miscellaneous pictures, and, finally, the scrapbook albums, which, although now dismembered, contained a variety of studies made throughout the artist's life. Because Miller copied so many of his western scenes, the presumed trail sketch has been assigned a catalogue number, and later versions or variations are designated in "A, B, C" fashion. Titles are indexed for quick reference, with the exception of the portraits, which are listed alphabetically, and the album studies, which often are untitled. Previously accepted titles are cited in parentheses after those currently in use: In citing dimensions, height precedes width. Location of inscriptions is indicated by the following abbreviations:

upper left	u.l.
upper center	u.c.
upper right	u.r.
lower left	l.l.
lower center	l.c.
lower right	l.r.

Dates given in parentheses are those established by documentation or stylistic analysis. Where dates of acquisition or ownership are not commonly known, they are given in parentheses in the provenance.

ACM: Amon Carter Museum, Fort Worth, Texas

BBHC: Buffalo Bill Historical Center, Cody, Wyoming

BNB: Boatmen's National Bank, St. Louis, Missouri

CGA: Corcoran Gallery of Art, Washington, D.C.

FARL: Frick Art Reference Library, New York

JAM: Joslyn Art Museum, Omaha, Nebraska

MFA: Museum of Fine Arts, Boston, Massachusetts

PAC: Public Archives of Canada, Ottawa, Ontario

PB: Parke-Bernet Galleries, Inc., New York

SLAM: St. Louis (Missouri) Art Museum

SPB: Sotheby Parke Bernet Galleries, Inc., New York

WAG: Walters Art Gallery, Baltimore, Maryland

WCMFA: Washington County Museum of Fine Arts, Hagerstown, Maryland

WMAA: Whitney Museum of American Art, New York

Account book: Miller's studio account book.

Bell: Ottawa. Public Archives of Canada. *Braves and Buffalo: Plains Indian Life in 1837.* Introduction by Michael Bell.

Brunet: Ottawa. Public Archives of Canada. Picture Division. *Descriptive Catalogue of a Collection of Water-colour Drawings by Alfred Jacob Miller (1810–1874) in the Public Archives of Canada.* Introduction by Pierre Brunet.

DeVoto: Bernard A. DeVoto. *Across the Wide Missouri.*

Goetzmann and Porter: William H. Goetzmann and Joseph C. Porter. *The West as Romantic Horizon.* Artists' biographies by David C. Hunt.

Hunter: Baltimore, Maryland. Peale Museum. *Alfred Jacob Miller: Artist of Baltimore and the West.* Text by Wilbur Harvey Hunter, Jr.

Journal: Miller's journal.

Lakeview: Lakeview Center for Arts and Sciences, Peoria, Illinois.

McNay: San Antonio, Texas. Marion Koogler McNay Art Institute. *Go West, Young Man.*

Murthly sale notices: Murthly Castle estate sale notices. *Scotsman,* June 1, 16, 17, 19, 1871.

Nelson: William Rockhill Nelson Gallery of Art. Kansas City, Missouri.

Nelson and Atkins: William Rockhill Nelson Gallery and Atkins Museum of Fine Arts. Kansas City, Missouri.

Porter and Davenport: Mae Reed Porter and Odessa Davenport. *Scotsman in Buckskin.*

Ross: Marvin C. Ross. *The West of Alfred Jacob Miller.*

Rossi and Hunt: Paul A. Rossi and David C. Hunt. *The Art of the Old West from the Collection of the Gilcrease Institute.*

Rough Draughts: Miller's "Rough Draughts for Notes to Indian Sketches."

Sandweiss: New Haven, Connecticut. Yale University Art Gallery. *Pictures from an Expedition.* Text by Martha A. Sandweiss.

Warner: Robert Combs Warner. *The Fort Laramie of Alfred Jacob Miller: A Catalogue of All the Known Illustrations of the First Fort Laramie.*

"Western Frontier": "Water Colors of the Western Frontier a Century Ago . . ." St. Louis (Missouri) Art Museum.

Withington: New Haven, Connecticut. Yale University Library. *A Catalogue of Manuscripts in the Collection of Western Americana Founded by William Robertson Coe, Yale University Library.* Compiled by Mary C. Withington.

1. *Study in the Life School*
Oil on paper mounted on cardboard
12 7/8 x 9 in. (32.8 x 22.9 cm.)
Signed: "AJM [monogram] iller"
Dated and inscribed on verso: "Painted at night, Rome
1834"
Norton Asner, Baltimore
PROVENANCE
the artist; by descent to Alfred J. Miller, Jr.

2. *The Young Sculptor*
Oil on wood
11 3/4 x 10 1/2 in. (29.8 x 26.7 cm.)
Signed: "AJM [monogram] iller PT"
(c. 1834?)
Inscribed: "Rome The Young Sculptor"
Mrs. Hugh Montgomery, Lookout Mountain, Tennessee
PROVENANCE
the artist; by descent to the present owner

3. *The Brigand*
Oil on artist's board
10 x 11 3/4 in. (25.4 x 29.8 cm.)
Signed, dated, and inscribed on verso: "The Brigand/
sketch painted at Rome/AJM [monogram] iller 1834"
The Cloisters Children's Museum, Baltimore
PROVENANCE
Mr. and Mrs. Sumner Parker

4. *"Savoyard," Itinerant Musician*
Oil on cardboard
8 3/16 x 6 3/8 in. (20.8 x 16.2 cm.)
Signed, l.l.: "Miller"
(1834)
Inscribed on mount: "Sketched in Paris—From Nature."
The Walters Art Gallery, Baltimore 37.1584
PROVENANCE
gift of the artist to Jennie Walters
REFERENCES
J. Walters to AJM, May 12, [c. 1859]; WAG, *Catalogue of
American Works of Art*, no. 31; Ross, p. XV (as *Savoyard
Boy*)

5. *Roma*
Oil on board
8 x 7 in. (20.3 x 17.8 cm.)
Inscribed and dated, l.c.: "Roma/1834"
The Thomas Gilcrease Institute of American History and
Art, Tulsa, Oklahoma 0176.744

6. *The Present*
Panel
11 1/2 x 13 in. (29.2 x 33.0 cm.)
Signed: "AJM [monogram] iller"
Dated and inscribed: *"The Present, Venice 1834"*
John S. Rieske, Ostrander, Ohio
PROVENANCE
the artist; by descent to Lloyd O. Miller
REFERENCES
Ross, p. XV

7. *Cobbler Reading President's Message*
Unlocated
EXHIBITIONS
Maryland Historical Society Annual Exhibition (1848),
no. 292 (collection of Dr. Edmondson); Maryland
Historical Society Annual Exhibition (1858), no. 237
(estate of Dr. Edmondson)

8. *Love and War*
Unlocated
EXHIBITIONS
Maryland Historical Society Annual Exhibition (1849),
no. 270 (collection of Johns Hopkins)

9. *Hard Sum*
Unlocated
EXHIBITIONS
Art-Union, New York (1853), $35

10. *Young America*
Unlocated
REFERENCES
account book, April 12, 1853, $45, for Dr. Edmondson

11. *Hard Times*

Unlocated

REFERENCES

account book, August 26, 1853, $25, to Art-Union, New York

12. *Boys Picking Eggs*

Unlocated [perhaps related to catalogue number 893–15]

EXHIBITIONS

Art-Union, New York (1853), $35

REFERENCES

account book, August 26, 1853

13. *Juvenile Soldiers*

Unlocated

REFERENCES

Maryland Historical Society Annual Exhibition (1858), no. 236 (estate of Dr. Edmondson)

14. *Election Scene at Catonsville [Maryland], 1845*

Pencil and wash, heightened with white, on brown paper

8 1/8 x 10 13/16 in. (20.7 x 27.5 cm.)

Inscribed, l.r.: "Election Scene at Catonsville 1845"

Museum of Fine Arts, Boston, Massachusetts 51.2537

PROVENANCE

the artist; by descent to Louisa Whyte Norton; Old Print Shop, New York (1947)

EXHIBITIONS

MFA, October 18, 1962–January 6, 1963

REFERENCES

Old Print Shop ledger book (June 18, 1947), no. 58; MFA, *Water Colors,* I, no. 548, fig. 119

14A. *Election Scene, Catonsville, Baltimore County*

Oil on academy board

11 1/4 x 15 1/2 in. (28.6 x 39.4 cm.)

Signed, l.r.: "AJM [monogram]"

(c. 1861)

Inscribed on paper attached to verso: "Election Scene, Catonsville, Balt County/Md Miller Pt Balt"

The Corcoran Gallery of Art, Washington, D.C. 60.3; gift of Mr. and Mrs. Lansdell K. Christie, 1960

PROVENANCE

the artist; Columbus A. Miller (1869); Charles Bowden; Henry Bowden; Baltimore Museum of Art (sold, late 1950s); Hirschl and Adler Galleries, New York

EXHIBITIONS

Pennsylvania Academy of the Fine Arts, Philadelphia, 1861; Baltimore Museum of Art, from 1846 (on deposit); Peale Museum, Baltimore, January 8–February 12, 1950; CGA, April 23–June 5, 1960

REFERENCES

Catalogue of the Thirty-Eighth Annual Exhibition of the Pennsylvania Academy of the Fine Arts (1861), no. 537 (as *An Election Scene,* for sale), cited in Rutledge, *Cumulative Record of Exhibition Catalogues,* p. 142; account book, May 4, 1869, $55, sold to Columbus A. Miller; *Sun,* December 30, 1949, illus.; Hunter, pp. [11, 14], pl. XII; Hirschl and Adler Galleries, *Selections from the Collection . . .* (1959), p. 9 (illus.); CGA, *American Painters of the South* (1960), no. 114, illus. p. 32; "Accessions of American and Canadian Museums, January–March, 1960," *Art Quarterly* 23, no. 2 (summer 1960): 185, illus. p. 192; "Nintieth Annual Report," *Corcoran Gallery of Art Bulletin* 11, no. 3 (May 1961): 18 (illus.); MFA, *Water Colors,* I, p. 237; M. H. Forbes, "Election Scene, Catonsville, Baltimore County," *Corcoran Gallery of Art Bulletin* 13, no. 3 (October 1963): 15 ff. (illus.); *Fifty American Masterpieces,* no. 20 (illus.); Hermann Warner Williams, Jr., *Mirror to the American Past,* p. 82, fig. 64; Randall, "Gallery for Alfred Jacob Miller," p. 840 (as *Catonsville Election*)

15. *Dutchman Smoking Pipe*

Cabinet picture

Unlocated

REFERENCES

account book, July 18, 1864, $45, for P. H. Sullivan

16. *Harry as Country Boy*

Unlocated

REFERENCES

account book, July 18, 1864, $60, for P. H. Sullivan

17. *Critic*

Unlocated

REFERENCES

account book, May 4, 1869, $45, for Columbus A. Miller

18. *Jacques Moralizing*

10 x 12 in. (25.4 x 30.5 cm.)

Unlocated

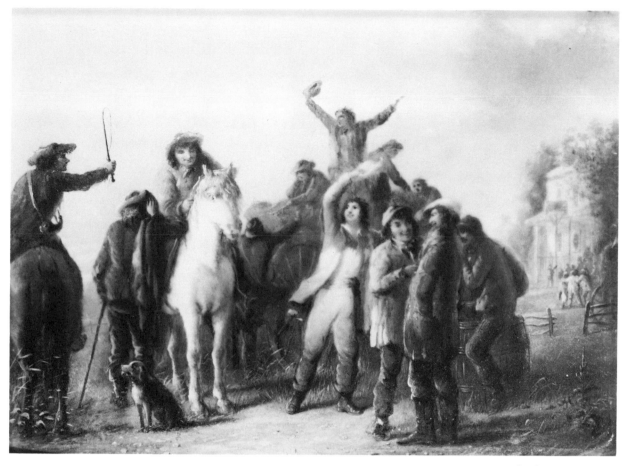

Catalogue number 14A.

REFERENCES
account book, November 7, 1870, $35, for Wm. H. Norris

19. *A Boy Selling the* Sun *Extra* [perhaps related to "Newspaper Boy," catalogue number 888–34]

Cabinet picture

Unlocated

PROVENANCE
the artist; Owen Gill

REFERENCES
AJM to sister Harriet, January 3, 1874: "Please present Mr. Owen Giles [*sic*] with the Cabinet picture of 'A boy selling the Sun Extra' (original) as a memento of our long & constant friendship—There are very few that I have more respect & regard for."

20. *Sunrise on the Coast of Zetland*

Small sketch

Unlocated

REFERENCES
Early, *Alfred J. Miller*, p. [5]

21. *The Pirate*

Small sketch

Unlocated

REFERENCES
Early, *Alfred J. Miller*, p. [5]

22. *The Berry Pickers*

Oil on academy board

9 x 14 1/2 in. (22.9 x 36.8 cm.)

Jim Fowler's Period Gallery West, Scottsdale, Arizona

PROVENANCE
Mr. Bassin, Post Road Antiques, Mamaroneck, N.Y.; Kennedy Galleries, New York (1968); Harry Lockwood, Cincinnati (1976)

EXHIBITIONS
"Arts of the Southern Highlands," Pennsylvania

Academy of the Fine Arts, Philadelphia, February 24–March 24, 1971

REFERENCES

Jim Fowler's Period Gallery West, *Volume 2—1980 Edition*, illus. p. 4

23. *A Boy Whittling*

Unlocated

PROVENANCE

estate of Hugh Caperton, Baltimore (1933)

REFERENCES

J. Hall Pleasants file

24. *Davie Mailseller*

Watercolor on paper

7 x 8 1/2 in. (17.8 x 21.6 cm.)

Signed, l.l.: "AJM [monogram]"

Inscribed, l.r.: "Davie Mailseller carrying/a letter to Mark [illeg.] Antiquary"

The Thomas Gilcrease Institute of American History and Art, Tulsa, Oklahoma 0226.1113

25. *Friend or Foe*

Oil on board

8 3/4 x 14 3/4 in. (22.2 x 37.5 cm.)

Inscribed on label on verso: "t [?] for C. Ketch/'But as Br____ bent over, the clear, mirrowing [*sic*] water, he beheld, on the oppos[ite] side, reflected in the limpid basin the [illeg.]u[illeg.] shadow of a stately Indian! With instinctiv[e] energy he sprang to regain his weapon while the Indian yelled, xxxx but as he seized his rifle & face the foe, the savage da[illeg.]ed open in fear of his gun & scattering the powder, extended his open palm in token of friendship' Tuh-gah-ju[?]y an by B. M[illeg.]er—page 28/s/A. J. Miller, pt."

Stark Museum of Art, Orange, Texas 31.34/44

PROVENANCE

Edward Eberstadt and Sons, New York

REFERENCES

Eberstadt catalogue 146 (1958), no. 123–10; Stark, *Western Collection*, p. 205

26. *The Gypsy Girl*

Oil on canvas

17 x 14 in. (43.2 x 35.6 cm.)

The Cloisters Children's Museum, Baltimore

PROVENANCE

Mr. and Mrs. Sumner Parker

27. *Hesitation at the School Room Door* [perhaps related to "School Room," catalogue number 893–65]

Ink on paper

7 3/4 x 5 in. (19.7 x 12.8 cm.)

Signed, l.l.: "AJM [monogram]"

Kennedy Galleries, Inc., New York (neg. no. T2822)

PROVENANCE

J. William Middendorf II

28. *Jessica* [Shakespeare, *Merchant of Venice*]

Oil on canvas

29 15/16 x 24 7/8 in. (76.1 x 63.2 cm.)

Signed: "AJM"

Maryland Historical Society, Baltimore 56.75.2v1

PROVENANCE

Mrs. Laurence R. Carton

EXHIBITIONS

Peale Museum, Baltimore, 1950

REFERENCES

Hunter, p. [14]

29. *A Knight*

Oil on paper

7 1/8 x 5 in. (18.1 x 12.8 cm.)

Signed, l.l.: "AJM [monogram]"

Maryland Historical Society, Baltimore 54.151.3; gift of Mrs. Laurence R. Carton

PROVENANCE

Mrs. Laurence R. Carton

30. *Last Look in the Mirror*

Oil on cardboard

11 3/4 x 10 in. (29.8 x 25.4 cm.)

Signed on verso: "AJM [monogram] iller"

Inscribed on verso: "105"

Stiles T. Colwill, Baltimore

PROVENANCE

Mrs. D. H. Miller

31. *Man with Flag*

Oil on board

5 1/2 x 7 1/2 in. (14.0 x 19.0 cm.)

Signed, l.c.: "AJM. [monogram]"

Private collection

PROVENANCE
Kennedy Galleries, New York (1965); Pittsford Picture Framing Co., Pittsford, N.Y.

REFERENCES
Kennedy Quarterly 5, no. 4 (August 1965): no. 226 (illus.)

32. *The Milkmaid*

Watercolor (oval)

Sight: 8 1/2 x 6 1/2 in. (21.6 x 16.5 cm.)

Signed, l.l.: "AJM [monogram]"

Norton Asner, Baltimore, Maryland

33. *Naval Action* [probably schooner *Experiment* in the West Indies, January 1, 1800]

Mariners Museum, Newport News, Virginia

PROVENANCE
Old Print Shop, New York; Mrs. Redpath (June 21, 1946)

REFERENCES
records of the Old Print Shop, New York, June 21, 1946

34. *Regimental Laundress*

Oil on board

7 x 5 in. (17.8 x 12.8 cm.)

Signed, l.l.: "AJM [monogram]"

Private collection

PROVENANCE
Wickersham Gallery, New York; Kennedy Galleries, New York (1965 or 1968); Joseph H. Willard, Pittsford, N.Y. (1979); Pittsford Picture Framing Co., Pittsford, N.Y.

REFERENCES
Kennedy Quarterly 5, no. 4 (August 1965): no. 232 (illus.)

35. *Reverie* [perhaps related to "The Dreamer," catalogue number 893-16]

Oil on paper

6 x 9 in. (15.2 x 22.9 cm.)

Signed, l.l.: "AJM [monogram]"

Inscribed, l.r.: "Reverie"

Martin Kodner, St. Louis, Missouri

PROVENANCE
Porter Collection; Rosenstock Arts, Denver

36. Untitled [hearth scene]

Oil on cardboard

13 x 9 3/4 in. (33.0 x 24.8 cm.)

Private collection

PROVENANCE
the artist; L. Vernon Miller, Sr.

37. Untitled [woman reading while seated]

Watercolor and gouache

6 x 7 1/2 in. (15.2 x 19.1 cm.)

Frederick and Lucy S. Herman Foundation, Norfolk, Virginia

PROVENANCE
the artist; Miller family; Anslew Gallery, Norfolk, Va.

GENRE SCENES: HISTORICAL

38. *Bombardment of Fort M^cHenry*

42 x 96 in. (106.7 x 243.8 cm.)

(c. 1828)

Maryland Historical Society, Baltimore

PROVENANCE
G. U. Porter, Baltimore

EXHIBITIONS
Maryland Historical Society Annual Exhibition (1894), estate of G. U. Porter

REFERENCES
J. Hall Pleasants file; Hunter, p. [1]; Randall, "Gallery for Alfred Jacob Miller," p. 840

39. *The Murder of Jane McCrea*

(life-size figures)

(c. 1828)

Unlocated

REFERENCES
Early, *Alfred J. Miller*, p. [1]; J. Hall Pleasants file

40. *Advent of the Locomotive in Oregon*

Watercolor and gouache on paper

8 x 10 in. (20.3 x 25.4 cm.)

Signed, l.r.: "AJM [monogram]"

The Thomas Gilcrease Institute of American History and Art, Tulsa, Oklahoma 0236.1109

41. *Capture of Andre* [Major André]

Unlocated

EXHIBITIONS

Boston Athenaeum (1835), no. 26 (for sale)

REFERENCES

Perkins and Gavin, *Boston Athenaeum Art Exhibition Index,* entry for "Miller"

42. *Don't Give up the Ship (The Death of Lawrence)*

Oil on paper, backed with canvas [originally mounted on board]

20 1/2 x 18 in. (52.1 x 45.7 cm.)

(before 1836)

The Walters Art Gallery, Baltimore 37.2463; purchase 1969, S. & A. P. Fund

PROVENANCE

the artist; by descent to Mrs. Hugh Purviance King (Virginia Miller), Long Island, N.Y.; Don S. Lewis, Anslew Gallery, Norfolk, Va.; Chapellier Galleries, New York

REFERENCES

Richard H. Randall, Jr., "Don't Give up the Ship," *Bulletin of the Walters Art Gallery* 22, no. 4 (January 1970): 2–3 (illus.); Randall, "Gallery for Alfred Jacob Miller,"
p. 841, fig. 10

GENRE SCENES: LITERARY

43. *James Hackett as Falstaff in the Battle of Shrewsbury Scene from Shakespeare's Henry IV*

Oil on academy board

9 1/2 x 11 1/4 in. (24.2 x 28.6 cm.)

Signed, l.r.: "AJM [monogram] iller pt"

(1830s)

Stiles T. Colwill, Baltimore

PROVENANCE

Mrs. Laura K. Renner

43A. *Falstaff on the Battlefield* [James Hackett]

Oil on canvas

20 x 24 in. (50.8 x 60.9 cm.)

Signed, l.r.: "AJM [monogram]"

Collection of George J. and Patricia Arden

PROVENANCE

American Shakespeare Theater, Stratford, Conn. (sale: SPB, January 15, 1976), lot 145 (illus.)

44. *The Marchioness* [from Dickens' *The Old Curiosity Shop*]

Oil on panel

11 3/4 x 10 3/8 in. (29.9 x 26.9 cm.)

The Walters Art Gallery, Baltimore 37.2538; gift of Miss Margaret Hodges, 1977

PROVENANCE

Charles Wilmer, Baltimore; Miss Margaret Hodges, Baltimore

REFERENCES

Johnston, "Alfred Jacob Miller, Would-be Illustrator," pp. 2–3 (illus.)

45. *Dr. Primrose Overturning the Cosmetic* [from Oliver Goldsmith, *The Vicar of Wakefield*]

EXHIBITIONS

Maryland Historical Society Annual Exhibition (1848), no. 187 (collection of the artist)

46. *Norna of the Fitful Head Stilling the Tempest* [from Sir Walter Scott, *The Pirate,* 1821]

Small sketch

Unlocated

REFERENCES

Early, *Alfred J. Miller,* p. [5]

47. *"Pirate Chief"* [from Sir Walter Scott, *The Pirate,* 1821]

Watercolor on paper

8 1/4 x 11 3/4 in. (20.9 x 29.8 cm.)

Inscribed on verso: "Walter Scotts' Pirate Chief Painted by A. J. Miller"

Mrs. Hugh Montgomery, Lookout Mountain, Tennessee

PROVENANCE

the artist; by descent to the present owner

48. *Vasco Nunez de Balboa*

Oil on paper

7 1/8 x 5 in. (18.4 x 12.7 cm.)

Inscribed: "Vasco Nunez/de Balboa Sept 25, 1513/When with Eagle's eyes/He stared at the Pacific & all his men/Looked at each other with a wild surmise/silent on a peak of Darien" [from Luis de Camões, *Os Lucíadas*] The L. Vernon Miller family

PROVENANCE

the artist; by descent to the present owners

49. *Rip Van Winkle in the Catskills* [from Washington Irving, *Sketch Book*]

Watercolor on paper

6 1/4 x 9 1/4 in. (15.9 x 23.5 cm.)

Inscribed, l.l.: "Rip Van Winkle"

The Thomas Gilcrease Institute of American History and Art, Tulsa, Oklahoma 0226.1098

PROVENANCE
the artist; by descent to Mrs. Eugenia R. Whyte, Baltimore; M. Knoedler and Company, New York, #WCA 1097 (1948)

REFERENCES
Hunter, p. [5]

50. *Actors of Holliday Street Theater 1830*

Ink on paper

13 1/4 x 19 7/8 in. (33.7 x 50.5 cm.)

Signed, l.r.: "AJM"

Inscribed: "Sketch for oil picture. Actors of Holliday Street Theater, 1830/Wemyss, Jefferson, Duff Warren, Francis Wood"

The L. Vernon Miller family

51. *Sir William Stewart*

Watercolor on paper

4 1/2 x 6 1/4 in. (15.9 x 11.5 cm.)

Signed, l.l.: "AJM [monogram]"

Inscribed, l.r.: "Sir Wm. D. Stewart"

Joslyn Art Museum, Omaha, Nebraska; InterNorth Art Foundation Collection 765

PROVENANCE
the artist; by descent to Mrs. Laurence R. Carton; M. Knoedler and Company, New York, #WCA 2232 (1965)

EXHIBITIONS
Peale Museum, Baltimore, 1932; "Gallery of Dudes," ACM, January 26–March 15, 1967

REFERENCES
Hunter, pp. [9, 15], pl. IV (as *Sir William Drummond Stewart*, 1838); Porter and Davenport, illus. fol. p. 148; Monaghan, "The Hunter and the Artist," *American West* 6, no. 6 (November 1969): 6 (illus.)

52. *Antoine—Principal Hunter*

Watercolor on paper (oval composition)

8 7/8 x 7 7/8 in. (22.6 x 20.0 cm.)

Signed, l.c. of composition: "AJM. [monogram]"

Inscribed, l.r. of composition: "Antoine/Principal Hunter to the Camp"; l.l. of sheet: "90"; l.r. of sheet: "Antoine principal hunter to Sir W.D.S"

Joslyn Art Museum, Omaha, Nebraska; InterNorth Art Foundation Collection 766

PROVENANCE
Mrs. Laurence R. Carton; M. Knoedler and Company, New York, #WCA 2233 (1965)

EXHIBITIONS
"Gallery of Dudes," ACM, January 26–March 15, 1967

REFERENCES
Hunter, pp. [9, 15] (as *Antoine*, 1838, collection of Mrs. Laurence R. Carton); Porter and Davenport, illus. fol. p. 148; Goetzmann and Porter, p. 69

52A. *Portrait of Antoine*

Oil on canvas

30 1/8 x 25 in. (76.8 x 63.5 cm.)

(c. 1840)

The Walters Art Gallery, Baltimore, Maryland 37.2573; gift of the Moser family in memory of Rebecca Ulman Weil

PROVENANCE
Sir William Drummond Stewart (c. 1840); Frank Nichols

(sale: Chapman's, Edinburgh, June 16–17, 1871); Rebecca Ulman Weil (c. 1900); Moser family

REFERENCES

AJM to D. H. Miller, October 31, 1840; Murthly sale notices

52B. *Antoine*

Unlocated

REFERENCES

account book, October 1, 1855, $50, for Murdock

52C. *Antoine Clement*

Watercolor on paper

11 7/8 x 9 13/16 in. (30.2 x 23.4 cm.)

Signed, l.l.: "AJM [monogram] iller"

(1858–1860)

Inscribed, l.r.: "90"

The Walters Art Gallery, Baltimore, Maryland 37.1940.37

PROVENANCE

William T. Walters, Baltimore

EXHIBITIONS

Denver Art Museum, October 15–November 21, 1955; "Gallery of Dudes," ACM, January 26–March 15, 1967; BBHC, May 1–September 30, 1978

REFERENCES

DeVoto, pl. LXXVII; Denver Art Museum, *Building the West*, no. 58 (illus.); Horan, *Great American West*, illus. p. 29; Ross, pl. 37; BBHC, *The Mountain Man*, pl. 22, and *Checklist of the Exhibition*, unpaginated

53. *Auguste*

Unlocated

PROVENANCE

Sir William Drummond Stewart (c. 1840); Frank Nichols (sale: Chapman's, Edinburgh, June 16–17, 1871)

REFERENCES

AJM to D. H. Miller, December 25, 1840, cited in Warner, p. 169; Murthly sale notices

54. *A Rocky Mountain Trapper—Bill Burrows*

Pencil, pen and ink, and wash on paper

13 x 8 1/8 in. (33.1 x 20.7 cm.)

Signed, l.r.: "AJM [monogram]"

Inscribed over signature, l.r.: "Bill Burrows"; on mount, l.r.: "A Rocky Mt Trapper/Bill Burrows.—Green River, Oregon"; u.r.: "Omitted for W"

Joslyn Art Museum, Omaha, Nebraska; InterNorth Art Foundation Collection 720

PROVENANCE

Porter Collection

EXHIBITIONS

Nelson, January 1939; "Western Frontier," SLAM, April 1–May 13, 1941 (as *Bill Burrows, a Rocky Mountain Trapper, Green River, Oregon*); BBHC, May 15–September 15, 1959

REFERENCES

DeVoto, pl. LXXVIII; BBHC, *Land of Buffalo Bill*, no. 49; Horan, *Great American West*, illus. p. 29, and rev. and exp. ed., illus. p. 27; FARL 121-1A/(52661)

54A. *Old Bill Burrows, a Free Trapper*

Watercolor on paper

4 1/8 x 6 3/16 in (10.8 x 15.7 cm.)

The Boatmen's National Bank of St. Louis, Missouri (May 26, 1947)

PROVENANCE

the artist; by descent to Louisa Whyte Norton; Old Print Shop, New York (1947)

REFERENCES

Mary Bartlett Cowdrey and Helen Comstock, "Alfred Jacob Miller and the Farthest West," *Panorama* [Harry Shaw Newman Gallery] 3, no. 1 (August–September 1947): 1; BNB, *Catalog*, no. 43

55. *Louis—Rocky Mountain Trapper*

Watercolor on paper

Sight: 7 7/8 x 5 3/4 in. (20.0 x 14.6 cm.)

Inscribed on mat, l.c.: "Louis, Rocky Mountain Trapper by A. J. Miller"

Whitney Gallery of Western Art, Buffalo Bill Historical Center, Cody, Wyoming 36.64; gift of the W. R. Coe Foundation, Oyster Bay, N.Y.

PROVENANCE

the artist; by descent to Louisa Whyte Norton; Old Print Shop, New York (1947); Peter Decker (1947); Hammer Galleries, New York (1961); Edward Eberstadt and Sons, New York

EXHIBITIONS

Fine Arts Museum of New Mexico, October 8–November 22, 1961; BBHC, May–September 1978

REFERENCES

DeVoto, pl. LXXII; Old Print Shop ledger book (June 18, 1947), no. 27 (as *Louis, Rocky Mountain Trapper*, 8 1/4 x 6 in.); "The Opening of the West," *Life*, July 4, 1949, p. 40 (illus.); Santa Fe, Fine Arts Museum of New Mexico, *The Artist in the American West, 1800–1900*, no. 43 (illus.); American Heritage, *Westward on the Oregon Trail*, illus. p. 41; Hammer Galleries, New York, *The Works of Charles M. Russell and Other Western Artists*, no. 31 (illus.); Alvin

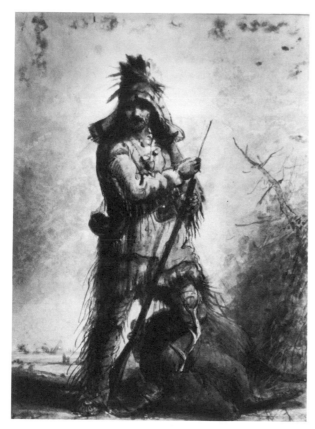

Catalogue number 55.

M. Josephy, Jr., ed., *American Heritage Book of Natural Wonders*, illus. p. 225; Clarence L. Ver Steeg, *Story of Our Country*, illus. p. 226 (as *Mountain Man*); BBHC, *The West of Buffalo Bill*, illus. p. 154 (as *Louis—Mountain Trapper*, 13 x 7 in.); BBHC, *Mountain Man*, pl. 15, and *Checklist of the Exhibition*, unpaginated; FARL 121–18

56. *Killbuck and La Bonté, Trappers*

Unlocated

REFERENCES
account book, April 7, 1851, $120, for H. Sullivan

57. *Western Cabin*

Watercolor and gouache on paper

8 x 12 1/2 in. (20.3 x 31.8 cm.)

Signed, l.r.: "A. J. Miller."

Inscribed on mat, l.l.: "Western Cabin"; l.r.: "From Nature by A J. Miller 1836 & 7"

The Thomas Gilcrease Institute of American History and Art, Tulsa, Oklahoma 0236.1064

PROVENANCE
Charles H. Linville, Baltimore (sale: Kende Galleries, New York, January 24, 1942)

EXHIBITIONS
Kende Galleries, New York, January 19–24, 1942

REFERENCES
Rough Draughts, no. 1; Kende Galleries, *The Collection of the Late Charles H. Linville, Baltimore*, no. 25 (illus.); John Francis McDermott, "A. J. Miller," *American Scene* 4, no. 3 (1962): 10 (illus.)

57A. *Western Log Cabin*

Watercolor on paper

9 3/16 x 14 7/16 in. (23.3 x 36.7 cm.)

Signed, l.r.: "A. Miller"

(1858–1860)

The Walters Art Gallery, Baltimore, Maryland 37.1940.48

PROVENANCE
William T. Walters, Baltimore

EXHIBITIONS
WCMFA, September 14–November 2, 1947; Lakeview, April 19–June 2, 1968

REFERENCES
WCMFA, *American Indian and the West*, no. 61 (as *Outpost House*); [Ruxton], *Ruxton of the Rockies*, illus. opp. p. 314; Lakeview, *Westward the Artist*, no. 94; Ross, pl. 48; Frank Getlein, *Lure of the Great West*, illus. p. 72; Barbara Gold, "Alfred Jacob Miller: 19th Century Artist," *Maryland* (Spring 1973): 27 (illus.)

58. *Starting the Caravan at Sunrise*

Pen and ink with sepia wash on paper

14 9/16 x 7 11/16 in. (37.5 x 19.5 cm.)

Signed, l.l.: "AJM. [monogram]"

Western Americana Collection, The Beinecke Rare Book and Manuscript Library, Yale University, New Haven, Connecticut (Coe V, 24–25)

PROVENANCE
the artist; by descent to Lloyd O. Miller

EXHIBITIONS
"Gallery of Dudes," ACM, January 26–March 15, 1967

REFERENCES
DeVoto, pl. XXI (as *Caravan Starting at Sunrise*); Withington, no. 342

58A. *Breaking up Camp at Sunrise*

Oil on canvas

30 x 44 in. (76.2 x 111.8 cm.)

Signed, l.r.: "A J Miller"

(c. 1845)

Mr. and Mrs. T. Edward Hambleton, New York

[the artist; Decatur Howard Miller, Baltimore; Dr. William H. Crim, Baltimore (sale: Baltimore, April 22, 1903)?]; Frank Sherwood Hambleton, Baltimore; by descent to the present owner

[*Catalogue of the Celebrated Dr. William H. Crim Collection . . . in the Fourth Regiment Armory . . .* , lot 1380 (as *Emigrant Train Crossing the Plains*)?]; Hunter, p. [14], pl. VIII; Warner, pp. 55-58, illus. p. 59; FARL 32503

58B. *Breaking up Camp at Sunrise*

Unlocated

account book, June 10, 1858, $200, for William T. Walters

58C. *Breaking up Camp at Sunrise*

Watercolor on paper

9 3/8 x 12 3/8 in. (23.8 x 31.5 cm.)

(1858–1860)

The Walters Art Gallery, Baltimore, Maryland
37.1940.142

William T. Walters, Baltimore

[WCMFA, September 14–November 2, 1947?]; Nelson and Atkins, October 5–November 17, 1957

[WCMFA, *American Indian and the West*, no. 73 (as *Wagon Train*)?]; Marshall B. Davidson, *Life in America*, I, illus. p. 198 (as *American Fur Company Caravan en Route to Wyoming*); Nelson and Atkins, *Last Frontier*, no. 39; Kent Ruth, *Great Day in the West*, illus. title page; Ross, pl. 142; Warner, p. 57

58D. *Breaking up Camp at Sunrise*

Watercolor, gouache, and pen and ink over pencil on paper
Sight: 7 11/16 x 14 3/16 in. (19.5 x 36.1 cm.)

Signed, l.c.: "AJM [monogram] iller Pt"

(1867)

Inscribed on mat, l.r.: "No. 27./Breaking up Camp./At Sunrise."

Public Archives of Canada, Ottawa, Ontario; gift of Mrs. J. B. Jardine (1946)

Alexander Brown, Liverpool, England (1867); by descent to Mrs. J. B. Jardine, Chesterknowes, Scotland

PAC museum, winter 1946–1947; Peale Museum, Baltimore, January 8–February 12, 1950; "Alfred Jacob Miller," ACM, February 13–March 26, 1972

account book, March 26, May 8, August 10, 1867; Hunter, p. [15]; Brunet, no. 27; Bell, p. 120, illus. p. 121; Warner, p. 57

58E. *Departure of the Caravan at Sunrise*

Gouache and oil on paper

7 1/8 x 14 in. (18.1 x 35.6 cm.)

Inscribed, u.r.: "No. 132"

The Boatmen's National Bank of St. Louis, Missouri (May 26, 1947)

the artist; by descent to Louisa Whyte Norton; Old Print Shop, New York (1947)

Cowdrey and Comstock, "Alfred Jacob Miller and the Farthest West," p. 1; BNB, *Catalog*, no. 56 (illus.)

59. *Attrapez des Chevaux*

Watercolor on paper

8 x 12 1/4 in. (20.3 x 31.1 cm.)

Inscribed: "Attrapez des Chevaux/Monsieur Proveau (loquitur)"

The Boatmen's National Bank of St. Louis, Missouri (May 26, 1947)

the artist; by descent to Louisa Whyte Norton; Old Print Shop, New York (1947)

Cowdrey and Comstock, "Alfred Jacob Miller and the Farthest West," p. 1

59A. *Catching Up*

Watercolor on paper

9 1/2 x 13 in. (24.1 x 33.0 cm.)

Signed, l.r.: "AJM [monogram]"

(1858–1860)

The Walters Art Gallery, Baltimore, Maryland
37.1940.197

William T. Walters, Baltimore

Hafen, *Mountain Men*, VI, frontis.; Ross, pl. 197; *Utah Historical Quarterly* 36, no. 2 (Spring 1968): cover (illus.)

60. *The Cavalcade or Caravan; Sir William Stewart Mounted on White Horse*

Oil on paper

9 x 15 in. (22.9 x 38.1 cm.)

Signed, l.c.: "AJM [monogram]"

Inscribed, u.r.: "THE CARAVAN"

Joslyn Art Museum, Omaha, Nebraska; InterNorth Art Foundation Collection 726

PROVENANCE

Porter Collection; M. Knoedler and Company, New York

EXHIBITIONS

BBHC, May 15–September 15, 1959; "Gallery of Dudes," ACM, January 26–March 15, 1967 (as *Caravan Starting at Sunrise*); Miller School, Cheyenne, July 1–August 15, 1967 Lakeview, April 19–June 2, 1968

REFERENCES

"How the West Was Won: Part I," *Life* 46, no. 14 (April 6, 1949): 90–91 (illus.); BBHC, *Land of Buffalo Bill*, no. 55; Porter and Davenport, illus. fol. p. 148; JAM, *Exploration in the West*, illus. p. 26; Sprague, *Gallery of Dudes*, illus. p. 20; Cheyenne Centennial Committee, *150 Years in Western Art*, illus. p. 28; John A. Hawgood, *America's Western Frontiers*, illus. p. 127; Lakeview, *Westward the Artist*, no. 95 (illus.); Monaghan, "Hunter and the Artist," pp. 4–5 (illus.); Martin Hillman, "Part Three: Bridging a Continent," in *The New World*, illus. p. 420; Goetzmann and Porter, pp. 33, 66, illus. p. 68.

60A. *Untitled* [Captain Stewart on a White Horse]

Pen and ink and watercolor, heightened with white, on paper

8 13/16 x 14 3/8 in. (22.4 x 36.6 cm.)

(c. 1837)

Inscribed, u.l.: "85"

Western Americana Collection, The Beinecke Rare Book and Manuscript Library, Yale University, New Haven, Connecticut; gift of Frederick William Beinecke

PROVENANCE

the artist; Sir William Drummond Stewart (c. 1839); Frank Nichols (sale: Chapman's, Edinburgh, June 16–17, 1871); Bonamy Mansell Power; willed to Edward Power (1900); by descent to Major G. H. Power, Great Yarmouth, England (sale: PB, New York, May 6, 1966); bought by Edward Eberstadt and Sons for Frederick William Beinecke

EXHIBITIONS

Denver Art Museum, April 15–24, 1966; PB, New York, April 29–May 6, 1966

REFERENCES

Murthly sale notices; PB sale 2436 (May 6, 1966), lot 11 (illus.); Sanka Knox, "83 Drawings from 1837 Trek to Rockies Are Auctioned Here," *New York Times*, May 7, 1966, p. 28

60B. *Caravan*

Unlocated

REFERENCES

account book, September 1, 1849, $150.00, for Dr. Edmondson

60C. *Caravan en Route*

Watercolor on paper

12 x 16 7/8 in. (30.5 x 42.9 cm.)

(1858–1860)

The Walters Art Gallery, Baltimore, Maryland 37.1940.51

PROVENANCE

William T. Walters, Baltimore

EXHIBITIONS

[WCMFA, September 14–November 2, 1947?]; Nelson and Atkins, October 5–November 17, 1957

REFERENCES

[WCMFA, *American Indian and the West*, no. 68 (as *Scout and Plain Procession*) or no. 73 (as *Wagon Train*)?]; Davidson, *Life in America*, I, illus. pp. 223–224; Nelson and Atkins, *Last Frontier*, no. 40; Don Berry, *Majority of Scoundrels*, illus. fol. p. 242; Ross, plates XLIII, 51; American Heritage, ed., *American Heritage Book of Great Adventures of the Old West*, illus. p. 126; Getlein, *Lure of the Great West*, illus. p. 68

60D. *Caravan en Route*

Watercolor, gouache, and pen and ink over pencil on paper

Sight: 8 9/16 x 15 9/16 in. (21.8 x 39.5 cm.)

Signed, l.l.: "AJM [monogram] iller Pt."

(1867)

Inscribed on mat, l.r.: "No. 17./Caravan en Route."

Public Archives of Canada, Ottawa, Ontario; gift of Mrs. J. B. Jardine (1946)

PROVENANCE

Alexander Brown, Liverpool, England (1867); by descent to Mrs. J. B. Jardine, Chesterknowes, Scotland

EXHIBITIONS

PAC museum, winter 1946–1947; Peale Museum, Baltimore, January 8–February 12, 1950; "Alfred Jacob Miller," ACM, February 13–March 26, 1972

REFERENCES

account book, March 26, May 8, August 10, 1867; Hunter, p. [15], pl. VI; Brunet, no. 17 (illus.); American Heritage, ed., *Trappers and Mountain Men*, illus. p. 97; Bell, p. 80, illus. p. 81

60E. *Caravan en Route*

Watercolor on paper

5 1/4 x 9 3/4 in. (13.3 x 24.8 cm.)

Signed, l.r.

Private collection

PROVENANCE

Mrs. Laurence R. Carton

REFERENCES

private collector to William R. Johnston, WAG, November 23, 1980

60F. *Caravan en Route*

Watercolor on paper

7 1/4 x 13 3/4 in. (18.4 x 34.9 cm.)

Unlocated

PROVENANCE

the artist; by descent to Louisa Whyte Norton; Old Print Shop, New York (1947); Everett D. Graff, Winnetka, Ill. (1947)

REFERENCES

Old Print Shop ledger book (June 18, 1947), no. 17

60G. *Caravan en Route*

Oil on canvas

21 x 47 in. (53.3 x 119.4 cm.)

The Boatmen's National Bank of St. Louis, Missouri (April 5, 1941)

PROVENANCE

Old Print Shop, New York

EXHIBITIONS

City Art Museum of St. Louis, 1954; BNB, May 4–29, 1964

REFERENCES

St. Louis, City Art Museum, *Westward the Way*, no. 138, illus. p. 175 (as *Sir William Drummmond Stewart's Caravan on the Platte*, 26 x 52 1/4 in.); Alvin M. Josephy, Jr., "First 'Dude Ranch' Trip to the Untamed West," *American Heritage* 7, no. 2 (February 1956): 8–9 (illus.); *Golden Book of America*, illus. p. 119; American Heritage, ed., *American Heritage Book of the Pioneer Spirit*, illus. pp. 164–165, and *Westward on the Oregon Trail*, illus. front endsheets; Rutherford Platt, *Adventures in the Wilderness*, illus. pp. 56–57 (as *Fur Trading Caravan*); BNB, *Catalog*, no. 11 (illus.); Bruce Hilton Nicoll, comp., *Nebraska, a Pictorial History*, illus. pp. 22–23; *200 Years: A Bicentennial Illustrated History of the United States*, illus. p. 249 (as *Fur Trading Caravan*)

61. *Noon Day Rest*

Watercolor and gouache on paper

7 1/4 x 11 in. (18.4 x 27.9 cm.)

Inscribed, u.r.: "Noon-day rest"

The Thomas Gilcrease Institute of American History and Art, Tulsa, Oklahoma 0236.1089

REFERENCES

Rough Draughts, no. 96

61A. *Repose at Mid-Day*

Pencil and pen and ink with brown wash, heightened with white, on gray card

8 7/8 x 11 in. (22.3 x 27.9 cm.)

(c. 1837)

Inscribed, u.l.: "57"

Amon Carter Museum, Fort Worth, Texas 22.66

PROVENANCE

the artist; Sir William Drummond Stewart (c. 1839); Frank Nichols (sale; Chapman's, Edinburgh, June 16–17, 1871); Bonamy Mansell Power; willed to Edward Power (1900); by descent to Major G. H. Power, Great Yarmouth, England (sale: PB, May 6, 1966)

EXHXBITIONS

Denver Art Museum, April 5–24, 1966; PB, April 29–May 6, 1966; Lakeview, April 19–June 2, 1968

REFERENCES

Murthly sale notices; PB sale 2436 (May 6, 1966), lot 12 (inscription listed as "51"); Lakeview, *Westward the Artist*, no. 85; ACM, *Catalogue of the Collection* (1972), no. 119, illus. p. 57

61B. *Noon-day Rest*

Watercolor on paper

9 7/16 x 13 1/8 in. (24.0 x 33.3 cm.)

Signed, l.l.: "AJM [monogram] iller"

(1858–1860)

The Walters Art Gallery, Baltimore, Maryland 37.1940.139

PROVENANCE

William T. Walters, Baltimore

REFERENCES

DeVoto, pl. XXXIV; Ross, plates LI, 139; Getlein, *Lure of the Great West*, illus. p. 90

62. *Crossing the River—Trapper Trying Its Depth &c.*

Watercolor on paper

8 3/4 x 12 5/16 in. (22.2 x 31.3 cm.)

Signed, l.r.: "AJM [monogram] iller"

(1858–1860)

The Walters Art Gallery, Baltimore, Maryland
37.1940.119

PROVENANCE

William T. Walters, Baltimore

EXHIBITIONS

[WCMFA, September 14–November 2, 1947?]; Montreal Museum of Fine Arts, June 9–July 30, 1967

REFERENCES

[WCMFA, *American Indian and the West*, no. 72 (as *Fording the River*)?]; Montreal Museum of Fine Arts, *The Painter and the New World*, no. 289 (illus.); Ross, pl. 119

63. *Fording the River*

Watercolor on paper

9 x 11 3/4 in. (23.0 x 29.8 cm.)

Private collection

PROVENANCE

Mrs. Laurence R. Carton

REFERENCES

private collector to William R. Johnston, WAG, November 23, 1980

64. *Forming Camp—Charettes Crossing the River, Kansas* [verso: *Man on Horse*]

Watercolor and gouache on paper [verso: pencil sketch, incomplete]

5 5/8 x 9 1/2 in. (14.3 x 24.1 cm.)

Inscribed, u.r.: "Making Camp [illeg.]"

Joslyn Art Museum, Omaha, Nebraska; InterNorth Art Foundation Collection 750

PROVENANCE

the artist; by descent to Louisa Whyte Norton; Old Print Shop, New York (1947); Porter Collection (1947)

EXHIBITIONS

BBHC, May 15–September 10, 1959

REFERENCES

Old Print Shop ledger book (June 18, 1947), no. 32 (as *Forming Camp . . . Kansas*, 5 3/4 x 9 1/2 in.); BBHC, *Land of Buffalo Bill*, no. 79

64A. *Crossing the Kansas*

Watercolor on paper

8 5/8 x 13 7/16 in. (21.9 x 34.2 cm.)

Signed, l.r.

(1858–1860)

The Walters Art Gallery, Baltimore, Maryland
37.1940.101

PROVENANCE

William T. Walters, Baltimore

REFERENCES

Ross, plates XLIX, 101; Getlein, *Lure of the Great West*, illus. p. 69

65. *Crossing to the North Fork of the Platte River*

Watercolor and gouache on paper

7 1/2 x 10 in. (19.0 x 25.4 cm.)

The Thomas Gilcrease Institute of American History and Art, Tulsa, Oklahoma 0236.1066

PROVENANCE

[Alfred Jacob Miller, Jr., Baltimore; M. Knoedler and Company, New York, #CA 3087 as *Indians Watching Trappers* (1948)?]

REFERENCES

Rough Draughts, no. 18

65A. *Crossing to the North Fork of the Platte*

Wash, heightened with white, on paper

11 13/16 x 9 1/2 in. (30.0 x 24.1 cm.)

Signed, l.l.: "Miller"

(1858–1860)

Inscribed, l.r.: "24"

The Walters Art Gallery, Baltimore, Maryland 37.1940.8

PROVENANCE

William T. Walters, Baltimore

REFERENCES

Oliver LaFarge, "Myths That Hide the American Indian,"
American Heritage 7, no. 6 (October 1956): 18 (illus.);
Ross, pl. 8

66. *Caravan on Platte River*

Watercolor on paper

8 5/8 x 11 3/4 in. (21.9 x 29.8 cm.)

Signed, l.l.: "AJM [monogram]"

Inscribed, u.r.: "Caravan on [illeg.] Water/Platte/River"

Joslyn Art Museum, Omaha, Nebraska; InterNorth Art
Foundation Collection 683

PROVENANCE

Porter Collection

EXHIBITIONS

Nelson, January 1939; "Western Frontier," SLAM, April
1–May 13, 1941; BBHC, May 15–September 15, 1959;
"Gallery of Dudes," ACM, January 26–March 15, 1967

REFERENCES

"America and the Future: West to the Rendezvous . . . ,"
Fortune 29, no. 1 (January 1944): 113 (illus.); DeVoto, pl.
VI; BBHC, *Land of Buffalo Bill*, no. 12; Nicoll, *Nebraska*,
illus. pp. 22–23

66A. *Caravan on the Platte*

Watercolor on paper

9 1/4 x 13 1/4 in. (23.5 x 33.7 cm.)

Signed, l.l.: "AJM [monogram]"

(1858–1860)

The Walters Art Gallery, Baltimore, Maryland
37.1940.155

PROVENANCE

William T. Walters, Baltimore

REFERENCES

Ross, pl. 155

66B. *Our Caravan enroute to the Rocky Mountains*

Oil on canvas

18 x 24 in. (45.7 x 61.0 cm.)

The Thomas Gilcrease Institute of American History and
Art, Tulsa, Oklahoma 0126.726

REFERENCES

Rough Draughts, no. 31; possibly the picture
commissioned by Wm. C. Waite, account book, March
23, 1857, as *Caravan on the Platte*, $45

67. *Approaching a Herd of Buffalo, Crossing the Platte River*

Oil on canvas

28 x 36 in. (71.1 x 91.4 cm.)

(c. 1839)

American Heritage Center, University of Wyoming,
Laramie; gift of the Everett D. Graff family

PROVENANCE

Sir William Drummond Stewart (1839); Frank Nichols
(sale: Chapman's, Edinburgh, June 16–17, 1871); Appleby
Brothers; B. F. Stevens and Brown, London (1937);
Everett D. Graff, Winnetka, Ill.

EXHIBITIONS

Apollo Gallery, New York, May 9–22, 1839

REFERENCES

"Apollo Gallery—Original Paintings," *Morning Herald*,
May 16, 1839, p. 2, col. 3, no. 4; Murthly sale notices;
B. F. Stevens and Brown, *Coronation Catalogue*, no. 94A
(c) (as *Buffaloes Crossing a Stream* . . . , 30 x 36 in.);
[University of Wyoming, Laramie] *Campus Pulse*, October
14, 1977, p. 3 (illus.); Ruth M. Collis to Ron Tyler,
September 7, 1981

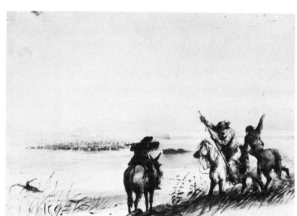

Catalogue number 68.

68. *Loading on Horseback—Buffalo Swimming the Platte*

Pen and ink with sepia wash on paper

11 5/8 x 8 1/16 in. (29.5 x 20.5 cm.)

Inscribed, l.r.: "Loading on horseback/Buffalo swimming
the Platte"

Western Americana Collection, The Beinecke Rare Book
and Manuscript Library, Yale University, New Haven,
Connecticut (Coe No. V, 24–25)

EXHIBITIONS

"Gallery of Dudes," ACM, January 26–March 15, 1967

REFERENCES

Withington, no. 342; John C. Ewers, *Artists of the Old
West*, illus. p. 120

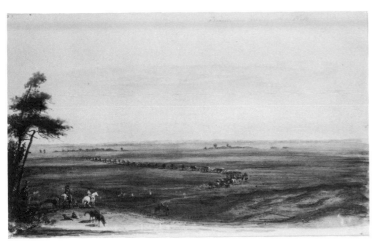

Catalogue number 69.

69. *View of the Prairie—Leaving the River Platte*

Watercolor drawing with touches of white on paper

7 13/16 x 12 3/8 in. (19.8 x 31.5 cm.)

(c. 1837)

Inscribed, u.l.: "23"; u.r.: "Prairie.—Leaving the Platte"; on mount, l.c.: "View of the Prairie—leaving the River Platte.—"

Western Americana Collection, The Beinecke Rare Book and Manuscript Library, Yale University, New Haven, Connecticut; gift of Frederick William Beinecke

PROVENANCE

the artist; Sir William Drummond Stewart (c. 1839); Frank Nichols (sale: Chapman's, Edinburgh, June 16–17, 1871); Bonamy Mansell Power; willed to Edward Power (1900); by descent to Major G. H. Power, Great Yarmouth, England (sale: PB, May 6, 1966); bought by Edward Eberstadt and Sons for Frederick William Beinecke

EXHIBITIONS

Denver Art Museum, April 15–24, 1966; PB, April 29–May 6, 1966

REFERENCES

Murthly sale notices; PB sale 2436 (May 6, 1966), lot 5 (illus.); Knox, "83 Drawings from 1837 Trek," p. 28

70. *Indians Threatening to Attack the Fur Boat, Nebraska River*

Watercolor and gouache on paper

6 1/2 x 13 in. (16.5 x 33.0 cm.)

Inscribed, u.l.: "25"

The Thomas Gilcrease Institute of American History and Art, Tulsa, Oklahoma 0226.1027

PROVENANCE

the artist; by descent to Alfred J. Miller, Jr.; M. Knoedler and Company, New York, #CA 3079, as *Indians Watching American Fur Co. Crossing River* (1948)

REFERENCES

Rough Draughts, no. 25; "America and the Future," p. 116 (illus.)

70A. *Indians Threatening to Attack the Fur Boats*

Watercolor on paper

9 7/8 x 13 1/16 in. (25.1 x 33.2 cm.)

(1858–1860)

The Walters Art Gallery, Baltimore, Maryland 37.1940.70

PROVENANCE

William T. Walters, Baltimore

REFERENCES

Paul Chrisler Phillips, *Fur Trade*, I, illus. opp. p. 455; Ross, pl. 70

71. *Caravan Crossing the River*

Watercolor and gouache on paper

9 x 11 3/4 in. (23.0 x 29.8 cm.)

The Thomas Gilcrease Institute of American History and Art, Tulsa, Oklahoma 0236.1023

PROVENANCE

[Victor D. Spark, New York; M. Knoedler and Company, New York, #WCA 886, as *Scout Leading a Wagon Train*, 11 3/4 x 8 3/4 in. (1948)?]

REFERENCES

Rough Draughts, no. 101

71A. *Caravan: Trappers Crossing the River &c.*

Watercolor on paper

9 1/8 x 12 15/16 in. (23.2 x 32.9 cm.)

Signed, l.c.: "AJM [monogram] iller"

(1858–1860)

The Walters Art Gallery, Baltimore, Maryland 37.1940.123

PROVENANCE

William T. Walters, Baltimore

EXHIBITIONS

[WCMFA, September 14–November 2, 1947?]

REFERENCES

[WCMFA, *American Indian and the West*, no. 72 (as *Fording the River*)?]; Ross, pl. 123

71B. *Captain William Drummond Stewart and Caravan in the Wind River Mountains*

Oil on canvas

12 x 16 in. (30.4 x 40.6 cm.)

The Grace and Herman Werner Collection, National Cowboy Hall of Fame, Oklahoma City, Oklahoma

PROVENANCE

private collection; James McCloskey, Baltimore

REFERENCES

Persimmon Hill 5, no. 3 (1975): [71] (illus.); Dean Fenton Krakel, *Adventures in Western Art*, pp. 282–284

72. *Crossing the River by Moonlight—Making Camp*

Watercolor on paper

8 3/4 x 12 7/8 in. (22.3 x 32.7 cm.)

Signed, l.l.: "AJM [monogram]"

Joslyn Art Museum, Omaha, Nebraska; InterNorth Art Foundation Collection 717

PROVENANCE

Porter Collection

EXHIBITIONS

Nelson, January 1939; "Western Frontier," April 1–May 13, 1941

REFERENCES

"America and the Future," p. 113 (illus. as *Crossing the River by Moonlight*); DeVoto, pl. XII (as *Crossing the River by Moonlight*)

72A. *Crossing the River: Moonlight*

Watercolor on paper

9 1/4 x 12 7/8 in. (23.5 x 32.7 cm.)

(1858–1860)

The Walters Art Gallery, Baltimore, Maryland 37.1940.162

PROVENANCE

William T. Walters, Baltimore

REFERENCES

Ross, pl. 162

73. *Bull Boating on the Platte River*

Watercolor on paper

9 1/2 x 15 1/4 in. (24.1 x 38.7 cm.)

Signed, l.c : "AJM [monogram]"

Inscribed, l.r.: "Bull Boating/on the Platte River"

Joslyn Art Museum, Omaha, Nebraska; InterNorth Art Foundation Collection 727

PROVENANCE

Porter Collection

EXHIBITIONS

Nelson, January 1939; "Western Frontier," April 1–May 13, 1941; City Art Museum of St. Louis, 1954; Denver Art Museum, October 15–November 21, 1955; BBHC, May 15–September 15, 1959; JAM, 1967

REFERENCES

"Water Color Sketches of Indian Life a Century Ago Acquired by a Kansas Citizen," *Kansas City Star*, December 4, 1938, rotogravure section, p. 3 (illus.); "America and the Future," p. 117 (illus.); DeVoto, pl; XXII; "How the West Was Won: Part I," pp. 90–91 (illus.); St. Louis, City Art Museum, *Westward the Way*, no. 135, illus. p. 172; Denver Art Museum, *Building the West*, no. 63 (as 15 x 8 1/2 in.); BBHC, *Land of Buffalo Bill*, no. 56; JAM, *Exploration in the West*, illus. p. 31; Harold W. Felton, *Edward Rose*, fol. p. 48; Monaghan, "Hunter and the Artist," p. 13 (illus.)

73A. *Bull Boating*

Watercolor on paper

8 1/2 x 14 7/8 in. (21.6 x 37.8 cm.)

(1858–1860)

The Walters Art Gallery, Baltimore, Maryland 37.1940.180

PROVENANCE

William T. Walters, Baltimore

REFERENCES

Berry, *Majority of Scoundrels*, illus. fol. p. 242; Ross, pl. 180; *Sportsman's Wilderness*, illus. pp. 140–141; Paul O'Neil, *The Rivermen*, illus. pp. 18-19; Bobby Bridger, "Seekers of the Fleece, Part I," *Four Winds*, issue 5 (Winter–Spring 1981), p. 64 (illus.)

73B. *Bull Boating*

Watercolor on paper

4 x 7 3/4 in. (10.2 x 19.7 cm.)

Unlocated

PROVENANCE

the artist; by descent to Louisa Whyte Norton; Old Print Shop, New York (1947); Everett D. Graff, Winnetka, Ill. (1947)

REFERENCES

Old Print Shop ledger book (June 18, 1947), no. 35

73C. *Caravan Trappers Fording River*

Oil on canvas

9 x 16 in. (23.0 x 40.7 cm.)

Signed, l.r.: "AJM [monogram]"

The Thomas Gilcrease Institute of American History and Art, Tulsa, Oklahoma 0126.730

REFERENCES

Rough Draughts, no. 101

74. *Bull Boating across the Platte*

Pencil, pen and ink, and wash on paper

5 1/8 x 9 1/4 in. (13.0 x 23.5 cm.)

Joslyn Art Museum, Omaha, Nebraska; InterNorth Art Foundation Collection 773

PROVENANCE

the artist; by descent to Mrs. Laurence R. Carton; M. Knoedler and Company, New York, #WCA 2225

75. *Landing the Charettes*

Brown wash on paper

9 1/4 x 15 1/4 in. (23.5 x 38.7 cm.)

Signed, l.r.: "A.J.M."

Inscribed, u.r.: "Landing the Charettes"

Joslyn Art Museum, Omaha, Nebraska; InterNorth Art Foundation Collection 728

PROVENANCE

Porter Collection

EXHIBITIONS

Nelson, January 1939; "Western Frontier," SLAM, April 1–May 13, 1941; CGA, June 8–December 17, 1950; Nelson and Atkins, October 5–November 17, 1957; BBHC, May 15–September 15, 1959; "Gallery of Dudes," ACM, January 16–March 15, 1967

REFERENCES

"America and the Future," p. 114 (illus.); DeVoto, pl. XXIII; CGA, *American Processional*, no. 142; Nelson and Atkins, *Last Frontier*, no. 35; BBHC, *Land of Buffalo Bill*, no. 57; American Heritage, ed., *Westward on the Oregon Trail*, illus. pp. 54–55; Monaghan, "Hunter and the Artist," p. 11 (illus.)

75A. *Landing the Charettes*

Watercolor on paper

9 1/4 x 15 in. (23.5 x 38.1 cm.)

Signed, l.c.: "AJM [monogram]"

(1858–1860)

The Walters Art Gallery, Baltimore, Maryland 37.1940.181

PROVENANCE

William T. Walters, Baltimore

EXHIBITIONS

[WCMFA, September 14–November 2, 1947)?]; Lakeview, April 19–June 2, 1963

REFERENCES

[WCMFA, *American Indian and the West*, no. 71 (as *Mounting Slope*)?]; Lakeview, *Westward the Artist*, no. 93, illus.; Ross, pl. 181; Shirley Glubok, *Art of the Old West*, illus. p. 11

76. *Our Camp. Sir William Stuart* [sic] *on White Horse*

Watercolor on paper

9 1/4 x 13 1/4 in.

Private collection

PROVENANCE

Mrs. Laurence R. Carton

REFERENCES

private collector to William R. Johnston, WAG, November 23, 1980

76A. *Camp Scene (Prairie)*

Unlocated

REFERENCES

account book, November 1, 1850, $125, for Josh Meredith

76B. *Our Camp*

Watercolor on paper

9 3/16 x 13 3/8 in. (23.5 x 34.0 cm.)

(1858–1860)

The Walters Art Gallery, Baltimore, Maryland 37.1940.177

PROVENANCE

William T. Walters, Baltimore

REFERENCES

Ross, pl. 177

76C. *Our Camp*

Oil on canvas

26 3/8 x 36 in. (67.0 x 91.4 cm.)

Whitney Gallery of Western Art, Buffalo Bill Historical Center, Cody, Wyoming 11.70; gift of the W. R. Coe Foundation, Oyster Bay, New York

PROVENANCE

the artist; by descent to his family; John Legg, Baltimore

(c. 1965); London Shop, Baltimore; M. Knoedler and Company, New York

EXHIBITIONS

National Cowboy Hall of Fame, Oklahoma City, June 25–October 10, 1965; BBHC, May–September 1978

REFERENCES

Oklahoma City, National Cowboy Hall of Fame, *Inaugural Exhibition*, p. 15; BBHC, *West of Buffalo Bill*, illus. p. [158]; BBHC, *Mountain Man*, pl. 11, and *Checklist of the Exhibition*, unpaginated

76D. *Sunset Campfires at Rendezvous*

Oil on panel

9 x 13 3/8 in. (23.0 x 34.0 cm.)

Western Americana Collection, The Beinecke Rare Book and Manuscript Library, Yale University, New Haven, Connecticut (Coe V, 24-25)

EXHIBITIONS

"Gallery of Dudes," ACM, January 26–March 15, 1967; Yale University Art Gallery, New Haven, September 20, 1978–January 6, 1979

REFERENCES

Withington, no. 342; Sandweiss, p. 62

77. *Reaching Camp, Removing the Saddles*

Pencil, pen and ink, wash, and gouache on paper

6 1/4 x 9 1/2 in. (15.9 x 24.2 cm.)

Joslyn Art Museum, Omaha, Nebraska; InterNorth Art Foundation Collection 694

PROVENANCE

Porter Collection

EXHIBITIONS

"Western Frontier," SLAM, April 1–May 13, 1941; BBHC, May 15–September 15, 1959

REFERENCES

DeVoto, pl. XLII (as *Removing the Saddles*); BBHC, *Land of Buffalo Bill*, no. 23

78. *Evening—Picketing Horses*

Pencil, wash, and gouache on paper

8 1/4 x 12 5/8 in. (21.0 x 32.1 cm.)

Inscribed, l.r.: "Evening—Picketing Horses."

Joslyn Art Museum, Omaha, Nebraska; InterNorth Art Foundation Collection 685

PROVENANCE

Porter Collection

EXHIBITIONS

Nelson, January 1939; "Western Frontier," SLAM, April 1–May 13, 1941; BBHC, May 15–September 15, 1959

REFERENCES

Paul I. Wellman, "An Artist Pictured the West He Visited a Century Ago," *Kansas City Star*, December 4, 1938, p. 6C (illus.); DeVoto, pl. XLIII; Ewers, *Artists of the Old West*, p. 121 (illus.); BBHC, *Land of Buffalo Bill*, no. 14; Ross, pp. XXXIV–XXXV

78A. *Picketing the Horses—At Evening*

Pen and ink with gray and brown washes on paper

7 5/8 x 12 1/8 in. (19.2 x 30.7 cm.)

(c. 1837)

Inscribed, u.l.: "86"

Amon Carter Museum, Fort Worth, Texas 24.66

PROVENANCE

the artist; Sir William Drummond Stewart (c. 1839); Frank Nichols (sale: Chapman's, Edinburgh, June 16–17, 1871); Bonamy Mansell Power; willed to Edward Power (1900); by descent to Major G. H. Power, Great Yarmouth, England (sale: PB, May 6, 1966)

EXHIBITIONS

Denver Art Museum, April 5–24, 1966; PB, April 29–May 6, 1966; Lakeview, April 19–June 2, 1968; Tyler Museum of Art, August 15–September 24, 1978

REFERENCES

Murthly sale notices; PB sale 2436 (May 6, 1966), lot 25 (illus.); Knox, "83 Drawings from 1837 Trek," p. 28; Ross, pp. XXXIV–XXXV; ACM, *Catalogue of the Collection* (1972), no. 116, illus. p. 57

78B. *Picketing Horses*

Watercolor on paper

8 3/4 x 12 1/2 in. (22.2 x 31.7 cm.)

(1858–1860)

The Walters Art Gallery, Baltimore, Maryland 37.1940.178

PROVENANCE

William T. Walters, Baltimore

EXHIBITIONS

WCMFA, September 14–November 2, 1947

REFERENCES

WCMFA, *American Indian and the West*, no. 62 (as *Staking out Horses*); Ross, pl. 178

79. *Mirage on the Prairie (Traders' Caravan)*

Watercolor on paper

7 x 13 1/2 in. (17.8 x 34.3 cm.)

Signed, l.l.: "AJM [monogram]"

Inscribed, u.r.: "Mirage on the Prairie"

The Thomas Gilcrease Institute of American History and Art, Tulsa, Oklahoma 0226.1032

PROVENANCE

the artist; by descent to L. Vernon Miller, Baltimore; M. Knoedler and Company, New York, #CA 3223-22, as *Movement of the Caravan, Mirage on the Prairie* (1949)

REFERENCES

Rough Draughts, no. 99; "America and the Future," p. 116 (illus.); DeVoto, pl. IV; Thomas D. Clark, *Frontier America*, illus. pp. ii–iii; McDermott, "A. J. Miller," p. 11 (illus. as *Prairie Scene—Mirage*); Rossi and Hunt, p. 325, illus. p. 130; Alistair Cooke, *Alistair Cooke's America*, illus. pp. 180–181

79A. *Mirage on the Prairie*

Watercolor on paper

8 3/4 x 13 1/2 in. (22.2 x 34.3 cm.)

Signed, l.l.: "AJM [monogram] iller"

(c. 1840)

Gerald Peters, Santa Fe, New Mexico

REFERENCES

advertisement for Gerald Peters, *Antiques* 120, no. 2 (August 1981): [233] (illus.)

79B. *Prairie Scene: Mirage*

Watercolor on paper

8 13/16 x 13 3/16 in. (22.4 x 33.5 cm.)

Signed, l.l.: "AJM [monogram] iller"

(1858–1860)

The Walters Art Gallery, Baltimore, Maryland 37.1940.149

PROVENANCE

William T. Walters, Baltimore

EXHIBITIONS

[WCMFA, September 14–November 2, 1947?]; "A. J. Miller Watercolors," Smithsonian, October 1956–November 1957; Marion Koogler McNay Art Institute, San Antonio, 1960

REFERENCES

[WCMFA, *American Indian and the West*, no. 73 (as *Wagon Train*)?]; American Heritage, ed., *American Heritage Book of the Pioneer Spirit*, illus. pp. 2–3; McNay, unpaginated; American Heritage, ed., *Westward on the Oregon Trail*, illus. pp. 46–47; Ross, pl. 149

80. *Prairie*

Pencil, watercolor, and gouache on paper

7 5/8 x 11 3/4 in. (19.4 x 29.9 cm.)

Signed, l.r.: "AJM [monogram]"

Joslyn Art Museum, Omaha, Nebraska; InterNorth Art Foundation Collection 684

PROVENANCE

the artist; by descent to Louisa Whyte Norton; Old Print Shop, New York (1947); Porter Collection (1947)

EXHIBITIONS

City Art Museum of St. Louis, 1954; BBHC, May 15–September 15, 1959; JAM, July 3–October 17, 1976; Yale University Art Gallery, New Haven, September 20, 1978–January 6, 1979

REFERENCES

Old Print Shop ledger book (June 18, 1947), no. 51 (as 7 3/4 x 11 3/4 in.); St. Louis, City Art Museum, *Westward the Way*, no. 9, illus. p. 40; BBHC, *Land of Buffalo Bill*, no. 13; JAM, *Artists of the Western Frontier*, no. 69, illus. p. 14; Sandweiss, p. 62 (listed as oil); Goetzmann and Porter, p. 62, illus. p. 47

81. *Caravan on the Broad Prairie*

Oil on paper

3 1/4 x 5 1/2 in. (8.3 x 14.0 cm.)

Inscribed (formerly) on mat, l.c.: "Caravan on the Broad Prairie"; l.r.: "the da aad [?] Praninn"

Stark Museum of Art, Orange, Texas 31.34/16

PROVENANCE

Edward Eberstadt and Sons, New York

REFERENCES

Eberstadt catalogue 146 (1958), no. 123–19; Stark, p. 205

82. *Camping on the Prairie*

Watercolor

Sight: 4 x 6 in. (10.2 x 15.3 cm.)

Kennedy Galleries, Inc., New York (1980)

PROVENANCE

the artist; by descent to Dr. William Pinckney Carton

83. *Fire on the Prairie Setting Fire to the Camp*

Wash with highlights on paper

8 7/8 x 14 1/2 in. (22.6 x 36.8 cm.)

Joslyn Art Museum, Omaha, Nebraska; InterNorth Art Foundation Collection 722

PROVENANCE
Porter Collection

EXHIBITIONS
Nelson, January 1939; "Western Frontier," SLAM, April 1–May 13, 1941; City Art Museum of St. Louis, 1954; Nelson and Atkins, October 5–November 17, 1957; BBHC, May 15–September 15, 1959

REFERENCES
"America and the Future," p. 114 (illus.); DeVoto, pl. XXIV; St. Louis, City Art Museum, *Westward the Way*, no. 136, illus. p. 173 (as *Prairie on Fire*); BBHC, *Land of Buffalo Bill*, no. 51; Denver Art Museum, *Building the West*, no. 61 (as *Prairie on Fire*, watercolor, 16 x 8 1/2 in.); Nelson and Atkins, *Last Frontier*, no. 33; "Records of a Lost World," *Museum News* 42, no. 3 (November 1963): 17 (illus.); JAM, *Exploration in the West*, illus. p. 32

83A. *Prairie on Fire*

Watercolor on paper

9 7/16 x 14 9/16 in. (24.0 x 37.0 cm.)

(1858–1860)

The Walters Art Gallery, Baltimore, Maryland 37.1940.198

PROVENANCE
William T. Walters, Baltimore

EXHIBITIONS
CGA, June 8–December 17, 1950; Marion Koogler McNay Art Institute, San Antonio, 1960

REFERENCES
CGA, *American Processional*, no. 143, illus. p. 129; McNay, unpaginated; American Heritage, ed., *Book of Indians*, text by William Brandon, illus. p. 351; Felton, *Edward Rose*, illus. fol. p. 48; Ross, pl. 198

83B. *Prairie on Fire*

Watercolor, gouache, and pen and ink over pencil on paper

Sight: 8 5/16 x 14 1/16 in. (21.1 x 35.8 cm.)

Signed, l.c.: "AJM [monogram] iller Pt"

(1867)

Inscribed on mat, l.r.: "Nᴼ. 32./Prairie on Fire."

Public Archives of Canada, Ottawa, Ontario; gift of Mrs. J. B. Jardine (1946)

PROVENANCE
Alexander Brown, Liverpool, England (1867); by descent to Mrs. J. B. Jardine, Chesterknowes, Scotland

EXHIBITIONS
PAC museum, winter 1946–1947; Peale Museum, Baltimore, January 8–February 12, 1950; "Alfred Jacob Miller," ACM, February 13–March 26, 1972

REFERENCES
account book, March 26, May 8, August 10, 1867; Hunter, p. [15]; Brunet, no. 32; Bell, p. 140, illus. p. 141

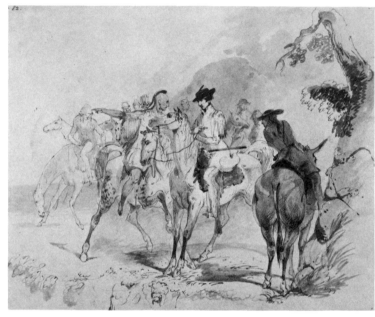

Catalogue number 84.

84. *The Indian Guide*

Pen and ink with gray wash on buff card

9 x 11 in. (22.6 x 27.8 cm.)

(c. 1837)

Inscribed, u.l.: "82"

Denver Art Museum, Denver, Colorado 1966.109; gift of Mr. John B. Bunker

PROVENANCE
the artist; Sir William Drummond Stewart (c. 1839); Frank Nichols (sale: Chapman's, Edinburgh, June 16–17, 1871); Bonamy Mansell Power; willed to Edward Power (1900); by descent to Major G. H. Power, Great Yarmouth, England (sale: PB, May 6, 1966); John B. Bunker

EXHIBITIONS
Denver Art Museum, April 15–24, 1966; PB, April 29–May 6, 1966; Denver Art Museum, January 13–April 15, 1973; MFA, January 23–March 16, 1975; Denver Art Museum, April 19–June 1, 1975; Fine Arts Gallery of San Diego, July 2–August 17, 1975; Nelson and Atkins,

September 17–November 2, 1975; Milwaukee Art Center, December 5, 1975–January 18, 1976

REFERENCES

Murthly sale notices; PB sale 2436 (May 6, 1966), lot 29, (illus.); Knox, 83 Drawings from 1837 Trek," p. 28; Ross, pl. 205; Denver Art Museum, *American Art from the Denver Art Museum Collection,* pl. 23, and *Colorado Collects Historic Western Art,* no. 47; MFA, *Frontier America,* no. 38 (illus.)

84A. *The Indian Certificate*

Watercolor on paper

9 1/4 x 12 1/8 in. (23.5 x 30.8 cm.)

(1858–1860)

The Walters Art Gallery, Baltimore, Maryland 37.1940.108

PROVENANCE

William T. Walters, Baltimore

REFERENCES

Ross, pl. 108; Martin Hillman, "Part Three: Bridging a Continent," illus. p. 429

85. *The Indian Guide*

Watercolor on paper

c. 8 x 9 3/4 in. (20.3 x 24.8 cm.)

Signed, l.l.: "AJM [monogram]"

Inscribed, l.r.: "The Indian Guide"; on mat, l.l.: "Wind River"; on mat, l.c.: "Stewart in yellow coat"; on mat, l.r.: Indian Guide"

Princeton Collections of Western Americana, Princeton University, Princeton, New Jersey; presented by William Pinkney Carton, Class of 1943, and his mother Mrs. Laurence R. Carton

PROVENANCE

the artist; by descent to William Pinkney Carton

85A. *An Indian Who Asks (by Signs) What Caravan Is Seen in the Plain*

Pen and ink with gray and yellow washes on paper

7 x 10 in. (16.5 x 24.6 cm.)

(c. 1837)

Inscribed, u.l.: "46"

Eugene B. Adkins, Tulsa, Oklahoma

PROVENANCE

the artist; Sir William Drummond Stewart (c. 1839); Frank Nichols (sale: Chapman's, Edinburgh, June 16–17, 1871); Bonamy Mansell Power; willed to Edward Power

(1900); by descent to Major G. H. Power, Great Yarmouth, England (sale: PB, May 6, 1966)

EXHIBITIONS

Denver Art Museum, April 15–24, 1966; PB, May 6, 1966; Phoenix Art Museum, November 1971–January 1972

REFERENCES

Murthly sale notices; PB sale 2365 (May 6, 1966), lot 15 (illus.); Knox, "83 Drawings from 1837 Trek," p. 28; Ross, p. XXXIV; Phoenix Art Museum, *Western Art from the Eugene B. Adkins Collection,* no. 49 (as *What Caravan Is It That Is Seen*)

85B. *Indian Guide*

Watercolor on paper

9 1/4 x 12 3/16 in. (23.5 x 31.0 cm.)

(1858–1860)

The Walters Art Gallery, Baltimore, Maryland 37.1940.55

PROVENANCE

William T. Walters, Baltimore

REFERENCES

Ross, pl. 55

86. *Conversing by Signs on the Trail*

Pencil, watercolor, and gouache on paper

7 x 9 1/4 in. (17.8 x 23.5 cm.)

Signed, l.r.: "AJM [monogram]"

Inscribed, u.l.: "92"

Joslyn Art Museum, Omaha, Nebraska; InterNorth Art Foundation Collection 740

PROVENANCE

Porter Collection

EXHIBITIONS

Nelson, January 1939 (as *Conversing by Signal*); "Western Frontier," SLAM, April 1–May 13, 1941 (as *Conversing by Signs*); BBHC, May 15–September 15, 1959

REFERENCES

BBHC, *Land of Buffalo Bill,* no. 68

86A. *Meeting a Snake Out Hunting Who Makes Signs That They Have Arrived in the Neighborhood "One Sun"*

Pencil with gray and yellow washes on paper

6 1/2 x 9 11/16 in. (16.5 x 24.6 cm.)

(c. 1837)

Inscribed, u.l.: "48"

Unlocated

PROVENANCE

the artist; Sir William Drummond Stewart (c. 1839); Frank Nichols (sale: Chapman's, Edinburgh, June 16–17, 1871); Bonamy Mansell Power; willed to Edward Power (1900); by descent to Major G. H. Power, Great Yarmouth, England (sale: PB, May 6, 1966)

EXHIBITIONS

Denver Art Museum, April 15–24, 1966; PB, April 29–May 6, 1966

REFERENCES

Murthly sale notices; PB sale 2436 (May 6, 1966), lot 58 (illus.); Knox, "83 Drawings from 1837 Trek," p. 28

86B. *Conversing by Signs*

Watercolor on paper

9 1/4 x 11 11/16 in. (23.5 x 29.7 cm.)

Signed, l.r.: "AJM [monogram] iller"

(1858–1860)

The Walters Art Gallery, Baltimore, Maryland 37.1940.102

PROVENANCE

William T. Walters, Baltimore

REFERENCES

Berry, *Majority of Scoundrels,* illus. fol. p. 24; Ross, pl. 102

87. *The Indian Oracle (Snake Tribe)*

Watercolor and gouache on paper

11 x 9 in. (27.9 x 23.0 cm.)

Inscribed, u.l.: "135"; u.r.: "A Snake Indian giving a description of a party who have previously passed by trails left on the ground."; l.l.: "A Snake Indian giving a description of a party who have previously passed by trails left on the ground."

The Thomas Gilcrease Institute of American History and Art, Tulsa, Oklahoma 0236.1072

PROVENANCE

[Mrs. Eugenia R. Whyte, Baltimore; M. Knoedler and Company, New York, # WCA 1099, as *Indian Reading Signs* (1948)?]

REFERENCES

Rough Draughts, no. 135

87A. *An Indian Giving Information of a Party Who Have Passed in Advance, by Impressions Left on the Ground*

Gray wash with touches of white on gray card

10 7/8 x 8 3/4 in. (27.7 x 22.3 cm.)

(c. 1837)

Inscribed, u.l.: "42"; u.r.: "An Indian giving information of a party who have passed in advance, by impressions left on the ground.—"

Unlocated

PROVENANCE

the artist; Sir William Drummond Stewart (c. 1839); Frank Nichols (sale: Chapman's, Edinburgh, June 16–17, 1871); Bonamy Mansell Power; willed to Edward Power (1900); by descent to Major G. H. Power, Great Yarmouth, England (sale: PB, May 6, 1966)

EXHIBITIONS

Denver Art Museum, April 15–24, 1966; PB, April 29–May 6, 1966

REFERENCES

Murthly sale notices; PB sale 2436 (May 6, 1966), lot 60 (illus.); Knox, "83 Drawings from 1837 Trek," p. 28

87B. *The Indian Oracle*

Watercolor on paper

11 x 9 7/8 in. (27.9 x 25.1 cm.)

Signed, l.l.: "AJM [monogram]"

(1858–1860)

The Walters Art Gallery, Baltimore, Maryland 37.1940.182

PROVENANCE

William T. Walters, Baltimore

REFERENCES

38 Ross, pl. 182

88. *Kansas Indian Recounting to a Trapper,— by Signs–the Migration of Buffalo*

Pencil and brown and black washes on paper

7 7/8 x 11 7/8 in. (20.0 x 30.2 cm.)

Joslyn Art Museum, Omaha, Nebraska; InterNorth Art Foundation Collection 674

PROVENANCE

Porter Collection

EXHIBITIONS

Nelson, January 1939; "Western Frontier," SLAM, April 1–May 13, 1941; BBHC, May 15–September 15, 1959

REFERENCES

BBHC, *Land of Buffalo Bill,* no. 3

88A. *An Indian Complaining of the Whites Having Destroyed the Game in Their Country, Pointing to a Plain, Which Was Once Covered with Buffalo—as Far as the Eye Could See—Now without a Sign of Animal Life*

Pencil and pen and ink with gray and yellow washes on paper

8 1/4 x 6 3/4 in. (21.0 x 17.2 cm.)

(c. 1837)

Inscribed: "45"

Unlocated

PROVENANCE

the artist; Sir William Drummond Stewart (c. 1839); Frank Nichols (sale: Chapman's, Edinburgh, June 16–17, 1871); Bonamy Mansell Power; willed to Edward Power (1900); by descent to Major G. H. Power, Great Yarmouth, England (sale: PB, May 6, 1966)

EXHIBITIONS

Denver Art Museum, April 15–24, 1966; PB, April 29–May 6, 1966

REFERENCES

Murthly sale notices; PB sale 2436 (May 6, 1966), lot 13; Knox, "83 Drawings from 1837," p. 28

88B. *Group of Mountaineers and Kansas Indians*

Watercolor and gouache on paper

7 1/2 x 6 3/4 in. (19.0 x 17.2 cm.)

The Thomas Gilcrease Institute of American History and Art, Tulsa, Oklahoma 0226.1085

REFERENCES

Rough Draughts, no. 111

88C. *Group of a Mountaineer and Kansas Indian*

Watercolor, heightened with white, on paper

9 1/2 x 8 1/2 in. (24.1 x 21.6 cm.)

Signed, l.c.: "AJM [monogram] iller"

(1858–1860)

The Walters Art Gallery, Baltimore, Maryland 37.1940.42

PROVENANCE

William T. Walters, Baltimore

REFERENCES

Ross, pl. 42

89. *The Indian Guide*

Gouache on paper

7 5/8 x 9 5/8 in. (19.4 x 24.5 cm.)

Signed, l.r.: "AJM [monogram]"

The Boatmen's National Bank of St. Louis, Missouri (May 26, 1947)

PROVENANCE

the artist; by descent to Louisa Whyte Norton; Old Print Shop, New York (1947)

EXHIBITIONS

BNB, May 4–29, 1964

REFERENCES

Cowdrey and Comstock, "Alfred Jacob Miller and the Farthest West," p. 1; BNB, *Catalog*, no. 55

90. *Trappers and Snake Indians Conversing by Signs*

Pencil, watercolor, and gouache on paper

9 x 13 7/8 in. (22.9 x 35.3 cm.)

Signed, l.l.: "AJM. [monogram]"

Inscribed, u.l.: "Trappers & Snake Indians/conversing by Signs"; u.r.: "Trappers &/Snake Indians"

Joslyn Art Museum, Omaha, Nebraska; InterNorth Art Foundation Collection 712

PROVENANCE

Porter Collection

EXHIBITIONS

Nelson, January 1939; "Western Frontier," SLAM, April 1–May 13, 1941; BBHC, May 15–September 15, 1959

REFERENCES

"Water Color Sketches of Indian Life a Century Ago," p. 3 (illus.); BBHC, *Land of Buffalo Bill*, no. 41

90A. *Trappers and Indians Communicating by Signs*

Watercolor on paper

9 3/4 x 14 1/4 in. (24.8 x 36.2 cm.)

Signed, l.l.: "AJM [monogram]"

(1858–1860)

The Walters Art Gallery, Baltimore, Maryland 37.1940.193

PROVENANCE

William T. Walters, Baltimore

REFERENCES

Ross, pl. 193

91. *Bee Hunters*

Oil on paper

7 x 10 1/2 in. (17.8 x 26.7 cm.)

Inscribed, u.l.: "97"; u.r.: " 'Bee Hunter' "; on mount: "Bee-hunter"

Joslyn Art Museum, Omaha, Nebraska; InterNorth Art Foundation Collection 751

PROVENANCE
Porter Collection

EXHIBITIONS
BBHC, May 15–September 15, 1959

REFERENCES
BBHC, *Land of Buffalo Bill*, no. 80

91A. *The Bee Hunter*

Watercolor on paper

9 1/8 x 12 7/8 in. (23.2 x 32.7 cm.)

Signed, l.l.: "AJM [monogram] iller"

(1858–1860)

The Walters Art Gallery, Baltimore, Maryland 37.1940.122

PROVENANCE
William T. Walters, Baltimore

REFERENCES
Ross, pl. 122

92. *Sunrise, Trappers and Voyageurs at Their Meals of Buffalo Hump Rib* [verso: *Self-portrait*]

Watercolor on paper [verso: pencil on paper]

7 5/8 x 9 in. (19.4 x 22.9 cm.)

Inscribed, u.r.: "33/Trappers & Voyageurs/at their Meals of/Buffalo Hump rib"

Joslyn Art Museum, Omaha, Nebraska; InterNorth Art Foundation Collection 743

PROVENANCE
Carrie C. Miller, Annapolis; Porter Collection; M. Knoedler and Company, New York

EXHIBITIONS
Nelson, January 1939; "Western Frontier," SLAM, April 1–May 13, 1941; Nelson and Atkins, October 5–November 17, 1957; BBHC, May 15–September 15, 1959

REFERENCES
DeVoto, pl. XLV (as *Trappers and Voyageurs at Their Meal of Buffalo Hump Rib*); Nelson and Atkins, *Last Frontier*, no. 38 (as *Trappers and Voyageurs at Their Meal of Buffalo Hump Rib*); BBHC, *Land of Buffalo Bill*, no. 72; G[ünter] Schomaekers, *Der Wilde Westen*, illus. p. 36

[Verso exhibitions: "Gallery of Dudes," ACM, January 26–March 15, 1967]

[Verso references: "America and the Future," p. 112 (illus.); DeVoto, pl. LXVII; Sprague, *Gallery of Dudes*, illus. p. 5; JAM, *Exploration in the West*, illus. p. 29; Art in America, ed., *Artist in America*, illus. p. 53; American Heritage, ed , *American Heritage Book of Great Adventures of the Old West*, illus. p. 128; Monaghan, "Hunter and the Artist," p. 7 (illus.); Reader's Digest, *Story of the Great American West*, illus. p. 104

92A. *An Early Dinner Party near Larrimer's [Laramie] Fork*

Pencil with brown and yellow washes on paper

11 1/2 x 8 in. (24.6 x 20.4 cm.)

(c. 1837)

Inscribed, u.l.: "9."; u.c.: "an Early Dinner Party./near Larrimer's Fork."

Eugene B. Adkins, Tulsa, Oklahoma (1977)

PROVENANCE
the artist; Sir William Drummond Stewart (c. 1839); Frank Nichols (sale: Chapman's, Edinburgh, June 16–17, 1871); Bonamy Mansell Power; willed to Edward Power (1900); by descent to Major G. H. Power, Great Yarmouth, England (sale: PB, May 6, 1966); Mrs. Tweet Kimball; Kennedy Galleries, New York (1967)

EXHIBITIONS
Denver Art Museum, April 15–24, 1966; PB, April 29–May 6, 1966

REFERENCES
Murthly sale notices; PB sale 2436 (May 6, 1966), lot 24; Knox, "83 Drawings from 1837 Trek," p. 28; *Kennedy Quarterly* 8, no. 2 (June 1968): no. 121, illus. p. 104 (as 11 1/2 x 8 in.)

92B. *Sunrise, Voyageurs at Breakfast*

Watercolor on paper

9 1/4 x 6 1/8 in. (23.5 x 15.5 cm.)

Western Americana Collection, The Beinecke Rare Book and Manuscript Library, Yale University, New Haven, Connecticut (Coe V, 24–25)

EXHIBITIONS
"Gallery of Dudes," ACM, January 26–March 15, 1967

REFERENCES
Withington, no. 342

92C. *Breakfast at Sunrise*

Watercolor on paper

10 1/4 x 13 7/8 in. (26.0 x 32.7 cm.)

(1858–1860)

The Walters Art Gallery, Baltimore, Maryland 37.1940.52

PROVENANCE

William T. Walters, Baltimore

EXHIBITIONS

Städelsches Kunstinstitut, Frankfurt, March 14–May 3, 1953; Bayerische Staats-Gemäldesammlungen, Munich, May 15–June 28, 1953; Kunsthalle, Hamburg, July 18–August 30, 1953; Charlottenburger Schloss, Berlin, September 8–October 13, 1953; Kunstsammlung der Stadt, Düsseldorf, November 1–December 15, 1953; Galleria Nazionale d'Arte Moderna, Rome, January 19–February 7, 1954; Dalazetto Reale, Milan, February 18–March 15, 1954; WMAA, New York, April 22–May 23, 1954; "Gallery of Dudes," ACM, January 26–March 15, 1967

REFERENCES

WMAA, *American Painting*, no. 34; Doyce Blackman Nunis, Jr., *Andrew Sublette, Rocky Mountain Prince*, illus. p. 54; William H. Goetzmann, *Exploration and Empire*, illus. p. 211; Sprague, *Gallery of Dudes*, illus. p. 19; Richard H. Randall, Jr., "Transformations and Imaginary Views by Alfred Jacob Miller," *Baltimore Museum of Art Annual III, Part One*, 1968, fig. 5; Ross, pl. 52; Reader's Digest, *Story of the Great American West*, illus. pp. 84–85; David Hawke, *Those Tremendous Mountains*, illus. p. 56; Bobby Bridger, "Seekers of the Fleece, Part II," *Four Winds*, issue 6 (Summer–Autumn 1981), p. 65 (illus.)

92D. *Breakfast at Sunrise*

Watercolor, gouache, and pen and ink over pencil on paper

Sight: 8 1/4 x 11 5/8 in. (21.0 x 29.5 cm.)

Signed, l.c.: "AJM [monogram] iller pt"

(1867)

Inscribed on mat, l.r.: "No. 24./Breakfast at Sunrise."

Public Archives of Canada, Ottawa, Ontario; gift of Mrs. J. B. Jardine (1946)

PROVENANCE

Alexander Brown, Liverpool, England (1867); by descent to Mrs. J. B. Jardine, Chesterknowes, Scotland

EXHIBITIONS

PAC museum, winter 1946–1947; Peale Museum, Baltimore, January 8–February 12, 1950; "Alfred Jacob Miller," ACM, February 13–March 26, 1972

REFERENCES

account book, March 26, May 8, August 10, 1867; Hunter p. [15]; Brunet, no. 24; American Heritage, *Trappers and Mountain Men*, illus. p. 110, and *American Heritage Book of Great Adventures of the Old West*, illus. p. 131; Bell, p. 108, illus. p. 109

93. *Group of Trappers and Indians*

Watercolor and gouache on paper

5 1/4 x 7 3/8 in. (13.4 x 18.8 cm)

Signed, l.r.: "AJM [monogram]"

Joslyn Art Museum, Omaha, Nebraska; InterNorth Art Foundation Collection 697

PROVENANCE

Carrie C. Miller, Annapolis; Porter Collection; M. Knoedler and Company, New York

EXHIBITIONS

"Western Frontier," SLAM, April 1–May 13, 1941; BBHC, May 15–September 15, 1959

REFERENCES

DeVoto, pl. XLVI; BBHC, *Land of Buffalo Bill*, no. 26; Wilbur Harvey Hunter, Jr., "A 'New' Painting by Alfred Jacob Miller," *Antiques* 101, no. 1 (January 1972): 222, fig. 2; Goetzmann and Porter, p. 63

93A. *Interior of an Indian Lodge*

Pencil, pen and ink, and wash on paper

7 7/8 x 6 11/16 in. (20.0 x 17.6 cm.)

(c. 1837)

Inscribed, u.l.: "13."; l.c.: "Interior of an Indian Lodge"

Joslyn Art Museum, Omaha, Nebraska; InterNorth Art Foundation Collection 784

PROVENANCE

the artist; Sir William Drummond Stewart (c. 1839); Frank Nichols (sale: Chapman's, Edinburgh, June 16–17, 1871); Bonamy Mansell Power; willed to Edward Power (1900); by descent to Major G. H. Power, Great Yarmouth, England (sale: PB, May 6, 1966)

EXHIBITIONS

Denver Art Museum, April 15–24, 1966; PB, April 29–May 6, 1966

REFERENCES

Murthly sale notices; PB sale 2436 (May 6, 1966), lot 57 (as 17.6 x 17.2 cm.); Knox, "83 Drawings from 1837 Trek," p. 28; Ross, pl. 208 (incorrectly identified as lot 56 in Power sale); Hunter, "A 'New' Painting by Alfred Jacob Miller," p. 222

93B. *Captain Stewart, Antoine, Pierre and Indians*

Watercolor on paper

6 3/16 x 10 1/4 in. (15.75 x 26.0 cm.)

Signed, l.r.: "AJM [monogram]"

Western Americana Collection, The Beinecke Rare Book and Manuscript Library, Yale University, New Haven, Connecticut (Coe No. V, 24–25)

EXHIBITIONS

"Gallery of Dudes," ACM, January 26–March 15, 1967; Yale University Art Gallery, New Haven, September 20, 1978–January 6, 1979

REFERENCES

Withington, no. 342; Sandweiss, p. 62 (as *Camp Fire*), pl. 23

94. *Campfire (Preparing the Evening Meal)*

Watercolor and gouache on paper

4 3/4 x 4 1/2 in. (12.1 x 11.4 cm.)

Inscribed, u.l.: "Camp Fire/Preparing the Evening Meal"

The Thomas Gilcrease Institute of American History and Art, Tulsa, Oklahoma 0236.1033

PROVENANCE

[Old Print Shop, New York?]

REFERENCES

Rough Draughts, nos. 4, 87, and 130; FARL 120–246 2/ (49207)

94A. *Camp Fire, Preparing the Evening Meal*

Watercolor, heightened with white, on paper

11 x 9 in. (27.9 x 23.0 cm.)

Signed, l.l.: "Miller"

(1858–1860)

Inscribed: "11"

The Walters Art Gallery, Baltimore, Maryland 37.1940.4

PROVENANCE

William T. Walters, Baltimore

REFERENCES

Ross, pl. 4; Getlein, *Lure of the Great West,* illus. p. 78; Clide Hollman, *Five Artists of the Old West,* illus. p. 75; American Heritage, ed., *The American Heritage Cookbook and Illustrated History of American Eating & Drinking,* illus. p. 67; WAG, *Private Collections,* illus. p. 58; *American Heritage* 30, no. 1 (December 1978): illus. p. 52

95. *Camp Fire at Night; Trapper Relating an Adventure*

Pencil, pen and ink, watercolor, and gouache on paper

7 1/2 x 10 in. (19.1 x 25.4 cm.)

Inscribed, u.r.: "60"; l.r.: "A Trapper relating an adventure"

Joslyn Art Museum, Omaha, Nebraska; InterNorth Art Foundation Collection 700

PROVENANCE

Carrie C. Miller, Annapolis; Porter Collection; M. Knoedler and Company, New York

EXHIBITIONS

"Western Frontier," SLAM, April 1–May 13, 1941; Nelson and Atkins, October 5–November 17, 1957; BBHC, May 15–September 15, 1959

REFERENCES

DeVoto, pl. XLIV (as *Trapper Relating an Adventure*); Nelson and Atkins, *Last Frontier,* no. 37 (as *Trapper Relating an Adventure*); BBHC, *Land of Buffalo Bill,* no. 29; "How the West Was Won: Part I," p. 92 (illus.); Porter and Davenport, illus. fol. p. 148; Robert V. Hine, *American West,* illus. p. 49

95A. *An Old Trapper Relating an Adventure*

Pen and ink with gray and yellow washes on paper

6 3/16 x 7 1/16 in. (15.7 x 18.0 cm.)

(c. 1837)

Inscribed: "55"

Unlocated

PROVENANCE

the artist; Sir William Drummond Stewart (c. 1839); Frank Nichols (sale: Chapman's, Edinburgh, June 16–17, 1871); Bonamy Mansell Power; willed to Edward Power (1900); by descent to Major G. H. Power, Great Yarmouth, England (sale: PB, May 6, 1966)

EXHIBITIONS

Denver Art Museum, April 15–24, 1966; PB, April 29–May 6, 1966

REFERENCES

Murthly sale notices; PB sale 2436 (May 6, 1966), lot 27; Knox, "83 Drawings from 1837 Trek," p. 28

95B. *Moonlight—Camp Scene*

Watercolor on paper

9 1/2 x 12 1/4 in. (24.1 x 31.1 cm.)

(1858–1860)

The Walters Art Gallery, Baltimore, Maryland 37.1940.135

PROVENANCE

William T. Walters, Baltimore

EXHIBITIONS

"Gallery of Dudes," ACM, January 26–March 15, 1967

REFERENCES

Sprague, *Gallery of Dudes,* illus. p. 31; Ross, pl. 135; Hillman, "Part Three: Bridging a Continent," illus p. 368; Schomaekers, *Wilde Westen,* illus. p. 79; Frank H. Dickson, "Hard on the Heels of Lewis and Clark," *Montana: The Magazine of Western History* 26, no. 1 (January 1976): 21 (illus.); Keith Wheeler, *The Chroniclers,* illus. p. 110; Bridger, "Seekers of the Golden Fleece, Part I," p. 60 (illus.)

96. *Trappers Dancing around the Camp Fire*

Sepia wash on paper

6 x 8 in. (15.2 x 20.4 cm.)

Inscribed, l.r.: "Trappers dancing/around the Camp Fire"; label on verso: Purnell Art Co., Baltimore

Kennedy Galleries, Inc. New York (1980)

PROVENANCE

the artist; by descent through his family to Dr. William Pinckney Carton

REFERENCES

DeVoto, pl. LXXIX; Reader's Digest, *Story of the Great American West,* illus. p. 104

97. *Camp Fire by Moonlight*

Pencil, pen and ink, and watercolor on paper

6 1/16 x 9 in. (15.4 x 22.9 cm.)

(c. 1837)

Inscribed, u.l.: "18"; on mount, l.c.: "Camp Fire—by Moonlight.—"

Western Americana Collection, The Beinecke Rare Book and Manuscript Library, Yale University, New Haven, Connecticut; gift of Frederick William Beinecke

PROVENANCE

the artist; Sir William Drummond Stewart (c. 1839); Frank Nichols (sale: Chapman's, Edinburgh, June 16–17, 1871); Bonamy Mansell Power; willed to Edward Power (1900); by descent to Major G. H. Power, Great Yarmouth, England (sale: PB, May 6, 1966); bought by Edward Eberstadt and Sons for Frederick William Beinecke

EXHIBITIONS

Denver Art Museum, April 15–24, 1966; PB, April 29–May 6, 1966

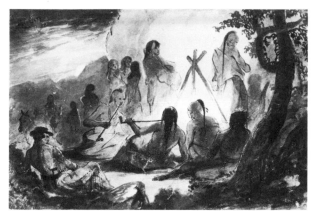

Catalogue number 97.

REFERENCES

Murthly sale notices; PB sale 2436 (May 6, 1966), lot 26 (illus.); Knox, "83 Drawings from 1837 Trek," p. 28

98. *Trappers at the Evening Meal*

Oil on paper, mounted on composition board

9 x 7 1/16 in. (22.9 x 17.9 cm.)

Signed, l.l.: "AJM [monogram]"

Stark Museum of Art, Orange, Texas 31.34/7

PROVENANCE

Edward Eberstadt and Sons, New York

REFERENCES

Eberstadt catalogue 146 (1958), no. 123–11; Stark, p. 207

99. *Chimney Rock*

Pencil and watercolor, heightened with white, on paper

Sight: 8 1/2 x 11 1/2 in. (21.6 x 24.6 cm.)

Private collection

Provenance: the artist; by descent to Louisa Whyte Norton; Old Print Shop, New York (1947); private collection (1947)

REFERENCES

Old Print Shop ledger book (June 18, 1947), no. 45 (as *Chimney Rock, Platte River,* 8 1/2 x 11 3/4 in.); Warner, pp. 66–67, n. 17

99A. *Chimney Rock on the Platte River*

Watercolor on paper

9 1/4 x 12 3/4 in. (23.5 x 32.4 cm.)

Inscribed, l.l.: "The 'Chimney' Rock near Jess's [?] Bluff"

The Boatmen's National Bank of St. Louis, Missouri (May 26, 1947)

the artist; by descent to Louisa Whyte Norton; Old Print Shop, New York (1947)

EXHIBITIONS
BNB, May 4–29, 1964

REFERENCES
Cowdrey and Comstock, "Alfred Jacob Miller and the Farthest West," p. 1; BNB, *Catalog*, no. 40; Warner, p. 67, n. 17

99B. *Chimney Rock*
Watercolor on paper

10 1/4 x 14 1/4 in. (26.0 x 36.2 cm.)

(1858–1860)

The Walters Art Gallery, Baltimore, Maryland 37.1940.54

PROVENANCE
William T. Walters, Baltimore

EXHIBITIONS
Cheyenne Centennial Committee, July 1–August 15, 1967

REFERENCES
DeVoto, pl. I; Horan, *Great American West*, illus. p. [74]; [Zenas Leonard], *Zenas Leonard Fur Trader*, ed. John C. Ewers, illus. opp. p. 13; American Heritage, ed., *Westward on the Oregon Trail*, illus. p. 15; Robert G. Athearn, *American Heritage New Illustrated History of the United States*, VI, illus. p. 518; Josephy, *American Heritage Book of Natural Wonders*, illus. p. 192; Ruth, *Great Day in the West*, illus. p. 137; Cheyenne Centennial Committee, *150 Years in Western Art*, illus. p. 25; Ross, pl. 54; Getlein, *Lure of the Great West*, illus. p. 89; Nicoll, *Nebraska*, illus. p. 23; Warner, illus. p. 69; Randall, "Gallery for Alfred Jacob Miller," p. 836 (illus.)

100. *Scotts Bluff near the Nebraska [Platte]*
Watercolor on paper

7 x 12 3/4 in. (17.8 x 32.4 cm.)

Inscribed, l.r.: "Scotts Bluffs . . . [illeg.]"

Joslyn Art Museum, Omaha, Nebraska; InterNorth Art Foundation Collection 688

PROVENANCE
the artist; Porter Collection (1939?)

EXHIBITIONS
Peale Museum, Baltimore, 1932; Nelson, January 1939 (as *Scotts Bluffs*); "Western Frontier," SLAM, April 1–May 13, 1941; Art Institute of Chicago, February 15–March 25, 1945; WMAA, April 17–May 18, 1945; City Art Museum of St. Louis, 1954; BBHC, May 15–September 15, 1959; "Gallery of Dudes," ACM, January 26–March 15, 1967; National Collection of Fine Arts, Smithsonian Institution,

Washington, D.C., June 23–August 27, 1972; JAM, July 3–October 17, 1976

REFERENCES
"America and the Future," p. 117 (illus.); Chicago, Art Institute of Chicago, *The Hudson River School and the Early American Landscape Tradition*, no. 135; DeVoto, pl. II; St. Louis, City Art Museum, *Westward the Way*, no. 10, illus. p. 41 (as *Scott's Bluff near the Platte*, 7 x 18 3/4 in.); [Matthew C. Field], *Prairie and Mountain Sketches*, coll. Clyde and Mae Reed Porter, ed. Kate L. Gregg and John Francis McDermott, illus. opp. p. 122; Merrill J. Mattes, *Scotts Bluff National Monument, Nebraska*, illus. p. 14 (incorrectly credited to WAG); BBHC, *Land of Buffalo Bill*, no. 17 (as *Scotts Bluffs near the Nebraska, Approaching from the East*); Smithsonian Institution, National Collection of Fine Arts, *National Parks and the American Landscape*, no. 43 (illus.); Nicoll, *Nebraska*, illus. p. 21; JAM, *Artists of the Western Frontier*, no. 70, illus. p. 14; Warner, pp. 71–74, illus. p. 75

100A. *Curious Formation . . . Scotts Bluffs*
Watercolor on paper

6 1/4 x 12 1/2 in. (15.9 x 31.7 cm.)

Unlocated

PROVENANCE
the artist; by descent to Louisa Whyte Norton; Old Print Shop, New York (1947); Everett D. Graff, Winnetka, Ill. (1947)

REFERENCES
Old Print Shop ledger book (June 18, 1947), no. 28

100B. *Scott's Bluffs*
Watercolor on paper

9 1/16 x 14 1/4 in. (23.0 x 36.2 cm.)

Signed, l.l.: "Miller"

(1858–1860)

The Walters Art Gallery, Baltimore, Maryland 37.1940.65

PROVENANCE
William T. Walters, Baltimore

EXHIBITIONS
Phoenix Art Museum, January 12–February 18, 1979; San Diego Museum of Art, March 10–April 15, 1979; Wichita Art Museum, May 1–June 15, 1979

REFERENCES
American Heritage, ed., *Westward on the Oregon Trail*, illus. pp 14–15; Josephy, *American Heritage Book of Natural Wonders*, illus. p. 192; Ruth, *Great Day in the West*, illus. p. 135; Ross, pl. 65; Getlein, *Lure of the Great West*, illus. p. 82; Phoenix Art Museum, *Beyond the Endless River*, p. 17, pl. 22

101. *Going to Meet a Band of Buffalo on the Move*

Pencil and pen and ink with gray and yellow washes on paper

8 1/2 x 6 5/8 in. (21.5 x 16.8 cm.)

(c. 1837)

Inscribed, u.l.: "11"; u.c.: "Going to meet a band of Buffalo on the move.—"

Amon Carter Museum, Fort Worth, Texas 25.66

PROVENANCE

the artist; Sir William Drummond Stewart (c. 1839); Frank Nichols (sale: Chapman's, Edinburgh, June 16–17, 1871); Bonamy Mansell Power; willed to Edward Power (1900); by descent to Major G. H. Power, Great Yarmouth, England (sale: PB, May 6, 1966)

EXHIBITIONS

Denver Art Museum, April 5–24, 1966; PB, April 29–May 6, 1966; Lakeview, April 19–June 2, 1968

REFERENCES

Murthly sale notices; PB sale 2436 (May 6, 1966), lot 34, illus. p. 7; Knox, "83 Drawings from 1837 Trek," p. 28; Sprague, *Gallery of Dudes*, illus. p. 13; ACM, *Catalogue of the Collection*, no. 113, illus. p. 55

101A. *Capt. Stewart Giving Signal to Hunters— Buffalo in Sight*

Oil on paper

7 1/2 x 8 1/16 in. (19.0 x 20.5 cm.)

Inscribed, l.c.: "Signal to Hunters"

Western Americana Collection, The Beinecke Rare Book and Manuscript Library, Yale University, New Haven, Connecticut (Coe No. V, 24–25)

EXHIBITIONS

"Gallery of Dudes," ACM, January 26–March 15, 1967

REFERENCES

Withington, no. 342

102. *Sir William Drummond Stewart and the Hunters*

Gouache

6 x 6 in. (15.2 x 15.2 cm.)

Unlocated

PROVENANCE

Porter Collection; Edward Eberstadt and Sons, New York (1954)

REFERENCES

Eberstadt catalogues 133 (1954), no. 643 (illus.), and 139 (n.d.), no. 85 (illus. as *Stewart and the Hunters*); "Trappers and Traders Were the True Pathfinders," *Fortune* 29, no. 1 (January 1944): 121 (illus.)

103. *Sketch from Nature (Wounded Buffalo)*

Pencil, pen and ink, and wash on paper

5 1/4 x 9 1/2 in. (13.3 x 24.1 cm.)

Inscribed, l.r.: "Sketching from/Nature"

The Thomas Gilcrease Institute of American History and Art, Tulsa, Oklahoma 0236.1061

REFERENCES

Rough Draughts, no. 54; Clark, *Frontier America*, illus. pp. 438–439

104. *Bull Buffalo*

Watercolor on paper

7 3/4 x 11 5/8 in. (19.7 x 29.6 cm.)

Signed, l.r.: "AJM. [monogram]"

Inscribed, on mount: "Bull Buffalo/40"

Joslyn Art Museum, Omaha, Nebraska; InterNorth Art Foundation Collection 678

PROVENANCE

Porter Collection

EXHIBITIONS

"Western Frontier," SLAM, April 1–May 13, 1941; BBHC, May 15–September 15, 1959

REFERENCES

BBHC, *Land of Buffalo Bill*, no. 7

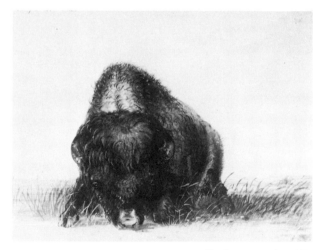

Catalogue number 107.

105. *Scenting the Breeze*

Watercolor on paper

10 5/8 x 16 1/2 in. (27.0 x 41.9 cm.)

Inscribed, u.r.: "Scenting the breeze."

Joslyn Art Museum, Omaha, Nebraska; InterNorth Art Foundation Collection 725

PROVENANCE
Porter Collection

EXHIBITIONS

["Western Frontier," SLAM, April 1–May 13, 1941 (as *Buffalo*)?]; City Art Museum of St Louis, 1954; BBHC, May 15–September 15, 1959

REFERENCES

[George Frederick Ruxton], *Life in the Far West*, ed. LeRoy R. Hafen, illus. opp. p. 62; St. Louis, City Art Museum, *Westward the Way*, no. 108, illus. p. 143 (as 16 x 16 1/2 in.); BBHC, *Land of Buffalo Bill*, no. 54

106. *Buffalo Head*

Watercolor on paper

6 3/4 x 4 1/2 in. (17.2 x 11.4 cm.)

The Thomas Gilcrease Institute of American History and Art, Tulsa, Oklahoma 0226.1114

107. *Wounded Buffalo*

Oil mounted on watercolor background

10 1/4 x 12 5/8 in. (32.0 x 26.0 cm.)

Signed, l.l.: "AJM [monogram]"

Inscribed, u.l.: "Buffalo wounded"; u.r.: "A Buf/A"

Western Americana Collection, The Beinecke Rare Book and Manuscript Library, Yale University, New Haven, Connecticut (Coe V, 26)

PROVENANCE

the artist; by descent to Louisa Whyte Norton; Old Print Shop, New York (1947); Edward Eberstadt and Sons, New York (1947)

EXHIBITIONS

"Gallery of Dudes," ACM, January 26–March 15, 1967; Yale University Art Gallery, New Haven, September 20, 1978–January 6, 1979

REFERENCES

Old Print Shop ledger book (June 18, 1947), no. 13 (as 10 1/4 x 13 1/4 in.); Cowdrey and Comstock, "Alfred Jacob Miller and the Farthest West," fig. 4 (as *Buffalo Wounded*, 10 1/4 x 13 1/4 in.); Withington, no. 341; Sandweiss, p. 63

108. *Buffaloes Watering*

Sepia

5 3/4 x 8 1/4 in. (14.6 x 21.0 cm.)

Kennedy Galleries, Inc., New York (1980)

PROVENANCE

the artist; by descent through his family to Dr. William Pinckney Carton

109. *Buffalo Skull*

5 x 6 in. (12.7 x 15.2 cm.)

Signed, l.r.: "AJM. [monogram]"

Kennedy Galleries, Inc., New York (neg. no. B 600)

PROVENANCE

Mr. Bassin, Post Road Antiques, Mamaroneck, N.Y.

109A. *Skull of a Cow* [Buffalo Skull?]

Pencil and wash on paper

4 1/2 x 6 1/4 in. (11.4 x 15.9 cm.)

Kennedy Galleries, Inc., New York (c. 1973; neg. no. 7754)

PROVENANCE

Edward Eberstadt and Sons, New York

110. *Preparing for a Buffalo Hunt; Sir W.D.S., Antoine and Auguste*

Pen and ink, wash, and gouache on paper

11 x 9 1/2 in. (28.0 x 24.2 cm.)

Signed, l.l.: "AJM. [monogram]"

Inscribed, l.r.: "Preparing for a Buffalo Hunt/Sir W.D.S. Antoine & Auguste"

Joslyn Art Museum, Omaha, Nebraska; InterNorth Art Foundation Collection 721

PROVENANCE

Porter Collection

EXHIBITIONS

"Western Frontier," SLAM, April 1–May 13, 1941 (as *Sir William Drummond Stewart and Two Voyageurs*); BBHC, May 15–September 15, 1959; Flint Institute of Arts, November 15–December 6, 1964

REFERENCES

[Field], *Prairie and Mountain Sketches*, illus. opp. p. 186; BBHC, *Land of Buffalo Bill*, no. 50; Porter and Davenport, illus. fol. p. 148; Flint Institute of Arts, *Artists of the Old West*, no. 35 (illus.)

110A. *Preparing for a Buffalo Hunt*

Wash, heightened with white, on paper

12 5/16 x 9 1/2 in. (31.3 x 24.1 cm.)

Signed, l.l: "Miller"

(1858–1860)

Inscribed: "10"

The Walters Art Gallery, Baltimore, Maryland 37.1940.2

PROVENANCE

William T. Walters, Baltimore

REFERENCES
Ross, pl. 2; Getlein, *Lure of the Great West,* illus. p. 76

111. *The Start of the Buffalo Hunt*

Watercolor

Unlocated

PROVENANCE

Johns Hopkins University (1940)

EXHIBITIONS

Baltimore Museum of Art, May 10–June 10, 1940

REFERENCES

Baltimore Museum of Art, *Souvenir of Romanticism in America,* ed. George Boas, unpaginated

112. *Might Scene—Buffaloes on the Prairie*

Watercolor and gouache on paper

7 3/8 x 12 1/8 in. (18.8 x 30.8 cm.)

Inscribed, u.r.: "no. 129"

Joslyn Art Museum, Omaha, Nebraska; InterNorth Art Foundation Collection 690

PROVENANCE

Porter Collection

EXHIBITIONS

Nelson, January 1939; "Western Frontier," SLAM, April 1–May 13, 1941; City Art Museum of St. Louis, 1954; BBHC, May 15–September 15, 1959

REFERENCES

DeVoto, pl. LVI; St. Louis, City Art Museum, *Westward the Way,* no. 109, illus. p. 144 (as *Buffaloes Drinking and Bathing at Night*); [Field], *Prairie and Mountain Sketches,* illus. opp. p. 58; BBHC, *Land of Buffalo Bill,* no. 19

112A. *Buffaloes Drinking and Bathing at Night*

Watercolor on paper

8 11/16 x 13 7/16 in. (22.1 x 34.1 cm.)

(1858–1860)

The Walters Art Gallery, Baltimore, Maryland 37.1940.100

PROVENANCE

William T. Walters, Baltimore

EXHIBITIONS

Seattle Art Museum, July 15–September 26, 1976

REFERENCES

Ross, pl. 100; Nicoll, *Nebraska,* illus. p. 22; Seattle Art Museum, *Lewis and Clark's America,* no. 57, illus. p. 24

113. *Buffalo Hunt*

Oil on canvas

38 x 57 in. (96.5 x 144.8 cm.)

(c. 1839)

U.S. Army Field Artillery and Fort Sill Museum, Fort Sill, Oklahoma; gift of General Henry W. Butner, 1936

PROVENANCE

Sir William Drummond Stewart (1839); Frank Nichols (sale: Chapman's, Edinburgh, June 16–17, 1871); Joseph McDonough Co., Albany, N.Y. (1910s?); Anderson Galleries, New York (c. 1926); E. W. Marland, Ponca City, Okla.; Gen. Henry W. Butner (late 1920s)

EXHIBITIONS

Apollo Gallery, New York, May 9–22, 1839

REFERENCES

"Apollo Gallery—Original Paintings," *Morning Herald,* May 16, 1839, p. 2, col. 3, no. 2 or 3; "Miller's Paintings of Oregon Scenery," *New-York Mirror,* May 25, 1839, p. 383; Murthly sale notices; No. 4 in undated sale notice of Joseph McDonough Co., Albany, in J. Hall Pleasants file; No. 3 or 4 in undated sale notice of Reynolds Galleries, 39 W. 57th Street, New York, in Alfred Jacob Miller vertical file, National Museum of American Art, Washington, D.C.; "Portrait of Sir William Drummond Stewart on Horseback Greeting a Group of Indians," undated note in Albert Duveen files, Archives of American Art, Washington, D.C., roll NDu2, frame 259; E. W. Marland to Amon Carter, July 16, 1935, Amon Carter Foundation files, Fort Worth

114. *The Buffalo Hunt*

Oil on canvas

38 1/2 x 56 1/2 in. (97.8 x 143.5 cm.)

(c. 1839)

Philbrook Art Center, Tulsa, Oklahoma; gift of Lydie Marland to honor George Marland and Governor E. W. Marland, 1961

PROVENANCE

Sir William Drummond Stewart (1839); Frank Nichols (sale: Chapman's, Edinburgh, June 16–17, 1871); Joseph McDonough Co., Albany, N.Y. (1910s?); Anderson Galleries, New York (c. 1926); E. W. Marland, Ponca City, Okla.; Lydie Marland, Ponca City, Okla.

EXHIBITIONS

Apollo Gallery, New York, May 9–22, 1839

REFERENCES

"Apollo Gallery—Original Paintings," *Morning Herald,* May 16, 1839, p. 2, col. 3, no. 2 or 3; "Miller's Paintings of Oregon Scenery," *New-York Mirror,* May 25, 1839, p. 383; Murthly sale notices; No. 3 in undated sale notice

of Joseph McDonough Co., Albany, in J. Hall Pleasants file; "Portrait of Sir William Drummond Stewart on Horseback Greeting a Group of Indians," undated note in Albert Duveen files, roll NDu2, frame 259; E. W. Marland to Amon Carter, July 16, 1935, Amon Carter Foundation files; JAM, *Life on the Prairie*, p. 5 (as *Buffalo Chase*); Tulsa, Philbrook Art Center, *American Art: The Philbrook Collection*, p. [20]

115. *Wounded Buffalo*

Watercolor on paper

9 3/8 x 12 5/16 in. (23.8 x 31.3 cm.)

Signed, l.r.: "AJM [monogram] iller"

(1858–1860)

Inscribed, l.c.: "54"

The Walters Art Gallery, Baltimore, Maryland 37.1940.56

PROVENANCE
William T. Walters, Baltimore

EXHIBITIONS
"A. J. Miller Watercolors," Smithsonian, October 1956–November 1957; University of Pennsylvania Museum, Philadelphia, 1958; "Gallery of Dudes," ACM, January 26–March 15, 1967

REFERENCES
Philadelphia, University of Pennsylvania Museum, *The Noble Savage*, no 39; Berry, *Majority of Scoundrels*, illus. fol. p. 242; Sprague, *Gallery of Dudes*, illus. p. 27; Ross, pl. 56

116. *Indians Escaping from a Wounded Buffalo while He Tears Their Clothes to Pieces*

Pencil and pen and ink with brown wash on paper

6 1/2 x 9 9/16 in. (16.5 x 24.3 cm.)

(c. 1837)

Inscribed: "19"

Unlocated

PROVENANCE
the artist; Sir William Drummond Stewart (c. 1839); Frank Nichols (sale: Chapman's, Edinburgh, June 16–17, 1871); Bonamy Mansell Power; willed to Edward Power (1900); by descent to Major G. H. Power, Great Yarmouth, England (sale: PB, May 6, 1966)

EXHIBITIONS
Denver Art Museum, April 15–24, 1966; PB, April 29–May 6, 1966

REFERENCES
Murthly sale notices; PB sale 2436 (May 6, 1966), lot 39 (illus.); Knox, "83 Drawings from 1837 Trek," p. 28

116A. *Buffalo Turning on His Pursuer: Narrow Escape from a Wounded Buffalo*

Watercolor and gouache on paper

6 1/2 x 9 in. (16.5 x 23.0 cm.)

Inscribed, u.l.: "83/Narrow Escape from a/wounded Buffalo"

The Thomas Gilcrease Institute of American History and Art, Tulsa, Oklahoma 0226.1093

REFERENCES
Rough Draughts, no. 83

116B. *Buffalo Turning on His Pursuers*

Watercolor on paper

8 3/4 x 12 in. (22.2 x 30.5 cm.)

Signed, l.l.: "AJM [monogram] iller"

(1858–1860)

The Walters Art Gallery, Baltimore, Maryland 37.1940.138

PROVENANCE
William T. Walters, Baltimore

REFERENCES
Ross, pl. 138

116C. *Buffalo Strikes Back*

Oil on paper

6 3/8 x 9 1/16 in. (16.2 x 23.0 cm.)

Signed, l.c.: "AJM [monogram]"

Stark Museum of Art, Orange, Texas 31.34/46

PROVENANCE
Edward Eberstadt and Sons, New York

REFERENCES
Eberstadt catalogue 146 (1958), no. 123–15; Stark, p. 205

117. *Taking the Hump Rib*

Pencil, watercolor, and gouache on paper

8 1/8 x 11 1/4 in. (20.7 x 28.6 cm.)

Inscribed, u.r.: "Taking the Hump rib"

Joslyn Art Museum, Omaha, Nebraska; InterNorth Art Foundation Collection 681

PROVENANCE
Porter Collection

EXHIBITIONS
"Western Frontier," SLAM, April 1–May 13, 1941; BBHC, May 15–September 15, 1959

REFERENCES
"Water Color Sketches of Indian Life a Century Ago," p.

3 (illus.); "America and the Future," p. 119 (illus.); DeVoto, pl. LVII; BBHC, *Land of Buffalo Bill*, no. 10; "How the West Was Won: Part I," p. 91 (illus.); Felton, *Edward Rose*, illus. fol. p. 48

117A. *Taking the Hump Rib*

Pen and ink with gray wash on gray card

8 1/8 x 10 7/8 in. (20.5 x 27.6 cm.)

(c. 1837)

Inscribed, u.l.: "29"

Amon Carter Museum, Fort Worth, Texas 28.66

PROVENANCE

the artist; Sir William Drummond Stewart (c. 1839); Frank Nichols (sale: Chapman's, Edinburgh, June 16–17, 1871); Bonamy Mansell Power; willed to Edward Power (1900); by descent to Major G. H. Power, Great Yarmouth, England (sale: PB, May 6, 1966)

EXHIBITIONS

Denver Art Museum, April 15–24, 1966; PB, April 29–May 6, 1966; Lakeview, April 19–June 2, 1968; ACM, February 17–April 3, 1977; BBHC, May 1–September 30, 1977; Glenbow-Alberta Institute, Calgary, October 15–November 17, 1977; JAM, December 20, 1977–January 29, 1978; Tyler Museum of Art, August 15–September 14, 1978

REFERENCES

Murthly sale notices; PB sale 2436 (May 6, 1966), lot 41; Knox, "83 Drawings from 1837 Trek," p. 28; ACM, *Catalogue of the Collection*, no. 120, illus. p. 57; Larry Barsness, "The Bison in Art and History," *American West* 14, no. 2 (March–April 1977): 18; ACM, *The Bison in Art*, p. 20, illus. p. 70

117B. *Supplying Camp with Buffalo Meat*

Watercolor on paper

8 7/16 x 13 in. (21.4 x 31.7 cm.)

Signed, l.r.: "AJM [monogram]"

(1858–1860)

The Walters Art Gallery, Baltimore, Maryland 37.1940.173

PROVENANCE

William T. Walters, Baltimore

REFERENCES

Ross, pl. 173; Francis Haines, *Buffalo*, illus. p. 88; *Reader's Digest, Story of the Great American West*, illus. p. 99

117C. *Camp Providers*

Watercolor, gouache, and pen and ink over pencil on paper

Sight: 7 13/16 x 11 11/16 in. (19.9 x 29.7 cm.)

Signed, l.r.: "AJM [monogram] iller. Pt"

(1867)

Inscribed on mat, l.r.: "Nº. 18./Camp Providers."

Public Archives of Canada, Ottawa, Ontario; gift of Mrs. J. B. Jardine (1946)

PROVENANCE

Alexander Brown, Liverpool, England (1867); by descent to Mrs. J. B. Jardine, Chesterknowes, Scotland

EXHIBITIONS

PAC museum, winter 1946–1947; Peale Museum, Baltimore, January 8–February 12, 1950; "Alfred Jacob Miller," ACM, February 13–March 26, 1972

REFERENCES

account book, March 26, May 8, August 10, 1867; Hunter, p. [15]; Brunet, no. 18 (illus.); Frank G. Roe, *The Indian and the Horse*, illus. fol. p. 110; Bell, p. 84, illus. p. 85

118. *Butchering the Buffalo*

Oil on canvas

30 x 43 in. (76.2 x 109.2 cm.)

(c. 1839)

American Heritage Center, University of Wyoming, Laramie; gift of the Everett D. Graff family

PROVENANCE

Sir William Drummond Stewart (1839); Frank Nichols (sale: Chapman's, Edinburgh, June 16–17, 1871); Appleby Brothers; B. F. Stevens and Brown, London (1937); Everett D. Graff, Winnetka, Ill. (1937)

EXHIBITIONS

Apollo Gallery, New York, May 9–22, 1839

REFERENCES

"Apollo Gallery—Original Paintings," *Morning Herald*, May 16, 1839, p. 2, col. 3, no. 8; Murthly sale notices; B. F. Stevens and Brown, *Coronation Catalogue*, no. 94A (e) (as *Taking the Hup* [sic] *Rib*, 31 x 43 in.); [University of Wyoming, Laramie] *Campus Pulse*, October 14, 1977, p. 3 (illus.); Ruth M. Collis to Ron Tyler, September 7, 1981

118A. *Taking the Hump Rib*

Gouache on paper

6 11/16 x 9 5/8 in. (17.0 x 24.4 cm.)

Signed, l.r.: "AJM [monogram]"

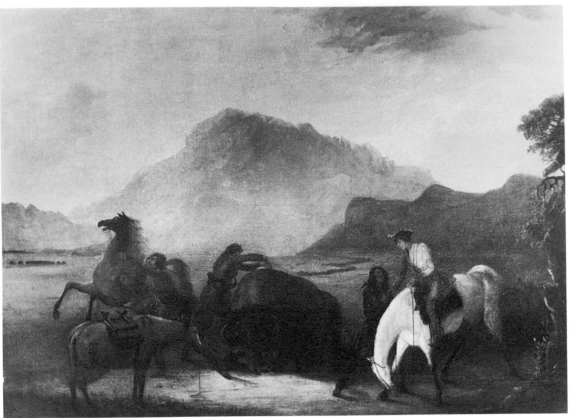

Catalogue number 118.

Inscribed, u.l.: "65 Taking the Hump Rib"

The Boatmen's National Bank of St. Louis, Missouri (May 26, 1947)

PROVENANCE

the artist; by descent to Louisa Whyte Norton; Old Print Shop, New York (1947)

EXHIBITIONS

BNB, May 4–29, 1964

REFERENCES

Cowdrey and Comstock, "Alfred Jacob Miller and the Farthest West," p. 1; Anne Terry White, ed., *Indians and the Old West*, illus. p. 27; Josephy, "First 'Dude Ranch' Trip to the Untamed West," p. 10 (illus.); BNB, *Catalog*, no. 50

118B. *Taking the Hump Rib*

Watercolor on paper

8 5/16 x 12 5/16 in. (21.1 x 31.3 cm.)

Signed, l.r.: "AJM [monogram] iller"

(1858–1860)

The Walters Art Gallery, Baltimore, Maryland 37.1940.85

PROVENANCE

William T. Walters, Baltimore

REFERENCES

Ross, plates XLVII, 85; Getlein, *Lure of the Great West*, illus. p. 89; *Sportsman's Wilderness*, illus. p. 143

119. *Return from Hunting*

Pencil, pen and ink, and gray wash on paper

8 11/16 x 7 1/16 in. (22.7 x 18.0 cm.)

(c. 1837)

Inscribed, u.c.: "7 Return from Hunting, near the Puine du Cerf"; l.c. of mount: "Return from Hunting/vicinity of Council Bluffs."

Joslyn Art Museum, Omaha, Nebraska; InterNorth Art Foundation Collection 781

PROVENANCE

the artist; Sir William Drummond Stewart (c. 1839); Frank Nichols (sale: Chapman's, Edinburgh, June 16–17, 1871); Bonamy Mansell Power; willed to Edward Power (1900); by descent to Major G. H. Power, Great Yarmouth, England (sale: PB, May 6, 1966)

EXHIBITIONS

Denver Art Museum, April 15–24, 1966; PB, April 29–May 6, 1966

REFERENCES

Murthly sale notices; PB sale 2436 (May 6, 1966), lot 30;

Knox, "83 Drawings from 1837 Trek," p. 28; Ross, pl. 201 (as *Return from Hunting [Vicinity of Council Bluffs]*)

119A. *Return from Hunting*

(1840)

Unlocated

PROVENANCE
Sir William Drummond Stewart (1840); Frank Nichols (sale: Chapman's, Edinburgh, June 16–17, 1871)

REFERENCES
AJM to Decatur H. Miller, December 25, 1840, cited in Warner, p. 169; Murthly sale notices

119B. *Camp Receiving a Supply of Meat*

Watercolor on paper

9 x 12 15/16 in. (23.0 x 32.9 cm.)

Signed, l.l.: "AJM [monogram] iller"

(1858–1860)

The Walters Art Gallery, Baltimore, Maryland 37.1940.50

PROVENANCE
William T. Walters, Baltimore

REFERENCES
Nunis, *Andrew Sublette*, illus. p. 59 (as *Trappers Camp*); Ross, pl. 50

119C. *Return from Hunting*

Oil on paper board

7 11/16 x 6 7/16 in. (19.5 x 16.25 cm.)

Signed, l.l.: "AJM. [monogram]"

Inscribed, l.r.: "Return from Hunting"

Western Americana Collection, The Beinecke Rare Book and Manuscript Library, Yale University, New Haven, Connecticut (Coe No. V, 24–25)

EXHIBITIONS
"Gallery of Dudes," ACM, January 26–March 15, 1967

REFERENCES
Withington, no. 342

120. *Trappers around a Campfire with the Wind River Mountains of the Rockies in the Background (Trappers' Camp) (Roasting the Hump Rib)*

Oil on canvas

38 1/4 x 32 1/8 in. (97.2 x 81.6 cm.)

(c. 1839)

The Warner Collection of Gulf States Paper Corporation, Tuscaloosa, Alabama (1975)

PROVENANCE
Sir William Drummond Stewart (1840); Frank Nichols (sale: Chapman's, Edinburgh, June 16–17, 1871); Steuart Fothringham family until 1963; Leo Heaps, Toronto; Hirschl & Adler Galleries, New York (1972–1973)

EXHIBITIONS
Apollo Gallery, New York, May 9–22, 1839; Hirschl & Adler Galleries, New York, December 5, 1972–January 6, 1973

REFERENCES
"Apollo Gallery—Original Paintings," *Morning Herald*, May 16, 1839, p. 2, col. 3, no. 17 (as *Trappers' Camp*); "Miller's Paintings of Oregon Scenery," *New-York Mirror*, May 25, 1839, p. 383; AJM to Decatur H. Miller, December 25, 1840, cited in Warner, p. 169; Murthly sale notices; Hirschl & Adler Galleries, *Faces and Places*, no. 66 (illus.); Dee Brown, *The Westerners*, pp. 22, 23, 62; Donald G. Pike, "Images of an Era: The Mountain Man," *American West* 12, no. 5 (September 1975): 36, illus. p. [37]; Gulf States Paper Corporation, *The Best of the West*, unpaginated (illus.)

120A. *Roasting the Hump Rib*

Unlocated

References: account book, May 24, 1850, $100, for H. Oelrichs

120B. *Roasting the Hump Rib*

Watercolor, heightened with white, on paper

11 1/2 x 10 in. (24.6 x 25.4 cm.)

Signed, l.c.: "AJM [monogram] iller"

(1858–1860)

The Walters Art Gallery, Baltimore, Maryland 37.1940.36

PROVENANCE
William T. Walters, Baltimore

REFERENCES
Berry, *Majority of Scoundrels*, illus. fol. p. 242; Ross, pl. 36; Dickson, "Hard on the Heels of Lewis and Clark," p. 22 (illus.)

121. *Black Hills*

Watercolor on paper

8 1/4 x 11 1/2 in. (21.0 x 24.6 cm.)

Signed, l.r.: "AJM [monogram]"

Inscribed, l.r.: "Black Hills"

Private collection (July 1980)

PROVENANCE
the artist; by descent through his family; Mae Reed Porter (1938); Dr. J. M. Christlieb, Omaha; Martin

Kodner, St. Louis; Kennedy Galleries, New York (1977); Harry Lockwood (1977); Rosenstock Arts, Denver

REFERENCES

DeVoto, pl. XLI (as *Black Hills, Oregon*); *Kennedy Quarterly* 15, no. 3 (June 1977): no. 116 (illus.)

121A. *Black Hills*

Watercolor on paper

8 1/16 x 11 11/16 in. (20.5 x 29.7 cm.)

(1858–1860)

The Walters Art Gallery, Baltimore, Maryland
37.1940.195

PROVENANCE

William T. Walters, Baltimore

REFERENCES

Ella E. Clark, *Indian Legends from the Northern Rockies*, illus. fol. p. 294; Ross, pl. 195

121B. *Black Hills*

Unlocated

REFERENCES

account book, July 14, 1863, $35, for Jas. B. Lippincott

121C. *Where the Clouds Love to Rest*

Oil on board

9 1/2 x 15 3/4 in. (24.1 x 40.0 cm.)

Signed, l.l.: "AJM [monogram]"; l.r.: "AJM [monogram] iller"

Dallas Museum of Fine Arts, Dallas, Texas 1955.20; gift of C. R. Smith

PROVENANCE

Mrs. K. Daniel; Old Print Shop, New York (1947); Edward Eberstadt and Sons, New York (1947); C. R. Smith, Washington, D.C.

REFERENCES

Old Print Shop ledger book (1947); *Dallas Museum of Fine Arts Newsletter* (Winter 1959); FARL 118–22 F/ (49203)

122. *Gorge . . . Black Hills*

Watercolor on paper

8 1/4 x 10 1/2 in. (21.0 x 26.7 cm.)

Unlocated

PROVENANCE

the artist; by descent to Louisa Whyte Norton; Old Print Shop, New York (1947); Everett D. Graff, Winnetka, Ill. (1947)

REFERENCES

Old Print Shop ledger book (June 18, 1947), no. 31

123. *Black Hills*

Oil on canvas

9 1/4 x 12 1/4 in. (23.5 x 31.1 cm.)

Howard P. Calhoun, Garrison, Maryland

PROVENANCE

Alexander H. Post; William J. Middendorf, Sr.

124. *Near the Black Hills*

Gouache on paper

8 1/2 x 11 1/2 in. (21.6 x 24.6 cm.)

Signed, l.l.: "AJM [monogram]"

Inscribed, u.l.: "85"; l.r.: "Near the/Black Hills"

Private collection, Baltimore

PROVENANCE

the artist; by descent to the present owner

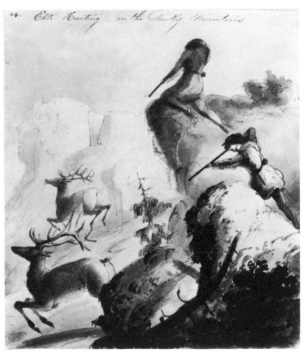

Catalogue number 125.

125. *Elk Hunting in the Rocky Mountains*

Pencil with brown and gray washes on paper

8 x 7 in. (20.3 x 17.7 cm.)

(c. 1837)

Inscribed, u.l.: "44"; u.c.: "Elk Hunting, in the Rocky Mountains"; on mat, l.c.: "Elk Hunting in the Rocky Mountains."

Whitney Gallery of Western Art, Buffalo Bill Historical Center, Cody, Wyoming 9.80; gift of the Joseph M. Roebling Estate

PROVENANCE

the artist; Sir William Drummond Stewart (c. 1839); Frank Nichols (sale: Chapman's, Edinburgh, June 16–17, 1871); Bonamy Mansell Power; willed to Edward Power (1900); by descent to Major G. H. Power, Great Yarmouth, England (sale: PB, May 6, 1966); Joseph M. Roebling

EXHIBITIONS

Denver Art Museum, April 15–24, 1966; PB, April 26–May 6, 1966

REFERENCES

Murthly sale notices; PB sale 2436 (May 6, 1966), lot 68; Knox, "83 Drawings from 1837 Trek," p. 28

125A. *Hunting Elk among the Black Hills*

Watercolor and gouache on paper

11 3/4 x 9 3/8 in. (29.8 x 23.8 cm.)

Signed, l.r.: "AJM [monogram] iller"

(1858–1860)

Inscribed, l.c.: "no 60"

The Walters Art Gallery, Baltimore, Maryland 37.1940.3

PROVENANCE

William T. Walters, Baltimore

REFERENCES

Ross, pl. 3; Getlein, *Lure of the Great West,* illus. p. 78; *Sportsman's Wilderness,* illus. p. 154; Reader's Digest, *Story of the Great American West,* illus. p. 91

125B. *Hunting Elk among the Black Hills*

Oil on panel

10 x 12 in. (25.4 x 30.5 cm.)

Signed, l.r.: "A M"

Mr. and Mrs. Daniel W. Calhoun, Jr.

PROVENANCE

by descent from Mrs. Calhoun's grandfather, Norman James

EXHIBITIONS

WAG loan no. 92.1941 #A797

126. *Death of the Elk*

Pen and ink with brown wash over pencil on paper

8 13/16 x 10 13/16 in. (22.5 x 27.6 cm.)

(c. 1837)

Inscribed, u.l.: "62"

Earl C. Adams, San Marino, California

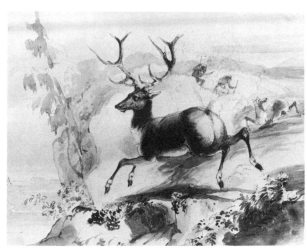

Catalogue number 126.

PROVENANCE

the artist; Sir William Drummond Stewart (c. 1839); Frank Nichols (sale: Chapman's, Edinburgh, June 16–17, 1871); Bonamy Mansell Power; willed to Edward Power (1900); by descent to Major G. H. Power, Great Yarmouth, England (sale: PB, May 6, 1966)

EXHIBITIONS

Denver Art Museum, April 15–24, 1966; PB, April 29–May 6, 1966; Old Mint, San Francisco, June 16–September 15, 1973; Santa Barbara Museum of Art, November 10, 1973–January 6, 1974

REFERENCES

Murthly sale notices; PB sale 2436 (May 6, 1966), lot 70; Knox, "83 Drawings from 1837 Trek," p. 28; Joseph Armstrong Baird, Jr., comp., *The West Remembered,* no. 2, illus. p. [19]

127. *Death of the Elk*

Pencil with brown wash on gray card

8 7/8 x 10 7/8 in. (22.5 x 27.7 cm.)

(c. 1837)

Inscribed, u.l.: "69"

The Dentzel Collection

PROVENANCE

the artist; Sir William Drummond Stewart (c. 1839); Frank Nichols (sale: Chapman's, Edinburgh, June 16–17, 1871); Bonamy Mansell Power; willed to Edward Power (1900); by descent to Major G. H. Power, Great Yarmouth, England (sale: PB, May 6, 1966)

EXHIBITIONS

Denver Art Museum, April 15–24, l966; PB, April 29–May 6, 1966; Los Angeles County Museum of Art, March 21–May 28, 1972

REFERENCES

Murthly sale notices; PB sale 2436 (May 6, 1966), lot 69

(illus.); Knox, "83 Drawings from 1837 Trek," p. 28; Los Angeles County Museum of Art, *The American West*, no. 7, pl. 25

128. *Elk Taking the Waters*

Gouache and watercolor over pencil on paper

7 x 9 in. (17.8 x 23.0 cm.)

Inscribed, l.r.: "Elk taking the Waters."

Earl C. Adams, San Marino, California (1953)

PROVENANCE

the artist; by descent through his family; Edward Eberstadt and Sons, New York (1953)

EXHIBITIONS

Old Mint, San Francisco, June 16–September 15, 1973; Santa Barbara Museum of Art, November 10, 1973–January 6, 1974

REFERENCES

Eberstadt catalogue 132 (1953), no. 431 (illus.); Charles Eberstadt to Earl C. Adams, January 5, 1954, collection of Earl C. Adams; Baird, *West Remembered*, no. 1, illus. p. 17 (as 6 1/2 x 9 3/8 in.)

128A. *A Wounded Stag Taking Soil, on a Tributary of the Yellow Stone*

Pencil with gray and brown washes on paper

6 15/16 x 8 3/8 in. (17.6 x 21.3 cm.)

(c. 1837)

Inscribed: "34"

Unlocated

PROVENANCE

the artist; Sir William Drummond Stewart (c. 1839); Frank Nichols (sale: Chapman's, Edinburgh, June 16–17, 1871); Bonamy Mansell Power; willed to Edward Power (1900); by descent to Major G. H. Power, Great Yarmouth, England (sale: PB, May 6, 1966)

EXHIBITIONS

Denver Art Museum, April 15–24, 1966; PB, April 29–May 6, 1966

REFERENCES

Murthly sale notices; PB sale 2436 (May 6, 1966), lot 83; Knox, "83 Drawings from 1837 Trek," p. 28

128B. *Hunting the Elk*

Watercolor on paper

9 1/4 x 14 1/4 in. (23.5 x 36.2 cm.)

Signed, l.r.: "AJM [monogram] iller"

(1858–1860)

The Walters Art Gallery, Baltimore, Maryland 37.1940.113

PROVENANCE

William T. Walters, Baltimore

REFERENCES

Ross, pl. 113

128C. *Elk Taking the Water*

Watercolor on paper

7 5/8 x 11 3/4 in. (19.4 x 29.8 cm.)

Inscribed, l.r.: "Elk Taking the Water"

The Boatmen's National Bank of St. Louis, Missouri (May 26, 1947)

PROVENANCE

the artist; by descent to Louisa Whyte Norton; Old Print Shop, New York (1947)

EXHIBITIONS

BNB, May 4–29, 1964

REFERENCES

Cowdrey and Comstock, "Alfred Jacob Miller and the Farthest West," p. 1; BNB, *Catalog*, no. 38

128D. *Lord Stewart Shooting the Elk*

Oil on mahogany panel

17 3/4 x 23 7/8 in. (45.1 x 60.6 cm.)

Stark Museum of Art, Orange, Texas 31.34/5

PROVENANCE

Edward Eberstadt and Sons, New York

REFERENCES

possibly the picture commissioned by William C. Wait, account book, June 30, 1859, as *Shooting Elk*, $35; Eberstadt catalogues 132 (1953), no. 432 (illus. as *Hunting the Elk*), and 139 (n.d.), no. 77 (illus. as *Hunting the Elk*); Stark, p. 206, illus. p. 67

129. *Elk—Rocky Mountains*

Pencil, pen and ink, and watercolor on paper

6 1/4 x 6 7/8 in. (15.9 x 17.5 cm.)

Joslyn Art Museum, Omaha, Nebraska; InterNorth Art Foundation Collection 759

PROVENANCE

Victor D. Spark, New York; M. Knoedler and Company, New York, #1353 (1951–1965)

130. *Elk—Head of*

Watercolor on paper

7 1/2 x 11 1/2 in. (19.1 x 29.2 cm.)

Inscribed, l.r.: "Elk"

Joslyn Art Museum, Omaha, Nebraska; InterNorth Art Foundation Collection 757

PROVENANCE
Porter Collection

EXHIBITIONS
"Western Frontier," SLAM, April 1–May 13, 1941 (as *Elk*)

131. *Herd of Antelope*

Watercolor and gouache on paper

7 x 10 3/4 in. (17.4 x 27.3 cm.)

Signed, l.r.: "AJM [monogram]"

Inscribed, u.r.: "Herd of Antelope"

The Thomas Gilcrease Institute of American History and Art, Tulsa, Oklahoma 0236.1073

PROVENANCE
the artist; by descent to L. Vernon Miller, Baltimore; M. Knoedler and Company, New York, #CA 3223-7 (1949)

REFERENCES
Rough Draughts, no. 138; DeVoto, pl. L

131A. *A Herd of Antelopes*

Watercolor on paper

7 5/8 x 12 7/8 in. (19.4 x 32.7 cm.)
Signed, l.c.: "AJM [monogram] iller"

(1858–1860)

The Walters Art Gallery, Baltimore, Maryland 37.1940.89

PROVENANCE
William T. Walters, Baltimore

EXHIBTIONS
"A. J. Miller Watercolors," Smithsonian, October 1956–November 1957

REFERENCES
Ross, pl. 89

131B. *Trappers Starting for the Hunt at Sunrise*

Sepia wash on paper

Sight: 6 1/4 x 9 1/2 in. (15.9 x 24.1 cm.)

Signed, l.r.: "AJM [monogram]"

Inscribed [formerly?]: "Trappers Starting for the Hunt at Sunrise"

Whitney Gallery of Western Art, Buffalo Bill Historical Center, Cody, Wyoming 34.64

PROVENANCE
the artist; by descent to Louisa Whyte Norton; Old Print Shop, New York (1947); Fred Rosenstock, Denver (1947); John Howell-Books, San Francisco (1961)

Catalogue number 131B.

REFERENCES
Old Print Shop ledger book (June 18, 1947), no. 4 (as 6 1/2 x 9 3/4 in., signed); Cowdrey and Comstock, "Alfred Jacob Miller and the Farthest West," fig. 2; John Swingle, comp., *Catalogue 33: Rare Books and Manuscripts*, no. 101 (as *Trappers Starting for the Hunt at Sunrise*, 6 1/2 x 9 3/4 in., without colors, monogrammed); BBHC, *West of Buffalo Bill*, illus. p. [156] (as *Snake Indians Pursuing Crows*, 8 x 15 in.); FARL 154-23/(49214)

132. *Head of the Antelope*

Pencil with gray and ochre washes on paper

7 1/8 x 6 in. (18.1 x 15.2 cm.)

(c. 1837)

Inscribed, u.l.: "52"

Unlocated

PROVENANCE
the artist; Sir William Drummond Stewart (c. 1839); Frank Nichols (sale: Chapman's, Edinburgh, June 16–17, 1871); Bonamy Mansell Power; willed to Edward Power (1900); by descent to Major G. H. Power, Great Yarmouth, England (sale: PB, May 6, 1966)

EXHIBITIONS
Denver Art Museum, April 15–24, 1966; PB, April 29–May 6, 1966

REFERENCES
Murthly sale notices; PB sale 2436 (May 6, 1966), lot 71 (illus.); Knox, "83 Drawings from 1837 Trek," p. 28

133. *Antelope Head*

Watercolor on paper

5 1/2 x 7 1/2 in. (14.0 x 19.1 cm.)

Inscribed (formerly), l.r.: "Head of [illeg.] Antelope"

David Warner Foundation, Tuscaloosa, Alabama (1979)

Catalogue number 133.

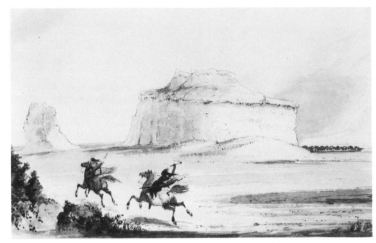

Catalogue number 135.

PROVENANCE

[Porter Collection?; Dawson's Book Shop, Los Angeles, (1952)?]; Dr. J. M. Christlieb, Omaha; Martin Kodner, St. Louis; Kennedy Galleries, New York (1977)

REFERENCES

[Dawson's Book Shop, Los Angeles, *An Exhibition of Original Western Paintings, Water Colors & Prints,* no. 2 (as 7 1/2 x 5 1/2 in.)?]

134. *Antelope*

Watercolor on paper

6 1/4 x 10 9/16 in. (15.9 x 26.9 cm.)

Inscribed, l.l.: "Antelope"

The Boatmen's National Bank of St. Louis, Missouri (May 26, 1947)

PROVENANCE

the artist; by descent to Louisa Whyte Norton; Old Print Shop, New York (1947)

EXHIBITIONS

BNB, May 4–29, 1964

REFERENCES

Cowdrey and Comstock, "Alfred Jacob Miller and the Farthest West," p. 1; BNB, *Catalog,* no. 33

135. *Curious Formations of Earth near the Platte River* [Court House Rock]

Pen and ink and watercolor on paper

7 1/2 x 13 in. (19.0 x 30.3 cm.)

(c. 1837)

Inscribed, u.l.: "24"; on mount, l.c.: "Curious Formation of Earth near the Platte River:

Western Americana Collection, The Beinecke Rare Book and Manuscript Library, Yale University, New Haven, Connecticut; gift of Frederick William Beinecke

PROVENANCE

the artist; Sir William Drummond Stewart (c. 1839); Frank Nichols (sale: Chapman's, Edinburgh, June 16–17, 1871); Bonamy Mansell Power; willed to Edward Power (1900); by descent to Major G. H. Power, Great Yarmouth, England (sale: PB, May 6, 1966); bought by Edward Eberstadt and Sons for Frederick William Beinecke

EXHIBITIONS

Denver Art Museum, April 15–24, 1966; PB, April 29–May 6, 1966

REFERENCES

Murthly sale notices; PB sale 2436 (May 6, 1966), lot 23 (illus.); Knox, "83 Drawings from 1837 Trek," p. 28

136. *Rocky Formations near the Nebraska or Platte River*

Watercolor on paper

7 1/2 x 11 7/8 in. (19.1 x 30.2 cm.)

Inscribed, u.l.: no. 128"; u.r.: "Rocky Formations near the Nebraska or Platte River"

The Boatmen's National Bank of St. Louis, Missouri (May 26, 1947)

PROVENANCE:

the artist; by descent to Louisa Whyte Norton; Old Print Shop, New York (1947)

EXHIBITIONS

BNB, May 4–29, 1964

REFERENCES

Cowdrey and Comstock, "Alfred Jacob Miller and the Farthest West," p. 1; BNB, *Catalog,* no. 48; Warner, pp. [iii], 61–62, illus. p. 63

136A. *Formations of Rock*

Watercolor on paper

8 7/16 x 12 1/4 in. (21.4 x 31.1 cm.)

Signed, l.l.: "AJM [monogram] iller"

(1858–1860)

The Walters Art Gallery, Baltimore, Maryland 37.1940.87

PROVENANCE

William T. Walters, Baltimore

REFERENCES

Ross, pl. 87

137. *Formations of Rock near the Sweet Water*
[Verso: *Interior of an Earth Lodge*]

Watercolor on paper

9 1/4 x 13 in. (23.5 x 33.0 cm.)

Inscribed, u.r.: "Lodge on reverse side"; l.c.: "Formations of Rock./near the Sweet Water"

Joslyn Art Museum, Omaha, Nebraska; InterNorth Art Foundation Collection 716

PROVENANCE

Porter Collection

EXHIBITIONS

Nelson, January 1939; "Western Frontier," SLAM, April 1–May 13, 1941; BBHC, May 15–September 15, 1959

REFERENCES

BBHC, *Land of Buffalo Bill*, no. 45 (as *Formation of Rock near the Sweet Water—Rattlesnake Mountains on the Sweet Water*)

137A. *Rock Formations &c.*

Watercolor on paper

8 7/8 x 13 in. (22.5 x 33.0 cm.)

Signed, l.r.: "AJM [monogram] iller"

(1858–1860)

The Walters Art Gallery, Baltimore, Maryland 37.1940.109

PROVENANCE

William T. Walters, Baltimore

REFERENCES

Ross, pl. 109

138. *Hunting the Mountain Sheep*

Pencil, pen and ink, watercolor, and gouache on paper

9 1/4 x 7 1/2 in. (19.1 x 23.5 cm.)

Inscribed, u.r.: "Hunting the Mountain/Sheep"; l.c.: "Hunting the Mountain Sheep"

Joslyn Art Museum, Omaha, Nebraska; InterNorth Art Foundation Collection 738

PROVENANCE

Porter Collection

EXHIBITIONS

Nelson, January 1939; "Western Frontier," SLAM, April 1–May 13, 1941; BBHC, May 15–September 15, 1959

REFERENCES

BBHC, *Land of Buffalo Bill*, no. 67

138A. *Hunting the Argali in the Rocky Mountains*

Pencil and pen and ink with gray and brown washes on white card blind-stamped "London Superfine"

8 7/16 x 7 1/4 in. (21.5 x 18.5 cm.)

(c. 1837)

Inscribed, u.l.: "33"; u.c.: "Hunting the Argali in the Rocky Mountains"; on mount, l.c.: "Hunting the 'Argali' in the Rocky Mountains"

Biltmore Galleries, Los Angeles, California

PROVENANCE

the artist; Sir William Drummond Stewart (c. 1839); Frank Nichols (sale: Chapman's, Edinburgh, June 16–17, 1871); Bonamy Mansell Power; willed to Edward Power (1900); by descent to Major G. H. Power, Great Yarmouth, England (sale: PB, May 6, 1966)

EXHIBITIONS

Denver Art Museum, April 15–24, 1966; PB, April 29–May 6, 1966

REFERENCES

Murthly sale notices; PB sale 2436 (May 6, 1966), lot 72 (illus.); Knox, "83 Drawings from 1837 Trek," p. 28

138B. *Hunting the Argoli* [sic], *at Big Horn, on Sweet Water River*

Oil on canvas

(c. 1839)

Unlocated

PROVENANCE

Sir William Drummond Stewart (1839); Frank Nichols (sale: Chapman's, Edinburgh, June 16–17, 1871)

EXHIBITIONS

Apollo Gallery, New York, May 9–22, 1839

REFERENCES

"Apollo Gallery—Original Paintings," *Morning Herald*, May 16, 1839, p. 2, col. 3, no. 13; Murthly sale notices

138C. *Hunting the Argali in the Black Hills*

Watercolor and gouache on paper

8 x 8 1/2 in. (20.4 x 21.6 cm.)

Signed, l.r.: "AJM [monogram]"

The Thomas Gilcrease Institute of American History and Art, Tulsa, Oklahoma 0226.1019

PROVENANCE

Mrs. Eugenia R. Whyte, Baltimore; M. Knoedler and Company, New York, #WCA 1098 (1948)

REFERENCES

Rough Draughts, no. 69

138D. *The Argali—Mountain Sheep*

Watercolor, heightened with white, on paper

12 5/16 x 9 3/8 in. (32.9 x 23.8 cm.)

Signed, l.l.: "AJM [monogram] iller"

(1858–1860)

Inscribed: "no. 69"

The Walters Art Gallery, Baltimore, Maryland 37.1940.30

PROVENANCE

William T. Walters, Baltimore

REFERENCES

Ross, pl. 30

139. *Argali; Rocky Mountain Sheep on Scott's Bluff*

Pen and ink and pencil on paper

5 3/4 x 7 7/8 in. (14.6 x 20.0 cm.)

Signed, l.l.: "AJM [monogram]"

Inscribed below drawing: "Argali/Rocky Mountain Sheep/on Scott's Bluffs"

The Warner Collection of Gulf States Paper Corporation, Tuscaloosa, Alabama

PROVENANCE

Kennedy Galleries, New York (1968)

REFERENCES

Kennedy Quarterly 8, no. 2 (June 1968): no. 50 (illus. as *Rocky Mountain Sheep on Scott's Bluff*)

140. *Female Argali or Mountain Sheep*

Watercolor on paper

5 3/4 x 7 1/2 in. (14.6 x 19.1 cm.)

David Warner Foundation, Tuscaloosa, Alabama

PROVENANCE

Dr. J. M. Christlieb, Omaha; Martin Kodner, St. Louis; Kennedy Galleries, New York (1977)

REFERENCES

Kennedy Quarterly 15, no. 3 (June 1977): no. 104 (illus.)

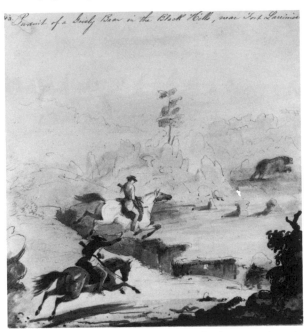

Catalogue number 141.

141. *Pursuit of a Grisly Bear* [sic] *Bear in the Black Hills near Fort Larrimer [Laramie].*

Pencil with brown and yellow washes on paper

7 3/4 x 7 1/8 in. (19.7 x 18.2 cm.)

(c. 1837)

Inscribed, u.l.: "43."; u.c.: "Pursuit of a Grisly [*sic*] Bear in the Black Hills, near Fort Larrimer [*sic*]"; on mount, l.c.: "Pursuit of a Grizly [*sic*] Bear in the Black Hills,/ near Fort Larrimer [*sic*]"

Sheldon Memorial Art Gallery, University of Nebraska, Lincoln; gift of Olga N. Sheldon

PROVENANCE

the artist; Sir William Drummond Stewart (c. 1839); Frank Nichols (sale: Chapman's, Edinburgh, June 16–17, 1871); Bonamy Mansell Power; willed to Edward Power (1900); by descent to Major G. H. Power, Great Yarmouth, England (sale: PB, May 6, 1966); Olga N. Sheldon

EXHIBITIONS

Denver Art Museum (April 15–24, 1966); PB, April 29–May 6, 1966

REFERENCES

Murthly sale notices; PB sale 2436 (May 6, 1966), lot 65; Knox, "83 Drawings from 1837 Trek," p. 28

141A. *The Grizzly Bear*

Watercolor, heightened with white, on paper

10 1/16 x 9 5/16 in. (25.6 x 23.7 cm.)

Signed, l.r.: "AJM [monogram] iller"

(1858–1860)

Inscribed: "68"

The Walters Art Gallery, Baltimore, Maryland 37.1940.32

PROVENANCE

William T. Walters, Baltimore

EXHIBITIONS

"A. J. Miller Watercolors," Smithsonian, October 1956–November 1957

REFERENCES

Ross, pl. 32

141B. *Chase of the Grizzly Bear, Black Hills*

Watercolor on paper

7 3/4 x 8 1/4 in. (19.7 x 21.0 cm.)

Inscribed, u.r.: "Black Hills"; l.r.: "Chasing [?] the Grizzly"

The Boatmen's National Bank of St. Louis, Missouri (May 26, 1947)

PROVENANCE

the artist; by descent to Louisa Whyte Norton; Old Print Shop, New York (1947)

EXHIBITIONS

BNB, May 4–29, 1964

REFERENCES

Cowdrey and Comstock, "Alfred Jacob Miller and the Farthest West," p. 1; Josephy, "First 'Dude Ranch' Trip to the Untamed West," p. 11 (illus.); BNB, *Catalog,* no. 41

142. *Starting a Grizzly Bear from Covert*

Pen and ink with gray wash on gray card

8 3/4 x 11 in. (22.7 x 27.8 cm.)

(c. 1837)

Inscribed: "67"

Rosenstock Arts, Denver, Colorado

PROVENANCE

the artist; Sir William Drummond Stewart (c. 1839); Frank Nichols (sale: Chapman's, Edinburgh, June 16–17, 1871); Bonamy Mansell Power; willed to Edward Power (1900); by descent to Major G. H. Power, Great Yarmouth, England (sale: PB, May 6, 1966); Kennedy Galleries, New York; Maxwell Galleries, San Francisco (on consignment, 1973–1974); [Gerald Peters?]; Rosenstock Arts, Denver; private collection

EXHIBITIONS

Denver Art Museum, April 15–24, 1966; PB, April 29–May 6, 1966

REFERENCES

Murthly sale notices; PB sale 2436 (May 6, 1966), lot 64 (illus.); Knox, "83 Drawings from 1837 Trek," p. 28; Maxwell Galleries, San Francisco, *Art of the West* (1973), no. 83 (illus. as *Startling a Grizzly from Cover*)

142A. *The Grizzly Bear*

Watercolor on paper

9 3/8 x 12 7/16 in. (23.8 x 31.6 cm.)

Signed, l.c.: "AJM [monogram] iller"

(1858–1860)

The Walters Art Gallery, Baltimore, Maryland 37.1940.125

PROVENANCE

William T. Walters, Baltimore

REFERENCES

Ross, pl. 125

142B. *Grizzly Bear Hunt*

Watercolor on paper

7 9/16 x 10 3/4 in. (19.2 x 27.3 cm.)

Inscribed, u.l.: "107"; u.r.: "Driving the Grizzly Bear From His Cover"

The Boatmen's National Bank of St. Louis, Missouri (May 26, 1947)

PROVENANCE

the artist; by descent to Louisa Whyte Norton; Old Print Shop, New York (1947)

EXHIBITIONS

BNB, May 4–29, 1964

REFERENCES

Cowdrey and Comstock, "Alfred Jacob Miller and the Farthest West," p. 1; BNB, *Catalog,* no. 46

143. *Hunting the Grisly* [sic] *Bear*

Oil on canvas

30 x 43 in. (76.2 x 109.2 cm.)

(c. 1839)

American Heritage Center, University of Wyoming, Laramie; gift of the Everett D. Graff family

PROVENANCE

Sir William Drummond Stewart (1839); Frank Nichols (sale: Chapman's, Edinburgh, June 16–17, 1871); Appleby

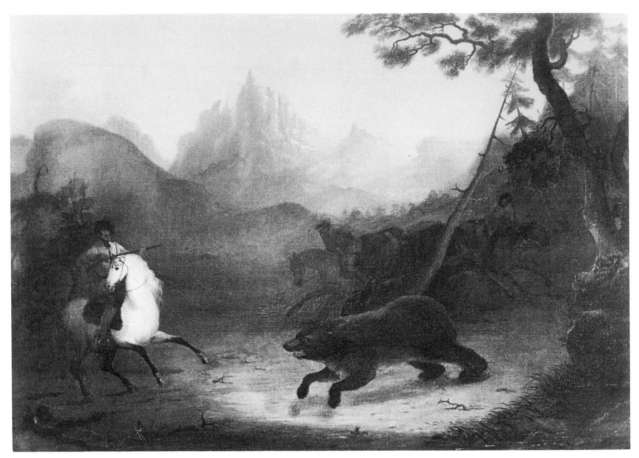

Catalogue number 143.

Brothers; B. F. Stevens and Brown, London (1937);
Everett D. Graff, Winnetka, Ill. (1937)

EXHIBITIONS

Apollo Gallery, New York, May 9–22, 1839

REFERENCES

"Apollo Gallery—Original Paintings," *Morning Herald,*
May 16, 1839, p. 2, col. 3, no. 7; "Miller's Paintings of
Oregon Scenery," *New-York Mirror,* May 25, 1839,
p. 383; Murthly sale notices; B. F. Stevens and Brown,
Coronation Catalogue, no. 94A (f) (as *Hunting the Black
Grizzly Bear,* 31 x 43 in.); [University of Wyoming]
Campus Pulse, October 14, 1977, p. 3 (illus.); Ruth
M. Collis to Ron Tyler, September 7, 1981

143A. *Hunting the Bear*

Watercolor on paper

9 3/16 x 13 1/16 in. (23.4 x 33.2 cm.)

Signed, l.l.: "AJM [monogram] iller"

(1858–1860)

The Walters Art Gallery, Baltimore, Maryland
37.1940.107

PROVENANCE

William T. Walters, Baltimore

REFERENCES

Ross, pl. 107

143B. *The Grizzly Bear*

Watercolor, gouache, and pen and ink over pencil on
paper

Sight: 7 13/16 x 12 3/8 in. (19.9 x 31.3 cm.)

Signed, l.l.: "AJM [monogram] iller Pt"

(1867)

Inscribed on mat, l.r.: "No. 21./The Grizzly Bear"

Public Archives of Canada, Ottawa, Ontario; gift of Mrs.
J. B. Jardine (1946)

PROVENANCE

Alexander Brown, Liverpool, England (1867); by descent
to Mrs. J. B. Jardine, Chesterknowes, Scotland

EXHIBITIONS

PAC museum, winter 1946–1947; Peale Museum, January
8–February 12, 1950; "Alfred Jacob Miller," ACM,
February 13–March 26, 1972

REFERENCES

account book, March 26, May 8, August 10, 1867;
Brunet, no. 21; Bell, p. 96, illus. p. 97

143C. *Hunting the Grizzly Bear*

Oil on paper

7 1/2 x 12 1/8 in. (19.0 x 31.8 cm.)

Signed, l.l.: "AJM [monogram]"

Inscribed, u.l.: "Hunting the Grizzly Bear"; l.r.: "Black
Hills"

Stark Museum of Art, Orange, Texas 31.34/21

PROVENANCE

Edward Eberstadt and Sons, New York

REFERENCES

Eberstadt catalogue 146 (1958), no. 123–26; Stark, p. 206

144. *Narrow Escape from a Grisly* [sic] *Bear near the Sources of the Platte River*

Pencil with black and gray washes on paper

7 x 10 1/2 in. (18.2 x 26.8 cm.)

(c. 1837)

Inscribed, u.l.: "5"; u.c.: "Narrow Escape from a *Grisly*
[sic] *Bear,* Near the sources of the Platte River"

Unlocated

PROVENANCE

the artist; Sir William Drummond Stewart (c. 1839);
Frank Nichols (sale: Chapman's, Edinburgh, June 16–17,
1871); Bonamy Mansell Power; willed to Edward Power
(1900); by descent to Major G. H. Power, Great
Yarmouth, England (sale: PB, May 6, 1966); Schweitzer
Gallery, New York (1966); Eugene Adkins, Tulsa (sale:
SPB, October 17, 1980)

EXHIBITIONS

Denver Art Museum, April 15–24, 1966; PB, April 29–
May 6, 1966; SPB, October 11–16, 1980

REFERENCES

Murthly sale notices; PB sale 2436 (May 6, 1966), lot 66
(illus.); SPB sale 4435M (October 17, 1980), lot 19 (illus.)

145. *Haunt of the Grizzly Bear*

Watercolor on paper

7 11/16 x 10 in. (19.5 x 25.4 cm.)

Signed, l.l.: "AJM [monogram] iller"

Stark Museum of Art, Orange, Texas 31.34/41

PROVENANCE

Edward Eberstadt and Sons, New York

REFERENCES

Eberstadt catalogue 146 (1958), no. 123–29; Stark, p. 205

146. *Death of a Panther*

Oil on canvas

32 1/2 x 27 in. (82.5 x 68.6 cm.)

(c. 1840–1841)

D. Steuart Fothringham, Murthly Castle, Perthshire,
Scotland

PROVENANCE

Sir William Drummond Stewart (c. 1841); Frank Nichols
(sale: Chapman's, Edinburgh, June 16–17, 1871);
purchased by a collateral descendant of Stewart; by
descent to the present owner

REFERENCES

Murthly sale notices; Warner, p. 43, no. 18

146A. *Shooting a Cougar*

Watercolor and gouache on paper

11 x 9 1/8 in. (27.9 x 23.2 cm.)

Signed, l.r.: "AJM [monogram] iller"

(1858–1860)

Inscribed: "113"

The Walters Art Gallery, Baltimore, Maryland 37.1940.27

PROVENANCE

William T. Walters, Baltimore

REFERENCES

Ross, pl. 27; Robert Elman, *Great American Shooting
Prints*, pl. 5; Getlein, *Lure of the Great West*, illus. p. 75

146B. *Indian Shooting Pistol*

Pencil, heightened with white, on blue wove paper

14 x 11 in. (35.6 x 27.9 cm.)

Inscribed on verso: "Cougar"

Stark Museum of Art, Orange, Texas 31.34/34

PROVENANCE

Edward Eberstadt and Sons, New York

REFERENCES

Eberstadt catalogue 146 (1958), no. 123–39; Stark, p. 206

146C. *Indian Shooting a Cougar*

Oil on canvas

24 x 19 15/16 in. (61.0 x 50.7 cm.)

Private collection

146D. *Indian Shooting a Cougar*

Unlocated

REFERENCES

account book, May 4, 1866, $50, for George Kalbfus

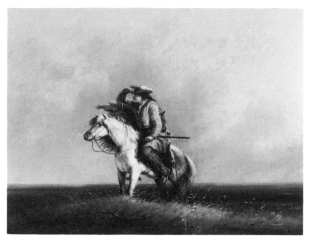

Catalogue number 147E.

147. *Lost Green Horn*

Pencil, pen and ink, and wash on paper

13 1/4 x 19 in. (33.7 x 48.3 cm.)

Inscribed, l.r.: "Lost Green Horn"; on verso: "Carrie C. Miller 3 Oklahoma Terrace Annapolis Maryland"

Joslyn Art Museum, Omaha, Nebraska; InterNorth Art Foundation Collection 730

PROVENANCE

Carrie C. Miller, Annapolis; Porter Collection

EXHIBITIONS

"Western Frontier," SLAM, April 1–May 13, 1941; BBHC, May 15–September 15, 1959; JAM, July 3–October 17, 1976

REFERENCES

[Ruxton], *Life in the Far West,* illus. opp. p. 206; BBHC, *Land of Buffalo Bill,* no. 59; Nunis, *Andrew Sublette,* illus. opp. p. 1; "Records of a Lost World," *Museum News* 42, no. 3 (November 1963): 17 (illus.); Ewers, *Artists of the Old West,* illus. p. 123; JAM, *Artists of the Western Frontier,* no. 67, illus. p. 15

147A. *The Lost Greenhorn*

Oil on canvas

16 x 20 in. (40.7 x 50.8 cm.)

Signed and dated, l.r.: "A. Miller/1851"

The Warner Collection of Gulf States Paper Corporation, Tuscaloosa, Alabama (1975)

PROVENANCE

Dr. C. A. Harris (1852); Robert G. Osborne, New York (1968); Richard Scudder, N.J. (1969); Kennedy Galleries, New York (1971); R. E. Peters, Scottsdale (1971); Kennedy Galleries, New York (1975)

EXHIBITIONS

Kennedy Galleries, New York, June 3–31, 1971; Phoenix Art Museum, February 8–March 9, 1975

REFERENCES

possibly the picture commissioned by Dr. C. A. Harris, account book, August 10, 1852, $50; *Kennedy Quarterly* 11, no. 1 (June 1971): 7 (illus.), cover, and 13, no. 2 (June 1974): no. 93 (illus.); Phoenix Art Museum, *American West,* no. 1, illus. p. 5; Gulf States Paper Corporation, *Best of the West,* unpaginated (illus.)

147B. *The Lost Greenhorn*

Watercolor on paper

9 7/16 x 12 5/16 in. (23.9 x 31.3 cm.)

Signed, l.c.: "AJM [monogram] iller"

(1858–1860)

The Walters Art Gallery, Baltimore, Maryland 37.1940.141

PROVENANCE

William T. Walters, Baltimore

REFERENCES

Ross, pl. 141; Randall, "Gallery for Alfred Jacob Miller," illus. p. [838]; Wheeler, *The Chroniclers,* illus. p. 111

147C. *The Lost Trapper (Lost on the Prairie)*

Watercolor on paper

9 1/4 x 13 1/2 in. (23.5 x 34.3 cm.)

Signed on back, l.l.: "AJM [monogram] iller"

Stark Museum of Art, Orange, Texas 31.34/11

PROVENANCE

Edward Eberstadt and Sons, New York

REFERENCES

Eberstadt catalogue 127 (1950), no. 278 (illus. as *Trapper Scanning the Prairie*); Brown, *Three Years in the Rocky Mountains,* no. 278 (illus.); Eberstadt catalogue 146 (1958), no. 123-23 (illus. as *Lost on the Prairie*); Stark, p. 207

147D. *Lost Green Horn*

Watercolor sketch

Unlocated

REFERENCES

account book, November 25, 1863, $12, for Harvey Schriver

147E. *Lost Green Horn*

Oil on canvas

14 1/4 x 19 3/4 in. (36.2 x 50.1 cm.)

private collection

PROVENANCE

the artist; Wm. S. G. Baker, Baltimore; by descent to a private collection

REFERENCES

Wm. S. G. Baker, account book, February 10, 1865, and entry 186 in advertisement for Grand Charity Art Exhibit, *Baltimore American*, January 17, 1874 (as *The Lost Hunter*, collection of W. S. G. Baker); *Sloan's*, brochure for Estate Auction, February 4-7, 1982, cover

147F. *Lost Green Horn*

Oil on canvas

17 7/8 x 23 7/8 in. (45.1 x 60.5 cm.)

Signed, l.r : "AJM [monogram]"

Whitney Gallery of Western Art, Buffalo Bill Historical Center, Cody, Wyoming 9.70; gift of the W. R. Coe Foundation, Oyster Bay, New York

PROVENANCE

W. McK. Gannon, Bremin, Me.; M. Knoedler and Co., New York

EXHIBITIONS

National Cowboy Hall of Fame, Oklahoma City, June 25-October 10, 1965; BBHC, May-September 1978

REFERENCES

possibly the picture commissioned by William Warfied, Lexington, Ky., account book, November 14, 1866, $75; Oklahoma City, National Cowboy Hall of Fame, *Inaugural Exhibition*, p.15; BBHC, *West of Buffalo Bill*, illus. p. [159]; BBHC, *Mountain Men*, pl. 14, and *Checklist of the Exhibition*, unpaginated

147G. *Lost on the Prairie*

Oil on canvas

20 x 24 in. (50.8 x 61.0 cm.)

Stark Museum of Art, Orange, Texas 31.34/1

PROVENANCE

Edward Eberstadt and Sons, New York

REFERENCES

Eberstadt catalogue 146 (1958), no. 123-4 (illus.); Stark, pp. 206-207

147H. *The Lost Green Horn*

Oil on canvas, mounted on masonite

15 1/2 x 23 in. (39.4 x 58.4 cm.)

The Dentzel Collection 0307

EXHIBITIONS

Charles W. Bowers Memorial Museum, Santa Ana, Calif., March 5-30, 1972

REFERENCES

Santa Ana, Charles W. Bowers Memorial Museum, *Painters of the West*, unpaginated

147I. *The Lost Greenhorn*

Oil on canvas

17 1/2 x 23 in. (44.5 x 58.4 cm.)

Signed, l.r.: "AJM [monogram] iller"

(c. 1845?)

Phelan Collection

PROVENANCE

Anslew Gallery, Norfolk, Va.

EXHIBITIONS

Government Services Savings and Loan, Bethesda, March 29-June 2, 1978; Longwood (College) Fine Arts Center, Farmville, Va., February 19-March 15, 1979

REFERENCES

Government Services Savings and Loan, Bethesda, *American West: Selected Works* [from the collection of Arthur J. Phelan, Jr.], no. 20; Farmville, Longwood Fine Arts Center, *The American West*, p. 15, illus. p. 12

148. *Lost Greenhorn*

Watercolor and gouache on paper

9 x 8 1/2 in. (23.0 x 21.6 cm.)

Inscribed, l.r.: "Lost Greenhorn"

The Thomas Gilcrease Institute of American History and Art, Tulsa, Oklahoma 0236.1021

PROVENANCE

the artist; by descent to L. Vernon Miller, Baltimore; M. Knoedler and Company, New York, #CA 3081, as *Lost Trapper* (1948)

REFERENCES

Rough Draughts, no. 115; McDermott, "A. J. Miller," p. 11 (illus. as *The Lost Trapper*); Rossi and Hunt, p. 324, illus. p. 105 (as *The Lost Trapper*, 9 1/2 x 8 in.); *Sportsman's Wilderness*, illus. p. 177

149. *Crossing the Divide, Thirsty Trappers Making a Rush for the River*

Watercolor on paper

8 1/2 x 11 1/2 in. (21.6 x 29.3 cm.)

Inscribed, u.l.: "110"; u.r.: "Crossing the Divide/Rush for Water"

Joslyn Art Museum, Omaha, Nebraska; InterNorth Art Foundation Collection 763

PROVENANCE

the artist; by descent to Mrs. Laurence R. Carton; M. Knoedler and Company, New York, #WCA 2054 (1957–1965)

EXHIBITIONS

"Far West," Knoedler Galleries, New York, November 15–December 4, 1954, no. 12

REFERENCES

Ewers, *Artists of the Old West*, illus. p. 122 (as *Crossing the Divide*); Goetzmann and Porter, p. 67, illus. p. 90

149A. *Crossing the Divide*

Watercolor on paper

9 x 14 13/16 in. (23.0 x 37.6 cm.)

Signed, l.l.: "AJM [monogram] iller"

(1858–1860)

The Walters Art Gallery, Baltimore, Maryland 37.1940.132

PROVENANCE

William T. Walters, Baltimore

REFERENCES

Ross, pl. 132

150. *Trappers Making Their Escape from Hostile Blackfeet*

Watercolor on paper

9 7/16 x 6 7/8 in. (24.0 x 17.5 cm.)

Signed and inscribed, l.r.: "AJM [monogram]"; "Trappers making their/escape from hostile Ind[ians]/Blackfoot"

Western Americana Collection, The Beinecke Rare Book and Manuscript Library, Yale University, New Haven, Connecticut (Coe V, 24–25)

EXHIBITIONS

"Gallery of Dudes," ACM, January 26–March 15, 1967

REFERENCES

Withington, no. 342; David Lavender, *American Heritage History of the Great West*, illus. p. 205 (as *Escape from Blackfeet*)

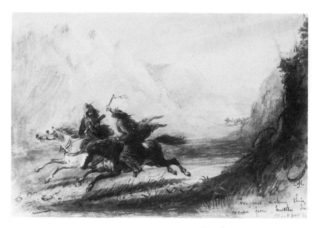

Catalogue number 150.

150A. *Escaping from a War Party*

Pen and ink with brown wash on paper

6 3/16 x 9 1/4 in. (15.7 x 23.5 cm.)

(c. 1837)

Inscribed, u.l.: "47"; u.c.: "Escaping from a War Party."

The Walters Art Gallery, Baltimore, Maryland 37.2437

PROVENANCE

the artist; Sir William Drummond Stewart (c. 1839); Frank Nichols (sale: Chapman's, Edinburgh, June 16–17, 1871); Bonamy Mansell Power; willed to Edward Power (1900); by descent to Major G. H. Power, Great Yarmouth, England (sale: PB, May 6, 1966)

EXHIBITIONS

Denver Art Museum, April 15–24, 1966; PB, April 29–May 6, 1966

REFERENCES

Murthly sale notices; PB sale 2436 (May 6, 1966), lot 61 (illus.); Knox, "83 Drawings from 1837 Trek," p. 28; Ross, pp. XXXIII–XXXIV, pl. 203; Randall, "Gallery for Alfred Jacob Miller," fig. 3

150B. *Escape from Blackfeet*

Watercolor on paper

9 1/8 x 13 3/4 in. (23.2 x 35.0 cm.)

(1858–1860)

The Walters Art Gallery, Baltimore, Maryland 37.1940.67

PROVENANCE

William T. Walters, Baltimore

REFERENCES

[Ruxton], *Life in the Far West*, illus. opp. p. 126; Goetzmann, *Exploration and Empire*, illus. p. 210; Frank Rasky, *Taming of the Canadian West*, illus. p. 120; Ross, pl. 67; Martin Hillman, "Part Three: Bridging a Continent," illus. pp. 398–399; David Holloway, *Lewis and Clark and the Crossing of North America*, illus. p.

192–193; *Sportsman's Wilderness,* illus. p. 143; Randall, "Gallery for Alfred Jacob Miller," p. 837; Hawke, *Those Tremendous Mountains,* illus. p. 250

151. *Trapper Making Escape from Blackfeet*
Watercolor on paper

8 11/16 x 6 3/16 in. (26.0 x 15.7 cm.)

Signed, l.r.: "AJM. [monogram]"

Western Americana Collection, The Beinecke Rare Book and Manuscript Library, Yale University, New Haven, Connecticut (Coe V, 24–25)

EXHIBITIONS
"Gallery of Dudes," ACM, January 26–March 15, 1967

REFERENCES
Withington, no. 342

152. *A Narrow Escape*
Oil on board

5 1/2 x 7 1/2 in. (14.0 x 19.1 cm.)

Signed, l.l.: "AJM [monogram]"

Private collection

PROVENANCE
Wickersham Gallery, New York; Kennedy Galleries, New York (1965 or 1968); T. R. Potter, St. Louis (1968); Kennedy Galleries, New York (1968); Warren Connell (1968); Kennedy Galleries, New York (1968); Gillian Attfield, New York (1968); Coe Kerr Gallery, New York

REFERENCES
Kennedy Quarterly 8, no. 2 (June 1968): no. 123 (illus.)

153. *Stampede by the Blackfeet*
Ink, wash, and gouache on dark paper

8 5/9 x 11 3/4 in. (22.0 x 29.9 cm.)

Signed, l.l.: "AJM [monogram]"

Inscribed, u.r.: "by the Blackfeet"

Joslyn Art Museum, Omaha, Nebraska; InterNorth Art Foundation Collection 675

PROVENANCE
Porter Collection

EXHIBITIONS
"Western Frontier," SLAM, April 1–May 13, 1941; BBHC, May 15–September 15, 1959

REFERENCES
"America and the Future," p. 115 (illus.); DeVoto, pl. LXIV; BBHC, *Land of Buffalo Bill,* no. 4

153A. *Stampede by Blackfeet Indians*
Watercolor, gouache, and pen and ink over pencil on paper

Sight: 8 9/16 x 12 3/8 in. (21.8 x 31.4 cm.)

Signed, l.r.: "AJM [monogram] iller Pt"

(1867)

Inscribed on mat, l.r.: "Nº. 35./Stampede by Blackfeet Indians."

Public Archives of Canada, Ottawa, Ontario; gift of Mrs. J. B. Jardine (1946)

PROVENANCE
Alexander Brown, Liverpool, England (1867); by descent to Mrs. J. B. Jardine, Chesterknowes, Scotland

EXHIBITIONS
PAC museum, winter 1946–1947; Peale Museum, Baltimore, January 8–February 12, 1950; "Alfred Jacob Miller," ACM, February 13–March 26, 1972

REFERENCES
account book, March 26, May 8, August 10, 1867; Hunter, p. [15]; Brunet, no. 35 (illus.); Roe, *The Indian and the Horse,* illus. opp. p. 111; Bell, p. 152, illus. p. 153

153B. *Stampede of Blackfeet*
Watercolor

Unlocated

REFERENCES
account book, July 19, 1867, $30, for George R. Vickers

154. *Breaking Trail to Escape from Indians*
Watercolor on paper

10 1/8 x 9 in. (25.7 x 22.9 cm.)

Signed, l.l.: "AJM [monogram]"

Joslyn Art Museum, Omaha, Nebraska; InterNorth Art Foundation Collection 692

PROVENANCE
Porter Collection

EXHIBITIONS
Nelson, January 1939; "Western Frontier," SLAM, April 1–May 13, 1941; Nelson and Atkins, October 5–November 17, 1957; BBHC, May 15–September 15, 1959

REFERENCES
DeVoto, pl XXXI; Nelson and Atkins, *Last Frontier,* no. 32; BBHC, *Land of Buffalo Bill,* no. 21; "Records of a Lost World," *Museum News* 42, no. 3 (November 1963): 17 (illus.); Monaghan, "Hunter and the Artist," p. 12 (illus.); Schomaekers, *Wilde Westen,* illus. p. 361

154A. *Caravan Taking to Water*

Watercolor on paper

11 13/16 x 9 1/4 in. (30.0 x 23.5 cm.)

(1858–1860)

The Walters Art Gallery, Baltimore, Maryland
37.1940.170

PROVENANCE

William T. Walters, Baltimore

REFERENCES

Ross, pl. 170

155. *Approach of a Band of Sioux*

Pen and ink with gray wash on paper

9 1/4 x 14 1/4 in. (23.8 x 36.6 cm.)

(c. 1837)

Inscribed, u.l.: "84"; (formerly) on mount, l.c.: "Approach of a Band of Sioux.—"

Brannin Collection

PROVENANCE

the artist; Sir William Drummond Stewart (c. 1839); Frank Nichols (sale: Chapman's, Edinburgh, June 16-17, 1871); Bonamy Mansell Power; willed to Edward Power (1900); by descent to Major G. H. Power, Great Yarmouth, England (sale: PB, May 6, 1966); Kennedy Galleries, New York (1966); Dr. Mac Reinhoff, Baltimore (1966); Kennedy Galleries, New York (1972); Gerald Peters, Santa Fe (1974); William S. Reese, New Haven; Jeffrey R. Brown, North Amherst, Mass. [from photo]

EXHIBITIONS

Denver Art Museum, April 15–24, 1966; PB, April 29–May 6, 1966; Kalamazoo Institute of Arts, February 17–March 19, 1967; Yale University Art Gallery, New Haven, September 20, 1978–January 6, 1979

REFERENCES

Murthly sale notices; PB sale 2436 (May 6, 1966), lot 7 (illus.); *Kennedy Quarterly* 6, no. 2 (June 1966): no. 62, illus. p. 74; Kalamazoo Institute of Arts, *Western Art*, illus. p. 5; *Kennedy Quarterly* 11, no. 4 (March 1972): no. 172, illus. p. 224; Sandweiss, p. 62, pl. 29

155A. *Threatened Attack—Approach of a Large Body of Indians*

Watercolor on paper

9 3/4 x 14 1/4 in. (24.8 x 36.2 cm.)

(1858–1860)

The Walters Art Gallery, Baltimore, Maryland 37.1940.76

PROVENANCE

William T. Walters, Baltimore

EXHIBITIONS

"A. J. Miller Watercolors," Smithsonian, October 1956–November 1957; University of Pennsylvania Museum, Philadelphia, 1958; Marion Koogler McMay Art Institute, San Antonio, 1960

REFERENCES

Philadelphia, University of Pennsylvania Museum, *Noble Savage*, no. 44; McNay, unpaginated; American Heritage, ed., *Trappers and Mountain Men*, illus. pp. 110-111; Robert G. Athearn, *American Heritage New Illustrated History of the United States*, VI, illus. pp. 532–533; LeRoy R. Hafen, "Etienne Provost, Mountain Man and Utah Pioneer," *Utah Historical Quarterly* 36, no. 2 (Spring 1968): 99 (illus.); Ross, pl. 76

155B. *Pawnee Indians on the War-Path*

Watercolor, gouache, and pen and ink over pencil on paper

Sight: 8 5/16 x 13 15/16 in. (21.1 x 35.4 cm.)

Signed, l.l.: "AJM [monogram] iller Pt"

(1867)

Inscribed on mat, l.r.: "N⁰. 34./Pawnee Indians./'On the War Path' "

Public Archives of Canada, Ottawa, Ontario; gift of Mrs. J. B. Jardine (1946)

PROVENANCE

Alexander Brown, Liverpool, England (1867); by descent to Mrs. J. B. Jardine, Chesterknowes, Scotland

EXHIBITIONS

PAC museum, winter 1946–1947; Peale Museum, Baltimore, January 8–February 12, 1950; "Alfred Jacob Miller," ACM, February 13–March 26, 1972

REFERENCES

account book, March 26, May 8, August 10, 1867; Hunter, p. [15]; Brunet, no. 34; Bell, p. 148, illus. p. 149

155C. *Threatened Attack on the Caravan by a Horde of Indians*

Oil on paper

9 x 14 1/2 in. (23.0 x 36.8 cm.)

Signed, l.r.: "AJM [monogram]"

The Thomas Gilcrease Institute of American History and Art, Tulsa, Oklahoma 0226.1078

PROVENANCE

the artist; by descent to Mrs. Laurence R. Carton, Towson, Md.; M. Knoedler and Company, New York, #CA 4299/WCA 2053 (1952–1958)

EXHIBITIONS

Knoedler Galleries, New York, October 20–November 1,

1952; "Far West," Knoedler Galleries, New York, November 15–December 4, 1954, no. 11; Denver Art Museum, October 15–November 21, 1955

REFERENCES
Rough Draughts, no. 56; Harold McCracken, *Portrait of the Old West,* illus. p. [63]; Knoedler Galleries, Inc., *An Exhibition Featuring Paintings from Harold McCracken's Book Portrait of the Old West,* no. 10; Denver Art Museum, *Building the West,* no. 60; Krakel, *Adventures in Western Art,* p. 336, n. 28 (as *Threatened Attack on the Caravan,* watercolor)

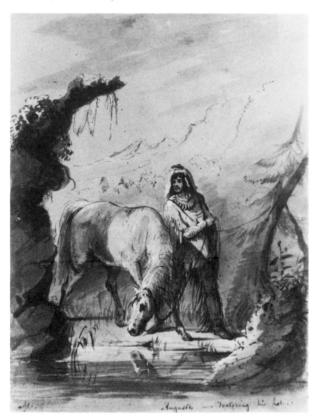

Catalogue number 156.

156. *Auguste Watering His Horse*

Pen and ink with sepia wash on paper

9 7/8 x 7 5/16 in. (25.0 x 18.5 cm.)

Signed, l.l.: "AJM. [monogram]"

Inscribed, l.r.: "Auguste—Watering his horse"

Western Americana Collection, The Beinecke Rare Book and Manuscript Library, Yale University, New Haven, Connecticut (Coe No. V, 24–25)

EXHIBITIONS
"Gallery of Dudes," ACM, January 26–March 15, 1967

REFERENCES
Withington, no. 342

156A. *Auguste and His Horse*

Watercolor, heightened with white, on paper

12 1/8 x 9 1/2 in. (30.8 x 24.1 cm.)

Signed: "Miller"

(1858–1860)

Inscribed, l.r.: "36"

The Walters Art Gallery, Baltimore, Maryland 37.1940.10

PROVENANCE
William T. Walters, Baltimore

EXHIBITIONS
"A. J. Miller Watercolors," Smithsonian, October 1956–November 1957

REFERENCES
Francis Haines, *Appaloosa: The Spotted Horse in Art and History,* illus. p. 72; Ross, pl. 10; Warner, illus. p. 81

156B. *August* [sic] *Watering His Horse*

Oil on paper

5 3/4 x 4 3/4 in. (14.6 x 12.1 cm.) (irreg.)

Stark Museum of Art, Orange, Texas 31.34/43

PROVENANCE
Edward Eberstadt and Sons, New York

REFERENCES
Eberstadt catalogue 146 (1958), no. 123-17 (illus.); Stark, p. 205

157. *Antoine Watering Stewart's Horse*

Oil on canvas

36 x 30 in. (91.4 x 76.2 cm.)

(c. 1840)

American Heritage Center, University of Wyoming, Laramie; gift of the Everett D. Graff family

PROVENANCE
Sir William Drummond Stewart (1840); Frank Nichols (sale: Chapman's, Edinburgh, June 16–17, 1871); Appleby Brothers; B. F. Stevens and Brown, London (1937); Everett D. Graff, Winnetka, Ill. (1937)

REFERENCES
Murthly sale notices; B. F. Stevens and Brown, *Coronation Catalogue,* no. 94A (g) (as *Antoine, the Indian Guide, Watering Stewart's White Arab Stallion . . .*); [University of Wyoming, Laramie] *Campus Pulse,* October 14, 1977, p. 3 (illus.); Ruth M. Collis to Ron Tyler, September 7, 1981

158. *Auguste Thrown by the Blooded Stallion— Fort Laramie*

Pen and ink with sepia wash on paper

5 1/2 x 9 in. (14.0 x 22.5 cm.)

Inscribed, u.l.: "Scenes—Fort Laramie"; u.r.: "Auguste thrown by the/blooded Stallion"; l.l.: "Je ne crains rien ni le diable lui meme [I fear nothing, not even the devil himself]"

Western Americana Collection, The Beinecke Rare Book and Manuscript Library, Yale University, New Haven, Connecticut (Coe No. V, 24–25)

EXHIBITIONS

"Gallery of Dudes," ACM, January 26–March 15, 1967; Yale University Art Gallery, New Haven, September 20, 1978–January 6, 1979

REFERENCES

Withington, no. 342; Sandweiss, p. 62 (as *Auguste Thrown from the Blooded Stallion*), pl. 28; Warner, pp. 77–80, illus. p. 81

159. *Fort Laramie or Sublette's Fort—near the Nebraska or Platte River*

Watercolor and gouache on paper

6 1/2 x 9 1/2 in. (16.5 x 24.1 cm.)

Inscribed, u.r.: "Fort Laramie or Sublette's Fort/—near the Nebraska/or Platte River"

Joslyn Art Museum, Omaha, Nebraska; InterNorth Art Foundation Collection 672

PROVENANCE

Carrie C. Miller, Annapolis; Porter Collection; M. Knoedler and Co., New York

EXHIBITIONS

Peale Museum, Baltimore, 1932; Nelson, January 1939; "Western Frontier," SLAM, April 1–May 13, 1941; City Art Museum of St. Louis, 1954; Denver Art Museum, October 15–November 21, 1955; BBHC, May 15–September 15, 1959; "Gallery of Dudes," ACM, January 16–March 15, 1967

REFERENCES

Hafen and Young, *Fort Laramie and the Pageant of the West*, frontis., n. 14; "Water Color Sketches of Indian Life a Century Ago Acquired by a Kansas Citizen," rotogravure section, p. 3 (illus.); LeRoy R. Hafen and Carl Coke Rister, *Western America*, illus. p. 229; "America and the Future," p. 118 (illus.); Gertrude Hartman, *America*, illus. p. 330, and rev. ed. (1952), illus. p. 350; DeVoto, pl. VIII; Edward Douglas Branch, *Story of America in Pictures*, unpaginated (illus.); David L. Hieb, *Fort Laramie National Monument—Wyoming*, illus. opp. p. 1; St. Louis, City Art Museum of St. Louis, *Westward*

the Way, no. 184, illus. p. 217; Denver Art Museum, *Building the West*, no. 62, illus. p. 11; [Field], *Prairie and Mountain Sketches*, frontis. Nelson and Atkins, *Last Frontier*, no. 34; American Heritage, ed., *American Heritage Book of Great Historic Places*, illus. p. 342; Life, ed., *America's Arts and Skills*, illus. p. 100; BBHC, *Land of Buffalo Bill*, no. 1; American Heritage, ed., *Treasury of American Heritage*, illus. p. [6]; Porter and Davenport, illus. fol. p. 148; "Records of a Lost World," *Museum News* 42, no. 3 (November 1963): 16 (illus.); Erwin N. Thompson, *Whitman Mission National Historic Site*, illus. pp. 24–25; Ewers, *Artists of the Old West*, illus. pp. [126–127] (as *Fort William*); Hafen, *Mountain Men*, I, illus. p. 153; Art in America, ed., *Artist in America*, illus. p. 55; Harry S. Drago, *Roads to Empire*, illus. p. 46; JAM, *Exploration in the West*, illus. p. 31; Franzwa, *Oregon Trail Revisited*, illus. p. 230; George Fronval, *La Veritable histoire des Indians Peaux-Rouges*, illus. p. 35; Reader's Digest, *Illustrated Guide to the Treasures of America*, illus. p. 370; *Art News* 74, no. 10 (December 1975): cover (illus.); Reader's Digest, *Story of the Great American West*, illus. p. 102; Warner, pp. 87–90, illus. p. 91; Goetzmann and Porter, pp. 33, 65, illus. p. 64

159A. *Fort Laramie. From Nature by A. J. Miller 1836 & 7*

Watercolor on paper

7 1/2 x 11 5/8 in. (19.0 x 29.5 cm.)

(c. 1837)

Inscribed on mount, l.l.: "Fort Laramie"; on mount, l.r.: "from Nature by A. J. Miller 1836 & 7"

Western Americana Collection, The Beinecke Rare Book and Manuscript Library, Yale University, New Haven, Connecticut (Coe No. V, 24–25)

EXHIBITIONS

"Gallery of Dudes," ACM, January 26–March 15, 1967; MFA, January 23–March 16, 1975; BBHC, May–September, 1978

REFERENCES

Withington, no. 342; Lavender, *American Heritage History of the Great West*, illus. p. 205; Marshall B. Davidson, *American Heritage History of the Artists' America*, illus. p. 139; MFA, *Frontier America*, no. 40; BBHC, *Mountain Man*, pl. 8, and *Checklist of the Exhibition*, unpaginated

159B. *Laramie's Fort*

Watercolor on paper

8 1/2 x 11 3/4 in. (21.6 x 29.8 cm.)

(1858–1860)

The Walters Art Gallery, Baltimore, Maryland 37.1940.49

PROVENANCE

William T. Walters, Baltimore

EXHIBITIONS

WCMFA, September 14–November 2, 1947; CGA, June 8–December 17, 1950; "A J. Miller Watercolors," Smithsonian, October 1956–November 1957

REFERENCES

WCMFA, *American Indian and the West*, no. 69 (as *Fort Exterior*); CGA, *American Processional*, no. 140, illus. p. 129; Davidson, *Life in America*, I, illus. p. 228 (as *Fort Laramie*); McCracken, *Portrait of the Old West*, illus. p. [62]; Eugene Kingman, "Painters of the Plains," *American Heritage* 6, no. 1, (December 1954): 35 (illus.); Wallace Stegner, "Ordeal by Handcart," *Colliers Magazine*, July 6, 1956, p. 81; Max Savelle, *Short History of American Civilization*, illus. p. 283; U.S. National Park Service, *Soldier and Brave*, illus. p. 3; Daniel M. Mendelowitz, *History of American Art*, illus. p. 318; Nunis, *Andrew Sublette*, illus. p. 60; Ruth, *Great Day in the West*, illus. p. 281; Hollmann, *Five Artists of the Old West*, illus. pp. 72–73; Charles Kelly and Dale L. Morgan, *Old Greenwood*, illus. endsheets; Alexander L. Crosby, *Old Greenwood*, illus. front endsheets; D. Alexander Brown, "Jim Bridger—A Personality Profile," *American History Illustrated* 3, no. 4 (July 1968): illus. p. 44; George E. Hyde, *Life of George Bent*, illus. opp. p. 199; Ross, pl. 49; George Fronval, *Fantastique épopée du Far West*, I, illus. p. 100; Getlein, *Lure of the Great West*, illus. p. 72; Gold, "Alfred Jacob Miller," illus. p. 24 (reversed); Abraham A. Davidson, *Story of American Painting*, illus. p. 36; Jeff C. Dykes, *Fifty Great Western Illustrators*, illus. opp. p. 246; Robert M. Utley and Wilcomb E. Washburn, *American Heritage History of the Indian Wars*, illus. p. 192; Warner, pp. 109–112, illus. p. 113

159C. *Fort Laramie*

Watercolor, gouache, and pen and ink over pencil on paper

Sight: 8 13/16 x 12 3/8 in. (22.4 x 31.4 cm.)

Signed, l.r.: "AJM [monogram] iller. Pt"

(1867)

Inscribed on mat, l.r.: "N⁰. 26./Fort Lamarie [*sic*]."

Public Archives of Canada, Ottawa, Ontario; gift of Mrs. J. B. Jardine (1946)

PROVENANCE

Alexander Brown, Liverpool, England (1867); by descent to Mrs. J. B. Jardine, Chesterknowes, Scotland

EXHIBITIONS

PAC museum, winter 1946–1947; Peale Museum, Baltimore, January 8–February 12, 1950; "Alfred Jacob Miller," ACM, February 13–March 26, 1972

REFERENCES

account book, March 26, May 8, August 10, 1867; Hunter, p. [15]; Brunet, no. 26; Bell, illus. p. 116, illus. p. 117; Warner, pp. 119–122, illus. p. 123; *Annals of Wyoming* 52, no. 2 (Fall 1980): cover (illus.)

159D. *Fort Laramie*

Watercolor and gouache on paper

4 1/4 x 6 in. (10.8 x 15.2 cm.)

Inscribed, l.c.: "11"

The Thomas Gilcrease Institute of American History and Art, Tulsa, Oklahoma 0236.1046

REFERENCES

Rough Draughts, no. 14; Warner, pp. 93–94, illus. p. 95

160. *Scene near Fort Laramie*

Pencil, watercolor, and gouache on paper

7 x 12 1/8 in. (17.8 x 30.8 cm.)

Signed, l.r.: "AJM [monogram]"

Joslyn Art Museum, Omaha, Nebraska; InterNorth Art Foundation Collection 691

PROVENANCE

Carrie C. Miller, Annapolis; Porter Collection; M. Knoedler and Co., New York

EXHIBITIONS

Peale Museum, Baltimore, 1932; Nelson, January 1939; "Western Frontier," SLAM, April 1–May 13, 1941; Nelson and Atkins, October 5–November 17, 1957; BBHC, May 15–September 15, 1959; "Gallery of Dudes," ACM, January 26–March 15, 1967

REFERENCES

DeVoto, pl. VII; Nelson and Atkins, *Last Frontier*, no. 36; BBHC, *Land of Buffalo Bill*, no. 20; Warner, pp. 83–84, 134, 138, illus. p. 85; Goetzmann and Porter, p. 65

160A. *Fort Laramie, Indian Girls Racing*

Oil on canvas

14 1/2 x 25 in. (36.8 x 63.5 cm.)

signed, l.r.: "AJM [monogram]"

(c. 1845)

Mr. and Mrs. T. Edward Hambleton, New York

PROVENANCE

[the artist; Decatur Howard Miller, Baltimore; Dr. William H. Crim, Baltimore (sale: Baltimore, April 22, 1903)?]; Frank Sherwood Hambleton, Baltimore; by descent to the present owner

EXHIBITIONS

[Fourth Regiment Armory, Baltimore, April 15–22, 1903?]; Peale Museum, Baltimore, January 8–February 12, 1950

REFERENCES

[*Catalogue of the Celebrated Dr. William H. Crim Collection . . .*, lot 1685 (as *Buffalo Hunt)?*]; Hunter, p. [14]; Warner, pp. 84, 133–134, illus. p. 135; FARL 32501

160B. *Fort Laramie (Fort Laramie Indian Camp) (Fort William on the Laramie)*

Oil on canvas

18 x 27 in. (45.7 x 68.5 cm.)

Signed and dated, l.l.: "A. J. Miller/1851"

The Thomas Gilcrease Institute of American History and Art, Tulsa, Oklahoma 0126.727

PROVENANCE

American Art-Union, New York (1851–1852, sale: December 15–17, 1852); Isaac Townsend, New York (1852); Mrs. William Bass, St. Louis; M. Knoedler and Company, New York, #CA 3161, as *Fort Laramie* or *Indians Crossing a Stream* (1948)

REFERENCES

Rough Draughts, no. 14; account book, May 6, 1851 (as *Fort Laramie Indian Camp*, $75, sent to Art-Union); *Catalogue of Pictures and Other Works of Art, the Property of the American Art Union. To Be Sold at Auction by David Austen, Jr.* (December 15–17, 1852), no. 252 (as *Racing at Laramie's Fort, on the Platte*, 27 x 18 in., sold to Isaac Townsend, New York): "The broad prairie with the isolated fort in the distance, and the foreground filled with mounted figures," cited in Cowdrey, *American Academy of Fine Arts and American Art-Union*, I: 301; [James T. Forrest], "Each Painting Its Own Story," *American Scene* 2, no. 4 (Winter 1959–1960): [1] (illus. as *Fort William*); American Heritage, ed., *Indians of the Plains*, illus. pp. 86–87; Oliver LaFarge, *American Indian*, illus. pp. 142–143; McDermott, "A. J. Miller," p. 12 (illus.); Athearn, *American Heritage New Illustrated History of the United States*, VI, illus. p. 525; [William Marshall Anderson], *Rocky Mountain Journals of William Marshall Anderson*, ed. Dale Morgan and Eleanor Towles Harris, illus. p. 37; Rossi and Hunt, p. 324, illus. p. 116 (as *Fort William on the Laramie*, ex-collection L. Vernon Miller); "Alfred Jacob Miller," *American Scene* 14, no. 4 (1973): [16–17] (illus.); "Treasures of the Gilcrease, Part I," *American Scene* 18–19, no. 1 (1978): 14 (illus.); Warner, pp. 129–130, illus. p. 131

160C. *Fort Laramie Racing*

Unlocated

REFERENCES

account book, May 31, 1864, $90 ($100–$10 commission), for Butler, Way and Co.

160D. *Racing by Indians at Fort Laramie*

9 x 14 in. (23.0 x 35.6 cm.)

Unlocated

REFERENCES

account book, May 4, 1866, $50, for George Kalbfus

160E. *Racing at Fort Laramie*

48 x 31 in. (122.0 x 78.7 cm.)

Unlocated

REFERENCES

account book, June 2, 1870, $200, for William Henry Norris

160F. *Fort Laramie*

Watercolor on blind-stamped "Bristol Board"

7 x 12 in. (17.8 x 30.5 cm.)

Signed, l.r.: "AJM [monogram] iller"

Unlocated

PROVENANCE

the artist; by descent to his niece, Mrs. Joseph Whyte (Eugenia Miller); Mrs. Arthur W. Norton, Baltimore (1973)

REFERENCES

Warner, pp. 125–126, 130, illus. p. 127

160G. *Racing at Fort Laramie*

Watercolor on paper

7 1/2 x 12 in. (19.1 x 30.5 cm.)

Signed, l.r.

Private collection

PROVENANCE

Mrs. Laurence R. Carton

REFERENCES

private collector to William R. Johnston, WAG, November 23, 1980

160H. *Fort Laramie, Indian Girls Racing*

Oil on canvas

9 1/2 x 15 1/2 in. (24.1 x 39.4 cm.)

Mr. and Mrs. J. Fife Symington, Jr., Lutherville, Maryland

PROVENANCE

[the artist; Decatur H. Miller; Dr. William H. Crim (sale: Fourth Regiment Armory, Baltimore, April 22, 1903)?]; purchased by Frank Sherwood Hambleton; by descent to the present owners

EXHIBITIONS

[Fourth Regiment Armory, Baltimore, Md., April 15–22, 1903?]

REFERENCES

[*Catalogue of the Celebrated Dr. William H. Crim Collection . . . ?*]; Warner, pp. 84, 137–138, illus. p. 139

161. *Interior of Laramie Fort*

Watercolor on paper

5 x 6 1/2 in. (12.7 x 16.5 cm.)

Signed, l.r.

Private collection

PROVENANCE

Mrs. Laurence R. Carton

REFERENCES

private collector to William R. Johnston, WAG, November 23, 1980

161A. *Interior of Fort Laramie*

Watercolor and gouache on paper

10 1/4 x 14 in. (26.0 x 35.5 cm.)

Signed, l.l.: "AJM [monogram]"

The Thomas Gilcrease Institute of American History and Art, Tulsa, Oklahoma 0236.1067

PROVENANCE

the artist; by descent to L. Vernon Miller, Baltimore; M. Knoedler and Company, New York, #CA 3223–20

REFERENCES

Rough Draughts, no. 72; "America and the Future," p. 118 (illus.); DeVoto, pl. IX; [Forrest], "Each Painting Its Own Story," p. 2 (illus. as *Interior of Ft. William*); LaFarge, *American Indian*, illus. p. 142; McDermott, "A. J. Miller," p. 12 (illus.); Hawgood, *America's Western Frontiers*, illus. p. 149; Remi Nadeau, *Fort Laramie and the Sioux Indians*, illus. opp. p. 178; Rossi and Hunt, p. 325, illus. p. 118 (as *Interior View of Fort William*); Benjamin Capps, *Indians*, illus. pp. 62–63; Cooke, *Alistair Cooke's America*, illus. pp. 172–173; Reader's Digest, *Illustrated Guide to the Treasures of America*, illus. p. 423; Warner, pp. 97–100, illus. p. 101

161B. *Interior of Fort Laramie*

Watercolor, heightened with white, on paper

11 5/8 x 14 1/8 in. (29.5 x 35.9 cm.)

Signed, l.l.: "AJM [monogram] iller"

(1858–1860)

Inscribed: "12"

The Walters Art Gallery, Baltimore, Maryland 37.1940.150

PROVENANCE

William T. Walters, Baltimore

EXHIBITIONS

Baltimore Museum of Art, May 11–June 17, 1945, no. 128; WCMFA, September 14–November 2, 1947; Nelson and Atkins, October 5–November 17, 1957; CGA, June 8–December 17, 1950

REFERENCES

Hafen and Young, *Fort Laramie and the Pageant of the West*, illus. p. 47; WCMFA, *American Indian and the West*, no. 75; Martin F. Schmitt and D. Alexander Brown, *Fighting Indians of the West*, illus. p. 27; CGA, *American Processional*, no. 141; Davidson, *Life in America*, I, illus. p. 229; Hieb, *Fort Laramie National Monument—Wyoming*, illus. p. 2; Lucius Beebe and Charles Clegg, *The American West*, illus. p. [15] (incorrectly credited to New York Public Library); Ray Allen Billington, *The Far Western Frontier, 1830–1860*, no. 10, illus. fol. p. 138; Oliver LaFarge, *Pictorial History of the American Indian*, illus. p. 177; Alexander Eliot, *Three Hundred Years of American Painting*, illus. pp. 90–91; Nelson and Atkins, *Last Frontier*, no. 41; American Heritage, ed., *American Heritage Book of the Pioneer Spirit*, illus. p. 344, and *Indians of the Plains*, illus. p. 87; Nunis, *Andrew Sublette*, illus. p. 61; American Heritage, ed., *Westward on the Oregon Trail*, illus. p. 14; Alpheus H. Favour, *Old Bill Williams*, illus. opp. p. 128; Athearn, *American Heritage New Illustrated History of the United States*, VI, illus. p. 526; Egbert W. Nieman and Elizabeth C. O'Daly, *Adventures for Readers: Book Two*, illus. p. 200; Henry W. Bragdon and Samuel P. McCutchen, *History of a Free People*, illus. p. 309; Lewis P. Todd and Merle Curti, *The Rise of the American Nation*, illus. p. 328; Fronval, *Fantastique épopée du Far West*, I, illus. p. 101; Ross, pl. 150; Dorothy Heiderstadt, *Painters of America*, illus. p. 56; U.S. National Park Service, *Soldier and Brave*, illus. p. 6; Franzwa, *Oregon Trail Revisited*, illus. p. 231; Schomaekers, *Wilde Westen*, illus. p. 82; Emily Wasserman, "The Artist-Explorers," *Art in America* 60, no. 4 (July–August 1972): 54 (illus.); *200 Years*, illus. p. 250; Reader's Digest, *Story of the Great American West*, illus. p. 103; Warner, illus. p. 107; Bobby Bridger, "Seekers of the Fleece, Part II," p. 68 (illus.)

162. *Rock of Independence, Groups of Antelope and Buffalo*

Watercolor on paper

8 3/8 x 12 7/8 in. (21.3 x 32.7 cm.)

Inscribed, u.r.: "Rock of Independence/near the Nebraska River/Groups of Antelope &/Buffalo"

Joslyn Art Museum, Omaha, Nebraska; InterNorth Art Foundation Collection 714

PROVENANCE

Porter Collection

EXHIBITIONS

Nelson, January 1939 (as *Rock of Independence near the Nebraska or Platte River—Groups of Antelope and Buffalo*); "Western Frontier," SLAM, April 1–May 13, 1941; BBHC, May 15–September 15, 1959

REFERENCES

[Field], *Prairie and Mountain Sketches*, illus. opp. p. 123; BBHC, *Land of Buffalo Bill*, no. 43; JAM, *Exploration in the West*, illus. p. 32

162A. *Rock of Independence*

Watercolor on paper

6 x 11 3/4 in. (15.2 x 29.8 cm.)

Unlocated

PROVENANCE

the artist; by descent to Louisa Whyte Norton; Old Print Shop, New York (1947); Everett D. Graff, Winnetka, Ill. (1947)

REFERENCES

Old Print Shop ledger book (June 18, 1947), no. 14

162B. *Rock of Independence*

Watercolor on paper

8 7/8 x 13 1/2 in. (22.5 x 34.3 cm.)

(1858–1860)

The Walters Art Gallery, Baltimore, Maryland 37.1940.69

PROVENANCE

William T. Walters, Baltimore

EXHIBITIONS

Denver Art Museum, October 15–November 21, 1955; Cheyenne Centennial Committee, July 1–August 15, 1967

REFERENCES

DeVoto, pl. X [reversed image?]; [Ruxton], *Ruxton of the Rockies*, illus. opp. p. 202 (as *Antelope*); Denver Art Museum, *Building the West*, no. 57 (as *Independence Rock*); Ruth, *Great Day in the West*, illus. p. 287; Cheyenne Centennial Committee, *150 Years in Western Art*, illus. p. 19; Ross, pl. 69

163. *Trappers without Ammunition and in a Starving Condition near Independence Rock*

Sepia wash on paper

14 1/4 x 18 5/8 in. (36.2 x 47.3 cm.)

Signed, l.l.: "AJM. [monogram]"

Inscribed, l.c.: "Trappers without Ammunition & in a Starving condition near Independence Rock."

Joslyn Art Museum, Omaha, Nebraska; InterNorth Art Foundation Collection 732

PROVENANCE

Porter Collection

EXHIBITIONS

"Western Frontier," SLAM, April 1–May 13, 1941; BBHC, May 15–September 15, 1959

REFERENCES

[Ruxton], *Life in the Far West*, illus. opp. p. 142; BBHC, *Land of Buffalo Bill*, no. 61 (as *Trapper without Ammunition and in a Starving Condition near Independence Rock—Killbuck and La Bonté*)

163A. *The Good Samaritan*

Oil on canvas

28 x 40 in. (71.1 x 101.6 cm.)

Signed and dated, l.c.: "A. Miller/1851"

The Thomas Gilcrease Institute of American History and Art, Tulsa, Oklahoma (1958) 0126.737

PROVENANCE

Mrs. Margaret S. Thom; M. Knoedler and Company, New York, #A4460 (1950–1959)

EXHIBITIONS

Knoedler Galleries, New York, October 20–November 1, 1952; Canadian National Exhibition, August 27–September 11, 1954, no. 119

REFERENCES

Rough Draughts, no. 21; Knoedler Galleries, *Exhibition Featuring Paintings from Harold McCracken's Book "Portrait of the Old West,"* no. 12; Krakel, *Adventures in Western Art*, p. 336, n. 28

163B. *Free Trappers in Trouble*

Watercolor on paper

8 5/16 x 12 1/8 in. (21.1 x 30.8 cm.)

Signed, l.r.: "AJM. [monogram]"

(1858–1860)

The Walters Art Gallery, Baltimore, Maryland 37.1940.163

PROVENANCE

William T. Walters, Baltimore

EXHIBITIONS

"A. J. Miller Watercolors," Smithsonian, October 1956–November 1957

REFERENCES

Ross, pl. 163; Peter H. Hassrick, *The Way West*, illus. p. 49; Bridger, "Seekers of the Golden Fleece, Part II," p. 58 (illus.)

164. *Starving Trappers near Independence Rock*

Sepia ink and wash on paper

7 3/4 x 13 in. (19.6 x 33.0 cm.)

Signed, l.l.: "AJM [monogram]"

Inscribed: "Starving Trappers near Independence Rock"

Private collection

PROVENANCE

Alfred J. Miller, Jr., Baltimore; Purnell Art Co., Baltimore; Goodyear family, Philadelphia; Kennedy Galleries, New York (1976); Joseph H. Willard, Pittsford, N.Y.; Pittsford Picture Framing Co., Pittsford, N.Y.

REFERENCES

Kennedy Quarterly 15, no. 1 (June 1976): no. 10 (illus.)

165. *Devils Gate*

Pencil, pen and ink, watercolor, and gouache on paper

11 x 9 in. (28.0 x 22.9 cm.)

Inscribed, u.r., and marked over: "Devils Gate/on the [illeg.]/River.—"

Joslyn Art Museum, Omaha, Nebraska; InterNorth Art Foundation Collection 686

PROVENANCE

Porter Collection

EXHIBITIONS

Nelson, January 1939; "Western Frontier," SLAM, April 1–May 13, 1941; BBHC, May 15–September 15, 1959

REFERENCES

BBHC, *Land of Buffalo Bill*, no. 15

165A. *Devil's Gate*

Wash and pen and ink on paper

7 x 6 1/4 in. (17.8 x 15.9 cm.)

Inscribed, l.l.: "the first/original sketch./1836"; l.r.: "Devils Gate"

The Thomas Gilcrease Institute of American History and Art, Tulsa, Oklahoma 0226.1107

PROVENANCE

M. Knoedler and Company, New York, #3174 (1948)

REFERENCES

Rough Draughts, no. 131; [Martin Wenger], "Miller Collection," *American Scene* 4, no. 3 (1962): 23

165B. *Hell-Gate, Sweet Water River (Porte d'Enfer)*

Oil on canvas

42 x 32 in. (106.7 x 81.3 cm.)

(c. 1839)

Leo J. Heaps, Toronto, Ontario, Canada

PROVENANCE

Sir William Drummond Stewart (1839); Frank Nichols (sale: Chapman's, Edinburgh, June 16–17, 1871); Farquharson family, Manor House, Scotland

EXHIBITIONS

Apollo Gallery, New York, May 9–22, 1839; University of Wyoming Art Gallery, Laramie, from 1975

REFERENCES

"Apollo Gallery—Original Paintings," *Morning Herald*, May 16, 1839, p. 2, col. 3, no 6; AJM to Decatur H. Miller, December 25, 1840, cited in Warner, p. 169; Murthly sale notices; Leo J. Heaps to Mrs. Herert W. Dickerman, Baltimore Museum of Art, July 21, 1969

165C. *The "Devil's Gate"*

Watercolor on paper

10 7/8 x 9 3/16 in. (27.6 x 23.4 cm.)

Signed, l.r.:

(1858–1860)

The Walters Art Gallery, Baltimore, Maryland 37.1940.164

PROVENANCE

William T. Walters, Baltimore

REFERENCES

DeVoto, pl; XI; Ruth, *Great Day in the West*, illus. p. 289; Ross, pl. 164; Hillman, "Part Three: Bridging a Continent," illus pp. 426–427

166. *Devil's Gate on the Sweetwater*

Oil and pencil on board

7 1/16 x 10 1/16 in. (17.9 x 25.6 cm.)

Signed, l.r.: "AJM [monogram]"

Inscribed (formerly) on mount: "Devil's Gate./on the Sweet Water"

Stark Museum of Art, Orange, Texas 31.34/35

PROVENANCE

Edward Eberstadt and Sons, New York

EXHIBITIONS

City Art Museum of St Louis, 1954

REFERENCES

Eberstadt catalogue 131 (1953), no. 449 (illus back cover as watercolor); St. Louis, City Art Museum, *Westward the Way*, no. 11, illus p. 42; Eberstadt catalogue 146 (1958), no. 123–46; Stark, p. 205

167. *Rocky Pass—in a Storm—Caravan Crossing the Heights*

Pen and ink with gray wash and touches of white over pencil on paper

8 3/8 x 18 1/2 in. (21.5 x 26.8 cm.)

(c. 1837)

Inscribed, u.l.: "74"

Earl C. Adams, San Marino, California (1966)

PROVENANCE

the artist; Sir William Drummond Stewart (c. 1839); Frank Nichols (sale: Chapman's, Edinburgh, June 16–17, 1871); Bonamy Mansell Power; willed to Edward Power (1900); by descent to Major G. H. Power, Great Yarmouth, England (sale: PB, May 6, 1966); Dawson's Book Shop, Los Angeles (1966)

EXHIBITIONS

Denver Art Museum, April 15–24, 1966; PB, April 29–May 6, 1966; Old Mint, San Francisco, June 16–September 15, 1973; Santa Barbara Museum of Art, November 10, 1973–January 6, 1974

REFERENCES

Murthly sale notices; PB sale 2436 (May 6, 1966), lot 62; Knox, "83 Drawings from 1837 Trek," p. 28; Dawson's Book Shop, Los Angeles, *Northwest Coast* (cat. 361, n.d.), no. 260 (illus.); Baird, *West Remembered*, no. 3, illus. p. [19]

167A. *Storm: Waiting for the Caravan*

Watercolor on paper

9 5/16 x 12 15/16 in. (23.7 x 32.9 cm.)

(1858–1860)

The Walters Art Gallery, Baltimore, Maryland 37.1940.147

PROVENANCE

William T. Walters, Baltimore

EXHIBITIONS

"Western Frontier," Denver Art Museum, 1966

REFERENCES

Ross, pl. 147

168. *Storm*

Pencil with brown wash on paper

6 1/2 x 8 3/8 in. (16.7 x 21.2 cm.)

(c. 1837)

Inscribed, u.l.: "49."; u.c.: "Storm"

Eugene B. Adkins, Tulsa, Oklahoma

PROVENANCE

the artist; Sir William Drummond Stewart (c. 1839); Frank Nichols (sale: Chapman's, Edinburgh, June 16–17, 1871); Bonamy Mansell Power; willed to Edward Power (1900); by descent to Major G. H. Power, Great Yarmouth, England (sale: PB, May 6, 1966); Kennedy Galleries, New York (1968)

EXHIBITIONS

Denver Art Museum, April 15–24, 1966; PB, April 29–May 6, 1966

REFERENCES

Murthly sale notices; PB sale 2365 (May 6, 1966), lot 63; Knox, "83 Drawings from 1837 Trek," p. 28; *Kennedy Quarterly* 8, no. 2 (June 1968): no. 122 (illus. as 6 1/2 x 12 1/2 in.)

169. *Greeting the Trappers*

Watercolor on paper

Sight: 6 1/2 x 9 1/2 in. (16.7 x 24.0 cm.)

Inscribed, l.r.: "Greeting the Trappers"

Whitney Gallery of Western Art, Buffalo Bill Historical Center, Cody, Wyoming 8.70; gift of the W. R. Coe Foundation, Oyster Bay, N.Y.

PROVENANCE

Lawrence A. Fleishman, Detroit, (c. 1960); M. Knoedler and Company, New York

EXHIBITIONS

National Cowboy Hall of Fame, Oklahoma City, June 25–October 10, 1965; BBHC, May–September 1978

REFERENCES

Oklahoma City, National Cowboy Hall of Fame, *Inaugural Exhibition*, p.15, illus. p. 16; BBHC, *Mountain Man*, pl. 18, and *Checklist of the Exhibition*, cover

169A. *Sir William Drummond Stewart Meeting Indian Chief (Greeting of the Snakes and the Whites, under the Mountains of the Winds)*

Oil on canvas

33 x 42 in. (83.8 x 106.7 cm.)

(c. 1839)

The Thomas Gilcrease Institute of American History and Art, Tulsa, Oklahoma 0126.73

PROVENANCE

Sir William Drummond Stewart (1839); Frank Nichols (sale: Chapman's, Edinburgh, June 16–17, 1871)

EXHIBITIONS

Apollo Gallery, New York, May 9–22, 1839

REFERENCES

Rough Draughts, no. 148; "Apollo Gallery—Original Paintings," *Morning Herald*, May 16, 1839, p. 2, col. 3, no. 12 (as *Greeting of the Snake Indians and the Whites, under the Mountains of the Winds*); Murthly sale notices; "Portrait of Sir William Drummond Stewart on Horseback Greeting a Group of Indians," undated note in the Albert Duveen files, roll NDu2, frame 259, and photograph, frame 260; "Sir William D. Stewart," *American Scene* 4, no. 3 (1962): 21 (illus.)

169B. *The Greeting*

Watercolor on paper

9 1/8 x 12 13/16 in. (23.2 x 32.6 cm.)

Signed, l.c.: "AJM [monogram] iller"

(1858–1860)

The Walters Art Gallery, Baltimore, Maryland 37.1940.133

PROVENANCE

William T. Walters, Baltimore

REFERENCES

Ross, pl. 133; Bridger, "Seekers of the Fleece, Part II," p. 54 (illus.)

170. *Indian Encampment near the Wind River Mountains*

Pencil with black and gray washes on paper

6 3/8 x 9 1/2 in. (16.2 x 24.1 cm.)

(c. 1837)

Inscribed, u.l.: "6"; u.c.: "Indian Encampment near the wind River Mountains"; on mount, l.c.: "Indian Encampment near the Wind-River Mountains"

Whitney Gallery of Western Art, Buffalo Bill Historical

Center, Cody, Wyoming 15.80; gift of the Joseph M. Roebling Estate

PROVENANCE

the artist; Sir William Drummond Stewart (c. 1839); Frank Nichols (sale: Chapman's, Edinburgh, June 16–17, 1871); Bonamy Mansell Power; willed to Edward Power (1900); by descent to Major G. H. Power, Great Yarmouth, England (sale: PB, May 6, 1966); Joseph M. Roebling

EXHIBITIONS

Denver Art Museum, April 15–24, 1966; PB, April 29–May 6, 1966

REFERENCES

Murthly sale notices; PB sale 2436 (May 6, 1966), lot 81; Knox, "83 Drawings from 1837 Trek," p. 28

170A. *Pipe of Peace at the Rendezvous (Camp of the Indians at the Rendezvous of the Whites near the Mountains of the Winds)*

Oil on canvas

39 1/4 x 69 1/4 in. (99.7 x 175.9 cm.)

(c. 1839)

Stark Museum of Art, Orange, Texas 31.34/29

PROVENANCE

Sir William Drummond Stewart; Frank Nichols (sale: Chapman's, Edinburgh, June 16–17, 1871); [Judah P. Benjamin, London (d. Paris, 1884)?]; Appleby Brothers; B. F. Stevens and Brown, London; Sir Henry Wellcome, London (sale: Christie's, London); Julian H. Youche, Crown Point, Ind. (unsold at sale: American Art Association Anderson Galleries, New York, December 9, 1938); Mrs. Anna K. Winter, New York; Old Print Shop, New York (1943–1944); withdrawn from PB sale, September 1944; Mae Reed Porter (December 7, 1944); Edward Eberstadt and Sons, New York (1954–1958)

EXHIBITIONS

Apollo Gallery, New York, May 9, 1839; American Art Association Anderson Galleries, New York, December 3–9, 1938; "Romantic Painting in America," Museum of Modern Art, New York, 1943 (not listed in catalogue); Rhode Island School of Design, Providence, April–August 1944; JAM, May 12–July 4, 1954

REFERENCES

"Apollo Gallery—Original Paintings," *Morning Herald*, May 16, 1839, p. 2, col. 3, no. 1 (as *Camp of the Indians at the Rendezvous of the Whites, near the Mountains of the Winds*); Murthly sale notices; "Sale of Pictures from Murthly Castle," *Scotsman*, June 17, 1871, p. 2, cols. 3–4 (as *Interview of Sir William Drummond Stewart with the Indians of the Rocky Mountains*); B. F. Stevens and Brown,

Coronation Catalogue, p. 13; American Art Association Anderson Galleries sale 4420 (December 9, 1938), lot 176 (illus. as *View of an Indian Encampment, White Explorers, and Numerous Indian Figures*); ledger book L-960, pp. 18–19 (1943–1945), and undated letter from Mrs. Anna K. Winter (as *Lafitte the Pirate*), Old Print Shop, New York; [Old Print Shop, New York] *Portfolio* 3, no. 3 (November 1943): 68–69, illus. p. 68; JAM, *Life on the Prairie: The Artist's Record*, p. 5; Eberstadt catalogues 139 (n.d.), no. 1, cover (illus.), and 146 (1958), no. 123–1 (illus.); Stark p. 207; FARL 120 B and vertical file, no. 7 (as *Lafitte the Pirate*, collection of Philip Benjamin); Miss Ruth M. Collis to Ron Tyler, September 7, 1981

170B. *The Pipe of Peace*

Watercolor on paper

8 3/8 x 14 1/2 in. (21.3 x 36.8 cm.)

Signed, l.l.: "AJM [monogram]"

(1858–1860)

The Walters Art Gallery, Baltimore, Maryland 37.1940.186

PROVENANCE

William T. Walters, Baltimore

EXHIBITIONS

Montreal Museum of Fine Arts, June 9–July 30, 1967

REFERENCES

Montreal Museum of Fine Arts, *Painter and the New World*, no. 290 (illus.); Ross, pl. 186

170C. *The Rendezvous near Green River, Oregon*

Watercolor, gouache, and pen and ink over pencil on paper

Sight: 7 9/16 x 14 1/16 in. (19.2 x 35.8 cm.)

Signed, l.l.: "AJM [monogram] iller Pt"

(1867)

Inscribed on mat, l.r.: "N⁰. 39./The Rendezvous,/'Near Green River Oregon' "

Public Archives of Canada, Ottawa, Ontario; gift of Mrs. J. B. Jardine (1946)

PROVENANCE

Alexander Brown, Liverpool, England (1867); by descent to Mrs. J. B. Jardine, Chesterknowes, Scotland

EXHIBITIONS

PAC museum, winter 1946–1947; Peale Museum, Baltimore, January 8–February 12, 1950; "Alfred Jacob Miller," ACM, February 13–March 26, 1972

REFERENCES

account book, March 26, May 8, August 10, 1867; Hunter p. [15]; Brunet, no. 39 (illus.); Bell, p. 172, illus. p. 173

171. *Encampment on Green River at the Base of Rocky Mountains*

Pencil, watercolor, and gouache on paper

8 1/4 x 14 3/8 in. (21.0 x 36.5 cm.)

Inscribed, u.l.: "Blkfeet as hostages [illeg.]eds [illeg.] waters"; u.r.: "Encampment on Green/River—at the base/of the Rocky Mountains"

Joslyn Art Museum, Omaha, Nebraska; InterNorth Art Foundation Collection 724

PROVENANCE

Carrie C. Miller, Annapolis; Porter Collection; M. Knoedler and Company, New York

EXHIBITIONS

Nelson, January 1939 (as *Encampment of Indians near the Rocky Mountains*); "Western Frontier," SLAM, April 1–May 13, 1941; BBHC, May 15–September 15, 1959; JAM, July 3–October 17, 1976; Yale University Art Gallery, New Haven, September 20, 1978–January 6, 1979

REFERENCES

DeVoto, pl. XXXIII (as *Camp along Green River*); "How the West Was Won: Part I," p. 92 (illus.); BBHC, *Land of Buffalo Bill*, no. 53 (as *Encampment of Indians near the Rocky Mountains*); Flexner, *That Wilder Image*, no. 21, illus. p. 91 (as *Camp Along Green River*, 5 1/2 x 7 7/8 in., collection of Knoedler Galleries); Porter and Davenport, illus. fol. p. 148; John Francis Roche, *Frontier Nation*, illus. p. 169; Hawgood, *America's Western Frontiers*, illus. p 100; Schomaekers, *Wilde Westen*, illus. p. 53; Robert V. Hine, *American West*, illus. p. 53 (as *Indian Encampment near Green River Rendezvous*); JAM, *Artists of the Western Frontier*, no. 71, illus. p. 15; Sandweiss, p. 62; Goetzmann and Porter, p. 66

171A. *Indian Village*

Oil on canvas

30 1/4 x 48 1/4 in. (76.7 x 122.5 cm.)

(c. 1850)

Amon Carter Museum, Fort Worth, Texas 20.66

PROVENANCE

Governor Thomas Swann of Maryland; by descent to Mrs. Charles Gillette, Baltimore; Kennedy Galleries, New York

EXHIBITIONS

USIA Traveling Exhibit, Amerykánski Zachód, 1974; Tokyo and Osaka, Japan, April–May 1976

REFERENCES

ACM, *Catalogue of the Collection*, no. 115, illus. p. 55; ibid., *Amerykański Zachód*, no. 25, illus. p. 36, and *Art Works of the American West*, no. 27 (illus.)

172. *Cut Rocks*

Pencil, watercolor, and gouache on paper

5 3/4 x 8 1/2 in. (14.6 x 21.6 cm.) Signed, l.l.: "AJM [monogram]"

Inscribed, u.r.: "Cut Rocks"

Joslyn Art Museum, Omaha, Nebraska; InterNorth Art Foundation Collection 698

PROVENANCE

Carrie C. Miller, Annapolis; Porter Collection; M. Knoedler and Company, New York

EXHIBITIONS

Nelson, January 1939; "Western Frontier," SLAM, April 1-May 13, 1941; BBHC, May 15-September 15, 1959

REFERENCES

"America and the Future," p. 111 (illus.); BBHC, *Land of Buffalo Bill*, no. 27; Goetzmann and Porter, pp. 65-66

172A. *Large Encampment Nr the Cut Rocks*

Watercolor on paper

8 5/8 x 12 3/8 in. (21.9 x 31.4 cm.)

(1858–1860)

The Walters Art Gallery, Baltimore, Maryland 37.1940.110

PROVENANCE

William T. Walters, Baltimore

EXHIBITIONS

[WCMFA, September 14–November 2, 1947?]; "A. J. Miller Watercolors," Smithsonian, October 1956–November 1957; University at Minnesota Gallery, Minneapolis, June 13–August 18, 1978

REFERENCES

[WCMFA, *American Indian and the West*, no. 65 (as *Encampment on the Plains*)?]; [Leonard], *Zenas Leonard Fur Trader*, illus. opp. p. 60 (as *Trappers' Rendezvous*); Ross, pl. 110; Hassrick, *Way West*, illus. p. 46; Minneapolis, University of Minnesota Gallery, *People of the Plains*, no. 45

173. *Rendezvous near Green River (General View of the Indian Camp under the Mountains of the Winds)*

Oil on canvas

32 x 38 in. (81.2 x 96.5 cm.)

(c. 1839)

American Heritage Center, University of Wyoming, Laramie; gift of the Everett D. Graff family

PROVENANCE

Sir William Drummond Stewart (1839); Frank Nichols (sale: Chapman's, Edinburgh, June 16–17, 1871); Appleby Brothers; B. F. Stevens and Brown, London (1937); Everett D. Graff, Winnetka, Ill. (1937)

EXHIBITIONS

Apollo Gallery, New York, May 9–22, 1839; City Art Museum of St. Louis, 1954; BBHC, 1978

REFERENCES

"Apollo Gallery—Original Paintings," *Morning Herald*, May 16, 1839, p. 2, col. 3, no. 14 (as *General View of the Indian Camp under the Mountains of the Winds*); Murthly sale notices; B. F. Stevens and Brown, *Coronation Catalogue*, no. 94A (a) (as *Encampment at the Base of the Rocky Mountains*, 26 x 38 in.), pl. 5; Jay Monaghan, "The Whimsical Art of Alfred Jacob Miller," *Chicago Tribune*, November 19, 1950, graphic section, p. 14, illus. p. 8; St. Louis, City Art Museum, *Westward the Way*, no. 137, illus. p. 174 (as *Rendezvous in the Wind River Mountains*, 26 x 38 in); William Brandon, "The Wild Freedom of the Mountain Men," *American Heritage* 6, no. 5 (August 1955): 9 (illus.); American Heritage, ed., *Golden Book of America*, illus. p. 99; Eliot, *Three Hundred Years of American Painting*, illus. p. 92; White, *Indians and the Old West*, illus. p. 31; American Heritage, ed., *America on Parade*, illus. p. 57, and *American Heritage Book of the Pioneer Spirit*, illus. p. 165, and *Trappers and Mountain Men*, illus. pp. 100–101; Athearn, *American Heritage New Illustrated History of the United States*, VI, illus. pp. 534–535; Robert L. Polley, ed., *Beauty of America in Great American Art*, illus. p. 76 (as *Fur Trappers Rendezvous*); [University of Wyoming, Laramie] *Campus Pulse*, October 14, 1977, p. 3; BBHC, *Mountain Man*, pl. 20, and *Checklist of the Exhibition*, unpaginated; Miss Ruth M. Collis to Ron Tyler, September 7, 1981

174. *Indian Encampment (Rendezvous—Rocky Mountains)*

Pen and ink with gray wash on pink card

8 3/8 x 13 1/2 in. (21.4 x 34.4 cm.)

(c. 1837)

Inscribed, u.l.: "56"

The Dentzel Collection 1731

the artist; Sir William Drummond Stewart (c. 1839);
Frank Nichols (sale: Chapman's, Edinburgh, June 16–17,
1871); Bonamy Mansell Power; willed to Edward Power
(1900); by descent to Major G. H. Power, Great
Yarmouth, England (sale: PB, May 6, 1966)

EXHIBITIONS

Denver Art Museum, April 15–24, 1966; PB, New York,
April 29–May 6, 1966; Los Angeles County Museum of
Art, March 21–May 28, 1972; BBHC, 1978; Seattle Art
Museum, July 15–September 26, 1976

REFERENCES

Murthly sale notices; PB sale 2436 (May 6, 1966), lot 73
(illus.); Knox, "83 Drawings from 1837 Trek," p. 28; Los
Angeles County Museum of Art, *American West*, no. 10,
pl. 28; Getlein, *Lure of the Great West*, illus. p. 70; Seattle
Art Museum, *Lewis and Clark's America*, no. 63, illus. p.
28 (as *Rendezvous—Rocky Mountains*); BBHC, *Mountain
Man: Checklist of the Exhibition*, unpaginated (as
Rendezvous—Rocky Mountains)

174A. *Rendezvous*

Watercolor on paper

8 1/2 x 14 3/8 in. (21.6 x 36.5 cm.)

Signed, l.l.: "AJM. [monogram]"

(1858–1860)

The Walters Art Gallery, Baltimore, Maryland
37.1940.159

PROVENANCE

William T. Walters, Baltimore

EXHIBITIONS

MFA, October 10–December 10, 1944; "Building the
West," Denver Art Museum, 1955; Nelson and Atkins,
October 5–November 17, 1957; "Gallery of Dudes,"
ACM, January 26–March 15, 1967; Cheyenne Centennial
Committee, July 1–August 15, 1967

REFERENCES

MFA, *Sport in American Art*, no. 77; DeVoto, pl. LXXIV
(as *Jim Bridger in Armor at Green River*); Davidson, *Life
in America*, I, illus. p. 199 (as *Scene at the Green River
Rendezvous of 1837*); Nelson and Atkins, *Last Frontier*
(1957), no. 43; Berry, *Majority of Scoundrels*, illus. fol.
p. 242; Phillips, *Fur Trade*, II, illus. opp. p. 121; J. Cecil
Alter, *Jim Bridger*, illus. opp. p. 260; Ruth, *Great Day in
the West*, illus. p. 279; Cheyenne Centennial Committee,
150 Years in Western Art; Brown, "Jim Bridger—A
Personality Profile," pp. 8–9 (illus.); Hafen, *Mountain
Men*, V, frontis.; Ross, pl. 159; Gordon Speck, *Breeds and
Halfbreeds*, illus. p. 264; Reader's Digest, *Story of the Great
American West*, illus. p. 105

174B. *Shoshone Encampment at Green River Rendezvous*

Watercolor and gouache on paper

7 x 14 in. (17.8 x 35.5 cm.)

Inscribed, l.r.: "Encampment of Shoshonee [sic] Indians
on the Green River"

The Thomas Gilcrease Institute of American History and
Art, Tulsa, Oklahoma 0236.1071

REFERENCES

Rough Draughts, no. 146

175. *Snake Indian Council*

Pencil, pen and ink, wash, and gouache on paper

8 1/4 x 13 1/2 in. (21.0 x 34.3 cm.)

Joslyn Art Museum, Omaha, Nebraska; InterNorth Art
Foundation Collection 715

PROVENANCE

Porter Collection

EXHIBITIONS

Nelson, January 1939; "Western Frontier," SLAM, April
1–May 13, 1941; BBHC, May 15–September 15, 1959

REFERENCES

DeVoto, pl. XXVII; BBHC, *Land of Buffalo Bill*, no. 44;
JAM, *Exploration in the West*, illus. p. 31

175A. *Indian Council*

Watercolor on paper

8 9/16 x 12 5/8 in. (21.8 x 32.0 cm.)

Signed, l.c.: "AJM [monogram] iller"

(1858–1860)

The Walters Art Gallery, Baltimore, Maryland
37.1940.127

PROVENANCE

William T. Walters, Baltimore

REFERENCES

Alexander Ross, *Fur Hunters of the Far West*, illus. fol.
p. 72; American Heritage, ed., *Indians of the Plains*, illus.
p. 43; Athearn, *American Heritage New Illustrated History
of the United States*, VI, illus. p. 506; John A. Garraty,
American Nation, illus. p. 467 (as *Snake Indian Council*);
Felton, *Edward Rose*, illus. fol. p. 48; Ross, pl. 127

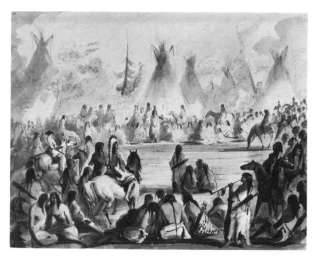

Catalogue number 176.

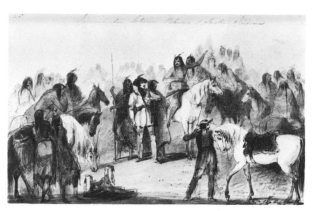

Catalogue number 177.

176. *Indians Assembled in Grand Council to Hold a "Talk"*

Pencil and pen and ink with gray wash on gray card

8 3/4 x 10 7/8 in. (21.4 x 27.7 cm.)

(c. 1837)

Inscribed, u.l.: "50"

Whitney Gallery of Western Art, Buffalo Bill Historical Center, Cody, Wyoming 3.73

PROVENANCE

the artist; Sir William Drummond Stewart (c. 1839); Frank Nichols (sale: Chapman's, Edinburgh, June 16–17, 1871); Bonamy Mansell Power; willed to Edward Power (1900); by descent to Major G. H. Power, Great Yarmouth, England (sale: PB, May 6, 1966)

EXHIBITIONS

Denver Art Museum, April 15–24, 1966; PB, April 29–May 6, 1966

REFERENCES

Murthly sale notices; PB sale 2436 (May 6, 1966), lot 75 (illus.); Knox, "83 Drawings from 1837 Trek," p. 28

177. *Reconciliation between Delaware and Snake Indians*

Pencil and pen and ink with brown and yellow washes, heightened with white, on paper

7 1/4 x 10 5/8 in. (18.2 x 27.0 cm.)

Inscribed, u.l.: "28"; u.c.: "Reconciliation between Deleware [*sic*] and Snake Indians"

Amon Carter Museum, Fort Worth, Texas 29.66

PROVENANCE

the artist; Sir William Drummond Stewart (c. 1839); Frank Nichols (sale: Chapman's, Edinburgh, June 16–17, 1871); Bonamy Mansell Power; willed to Edward Power (1900); by descent to Major G. H. Power, Great Yarmouth, England (sale: PB, May 6, 1966)

EXHIBITIONS

Denver Art Museum, April 15–24, 1966; PB, April 29–May 6, 1966; Huntsville Museum of Art, September 8–November 26, 1978

REFERENCES

Murthly sale notices; PB sale 2435 (May 6, 1966), no. 77 (illus.); Knox, "83 Drawings from 1837 Trek," p. 28; ACM, *Catalogue of the Collection*, no. 118, illus. p. 57; Huntsville Museum of Art, *Art of the American West*, no. 9

178. *Indian Procession, Headed by the Chief Ma-Wo-Ma*

Pencil, pen and ink, and watercolor, heightened with white, on paper

7 7/8 x 14 5/8 in. (19.9 x 37.1 cm.)

(c. 1837)

Inscribed, u.l.: "80"

Unlocated

PROVENANCE

the artist; Sir William Drummond Stewart (c. 1839); Frank Nichols (sale: Chapman's, Edinburgh, June 16–17, 1871); Bonamy Mansell Power; willed to Edward Power (1900); by descent to Major G. H. Power, Great Yarmouth, England (sale: PB, May 6, 1966)

EXHIBITIONS

Denver Art Museum, April 15–24, 1966; PB, April 29–May 6, 1966

REFERENCES

Murthly sale notices; PB sale 2436 (May 6, 1966), lot 79 (illus.); Knox, "83 Drawings from 1837 Trek," p. 28

178A. *Cavalcade (Indian Grand Parade) (Indian Procession)*

Oil on canvas

69 x 96 in. (175.3 x 251.5 cm.)

Signed and dated, l.r.: "Alfred Miller Pt/1839"

State Museum, Oklahoma Historical Society, Oklahoma City; gift of E. W. Marland (1935)

PROVENANCE

Sir William Drummond Stewart (1839); Frank Nichols (sale: Chapman's, Edinburgh, June 16–17, 1871); Joseph McDonough Co., Albany, N.Y. (1910s?); Anderson Galleries, New York (c. 1926); Norman James, Baltimore; E. W. Marland, Ponca City, Okla. (until 1935)

EXHIBITIONS

Apollo Gallery, New York, May 9–22, 1839; Fort Worth Club, July 1935

REFERENCES

"Sir William Stewart—His Paintings—Taste—Character, etc.," *Morning Herald*, October 2, 1839, p. 2, col. 5, and *Perthshire [Scotland] Courier*, November 7, 1839, p. 4, col. 1; "Apollo Gallery," *New-York Mirror*, November 9, 1839, p. 159, and November 16, 1839, p. 166 (as *Indian Procession*); *Catalogue of Paintings and Sculpture, by Living Artists in the Fall Exhibition of the "Apollo Association for the Promotion of the Fine Arts in the United States"* . . . (October 1839), no. 247, cited in Cowdrey, *American Academy of Fine Arts and American Art-Union*, I, 270–271, and II, 254; Murthly sale notices; No 1 in undated sale notice of Joseph McDonough Co., Albany, in J. Hall

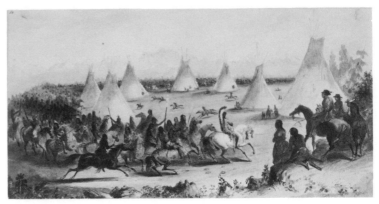

Catalogue number 178.

Pleasants file; No. 1 in undated sale notice of Reynolds Galleries, 39 W; 57th Street, New York, in Alfred Jacob Miller vertical file; "Portrait of Sir William Drummond Stewart on Horseback Greeting a Group of Indians," undated note in Albert Duveen files, roll NDu2, frame 259; Amon Carter to E. W. Marland, July 13, 1935, and E. W. Marland to Amon Carter, July 16, 1935 (as *Indian Encampment*), Amon Carter Foundation files; W. J. Ghent, *Early Far West*, illus. opp. p. 262 (as *A Rendezvous in the Mountains*, courtesy Norman James); Sydney Greenbie, *Furs to Furrows*, frontis.

178B. *Cavalcade*

Watercolor on paper

10 7/8 x 15 in. (27.6 x 38.1 cm.)

Signed, l.r.: "AJM [monogram]"

(1858–1860)

The Walters Art Gallery, Baltimore, Maryland 37.1940.199

PROVENANCE

William T. Walters, Baltimore

REFERENCES

Virginia C. Trenholm and Maurine Carley, *Shoshonis*, illus. opp. p. 66; Ross, pl. 199; Benjamin Capps, *Great Chiefs*, illus. pp. 134–135

178C. *Rendezvous—Indian Procession in Honor of Capt. W. D. Stewart in the Rocky Mtns.*

Pencil, watercolor, and gouache on paper

9 3/4 x 15 1/4 in. (24.8 x 38.8 cm.)

The Thomas Gilcrease Institute of American History and Art, Tulsa, Oklahoma 0236.1092

PROVENANCE

the artist; by descent to L. Vernon Miller, Baltimore; M. Knoedler and Company, New York, #CA 3223–23 (1949)

REFERENCES

Rough Draughts, no. 164; "America and the Future," p. 120 (illus.); DeVoto, pl. XIII; Josephy, "First 'Dude Ranch' Trip to the Untamed West," p. 15 (illus.); American Heritage, ed., *Golden Book of America*, illus. p. 119; McDermott, "A. J. Miller," p. 7 (illus.); American Heritage, ed., *Westward on the Oregon Trail*, illus. pp. 60–61; Ewers, *Artists of the Old West*, illus. pp. [130–131]; Harold Haydon, *Great Art Treasures in American Museums*, illus. p. 164, and *Great Art Treasures in America's Smaller Museums*, illus. p. 164; Rossi and Hunt, p. 325, illus. p. 120 (as *Trappers' Rendezvous*); Getlein, *Lure of the Great West*, illus. p. 88; Saint Stephens Indian School, Wind River Reservation, Saint Stephens, Wyo., *Wind River Rendezvous*, p. [1] (illus. as *Shoshoni Indian Procession at the Trappers' Rendezvous on Green River*)

179. *Green River, Oregon*

Watercolor on paper

7 1/2 x 11 3/4 in. (19.1 x 29.8 cm.)

Private collection

PROVENANCE

Mrs. Laurence R. Carton

REFERENCES

private collector to William R. Johnston, WAG, November 23, 1980

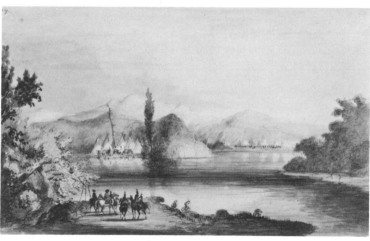

Catalogue number 180.

180. *Green River Camp & Rendezvous— Mountains in the Distance Covered with Snow*

Pencil and watercolor on white card blind-stamped "Bristol Board"

7 5/8 x 14 9/16 in. (19.3 x 30.7 cm.)

(c. 1837)

Inscribed, u.l.: "79"; on mount, l.c.: "Green River Camp & Rendezvous—Mountains in the/distance covered with Snow.—"

Western Americana Collection, The Beinecke Rare Book and Manuscript Library, Yale University, New Haven, Connecticut; gift of Frederick William Beinecke

PROVENANCE

the artist; Sir Williiam Drummond Stewart (c. 1839); Frank Nichols (sale: Chapman's, Edinburgh, June 16–17, 1871); Bonamy Mansell Power; willed to Edward Power (1900); by descent to Major G. H. Power, Great Yarmouth, England (sale: PB, May 6, 1966); bought by Edward Eberstadt and Sons for Frederick William Beinecke

EXHIBITIONS

Denver Art Museum, April 15–24, 1966; PB, April 29–May 6, 1966

REFERENCES

Murthly sale notices; PB sale 2436 (May 6, 1966), lot 78 (illus.); Knox, "83 Drawings from 1837 Trek," p. 28

181. *Indian Race*

Pen and ink with gray wash on white card blind-stamped "Bristol Board"

7 5/8 x 12 7/8 in. (19.5 x 31.0 cm.)

(c. 1837)

Inscribed, u.l.: "70"

Whitney Gallery of Western Art, Buffalo Bill Historical Center, Cody, Wyoming 4.73

PROVENANCE

the artist; Sir William Drummond Stewart (c. 1839); Frank Nichols (sale: Chapman's, Edinburgh, June 16–17, 1871); Bonamy Mansell Power; willed to Edward Power (1900); by descent to Major G. H. Power, Great Yarmouth, England (sale: PB, May 6, 1966)

EXHIBITIONS

Denver Art Museum, April 15–24, 1966; PB, April 29–May 6, 1966

REFERENCES

Murthly sale notices; PB sale 2436 (May 6, 1966), lot 20 (illus.); Knox, "83 Drawings from 1837 Trek," p. 28

182. *Scene at "Rendezvous"*

Watercolor on paper

9 x 15 1/2 in. (23.0 x 39.4 cm.)

(1858–1860)

The Walters Art Gallery, Baltimore, Maryland
37.1940.175

PROVENANCE

William T. Walters, Baltimore

EXHIBITIONS

MFA, October 10–December 10, 1944; "Major Work in Minor Scale," American Federation of Arts, 1959–1960

REFERENCES

MFA, *Sport in American Art*, no. 76; Nunis, *Andrew Sublette*, illus. p. 56; Felton, *Jim Beckwourth*, illus. fol. p. 46; Ross, plates LIII, 175; Hillman, "Part Three: Bridging a Continent," illus. pp. 454–455; Getlein, *Lure of the Great West*, illus. pp. 62–63; Fraser Symington, *First Canadians* (1978), illus. p. 2; Truettner, *Natural Man Observed*, illus. p. 47; Bridger, "Seekers of the Golden Fleece, Part II," p. 63 (illus.)

182A. *Horse Racing near Wind River, Oregon*

Watercolor on paper

8 3/4 x 13 3/4 in. (22.2 x 35.0 cm.)

Signed, l.l.: "AJM [monogram]"

Inscribed, u.r.: "Racing/near Wind River/Oregon"

The Thomas Gilcrease Institute of American History and Art, Tulsa, Oklahoma 0236.1091

PROVENANCE

Edward Eberstadt and Sons, New York (c. 1957)

REFERENCES

Rough Draughts, no. 164; Eberstadt catalogue 139 (1957?), no. 79 (illus. as *Horserace at the Rendezvous*, gouache, 9 x 14 in.); Ernest F. Darling, "Rendezvous at Pierre's Hole Was One Wingding of a Fling," *Gilcrease Magazine of American History and Art* 3, no. 2 (April 1981): 22–23 (illus. as *Horse Racing through Wind River, Oregon*, oil)

183. *Racing—near Wind River Mountain*

Pencil, pen and ink, and watercolor on paper

7 1/16 x 8 5/16 in. (17.9 x 21.2 cm.)

(c. 1837)

Inscribed, u.l.: "1"; on mount, l.c.: "Racing—near Wind River Mountains"

Western Americana Collection, The Beinecke Rare Book and Manuscript Library, Yale University, New Haven, Connecticut; gift of Frederick William Beinecke

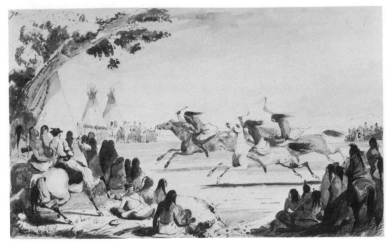

Catalogue number 181.

PROVENANCE

the artist; Sir William Drummond Stewart (c. 1839); Frank Nichols (sale: Chapman's, Edinburgh, June 16–17, 1871); Bonamy Mansell Power; willed to Edward Power (1900); by descent to Major G. H. Power, Great Yarmouth, England (sale: PB, May 6, 1966); bought by Edward Eberstadt and Sons for Frederick William Beinecke

EXHIBITIONS

Denver Art Museum, April 15–24, 1966; PB, April 29–May 6, 1966

REFERENCES

Murthly sale notices; PB sale 2436 (May 6, 1966), lot 80 (illus.); Knox, "83 Drawings from 1837 Trek," p. 28

184. *Shoshone Camp (Shoshones)*

Watercolor on paper

Sight: 7 1/4 x 10 5/8 in. (18.4 x 27.0 cm.)

Inscribed, l.r.: "Shoshones"

Whitney Gallery of Western Art, Buffalo Bill Historical Center, Cody, Wyoming 32.64; gift of the W. R. Coe Foundation, Oyster Bay, New York

PROVENANCE

the artist; by descent to Louisa Whyte Norton; Old Print Shop, New York (1947); Jack Bartfield; Edward Eberstadt and Sons, New York; John Howell—Books, San Francisco (1961)

REFERENCES

Old Print Shop ledger book (June 18, 1947), no. 19 (as *Shoshone or Snake Indians*, 7 3/4 x 11 in.); Swingle, *Catalogue 33: Rare Books and Manuscripts*, no. 101 (as *Shoshones*, 7 5/8 x 10 7/8 in.)

184A. *Encampment*

Watercolor on paper

8 5/16 x 12 3/8 in. (21.1 x 31.4 cm.)

(1858–1860)

The Walters Art Gallery, Baltimore, Maryland
37.1940.129

PROVENANCE

William T. Walters, Baltimore

EXHIBITIONS

[WCMFA, September 14–November 2, 1947?]

REFERENCES

[WCMFA, *American Indian and the West*, no. 65 (as *Encampment on the Plains*)?]; Ross, pl. 129

185. *Females; Snake Tribe, Driving Horses*

Pencil, watercolor, and gouache on paper

4 1/4 x 7 3/4 in. (10.8 x 19.7 cm.)

Signed, l.r.: "AJM [monogram]"

Joslyn Art Museum, Omaha, Nebraska; InterNorth Art
Foundation Collection 771

PROVENANCE

the artist; by descent to Mrs. Laurence R. Carton; M.
Knoedler and Company, New York, #WCA 2228 (1965)

185A. *Indian Girls: Racing*

Watercolor on paper

8 15/16 x 13 in. (22.7 x 33.0 cm.)

(1858–1860)

The Walters Art Gallery, Baltimore, Maryland 37.1940.96

PROVENANCE

William T. Walters, Baltimore

REFERENCES

Ross, pl. 96

186. *Hunting Elk by Moonlight*

Watercolor on paper

8 x 11 1/2 in. (20.4 x 29.2 cm.)

Signed, l.r.: "AJM [monogram]"

Inscribed on verso: "property of Mrs. Joseph Whyte 27."

Mandel Ourisman, Washington, D.C. (1973)

PROVENANCE

Mrs. Joseph Whyte; Mrs. Bernadette Larkin, Baraboo,
Wisc.; Kramer, Minneapolis; Kennedy Galleries, New
York

187. *Leaving Camp at Sunrise*

Pencil and ink with gray wash on white card blind-
stamped "Bristol Board"

7 5/8 x 12 3/16 in. (19.4 x 31.0 cm.)

(c. 1837)

Inscribed: "75"

Unlocated

PROVENANCE

the artist; Sir William Drummond Stewart (c. 1839);
Frank Nichols (sale: Chapman's, Edinburgh, June 16–17,
1871); Bonamy Mansell Power; willed to Edward Power
(1900); by descent to Major G. H. Power, Great
Yarmouth, England (sale: PB, May 6, 1966)

EXHIBITIONS

Denver Art Museum, April 15–24, 1966; PB, April
29–May 6, 1966

REFERENCES

Murthly sale notices; PB sale 2436 (May 6, 1966), lot 28
(illus.); Knox, "83 Drawings from 1837 Trek," p. 28

187A. *Moving Camp*

Watercolor on paper

8 3/4 x 12 11/16 in. (22.2 x 32.2 cm.)

(1858–1860)

The Walters Art Gallery, Baltimore, Maryland
37.1940.187

PROVENANCE

William T. Walters, Baltimore

REFERENCES

Ross, pl. 187

187B. *Departure of the Camp at Sunrise*

Watercolor and gouache on paper

7 x 11 1/2 in. (17.8 x 24.6 cm.)

Inscribed, l.l.: "Departure of the camp at sunrise"

The Thomas Gilcrease Institute of American History and
Art, Tulsa, Oklahoma 0236.1088

REFERENCES

Rough Draughts, no. 132

188. *Shoshone Slicing Meat*

Watercolor on paper

4 9/16 x 4 3/4 in. (11.5 x 12.0 cm.)

Western Americana Collection, The Beinecke Rare Book
and Manuscript Library, Yale University, New Haven,
Connecticut (Coe No. V, 24–25)

"Gallery of Dudes," ACM, January 26–March 15, 1967

REFERENCES

Withington, no. 342

188A. *Shoshonee* [sic] *Indian Preparing His Meal*

Watercolor, heightened with white, on paper

10 x 8 5/8 in. (25.4 x 21.9 cm.)

Signed: "Miller"

(1858–1860)

Inscribed: "9"

The Walters Art Gallery, Baltimore, Maryland 37.1940.24

PROVENANCE

William T. Walters, Baltimore

EXHIBITIONS

"A. J. Miller Watercolors," Smithsonian, October 1956–November 1957

REFERENCES

Ross, pl. 24

189. *Shoshone Mother and Children*

Pencil, pen and ink, watercolor, and gouache on paper

8 1/4 x 11 in. (21.0 x 28.0 cm.)

Inscribed, l.c.: "Shoshonee [sic] Mother & Children"

Joslyn Art Museum, Omaha, Nebraska; InterNorth Art Foundation Collection 682

PROVENANCE

Porter Collection

EXHIBITIONS

Nelson, January 1939; "Western Frontier," SLAM, April 1–May 13, 1941; BBHC, May 15–September 15, 1959

REFERENCES

BBHC, *Land of Buffalo Bill*, no. 11 (as *Shoshone Mother and Child*)

189A. *Visit to the Lodge of an Indian Chief*

Pen and ink with gray and yellow washes, heightened with white (oxidized)

7 1/2 x 10 1/2 in. (18.1 x 27.0 cm.)

(c. 1837)

Inscribed, u.l.: "87"

Eugene B. Adkins, Tulsa, Oklahoma

PROVENANCE

the artist; Sir William Drummond Stewart (c. 1839); Frank Nichols (sale: Chapman's, Edinburgh, June 16–17, 1871); Bonamy Mansell Power; willed to Edward Power (1900); by descent to Major G. H. Power, Great

Yarmouth, England (sale: PB, May 6, 1966); Chapellier Galleries, New York (1966)

EXHIBITIONS

Denver Art Museum, April 15–24, 1966; PB, April 29–May 6, 1966; Phoenix Art Museum, November 1971–January 1972

REFERENCES

Murthly sale notices; PB sale 2365 (May 6, 1966), lot 19; Knox, "83 Drawings from 1837 Trek," p. 28; Chapellier Galleries, New York, *One Hundred American Selections . . .* , no. 60 (illus.); Ross, p. XXXIV; Phoenix Art Museum, *Western Art from the Eugene B. Adkins Collection*, no. 50

189B. *Encampment of Indians*

Watercolor on paper

8 5/8 x 11 13/16 in. (21.9 x 30.0 cm.)

Signed, l.c.: "AJM—[monogram]"

(1858-1860)

The Walters Art Gallery, Baltimore, Maryland 37.1940.167

PROVENANCE

William T. Walters, Baltimore

REFERENCES

Ross, pl. 167

189C. *Shoshone Mother and Children*

Watercolor on paper

6 x 5 in. (15.2 x 12.7 cm.)

Unlocated

PROVENANCE

the artist; by descent to Louisa Whyte Norton; Old Print Shop, New York (1947); Everett D. Graff, Winnetka, Ill. (1947)

REFERENCES

Old Print Shop ledger book (June 18, 1947), no. 38

190. *Visit to an Indian Camp of the Border of a Lake*

Watercolor on paper

7 7/8 x 12 7/8 in. (19.9 x 32.7 cm.)

Signed, l.r.: "AJM [monogram]"

Inscribed, l.r.: "Visit to an Indian Camp on the Border of a Lake"

The Boatmen's National Bank of St. Louis, Missouri (May 26, 1947)

PROVENANCE
the artist; by descent to Louisa Whyte Norton; Old Print Shop, New York (1947)

EXHIBITIONS
BNB, May 4–29, 1964

REFERENCES
Cowdrey and Comstock, "Alfred Jacob Miller and the Farthest West," p. 1; BNB, *Catalog,* no. 35

190A. *Visit to an Indian Camp*

Watercolor on paper

8 15/16 x 13 3/16 in. (22.7 x 33.5 cm.)

(1858–1860)

The Walters Art Gallery, Baltimore, Maryland
37.1940.152

PROVENANCE
William T. Walters, Baltimore

REFERENCES
Ross, pl. 152

191. *The Trapper's Bride*

Watercolor and gouache on paper

10 3/4 x 8 1/2 in. (27.3 x 21.6 cm.)

Signed, l.l.: "AJM [monogram]"

Inscribed, u.r.: "The Trappers Bride"

The Thomas Gilcrease Institute of American History and Art, Tulsa, Oklahoma 0236.1063

PROVENANCE
Maryland Historical Society; M. Knoedler and Company, New York, #CA 3981/WCA 1702, as 11 x 13 3/8 in. (1954–1959)

REFERENCES
Rough draughts, no. 2; "Alfred Jacob Miller," *American Scene* 14, no. 4 (1973): [18] (illus.); Krakel, *Adventures in Western Art,* p. 336, n. 28; Darling, "Rendezvous at Pierre's Hole Was One Wingding of a Fling," p. 24 (illus.)

191A. *The Trapper's Bride (An American Indian Marriage)*

Oil on canvas

(1841)

Unlocated

PROVENANCE
Sir William Drummond Stewart (1841); Frank Nichols (sale: Chapman's, Edinburgh, June 16–17, 1871)

REFERENCES
AJM to Decatur H. Miller, June 24, November 1, May

19, 1841, cited in Warner, pp. 43, 44, 47, 174; Murthly sale notices

191B. *Trapper's Bride*

Oil on canvas

19 x 16 in. (48.3 x 40.7 cm.)

Signed, l.l.: "AJM [monogram] iller"

(early 1840s)

Scott L. Probasco, Jr.

REFERENCES
Chattanooga, Hunter Museum of Art, *An American Collection,* no. 1 (illus.)

191C. *Bartering for a Bride (The Trapper's Bride)*

Oil on canvas

36 x 28 in. (91.4 x 71.1 cm.)

Signed and dated, l.c.: "A. Miller/1845"

Inscribed, verso on stretcher (before relining): "B. Cunard Esq. [B. C. Ward Esq?]"

Harrison Eiteljorg, Indianapolis, Indiana

PROVENANCE
private collection, Boston; William Postar, Boston; Kennedy Galleries, New York (1978)

REFERENCES
probably the picture purchased by B. C. Ward, account book, January 20, 1846; *Kennedy Quarterly* 16, no. 2 (June 1978): no. 81 (illus.); Harrison Eiteljorg, *Treasures of the American West,* illus. p. 21

191D. *Indian Bride*

Unlocated

REFERENCES
account book, January 20, 1846, $150, for B. C. Ward; Maryland Historical Society Annual Exhibition (1848), no. 34 (as *Trappers Bride*)

191E. *The Trapper's Bride*

Oil on canvas

35 1/2 x 28 1/2 in. (90.2 x 72.4 cm.)

Johns Hopkins Hospital, Baltimore

PROVENANCE
Johns Hopkins, Baltimore (1846)

REFERENCES
account book, February 15, 1846, $150, for Johns Hopkins; J. Hall Pleasants file

191F. *The Trapper's Bride*

Oil on canvas

30 x 25 in. (81.3 x 63.5 cm.)

Signed, and dated, l.l.: "Miller/1850"

Joslyn Art Museum, Omaha, Nebraska 1963.612

PROVENANCE

Porter Collection; M. Knoedler and Company, New York, #A 7598 (1960–1965)

EXHIBITIONS

BBHC, May 15–September 15, 1959; Flint Institute of Arts, November 15–December 6, 1964; BBHC, 1978

REFERENCES

possibly the painting commissioned by H. Oelrichs, account book, September 1, 1850, $125; *Beaver: Magazine of the North* 285 (Autumn 1954): illus. inside back cover, and (September 1954): illus. p. 59; BBHC, *Land of Buffalo Bill*, no. 83; "How the West Was Won: Part I," p. 93 (illus.); American Heritage, ed., *Trappers and Mountain Men*, illus. p. 131; Favour, *Old Bill Williams*, illus. opp. p. 81; Flint Institute of Arts, *Artists of the Old West*, no. 36 (illus.); Ewers, *Artists of the Old West*, illus. p. [125]; Walter O'Meara, *Daughters of the Country*, illus. fol. p. 178; Vincent Price, *Vincent Price Treasury of American Art*, illus. p. 79; Schomaekers, *Wilde Westen*, illus. p. 54; Fronval, *Veritable histoire des Indians Peaux Rouges*, illus. p. 30; Getlein, *Lure of the Great West*, illus. p. 73; JAM, *Artists of the American Frontier*, no. 65, illus. p. 14; George P. Tomko to Arthur J. Phelan, Jr., September 12, 1977, collection of Arthur J. Phelan, Jr.; Reader's Digest, *Story of the Great American West*, illus. p. 95; Monaghan, "Hunter and the Artist," p. [9] (illus.); BBHC, *Mountain Man*, pl. 21, and *Checklist of the Exhibition*, unpaginated

191G. *Trappers Bride*

Unlocated

REFERENCES

account book, June 12, 1856, $175, for Chas. Deford

191H. *The Trapper's Bride*

Watercolor, heightened with white, on paper

12 x 9 3/8 in. (30.5 x 23.8 cm.)

Signed, l.r.: "A JMiller"

(1858–1860)

Inscribed, l.c.: "2"

The Walters Art Gallery, Baltimore, Maryland 37.1940.12

PROVENANCE

William T. Walters, Baltimore

EXHIBITIONS

Baltimore Musuem of Art, May 11–June 17, 1945; Lakeview, April 19–June 2, 1968

REFERENCES

Baltimore Museum of Art, *Two Hundred Years of Painting in Maryland*, no. 126; [Ruxton], *Life in the Far West*, illus. opp. p. 94 (incorrrectly credited to Porter Collection); Nunis, *Andrew Sublette*, illus. p. 62; Berry, *Majority of Scoundrels*, illus. fol. p. 242; Alter, *Jim Bridger*, illus. opp. p. 261; John Willard, *Adventure Trails in Montana*, illus. p. 147; Brown, "Jim Bridger—A Personality Profile," p. 10 (illus.); Lakeview, *Westward the Artist*, no. 92 (illus.); 13; Ross, pl. 12; Glubok, *Art of the Old West*, illus p. 13; Bridger, "Seekers of the Fleece, Part II," p. 66 (illus.)

192. *Making Presents to Snake Indians*

Oil on paper

7 x 6 1/4 in. (17 8 x 15.9 cm.)

Inscribed, u.c.: "Presents to the Snake Indians"

Joslyn Art Museum, Omaha, Nebraska; InterNorth Art Foundation Collection 741

PROVENANCE

Carrie C. Miller, Annapolis; Porter Collection; M. Knoedler and Company, New York

EXHIBITIONS

Nelson, January 1939; "Western Frontier," SLAM, April 1–May 13, 1941; BBHC, May 15–September 15, 1959

REFERENCES

DeVoto, pl. LXXIII; BBHC, *Land of Buffalo Bill*, no. 70; Goetzmann and Porter, p. 65

192A. *Confering* [sic] *Presents on Indian Chiefs*

Pencil with gray and yellow washes on paper

6 7/8 x 6 1/16 in. (17.5 x 15.4 cm.)

(c. 1837)

Inscribed, u.l.: "37"

Unlocated

PROVENANCE

the artist; Sir William Drummond Stewart (c. 1839); Frank Nichols (sale: Chapman's, Edinburgh, June 16–17, 1871); Bonamy Mansell Power; willed to Edward Power (1900); by descent to Major G. H. Power, Great Yarmouth, England (sale: PB, May 6, 1966)

EXHIBITIONS

Denver Art Museum, April 15–24, 1966; PB, April 29–May 6, 1966

REFERENCES

Murthly sale notices; PB sale 2436 (May 6, 1966), lot 76 (illus.); Knox, "83 Drawings from 1837 Trek," p. 28

192B. *Presents to Indians*

Watercolor, heightened with white, on paper

11 1/4 x 9 7/16 in. (28.6 x 24.0 cm.)

Signed. l.l.: "AJM [monogram] iller"

(1858–1860)

Inscribed, l.r.: "51"

The Walters Art Gallery, Baltimore, Maryland 37.1940.13

PROVENANCE

William T. Walters, Baltimore

EXHIBITIONS

"Western Frontier," Denver Art Museum, 1966

REFERENCES

Davidson, *Life in America,* I, illus. p. 197; Nunis, *Andrew Sublette,* illus p. 57; Rasky, *Taming of the Canadian West,* illus. p. 117; Ross, pl. 13; American Heritage, ed., *American Heritage Book of Great Adventures of the Old West,* illus. p. 137; Hillman, "Part Three: Bridging a Continent," illus. p. 362; Schomaekers, *Wilde Westen,* illus. p. 77; Getlein, *Lure of the Great West,* p. 63 (illus as *Presents for the Snake Indians*); Reader's Digest, *Story of the Great American West,* illus. p. 105

193. *Enroute, Rocky Mountains*

Watercolor on paper

4 3/4 x 7 1/2 in. (12.1 x 19.0 cm.)

Stark Museum of Art, Orange, Texas 31.34/15

PROVENANCE

Edward Eberstadt and Sons, New York

REFERENCES

Eberstadt catalogues 134 (1954), no. 402, and 146 (1958), no. 123–36; Stark, p. 205

194. *River Scenery in Route to Rocky Mountains*

Watercolor on paper

3 3/4 x 6 in. (9.5 x 15.2 cm.)

The Thomas Gilcrease Institute of American History and Art, Tulsa, Oklahoma 0236.1117

REFERENCES

perhaps one of two landscapes commissioned by William C. Wilson, account book, June 25, 1853

195. *Rocky Mountains*

Watercolor on paper

9 x 12 3/4 in. (23.0 x 32.4 cm.)

Unlocated

PROVENANCE

the artist; by descent to Louisa Whyte Norton; Old Print Shop, New York (1947); Everett D. Graff, Winnetka, Ill. (1947)

REFERENCES

Old Print Shop ledger book (June 18, 1947), no. 15

196. *River Eau Sucre*

Watercolor on paper

8 11/16 x 12 1/4 in. (22.1 x 31.1 cm.)

Signed, l.c.: "AJM [monogram] iller"

(1858–1860)

The Walters Art Gallery, Baltimore, Maryland 37.1940.97

PROVENANCE

William T. Walters, Baltimore

EXHIBITIONS

"A. J. Miller Watercolors," Smithsonian, October 1956–November 1957; University of Pennsylvania Museum, Philadelphia, May 8–September 8, 1958

REFERENCES

Philadelphia, University of Pennsylvania Museum, *Noble Savage,* no. 42; Ross, pl. 97; Capps, *Great Chiefs,* illus. pp. 130–131

196A. *Eau Sucre River (Camp on Lake)*

Oil on pebble texture board

Sight: 6 3/4 x 9 1/2 in. (17.2 x 24.1 cm.)

Whitney Gallery of Western Art, Buffalo Bill Historical Center, Cody, Wyoming 38.64; gift of the W. R. Coe Foundation, Oyster Bay, New York

PROVENANCE

the artist; by descent to Louisa Whyte Norton; Old Print Shop, New York (1947); Peter Decker, New York (1947); Hammer Galleries, New York (1961–1963); Edward Eberstadt and Sons, New York

EXHIBITIONS

Fine Arts Museum of New Mexico, Santa Fe, October 8–November 22, 1961

REFERENCES

Old Print Shop ledger book (June 18, 1947), no. 44 (as *Eau Sucre River,* 7 x 10 in.); Santa Fe, Fine Arts Museum of New Mexico, *Artist in the American American West, 1800–1900,* no. 44; Hammer Galleries, *Works of Charles M. Russell and Other Western Artists,* no. 32 (illus.)

196B. *Mountain Lake*

Oil on canvas

9 x 18 in. (23.0 x 45.7 cm.)

Signed, l.l.: "AJM [monogram]"

The Thomas Gilcrease Institute of American History and Art, Tulsa, Oklahoma 0126.724

PROVENANCE

[Victor D. Spark, New York; M. Knoedler and
Company, New York, #A 4031, as *Indian Encampment*
(1948–1949)?]

REFERENCES

Rough Draughts, no. 39

197. *Landscape, Distant Mountains* [Indian village in foreground]

Watercolor, heightened with white, on paper

Sight: 7 3/4 x 10 7/8 in. (19.7 x 27.6 cm.)

Private collection

PROVENANCE

the artist; by descent to Louisa Whyte Norton; Old Print
Shop, New York (1947); private collection (1947)

REFERENCES

Old Print Shop ledger book (June 18, 1947), no. 30

198. *Indian Encampment, Wind River Mountains*

Pencil and gouache on paper

6 1/8 x 9 1/2 in. (15.6 x 24.1 cm.)

Signed, l.r.: "A. Miller"

Inscribed (formerly) on mount: "Carrie C. Miller, 3
Oklahoma Terrace, Annapolis, Maryland. Wind River
Mountains Oregon."

Stark Museum of Art, Orange, Texas 31.34/26

PROVENANCE

Carrie C. Miller, Annapolis; Edward Eberstadt and Sons,
New York

REFERENCES

Eberstadt catalogue 146 (1958), no. 123–43; Stark, p. 206

199. *The Mountain Torrent*

Watercolor on paper

9 5/16 x 12 1/2 in. (23.6 x 31.7 cm.)

Signed, l.l.: "AJM [monogram] iller"

(1858–1860)

The Walters Art Gallery, Baltimore, Maryland
37.1940.120

PROVENANCE

William T. Walters, Baltimore

EXHIBITIONS

"A. J. Miller Watercolors," Smithsonian, October
1956–November 1957; "American Landscape: A Changing
Frontier," National Collection of Fine Arts, Smithsonian
Institution, April 28–June 19, 1966 (not in catalogue);
Seattle Art Museum, July 15–September 26, 1976

REFERENCES

Ross, pl. 120; Seattle Art Museum, *Lewis and Clark's
America*, no. 55, illus. p. 58

199A. *The Mountain Torrent*

Watercolor and gouache on paper

8 1/4 x 10 1/4 in. (21.0 x 26.0 cm.)

Signed, l.l.: "AJM [monogram]"

The Thomas Gilcrease Institute of American History and
Art, Tulsa, Oklahoma 0236.1083

REFERENCES

Rough Draughts, no. 150

200. *Lake Scene—Wind River Mountains*

Pencil, watercolor, and gouache on paper

8 3/8 x 11 5/8 in. (21.3 x 29.5 cm.)

Joslyn Art Museum, Omaha, Nebraska; InterNorth Art
Foundation Collection 774

PROVENANCE

estate of Mrs. Laurence R. Carton; M. Knoedler and
Company, New York, #WCA 2223 (1965)

EXHIBITIONS

JAM, 1967

REFERENCES

[BBHC, *Land of Buffalo Bill*, no. 6 or 25?]; Ewers, *Artists
of the Old West*, illus. p. [128]; JAM, *Exploration in the
West*, illus. p. 32; J. Gray Sweeney, "The Artist-Explorers
of the American West, 1860–1880," Ph.D. dissertation, p.
108, fig. 22 (as *Wind River Mountains*)

200A. *Lake Scene W. River Mountain*

Watercolor on paper

9 1/8 x 12 1/2 in. (23.2 x 31.7 cm.)

Signed, l.c.

(1858–1860)

The Walters Art Gallery, Baltimore, Maryland 37.1940.81

PROVENANCE

William T. Walters, Baltimore

EXHIBITIONS

"A. J. Miller Watercolors," Smithsonian, October 1956–
November 1957

REFERENCES

Ross, pl. 81

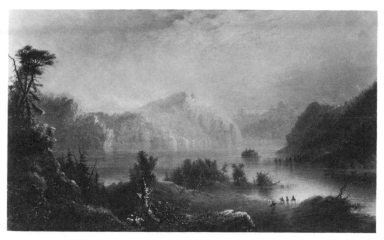

Catalogue number 200B.

EXHIBITIONS

"Gallery of Dudes," ACM, January 26–March 15, 1967

REFERENCES

Old Print Shop ledger book (June 18, 1947), no. 49 (as *River Scenery, Rocky Mountains*, 5 x 7 1/4 in.); Withington, no. 341

200B. *Trappers Enroute to the Rendezvous*

Oil on board

10 x 16 in. (25.4 x 40.6 cm.)

The Gund Collection of Western Art, Cleveland, Ohio; gift of George Gund III, 1973

PROVENANCE

Mrs. K. Daniel; Old Print Shop, New York (1947); Edward Eberstadt and Sons, New York (1947); C. R. Smith, Washington, D.C.; Kennedy Galleries, New York (1966); George Gund III, San Francisco

REFERENCES

Old Print Shop ledger book (1947); [Eberstadt catalogue 130 (1952), no. 385?]; American Heritage, ed., *Westward on the Oregon Trail*, illus. pp. 20–21; *Kennedy Quarterly* 6, no. 2 (June 1966): no. 63 (illus. as *Enroute for the Rendezvous—Wind River Country*, oil on canvas); Wallace Stegner, "Historian by Serendipity," *American Heritage* 24, no. 5 (August 1973): 30–31 (illus.); Cleveland, The Gund Collection, *The Gund Collection of Western Art*, no. 64 (as *Trappers Going to the Rendezvous*)

201. *River Scenery en Route—Rocky Mountains*

Oil on paper, mounted on board

6 3/4 x 4 3/4 in. (17.0 x 12.0 cm.)

Inscribed on mount: "River Scenery en route Rocky Mountains"

Western Americana Collection, The Beinecke Rare Book and Manuscript Library, Yale University, New Haven, Connecticut (Coe No. V, 26)

PROVENANCE

the artist; by descent to Louisa Whyte Norton; Old Print Shop, New York (1947); Edward Eberstadt and Sons, New York

202. *Lake—Wind River Range*

Pencil, watercolor, and gouache on paper

7 x 10 3/4 in. (17.8 x 27.3 cm.)

Joslyn Art Museum, Omaha, Nebraska; InterNorth Art Foundation Collection 772

PROVENANCE

estate of Mrs. Laurence R. Carton; M. Knoedler and Company, New York, #WCA 2227 (1965)

202A. *Lake Scene*

Watercolor on paper

9 3/16 x 12 5/16 in. (23.4 x 31.2 cm.)

(1858–1860)

The Walters Art Gallery, Baltimore, Maryland 37.1940.77

PROVENANCE

William T. Walters, Baltimore

REFERENCES

William C. Kennerly, *Persimmon Hill*, illus. opp. p. 196; Ross, pl. 77

203. *Lake Scene—Wind River Range*

Oil on canvas

9 x 12 1/4 in. (23.0 x 31.1 cm.)

Signed, l.r.: "A M"

Mr. and Mrs. Daniel W. Calhoun, Jr.

PROVENANCE

by descent from Mr. Calhoun's great uncle, Alexander H. Post

204. *Lake, Wind River Mountains*

Watercolor and gouache

Sight: 8 13/16 x 12 1/2 in. (22.4 x 31.7 cm.)

Signed, l.l.: "AJM [monogram] iller"

Rosenstock Arts, Denver, Colorado

PROVENANCE

[M. Knoedler and Company, New York, #WCA 3445; Dean Fenton Krakel, Oklahoma City?]; Rosenstock Arts, Denver; private collection

205. *Lake, Wind River Mountains*

Pencil, watercolor, and gouache on paper

9 1/8 x 12 1/8 in. (23.2 x 30.8 cm.)

Signed, l.c.: "AJM [monogram]"

Inscribed, u.r.: "Lake Scene/Wind River Moun [illeg.]"

Joslyn Art Museum, Omaha, Nebraska; InterNorth Art Foundation Collection 687

PROVENANCE
Carrie C. Miller, Annapolis; Porter Collection; M. Knoedler and Company, New York

EXHIBITIONS
"Western Frontier," SLAM, April 1–May 13, 1941; [City Art Museum of St. Louis, 1954?]; BBHC, May 15–September 15, 1959

REFERENCES
St. Louis, City Art Museum, *Westward the Way*, no. 12, illus. p. 43 (as *Lake Scene. Wind River Mountains*, 10 x 12 1/2 in.); BBHC, *Land of Buffalo Bill*, no. 16; Goetzmann and Porter, p. 62, illus. p. 50

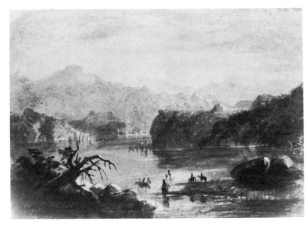

Catalogue number 205A.

205A. *Lake Damala—Wind River Range*

Watercolor on paper

5 1/8 x 7 5/16 in. (18.5 x 13.0 cm.)

Western Americana Collection, The Beinecke Rare Book and Manuscript Library, Yale University, New Haven, Connecticut (Coe No. V, 24–25)

EXHIBITIONS
"Gallery of Dudes," ACM, January 26–March 15, 1967

REFERENCES
Withington, no. 342

205B. *Lake Scene*

Watercolor on paper

8 3/16 x 11 1/2 in. (20.8 x 24.6 cm.)

(1858–1860)

The Walters Art Gallery, Baltimore, Maryland
37.1940.154

PROVENANCE
William T. Walters, Baltimore

REFERENCES
Ross, pl. 154

206. *Chain Lake in the Rocky Mountains*

Pencil, watercolor, and gouache on paper

8 5/8 x 11 3/8 in. (21.9 x 29.9 cm.)

Signed, l.r.: "AJM [monogram]"

Joslyn Art Museum, Omaha, Nebraska; InterNorth Art Foundation Collection 780

PROVENANCE
Mrs. Lloyd O. Miller; M. Knoedler and Company, New York, #WCA 2434 (1960–1965)

REFERENCES
"Records of a Lost World," *Museum News* 42, no. 3 (November 1963): 16 (illus.); Art in America, *Artist in America*, illus. p. 55

206A. *Lake Scene—Wind River Mts.*

Watercolor on paper

9 7/16 x 13 in. (24.0 x 33.0 cm.)

[Signed, l.c.: "Miller" ?]

(1858–1860)

The Walters Art Gallery, Baltimore, Maryland
37.1940.146

PROVENANCE
William T. Walters, Baltimore

206B. *Lake in Wind River Mountains*

Pencil, watercolor, and gouache on paper

9 x 11 1/2 in. (23.0 x 24.6 cm.)

The Thomas Gilcrease Institute of American History and Art, Tulsa, Oklahoma 0236.1022

PROVENANCE
Victor D. Spark, New York; M. Knoedler and Company, New York, #WCA 884, as *Indian Encampment by Lake* (1948)

REFERENCES
Rough Draughts, no. 98; *Look to the Mountain Top*, ed. Charles Jones, illus. p. 3

EXHIBITIONS

"A. J. Miller Watercolors," Smithsonian, October 1956–November 1957

REFERENCES

Ross, pl. 146

207. *Lake Scene, Wind River Mountains*

Watercolor and gouache on paper

5 x 7 3/4 in. (12.7 x 19.7 cm.)

Signed, l.r.: "AJM [monogram]"

Joslyn Art Museum, Omaha, Nebraska; InterNorth Art Foundation Collection 696

PROVENANCE

Porter Collection

EXHIBITIONS

"Western Frontier," SLAM, April 1–May 13, 1941

REFERENCES

[BBHC, *Land of Buffalo Bill*, no. 6 or 25?]

208. *Lake Scene—Wind River Mountains*

Watercolor on paper

7 3/4 x 11 1/4 in. (19.7 x 28.6 cm.)

Signed, l.l.: "AJM [monogram]"

Inscribed, u.r.: "Lake Scene—Wind River Mountain"; u.l.: "N 44"; l.l.: "Lake of Wind River Mountain"

Joslyn Art Museum, Omaha, Nebraska; InterNorth Art Foundation Collection 677

PROVENANCE

Porter Collection

EXHIBITIONS

"Western Frontier," SLAM, April 1–May 13, 1941

REFERENCES

[BBHC, *Land of Buffalo Bill*, no. 6 or 25?]

208A. *Lake Scene*

Watercolor on paper

9 1/16 x 15 15/16 in. (23.0 x 40.5 cm.)

(1858–1860)

The Walters Art Gallery, Baltimore, Maryland 37.1940.116

PROVENANCE

William T. Walters, Baltimore

REFERENCES

Ross, pl. 116

208B. *Lake in Wind River Mountains*

Watercolor with pen and ink on paper

9 x 14 5/8 in. (22.9 x 37.2 cm.)

Signed, l.l.: "AJM [monogram] iller"

Stark Museum of Art, Orange, Texas 31.34/10

PROVENANCE

Edward Eberstadt and Sons, New York

REFERENCES

Eberstadt catalogue 146 (1958), no. 123–22; Stark, p. 206

209. *Lake Scene—Rocky Mountains*

Watercolor on paper

4 3/4 x 7 1/4 in. (12.1 x 18.4 cm.)

Signed, l.r.: "AJM [monogram]"

Joslyn Art Museum, Omaha, Nebraska; InterNorth Art Foundation Collection 769

PROVENANCE

the artist; by descent to Mrs. Laurence R. Carton; Porter Collection; M. Knoedler and Company, New York, #CA 4310/WCA 2229 (1965)

REFERENCES

Goetzmann and Porter, p. 63

210. *Wind River Chain*

Watercolor on paper

7 1/2 x 11 1/2 in. (19.1 x 24.6 cm.)

Signed, l.r.

Private collection

PROVENANCE

Mrs. Laurence R. Carton

REFERENCES

private collector to William R. Johnston, WAG, November 23, 1980

211. *Lake, Wind River Chain of Mountains*

Watercolor on paper

7 3/8 x 11 7/8 in. (18.8 x 30.2 cm.)

Inscribed, u.l.: "Wind River Mountains"; u.r.: "no. 151"; on mount: "Lake./Wind river chain of mountains"; on verso: "Carrie C. Miller/3 Oklahoma Terrace/Annapolis Maryland"

Joslyn Art Museum, Omaha, Nebraska; InterNorth Art Foundation Collection 689

PROVENANCE

Carrie C. Miller, Annapolis; Porter Collection; M. Knoedler and Company, New York

EXHIBITIONS

Nelson, January 1939; "Western Frontier," SLAM, April 1–May 13, 1941; Art Institute of Chicago, February 15–March 25, 1945; WMAA, April 17–May 18, 1945; BBHC, May 15–September 15, 1959; Los Angeles County Museum of Art, March 21–May 28, 1972; JAM, July 3–October 17, 1976

REFERENCES

Chicago, Art Institute of Chicago, *Hudson River School and the Early American Landscape Tradition*, no. 134, illus. p. 75; DeVoto, pl. XXIX; BBHC, *Land of Buffalo Bill*, no. 18; Los Angeles County Museum of Art, *American West*, no. 11, illus. p. 53; Getlein, *Lure of the Great West*, illus. p 87; JAM, *Artists of the Western Frontier*, no. 72, illus. p. 15; Sweeney, "Artist-Explorers of the American West," pp. 108–109, fig. 23; Goetzmann and Porter, p. 63

211A. *Mountain Lake*

Watercolor on paper

8 15/16 x 13 in. (22.7 x 33.0 cm.)

Signed, l.l.: "AJM [monogram]"

(1858–1860)

The Walters Art Gallery, Baltimore, Maryland 37.1940.183

PROVENANCE

William T. Walters, Baltimore

EXHIBITIONS

"A. J. Miller Watercolors," Smithsonian, October 1956–November 1957

REFERENCES

Ross, pl. 183

211B. *The Lake Her Lone Bosom Expands to the Sky*

Oil on board

9 1/2 x 15 1/2 in. (24.1 x 39.4 cm.)

Signed, l.l.: "A J Miller"

Dallas Museum of Fine Arts, Dallas, Texas 1955.21; gift of C. R. Smith

PROVENANCE

Mrs. K. Daniel; Old Print Shop, New York (1947); Edward Eberstadt and Sons, New York (1947); C. R. Smith, Washington, D.C.

REFERENCES

Old Print Shop ledger book (1947)

211C. *Mountain Lake*

Oil on canvas

22 x 34 in. (55.9 x 86.4 cm.)

Signed, l.r.: "Miller"

The Thomas Gilcrease Institute of American History and Art, Tulsa, Oklahoma 0126.735

PROVENANCE

John Levy Galleries; M. Knoedler and Company, New York, #A4179, as *Landscape with Indians* (1949)

REFERENCES

Rough Draughts, no. 109

212. *Water of the Lake*

Watercolor on paper

6 1/4 x 9 in. (15.9 x 23.0 cm.)

Signed, l.r.: "AJM [monogram]"

The Thomas Gilcrease Institute of American History and Art, Tulsa, Oklahoma 0236.1056

PROVENANCE

L. Vernon Miller; M. Knoedler and Company, New York, #CA3223-9, as 7 3/4 x 5 1/2 in. (1949)

REFERENCES

Rough Draughts, no. 34

213. *Wind River Mountains*

Pencil, watercolor and gouache on paper

5 1/2 x 8 in. (14.0 x 20.4 cm.)

Inscribed on mount: "Wind river Mts.—/58"; on verso: "Carrie C. Miller/3 Oklahoma Terrace/Annapolis, Maryland"

Joslyn Art Museum, Omaha, Nebraska; InterNorth Art Foundation Collection 695

PROVENANCE

Carrie C. Miller, Annapolis; Porter Collection

EXHIBITIONS

Nelson, January 1939; "Western Frontier," SLAM, April 1–May 13, 1941; BBHC, May 15–September 15, 1959

REFERENCES

[Field], *Prairie and Mountain Sketches*, illus. opp. p. 187 (as *Wind River Mountains, showing Frémont Peak*); BBHC, *Land of Buffalo Bill*, no. 24

213A. *Lake Scene (Wind River Mountain)*
Watercolor on paper
9 3/8 x 12 3/16 in. (23.8 x 31.0 cm.)
Signed, l.c.: "A. Miller Pt"
(1858–1860)
Inscribed at right of drawing: "39"
The Walters Art Gallery, Baltimore, Maryland 37.1940.59

PROVENANCE
William T. Walters, Baltimore

EXHIBITIONS
"American Landscape: A Changing Frontier," National
Collection of Fine Arts, Smithsonian, April 28–June 19,
1966 (not in catalogue); "Gallery of Dudes," ACM,
January 26–March 15, 1967

REFERENCES
Ross, pl. 59; Schomaekers, *Wilde Westen*, illus. p. 78;
Getlein, *Lure of the Great West*, illus. pp. 84–85

214. *Lake–Wind River*
Pencil, watercolor, and gouache on paper
7 5/8 x 10 1/2 in. (19.5 x 26.7 cm.)
Signed, l.c.: "AJM [monogram]"
Joslyn Art Museum, Omaha, Nebraska; InterNorth Art
Foundation Collection 753

PROVENANCE
Carrie C. Miller, Annapolis; Porter Collection; M.
Knoedler and Company, New York

EXHIBITIONS
Nelson, January 1939; BBHC, May 15–September 15,
1959

REFERENCES
BBHC, *Land of Buffalo Bill*, no. 82; Goetzmann and
Porter, p. 63

215. *Lake Scene—Wind River Mountains*
Pencil, watercolor, and gouache on paper
6 3/8 x 9 1/4 in. (16.2 x 23.5 cm.)
Joslyn Art Museum, Omaha, Nebraska; InterNorth Art
Foundation Collection 775

PROVENANCE
Porter Collection

EXHIBITIONS
"Western Frontier," SLAM, April 1–May 13, 1941

REFERENCES
[BBHC, *Land of Buffalo Bill*, no. 6 or 25?]

215A. *Lake Scene, Wind River Mountains*
Watercolor and gouache on paper
8 3/4 x 11 1/4 in. (22.2 x 28.6 cm.)
The Thomas Gilcrease Institute of American History and
Art, Tulsa, Oklahoma 0236.1014

PROVENANCE
Victor D. Spark, New York; M. Knoedler and Company,
New York, #WCA 885, as *Lake Scene with Two Indians*,
11 3/4 x 8 3/4 in. (1948)

REFERENCES
Rough Draughts, no. 98

216. *Wind River Mountains*
Pencil and watercolor, heightened with white, on paper
Sight: 5 7/8 x 9 3/8 in. (14.9 x 23.8 cm.)
Private collection

PROVENANCE
the artist; by descent to Louisa Whyte Norton; Old Print
Shop, New York (1947); private collection (1947)

REFERENCES
Old Print Shop ledger book (June 18, 1947), no. 37

217. Untitled [landscape—autumn]
Oil on paper
Sight: 3 1/2 x 6 in. (8.9 x 15.2 cm.)
The Dentzel Collection 0259

218. *Lake in Oregon*
Sepia wash with chinese white on paper
5 1/4 x 7 3/8 in. (14.0 x 18.7 cm.)
Inscribed (formerly) on mount, l.l.: "Lake in/Oregon"; on
verso: "116—Carrie C. Miller, 3 Oklahoma Terrace,
Annapolis, Maryland"
Stark Museum of Art, Orange, Texas 31.34/24

PROVENANCE
Carrie C. Miller, Annapolis; Edward Eberstadt and Sons,
New York

REFERENCES
Eberstadt catalogue 146 (1958), no. 123–45 (as *Lake Scene
in Oregon*); Stark, p. 206, illus. p. 64

219. *Lake Scene Oregon*
Watercolor on paper
Sight: 7 5/8 x 11 7/8 in. (19.4 x 30.2 cm.)
Private collection

PROVENANCE
the artist; by descent to Louisa Whyte Norton; Old Print
Shop, New York (1947); private collection (1947)

REFERENCES
Old Print Shop ledger book (June 18, 1947), no. 16;
Cowdrey and Comstock, "Alfred Jacob Miller and the
Farthest West," fig. 6

220. *Lake Scene, Oregon*

Watercolor on paper

7 1/8 x 12 1/8 in. (18.1 x 30.8 cm.)

Signed, l.l.: "AJM. [monogram]"

Clara Peck, New York

PROVENANCE
Dr. J. M. Christlieb, Omaha; Martin Kodner, St. Louis;
Kennedy Galleries, New York (1977)

REFERENCES
Kennedy Quarterly 15, no. 3 (June 1977): no. 115 (illus.)

221. *Lake Scene: Oregon*

Watercolor on paper

12 x 7 in. (30.5 x 17.8 cm.)

Signed, l.l.: "AJM"

Unlocated

PROVENANCE
Dawson's Book Shop, Los Angeles (1952)

EXHIBITIONS
Dawson's Book Shop, Los Angeles, beginning October
15, 1952

REFERENCES
Dawson's Book Shop, Los Angeles, *Exhibition of
Original Western Paintings*, no. 1

222. *Encampment of Snake Indians, Wind River Mountains*

Watercolor on paper

10 7/8 x 7 3/16 in. (27.6 x 18.3 cm.)

Joslyn Art Museum, Omaha, Nebraska 1952.79, gift of
Jasper Hall and Ellsworth Moser

223. Untitled [landscape—the storm]

Oil on paper

Sight: 7 x 10 in.

The Dentzel Collection 0255

224. *Lake Scene—Mountain of Winds*

Watercolor on paper

9 3/16 x 13 9/16 in. (23.3 x 34.4 cm.)

(1858–1860)

The Walters Art Gallery, Baltimore, Maryland 37.1940.93

PROVENANCE
William T. Walters, Baltimore

EXHIBITIONS
"Gallery of Dudes," ACM, January 26–March 15, 1967;
JAM, 1973

REFERENCES
Sprague, *Gallery of Dudes*, illus. p. 16; Ross, pl. 93; Alan
Gussow, *Sense of Place*, II, no. 183, illus. p. 74; Donelson
F. Hoopes, *American Watercolor Painting*, illus. p. 52

224A. *The Sirens Were Singing from the Tops of the Peaks* [Wind River Mountain Lake Scene]

Oil on panel

9 5/8 x 15 3/4 in. (24.4 x 40.0 cm.)

C. R. Smith; on loan to the University of Texas Art
Museum, Austin

PROVENANCE
Miller family; Mrs. K. Daniel; Old Print Shop, New
York (1947); Edward Eberstadt and Sons, New York
(1947–1952)

EXHIBITIONS
Brooklyn Museum of Fine Arts; Joslyn Memorial Art
Museum, Omaha

REFERENCES
Old Print Shop ledger book (1947); "Opening of the
West," pp. 46–47 (illus.); Eberstadt catalogues 126 (1950),
no. 292 (illus. as *Wind River Mountain Lake Scene*), and
130 (1952), no. 384 (illus. as *Wind River Mountain Lake
Scene*); Josephy, "First 'Dude Ranch' Trip to the Untamed
West," pp. 12–13 (illus.); American Heritage, ed., *America
on Parade*, illus. front endsheets; New York University,
Institute of Economic Affairs, *Permanent Frontier*, illus. p.
[iv]; Austin, University of Texas Art Museum, *The Great
American West*, written by Margaret Blagg, unpaginated
(illus.)

224B. *Avalanche Lake*

Oil on canvas

10 x 12 1/4 in. (25.4 x 31.1 cm.)

Private collection

PROVENANCE
Hirschl & Adler Galleries, New York (1979); Gerald
Peters

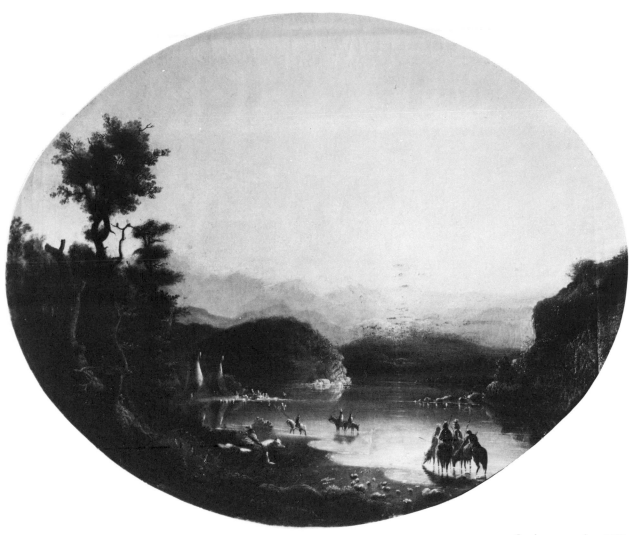

Catalogue number 225B.

225. *Green River Mountains*

Gouache on paper

8 1/2 x 12 in. (21.6 x 30.5 cm.)

Signed, l.r.: "AJM [monogram]"

Francis H. Jencks, Baltimore

225A. *Green River (Oregon)*

Watercolor on paper

9 1/16 x 12 1/4 in. (23.0 x 31.1 cm.)

(1858–1860)

The Walters Art Gallery, Baltimore, Maryland 37.1940.82

PROVENANCE

William T. Walters, Baltimore

REFERENCES

Ross, *Fur Hunters of the Far West,* illus. opp. p. 137; Ross, pl. 82; Bil Gilbert, *The Trailblazers,* illus. pp. 92-93;

Gold, "Alfred Jacob Miller," illus. p. 27; Randall, "Gallery for Alfred Jacob Miller," fig. 2 (as *Green River, with the Rocky Mountains in the Distance*); Dickson, "Hard on the Heels of Lewis and Clark," pp. 24–25 (illus.)

225B. *Lake Fremont*

Oil on canvas (oval)

28 3/4 x 36 1/2 in. (73.0 x 92.7 cm.)

Denver Art Museum, Denver, Colorado 1961.25

EXHIBITIONS

Denver Art Museum, January 13–April 15, 1973

REFERENCES

Denver Art Museum, *Colorado Collects Historic Western Art,* no. 46, illus. p. 53

225C. *Green River, Oregon*

Oil on canvas (oval)

29 x 36 in. (73.7 x 91.4 cm.)

The Thomas Gilcrease Institute of American History and Art, Tulsa, Oklahoma 0126.736

PROVENANCE

Martin Weisendanger, Tulsa, Okla.; M. Knoedler and Company, New York, #A 4149, as *Indian Encampment* (1949)

REFERENCES

Rough Draughts, no. 49; McDermott, "A. J. Miller," p. 15 (illus.); "Chapter IV, The Northwest Quadrant: Expansion," *American Scene* 17, no. 4 (1976): 26 (illus.)

225D. *Green River, Oregon*

Oil on paper, mounted on board

8 x 10 3/4 in. (20.4 x 27.5 cm.)

Inscribed on verso, l.r.: "Green River, Oregon"

Whitney Gallery of Western Art, Buffalo Bill Historical Center, Cody, Wyoming 7.59

PROVENANCE

gift of M. Knoedler and Company, New York

226. *Green River*

Oil on paper, mounted on composition board

3 1/4 x 5 7/8 in. (8.3 x 14.9 cm.)

Signed, l.l.: "AJM [monogram]"

Inscribed (formerly) on mat, l.c.: "Green River"

Stark Museum of Art, Orange, Texas 31.34/14

PROVENANCE

Edward Eberstadt and Sons, New York

REFERENCES

Eberstadt catalogue 146 (1958), no. 123–20; Stark, p. 205

227. *Lake Scene, Wind River Mountains* [verso: untitled (heads)]

Pencil and gouache on paper [verso: pencil]

6 1/4 x 9 1/2 in. (15.9 x 24.1 cm.)

Inscribed (formerly) on verso of mount: "125—Carrie C. Miller, 3 Oklahoma Terrace, Annapolis, Maryland"

Stark Museum of Art, Orange, Texas 31.34/28

PROVENANCE

Carrie C. Miller, Annapolis; Edward Eberstadt and Sons, New York

REFERENCES

Eberstadt catalogue 146 (1958), no. 123–41; Stark, p. 206

228. *Wind River Chain*

Watercolor on paper

8 9/16 x 12 7/16 in. (21.8 x 31.6 cm.)

(1858–1860)

The Walters Art Gallery, Baltimore, Maryland 37.1940.157

PROVENANCE

William T. Walters, Baltimore

EXHIBITIONS

"A. J. Miller Watercolors," Smithsonian, October 1956– November 1957

REFERENCES

Ross, pl. 157

228A. *Smoke Signals*

Oil on canvas

18 x 31 in. (45.7 x 78.7 cm.)

The Thomas Gilcrease Institute of American History and Art, Tulsa, Oklahoma 0126.748

PROVENANCE

Victor D. Spark, New York; M. Knoedler and Company, New York, #A 4475, as *Landscape* (1950–1969)

REFERENCES

Rough Draughts, no. 148

229. *Wind River, Mountain Gorge*

Watercolor with pencil on paper

7 11/16 x 10 7/8 in. (19.5 x 27.6 cm.)

Inscribed (formerly) on mat, l.r.: "Mountain Gorge"; (formerly) on mount: "Lloyd O. Miller"

Stark Museum of Art, Orange, Texas 31.34/33

PROVENANCE

the artist; Lloyd O. Miller; Edward Eberstadt and Sons, New York

REFERENCES

Eberstadt catalogue 146 (1958), no. 123–28; Stark, p. 207

230. *Lake and Mountain Scene*

Watercolor on paper

7 1/16 x 11 1/2 in. (18.0 x 24.6 cm.)

(1858–1860)

The Walters Art Gallery, Baltimore, Maryland 37.1940.104

PROVENANCE

William T. Walters, Baltimore

REFERENCES

Ross, pl. 104

231. *Green River—Oregon*
Watercolor on paper
7 15/16 x 13 3/4 in. (20.2 x 34.9 cm.)
Signed, l.c.: "AJM [monogram]"
(1858–1860)
The Walters Art Gallery, Baltimore, Maryland
37.1940.185

PROVENANCE
William T. Walters, Baltimore

REFERENCES
Ross, pl. 185; Wolfgang Born, *American Landscape Painting*, illus. p. 57; Getlein, *Lure of the Great West*, illus. p. 87

232. *Green River, Oregon*
Oil on canvas
9 1/8 x 18 in. (23.2 x 45.7 cm.)
Private collection, Baltimore

PROVENANCE
Mrs. William Wilkins, Baltimore

233. *Lake and Mountain Scenery*
Watercolor and gouache on paper
5 1/4 x 7 1/4 in. (13.3 x 18.4 cm.)
The Thomas Gilcrease Institute of American History and Art, Tulsa, Oklahoma 0236.1036

REFERENCES
Rough Draughts, no. 120

234. *Lake Scene*
Watercolor on paper
9 1/8 x 12 3/16 in. (23.2 x 30.9 cm.)
Signed, l.l.: "AJM [monogram] iller"
(1858–1860)
The Walters Art Gallery, Baltimore, Maryland
37.1940.130

PROVENANCE
William T. Walters, Baltimore

REFERENCES
Ross, pl. 130

235. *Lake Scene—Rocky Mts.*
Watercolor on paper
7 3/4 x 11 3/8 in. (19.7 x 28.9 cm.)
(1858–1860)
The Walters Art Gallery, Baltimore, Maryland
37.1940.172

PROVENANCE
William T. Walters, Baltimore

EXHIBITIONS
"A. J. Miller Watercolors," Smithsonian, October 1956–November 1957

REFERENCES
Ross, pl. 172

236. *Grand Tetons*
Oil on paper
6 x 9 3/4 in. (15.2 x 24.8 cm.)
The Thomas Gilcrease Institute of American History and Art, Tulsa, Oklahoma 0236.1103

237. *Sunset on Lake in Rocky Mountains*
Oil on paper
5 x 7 in. (12.7 x 17.8 cm.)
Inscribed, l.r.: "River Scenery—In route—to Rocky Mts."
The Thomas Gilcrease Institute of American History and Art, Tulsa, Oklahoma 0236.1110

PROVENANCE
L. Vernon Miller, Baltimore; M. Knoedler and Company, New York, #CA 3223–18

238. *Trappers Saluting the Rocky Mountains*
Watercolor on paper
6 x 9 1/2 in. (15.2 x 24.1 cm.)
Unlocated

PROVENANCE
the artist; by descent to Louisa Whyte Norton; Old Print Shop, New York (1947); Everett D. Graff, Winnetka, Ill. (1947)

REFERENCES
Old Print Shop ledger book (June 18, 1947), no. 36

238A. *Trappers Saluting the Rocky Mountains*
Oil on canvas
25 x 38 7/8 in. (63.6 x 98.8 cm.)
Signed, l.r.: "AJM [monogram]"
Whitney Gallery of Western Art, Buffalo Bill Historical Center, Cody, Wyoming 10.70; gift of the W. R. Coe Foundation, Oyster Bay, New York

PROVENANCE
M. Knoedler and Company, New York

EXHIBITIONS
National Cowboy Hall of Fame, Oklahoma City, June 25–October 10, 1965; "Paintings from American

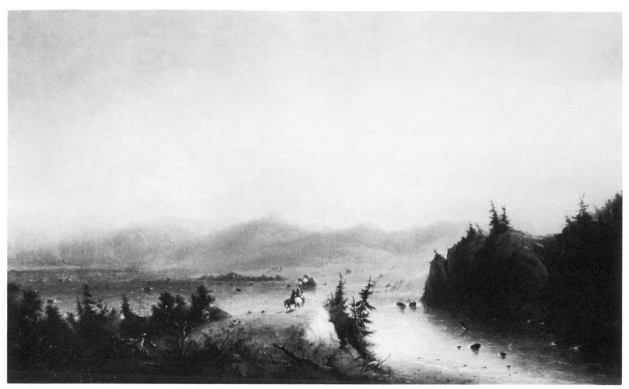

Catalogue number 238A.

Museums," Russian-European exhibit, February–November 1976; Denver Art Museum, December, 1976–April, 1977; BBHC, May–September 1978

REFERENCES
Oklahoma City, National Cowboy Hall of Fame, *Inaugural Exhibition*, p. 15, illus. p. 16; BBHC, *West of Buffalo Bill*, illus. p. [155] (dimensions given as 22 x 26 in.), and *Mountain Man*, pl. 7, and *Checklist of the Exhibition*, unpaginated

238B. *Sunset, Wind River*

Oil on canvas
6 x 9 in. (15.2 x 23.0 cm.)
Signed, l.r.: "AJM [monogram]"
Martin Kodner, St. Louis, Missouri

239. Untitled [landscape at sunset]

Oil on paper
Sight: 5 3/4 x 7 in. (14.6 x 17.8 cm.)
The Dentzel Collection 0257

240. *Sunset: Wind River Mountains*

Oil
7 x 4 1/8 in. (17.8 x 10.5 cm.)
Signed, l.r.
Unlocated

PROVENANCE
Dawson's Book Shop, Los Angeles (1952)

EXHIBITIONS
Dawson's Book Shop, Los Angeles, beginning October 15, 1952

REFERENCES
Dawson's Book Shop, Los Angeles, *Exhibition of Original Western Paintings, Water Colors, & Prints* (1952), no. 3

241. Untitled [landscape with elk]

Oil on paper
Sight: 7 x 10 in. (17.8 x 25.4 cm.)
The Dentzel Collection 0256

242. *Sunset, Wind River Mountains* [verso: untitled (head and building)]

Watercolor on paper [verso: pencil and watercolor on paper]
5 1/8 x 8 1/16 in. (13.0 x 20.5 cm.)

Inscribed (formerly) on verso of mount: "183—Carrie C. Miller, 3 Oklahoma Terrace, Annapolis, Maryland/Sunset, Wind river Mts"

Stark Museum of Art, Orange, Texas 31.34/23

PROVENANCE

Carrie C. Miller, Annapolis; Edward Eberstadt and Sons, New York

REFERENCES

Eberstadt catalogue 146 (1958), no. 123–34; Stark, p. 207

243. *Indian Hunters Searching for Game*

Pencil, watercolor, and gouache on paper

7 1/8 x 10 3/4 in. (18.2 x 29.9 cm.)

Inscribed on mount: "Indian hunters searching/for game/74"; on verso: "Carrie C. Miller/3 Oklahoma Terrace/Annapolis, Maryland"

Joslyn Art Museum, Omaha, Nebraska; InterNorth Art Foundation Collection 676

PROVENANCE

Carrie C. Miller, Annapolis; Porter Collection

EXHIBITIONS

Nelson, January 1939; "Western Frontier," SLAM, April 1–May 13, 1941; BBHC, May 15–September 15, 1959

REFERENCES

BBHC, *Land of Buffalo Bill,* no. 5

244. *Trappers Looking for Game*

Pencil, watercolor, and gouache on paper

6 3/4 x 10 3/4 in. (17.2 x 27.4 cm.)

Joslyn Art Museum, Omaha, Nebraska; InterNorth Art Foundation Collection 752

PROVENANCE

Porter Collection

EXHIBITIONS

Nelson, January 1939; BBHC, May 15–September 15, 1959

REFERENCES

BBHC, *Land of Buffalo Bill,* no. 81

245. *Oregon Lake by Moonlight* [verso: untitled (two statues, one side view, one back view)]

Watercolor on paper [verso: pencil]

9 x 12 3/4 in. (22.9 x 32.4 cm.)

Inscribed (formerly) on mount, l.r.: "Lake by Moonlight"

Stark Museum of Art, Orange, Texas 31.34/42

PROVENANCE

Edward Eberstadt and Sons, New York

REFERENCES

[Eberstadt catalogues 134 (1954), no. 401 (illus. as *Indian Camp on Wind River Lake, by Moonlight,* 8 1/2 x 12 in.), and 139, no. 78 (illus. as *Indian Camp by Moonlight)?*]; Eberstadt catalogue 146 (1958), no. 123–25; Stark, p. 207

246. *Moonlight—Wind River Lake*

Oil on canvas

7 1/4 x 10 1/4 in. (18.4 x 26.0 cm.)

Kennedy Galleries, Inc. New York (1973; neg. no. T 1992)

PROVENANCE

the artist; by descent to Louisa Whyte Norton; Old Print Shop, New York (1947); Edward Eberstadt and Sons, New York

REFERENCES

Old Print Shop ledger book (June 18, 1947), no. 48 (as *Moonlight on Wind Green River Lake* [sic], 7 1/4 x 10 in.)

247. *Distant View of Lake (Mountain of Winds)*

Watercolor on paper

8 3/16 x 11 3/4 in. (20.8 x 29.8 cm.)

(1858–1860)

The Walters Art Gallery, Baltimore, Maryland 37.1940.114

PROVENANCE

William T. Walters, Baltimore

REFERENCES

Ross, pl. 114

247A. *Distant View, Mountain of Winds*

Watercolor and gouache on paper

6 1/4 x 9 1/4 in. (15.9 x 23.5 cm.)

The Thomas Gilcrease Institute of American History and Art, Tulsa, Oklahoma 0236.1035

REFERENCES

Rough Draughts, no. 134

248. *Wind Scenery (Making a Cache)*

Watercolor on paper

9 1/4 x 12 13/16 in. (23.5 x 32.5 cm.)

Signed, l.c.: "Miller"

(1858–1860)

The Walters Art Gallery, Baltimore, Maryland 37.1940.112

PROVENANCE

William T. Walters, Baltimore

EXHIBITIONS

"American Landscape: A Changing Frontier," National Collection of Fine Arts, Smithsonian Institution, April 28–June 19, 1966 (not in catalogue)

REFERENCES

[Ruxton], *Ruxton of the Rockies*, illus. opp. p. 218 (as *Wild Scenery*); American Heritage, ed., *Trappers and Mountain Men*, illus. pp. 122–123 (as *Wild Scenery*); Goetzmann, *Exploration and Empire*, illus. p. 202 (as *Wild Scenery*); Ross, pl. 112

249. *Oregon Lake Scene*

Oil on paper

9 7/8 x 6 3/4 in. (25.0 x 17.0 cm.)

Inscribed on mount: "Oregon Lake Scene"

Western Americana Collection, The Beinecke Rare Book and Manuscript Library, Yale University, New Haven, Connecticut (Coe No. V, 26)

PROVENANCE

the artist; by descent to Louisa Whyte Norton; Old Print Shop, New York (1947); Edward Eberstadt and Sons, New York

EXHIBITIONS

"Gallery of Dudes," ACM, January 26–March 15, 1967

REFERENCES

Withington, no. 341

250. *Storm on Wind River Lake, Rocky Mountains*

Oil on paper

7 x 10 in. (17.8 x 25.4 cm.) (irreg.)

Inscribed (formerly) on mount, l.r.: "Storm on Wind River Lake/Rocky Mts"; (formerly) on verso of mount: "96—Carrie C. Miller—/3 Oklahoma Terrace—/ Annapolis—/Maryland—Trappers hunting"

Stark Museum of Art, Orange, Texas 31.34/37

PROVENANCE

Carrie C. Miller, Annapolis; Edward Eberstadt and Sons, New York

REFERENCES

Eberstadt catalogue 146 (1958), no. 123–14 (as *Storm on Wind River Lake*); Stark, p. 207

251. *Effects of Rain Clouds on Lake*

Oil on panel

7 x 10 in. (17.8 x 25.4 cm.)

The Thomas Gilcrease Institute of American History and Art, Tulsa, Oklahoma 0126.746

252. *Indian Encampment*

Oil on canvas

8 x 13 in. (20.3 x 33.1 cm.)

Whitney Gallery of Western Art, Buffalo Bill Historical Center, Cody, Wyoming 8.59

PROVENANCE

gift of M. Knoedler and Company, New York

253. *Wind River Mountain*

Oil on canvas

8 x 13 1/8 in. (20.3 x 33.3 cm.)

Signed, l.r.: "A. M."

Joslyn Art Museum, Omaha, Nebraska 1963.613

PROVENANCE

Victor D. Spark, New York; M. Knoedler and Company, New York, #A 4369, as *Wind River Mountain, Colorado* (1950–1965)

EXHIBITIONS

Los Angeles County Museum of Art, March 21–May 28, 1972; M. H. de Young Memorial Museum, San Francisco, June 9–September 17, 1972; SLAM, November 2–December 31, 1972; BBHC, 1978

REFERENCES

Los Angeles County Museum of Art, *American West*, no. 15, illus. pl. 32; George P. Tomko to Arthur J. Phelan, Jr., September 12, 1977, collection of Arthur J. Phelan, Jr.; BBHC, *Mountain Man: Checklist of the Exhibition*, unpaginated (as *Lake Wind River Chain of Mountains*)

254. *Indian Encampment*

Oil on canvas

9 x 13 in. (22.9 x 33.1 cm.)

Whitney Gallery of Western Art, Buffalo Bill Historical Center, Cody, Wyoming 9.59

PROVENANCE

gift of M. Knoedler and Company, New York

255. *River Scene: Indians in Canoes*

Oil on canvas

10 x 16 in. (25.4 x 40.6 cm.)

Joslyn Art Museum, Omaha, Nebraska 1963.616

PROVENANCE

Joseph Katz; M. Knoedler and Company, New York, #CA 4624 (1954–1965)

REFERENCES

George P. Tomko to Arthur J. Phelan, Jr., September 12, 1977, collection of Arthur J. Phelan, Jr.

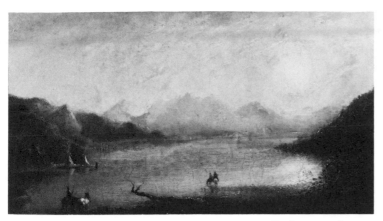

Catalogue number 256.

256. *Indian Encampment*

Oil on canvas

11 x 19 3/4 in. (27.9 x 50.2 cm.)

Whitney Gallery of Western Art, Buffalo Bill Historical
Center, Cody, Wyoming 10.59

PROVENANCE
gift of M. Knoedler and Company, New York

257. *The Lookout*

Oil on canvas

17 x 24 in. (43.2 x 61.0 cm.)

The Thomas Gilcrease Institute of American History and
Art, Tulsa, Oklahoma 0126.734

REFERENCES
Rough Draughts, no. 59

258. *Indian Encampment (Wind River Mountains—Lake Scene)*

Oil on canvas

17 1/2 x 23 1/2 in. (44.5 x 59.7 cm.)

Signed, l.r.: "AJM [monogram] iller"

The Dentzel Collection 2672

EXHIBITIONS
Los Angeles County Museum of Art, March 21–May 28,
1972; Seattle Art Museum, July 15–September 26, 1976

REFERENCES
Los Angeles County Museum of Art, *American West*, no.
14, pl. 31; Seattle Art Museum, *Lewis and Clark's
America*, no. 60, illus. p. 67 (as *Wind River Mountains—
Lake Scene*, 17 1/4 x 23 1/2 in.).

259. *Rocky Mountain Scene, Wind River Mountains*

Oil on canvas

18 x 24 in. (45.7 x 61.0 cm.)

Signed and dated, l.r.: "A J Miller 1853"

J. N. Bartfield Art Galleries, New York

PROVENANCE
Lennox Birkhead family; William C. Whitridge

REFERENCES
perhaps one of two landscapes commissioned by William
C. Wilson, account book, June 25, 1853

259A. *Indians at the Mountain Lake*

Oil on canvas

18 x 23 in. (45.7 x 58.4 cm.)

Stark Museum of Art, Orange, Texas 31.34/3

PROVENANCE
Edward Eberstadt and Sons, New York

REFERENCES
Eberstadt catalogue 146 (1958), no. 123–7 (illus.); Stark,
p. 206

260. *Lake in Wind River Country*

Oil on canvas

18 x 24 in. (45.7 x 61.0 cm.)

Signed and dated, l.r.: "Miller 1854"

William J. Williams Family Collection

PROVENANCE
C. R. Smith, Washington, D.C.; Kennedy Galleries, New
York (1968–1977)

EXHIBITIONS
South Dakota Memorial Art Center, Brookings,
September 15–October 27, 1974; Seattle Art Museum,
July 15–September 26, 1976

REFERENCES
possibly the picture listed in account book, December
13, 1854, as *Sun Set View (Oregon)*, Mr. Melville Wilson,
$60; *Kennedy Quarterly* 8, no. 2 (June 1968): no. 46, illus.
p. 54 (as *Landscape in Oregon*); *Kennedy Quarterly* 12, no. 3
(June 1973): no. 138 (illus. as *Western Landscape*);
Brookings, South Dakota Memorial Art Center, *Art of
South Dakota*, text by Joseph Stuart, no. 57, illus. p. 34 (as
Western Landscape); Seattle Art Museum, *Lewis and
Clark's America*, no. 58, illus. p. 73 (as *Western Landscape*);
Kennedy Quarterly 15, no. 3 (June 1977): no. 117 (illus.)

261. *Indians on Green River*

Oil on canvas

Sight: 21 3/4 x 36 in. (55.2 x 91.4 cm.)

Signed, l.r.: "AJM [monogram]"

The Thomas Gilcrease Institute of American History and Art, Tulsa, Oklahoma 0126.732

REFERENCES

Rough Draughts, no. 49

262. *Stewart's Camp, Wind River Range, Western Wyoming*

Oil on canvas

31 x 48 in. (78.8 x 121.9 cm.)

Signed, l.c.: "AJM [monogram] iller Pt."

(c. 1865)

The Peale Museum, Baltimore, Maryland; gift of the Maryland National Bank

PROVENANCE

private collection in Baltimore; located by Wilbur Harvey Hunter and purchased for the Peale Museum by the Maryland National Bank (c. 1971)

REFERENCES

possibly the painting listed in the account book, June 16, 1865 (as *Lake Scene Rocky Mts.*, 4 feet x 32 inches) for William S. G. Baker; *Sun,* January 12, 1969, Sunday magazine section; Hunter, "A 'New' Painting by Alfred Jacob Miller," pp. 222–223, illus. pp. 224, 225

263. Untitled [Wind River Mountain landscape]

Unlocated

PROVENANCE

Edward Eberstadt and Sons, New York; C. R. Smith

REFERENCES

Eberstadt catalogue 130 (1952), no. 385

264. *Camping on the Powder River*

Watercolor

3 1/8 x 4 3/8 in. (7.9 x 11.1 cm.)

Signed, l.r.: AJM

Fenn Gallery

265. *Fishing on Grand River*

Oil on canvas

(c. 1839)

Unlocated

PROVENANCE

Sir William Drummond Stewart (1839); Frank Nichols (sale: Chapman's, Edinburgh, June 16–17, 1871)

EXHIBITION

Apollo Gallery, New York, May 9–22, 1839

REFERENCES

"Apollo Gallery—Original Paintings," *Morning Herald,* May 16, 1839, p. 2, col. 3, no. 16; Murthly sale notices

266. *Crossing One of the Sources of the Colorado of the West, in the Mountains of the Winds*

Pencil with gray wash on paper

9 3/4 x 7 1/8 in. (24.7 x 18.1 cm.)

(c. 1837)

Inscribed, u.l.: "8"; u.c.: "Crossing one of the Sources of the Colorado of the West, in the Mountains of the Winds"; on mat, l.c.: "Crossing one of the Sources of the Colorado of the West/in the Mountains of the Winds"

Whitney Gallery of Western Art, Buffalo Bill Historical Center, Cody, Wyoming 10.80; gift of the Joseph M. Roebling Estate

PROVENANCE

the artist; Sir William Drummond Stewart (c. 1839); Frank Nichols (sale: Chapman's, Edinburgh, June 16–17, 1871); Bonamy Mansell Power; willed to Edward Power (1900); by descent to Major G. H. Power, Great Yarmouth, England (sale: PB, May 6, 1966); Joseph M. Roebling

EXHIBITIONS

Denver Art Museum, April 15–24, 1966; PB, April 26–May 6, 1966

REFERENCES

Murthly sale notices; PB sale 2436 (May 6, 1966), lot 82 (illus.); Knox, "83 Drawings From 1837 Trek," p. 28

266A. *One of the Sources of the Colorado*

Oil on canvas

(c. 1839)

Unlocated

PROVENANCE

Sir William Drummond Stewart (1839); Frank Nichols (sale: Chapman's, Edinburgh, June 16–17, 1871)

EXHIBITIONS

Apollo Gallery, New York, May 9–22, 1839

REFERENCES

"Apollo Gallery—Original Paintings," *Morning Herald,* May 16, 1839, p. 2, col. 3, no. 18; Murthly sale notices

266B. *One of the Sources of the Colorado of the West—Wind River Mountains*

Oil on canvas

(c. 1839)

Unlocated

PROVENANCE

Sir William Drummond Stewart (1839); Frank Nichols (sale: Chapman's, Edinburgh, June 16–17, 1871)

EXHIBITIONS

Apollo Gallery, New York, May 9–22, 1839

REFERENCES

"Apollo Gallery—Original Paintings," *Morning Herald*, May 16, 1839, p. 2, col. 3, no. 15; Murthly sale notices

267. *Portrait of Captain Joseph Reddeford Walker*

Oil on canvas

23 3/8 x 19 1/2 in. (59.4 x 49.5 cm.)

Signed, l.r.: "A J Miller."

Joslyn Art Museum, Omaha, Nebraska 1963.610

PROVENANCE

Porter collection; Jake Zeitlin (1959); Harold McCracken; M. Knoedler and Company, New York, #A 7328 (1959–1965)

EXHIBITIONS

BBHC, 1959; JAM, July 3–October 17, 1976; BBHC, 1978

REFERENCES

[Ruxton], *Life in the Far West*, illus. opp. p. 158; Henry J. Seldis, "Boom Interest in Western Art," *Art in America* 47, no. 3 (Fall 1959): 61 (illus.); Gloria Griffin Cline, *Exploring the Great Basin*, illus. fol. p. 142; Ewers, *Artists of the Old West*, p. 136, illus. p. [128]; Hafen, *Mountain Men*, V, p. [20] (illus.); Monaghan, "Hunter and the Artist," p. 12 (illus.); Robert V. Hine and Savoie Lottinville, *Soldier in the West*, illus. fol. p. 134; Hillman, "Part Three: Bridging A Continent," illus. p. 472; JAM, *Artists of the Western Frontier*, no. 66, illus. p. 15; George P. Tomko to Arthur J. Phelan, Jr., September 12, 1977, collection of Arthur J. Phelan, Jr.; Reader's Digest, *Story of the Great American West*, illus. p. 93; BBHC, *Mountain Man*, pl. 16, and *Checklist of the Exhibition*, unpaginated

268. *Captain Walker (Joseph Reddeford Walker)*

Watercolor on paper

7 x 9 1/4 in. (17.8 x 23.5 cm.)

Inscribed, u.r. of composition: "55 [or 53?]/Bourgeois [and his Squaw?]"; l.r. of sheet: "Capt W [sight]"

Joslyn Art Museum, Omaha, Nebraska; InterNorth Art Foundation Collection 734

PROVENANCE

the artist; by descent to Louisa Whyte Norton; Old Print Shop, New York (1947); Porter Collection (1947)

EXHIBITIONS

BBHC, May 15–September 15, 1959; "Gallery of Dudes," ACM, January 26–March 15, 1967

REFERENCES

DeVoto, pl. LXXXI (as *Bourgeois Walker and His Wife*); Old Print Shop ledger book (June 18, 1947), no. 26 (as *Capt. Walker. . . & Squaw*, 7 1/4 x 9 in.); BBHC, *Land of Buffalo Bill*, no. 63 (as *Captain Walker [Joseph Reddeford Walker] "A Bourgeois and His Squaw"*); Schomaekers, *Wilde Westen*, illus. p. 54; Hawgood, *America's Western Frontiers*, illus. p. 126; Hine, *American West*, illus. p. 55 (as *Joseph Walker and His Squaw*); Hillman, "Part Three: Bridging A Continent," illus. p. 421

268A. *A "Bourgeois" of the Rocky Mountains*

Pen and ink with gray wash on gray card

8 3/4 x 10 7/8 in. (22.5 x 27.7 cm.)

(c. 1837)

Inscribed, u.l.: "59"

The Dentzel Collection 1733

PROVENANCE

the artist; Sir William Drummond Stewart (c. 1839); Frank Nichols (sale: Chapman's, Edinburgh, June 16–17, 1871); Bonamy Mansell Power; willed to Edward Power (1900); by descent to Major G. H. Power, Great Yarmouth, England (sale: PB, May 6, 1966)

EXHIBITIONS

Denver Art Museum, April 15–24, 1966; PB, April 29–May 6, 1966; Los Angeles County Museum of Art, March 21–May 28, 1972; Seattle Art Museum, July 15–September 26, 1976; BBHC, 1978

REFERENCES

Murthly sale notices; PB sale 2436 (May 6, 1966), lot 4 (illus.); Knox, "83 Drawings From 1837 Trek," p. 28; Ross, p. XXXIV; Los Angeles County Museum of Art, *American West*, no. 8, pl. 26; Seattle Art Museum, *Lewis and Clark's America*, no. 62, illus. p. 64; BBHC, *Mountain Man*, pl. 23 (as *The Bourgeois Walker and Indian Wife*, watercolor), and *Checklist of the Exhibition*, unpaginated

268B. *"Bourgeois" W——r, and His Squaw*

Watercolor on paper

9 5/16 x 11 11/16 in. (23.7 x 29.7 cm.)

Signed, l.r.: "AJM [monogram] iller"

(1858–1860)

The Walters Art Gallery, Baltimore, Maryland 37.1940.78

PROVENANCE

William T. Walters, Baltimore

EXHIBITIONS

"A. J. Miller Watercolors," Smithsonian, October 1956–November 1957

REFERENCES

Daniel Ellis Conner, *Joseph Reddeford Walker and the Arizona Adventure*, illus. opp. p. 10; American Heritage, *American Heritage Book of the Pioneer Spirit*, illus. p. 5; [Leonard], *Zenas Leonard Fur Trader*, illus. opp. p. 61 (as *Captain Walker and His Squaw*); Nunis, *Andrew Sublette*, illus. p. 53 (as *Mountain Man and Squaw*); Irving, *Adventures of Captain Bonneville*, illus. opp. p. 11 (as *Joseph Reddeford Walker and His Squaw*); Rasky, *Taming of the Canadian West*, illus. pp. 118–119; Ross, pl. 78; Reader's Digest, *Story of the Great American West*, illus. p. 73

269. *Jim Bridger, in a Suit of English Armor*

Pen and ink and wash on paper

5 3/4 x 7 3/4 in. (14.6 x 19.7 cm.)

Inscribed on mat, l.c.: "Capt Bridger, a celebrated Leader or Bourgeois/in the Rocky mountains, was a great favorite of Sir Wm Stewart/who imported a full suit of English armor & presented it to/Bridger, who donned it on all special occasions, & rode/so accoutered at the head of his men."

Joslyn Art Museum, Omaha, Nebraska; InterNorth Art Foundation Collection 699

PROVENANCE

the artist; by descent to Mrs. Joseph Whyte; Porter Collection (1959); M. Knoedler and Company, New York

EXHIBITIONS

Denver Art Museum, October 15–November 21, 1955; BBHC, May 15–September 15, 1959; "Gallery of Dudes," ACM, January 26–March 15, 1967

REFERENCES

DeVoto, pl. LXXV (as *Jim Bridger in Armor Crossing a River*); Denver Art Museum, *Building the West*, no. 57 (listed as watercolor from Walters Art Gallery); BBHC, *Land of Buffalo Bill*, no. 28; Horan, *Great American West*, illus. p. 29 (as *Jim Bridger Crossing a River*), and rev. and exp. ed., illus. p. 27; American Heritage, ed., *Westward on the Oregon Trail*, illus. p. 43; Porter and Davenport, illus. fol. p. 148; American Heritage, ed., *American Heritage Book of Great Adventures of the Old West*, illus. p. 156; Mildred Goosman, "Collector's Choice: Old Gabe of Her Majesty's English Life Guards," *American West* 6, no. 6 (November 1969): 15 (illus.).

270. *Trappers Starting for the Beaver Hunt*

Pencil, watercolor, and gouache on paper

5 1/4 x 4 1/2 in. (13.4 x 11.4 cm.)

Inscribed, u.r.: "Trappers starting for/a Beaver Hunt"

The Thomas Gilcrease Institute of American History and Art, Tulsa, Oklahoma 0236.1034

REFERENCES

Rough Draughts, no. 55

270A. *Trappers Starting for the Beaver Hunt*

Watercolor and gouache on paper

11 3/16 x 9 3/8 in. (28.4 x 23.8 cm.)

Signed, l.r.: "AJM [monogram] iller"

(1858–1860)

Inscribed: "55"

The Walters Art Gallery, Baltimore, Maryland 37.1940.1

PROVENANCE

William T. Walters, Baltimore

EXHIBITIONS

"A. J. Miller Watercolors," Smithsonian, October 1956–November 1957

REFERENCES

Ross, plates XXXIX, 1; Getlein, *Lure of the Great West*, illus. p. 91; Dickson, "Hard on the Heels of Lewis and Clark," p. 17 (illus.)

270B. *Trappers Starting for Beaver Hunt*

Oil on paper

6 1/2 x 6 in. (16.5 x 15.2 cm.)

Signed, l.r.: "AJM [monogram]"

The Thomas Gilcrease Institute of American History and Art, Tulsa, Oklahoma 0236.1096

REFERENCES

Rough Draughts, no. 55; DeVoto, pl. XLVIII; Charles Neider, ed., *Great West*, illus. p. 165 (as *Trappers Setting out for the Hunt*)

271. *Trappers Searching for Beaver Sign*

Oil on paper, mounted on board

7 1/2 x 10 in. (19.1 x 25.4 cm.)

Signed, l.r.: "JA [monogram] M [*sic*]"

Inscribed and signed on verso: "Trappers Searching for Beaver Sign/AJM. [monogram]"

Dr. and Mrs. Donald L. Curry, Suisun, California

PROVENANCE

Albert Rosenthal, New York; M. Knoedler and Company, New York

272. *Trappers Hunting Deer—Oregon 1838*

Oil on board

7 3/4 x 9 3/4 in. (19.75 x 24.75 cm.)

Label on verso: "Trappers Hunting Deer, Oregon 1838"

Western Americana Collection, The Beinecke Rare Book and Manuscript Library, Yale University, New Haven, Connecticut (Coe V, 24–25)

PROVENANCE

[the artist; by descent to Louisa Whyte Norton; Old Print Shop, New York (1947); Edward Eberstadt and Sons, New York (1947)?]

EXHIBITIONS

"Gallery of Dudes," ACM, January 26–March 15, 1967; Yale University Art Gallery, New Haven, September 20, 1978–January 6, 1979

REFERENCES

[Old Print Shop ledger book (June 18, 1947), no. 46 (as *Trappers Hunting Deer*, 8 x 10 1/4 in.?]; Withington, no. 342; Sandweiss, p. 62 (as *Trapper Hunting Deer*)

273. *Trapper's Encampment—Lake Scene—Wind River Mountains*

Pencil, watercolor, and gouache on paper

10 1/4 x 13 3/8 in. (26.1 x 34.0 cm.)

Inscribed, u.r.: "Trappers Encampment/Lake Scene/Wind River Mountains"

Joslyn Art Museum, Omaha, Nebraska; InterNorth Art Foundation Collection 719

PROVENANCE

Porter Collection

EXHIBITIONS

Nelson, January 1939 (as *Trappers Encampment—Lake Scene—Rocky Mountains*); "Western Frontier," SLAM, April 1–May 13, 1941; BBHC, May 15–September 15, 1959

REFERENCES

DeVoto, pl. XL; BBHC, *Land of Buffalo Bill*, no. 48 (as *Trapper's Encampment—Lake Scene, Rocky Mountains*); Felton, *Edward Rose*, illus. fol. p. 48

273A. *Lake Scene—Rocky Mts*

Watercolor on paper

9 1/8 x 13 1/2 in. (23.2 x 34.3 cm.)

Signed, l.c.: "AJM [monogram]"

(1858–1860)

The Walters Art Gallery, Baltimore, Maryland 37.1940.161

PROVENANCE

William T. Walters, Baltimore

REFERENCES

Ross, pl. 161

273B. *In the Rocky Mountains*

Oil

14 3/8 x 20 in. (36.5 x 50.8 cm.)

Signed, l.c.: "Miller"

Joslyn Art Museum, Omaha, Nebraska 1963.615

PROVENANCE

W. H. Loudermilk and Company, Washington, D.C.; M. Knoedler and Company, New York, #A 4020 (1948–1965)

EXHIBITIONS

Los Angeles County Museum of Art, March 21–May 28, 1972; BBHC, 1978

REFERENCES

Los Angeles County Museum of Art, *American West*, no. 16, pl. 33; Hunter, "A 'New' Painting by Alfred Jacob Miller," p. 223 (as *Lake Scene—Rocky Mountains*); Getlein, *Lure of the Great West*, illus. p. 83; Donald G. Pike, "The World of the Mountain Man," *American West* 12, no. 5 (September 1975): 28 (illus.); George P. Tomko to Arthur J. Phelan, Jr., September 12, 1977, collection of Arthur J. Phelan, Jr.; BBHC, *Mountain Man*, pl. 6, and *Checklist of the Exhibition*, unpaginated

274. *The Trappers*

Oil on board

7 x 10 in. (17.8 x 25.4 cm.)

The Thomas Gilcrease Institute of American History and Art, Tulsa, Oklahoma 0136.742

REFERENCES

Rough Draughts, nos. 4 and 130–187

275. *Campfire on the Shore*

Oil on carton

Signed and dated, l.l.: "A. M. '37"

Unlocated

PROVENANCE

William J. Holliday, Indianapolis; Hammer Galleries, New York (1959); Bruce Norris, Chicago (1960)

276. *Wind River Country*

Watercolor on paper

Sight: 8 1/2 x 11 3/4 in. (21.6 x 29.8 cm.)

Whitney Gallery of Western Art, Buffalo Bill Historical Center, Cody, Wyoming 35.64

PROVENANCE
Hammer Galleries, New York (1961–1963)

EXHIBITIONS
Fine Arts Museum of New Mexico, Santa Fe, October 8–November 22, 1961

REFERENCES
Santa Fe, Fine Arts Museum of New Mexico, *Artist in the American West*, no. 46; Hammer Galleries, *Works of Charles M. Russell and Other Western Artists*, no. 34 (illus.)

277. *A Trapper in His Solitary Camp*

Watercolor on paper

8 5/8 x 7 3/8 in. (21.9 x 18.8 cm.)

Joslyn Art Museum, Omaha, Nebraska; InterNorth Art Foundation Collection 739

PROVENANCE
Porter Collection; M. Knoedler and Company, New York (1962)

EXHIBITIONS
Nelson, January 1939; "Western Frontier," SLAM, April 1–May 13, 1941; BBHC, May 15–September 15, 1959

REFERENCES
DeVoto, pl. XXXVII; BBHC, *Land of Buffalo Bill*, no. 68; American Heritage, ed., *Westward on the Oregon Trail*, illus. p. 40

278. *Trappers*

Pen and ink, watercolor, and gouache on paper

4 1/4 x 4 1/2 in. (10.8 x 11.5 cm.)

Joslyn Art Museum, Omaha, Nebraska; InterNorth Art Foundation Collection 708

PROVENANCE
Porter Collection

EXHIBITIONS
Nelson, January 1939; "Western Frontier," SLAM, April 1–May 13, 1941; BBHC, May 15–September 15, 1959

REFERENCES
"America and the Future," p. 121 (illus.); [Ruxton], *Life in the Far West*, illus. opp. p. 14; BBHC, *Land of Buffalo Bill*, no. 37; [Field], *Matt Field on the Santa Fe Trail*, frontis.; Favour, *Old Bill Williams*, illus. opp. p. 67 (as *Mountain Man Preparing Supper*); Felton, *Edward Rose*, illus. fol. p. 48

279. *Trapper Disturbed in Rest by a Herd of Buffalo*

Pencil, pen and ink, and wash on paper

5 5/8 x 8 1/2 in. (14.3 x 21.6 cm.)

Inscribed, u.l.: "Night Scene/[illeg.]/the Buffalos"

Joslyn Art Museum, Omaha, Nebraska; InterNorth Art Foundation Collection 703

PROVENANCE
Porter Collection

EXHIBITIONS
Nelson, January 1939; "Western Frontier," SLAM, April 1–May 13, 1941 (as *Night Scene. Trapper Disturbed in His Rest by a Herd of Buffaloes*); BBHC, May 15–September 15, 1959

REFERENCES
"America and the Future," p. 115 (illus.); BBHC, *Land of Buffalo Bill*, no. 32; Goetzmann, *Exploration and Empire*, illus. p. [211]

280. *Fontenelle Chased by a Grizzly Bear*

Pen and ink and wash on paper

5 x 7 3/4 in. (12.7 x 19.7 cm.)

Signed, l.l.: "AJM [monogram]"

Inscribed, l.l.: "Fontenelle chased by a Grizzly Bear."

Joslyn Art Museum, Omaha, Nebraska; InterNorth Art Foundation Collection 758

281. *François Preparing Supper*

Pencil, pen and ink, wash, and gouache on paper

4 3/8 x 6 1/4 in. (11.1 x 15.9 cm.)

Joslyn Art Museum, Omaha, Nebraska; InterNorth Art Foundation Collection 709

PROVENANCE
Porter Collection

EXHIBITIONS
"Western Frontier," SLAM, April 1–May 13, 1941; BBHC, May 15–September 15, 1959

REFERENCES
BBHC, *Land of Buffalo Bill*, no. 38

282. *Mule Equipment*

Pencil and wash on paper

6 1/2 x 7 5/8 in. (16.6 x 20.0 cm.)

Signed, l.r.: "AJM [monogram]"

Joslyn Art Museum, Omaha, Nebraska; InterNorth Art Foundation Collection 702

PROVENANCE
Porter Collection

EXHIBITIONS
"Western Frontier," SLAM, April 1–May 13, 1941; BBHC, May 15–September 15, 1959

REFERENCES
DeVoto, pl. XXXII; BBHC, *Land of Buffalo Bill*, no. 31

282A. *Mule Equipment*

Pen and ink with wash on paper

Sight: 6 1/16 x 7 7/16 in. (15.4 x 18.9 cm.)

Private collection

PROVENANCE

the artist; by descent to Louisa Whyte Norton; Old Print Shop, New York (1947); private collection (1947)

REFERENCES

Old Print Shop ledger book (June 18, 1947), no. 47

283. *Mule Throwing off His Pack*

Pencil, pen and ink, and wash on paper

5 3/8 x 8 1/2 in. (13.7 x 21.6 cm.)

Inscribed, l.c.: "Mule throwing off his pack"

Joslyn Art Museum, Omaha, Nebraska; InterNorth Art Foundation Collection 731

PROVENANCE

Porter Collection

EXHIBITIONS

BBHC, May 15–September 15, 1959

REFERENCES

[Field], *Prairie and Mountain Sketches*, illus. opp. p. 74; BBHC, *Land of Buffalo Bill*, no. 60

284. *Watering the Pack Mule*

Pencil, pen and ink, and wash on paper

4 3/4 x 9 in. (12.1 x 23.0 cm.)

The Thomas Gilcrease Institute of American History and Art, Tulsa, Oklahoma 0236.1112

285. *Struggling through the Quicksand*

Pencil, pen and ink, and wash on paper

7 x 10 7/8 in. (17.8 x 27.7 cm.)

Signed, l.l.: "AJM. [monogram]"

Inscribed, l.r.: "The Quick sand"; on mount: "Struggling through the quick-/sand"; on verso: "Carrie C. Miller/3 Oklahoma Terrace/Annapolis, Maryland"

Joslyn Art Museum, Omaha, Nebraska; InterNorth Art Foundation Collection 746

PROVENANCE

Carrie C. Miller, Annapolis; Porter Collection

EXHIBITIONS

Nelson, January 1939; "Western Frontier," SLAM, April 1–May 13, 1941; BBHC, May 15–September 15, 1959

REFERENCES

"America and the Future," p. 114 (illus.); DeVoto, pl. LXXX; BBHC, *Land of Buffalo*, no. 75; American Heritage, ed., *Westward the Oregon Trail*, illus. p. 13

286. *Trappers' Encampment on the Big Sandy River*

Watercolor and gouache on paper

9 x 12 1/2 in. (23.0 x 31.7 cm.)

Signed, l.l.: "AJM [monogram]"

Inscribed, u.r.: "Green River"

The Thomas Gilcrease Institute of American History and Art, Tulsa, Oklahoma 0236.1097

PROVENANCE

[L. Vernon Miller; M. Knoedler and Company, New York, #CA 3223–16, as *Big Sande* [sic] *Green River* (1949)?]

REFERENCES

McDermott, "A. J. Miller," p. 14 (illus.); Rossi and Hunt, p. 324, illus. p. 106 (as *Trappers on the Big Sandy*); Dickson, "Hard on the Heels of Lewis and Clark," cover

286A. *Trapper's Encampment on the "Big Sandy" River*

Watercolor on paper

8 1/8 x 12 11/16 in. (20.7 x 32.3 cm.)

Signed, l.l.: "AJM. [monogram]"

(1858–1860)

The Walters Art Gallery, Baltimore, Maryland 37.1940.156

PROVENANCE

William T. Walters, Baltimore

REFERENCES

Ross, pl. 156; *Sportsman's Wilderness*, illus. p. 144

287. *Scene on "Big Sandy" River*

Watercolor over pencil on paper

8 3/4 x 7 7/8 in. (22.2 x 20.0 cm.)

Signed, l.l.: "AJM [monogram]"

Museum of Fine Arts, Boston 58.1148

EXHIBITIONS

MFA, October 18, 1962–January 6, 1963

REFERENCES

MFA, *Water Colors*, I, no. 552

288. *Trappers, August and Louis* [verso: *Portrait of a Young Man*]

Pencil and sepia wash, heightened with white, on brown paper

9 15/16 x 7 3/4 in. (25.3 x 19.7 cm.)

Inscribed, l.l.: "Trappers"; l.r.: "Half Breeds"

The Boatmen's National Bank of St. Louis, Missouri (May 26, 1947)

PROVENANCE

the artist; by descent to Louisa Whyte Norton; Old Print Shop, New York (1947)

EXHIBITIONS

BNB, May 4–29, 1964

REFERENCES

Cowdrey and Comstock, "Alfred Jacob Miller and the Farthest West," p. 1; BNB, *Catalog*, no. 54

288A. *Trappers*

Watercolor and gouache on paper

11 15/16 x 9 7/16 in. (30.3 x 24.0 cm.)

Signed, l.r.: "AJM [monogram] iller"

(1858–1860)

Inscribed, l.r.: "130"

The Walters Art Gallery, Baltimore, Maryland 37.1940.29

PROVENANCE

William T. Walters, Baltimore

EXHIBITIONS

Seattle Art Museum, July 15–September 26, 1976

REFERENCES

[Ruxton], *Life in the Far West*, illus. opp. p. 30; American Heritage, ed., *Trappers and Mountain Men*, illus. p. 105; Berry, *Majority of Scoundrels*, illus. fol. p. 242; Phillips, *Fur Trade*, II, illus. opp. p. 120; Lavender, *American Heritage History of the Great West*, illus. p. 204; Felton, *Jim Beckwourth*, illus. fol. p. 46; Hafen, *Mountain Men*, IV, frontis.; Art in America, ed., *The Artist in America*, illus. p. 62; Ross, plates XLI, 29; Getlein, *Lure of the Great West*, illus. p. 65; Seattle Art Museum, *Lewis and Clark's America*, no. 59, illus. p. 55; Reader's Digest, *Story of the Great American West*, illus. p. 91; Keith Wheeler, *The Scouts*, illus. p. 46; Bridger, "Seekers of the Fleece, Part I," p. 61 (illus.)

289. *Fur Trappers*

Watercolor on paper

5 1/2 x 8 1/2 in. (14.0 x 21.6 cm.)

Unlocated

PROVENANCE

the artist; by descent to Louisa Whyte Norton; Old Print

Shop, New York (1947); Everett D. Graff, Winnetka, Ill. (1947)

REFERENCES

Old Print Shop ledger book (June 18, 1947), no. 29

290. *Setting Traps for Beaver*

Pencil, watercolor, and gouache on paper

8 x 11 (20.4 x 28.0 cm.)

Signed, l.r.:"AJM. [monogram]"

Joslyn Art Museum, Omaha, Nebraska; InterNorth Art Foundation Collection 680

PROVENANCE

Carrie C. Miller, Annapolis; Porter Collection; M. Knoedler and Company, New York (1962)

EXHIBITIONS

"Western Frontier," SLAM, April 1–May 13, 1941; CGA, June 8–December 17, 1950; BBHC, May 15–September 15, 1959

REFERENCES

"America and the Future," p. 120 (illus.); DeVoto, pl. XLVII; CGA, *American Processional*, no. 144; Brandon, "Wild Freedom of the Mountain Men," pp. 6–7 (illus.); Neider, *Great West*, illus. p. [100]; BBHC, *Land of Buffalo Bill*, no. 9; American Heritage, ed., *American Heritage Book of the Pioneer Spirit*, illus. pp. 162–163, and *Trappers and Mountain Men*, illus. pp. 94–95; Flexner, *That Wilder Image*, no. 22, illus. p. 93; Ewers, *Artists of the Old West*, illus. p. 135; Rasky, *Taming of the Canadian West*, illus. p. 120; Colonel William Gardner Bell, *The Snake*, illus. p. 6; Schomaekers, *Wilde Westen*, illus. p. 55; Hine, *American West*, illus. p. 46; Pike, "World of the Mountain Man," p. 30 (illus.); Goetzmann and Porter, pp. 33, 63, illus. p. 56

290A. *Trapping Beaver*

Watercolor on paper

8 7/8 x 13 3/4 in. (22.5 x 32.4 cm.)

Signed, l.r.: "AJM [monogram] iller"

(1858–1860)

The Walters Art Gallery, Baltimore, Maryland 37.1940.111

PROVENANCE

William T. Walters, Baltimore

EXHIBITIONS

WCMFA, September 14–November 2, 1947; Seattle Art Museum, July 15–September 26, 1976; BBHC, 1978

REFERENCES

WCMFA, *American Indian and the West*, no. 59 (as *Trap Laying*); [Leonard], *Zenas Leonard Fur Trader*, illus. opp. p. 28; Berry, *Majority of Scoundrels*, illus. fol. p. 242; Phillips, *Fur Trade*, II, illus. opp. p. 89; Felton, *Jim*

Beckwourth, illus. fol. p. 46; Goetzmann, *Exploration and Empire*, illus. p. 210; Ross, pl. 111; Hafen, *Mountain Men*, IX, frontis.; Dickson, "Hard on the Heels of Lewis and Clark," pp. 18–19 (illus.); Seattle Art Museum, *Lewis and Clark's America*, no. 56, illus. p. 54; Hassrick, *Way West*, illus. p. 46; BBHC, *Mountain Man*, pl. 12, and *Checklist of the Exhibition*, unpaginated; Hawke, *Those Tremendous Mountains*, illus. p. 113; Bridger, "Seekers of the Fleece, Part I," p. 56 (illus.)

291. *Pierre—A Rocky Mountain Trapper*

Pencil, pen and ink, wash, and gouache on paper

6 3/4 x 9 1/4 in. (17.2 x 23.5 cm.)

Inscribed, l.l.: "52"; l.r.: "Pierre.—Rocky Mountain/ Trapper"

The Thomas Gilcrease Institute of American History and Art, Tulsa, Oklahoma 0236.1060

PROVENANCE

the artist; by descent to L. Vernon Miller, Baltimore; M. Knoedler and Company, New York, #CA 3223-5 (1949)

REFERENCES

Rough Draughts, no. 52; McDermott, "A. J. Miller," p. 15 (illus.); Ewers, *Artists of the Old West*, illus. p. 124; Rossi and Hunt, p. 325, illus. p. 120; Theodore E. Stebbins, Jr., *American Master Drawings and Watercolors*, p. 138; Darling, "Rendezvous at Pierre's Hole Was One Wingding of a Fling," p. 27 (illus. as watercolor)

291A. *Pierre*

Pencil with gray wash on paper

7 x 8 1/4 in. (17.7 x 20.9 cm.)

(c. 1837)

Inscribed, u.l.: "10"; (formerly) l.r.: "Pierre"; on mount, l.c.: "Pierre."

Whitney Gallery of Western Art, Buffalo Bill Historical Center, Cody, Wyoming 13.80; gift of the Joseph M. Roebling Estate

PROVENANCE

the artist; Sir William Drummond Stewart (c. 1839); Frank Nichols (sale: Chapman's, Edinburgh, June 16–17, 1871); Bonamy Mansell Power; willed to Edward Power (1900); by descent to Major G. H. Power, Great Yarmouth, England (sale: PB, May 6, 1966); Joseph M. Roebling

EXHIBITIONS

Denver Art Museum, April 15–24, 1966; PB, April 29–May 6, 1966

REFERENCES

Murthly sale notices; PB sale 2436 (May 6, 1966), lot 3 (illus.); Knox, "83 Drawings from 1837 Trek," p. 28

291B. *Pierre*

Watercolor on paper

9 5/16 x 12 3/16 in. (23.7 x 31.0 cm.)

Signed, l.c.: "AJM [monogram] iller [?]"

(1858–1860)

Inscribed, l.r.: "5 [?]"

The Walters Art Gallery, Baltimore, Maryland 37.1940.53

PROVENANCE

William T. Walters, Baltimore

EXHIBITIONS

"A. J. Miller Watercolors," Smithsonian, October 1956–November 1957; American Federation of Arts, 1976

REFERENCES

Ross, pl. 53; Randall, "Gallery for Alfred Jacob Miller," illus. p. [839]; Shirley Glubok, *Art of America from Jackson to Lincoln*, p. 48; Stebbins, *American Master Drawings and Watercolors*, fig. 109

292. *Striking Back, Coming to the Rescue*

Gouache on paper

8 15/16 x 8 9/16 in. (17.6 x 21.8 cm.)

Signed, l.l.: "AJM [monogram] iller"

Inscribed (formerly) on mount:"Lloyd O. Miller Striking back./Coming to the rescue."

Stark Museum of Art, Orange, Texas 31.34/25

PROVENANCE

the artist; Lloyd O. Miller; L. Vernon Miller; Edward Eberstadt and Sons, New York

REFERENCES

DeVoto, pl. LIV (as *Striking Back*, collection of L. Vernon Miller); Eberstadt catalogue 146 (1958), no. 123–44 (as *Buffalo Striking Back*); Stark, p. 207

293. *A Wounded Buffalo Overthrowing a Hunter in Pursuit*

Pencil and pen and ink with gray and yellow washes on paper

6 15/16 x 10 in. (17.6 x 25.4 cm.)

(c. 1837)

Inscribed: "32"

Unlocated

PROVENANCE

the artist; Sir William Drummond Stewart (c. 1839); Frank Nichols (sale: Chapman's, Edinburgh, June 16–17, 1871); Bonamy Mansell Power; willed to Edward Power (1900); by descent to Major G. H. Power, Great Yarmouth, England (sale: PB, May 6, 1966)

EXHIBITIONS
Denver Art Museum, April 15–24, 1966; PB, April
29–May 6, 1966

REFERENCES
Murthly sale notices; PB sale 2436 (May 6, 1966), lot 38;
Knox, "83 Drawings from 1837 Trek," p. 28

293A. *Pierre and the Buffalo*

Watercolor on paper

10 3/8 x 14 in. (26.4 x 35.5 cm.)

Signed, l.l: "Miller"

(1858–1860)

Inscribed, l.r.: "29 [?]"

The Walters Art Gallery, Baltimore, Maryland 37.1940.58

PROVENANCE
William T. Walters, Baltimore

EXHIBITIONS
WCMFA, September 14–November 2, 1947; Phoenix Art
Musuem, January 12–February 18, 1979; San Diego
Museum of Fine Arts, March 10–April 15, 1979; Wichita
Art Museum, May 1–June 15, 1979

REFERENCES
WCMFA, *American Indian and the West,* no. 67 (as
Buffalo Spill); Hollmann, *Five Artists of the Old West,*
illus. p. 69; Ross, pl. 58; Phoenix Art Museum, *Beyond the
Endless River,* p. 17, pl. 21

293B. *Pierre and the Buffalo (A Tumble at the Kill)*

Oil on cardboard

7 x 9 in. (17.8 x 23.0 cm.)

Signed, l.r.: "AJM. [monogram]"

The Warner Collection of Gulf States Paper Corporation,
Tuscaloosa, Alabama (1979)

PROVENANCE
Post Road Antiques, Mamaroneck, N.Y.; Kennedy
Galleries, New York (1968); William J. Williams,
Cincinnati; Mongerson Galleries, Chicago; Gerald Peters,
Santa Fe; James Maroney, New York

REFERENCES
Kennedy Quarterly 8, no. 2 (June 1968): no. 130 (illus.)

293C. *Pierre and the Buffalo*

Watercolor

17 x 23 1/2 in. (43.2 x 59.7 cm.)

Private collection, Virginia

PROVENANCE
the artist; his family

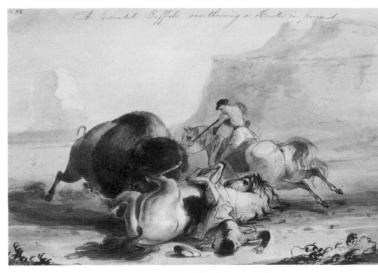

Catalogue number 293.

294. *Ma-Wo-Ma, Little Chief (Snake Indian)*

Watercolor on paper

11 x 9 in. (27.9 x 23.0 cm.)

Signed, l.r.: "AJM [monogram]"

Dated, l.l.: "1837"

Inscribed, l.r.: "Ma-wo-ma/Little Chief"

The Thomas Gilcrease Institute of American History and
Art, Tulsa, Oklahoma 0236.1095

REFERENCES
Rough Draughts, no. 64

294A. *The Chief of the Snake Nation*

Oil on canvas

(c. 1839)

Unlocated

PROVENANCE
Sir William Drummond Stewart (1839); Frank Nichols
(sale: Chapman's, Edinburgh, June 16–17, 1871)

EXHIBITIONS
Apollo Gallery, New York, May 9–22, 1839

REFERENCES
"Apollo Gallery—Original Paintings," *Morning Herald,*
May 16, 1839, p. 2, col. 3, no. 11; Murthly sale notices

294B. *Ma-wo-ma*

Watercolor and gouache on tan paper

12 1/4 x 9 1/2 in. (31.1 x 24.1 cm.)

Signed, l.c.: "AJM [monogram] iller"

(1858–1860)

Inscribed, l.r.: "Ma-wo-ma 64"

The Walters Art Gallery, Baltimore, Maryland 37.1940.35

PROVENANCE

William T. Walters, Baltimore

REFERENCES

Ross, pl. 35

294C. *Ma-wo-ma ("Little Chief")*

Watercolor, gouache, and pen and ink over pencil on paper

Sight: 11 11/16 x 9 11/16 in. (29.6 x 24.6 cm.)

Signed, l.r.: "AJM [monogram] iller Pt."

(1867)

Inscribed on mat, l.l.: "No. 13./Ma-wo-ma./'Little Chief.' "

Public Archives of Canada, Ottawa, Ontario; gift of Mrs. J. B. Jardine (1946)

PROVENANCE

Alexander Brown, Liverpool, England (1867); by descent to Mrs. J. B. Jardine, Chesterknowes, Scotland

EXHIBITIONS

PAC museum, winter 1946–1947; Peale Museum, Baltimore, January 8–February 12, 1950; "Alfred Jacob Miller," ACM, February 13–March 26, 1972

REFERENCES

account book, March 26, May 8, August 10, 1867; Hunter, p. [15]; Brunet, no. 13; *Beaver: Magazine of the North* 285 (Winter 1954–1955): cover; Bell, p. 62, illus. p. 63

295. *Facsimile of a Drawing Made by Ma-wo-ma*

Watercolor, gouache, and pen and ink over pencil on paper

Sight: 8 7/16 x 9 7/16 in. (18.8 x 24.6 cm.)

(1867)

Inscribed, l.r.: "Fac-Simile of a drawing/made by Ma-wó-ma—Chief of Snake/ Indians,—West of Rocky Mts."; on mat, l.r.: "No. 13./See/Ma' Wo' Ma." Public Archives of Canada, Ottawa, Ontario; gift of Mrs. J. B. Jardine (1946)

PROVENANCE

Alexander Brown, Liverpool, England (1867); by descent to Mrs. J. B. Jardine, Chesterknowes, Scotland

EXHIBITIONS

PAC museum, winter 1946–1947; Peale Museum, Baltimore, January 8–February 12, 1950; "Alfred Jacob Miller," ACM, February 13–March 26, 1972

REFERENCES

account book, March 26, May 8, August 10, 1867; Hunter, p. [15]; Brunet, no. 13; Bell, p. 62, illus. p. 65

296. *In-ca-tash-a-pa*

Watercolor, heightened with white, on paper

11 5/8 x 9 1/16 in. (29.5 x 23.0 cm.)

Signed, l.r.: "AJM [monogram] iller"

(1858–1860)

Inscribed: "85"

The Walters Art Gallery, Baltimore, Maryland 37.1940.31

PROVENANCE

William T. Walters, Baltimore

REFERENCES

Ross, pl. 31; Reader's Digest, *Story of the Great American West*, illus. p. 104

296A. *In-ca-tash-a-pa (Red Elk) Snake Warrior*

Oil on paper (oval)

7 5/8 x 9 1/4 in. (19.5 x 23.5 cm.)

Inscribed, l.r.: illeg. ["In-ca-tash-a-pa (Red Elk) Snake Warrior"?]; on mount: "In-ca-tash-a-pa (Red Elk) Snake Warrior/No 88/36"

Western Americana Collection, The Beinecke Rare Book and Manuscript Library, Yale University, New Haven, Connecticut (Coe V, 26)

PROVENANCE

the artist; by descent to Louisa Whyte Norton, Old Print Shop, New York (1947); Edward Eberstadt and Sons, New York

EXHIBITIONS

"Gallery of Dudes," ACM, January 26–March 15, 1967

REFERENCES

Old Print Shop ledger book (June 18, 1947), no. 33 (as 9 1/2 x 8 in.); Withington, no. 341

297. *Chinook Indian:—Columbia River*

Watercolor on paper

12 7/16 x 9 1/2 in. (31.6 x 24.1 cm.)

(1858–1860)

Inscribed, l.l.: "20"; l.r.: "Chinook Indian/Columbia River"

The Walters Art Gallery, Baltimore, Maryland 37.1940.7

PROVENANCE
William T. Walters, Baltimore

REFERENCES
Ross, pl. 7; LaFarge, *Pictorial History of the American Indian*, illus. p. 203, and *American Indian*, illus. p. 64; Ross, *Fur Hunters of the Far West*, illus. opp. p. 25

297A. *Chinook Maiden—Columbia River*

Oil, oval 6 1/8 x 7 1/4 in. (15.5 x 18.5 cm.), mounted on watercolor background,
8 7/16 x 10 13/16 in. (21.5 x 27.5 cm.)

Inscribed, l.r.: "Chinook/Columbia River"

Western Americana Collection, The Beinecke Rare Book and Manuscript Library, Yale University, New Haven, Connecticut (Coe V, 26)

PROVENANCE
the artist; by descent to Louisa Whyte Norton; Old Print Shop, New York (1947); Edward Eberstadt and Sons, New York

EXHIBITIONS
"Gallery of Dudes," ACM, January 26–March 15, 1967; Yale University Art Gallery, New Haven, September 20, 1978–January 6, 1979

REFERENCES
Old Print Shop ledger book (June 18, 1947), no. 53 (as *Chinook, Columbia River*, 11 1/4 x 8 3/4 in.); Withington, no. 341; Sandweiss, p. 62

298. *Nez Perces*

Watercolor on paper
8 x 6 1/2 in. (20.4 x 16.5 cm.)

Inscribed, l.r.: "Nez Perces Indian"

The Thomas Gilcrease Institute of American History and Art, Tulsa, Oklahoma 0236.1017

REFERENCES
Rough Draughts, no. 66; McDermott, "A. J. Miller," p. 14 (illus.)

298A. *Nez Percés Indian*

Watercolor, heightened with white, on brown paper
12 9/16 x 9 7/16 in. (31.9 x 24.0 cm.)

Signed, l.l: "AJM [monogram] iller"
(1858–1860)

Inscribed, l.r.: "Nez-Percés 66"

The Walters Art Gallery, Baltimore, Maryland 37.1940.33

PROVENANCE
William T. Walters, Baltimore

REFERENCES
Ross, *Fur Hunters of the Far West*, illus. opp. p. 153; LaFarge, *American Indian*, illus. p. 60; Ross, pl. 33

298B. *Nez Percé Indian*

Watercolor, gouache, and pen and ink over pencil on paper
Sight: 11 15/16 x 9 5/16 in. (30.3 x 23.7 cm.)

Signed, l.r.: "AJM [monogram] iller. Pt"
(1867)

Inscribed on mat, l.l.: "Nº. 20./Nez Perces Indian."

Public Archives of Canada, Ottawa, Ontario; gift of Mrs. J. B. Jardine (1946)

PROVENANCE
Alexander Brown, Liverpool, England (1867); by descent to Mrs. J. B. Jardine, Chesterknowes, Scotland

EXHIBITIONS
PAC museum, winter 1946–1947; Peal Museum, Baltimore, January 8–February 12, 1950; "Alfred Jacob Miller," ACM, February 13–March 26, 1972

REFERENCES
account book, March 26, May 8, August 10, 1867; Hunter, p. [15]; Brunet, no. 20; Bell, p. 92, illus. p. 93

299. *Big Bowl (High Lance)*

Watercolor on paper
10 1/2 x 7 1/4 in. (26.7 x 18.4 cm.)

Signed, l.l.: "AJM [monogram]"

Inscribed, u.l.: "3"; l.r.: "Big-bowl"

The Thomas Gilcrease Institute of American History and Art, Tulsa, Oklahoma 0236.1024

REFERENCES
Rough Draughts, no. 28

299A. *Shim-a-co-che, Crow Chief*

Watercolor and gouache on paper
12 9/16 x 9 7/16 in. (31.9 x 24.0 cm.)

Signed, l.l.: "AJM [monogram] iller"
(1858–1860)

Inscribed: "108"

The Walters Art Gallery, Baltimore, Maryland 37.1940.39

PROVENANCE
William T. Walters, Baltimore

REFERENCES
Ross, pl. 39

299B. *Schim-a-co-che ("High Lance"), a Crow Indian*

Watercolor, gouache, and pen and ink over pencil on paper

Sight: 11 11/16 x 9 5/16 in. (29.7 x 23.7 cm.)

Signed, l.r.: "AJM [monogram] iller Pt"

(1867)

Inscribed on mat, l.l.: "N⁰ 4/Schim-a-co-che./'High Lance.'/A Crow Indian"

Public Archives of Canada, Ottawa, Ontario; gift of Mrs. J. B. Jardine (1946)

PROVENANCE

Alexander Brown, Liverpool, England (1867); by descent to Mrs. J. B. Jardine, Chesterknowes, Scotland

EXHIBITIONS

PAC museum, winter 1946–1947; Peale Museum, Baltimore, January 8–February 12, 1950; "Alfred Jacob Miller," ACM, February 13–March 26, 1972

REFERENCES

account book, March 26, May 8, August 10, 1867; Hunter, p. [15]; Brunet, no. 4; Bell, p. 26, illus. p. 27

299C. *Schim-a-co-che (High Lance), Crow*

Oil on board (oval cut-out frame)

12 x 9 1/2 in. (30.5 x 24.1 cm.)

Inscribed, l.l.: "108"; l.c.: "Schim-a-co che/High-Lance/A Crow Ind[ian]

Private collection

PROVENANCE

the artist; by descent to his grandnephew, L. Vernon Miller; Mrs. L. Vernon Miller; Graham Gallery, New York (no. 28818); Gerald Peters, Santa Fe

300. *A Young Woman of the Flat Head Tribe*

Gouache on paper

8 1/4 x 7 1/2 in. (21.0 x 19.1 cm.)

Signed: "AJM [monogram]"

Inscribed: "No. 26 Walters, Philipton Suckling X of herself, X without background."

Private collection, Baltimore

PROVENANCE

descended through the family to the present owner

300A. *A Young Woman of the Flat Head Tribe*

Watercolor, heightened with white, on paper

11 1/16 x 9 7/16 in. (28.1 x 24.0 cm.)

Signed, l.r.: "A. Miller"

(1858–1860)

Inscribed, l.r.: "26"

The Walters Art Gallery, Baltimore, Maryland 37.1940.11

PROVENANCE

William T. Walters, Baltimore

REFERENCES

[Ruxton], *Life in the Far West*, illus. opp. p. 190; American Heritage, ed., *Trappers and Mountain Men*, illus. p. 104; Ross, pl. 11

300B. *A Young Woman of the Flat-Head Tribe*

Watercolor, gouache, and pen and ink over pencil on paper

Sight: 11 5/8 x 9 7/16 in. (28.5 x 24.0 cm.)

Signed, l.r.: "AJM [monogram] iller. Pt."

(1867)

Inscribed on mat, l.r.: "N⁰. 38./A Young Woman,/'Of the Flat Head Tribe.' "

Public Archives of Canada, Ottawa, Ontario; gift of Mrs. J. B. Jardine (1946)

PROVENANCE

Alexander Brown, Liverpool, England (1867); by descent to Mrs. J. B. Jardine, Chesterknowes, Scotland

EXHIBITIONS

PAC museum, winter 1946–1947; Peale Museum, Baltimore, January 8–February 12, 1950; "Alfred Jacob Miller, "ACM, February 13–March 26, 1972

REFERENCES

account book, March 26, May 8, August 10, 1867; Hunter, p. [15]; Brunet, 38; Bell, p. 168, illus. p. 169

301. *Aricara [sic] Woman*

Watercolor on paper

8 x 5 3/4 in. (20.4 x 14.6 cm.)

Signed, l.l.: "AJM [monogram]"

Inscribed, l.r.: "An Aricara [sic]"

The Thomas Gilcrease Institute of American History and Art, Tulsa, Oklahoma 0226.1028

REFERENCES

Rough Draughts, no. 38

301A. *Arickara* [sic] *Squaw*

Oil on canvas

(c. 1839)

Unlocated

PROVENANCE

Sir William Drummond Stewart (1839); Frank Nichols (sale: Chapman's, Edinburgh, June 16–17, 1871)

EXHIBITIONS

Apollo Gallery, New York, May 9–22, 1839

REFERENCES

"Apollo Gallery—Original Paintings," *Morning Herald,* May 16, 1839, p. 2, col. 3, no. 9; Murthly sale notices

301B. *Aricara* [sic] *Female*

Watercolor, heightened with white, on paper

11 3/4 x 9 3/8 in. (29.8 x 23.8 cm.)

(1858–1860)

Inscribed, l.r.: "38"

The Walters Art Gallery, Baltimore, Maryland 37.1940.19

PROVENANCE

William T. Walters, Baltimore

REFERENCES

Ross, pl. 19

302. *Bannock Indian*

Watercolor on paper

12 1/2 x 9 9/16 in. (31.7 x 24.4 cm.)

Signed, l.r.: "AJM [monogram] iller"

(1858–1860)

Inscribed, l.r.: "103"

The Walters Art Gallery, Baltimore, Maryland 37.1940.28

PROVENANCE

William T. Walters, Baltimore

REFERENCES

Ross, pl. 28

303. *Big Bowl, Crow Chief*

Watercolor on paper

9 x 6 3/4 in. (23.0 x 17.2 cm.)

Signed, l.l.: "AJM. [monogram]"

Inscribed, l.l.: "Big—Bowl"; l.c.: "Crow Chief"

Mrs. Hugh Montgomery, Lookout Mountain, Tennessee

PROVENANCE

the artist; by descent to the present owner

303A. *Big Bowl, Principal Chief of the Crow Indians*

Oil on canvas

(c. 1839)

Unlocated

PROVENANCE

Sir William Drummond Stewart (1839); Frank Nichols (sale: Chapman's, Edinburgh, June 16–17, 1871)

EXHIBITIONS

Apollo Gallery, New York, May 9–22, 1839

REFERENCES

"Apollo Gallery—Original Paintings," *Morning Herald,* May 16, 1839, p. 2, col. 3, no. 10; Murthly sale notices

303B. *"Big Bowl"(A Crow Chief)*

Watercolor, heightened with white, on paper

11 15/16 x 9 1/2 in. (30.3 x 24.1 cm.)

Signed, l.r.: "Miller Pt."

(1858–1860)

Inscribed, l.r.: "28"

The Walters Art Gallery, Baltimore, Maryland 37.1940.15

PROVENANCE

William T. Walters, Baltimore

EXHIBITIONS

University of Pennsylvania Museum, Philadelphia, May 8–September 8, 1958; "A. J. Miller Watercolors," Smithsonian, October 1956–November 1957

REFERENCES

Philadelphia, University of Pennsylvania Museum, *Noble Savage,* no. 48; Ross, pl. 15

304. *"Elk Horn" Crow Indian (Pa-de-he'wa-con-da)*

Oil on paper (oval)

8 x 7 1/4 in. (20.4 x 18.4 cm.)

Inscribed, u.c.: "Pa-de-he'wa-con-da Elk Horn/No. 117"; l.r.: "Pade-he'wa-con-da"

The Thomas Gilcrease Institute of American History and Art, Tulsa, Oklahoma 0136.2247

REFERENCES

Rough Draughts, no. 117

304. *Pa-da-he: Wa-con-da—Elk Horn:—A Crow Indian*

Watercolor, heightened with white, on paper

11 9/16 x 8 3/4 in. (29.3 x 22.2 cm.)

Signed, l.r.: "AJM [monogram]"

(1858–1860)

Inscribed: "117"

The Walters Art Gallery, Baltimore, Maryland 37.1940.43

PROVENANCE

William T. Walters, Baltimore

REFERENCES

Ross, pl. 43

305. *Flat Head (Oregon)*

Watercolor on paper

5 3/4 x 4 3/4 in. (14.6 x 12.1 cm.)

Inscribed, l.r.: "Flat Head/Oregon"

The Thomas Gilcrease Institute of American History and Art, Tulsa, Oklahoma 0236.1026

REFERENCES

Rough Draughts, no. 26

306. *Iroquois Indian*

Watercolor on paper

12 11/16 x 10 in. (32.3 x 25.4 cm.)

Signed, l.l.: "AJM [monogram] iller"

(1858–1860)

Inscribed, l.r.: "61"

The Walters Art Gallery, Baltimore, Maryland 37.1940.41

PROVENANCE

William T. Walters, Baltimore

REFERENCES

Ross, pl. 41

307. *White Plume—Kansas Indian*

Watercolor on paper

5 x 4 in. (12.7 x 10.2 cm.)

Inscribed, l.r.: "Kaw"; label on verso: Purnell Art Co., Baltimore

Kennedy Galleries, Inc., New York (1980)

PROVENANCE

the artist; by descent through his family to Dr. William Pinckney Carton

307A. *White Plume, Chief of the Kansas*

Watercolor on paper

9 1/2 x 7 1/2 in. (24.1 x 19.1 cm.)

Inscribed, l.r.: "46"; l.l.: "White Plume/Chief of the Kansas"

The Thomas Gilcrease Institute of American History and Art, Tulsa, Oklahoma 0236.1059

REFERENCES

Rough Draughts, no. 46

307B. *White Plume*

Watercolor, heightened with white, on paper

12 1/16 x 9 3/8 in. (30.6 x 23.8 cm.)

Signed, l.r.: "AJM [monogram] iller"

(1858–1860)

Inscribed, l.r.: "46"

The Walters Art Gallery, Baltimore, Maryland 37.1940.17

PROVENANCE

William T. Walters, Baltimore

EXHIBITIONS

"A. J. Miller Watercolors," Smithsonian, October 1956–November 1957

REFERENCES

Ross, pl. 17

308. *Kansas Indian—Head*

Pencil, watercolor, and gouache on paper

6 1/4 x 5 1/8 in. (15.9 x 13.0 cm.)

Joslyn Art Museum, Omaha, Nebraska; InterNorth Art Foundation Collection 776

PROVENANCE

the artist; by descent to Mrs. Laurence R. Carton; Porter Collection; M. Knoedler and Company, New York, #WCA 2235 (1965)

REFERENCES

JAM, *Exploration in the West*, illus. p. 31; Goetzmann and Porter, p. 70

309. *Portrait of an Indian* [Kansas]

Pencil, ink, and wash on paper

6 x 5 in. (15.2 x 12.7 cm.)

Signed, l.l.: "AJM [monogram]"

Inscribed, l.r.: "Kansas"

Gerald Peters, Santa Fe, New Mexico

PROVENANCE

the artist; Mrs. L. Vernon Miller; Graham Gallery, New York

310. *Kaw Man* [portrait]

Watercolor on paper

10 1/2 x 7 1/2 in. (26.7 x 19.1 cm.)

Signed, l.r.: "AJM [monogram]"

Inscribed, l.r.: "Kaw Indian"

The Thomas Gilcrease Institute of American History and Art, Tulsa, Oklahoma 0226.1037

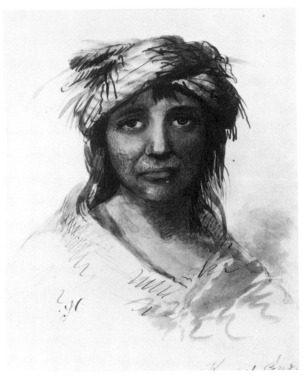

Catalogue number 311.

311. *Kansas Indian*

5 1/2 x 6 3/4 in. (14.0 x 17.0 cm.)

Signed, l.l.: "AJM [monogram]"

Inscribed, l.r.: "Kansas Indian"

Western Americana Collection, The Beinecke Rare Book and Manuscript Library, Yale University, New Haven, Connecticut (Coe V, 26)

PROVENANCE

the artist; by descent to Louisa Whyte Norton; Old Print Shop, New York (1947); Edward Eberstadt and Sons

EXHIBITIONS

"Gallery of Dudes," ACM, January 26–March 15, 1967; Yale University Art Gallery, New Haven, September 20, 1978–January 6, 1979

REFERENCES

Old Print Shop ledger book (June 18, 1947), no. 7 (as 7 x 6 in.); Withington, no. 341; Sandweiss, p. 62

312. *Kansas* [portrait of an Indian]

Gouache on paper

7 1/2 x 6 1/4 in. (19.1 x 15.9 cm.)

Signed, l.l.: "AJM [monogram]"

Inscribed, l.r.: "Kansas."

Private collection, Baltimore

PROVENANCE

descended through the family to the present owner

313. *Tribe Kansas*

Watercolor on paper

9 x 7 1/2 in. (22.9 x 19.1 cm.)

Signed, l.l.: "AJM [monogram]"

Inscribed, l.r.: "Kans" [sight]

Joslyn Art Museum, Omaha, Nebraska; InterNorth Art Foundation Collection 744

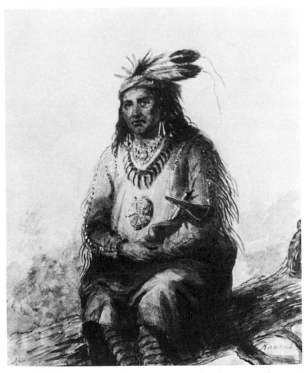

Catalogue number 314.

314. *Kansas* [Indian portrait]

Watercolor on paper

11 1/2 x 9 3/4 in. (29.2 x 24.8 cm.)

Signed, l.l.: "AJM [monogram]"

Inscribed, l.r.: "Kansas"

The Thomas Gilcrease Institute of American History and Art, Tulsa, Oklahoma 0236.1025

REFERENCES

McDermott, "A. J. Miller," p. 10 (illus.)

315. *Indian*

Watercolor on paper

7 x 5 1/2 in. (17.8 x 14.0 cm.)

The Thomas Gilcrease Institute of American History and Art, Tulsa, Oklahoma 0236.1084

316. *Kansas Indian*

Pen and ink and watercolor on paper

6 1/8 x 4 7/8 in. (15.6 x 12.4 cm.)

Inscribed, l.r.: "Kansas/Indian—"

Joslyn Art Museum, Omaha, Nebraska; InterNorth Art Foundation Collection 778

PROVENANCE
Miss Jane Miller; M. Knoedler and Company, New York, #WCA 2737 (1965)

REFERENCES
Goetzmann and Porter, p. 70

316A. *A Kansas Indian*

Watercolor, gouache, and pen and ink over pencil on paper

Sight: 11 11/16 x 9 3/8 in. (29.8 x 23.7 cm.)

Signed, l.r.: "AJM [monogram] iller Pt"

(1867)

Inscribed on mat, l.l.: "No. 37./A Kansas Indian."

Public Archives of Canada, Ottawa, Ontario; gift of Mrs. J. B. Jardine (1946)

PROVENANCE
Alexander Brown, Liverpool, England (1867); by descent to Mrs. J. B. Jardine, Chesterknowes, Scotland

EXHIBITIONS
PAC museum, winter 1946–1947; Peale Museum, Baltimore, January 8–February 12, 1950; "Alfred Jacob Miller," ACM, February 13–March 26, 1972

REFERENCES
account book, March 26, May 8, August 10, 1867; Hunter, p. [15]; Brunet, no. 37; Bell, p. 164, illus. p. 165

317. *Kaw Man* [portrait]

Watercolor on paper

7 x 5 1/2 in. (17.8 x 14.0 cm.)

Inscribed, l.r.: "Kaw Indian"

The Thomas Gilcrease Institute of American History and Art, Tulsa, Oklahoma 0226.1039

318. *Kansas Indian* [male portrait]

Watercolor on paper

6 1/2 x 5 1/2 in. (16.5 x 14.0 cm.)

Inscribed, u.r.: "Kansas"

The Thomas Gilcrease Institute of American History and Art, Tulsa, Oklahoma 0226.1074

REFERENCES
Rough Draughts, no. 161

319. *Kansas Indian* [male portrait]

Watercolor on paper

6 3/4 x 5 1/2 in. (17.2 x 14.0 cm.)

The Thomas Gilcrease Institute of American History and Art, Tulsa, Oklahoma 0226.1050

320. *Kansas Indians* [portrait of two men]

Watercolor on paper

5 1/4 x 7 1/2 in. (13.3 x 19.1 cm.)

The Thomas Gilcrease Institute of American History and Art, Tulsa, Oklahoma 0226.1049

321. *Kansas Indian Woman* [portrait]

Ink on paper

7 1/4 x 5 3/4 in. (18.4 x 14.6 cm.)

The Thomas Gilcrease Institute of American History and Art, Tulsa, Oklahoma 1326.1072

PROVENANCE
[L. Vernon Miller; M. Knoedler and Company, New York, #CA 3223–19, as *Portrait of an Indian Girl* (1949)?]

REFERENCES
McDermott, "A. J. Miller," p. 16 (illus.)

322. *Tribe Shoshone*

Pen and ink, watercolor, and gouache on paper

8 7/8 x 7 1/4 in. (22.6 x 18.5 cm.)

Inscribed on mount, l.r.: "Tribe Shoshone"

Joslyn Art Museum, Omaha, Nebraska; InterNorth Art Foundation Collection 742

EXHIBITIONS
BBHC, May 15–September 15, 1959

REFERENCES
[Field], *Prairie and Mountain Sketches*, illus. opp. p. 170 (as *Shoshone Indian*); BBHC, *Land of Buffalo Bill*, no. 71; Ewers, *Artists of the Old West*, illus. p. [133]; JAM, *Exploration in the West*, illus. p. 31 (as *Indian of Shoshone Tribe*)

323. *Head of "Matau-Tathonca," "Bull Bear"—
an Ogillalah* [sic]
Watercolor and gouache on paper
11 1/4 x 8 11/16 in. (28.6 x 22.1 cm.)
Signed, l.l.: "AJM [monogram] iller"
(1858–1860)
Inscribed: "143"
The Walters Art Gallery, Baltimore, Maryland 37.1940.45

PROVENANCE
William T. Walters, Baltimore

EXHIBITIONS
"Western Frontier," Denver Art Museum, 1966;
University of Minnesota Gallery, Minneapolis, June
13–August 18, 1978

REFERENCES
DeVoto, pl. LXIX (as *Bear Bull*); Royal B. Hassrick, *The
Sioux*, illus. fol. p. 100; *Denver Art Museum Quarterly*,
Summer 1966, illus.; Ross, pl. 45; Minneapolis, University
of Minnesota Gallery, *People of the Plains*, no. 43

324. *Head of a Sioux*
Watercolor on paper embossed "Boards Extra Superfine
London"
8 5/16 x 6 7/8 in. (21.1 x 17.5 cm.)
(1858–1860)
Inscribed, l.r.: "17"
The Walters Art Gallery, Baltimore, Maryland 37.1940.23

PROVENANCE
William T. Walters, Baltimore

REFERENCES
Ross, pl. 23

324A. *Head of a Sioux Indian*
Watercolor, gouache, and pen and ink over pencil on
paper
Sight: 6 11/16 x 5 7/8 in. (17.5 x 15.1 cm.)
Signed, l.r.: "AJM [monogram]"
(1867)
Inscribed on mat, l.l.: "Nº. 10./Head of a Sioux Indian."
Public Archives of Canada, Ottawa, Ontario; gift of Mrs.
J. B. Jardine (1946)

PROVENANCE
Alexander Brown, Liverpool, England (1867); by descent
to Mrs. J. B. Jardine, Chesterknowes, Scotland

EXHIBITIONS
PAC museum, winter 1946–1947; Peale Museum,
Baltimore, January 8–February 12, 1950; "Alfred Jacob
Miller," ACM, February 13–March 26, 1972

REFERENCES
account book, March 26, May 8, August 10, 1867;
Hunter, p. [15]; Brunet, no. 10; Bell, p. 50, illus. p. 51

325. *Sioux Brave*
Pencil, watercolor, and gouache on paper (circular
composition)
8 1/4 in. diameter (21.1 cm.)
Signed, l.r.: "AJ Miller"
Inscribed on mount, l.l.: "Sioux Brave"; on mount, l.r.:
"From Nature by A. J. Miller 1836 & 7"
Joslyn Art Museum, Omaha, Nebraska; InterNorth Art
Foundation Collection 762

PROVENANCE
Mrs. Crawford Smith, Baltimore; M. Knoedler and
Company, New York, #WCA 1369 (1951–1965)

EXHIBITIONS
M. Knoedler Galleries, New York, October
20–November 1, 1952, and "Far West," New York,
November 15–December 4, 1954, no. 9; Jackson Lake
Lodge, Grand Teton National Park, Wyo.

REFERENCES
M. Knoedler Galleries, New York, *Exhibition Featuring
Paintings from Harold McCracken's Book Portrait of the Old
West*, no. 15; Grand Teton National Park, *First Painters
of the West*, no. 9; Goetzmann and Porter, p. 69

325A. *Sioux Indian*
Watercolor, heightened with white, on paper
11 5/8 x 9 3/8 in. (29.5 x 23.8 cm.)
Signed, l.r.: "AJM [monogram] iller"
(1858–1860)
Inscribed, l.r.: "58"
The Walters Art Gallery, Baltimore, Maryland 37.1940.6

PROVENANCE
William T. Walters, Baltimore

REFERENCES
Ross, pl. 6; Schomaekers, *Wilde Westen*, illus. p. 198;
Holloway, *Lewis and Clark and the Crossing of North
America*, illus. p. 50

326. *Si Roc U An Tua (Snake Indian)*
Watercolor on paper
8 3/4 x 6 1/2 in. (22.2 x 16.5 cm.)
Inscribed, l.r.: "Si-roc-u-an-tua—Chief/Son of Mawama
[*sic*]/Snake Indian"
The Thomas Gilcrease Institute of American History and
Art, Tulsa, Oklahoma 0236.1038

REFERENCES
Rough Draughts, no. 45

326A. *Indian*

Watercolor on paper (oval)

11 x 8 3/4 in. (27.9 x 22.2 cm.)

The Thomas Gilcrease Institute of American History and Art, Tulsa, Oklahoma 0236.1029

REFERENCES

Rough Draughts, no. 45; "Alfred Jacob Miller," *American Scene* 14, no. 4 (1973): [18] (illus.)

326B. *Si-roc-u-an-tua*

Watercolor, heightened with white, on paper watermarked "DE CANSON"

11 1/4 x 8 13/16 in. (28.6 x 22.4 cm.)

Signed, l.r.: "AJM [monogram] iller"

(1858–1860)

Inscribed, l.r.: "45"

The Walters Art Gallery, Baltimore, Maryland 37.1940.25

PROVENANCE

William T. Walters, Baltimore

REFERENCES

Ross, pl. 25

327. *Snake Indian* [male portrait]

Watercolor on paper

7 x 5 1/2 in. (17.8 x 14.0 cm.)

Inscribed, l.r.: "Shoshonee [*sic*]/or Snake Indian"

The Thomas Gilcrease Institute of American History and Art, Tulsa, Oklahoma 0236.1051

328. *Indian*

Watercolor on paper

10 1/4 x 7 1/4 in. (26.0 x 18.4 cm.)

The Thomas Gilcrease Institute of American History and Art, Tulsa, Oklahoma 0236.1045

329. *Snake Tribe*

Watercolor on paper

5 1/4 x 4 3/4 in. (13.3 x 12.0 cm.)

[Label on verso: Purnell Art Co., Baltimore]

Kennedy Galleries, Inc., New York (1980)

PROVENANCE

the artist; by descent through his family to Dr. William Pinckney Carton

330. *Snake Indians*

Watercolor on white card blind-stamped "Reynolds Drawing Board/Abraded Surface"

5 9/16 x 4 7/8 in. (14.2 x 12.3 cm.)

(c. 1837)

Inscribed: "39"

Unlocated

PROVENANCE

the artist; Sir William Drummond Stewart (c. 1839); Frank Nichols (sale: Chapman's, Edinburgh, June 16–17, 1871); Bonamy Mansell Power; willed to Edward Power (1900); by descent to Major G. H. Power, Great Yarmouth, England (sale: PB, May 6, 1966)

EXHIBITIONS

Denver Art Museum, April 15–24, 1966; PB, April 29–May 6,1966

REFERENCES

Murthly sale notices; PB sale 2436 (May 6, 1966), lot 48; Knox, "83 Drawings from 1837 Trek," p. 28

331. *Otium Cum Dignitati Smoking the Calumet*

Pencil, watercolor, and gouache on paper

8 x 7 1/2 in. (20.3 x 19.1 cm.)

Joslyn Art Museum, Omaha, Nebraska; InterNorth Art Foundation Collection 735

PROVENANCE

Porter Collection

EXHIBITIONS

Nelson, January 1939 (as *Smoking the Calumet*); "Western Frontier," SLAM, April 1–May 13, 1941 (as *Old Age with Dignity—Smoking the Calumet*); BBHC, May 15–September 15, 1959

REFERENCES

[Ruxton], *Life in the Far West*, illus. opp. p. 46 (as *Old Age with Dignity*); BBHC, *Land of Buffalo Bill*, no. 64 (as "*Otium Cum Dignitati*" [*Old Age with Dignity*] *Smoking the Calumet*)

331A. *Snake Indian—Full Costume*

Pencil and watercolor on paper

8 x 6 1/2 in. (20.4 x 16.5 cm.)

Inscribed, u.l.: "15"

The Gund Collection of Western Art, Cleveland, Ohio (1973)

PROVENANCE

the artist; Sir William Drummond Stewart (c. 1839); Frank Nichols (sale: Chapman's, Edinburgh, June 16–17, 1871); Bonamy Mansell Power; willed to Edward Power (1900); by descent to Major G. H. Power, Great

Yarmouth, England (sale: PB, May 6, 1966); (sale: SPB, April 11, 1973)

EXHIBITIONS
Denver Art Museum, April 15–24, 1966; PB, April 29–May 6, 1966

REFERENCES
Murthly sale notices; PB sale 2436 (May 6, 1966), lot 50; Knox, "83 Drawings from 1837 Trek," p. 28; SPB sale 3498 (April 11, 1973), lot 61

331B. *A Shoshonee* [sic] *Indian Smoking*

Watercolor, heightened with white, on paper

11 5/16 x 9 7/8 in. (28.7 x 25.1 cm.)

Signed: "A. J. Miller"

(1858–1860)

Inscribed: "70"

The Walters Art Gallery, Baltimore, Maryland 37.1940.40

PROVENANCE
William T. Walters, Baltimore

REFERENCES
Ross, pl. 40; Capps, *Great Chiefs,* illus. p. 133

332. *Shoshones—Green River*

Watercolor and gouache on paper

7 3/4 x 5 1/2 in. (19.7 x 14.0 cm.)

Signed, l.l.: "AJM [monogram]"

Joslyn Art Museum, Omaha, Nebraska; InterNorth Art Foundation Collection 711

PROVENANCE
Porter Collection

EXHIBITIONS
BBHC, May 15–September 15, 1959

REFERENCES
BBHC, *Land of Buffalo Bill,* no. 40

333. *Shoshone. Wind River*

Watercolor on paper

4 5/16 x 4 3/4 in. (11.0 x 12.0 cm.)

Inscribed on mount: "Shoshone. Wind River"

Western Americana Collection, The Beinecke Rare Book and Manuscript Library, Yale University, New Haven, Connecticut (Coe V, 26)

PROVENANCE
the artist; by descent to Louisa Whyte Norton; Old Print Shop, New York (1947); Edward Eberstadt and Sons, New York

EXHIBITIONS
"Gallery of Dudes," ACM, January 26–March 15, 1967

REFERENCES
Old Print Shop ledger book (June 18, 1947), no. 40 (as 5 x 4 3/4 in.); Withington, no. 341

334. *War Dress*

Pencil, pen and ink, watercolor, and gouache on paper

8 1/4 x 5 1/4 in. (21.0 x 13.4 cm.)

Joslyn Art Museum, Omaha, Nebraska; InterNorth Art Foundation Collection 777

PROVENANCE
Miss Jane H. Miller; M. Knoedler and Company, New York, #WCA 2738 (1965)

335. *Flatheads and Nez Perce (Snakes, Flatheads and Nez Perces)*

Watercolor on paper

Sight: 7 x 9 in. (17.7 x 22.9 cm.)

Inscribed, l.l.: "Snakes Flatheads and Nez Perces"

Whitney Gallery of Western Art, Buffalo Bill Historical Center, Cody Wyoming 31.64; gift of the W. R. Coe Foundation, Oyster Bay, New York

PROVENANCE
The artist; by descent to Louisa Whyte Norton; Old Print Shop, New York (1947); Edward Eberstadt and Sons, New York; John Howell-Books, San Francisco (1961)

REFERENCES
Old Print Shop ledger book (June 18, 1947), no. 24 (as *Flat Heads & Nez-perces,* 7 1/4 x 9 1/4 in.); Swingle, *Catalogue 33: Rare Books and Manuscripts,* no. 101 (as *Snakes, Flat-heads & Nez-Perces,* 7 1/4 x 9 1/4 in.)

336. *Kansas Indian*

Watercolor on paper

5 5/8 x 3 3/8 in. (14.3 x 8.6 cm.)

Inscribed, u.r.: "Kansas"

The Thomas Gilcrease Institute of American History and Art, Tulsa, Oklahoma 0226.1104

REFERENCES
Rough Draughts, no. 19

337. *Kansas Tribe*

Watercolor and gouache on paper

6 1/8 x 7 3/4 in. (15.6 x 19.7 cm.)

Inscribed, l.r.: "Kansas"

Joslyn Art Museum, Omaha, Nebraska; InterNorth Art Foundation Collection 701

PROVENANCE

Carrie C. Miller, Annapolis; Porter Collection; M.
Knoedler and Company, New York

EXHIBITIONS

"Western Frontier," SLAM, April 1–May 13, 1941 (as
Kansas); BBHC, May 15–September 15, 1959; JAM,
November 15, 1980–January 4, 1981

REFERENCES

BBHC, *Land of Buffalo Bill*, no. 30; JAM, *Angels and
Urchins* (1980), no. 54, pp. 65, 68; Goetzmann and Porter,
p. 66

338. *Sioux Guard*

Watercolor and gouache on paper

5 3/4 x 3 3/8 in. (14.6 x 8.6 cm.)

The Thomas Gilcrease Institute of American History and
Art, Tulsa, Oklahoma 0226.1040

REFERENCES

Rough Draughts, no. 59

338A. *Sioux Indian Guard*

Watercolor, heightened with white, on paper

11 3/4 x 9 1/8 in. (29.8 x 23.2 cm.)

Signed, l.r.: "A JMiller"

(1858–1860)

Inscribed:"18"

The Walters Art Gallery, Baltimore, Maryland 37.1940.18

PROVENANCE

William T. Walters, Baltimore

EXHIBITIONS

"A. J. Miller Watercolors," Smithsonian, October
1956–November 1957

REFERENCES

Ross, pl. 18

339. *Sioux*

Watercolor on paper

4 1/2 x 31/2 in. (11.4 x 8.9 cm.)

Private collection

PROVENANCE

Mrs. Laurence R. Carton

REFERENCES

private collector to William R. Johnston, WAG,
November 23, 1980

340. *Snake Indians in Full War Dress*

Watercolor and gouache on paper

8 3/4 x 13 3/4 in. (22.2 x 34.9 cm.)

Inscribed, l.r.: "Snake Indians"; u.l.: "136"

The Thomas Gilcrease Institute of American History and
Art, Tulsa, Oklahoma 0236.1081

PROVENANCE

[Alfred J. Miller, Jr., Baltimore; M. Knoedler and
Company, New York, #CA 3090 as *Indians on Horses*
(1948)?]

REFERENCES

Rough Draughts, no. 136

340A. *Snake Indians in Full Costume*

Pen and ink with brown wash, heightened with white, on
buff paper

11 1/2 x 14 1/4 in. (29.3 x 36.9 cm.)

(c. 1837)

Inscribed, u.l.: "61"

Rosenstock Arts, Denver, Colorado

PROVENANCE

the artist; Sir William Drummond Stewart (c. 1839);
Frank Nichols (sale: Chapman's, Edinburgh, June 16–17,
1871); Bonamy Mansell Power; willed to Edward Power
(1900); by descent to Major G. H. Power, Great
Yarmouth, England (sale: PB, May 6, 1966); Martin
Kodner, St. Louis; private collection

EXHIBITIONS

Denver Art Museum, April 15–24, 1966; PB, April
19–May 6, 1966

REFERENCES

Murthly sale notices; PB sale 2436 (May 6, 1966), lot 53
(illus.); Knox, "83 Drawings from 1837 Trek," p. 28

340B. *Snake Indians*

Watercolor on paper

9 3/8 x 13 3/4 in. (23.8 x 35.0 cm.)

Signed, l.r.: "AJM [monogram] iller"

(1858–1860)

The Walters Art Gallery, Baltimore, Maryland 37.1940.88

PROVENANCE

William T. Walters, Baltimore

REFERENCES

Ross, pl. 88

341. *A Flat Head and a Nez Percé Indian*

Pencil, pen and ink, and watercolor on paper

6 x 6 1/2 in. (14.4 x 12.7 cm.)

Inscribed, u.l.: "21"

Unlocated

PROVENANCE

the artist; Sir William Drummond Stewart (c. 1839); Frank Nichols (sale: Chapman's, Edinburgh, June 16–17, 1871); Bonamy Mansell Power; willed to Edward Power (1900); by descent to Major G. H. Power, Great Yarmouth, England (sale: PB, May 6, 1966); Biltmore Galleries, Los Angeles (1969)

EXHIBITIONS

Denver Art Museum, April 15–24, 1966; PB, April 29–May 6, 1966

REFERENCES

Murthly sale notices; PB sale 2436 (May 6, 1966), lot 49; Knox, "83 Drawings from 1837 Trek," p. 28; Biltmore Galleries, Los Angeles, [Partial Western Collection] *Catalogue* (May 1969), no. 46 (illus.)

342. Untitled [group of three Indians]

Pencil and watercolor on paper

7 1/16 x 5 15/16 in. (18.0 x 15.1 cm.)

(c. 1837)

Inscribed: "53"

Unlocated

PROVENANCE

the artist; Sir William Drummond Stewart (c. 1839); Frank Nichols (sale: Chapman's, Edinburgh, June 16-17, 1871); Bonamy Mansell Power; willed to Edward Power (1900); by descent to Major G. H. Power, Great Yarmouth, England (sale: PB, May 6, 1966)

EXHIBITIONS

Denver Art Museum, April 15–24, 1966; PB, April 29–May 6, 1966

REFERENCES

Murthly sale notices; PB sale 2436 (May 6, 1966), lot 44; Knox, "83 Drawings from 1837 Trek," p. 28

343. *Group of Indians*

Watercolor on paper

11 3/8 x 9 3/8 in.

Unlocated

PROVENANCE

the artist; by descent to Louisa Whyte Norton; Old Print Shop, New York (1947); Everett D. Graff, Winnetka, Ill. (1947)

REFERENCES

Old Print Shop ledger book (June 18, 1947), no. 1

344. *Indian on Horseback* [Indian cut out and silhouetted]

8 3/4 x 7 in. (22.2 x 17.8 cm.)

Kennedy Galleries, Inc., New York (1980)

PROVENANCE

the artist; by descent through his family to Dr. William Pinckney Carton

345. *Indian on Horseback*

Oil on canvas, mounted on panel

7 3/8 x 10 9/16 in. (18.7 x 26.8 cm.)

Private collection (August 1980)

PROVENANCE

[(sale: C. G. Sloan and Company, Washington, D.C., June 8, 1980)?]; Alexander Gallery, New York

REFERENCES

[C. G. Sloan and Company, Washington, D.C., sale catalogue (June 8, 1980), lot 2392 (illus. as *Shoshone Indians Pursuing Deer*, oil on paper mounted on panel, 7 1/2 x 10 1/2 in.)?]

346. *Snake Indians Watching the Approach of a Canoe*

Pencil, watercolor, and gouache on paper

7 3/8 x 10 3/4 in. (18.8 x 27.3 cm.)

Inscribed, l.r.: "of a Canoe/Snake Indians watching the approach"

Joslyn Art Museum, Omaha, Nebraska; InterNorth Art Foundation Collection 747

PROVENANCE

Porter Collection

EXHIBITIONS

Nelson, January 1939; "Western Frontier," SLAM, April 1–May 13, 1941; BBHC, May 15–September 15, 1959

REFERENCES

BBHC, *Land of Buffalo Bill*, no. 76

346A. *Indians Watching a Canoe*

Watercolor on paper

8 13/16 x 12 3/8 in. (22.4 x 31.4 cm.)

Signed, l.r.: "AJM [monogram] iller [?]"

(1858–1860)

The Walters Art Gallery, Baltimore, Maryland 37.1940.75

PROVENANCE
William T. Walters, Baltimore

REFERENCES
Ross, pl. 75

347. *Birch Bark Canoe*

Watercolor and gouache on paper

6 3/4 x 10 in. (17.2 x 25.4 cm.)

Inscribed, u.r.: "Birch bark Canoe"

The Thomas Gilcrease Institute of American History and Art, Tulsa, Oklahoma 0226.1042

PROVENANCE
L. Vernon Miller; M. Knoedler and Company, New York, #CA 3223-15 (1949)

REFERENCES
Rough Draughts, no. 67

347A. *Indian Canoe*

Watercolor on paper

8 5/16 x 13 13/16 in. (21.1 x 32.6 cm.)

Signed, l.r.: "AJM [monogram]"

(1858–1860)

The Walters Art Gallery, Baltimore, Maryland 37.1940.165

PROVENANCE
William T. Walters, Baltimore

REFERENCES
Robert Stuart, *On the Oregon Trail,* illus. opp. p. 34; Ross, *Fur Hunters of the Far West,* illus. opp. p. 24; Ross, pl. 165

348. *The War Canoe*

Oil on paper

6 3/4 x 9 1/2 in. (17.2 x 24.1 cm.)

The Thomas Gilcrease Institute of American History and Art, Tulsa, Oklahoma 0226.1079

REFERENCES
Rough Draughts, no. 57

349. *Departure of the War Canoe*

Pencil and wash on paper

5 3/4 x 7 1/4 in. (14.6 x 18.4 cm.)

Inscribed, u.l.: "Departure of the War Canoe."

The Thomas Gilcrease Institute of American History and Art, Tulsa, Oklahoma 0236.1108

349A. *Departure of the War Canoe*

20 x 14 in. (50.8 x 35.5 cm.)

Unlocated

REFERENCES
account book, July 10, 1865, $80, for Jacob Brandt, Jr.

349B. *Departure of the War Canoe*

Oil on academy board

12 x 15 5/8 in. (30.5 x 39.7 cm.)

Signed in red, l.r.: "AJM [monogram] iller"

Stenciled on verso: "6 Muller, Fils, Paris" (in red); "From G. R. Dodge Co., Artists & Painters Supply Store, 42 Balt. St. Baltimore" (in black)

Stark Museum of Art, Orange, Texas 31.34/6

PROVENANCE
Edward Eberstadt and Sons, New York

REFERENCES
Eberstadt catalogue 146 (1958), no. 123–46; Stark, p. 205

350. *Indian Female Running a Buffalo*

Watercolor on paper

4 3/4 x 6 1/4 in. (12.1 x 15.9 cm.)

Signed, l.l.: "AJM [monogram]"

Inscribed, u.l.: "Running a Bull Buffalo."

Joslyn Art Museum, Omaha, Nebraska; InterNorth Art Foundation Collection 736

PROVENANCE
Porter Collection

EXHIBITIONS
Nelson, January 1939; "Western Frontier," SLAM, April 1–May 13, 1941; BBHC, May 15–September 15, l959

REFERENCES
DeVoto, pl. LV; BBHC, *Land of Buffalo Bill,* no. 65

350A. *Buffalo Chase—by a Female*

Watercolor on paper

8 7/8 x 12 1/4 in. (22.5 x 31.1 cm.)

(1858–1860)

The Walters Art Gallery, Baltimore, Maryland 37.1940.90

PROVENANCE
William T. Walters, Baltimore

REFERENCES
John C. Ewers, "Deadlier Than the Male," *American Heritage* 16, no. 4 (June 1965): 11 (illus.); Ross, pl. 90; Hassrick, *Way West,* illus. p. 159

351. *Buffalo Hunting*

Watercolor with pen and ink on paper

8 3/8 x 13 3/8 in. (21.3 x 34.0 cm.)

Inscribed, u.r.: "Crow Indians driving Buffalo/over a precipice.–by [this]/stratagum [*sic*] they are killed in/ great numbers"; (formerly) on verso of mount: "Lloyd O. Miller"

Stark Museum of Art, Orange, Texas 31.34/36

PROVENANCE

the artist; Lloyd O. Miller; Edward Eberstadt and Sons, New York

REFERENCES

Eberstadt catalogues 139 (n.d.), no. 81 (illus.), and 146 (1958), no. 123–34 (illus.); Stark, p. 205

351A. *Driving Herds of Buffalo over a Precipice*

Pencil, pen and ink, and watercolor on paper

7 5/8 x 12 1/8 in. (19.3 x 30.7 cm.)

(c. 1837)

Inscribed, u.l.: "65"; l.c. of mount: "Driving herds of Buffalo over a precipice.—"

Joslyn Art Museum, Omaha, Nebraska; InterNorth Art Foundation Collection 783

PROVENANCE

the artist; Sir William Drummond Stewart (c. 1839); Frank Nichols (sale: Chapman's, Edinburgh, June 16–17, 1871); Bonamy Mansell Power; willed to Edward Power (1900); by descent to Major G. H. Power, Great Yarmouth, England (sale: PB, May 6, 1966)

EXHIBITIONS

Denver Art Museum, April 15–24, 1966; PB, April 29–May 6, 1966

REFERENCES

Murthly sale notices; PB sale 2436 (May 6, 1966), no. 40 (illus.); Knox, "83 Drawings from 1837 Trek," p. 28; Ross, pl. 207; Goetzmann and Porter, p. 69

351B. *Hunting Buffalo*

Watercolor on paper

8 5/16 x 14 1/8 in. (21.1 x 35.9 cm.)

(1858–1860)

The Walters Art Gallery, Baltimore, Maryland 37.1940.190

PROVENANCE

William T. Walters, Baltimore

EXHIBITIONS

Baltimore Museum of Art, May 11–June 17, 1945 (no. 129 on unpublished checklist); WCMFA, September 14–November 2, 1947

REFERENCES

DeVoto, pl. LX; WCMFA, *American Indian and the West*, no. 76 (as *Buffalo Run over the Cliff*); American Heritage, ed., *American Heritage Cookbook*, illus. pp. 40–41; Clark, *Indian Legends from the Northern Rockies*, illus. fol. 294; Goetzmann, *Exploration and Empire*, illus. p. 208; Rasky, *Taming of the Canadian West*, illus. p. 52–53; Ross, pl. 190; American Heritage, ed., *American Heritage Book of Great Adventures of the Old West*, illus. p. 134; Haines, *Buffalo*, illus. p. 88; Schomaekers, *Wilde Westen*, illus. p. 195; Gold, "Alfred Jacob Miller," p. 24 (illus. as *Buffalo Hunt with Lance*)

351C. *A Buffalo Rift*

Watercolor, gouache, and pen and ink over pencil on paper

Sight: 8 3/4 x 13 3/4 in. (22.2 x 35.0 cm.)

Signed, l.r.: "AJM [monogram] iller"

(1867)

Inscribed on mat, l.r.: "N⁰. 3./A Buffalo Rift."

Public Archives of Canada, Ottawa, Ontario; gift of Mrs. J. B. Jardine (1946)

PROVENANCE

Alexander Brown, Liverpool, England (1867); by descent to Mrs. J. B. Jardine, Chesterknowes, Scotland

EXHIBITIONS

PAC museum, winter 1946–1947; Peale Museum, Baltimore, January 8–February 12, 1950; "Alfred Jacob Miller," ACM, February 13–March 26, 1972

REFERENCES

account book, March 26, May 8, August 10, 1867; Hunter, p. [15]; Brunet no. 3 (illus.); Bell, p. 22, illus. p. 23

351D. *Hunting Buffalo*

Oil on canvas

10 x 15 5/8 in. (25.4 x 39.7 cm.)

Signed, l.r.: "AJM [monogram] iller"

Stark Museum of Art, Orange, Texas 31.34/9

PROVENANCE

Edward Eberstadt and Sons, New York

REFERENCES

Eberstadt catalogues 139 (n.d.), no. 82 (illus. as *Buffalo Hunting*), and 146 (1958), no. 123–9 (illus. as *Buffalo Hunting*); Stark, p. 206, illus. p. 66

351E. *Indian Buffalo Hunt*

10 1/8 x 15 3/4 in. (25.7 x 38.1 cm.)

Unlocated

PROVENANCE

Charles H. Linville, Baltimore (sale: Kende Galleries, New York, January 24, 1942)

EXHIBITIONS

Kende Galleries, New York, January 19–24, 1942

REFERENCES

Kende Galleries, *The Collection of the Late Charles H. Linville, Baltimore,* no. 2 (illus.)

352. *A Surround*

Wash on paper

10 1/4 x 17 1/4 in. (26.1 x 43.8 cm.)

Inscribed, l.l.: " 'A Surround'/176"; at left horizon: "more space"; at center horizon: "dust"; on verso of mount: "Carrie C. Miller/3 Oklahoma Terrace/Annapolis/ Maryland"

Joslyn Art Museum, Omaha, Nebraska; InterNorth Art Foundation Collection 723

PROVENANCE

Carrie C. Miller, Annapolis; Porter Collection

EXHIBITIONS

Nelson, January 1939; "Western Frontier," SLAM, April 1–May 13, 1941; BBHC, May 15–September 15, 1959

REFERENCES

"Water Color Sketches of Indian Life a Century Ago," p. 3 (illus.); DeVoto, pl. LXI; R. W. G. Vail, "The First Artist of the Oregon Trail," *New-York Historical Society Quarterly* 34, no. 1 (January 1950): 28; BBHC, *Land of Buffalo Bill,* no. 52, 58, or 74

352A. *A Buffalo Surround in the Pawnee Country, 1837*

Sepia wash drawing, heightened with white, on paper

6 1/2 x 9 15/16 in. (16.5 x 25.3 cm.) joined to an L-shaped sheet, measuring overall 9 3/16 x 14 7/16 in. (23.4 x 36.7 cm.)

Signed, dated, and inscribed, l.l.: "XXI/1840/AJM [monogram]"

Inscribed (formerly), l.l: "A Surround [?]"

The New-York Historical Society, New York 1949.273; gift of Messrs. Dunlap, Streeter, Wicker, Wills, and Zabriskie, 1949

PROVENANCE

secured in Great Britain by an unknown private collector

REFERENCES

Ross, p. XXI; Vail, "First Artist of the Oregon Trail," pp. 25–30, illus. p. [24]

352B. *A Surround of Buffalo by Indians*

Oil on canvas

30 3/8 x 44 1/8 in. (77.1 x 112.1 cm.)

Signed, l.l.: "A. Miller"

(c. 1848–1858)

Whitney Gallery of Western Art, Buffalo Bill Historical Center, Cody, Wyoming 2.76; gift of Mr. William E. Weiss, Jr., Cody, Wyoming

PROVENANCE

private collection, Paris, France; Wildenstein and Co., New York (sold 1973)

352C. *The Buffalo Hunt*

Oil on canvas

23 1/2 x 35 1/2 in. (59.2 x 90.0 cm.)

(c. 1848–1858)

Phoenix Art Museum, Phoenix, Arizona; gift of Mr. and Mrs. Read Mullan in memory of John W. Kieckhefer

PROVENANCE

Quinn sale, Baltimore (c. 1910); Norman James; Mrs. Norman James; by descent to Janon Fisher III, stepson of above (until 1967); Middendorf Collection; Mr. and Mrs. Read Mullan

EXHIBITIONS

"Exhibition of the Works of Alfred J. Miller," Peale Museum, Baltimore, [1933]; State Reception Rooms, U.S. Department of State, Washington, D.C., 1969–1970

352D. *Surround of Buffalo*

Unlocated

REFERENCES

account book, March 20, 1848, $75, for Owen Gill

352E. *A "Surround"*

Unlocated

REFERENCES

account book, June 15, 1858, $200, for Mr. Chas. Harvey

352F. *A "Surround" of Buffalo by Indians*

Watercolor on paper

9 9/16 x 17 9/16 in. (24.3 x 44.6 cm.)

(1858–1860)

The Walters Art Gallery, Baltimore, Maryland 37.1940.200

PROVENANCE

William T. Walters, Baltimore

"A. J. Miller Watercolors," Smithsonian, October 1956–November 1957; University of Pennsylvania Museum, Philadelphia, May 8–September 8, 1958

REFERENCES
Philadelphia, University of Pennsylvania Museum, *Noble Savage*, no. 38; Ross, pl. 200; Haines, *Buffalo*, illus. p. 35; Randall, "Gallery for Alfred Jacob Miller," p. [838] (illus.)

352G. *A Surround*

Watercolor, gouache, and pen and ink over pencil on paper
Sight: 10 1/16 x 17 1/16 in. (25.5 x 43.3 cm.)
Signed, l.l.: "AJM [monogram] iller. Pt"
(1867)
Inscribed on mat, l.r.: "NO. 40./A Surround."
Public Archives of Canada, Ottawa, Ontario; gift of Mrs. J. B. Jardine (1946)

PROVENANCE
Alexander Brown, Liverpool, England (1867); by descent to Mrs. J. B. Jardine, Chesterknowes, Scotland

EXHIBITIONS
PAC museum, winter 1946–1947; Peale Museum, Baltimore, January 8–February 12, 1950; "Alfred Jacob Miller," ACM, February 13–March 26, 1972

REFERENCES
account book, March 26, May 8, August 10, 1867; Hunter, p. [15]; Brunet, no. 40; Albert J. Rorabacker, *American Buffalo in Transition*, illus. p. 22; Bell, p. 160, illus. p. 161

353. *The Surround*

Oil on canvas
65 x 93 1/2 in. (165.1 x 236.2 cm.)
(c. 1840)
Joslyn Art Museum, Omaha, Nebraska 1963.611

PROVENANCE
Sir William Drummond Stewart (1840); Frank Nichols (sale: Edinburgh, June 16–17, 1871); Joseph McDonough Co., Albany, N.Y. (1910s?); Reynolds Galleries, New York; Anderson Galleries, New York (c. 1926); Norman James, Baltimore; E. W. Marland, Ponca City, Okla.; Lydie Marland; M. Knoedler and Company, New York, #CA 4235/A 7552 (1960–1965)

EXHIBITIONS
Oklahoma Historical Society, c. 1935; Philbrook Art Center, Tulsa, 1951; City Art Museum of St. Louis, 1954; JAM, May 12–July 4, 1954; Denver Art Museum, October 15–November 21, 1955; Nelson and Atkins, October 5–November 17, 1957; "Two Centuries of American Painting," Cincinnati Art Museum, October 4–November 4, 1958, no. 20; JAM, July 3–October 17, 1976; ACM, February 17–April 3, 1977; BBHC, May 1–September 30, 1977; Glenbow-Alberta Institute, Calgary, October 15–November 27, 1977; JAM, December 20, 1977–January 29, 1978

REFERENCES
Murthly sale notices; No. 2 in undated sale notice of Joseph McDonough Co., Albany, N.Y., in J. Hall Pleasants file; No. 2 in undated sale notice of Reynolds Galleries, 39 W. 57th Street, New York, in Alfred Jacob Miller vertical file; "Portrait of Sir William Drummond Stewart on Horseback Greeting a Group of Indians," undated note in Albert Duveen files, roll NDu2, frame 259; E. W. Marland to Amon Carter, July 16, 1935, Amon Carter Foundation files; Vail, "First Artist of the Oregon Trail," p. 29; St. Louis, City Art Museum, *Westward the Way*, no. 70, illus. p. 103; JAM, *Life on the Prairie*, illus. p. 4; Denver Art Museum, *Building the West*, no. 59; Nelson and Atkins, *Last Frontier*, no. 31; American Heritage, ed., *Indians of the Plains*, illus. pp. 26–27; JAM, *Exploration in the West*, p. 28, illus. p. 33; Monaghan, "Hunter and the Artist," p. 8 (illus.); Fronval, *Veritable histoire des Indians Peaux-Rouges*, illus. p. 56; JAM, *Artists of the Western Frontier*, no. 64, illus. p. 14; George P. Tomko to Arthur J. Phelan, Jr., September 12, 1977, collection of Arthur J. Phelan, Jr.; ACM, *Bison in Art*, p. 104, illus. p. 105

354. *A Surround* [verso: *House*]

Pen and ink, wash, and gouache on paper
7 x 10 1/2 in. (17.9 x 26.7 cm)
Inscribed, l.r.: "Surround"
Joslyn Art Museum, Omaha, Nebraska; InterNorth Art Foundation Collection 745

PROVENANCE
Porter Collection

EXHIBITIONS
Nelson, January 1939; "Western Frontier," SLAM, April 1–May 13, 1941; BBHC, May 15–September 15, 1959; Phoenix Art Museum, January 12–February 18, 1979; San Diego Museum of Art, March 10–April 15, 1979; Wichita Art Museum, May 1–June 15, 1979

REFERENCES
BBHC, *Land of Buffalo Bill*, no. 52, 58, or 74; JAM, *Exploration in the West*, illus. p. 30; Phoenix Art Museum, *Beyond the Endless River*, p. 72, pl. 20

355. *A Surround*

Pencil, pen and ink, watercolor, and gouache on paper

9 1/4 x 14 5/8 in (23.5 x 37.2 cm.)

Inscribed, u.r.: "Buffalo.—" [sight]; l.r.: "A Surround."

Joslyn Art Museum, Omaha, Nebraska; InterNorth Art Foundation Collection 729

PROVENANCE

Carrie C. Miller, Annapolis; Porter Collection; M. Knoedler and Company, New York

EXHIBITIONS

Nelson, January 1939; "Western Frontier," SLAM, April 1–May 13, 1941; BBHC, May 15–September 15, 1959

REFERENCES

"America and the Future," p. 119 (illus.); DeVoto, pl. V; BBHC, *Land of Buffalo Bill*, no. 58 or 74; "Records of a Lost World," *Museum News* 42, no. 3 (November 1963): 17 (illus. as *A Surround of the Buffalos*); JAM, *Exploration in the West*, illus. p. 30; Goetzmann and Porter, p. 69

356. *Buffalo Chase by Snake Indians near Independence Rock*

Pencil, pen and ink, watercolor, and gouache on paper

8 1/4 x 13 1/4 in. (21.0 x 33.6 cm.)

Signed, l.r.: "AJM. [monogram]

Inscribed, u.l.: "Buffalo Chase/by Snake Indians near Independence Rock"

Joslyn Art Museum, Omaha, Nebraska; InterNorth Art Foundation Collection 718

PROVENANCE

Carrie C. Miller, Annapolis; Porter Collection; M. Knoedler and Company, New York

EXHIBITIONS

Nelson, January 1939; "Western Frontier," SLAM, April 1–May 13, 1941; BBHC, May 15–September 15, 1959

REFERENCES

DeVoto, pl. LVIII (as *Buffalo Chase*); BBHC, *Land of Buffalo Bill*, no. 47; Goetzmann and Porter, pp. 67, 69, illus. p. 97

356A. *Buffalo Hunting, near Independence Rock*

Watercolor on paper

9 1/4 x 13 3/4 in. (23.5 x 34.9 cm.)

Signed, l.r.: "AJM [monogram] iller"

(1858–1860)

Inscribed, l.r.: "102 [?]"

The Walters Art Gallery, Baltimore, Maryland 37.1940.105

PROVENANCE

William T. Walters, Baltimore

EXHIBITIONS

"A. J. Miller Watercolors," Smithsonian, October 1956–November 1957

REFERENCES

William Clark Kennerly, *Persimmon Hill*, illus. opp. p. 149; Alter, *Jim Bridger*, illus. opp. p. 164; Ross, pl. 105

356B. *Buffalo Hunt*

Oil on canvas

30 x 40 in. (76.2 x 101.6 cm.)

Signed, l.r.: "A Miller"

The Thomas Gilcrease Institute of American History and Art, Tulsa, Oklahoma 0126.739

PROVENANCE

Victor D. Spark; [M. Knoedler and Company, New York, #A 3713, as *Chasing a Buffalo*, 24 3/4 x 16 1/2 in. unframed (1948)?]

EXHIBITIONS

Museum of Modern Art, New York, 1943

REFERENCES

Rough Draughts, no. 139; New York, Museum of Modern Art, *Romantic Painting in America*, no. 146 (illus. as collection of Victor D. Spark); American Heritage, ed., *American Heritage Book of Great Adventures of the Old West*, illus. p. 142; Rossi and Hunt, p. 325, illus. p. 175; Cooke, *Alistair Cooke's America*, illus. p. 154; Getlein, *Lure of the Great West*, illus. p. 77; Herbert Wilson Gottfried, "Spatiality and the Frontier: Spatial Themes in Western American Painting and Literature," Ph.D. dissertation, pp. 134–138, pl. XIII

357. *Buffalo Hunt, Black Hills*

Sepia, heightened with white, on brown paper

10 x 15 3/8 in. (25.4 x 39.0 cm.)

Inscribed: "Hunt of Buffalo Black Hills"; u.r.: "Buffalo [?] in Herds"

The Boatmen's National Bank of St. Louis, Missouri (May 26, 1947)

PROVENANCE

the artist; by descent to Louisa Whyte Norton; Old Print Shop, New York (1947)

EXHIBITIONS

BNB, May 4–29, 1964

REFERENCES

Cowdrey and Comstock, "Alfred Jacob Miller and the Farthest West," p. 1; BNB, *Catalog*, no. 45

357A. *Hunting the Buffalo in Herds*

Watercolor, gouache, and pen and ink over pencil on paper

Sight: 9 3/16 x 14 13/16 in. (23.3 x 37.6 cm.)

Signed, l.r.: "AJM [monogram] iller. Pt"

(1867)

Inscribed on mat, l.r.: "Nº. 29./Hunting the Buffalo./In Herds."

Public Archives of Canada, Ottawa, Ontario; gift of Mrs. J. B. Jardine (1946)

PROVENANCE

Alexander Brown, Liverpool, England (1867); by descent to Mrs. J. B. Jardine, Chesterknowes, Scotland

EXHIBITIONS

PAC museum, winter 1946–1947; Peale Museum, Baltimore, January 8–February 12, 1950; "Alfred Jacob Miller," ACM, February 13–March 26, 1972

REFERENCES

account book, March 26, May 8, August 10, 1867; Hunter, p. [15]; Brunet, no. 29 (illus.); Bell, p. 128, illus. p. 129

358. *Wounded Buffalo*

Watercolor on paper

6 7/8 x 9 5/8 in. (24.5 x 17.5 cm.)

Inscribed, u.l.: "Wounded Buffalo"; u.r.: illeg.; l.r.: "Hunt of the/Buffalo"

Western Americana Collection, The Beinecke Rare Book and Manuscript Library, Yale University, New Haven, Connecticut (Coe V, 24–25)

EXHIBITIONS

"Gallery of Dudes," ACM, January 26–March 15, 1967; Yale University Art Gallery, New Haven, September 20, 1978–January 6, 1979

REFERENCES

Withington, no. 342; Sandweiss, p. 62 (as *Buffalo Wounded*)

358A. *Buffalo at Bay*

Watercolor on paper

8 13/16 x 12 4/16 in. (20.8 x 31.1 cm.)

Signed, l.r.: "AJM [monogram] iller"

(1858–1860)

The Walters Art Gallery, Baltimore, Maryland 37.1940.91

PROVENANCE

William T. Walters, Baltimore

REFERENCES

Ross, pl. 91

359. *The Bravado (Lassoing a Buffalo)*

Watercolor and gouache on paper

9 x 15 in. (22.8 x 38.1 cm.)

Inscribed, u.r.: "No 100"

The Thomas Gilcrease Institute of American History and Art, Tulsa, Oklahoma 0236.1053

REFERENCES

Rough Draughts, no. 100

359A. *The Bravado*

Watercolor on paper

9 1/2 x 15 1/8 in. (24.1 x 38.4 cm.)

Signed, l.r.: "AJM [monogram] iller"

(1858–1860)

The Walters Art Gallery, Baltimore, Maryland 37.1940.99

PROVENANCE

William T. Walters, Baltimore

EXHIBITIONS

Städelsches Kunstinstitut, Frankfurt, March 14–May 3, 1953; Bayerische Staats-Gemäldesammlungen, Munich, May 15–June 28, 1953; Kunsthalle, Hamburg, July 18–August 30, 1953; Charlottenburger Schloss, Berlin, September 8–October 13, 1953; Kunstsammlung der Stadt, Düsseldorf, November 1–December 15, 1953; Galleria Nazionale d'Arte Moderna, Rome, January 19–February 7, 1954; Dalazetto Reale, Milan, February 18–March 15, 1954; WMAA, April 22–May 23, 1954

REFERENCES

John I. H. Baur, *American Painting in the Nineteenth Century*, illus. p. 47; WMAA, *American Painting*, no. 33; Ross, pl. 99; Glubok, *Art of the Old West*, illus. cover

359B. *Buffalo Hunt*

Watercolor, gouache, and pen and ink over pencil on paper

Sight: 8 15/16 x 15 5/16 in. (22.7 x 38.9 cm.)

Signed, l.l.: "AJM [monogram] iller Pt"

(1867)

Inscribed on mat, l.r.: "Nº. 36./Buffalo Hunt."

Public Archives of Canada, Ottawa, Ontario; gift of Mrs. J. B. Jardine (1946)

PROVENANCE

Alexander Brown, Liverpool, England (1867); by descent to Mrs. J. B. Jardine, Chesterknowes, Scotland

EXHIBITIONS

PAC museum, winter 1946–1947; Peale Museum, Baltimore, January 8–February 12, 1950; "Alfred Jacob Miller," ACM, February 13–March 26, 1972

REFERENCES
account book, March 26, May 8, August 10, 1867;
Hunter, p. [15]; Brunet, no. 36; Bell, p. 156, illus. p. 157

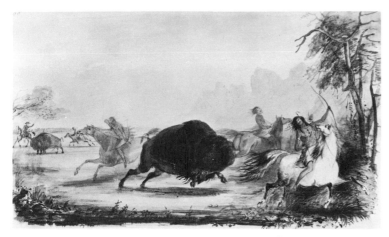

Catalogue number 360.

360. *Indians Tantalizing a Wounded Buffalo*

Pencil and pen and ink with watercolor on pink card

8 1/2 x 13 3/4 in. (21.4 x 34.7 cm.)

(c. 1837)

Inscribed, u.l.: "68"

Amon Carter Museum, Fort Worth, Texas 27.66

PROVENANCE
the artist; Sir William Drummond Stewart (c. 1839);
Frank Nichols (sale: Chapman's, Edinburgh, June 16–17,
1871); Bonamy Mansell Power; willed to Edward Power
(1900); by descent to Major G. H. Power, Great
Yarmouth, England (sale: PB, New York, May 6, 1966)

EXHIBITIONS
Denver Art Museum, April 15–24, 1966; PB, April
29–May 6, 1966; Lakeview, April 19–June 2, 1968; Seattle
Art Museum, July 8–September 28, 1976; Worcester Art
Museum, April 25–June 24, 1979

REFERENCES
Murthly sale notices; PB sale 2436 (May 6, 1966), lot 37
(illus.); Knox, "83 Drawings from 1837 Trek," p. 28;
Sprague, *Gallery of Dudes*, illus. p. 10; Ross, p. XXXIV;
Lakeview, *Westward the Way*, no. 90 (illus.); ACM,
Catalogue of the Collection, no. 114, illus. p. 55

360A. *Buffalo Hunt*

Oil on canvas

30 x 50 in. (76.2 x 127.0 cm.)

(c. 1850)

Anschutz Collection

PROVENANCE
Governor Thomas Swann of Maryland; by descent to

Mrs. Charles Gillette, Baltimore; Kennedy Galleries, New
York (1966–1972)

EXHIBITIONS
Delaware Art Museum, Wilmington, November 4–28,
1971; Los Angeles County Museum of Art, March
21–May 28, 1972; M. H. de Young Memorial Museum,
San Francisco, June 29–September 17, 1972; SLAM,
November 2–December 31, 1972; Denver Art Museum,
January 13–April 15, 1973; Boise Gallery of Art, April
26–June 16, 1974

REFERENCES
Kennedy Quarterly 6, no. 2 (June 1966): no. 59, illus. p. 72;
Los Angeles County Museum of Art, *American West*, no.
18, pl. 34; Denver Art Museum, *Colorado Collects Historic
Western Art*, no. 17, illus. p. 12; Boise Gallery of Art,
American Masters in the West, illus. p. 9

361. *Specks of the Rocky Mountains. Baiting the Buffalo*

Watercolor on paper

7 1/2 x 11 1/4 in. (19.1 x 28.6 cm.)

Private collection

PROVENANCE
Mrs. Laurence R. Carton

REFERENCES
private collector to William R. Johnston, WAG,
November 23, 1980

362. *Baiting a Wounded Buffalo*

Oil on canvas

(c. 1839)

Unlocated

PROVENANCE
Sir William Drummond Stewart (1839); Frank Nichols
(sale: Chapman's, Edinburgh, June 16–17, 1871)

EXHIBITIONS
Apollo Gallery, New York, May 9-22, 1839

REFERERENCES
"Apollo Gallery—Original Paintings," *Morning Herald*,
May 16, 1839, p. 2, col. 3, no. 5; Murthly sale notices

363. *Chase by Pawnee Indians*

Watercolor with pen and ink on paper

6 1/16 x 7 3/16 in. (15.7 x 18.3 cm.)

Signed, l.l.: "AJM [monogram]"

Inscribed, l.r.: "Chase by Pawnee Indians"; (formerly) on
verso of mount: "Lloyd Miller"

Stark Museum of Art, Orange, Texas 31.34/31

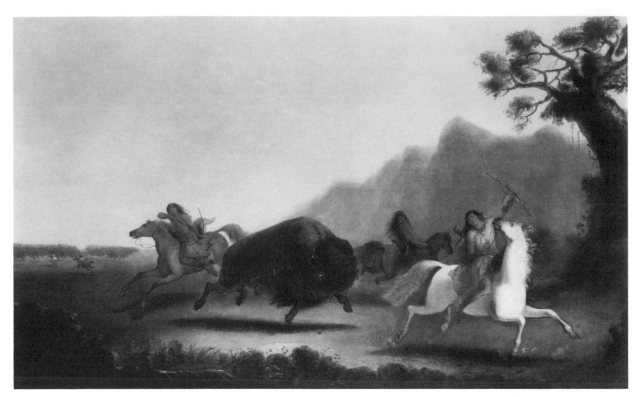

Catalogue number 360A.

PROVENANCE

the artist; Lloyd O. Miller; Edward Eberstadt and Sons, New York

REFERENCES

Eberstadt catalogue 146 (1958), no. 123–32 (as *Buffalo Chase by Pawnees,* 6 x 10 in.); Stark, p. 205

363A. *Pawnee Running Buffalo*

Watercolor on paper

8 1/4 x 11 11/16 in. (21.0 x 29.7 cm.)

Signed, l.l.: "AJM [monogram] iller"

(1858–1860)

The Walters Art Gallery, Baltimore, Maryland 37.1940.121

PROVENANCE

William T. Walters, Baltimore

EXHIBITIONS

Nelson and Atkins, October 5–November 17, 1957; "Homefront, 1861," Virginia Museum of Fine Arts, Richmond, 1961

REFERENCES

Nelson and Atkins, *Last Frontier,* no. 42; Ross, pl. 121

364. *Pawnee Chasing a Buffalo*

Oil on canvas (oval)

19 x 22 7/8 in. (48.3 x 58.1 cm.); stretcher: 20 x 24 in. (50.8 x 61.0 cm.)

Signed, l.r.

(c. 1854)

Inscribed on stretcher: "W. C. Wilson"

Mr. and Mrs. Hugh Bennett

PROVENANCE

William C. Wilson

REFERENCES

account book, January 15, 1854, as *Pawnee (running) a buffalo,* $60, for W. C. Wilson

365. *Running Buffalo (The Buffalo Hunt)*

Watercolor on paper

Sight: 7 1/4 x 12 5/8 in. (18.4 x 32.1 cm.)

Whitney Gallery of Western Art, Buffalo Bill Historical Center, Cody, Wyoming 12.70; gift of the W. R. Coe Foundation, Oyster Bay, New York

PROVENANCE

Lawrence A. Fleischman, Detroit, (c. 1960); M. Knoedler and Company, New York

EXHIBITIONS
National Cowboy Hall of Fame, Oklahoma City, June 25-
October 10, 1965

REFERENCES
Oklahoma City, National Cowboy Hall of Fame,
Inaugural Exhibition, p. 15

365A. *Running Buffalo*

Watercolor on paper

10 x 13 3/8 in. (25.4 x 34.0 cm.)

(1858–1860)

The Walters Art Gallery, Baltimore, Maryland 37.1940.57

PROVENANCE
William T. Walters, Baltimore

REFERENCES
Ross, pl. 57

366. *Attack of Buffalo*

18 x 24 in. (45.7 x 61.0 cm.)

Unlocated

REFERENCES
account book, September 3, 1864, $60, for G. Kalbfus

367. *Crow Indians Attacking a Buffalo with the Lance near the Sweet Water River*

Watercolor on paper

9 x 14 1/4 in. (22.9 x 36.2 cm.)

Inscribed, u.r.: "Crow Indians attacking/a Buffalo with
the lance/near the 'Sweet Water'/River"

Unlocated

PROVENANCE
the artist; by descent to Louisa Whyte Norton; Old Print
Shop, New York (1947); Peter Decker, New York (1947);
William J. Holliday, Indianapolis; Hammer Galleries,
New York (1959); Bruce Norris, Chicago (1960)

REFERENCES
Old Print Shop ledger book (June 18, 1947), no. 20;
Cowdrey and Comstock, "Alfred Jacob Miller and the
Farthest West," p. 9, fig. 1; DeVoto, pl. LI; Neider, *Great
West*, illus. p. 78

367A. *Two Indians Killing a Buffalo*

Watercolor on paper

9 x 14 5/8 in. (22.9 x 37.2 cm.)

Signed, l.r.: "A. J. Mill[er]"

The Boatmen's National Bank of St. Louis, Missouri
(May 26, 1947)

PROVENANCE
the artist; by descent to Louisa Whyte Norton; Old Print
Shop, New York (1947)

EXHIBITIONS
BNB, May 4–29, 1964

REFERENCES
Cowdrey and Comstock, "Alfred Jacob Miller and the
Farthest West," p. 1; BNB, *Catalog*, no. 31 (as *Buffalo
Kill*)

367B. *Buffalo Hunt*

Oil on canvas

30 1/4 x 50 1/8 in. (76.7 x 127.3 cm.)

(c. 1850)

Amon Carter Museum, Fort Worth, Texas 21.66

PROVENANCE
Governor Thomas Swann of Maryland; by descent to
Mrs. Charles Gillette, Baltimore; Kennedy Galleries, New
York

EXHIBITIONS
Tokyo and Osaka, April–May 1976; ACM, February
17–April 3, 1977; BBHC, May 1–September 30, 1977;
JAM, December 20, 1977–January 29, 1978; Huntsville
Museum of Art, September 8–November 26, 1978;
Worcester Art Museum, April 25–June 24, 1979

REFERENCES
ACM, *Catalogue of the Collection*, no. 112, illus. p. 55, *Art
Works of the American West*, no. 28 (illus.), and *Bison in
Art*, p. 65 (illus.); Barsness, "The Bison in Art and
History," p. 16 (illus.); Huntsville Museum of Art, *Art of
the American West*, no. 7 (illus.)

367C. *Buffalo Hunt with Lance*

Unlocated

REFERENCES
account book, [June?] 10, 1858, $92, for William T.
Walters

367D. *Killing Buffalo with the Lance*

Watercolor on paper

8 5/8 x 14 3/16 in. (21.9 x 36.0 cm.)

Signed, l.c.: "AJM. [monogram]"

(1858–1860)

The Walters Art Gallery, Baltimore, Maryland
37.1940.184

PROVENANCE
William T. Walters, Baltimore

EXHIBITIONS

"A. J. Miller Watercolors," Smithsonian, October 1956–November 1957

REFERENCES

Felton, *Edward Rose*, illus. fol. p. 48; Ross, pl. 184; Haines, *Buffalo*, illus. p. 58; Getlein, *Lure of the Great West*, illus. p. 77

367E. *Hunting the Buffalo: Attack with Lances*

Watercolor, gouache, and pen and ink over pencil on paper

Sight: 8 x 13 1/8 in. (20.3 x 33.4 cm.)

Signed, l.r.: "AJM [monogram] iller"

(1867)

Inscribed on mat, l.r.: "N⁰. l/Hunting the Buffalo./ 'Attack with Lances' "

Public Archives of Canada, Ottawa, Ontario; gift of Mrs. J. B. Jardine (1946)

PROVENANCE

Alexander Brown, Liverpool, England (1867); by descent to Mrs. J. B. Jardine, Chesterknowes, Scotland

EXHIBITIONS

PAC museum, winter 1946–1947; Peale Museum, Baltimore, January 8–February 12, 1950; "Alfred Jacob Miller," ACM, February 13–March 26, 1972

REFERENCES

account book, March 26, May 8, August 10, 1867; Hunter, p. [15], pl. VII; Brunet, no. 1 (illus.); Bell, p. 14, illus. p. 15

368. *Approaching Buffalo*

Watercolor and gouache on paper

6 5/8 x 8 1/2 in. (21.6 x 16.9 cm.)

Joslyn Art Museum, Omaha, Nebraska; InterNorth Art Foundation Collection 704

PROVENANCE

Carrie C. Miller, Annapolis; Porter Collection; M. Knoedler and Company, New York

EXHIBITIONS

Nelson, January 1939; "Western Frontier," SLAM, April 1–May 13, 1941; BBHC, May 15–September 15, 1959

REFERENCES

DeVoto, pl. LII; BBHC, *Land of Buffalo Bill*, no. 33

368A. *Approaching Buffalo*

Pencil and pen and ink with gray and yellow washes on paper

6 9/16 x 9 11/16 in. (16.6 x 24.6 cm.)

(c. 1837)

Inscribed: "16"

Unlocated

PROVENANCE

the artist; Sir William Drummond Stewart (c. 1839); Frank Nichols (sale: Chapman's, Edinburgh, June 16–17, 1871; Bonamy Mansell Power; willed to Edward Power (1900); by descent to Major G. H. Power, Great Yarmouth, England (sale: PB, May 6, 1966)

EXHIBITIONS

Denver Art Museum, April 15–24, 1966; PB, April 29–May 6, 1966

REFERENCES

Murthly sale notices; PB sale 2436 (May 6, 1966), lot 35; Knox, "83 Drawings from 1837 Trek," p. 28

368B. *Approaching Buffalo*

Watercolor on paper

9 1/2 x 12 1/16 in. (24.1 x 30.6 cm.)

Signed, l.c.: "AJM [monogram] iller"

(1858–1860)

The Walters Art Gallery, Baltimore, Maryland 37.1940.84

PROVENANCE

William T. Walters, Baltimore

REFERENCES

Ross, pl. 84

368C. *Approaching Buffalo*

Watercolor, gouache, and pen and ink over pencil on paper

Sight: 7 11/16 x 11 9/16 in. (19.5 x 29.4 cm.)

Signed, l.r.: "AJM [monogram] iller Pt"

(1867)

Inscribed on mat, l.r.: "N⁰. 33./Approaching Buffalo."

Public Archives of Canada, Ottawa, Ontario; gift of Mrs. J. B. Jardine (1946)

PROVENANCE

Alexander Brown, Liverpool, England (1867); by descent to Mrs. J. B. Jardine, Chesterknowes, Scotland

EXHIBITIONS

PAC museum, winter 1946–1947; Peale Museum, Baltimore, January 8–February 12, 1950; "Alfred Jacob Miller," ACM, February 13–March 26, 1972

REFERENCES
account book, March 26, May 8, August 10, 1867;
Hunter, p. [15]; Brunet, no. 33; Bell, p. 144, illus. p. 145

368D. *Hunters Approaching Buffalo*

Oil on paper

3 3/8 x 6 in. (8.6 x 15.2 cm.)

Inscribed (formerly) on mat, l.c.: "Hunters Approaching Buffalo"

Stark Museum of Art, Orange, Texas 31.34/13

PROVENANCE
Edward Eberstadt and Sons, New York

REFERENCES
Eberstadt catalogue 146 (1958), no. 123–21 (illus.); Stark, pp. 205–206

369. Untitled [landscape—stalking game at dusk]

Oil on paper

Sight: 5 1/2 x 8 in. (14.0 x 20.4 cm.)

The Dentzel Collection 0258

370. *Indians Stalking Buffalo*

Oil on paper

9 1/2 x 7 in. (24.1 x 17.8 cm.)

Signed, l.l.: "AJM [monogram]"

Stark Museum of Art, Orange, Texas 31.34/8

PROVENANCE
Edward Eberstadt and Sons, New York

REFERENCES
Eberstadt catalogue 146 (1958), no. 123–12; Stark, p. 206

371. *Approaching the Buffalo Herd*

Watercolor and gouache on paper

6 3/4 x 9 3/4 in. (17.2 x 24.8 cm.)

The Thomas Gilcrease Institute of American History and Art, Tulsa, Oklahoma 0226.1054

REFERENCES
Rough Draughts, no. 125

371A. *Approaching Buffalo under the Disguise of a Wolf*

Pen and ink and watercolor on pink card blind-stamped "De la Rue Cornish and Rock/Extra London Crayon Board"

6 1/8 x 8 1/2 in. (15.6 x 21.6 cm.)

(c. 1837)

Inscribed, u.l.: "17"

Amon Carter Museum, Fort Worth, Texas 26.66

PROVENANCE
the artist; Sir William Drummond Stewart (c. 1839); Frank Nichols (sale: Chapman's, Edinburgh, June 16–17, 1871); Bonamy Mansell Power; willed to Edward Power (1900); by descent to Major G. H. Power, Great Yarmouth, England (sale: PB, May 6, 1966)

EXHIBITIONS
Denver Art Museum, April 15–24, 1966; PB, April 29–May 6, 1966; Lakeview, April 19–June 2, 1968; ACM, February 17–April 3, 1977; BBHC, May 1–September 30, 1977; Glenbow-Alberta Institute, Calgary, October 15–November 27, 1977; JAM, December 20, 1977–January 29, 1978; Huntsville Museum of Art, September 8–November 26, 1978

REFERENCES
Murthly sale notices; PB sale 2436 (May 6, 1966), lot 36 (illus.); Knox, "83 Drawings From 1837 Trek," p. 28; Lakeview, *Westward the Artist*, no. 89; ACM, *Catalogue of the Collection*, no. 111 (illus.), and *Bison in Art*, p. 68, illus. p. 69; Huntsville Museum of Art, *Art of the American West*, no. 8

371B. *Approaching Buffalo*

Watercolor on paper

7 3/4 x 12 3/4 in. (19.7 x 32.4 cm.)

Signed, l.r.: "AJM [monogram] iller"

(1858–1860)

The Walters Art Gallery, Baltimore, Maryland 37.1940.106

PROVENANCE
William T. Walters, Baltimore

REFERENCES
Felton, *Edward Rose*, illus. fol. p. 48; Ross, pl. 106

371C. *Approaching the Buffalo*

Watercolor, gouache, and pen and ink over pencil on paper

Sight: 8 3/4 x 12 in. (22.2 x 30.5 cm.)

Signed, l.r.: "AJM [monogram]"

(1867)

Inscribed on mat, l.r.: "Nº. 2./Approaching the Buffalo"

Public Archives of Canada, Ottawa, Ontario; gift of Mrs. J. B. Jardine (1946)

PROVENANCE

Alexander Brown, Liverpool, England (1867); by descent to Mrs. J. B. Jardine, Chesterknowes, Scotland

EXHIBITIONS

PAC museum, winter 1946–1947; Peale Museum, Baltimore, January 8–February 12, 1950; "Alfred Jacob Miller," ACM, February 13–March 26, 1972

REFERENCES

account book, March 26, May 8, August 10, 1867; Hunter, p. [15]; Brunet, no. 2; Bell, p. 18, illus. p. 19

371D. *Approaching Buffalo (Indian Approaching Buffalo)*

Watercolor on paper

Sight: 7 5/8 x 12 7/8 in. (19.4 x 32.7 cm.)

Signed, l.r.: "AJM [monogram] iller"

Inscribed on mat, l.c.: "Approaching Buffalo/A. J. Miller"

Whitney Gallery of Western Art, Buffalo Bill Historical Center, Cody, Wyoming 29.64; gift of the W. R. Coe Foundation, Oyster Bay, New York

PROVENANCE

the artist; by descent to Louisa Whyte Norton; Old Print Shop, New York (1947); Peter Decker, New York (1947); Hammer Galleries, New York (1961–1963); Edward Eberstadt and Sons, New York

EXHIBITIONS

Fine Arts Museum of New Mexico, Santa Fe, October 8–November 22, 1961; High Museum of Art, Atlanta, November 1975–January 1976

REFERENCES

Old Print Shop ledger book (June 18, 1947), no. 2 (as *Approaching Buffalo,* 8 x 13 1/4 in.); Cowdrey and Comstock, "Alfred Jacob Miller and the Farthest West," frontis. (dimensions given as 8 x 13 1/4 in.); Santa Fe, Fine Arts Museum of New Mexico, *Artist in the American West,* no. 45; Hammer Galleries, *Works of Charles M. Russell and Other Western Artists,* no. 33; BBHC, *West of Buffalo Bill,* illus. p. [156] (as *Indians Approaching Buffalo,* 9 x 17 in.)

372. *Yell of Triumph*

Pencil, pen and ink, watercolor, and gouache on paper

9 1/4 x 13 3/4 in. (23.5 x 35.0 cm.)

Signed, l.r.: "AJM. [monogram]"

Inscribed, u.c.: "Yell of Triump [*sic*]"

Joslyn Art Museum, Omaha, Nebraska; InterNorth Art Foundation Collection 713

PROVENANCE

Porter Collection; M. Knoedler and Company, New York

EXHIBITIONS

BBHC, May 15–September 15, 1959

REFERENCES

BBHC, *Land of Buffalo Bill,* no. 42; Goetzmann and Porter, p. 67, illus. p. 94

372A. *Yell of Triumph*

Watercolor on paper

8 1/8 x 12 7/16 in. (20.6 x 31.6 cm.)

(1858–1860)

The Walters Art Gallery, Baltimore, Maryland 37.1940.151

PROVENANCE

William T. Walters, Baltimore

EXHIBITIONS

"A. J. Miller Watercolors," Smithsonian, October 1956–November 1957; ACM, February 17–April 3, 1977; BBHC, May 1–September 30, 1977; Glenbow-Alberta Institute, Calgary, October 15–November 27, 1977; JAM, December 20, 1977–January 29, 1978

REFERENCES

DeVoto, pl. LIX; Garraty, *American Nation,* illus. p. 456; Rasky, *Taming of the Canadian West,* illus. p. 49; Ross, pl. 151; ACM, *Bison in Art,* p. 20, illus. p. 21; Reader's Digest, *Story of the Great American West,* illus. p. 99

372B. *The Yell of Triumph*

Watercolor, gouache, and pen and ink over pencil on paper

Sight: 8 3/16 x 14 9/16 in. (20.8 x 37.1 cm.)

Signed, l.r.: "AJM [monogram] iller Pt"

(1867)

Inscribed on mat, l.r.: "Nº. 30./The Yell of Triumph."

Public Archives of Canada, Ottawa, Ontario; gift of Mrs. J. B. Jardine (1946)

PROVENANCE

Alexander Brown, Liverpool, England (1867); by descent to Mrs. J. B. Jardine, Chesterknowes, Scotland

EXHIBITIONS

PAC museum, winter 1946–1947; Peale Museum, Baltimore, January 8–February 12, 1950; "Alfred Jacob Miller," ACM, February 13–March 26, 1972

REFERENCES

account book, March 26, May 8, August 10, 1867; Hunter, p. [15]; Brunet, no. 30; Bell, p. 132, illus. p. 133

373. *Running a Band of Elk, near the Cut Rocks of the Platte*

Pencil and pen and ink with gray wash on paper

6 7/8 x 10 5/8 in. (17.4 x 27.0 cm.)

(c. 1837)

Inscribed, u l : "30"; u.c.: "Running a Band of Elk, near the Cut Rocks of the Platte"

Unlocated

PROVENANCE

the artist; Sir William Drummond Stewart (c. 1839); Frank Nichols (sale: Chapman's, Edinburgh, June 16–17, 1871); Bonamy Mansell Power; willed to Edward Power (1900); by descent to Major G. H. Power, Great Yarmouth, England (sale: PB, May 6, 1966)

EXHIBITIONS

Denver Art Museum, April 15–24, 1966; PB, April 29–May 6, 1966

REFERENCES

Murthly sale notices; PB sale 2436 (May 6, 1966), lot 67 (illus.); Knox, "83 Drawings from 1837 Trek," p. 28; Randall, "Transformations and Imaginary Views by Alfred Jacob Miller," pp. 44–45

373A. *Hunting Elk*

Watercolor on paper

8 1/2 x 12 5/16 in. (21.6 x 31.3 cm.)

Signed, l c.: "AJM [monogram]"

(1858–1860)

The Walters Art Gallery, Baltimore, Maryland 37.1940.158

PROVENANCE

William T. Walters, Baltimore

REFERENCES

Ross, pl. 158; Getlein, *Lure of the Great West*, illus. p. 79

373B. *Herd of Elk*

Watercolor, gouache, and pen and ink over pencil on paper

Sight: 8 1/8 x 11 11/16 in. (20.6 x 29.7 cm.)

Signed, l.l.: "AJM [monogram] iller Pt"

(1867)

Inscribed on mat, l.r.: "No. 25/Herd of Elk."

Public Archives of Canada, Ottawa, Ontario; gift of Mrs. J. B. Jardine (1946)

PROVENANCE

Alexander Brown, Liverpool, England (1867); by descent to Mrs. J. B. Jardine, Chesterknowes, Scotland

EXHIBITIONS

PAC museum, winter 1946–1947; Peale Museum, Baltimore, January 8–February 12, 1950; "Alfred Jacob Miller," ACM, February 13–March 26, 1972

REFERENCES

account book, March 26, May 8, August 10, 1867; Hunter, p. [15]; Brunet, no. 25; Bell, p. 112, illus. p. 113

374. *Indians Pursuing an Elk (Elk Taking to the Platte)*

Pen and ink with watercolor on two pieces of paper, joined to right of center

6 5/8 x 11 7/8 in. (16.8 x 29.2 cm.)

Signed, l.l.: "AJM [monogram]"

Inscribed, u.r.: "Indians Pursuing an Elk"; on verso: "Elk taking to the River"

Stark Museum of Art, Orange, Texas 31.34/22

PROVENANCE

Edward Eberstadt and Sons, New York

REFERENCES

Eberstadt catalogue 146 (1958), no. 123-27 (illus. as *Hunting the Elk*); Stark, p. 206

374A. *Indians Chasing Elk*

Unlocated

REFERENCES

account book, October 1, 1849, $50, for Alex Rieman

374B. *Elk Swimming the Platte*

Watercolor on paper

7 11/16 x 12 7/8 in. (19.6 x 32.7 cm.)

Signed, l.c.: "AJM [monogram] iller"

(1858–1860)

The Walters Art Gallery, Baltimore, Maryland 37.1940.98

PROVENANCE

William T. Walters, Baltimore

REFERENCES

Ross, pl. 98; Randall, "Transformations and Imaginary Views by Alfred Jacob Miller," no. 3, illus. p. [45]

374C. *Indians Pursuing Elk*

Unlocated

REFERNCES

account book, July 18, 1864, $40, for P. H. Sullivan

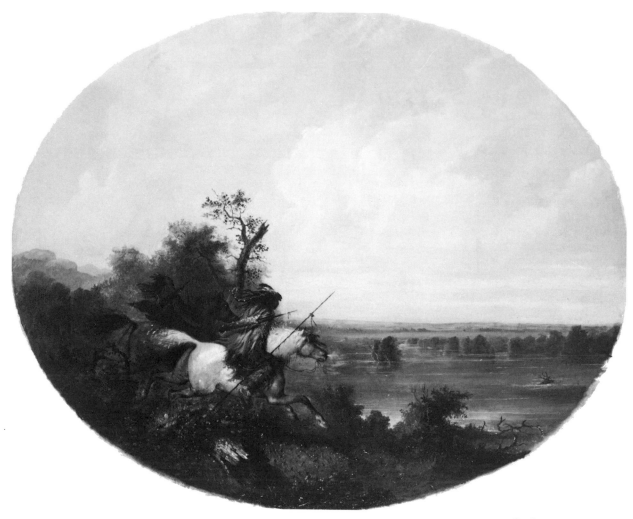

374D. *Indian Scene*

Oil on canvas (oval composition)

28 1/4 x 36 1/4 in. (71.8 x 92.1 cm.)

Signed and dated: "Miller 1865"

The Baltimore Museum of Art 46.3; gift of Alfred Miller

PROVENANCE

the artist; by descent to Alfred Miller, Baltimore

374E. *Snake Indians Fording a River*

Oil on canvas

12 x 20 in. (30.5 x 50.8 cm.)

The Thomas Gilcrease Institute of American History and Art, Tulsa, Oklahoma 0126.723

PROVENANCE

M. Knoedler and Company, New York (1948 or 1962)

REFERENCES

Rough Draughts, no. 141; Krakel, *Adventures in Western Art,* p. 30 or 337, n. 28 (as *Indians Crossing a Stream*)

374F. *Hunting the Elk*

Oil on canvas

20 x 24 in. (50.8 x 61.0 cm.)

Stark Museum of Art, Orange, Texas 31.34/2

PROVENANCE

Edward Eberstadt and Sons, New York

REFERENCES

Eberstadt catalogue 146 (1958), no. 123-3 (illus.); Stark, p. 206

374G. *Elk Swimming the Platte*

Oil on canvas mounted on board

21 3/4 x 37 in. (55.2 x 94.0 cm.)

Gerald Peters, Santa Fe, New Mexico

PROVENANCE

book dealer in Chicago (c. 1955); Benjamin Putnam, Louisville (1974); Kennedy Galleries, New York (1975); returned to Benjamin Putnam (1975)

EXHIBITIONS
BBHC, 1981

REFERENCES
Kennedy Quarterly 14, no. 2 (June 1975): no. 92 (illus. as *Indians Hunting Deer,* oil on cardboard mounted on panel); advertisement for Gerald Peters, *Antiques* 117, no. 4 (April 1980): [765] (illus.)

375. *Pawnee Indians Hunting Elk*

Watercolor and gouache on paper

8 x 11 in. (20.4 x 27.9 cm.)

The Thomas Gilcrease Institute of American History and Art, Tulsa, Oklahoma 0226. 1077

REFERENCES
Rough Draughts, no. 60

375A. *Hunting Elk*

Watercolor on paper

8 13/16 x 12 5/16 in. (22.4 x 31.3 cm.)

Signed, l.l.: "AJM [monogram] iller"

(1858–1860)

The Walters Art Gallery, Baltimore, Maryland 37.1940.140

PROVENANCE
William T. Walters, Baltimore

EXHIBITIONS
"A. J. Miller Watercolors," Smithsonian, October 1956–November 1957; University of Pennsylvania Museum, Philadelphia, May 8–September 8, 1958

REFERENCES
Philadelphia, University of Pennsylvania Museum, *Noble Savage,* no. 40; Ross, pl. 140

375B. *Hunting Elk*

Oil on canvas

14 x 20 in. (35.5 x 50.8 cm.)

Signed and dated, l.l.: "AJM [monogram] iller/1865"

American Heritage Center, University of Wyoming, Laramie; gift of the Everett D. Graff family

PROVENANCE
Col. George D. Wise (1865); Everett D. Graff, Winnetka, Ill.

REFERENCES
account book, May 2, 1865; Monaghan, "Whimsical Art of Alfred Jacob Miller," p. 8 (illus. as *Indian Hunting Antelope*), 14; *Laramie Daily Boomerang,* August 23, 1973, p. 3

375C. *Shooting the Elk*

Watercolor, gouache, and pen and ink over pencil on paper

Sight: 8 5/6 x 11 13/16 in. (22.0 x 29.9 cm.)

Signed, l.l.: "AJM [monogram] iller"

(1867)

Inscribed on mat, l.r.: "Nº. 11./Shooting Elk."

Public Archives of Canada, Ottawa, Ontario; gift of Mrs. J. B. Jardine (1946)

PROVENANCE
Alexander Brown, Liverpool, England (1867); by descent to Mrs. J. B. Jardine, Chesterknowes, Scotland

EXHIBITIONS
PAC museum, winter 1946–1947; Peale Museum, Baltimore, January 8–February 12, 1950; "Alfred Jacob Miller," ACM, February 13–March 26, 1972

REFERENCES
account book, March 26, May 8, August 10, 1867; Hunter, p. [15]; Brunet, no. 11; Bell, p. 54, illus. p. 55

375D. *Plains Indians Pursuing Deer*

Oil on paper, mounted on panel

10 1/4 x 13 in. (26.0 x 33.0 cm.)

The Warner Collection of Gulf States Paper Corporation, Tuscaloosa, Alabama (1977)

PROVENANCE
C. G. Sloan and Company, Washington, D.C.

REFERENCES
Gulf States Paper Corporation, Tuscaloosa, *Best of the West,* unpaginated (illus.)

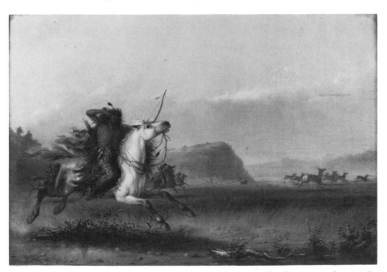

Catalogue number 375B.

376. Untitled [Wind River Mountains—Indians chasing deer]

Oil on canvas

Stretcher: 18 x 24 in. (45.7 x 61.0 cm.)

Mr. and Mrs. Hugh Bennett

377. *Trappers Threatened by Crow Indians*

Watercolor and gouache on paper

9 x 12 1/2 in. (23.0 x 31.7 cm.)

Signed, l.c.: "AJM [monogram]"

The Thomas Gilcrease Institute of American History and Art, Tulsa, Oklahoma 0236.1094

PROVENANCE

L. Vernon Miller; M. Knoedler and Company, New York, #CA 3223–26, as *Trappers Threatened by Indian* (1949)

REFERENCES

Rough Draughts, no. 149; McDermott, "A. J. Miller," p. [8] (illus. as *Threatened Attack)*; "Alfred Jacob Miller," *American Scene* 14, no. 4 (1973): 14 (illus. as *Attack by Indians [Crows]*; "Chapter IV: The Northwest Quadrant; Native Settlement," *American Scene* 17, no. 4 (1976): 8 (illus.); Darling, "Rendezvous at Pierre's Hole Was One Wingding of a Fling," p. 26 (illus. as *Trappers and Crow Indians*, oil)

377A. *An Attack by the Crows on the Whites on the Big Horn River East of the Rocky Mountains*

Oil on canvas

60 x 108 in. (152.4 x 274.3 cm.)

(c. 1840)

D. Steuart Fothringham, Murthly Castle, Perthshire, Scotland

PROVENANCE

Sir William Drummond Stewart (c. 1840); Frank Nichols (sale: Chapman's, Edinburgh, June 16–17, 1871); purchased by a collateral descendant of Stewart; by descent to the present owner

REFERENCES

AJM to Dr. Cockey, Baltimore, November 15, 1840, cited in Warner, p. 43; Murthly sale notices

377B. *Attack by Crow Indians*

Watercolor on paper

9 7/8 x 13 5/8 in. (25.1 x 34.6 cm.)

(1858–1860)

The Walters Art Gallery, Baltimore, Maryland 37.1940.179

PROVENANCE

William T. Walters, Baltimore

EXHIBITIONS

WCMFA, September 14–November 2, 1947; "Gallery of Dudes," ACM, January 26–March 15, 1967

REFERENCES

WCMFA, *American Indian and the West*, no. 60 (as *Traders Surrounded*); Sprague, *Gallery of Dudes*, illus. p. 14; Ross, pl. 179

378. *Sir William Drummond Stewart and Antoine*

Watercolor on paper

7 1/4 x 9 3/4 in. (18.5 x 24.8 cm.)

Inscribed, l.r.: "Sir W. D. S./& Antoine (Canadian)/Half breed"

The Thomas Gilcrease Institute of American History and Art, Tulsa, Oklahoma 0236.1070

PROVENANCE

the artist; by descent to L. Vernon Miller, Baltimore; M. Knoedler and Company, New York, #CA 3223–14

REFERENCES

Rough Draughts, no 90; DeVoto, pl. LXXVI (as *Stewart and Antoine*); Josephy, "First 'Dude Ranch' Trip to the Untamed West," p. 8 (illus.); McDermott, "A. J. Miller," p. 20 (illus.); American Heritage, ed., *American Heritage Book of Great Adventures of the Old West*, illus. p. 129; Rossi and Hunt, p. 325, illus. p. 122; Stegner, "Historian by Serendipity," p. 93 (illus.); Reader's Digest, *Story of the Great American West*, illus. p. 104

379. *Snake and Sioux on Warpath*

Pen and wash and gouache, highlighted by white, on paper

5 1/4 x 9 in. (13.3 x 23.0 cm.)

Signed, l.l.: "AJM [monogram]"

The Thomas Gilcrease Institute of American History and Art, Tulsa, Oklahoma 0236.1076

PROVENANCE

the artist; by descent to L. Vernon Miller; M. Knoedler and Company, New York, #CA 3223–1 (1949)

REFERENCES

Rough Draughts, no. 62; Rossi and Hunt, p. 122 (illus. as *Snake and Sioux on Path*, watercolor); McDermott, "A. J. Miller," p. 13 (illus.)

379A. *Snake and Sioux on Warpath*

Watercolor and gouache on paper

14 x 20 in. (35.5 x 50.8 cm.)

The Thomas Gilcrease Institute of American History and Art, Tulsa, Oklahoma 0236.1075

PROVENANCE

the artist; by descent to L. Vernon Miller, Baltimore; M. Knoedler and Company, New York, #CA 3075, listed as ex-collection Alfred J. Miller, Jr. (1948)

REFERENCES

Rough Draughts, no. 62; Rossi and Hunt, p. 325

379B. *Snake and Sioux Indians on Warpath (Snake and Sioux Indians)*

Oil on canvas

29 x 36 in. (73.7 x 91.5 cm.)

Signed, l.l.: "AJM [monogram] iller/Pt."

Inscribed on verso: "Snake and Sioux Indians on the War Path; A. Miller pt. 1856"

The Thomas Gilcrease Institute of American History and Art, Tulsa, Oklahoma 0126.731

PROVENANCE

Mr. Carl Free; his brother; Old Print Shop, New York; M. Knoedler and Company, New York, #A 4186

REFERENCES

Rough Draughts, no. 62; LaFarge, "Myths That Hide the American Indian," pp. 18–19 (illus.); *Golden Book of America*, illus. pp. 16–17; American Heritage, ed., *American Heritage Book of Great Historic Places*, illus. pp. 278–279, and *America on Parade*, illus. pp. 16–17; White, *Indians and the Old West*, illus. pp. 34–35; American Heritage, ed., *Indians of the Plains*, illus. p. 24; McDermott, "A. J. Miller," p. 13; American Heritage, ed., *American Heritage Book of Great Adventures of the Old West*, illus. p. 133; Fronval, *Fantastique épopée du Far West*, I, p. 17 (illus.); "Alfred Jacob Miller," *American Scene* 14, no. 4 (1973): 15 (illus. as *Dodging an Arrow [Crows]*); "Treasures of the Gilcrease, Part I," *American Scene* 18 and 19, no. 1 (1978): 1 (illus.)

379C. *War Path (Snakes & Sioux Indians Fighting)*

Unlocated

REFERENCES

account book, November 14, 1866, $175, for William Warfield, Lexington, Ky.

379D. *On the Warpath—Running Fight*

Sepia, heightened with white, on brown paper

7 3/4 x 11 1/8 in. (19.7 x 28.2 cm.)

Signed, l.r.: "AJM [monogram]"

The Boatmen's National Bank of St. Louis, Missouri (May 26, 1947)

PROVENANCE

the artist; by descent to Louisa Whyte Norton; Old Print Shop, New York (1947)

EXHIBITIONS

BNB, May 4–29, 1964

REFERENCES

Cowdrey and Comstock, "Alfred Jacob Miller and the Farthest West," p. 1; BNB, *Catalog*, no. 52

379E. *War Path*

Gouache on paper

8 7/8 x 11 7/8 in. (22.6 x 30.2 cm.)

Signed, l.r.: "AJM [monogram]"

The Boatmen's National Bank of St. Louis, Missouri (May 26, 1947)

PROVENANCE

the artist; by descent to Louisa Whyte Norton; Old Print Shop, New York (1947)

REFERENCES

Cowdrey and Comstock, "Alfred Jacob Miller and the Farthest West," p. 1

379F. *War Ground*

Ink and wash on paper

Sight: 13 1/2 x 18 in. (34.3 x 45.7 cm.)

Inscribed, l.r.: "War-ground"

The Rockwell-Corning Museum, Corning, New York

PROVENANCE

[Porter Collection?]

REFERENCES

[Ruxton], *Life in the Far West*, illus. opp. p. 174 (credited to Porter Collection); [Leonard], *Adventures of Zenas Leonard, Fur Trader*, illus. opp. p. 29

380. *On the War Path*

Watercolor on paper

7 1/2 x 9 1/2 in. (19.1 x 24.1 cm.)

Private collection

PROVENANCE

Mrs. Laurence R. Carton

REFERENCES

private collector to William R. Johnston, WAG, November 23, 1980

381. *Sioux Reconnoitering*

Watercolor on paper

7 1/4 x 8 1/2 in. (18.4 x 21.6 cm.)

Inscribed, u.r.: "Sioux Reconnoitering"

C. Thomas May, Jr., Dallas, Texas

PROVENANCE

the artist; by descent to Mrs. Laurence R. Carton; William S. Reese, Baltimore; Kennedy Galleries, New York; Lawrence Fleischman, New York; M. Knoedler and Company, New York; Dr. and Mrs. Irving Levitt, Southfield, Mich. (1961); M. Knoedler and Company, New York; Dean Krakel, Oklahoma City

EXHIBITIONS

CGA, April 3–May 17, 1959; Columbia (S.C.) Museum of Art, January 29–March 14, 1976

REFERENCES

Henri Dorra, *American Muse,* illus. p. 63 (as collection of Dr. and Mrs. Irving Levitt); Columbia (S.C.) Museum of Art, *Americana,* no. 12 (illus.)

381A. *Sioux Reconnoitering*

Watercolor on paper

8 11/16 x 13 in. (22.1 x 33.0 cm.)

(1858–1860)

The Walters Art Gallery, Baltimore, Maryland 37.1940.79

PROVENANCE

William T. Walters, Baltimore

REFERENCES

DeVoto, pl. III; Ross, pl. 79

382. *Snake Indians*

Pen and ink with brown wash, heightened with white, on buff paper

9 x 10 1/2 in. (23.1 x 26.9 cm.)

(c. 1837)

Inscribed, u.l.: "71"

Eugene B. Adkins, Tulsa, Oklahoma

PROVENANCE

the artist; Sir William Drummond Stewart (c. 1839); Frank Nichols (sale: Chapman's, Edinburgh, June 16–17, 1871); Bonamy Mansell Power; willed to Edward Power (1900); by descent to Major G. H. Power, Great Yarmouth, England (sale: PB, May 6, 1966); Kennedy Galleries, New York (1968)

EXHIBITIONS

Denver Art Museum, April 15–24, 1966; PB, April 29–May 6, 1966

REFERENCES

Murthly sale notices; PB sale 2436 (May 6, 1966), lot 52; Knox, "83 Drawings From 1837 Trek," p. 28; *Kennedy Quarterly* 8, no. 2 (June 1968): no. 76 (illus. as *The Runaways*)

383. *Blackfeet on the Warpath*

Watercolor and gouache on paper

8 1/2 x 12 1/4 in. (21.6 x 31.1 cm.)

Signed, l.r.: "AJM [monogram]"

The Thomas Gilcrease Institute of American History and Art, Tulsa, Oklahoma 0236.1055

REFERENCES

Rough Draughts, no. 121

383A. *The Blackfeet*

Watercolor on paper

9 7/8 x 13 3/16 in. (25.1 x 33.5 cm.)

Signed, l.r.: "AJM [monogram] iller"

(1858–1860)

The Walters Art Gallery, Baltimore, Maryland 37.1940.147

PROVENANCE

William T. Walters, Baltimore

EXHIBITIONS

"A. J. Miller Watercolors," Smithsonian, October 1956–November 1957; "Western Frontier," Denver Art Museum, 1966

REFERENCES

[Ruxton], *Ruxton of the Rockies,* illus. opp. p. 219; Berry, *Majority of Scoundrels,* illus. fol. p. 242; Rasky, *Taming of the Canadian West,* illus. p. 25; Ross, pl. 148; Schomaekers, *Wilde Westen,* illus. p. 35; Wasserman, "Artist—Explorers," p. 56 (illus.); Eva Gerhards, *Blackfoot-Indianer,* illus. back cover

383B. *The Blackfeet*

Watercolor, gouache, and pen and ink over pencil on paper

Sight: 9 9/16 x 14 3/4 in. (25.0 x 37.4 cm.)

Signed, l.r.: "AJM [monogram] iller. Pt"

(1867)

Inscribed on mat, l.r.: "Nº. 28./The Blackfeet."

Public Archives of Canada, Ottawa, Ontario; gift of Mrs. J. B. Jardine (1946)

Alexander Brown, Liverpool, England (1867); by descent to Mrs. J. B. Jardine, Chesterknowes, Scotland

EXHIBITIONS

PAC museum, winter 1946–1947; Peale Museum, Baltimore, January 8–February 12, 1950; "Alfred Jacob Miller," ACM, February 13–March 26, 1972

REFERENCES

account book, March 26, May 8, August 10, 1867; Hunter, p. [15]; Brunet, no. 28; Roe, *Indian and the Horse*, illus. opp. p. 111; Bell, p. 124, illus. p. 125

384. *Snake Pursued by Blackfeet*

Watercolor on paper

4 1/8 x 5 in. (10.5 x 12.7 cm.)

Inscribed, u.l.: "52"

Joslyn Art Museum, Omaha, Nebraska; InterNorth Art Foundation Collection 767

PROVENANCE

the artist; by descent to Mrs. Laurence R. Carton; M. Knoedler and Company, New York, #WCA 2234

384A. *Beating a Retreat*

Oil on canvas

29 x 36 in. (73.6 x 91.4 cm.)

Signed, l.r.: "AJM [monogram] iller"

(c. 1842)

Museum of Fine Arts, Boston, Massachusetts; M. and M. Karolik Collection 48.454

PROVENANCE

found near Baltimore; with Victor Spark, New York (1946)

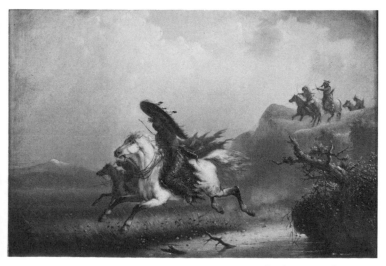

Catalogue number 384D.

EXHIBITIONS

"American Paintings, 1815–1865: One Hundred and Thirty-six Paintings from the M. and M. Karolik Collection in the Museum of Fine Arts, Boston, together with Fourteen Paintings from the Private Collection of Maxim Karolik" (traveling exhibition, 1957–1959); MFA, January 23–March 16, 1975; Denver Art Museum, April 19–June 1, 1975; Fine Arts Gallery of San Diego, July 2–August 17, 1975; Nelson, September 17–November 2, 1975; Milwaukee Art Center, December 5, 1975–January 18, 1976

REFERENCES

[possibly the picture commissioned by Jos. Freyer, account book, April 10, 1863, as *War Ground*, 29 x 36 in., $75?]; MFA, *M. and M. Karolik Collection of American Paintings*, no. 190, illus. p. 425, *American Paintings, 1815–1865*, no. 116, illus. p. 83, and *American Paintings in the Museum of Fine Arts*, no. 758 (illus.); Glubok, *Art of the Old West*, illus. p. 12; Getlein, *Lure of the Great West*, illus. p. 81; MFA, *Frontier America*, no. 39

384B. *Sioux Attacked by Blackfeet*

Oval

Unlocated

REFERENCES

account book, November 24, 1854, $100, for William C. Wilson

384C. *Beating a Retreat*

Watercolor on paper

9 5/16 x 12 1/4 in. (25.3 x 31.1 cm.)

(1858–1860)

The Walters Art Gallery, Baltimore, Maryland 37.1940.95

PROVENANCE

William T. Walters, Baltimore

REFERENCES

Ross, pl. 95

384D. *War Ground. "Beating a Retreat"*

Oil on canvas

14 x 20 in. (35.5 x 50.8 cm.)

Signed, l.r.: "AJM [monogram] iller"

(c. 1865)

American Heritage Center, University of Wyoming, Laramie; gift of the Everett D. Graff family

PROVENANCE

Col. George D. Wise (1865); Everett D. Graff, Winnetka, Ill.

EXHIBITIONS

City Art Museum of St. Louis, 1954

REFERENCES
account book, May 2, 1865; Monaghan, "Whimsical Art of Alfred Jacob Miller," p. 14, illus. p. 8 (as *Indian Retreat*); St. Louis, City Art Museum, *Westward the Way*, no. 69, illus. p. 102 (as *Indian Pursuit*); *Laramie Daily Boomerang*, August 23, 1973, p. 3

384E. *War Ground: Beating a Retreat*

Watercolor, gouache, and pen and ink over pencil on paper

Sight: 9 7/16 x 14 3/16 in. (23.9 x 36.0 cm.)

Signed, l.r.: "AJM [monogram] iller"

(1867)

Inscribed on mat, l.r.: "Nº. 15./War Ground,/'Beating a Retreat.' "

Public Archives of Canada, Ottawa, Ontario; gift of Mrs. J. B. Jardine (1946)

PROVENANCE
Alexander Brown, Liverpool, England (1867); by descent to Mrs. J. B. Jardine, Chesterknowes, Scotland

EXHIBITIONS
PAC museum, winter 1946–1947; Peale Museum, Baltimore, January 8–February 12, 1950; "Alfred Jacob Miller," ACM, February 13–March 26, 1972

REFERENCES
account book, March 26, May 8, August 10, 1867; Hunter, p. [15]; Brunet, no. 15; Bell, p. 72, illus. p. 73

384F. *Indian Beating a Retreat*

Watercolor on paper

13 3/16 x 9 1/16 in. (33.5 x 23.0 cm.)

Signed, l.l.: "AJM. [monogram]"

Western Americana Collection, The Beinecke Rare Book and Manuscript Library, Yale University, New Haven, Connecticut (Coe No. V, 24–25)

PROVENANCE
the artist; by descent to Lloyd O. Miller

EXHIBTIONS
"Gallery of Dudes," ACM, January 26–March 15, 1967

REFERENCES
DeVoto, pl. LXV (as *Beating a Retreat*); Withington, no. 342

384G. *Pursuit*

Ink and wash on paper

Sight: 15 x 20 1/4 in. (38.1 x 51.4 cm.)

The Rockwell-Corning Museum, New York

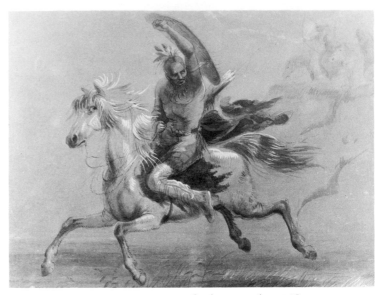

Catalogue number 384G.

385. *A Snake Pursuing a Crow Horse Stealer*

Pencil and watercolor, heightened with white, on paper

5 3/4 x 7 in. (14.8 x 17.8 cm.)

(c. 1837)

Inscribed, u.l.: "4"; l.c.: "A Snake pursuing a Crow Horse Stealer"; on label on verso: "A Snake pursuing a Crow Indian Horse Stealer"

Private collection

PROVENANCE
the artist; Sir William Drummond Stewart (c. 1839); Frank Nichols (sale: Chapman's, Edinburgh, June 16–17, 1871); Bonamy Mansell Power; willed to Edward Power (1900); by descent to Major G. H. Power, Great Yarmouth, England (sale: PB, May 6, 1966)

EXHIBITIONS
Denver Art Museum, April 15–24, 1966; PB, April 29–May 6, 1966

REFERENCES
Murthly sale notices; PB sale 2436 (May 6, 1966), lot 46 (illus.); Knox, "83 Drawings from 1837 Trek," p. 28

385A. *Snake Indian Pursuing a "Crow" Horse Thief*

Watercolor on paper

9 3/8 x 13 1/8 in. (23.8 x 33.3 cm.)

Signed, l.c.: "AJM [monogram] iller"

(1858–1860)

The Walters Art Gallery, Baltimore, Maryland 37.1940.145

PROVENANCE
William T. Walters, Baltimore

EXHIBITIONS
WCMFA, September 14–November 2, 1947

REFERENCES
WCMFA, *American Indian and the West*, possibly no. 64
(as *The Chase*); Ross, pl. 145

385B. *Snake Indian Pursuing a Crow Horse Thief*

Watercolor on paper

6 x 8 1/4 in. (15.2 x 21.0 cm.)

Inscribed, l.r.: "Snake Ind[ian] pursuing a [hor]se-thief"

Stark Museum of Art, Orange, Texas 31.34/40

PROVENANCE
Edward Eberstadt and Sons, New York

REFERENCES
Eberstadt catalogues 128 (1950), no. 380 (illus. as *Snake
Indian Pursuing a Horse Thief*), 138 (1956), no. 438 (illus.),
139 (n.d.), no. 88 (illus. as *Pursuing a Crow Horse Thief*),
and 146 (1958), no. 123–35 (as *Shoshones Escaping from
Enemies*); Stark, p. 207

385C. *Snake Indian Pursuing Crow Horse Thief*

Watercolor and gouache on paper

7 7/16 x 10 13/16 in. (18.9 x 27.5 cm.)

Signed, l.r.: "Miller"

Museum of Fine Arts, Boston, Massachusetts; M. and M.
Karolik Collection 58.1149

EXHIBITIONS
MFA, October 18, 1962–January 6, 1963, and January
23–March 16, 1975; Nelson, September 17–November 2,
1975; Milwaukee Art Center, December 5, 1975–January
18, 1976

REFERENCES
MFA, *Water Colors*, I, no. 550, and *Frontier America*,
no. 42

385D. *A Snake Pursuing a Crow Indian Horse Stealer*

Watercolor on paper

6 x 7 in. (15.2 x 17.8 cm.)

Eugene B. Adkins, Tulsa, Oklahoma

EXHIBITIONS
Phoenix Art Museum, November 1971–January 1972

REFERENCES
Phoenix Art Museum, *Western Art from the Eugene B.
Adkins Collection*, no. 52

386. *Shoshone Indians Pursuing Deer*

Oil on paper, affixed to panel

7 1/2 x 10 1/2 in. (19.1 x 26.7 cm.)

Unlocated

REFERENCES
C. G. Sloan and Company, Washington, D.C., auction
catalogue (June 8, 1980), lot 2392 (illus.)

387. *Clouds of Dust*

Pen and ink with gouache on paper

3 1/2 x 5 5/8 in. (8.9 x 14.3 cm.)

Inscribed, u.l.: "Clouds of dust"

Stark Museum of Art, Orange, Texas 31.34/20

PROVENANCE
Edward Eberstadt and Sons, New York

REFERENCES
Eberstadt catalogue 146 (1958), no. 123–46; Stark, p. 205

388. *Snake Indians on the Look Out*

Pen and ink with gray-brown wash, heightened with
white, on buff paper

9 x 13 7/8 in. (23.0 x 35.7 cm.)

(c. 1837)

Inscribed, u.l.: "83"

Unlocated

PROVENANCE
the artist; Sir William Drummond Stewart (c. 1839);
Frank Nichols (sale: Chapman's, Edinburgh, June 16–17,
1871); Bonamy Mansell Power; willed to Edward Power
(1900); by descent to Major G. H. Power, Great
Yarmouth, England (sale: PB, May 6, 1966); Kennedy
Galleries, New York (1968); sale: SPB, October 17, 1980

EXHIBITIONS
Denver Art Museum, April 15–24, 1966; PB, April
29–May 6, 1966; SPB, October 11–16, 1980

REFERENCES
Murthly sale notices; PB sale 2436 (May 6, 1966), lot 55
(illus.); Knox, "83 Drawings from 1837 Trek," p. 28;
Kennedy Quarterly 8, no. 2 (June 1968): no. 77 (illus. as
The Pursuit); SPB sale 4435M (October 17, 1980), lot 18
(illus.)

389. *Indians on War Path*
Watercolor and gouache on paper
7 3/4 x 11 in. (19.7 x 27.9 cm.)
Signed, l.r.: "AJM [monogram]"
The Thomas Gilcrease Institute of American History and
Art, Tulsa, Oklahoma 0226.1057

PROVENANCE
[Alfred J. Miller, Jr., Baltimore; M. Knoedler and
Company, New York, #CA 3089 (1948)?]

REFERENCES
Rough Draughts, no. 43

389A. *Indians on the War Path*
Watercolor on paper
8 1/8 x 12 3/4 in. (20.6 x 32.4 cm.)
Signed, l.l.: "AJM [monogram] iller"
(1858–1860)
Inscribed, l.l.: "45" or "43"
The Walters Art Gallery, Baltimore, Maryland 37.1940.61

PROVENANCE
William T. Walters, Baltimore

EXHIBITIONS
"A. J. Miller Watercolors," Smithsonian, October
1956–November 1957; University of Pennsylvania
Museum, Philadelphia, May 8–September 8, 1958

REFERENCES
[Ruxton], *Ruxton of the Rockies*, illus. opp. p. 250;
Philadelphia, University of Pennsylvania Museum, *Noble
Savage*, no. 43; Felton, *Edward Rose*, illus. fol. p. 48; Ross,
pl. 61

389B. *Braving the Enemy*
Oil on canvas
22 x 27 in. (55.9 x 68.6 cm.)
The Thomas Gilcrease Institute of American History and
Art, Tulsa, Oklahoma 0126.749

PROVENANCE
[Joseph Katz Company and M. Knoedler and Company,
New York, #A 4478, as *Indian on Horseback*, 27 x 21 3/4
in. (1950–1969)?]

REFERENCES
Rough Draughts, no. 32

389C. *War Path*
Watercolor
5 x 5 in. (12.7 x 12.7 cm.)
Unlocated

PROVENANCE
Edward Eberstadt and Sons, New York

REFERENCES
Eberstadt catalogues 133 (1954), no. 642 (illus.), and 129
(n.d.), no. 84 (illus. as *On the War Path*)

390. *Dodging an Arrow (Crow)*
Watercolor on paper
8 15/16 x 11 5/16 in. (22.7 x 30.3 cm.)
Signed, l.l.: "AJM [monogram] iller"
(1858–1860)
The Walters Art Gallery, Baltimore, Maryland
37.1940.134

PROVENANCE
William T. Walters, Baltimore

REFERENCES
Ross, pl. 134

390A. *Skirmishing: Crow Indians*
Watercolor, gouache, and pen and ink over pencil on
paper
Sight: 8 11/16 x 11 11/16 in. (22.0 x 29.7 cm.)
Signed, l.r.: "AJM [monogram] iller"
(1867)
Inscribed on mat, l.r.: "N⁰. 12./Skirmishing./Crow
Indians."
Public Archives of Canada, Ottawa, Ontario; gift of Mrs.
J. B. Jardine (1946)

PROVENANCE
Alexander Brown, Liverpool, England (1867); by descent
to Mrs. J. B. Jardine, Chesterknowes, Scotland

EXHIBITIONS
PAC museum, winter 1946–1947; Peale Museum,
Baltimore, January 8–February 12, 1950; "Alfred Jacob
Miller," ACM, February 13–March 26, 1972

REFERENCES
account book, March 26, May 8, August 10, 1867;
Hunter, p. [15]; Brunet, no. 12; Bell, p. 58, illus. p. 59

390B. *Dodging an Arrow (Crow)*
Watercolor on paper mounted on board
8 1/2 x 11 3/4 in. (21.5 x 29.8 cm.)
Signed, l.l.: "AJM [monogram] iller"
On verso: "The Myers & Hedian Art Galleries, 214 N.
Charles St., Baltimore"
Unlocated

The Myers and Hedian Art Galleries, Baltimore; sale:
SPB, April 23, 1981

SPB, April 18–22, 1981

SPB sale 4583M (April 23, 1981), lot 93 (illus.)

391. *Running Fight–Sioux and Crows*

Watercolor, heightened with white, on brown paper

8 x 11 5/8 in. (20.3 x 29.4 cm.)

Inscribed, u.r.: "Running Fight/Sioux & Crows"

Museum of Fine Arts, Boston, Massachusetts; M. and M.
Karolik Collection 55.777

Porter Collection (1947); Edward Eberstadt and Sons,
New York (1950)

MFA, October 18, 1962–January 6, 1963; Los Angeles
County Museum of Art, March 21–May 28, 1972; M. H.
de Young Memorial Museum, San Francisco, June
9–September 17, 1972; SLAM, November 2–December
31, 1972

DeVoto, pl. LXIII; Eberstadt catalogue 127 (1950), no.
277, illus. cover; MFA, *Water Colors*, I, no. 549; Los
Angeles County Museum of Art, *American West*, no. 12,
pl. 29

392. *Shoshones Escaping from Hostile Indians*

Watercolor on paper

5 3/8 x 7 1/4 in. (13.6 x 18.4 cm.)

Stark Museum of Art, Orange, Texas 31.34/19

Edward Eberstadt and Sons, New York

Eberstadt catalogue 146 (1958), no. 123–35 (as *Shoshones
Escaping from Enemies*); Stark, p. 207

393. *Battle of Indians*

Watercolor on paper

7 1/2 x 11 1/2 in. (19.1 x 29.2 cm.)

Private collection

Mrs. Laurence R. Carton

private collector to William R. Johnston, WAG,
November 23, 1980

394. *After the Battle: Making off with the Scalp-Lock*

Wash on gray paper

16 1/4 x 14 1/4 in. (41.4 x 36.3 cm.)

Inscribed, l.l.: "After the Battle/making off with the
Scalp-lock"

Mead Art Gallery, Amherst College, Amherst,
Massachusetts 1947.99

the artist; by descent to Louisa Whyte Norton; Old Print
Shop, New York (1947)

Mead Art Building, Amherst College, February 1–28,
1973

Old Print Shop ledger book (June 18, 1947), no. 2 (as
Making off with the Scalp, 16 1/4 x 14 3/4 in.); Amherst
College, Mead Art Gallery, *Cowboys, Indians, Trappers &
Traders*, unpaginated (illus.), and *American Art at
Amherst*, p. 144 (illus.)

394A. *An Indian with the Scalp of His Enemy*

Pencil and watercolor on white card blind-stamped
"London Superfine"

9 1/2 x 7 13/16 in. (24.1 x 19.9 cm.)

(c. 1837)

Inscribed, u.l.: "20"

Unlocated

the artist; Sir William Drummond Stewart (c. 1839);
Frank Nichols (sale: Chapman's, Edinburgh, June 16–17,
1871; Bonamy Mansell Power; willed to Edward Power
(1900); by descent to Major G. H. Power, Great
Yarmouth, England (sale: PB, May 6, 1966)

Denver Art Museum, April 15–24, 1966; PB, April
29–May 6, 1966

Murthly sale notices; PB sale 2436 (May 6, 1966), lot 51
(illus.); Knox, "83 Drawings from 1837 Trek," p. 28

394B. *The Scalp-Lock*

Watercolor on paper

11 3/4 x 9 1/4 in. (29.9 x 23.5 cm.)

(1858–1860)

The Walters Art Gallery, Baltimore, Maryland
37.1940.192

William T. Walters, Baltimore

REFERENCES
Ross, pl. 192

394C. *"After the Battle" Scalp-lock*
Unlocated

REFERENCES
account book, February 22, 1865, $65, for F. Judge

394D. *On the Warpath (The Scalp Lock)*
Oil on canvas

22 x 17 1/2 in. (55.9 x 44.5 cm.)

The Thomas Gilcrease Institute of American History and Art, Tulsa, Oklahoma 0126.729

PROVENANCE
Joseph Katz; M. Knoedler and Company, New York, #CA 3383 (1949)

394E. *The Scalp Lock*
Oil on canvas

35 x 28 1/2 in. (88.9 x 72.4 cm.)

Harmsen's Western Americana, Denver, Colorado

PROVENANCE
sale: Christie's, London, June 1968 (as unidentified artist); Kennedy Galleries, New York (1969)

EXHIBITIONS
Denver Art Museum, January 13–April 15, 1973

REFERENCES
Kennedy Quarterly 11, no. 1 (June 1969): no. 9, (illus.); Dorothy Harmsen, *Harmsen's Western Americana*, illus. p. 143; Denver Art Museum, *Colorado Collects Historic Western Art*, no. 118; Jeff Dykes, *Fifty Great Western Illustrators*, illus. p. [240]

394F. *The Scalp Lock*
Oil on canvas

24 x 18 in. (60.9 x 45.7 cm.)

(c. 1865)

American Heritage Center, University of Wyoming, Laramie; Patrons of the University of Wyoming

PROVENANCE
Bertha and Sally Ballou, Spokane; Maxwell Galleries, San Francisco (1968–1969)

EXHIBITIONS
Maxwell Galleries, San Francisco, August 2–31, 1968

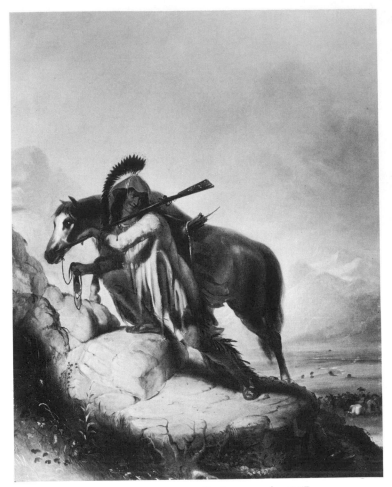

Catalogue number 394E.

REFERENCES
Maxwell Galleries, *American Art since 1850*, no. 226, illus. p. 20

395. *Crow Indian on Lookout*
Pen and ink, wash, and gouache on paper

10 1/4 x 7 7/8 in. (26.1 x 20.0 cm.)

Inscribed, u.l.: "59"; l.l.: "Crow Indian/on the Look out."; l.c.: "Indian longer in body"

Joslyn Art Museum, Omaha, Nebraska; InterNorth Art Foundation Collection 764

PROVENANCE
the artist; by descent to Mrs. Laurence R. Carton; M. Knoedler and Company, New York, #CA 4300/WCA 2222 (1965)

REFERENCES
Chronicle of the Horse 37, no. 29 (July 19, 1974): cover (illus.)

395A. *Crow Indian on the Lookout*

Oil on canvas

10 x 12 in. (25.4 x 30.5 cm.)

(c. 1844)

Peabody Museum, Harvard University, Cambridge, Massachusetts; Bushnell Collection 41-72-10/442

PROVENANCE

David Ives Bushnell, Jr.

EXHIBITIONS

Fogg Art Museum, Harvard University, Cambridge, April 19–June 18, 1972; Mead Art Building, Amherst College, February 1–28, 1973

REFERENCES

Cambridge, Harvard University, Fogg Art Museum, *American Art at Harvard*, no. 29 (illus.); Amherst College, Mead Art Gallery, *Cowboys, Indians, Trappers & Traders*, unpaginated (illus.)

395B. *The Reconnoitre*

Unlocated

REFERENCES

account book, March 16, 1850, $75, for Woodville

395C. *Indian Scout (Crow Indian on the Lookout)*

Oil on canvas

17 1/2 x 23 1/4 in. (44.5 x 59.0 cm.)

Signed and dated, l.c.: "A J Miller/1851"

Western History Department, Denver Public Library

PROVENANCE

Fred Rosenstock, Denver (1956)

REFERENCES

possibly the picture commissioned by Sam Early, account book, January 18, 1851, as *(Indian) Reconnoitre*, $100; Schomaekers, *Wilde Westen*, illus. p. 184; Peggy Samuels and Harold Samuels, *Illustrated Biographical Encyclopedia of Artists of the American West*, pl. 201

395D. *"Reconnoitre"*

Cabinet picture

Unlocated

REFERENCES

account book, April 12, 1853, $33, for Dr. Edmondson

395E. *Crow Indian on the Lookout*

Watercolor, heightened with white, on paper

12 1/4 x 9 7/16 in. (31.1 x 24.0 cm.)

Signed, l.l.: "AJM [monogram] iller"

(1858–1860)

Inscribed, l.r.: "59"

The Walters Art Gallery, Baltimore, Maryland 37.1940.5

PROVENANCE

William T. Walters, Baltimore

EXHIBITIONS

WCMFA, September 14–November 2, 1947; "A. J. Miller Watercolors," Smithsonian, October 1956–November 1957

REFERENCES

WCMFA, *American Indian and the West*, no. 74 (as *Indian Lookout*); Ross, pl. 5; Gold, "Alfred Jacob Miller," p. 26 (illus.)

395F. *Crow Indian on the Lookout (Indian on White Horse)*

Watercolor and gouache on paper

11 x 9 in. (27.9 x 22.8 cm.)

Signed and dated, l.l.: "AJM [monogram]/1860"

The Thomas Gilcrease Institute of American History and Art, Tulsa, Oklahoma 0236.1016

PROVENANCE

Mrs. Crawford Smith, Baltimore; M. Knoedler and Company, New York, #WCA 1371 (1951–1959)

EXHIBITIONS

Knoedler Galleries, New York, October 20–November 1, 1952, and "Far West," November 15–December 4, 1954, no. 10 (as *Indian on a White Horse*)

REFERENCES

Rough Draughts, no. 59; Knoedler Galleries, *Exhibition Featuring Paintings from Harold McCracken's Book Portrait of the Old West*, no. 16; Bryan Holme, ed., *Pictures to Live With*, illus. p. 68 (as *Indian on a White Horse*); "Alfred Jacob Miller," *American Scene* 14, no. 4 (1973): 20 (illus.); Krakel, *Adventures in Western Art*, p. 336, n. 28 (as *Indian on a White Horse*)

395G. *Indians Reconnoitreing*

20 x 14 in. (50.8 x 35.5 cm.)

Unlocated

REFERENCES

account book, July 12, 1865, $80, for Isaac Bell

395H. *Indians Reconnoitre*

Unlocated

REFERENCES

account book, August 9, 1865, $80, for William J. Reese

395I. *A Reconnoitre*

Watercolor, gouache, and pen and ink over pencil on paper

11 1/2 x 9 9/16 in. (29.3 x 24.3 cm.)

Signed, l.c.: "AJM [monogram] iller"

(1867)

Inscribed on mat, l.l.: "No. 14./A Reconnoitre."

Public Archives of Canada, Ottawa, Ontario; gift of Mrs. J. B. Jardine (1946)

PROVENANCE

Alexander Brown, Liverpool, England (1867); by descent to Mrs. J. B. Jardine, Chesterknowes, Scotland

EXHIBITIONS

PAC museum, winter 1946–1947; Peale Museum, Baltimore, January 8–February 12, 1950; "Alfred Jacob Miller," ACM, February 13–March 26, 1972

REFERENCES

account book, March 26, May 8, August 10, 1867; Hunter, p. [15]; Brunet, no. 14; *Beaver: Magazine of the North* 287 (Winter 1956): 54, illus. front cover; Bell, p. 68, illus. p. 69

395J. *Crow Indian on the Lookout*

Oil on canvas

30 x 25 in. (76.2 x 63.5 cm.)

Signed, l.l.: "AJM. [monogram]"

Private collection

PROVENANCE

the artist; by descent to his grandnephew L. Vernon Miller; Mrs. L. Vernon Miller; Graham Gallery, New York; Gerald Peters, Santa Fe; private collection

395K. *Crow Indian on the Lookout*

[Oil on board?]

12 x 10 in. (30.5 x 25.4 cm.)

Inscribed, l.l.: "CDS"; on verso in pencil: "Murdock/July 30, 1863/[Charles B. Dillon or Charles R. Dillery]/14 x 10/Springfield Illinois"; stencil on verso: "From/G. R. Dodge & Co./42 Balt. St./Baltimore"; label on verso: "Prepared Mill-Board/Winsor and Newton/Artists Colourmen/to her Majesty/and to/His Royal Highness Prince Albert/38 Rathbone Place, London"

Randy Sandler, Cincinnati, Ohio

396. *Reconnoitering*

Watercolor with touches of white on paper

6 1/4 x 5 3/16 in. (15.9 x 13.2 cm.)

(c. 1837)

Inscribed, u.l.: "78"

Unlocated

PROVENANCE

the artist; Sir William Drummond Stewart (c. 1839); Frank Nichols (sale: Chapman's, Edinburgh, June 16–17, 1871); Bonamy Mansell Power; willed to Edward Power (1900); by descent to Major G. H. Power, Great Yarmouth, England (sale: PB, May 6, 1966)

EXHIBITIONS

Denver Art Museum, April 15–24, 1966; PB, New York, April 29–May 6, 1966

REFERENCES

Murthly sale notices; PB sale 2436 (May 6, 1966), lot 42 (illus.); Knox, "83 Drawings from 1837 Trek," p. 28

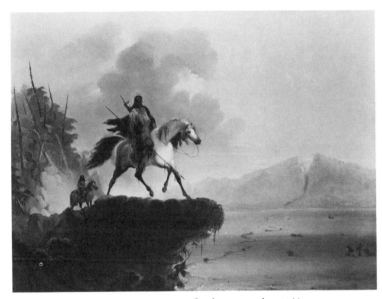

Catalogue number 396A.

396A. *Snake Indians*

Oil on canvas

18 x 24 1/2 in. (45.7 x 62.2 cm.)

Signed and dated on verso: "Miller 1840"

The Gund Collection of Western Art, Cleveland, Ohio (1973)

PROVENANCE

Sir William Drummond Stewart (1840); Frank Nichols (sale: Chapman's, Edinburgh, June 16-17, 1871); Mrs. Garland (née Jenkins), Wilmington, Del.; the Hon. Sir Patrick O'Connor (sale: Christie's [London?], February 19, 1971); Hirschl & Adler Galleries and Newhouse Galleries, New York (1973)

EXHIBITIONS

Los Angeles County Museum of Art, March 21–May 28, 1972; M. H. de Young Memorial Museum, San Francisco, June 9–September 17, 1972; City Art Museum of St. Louis, November 2–December 31, 1972

REFERENCES

Murthly sale notices; *Christie's Review of the Year 1970/ 1971*, p. 162 (illus. as 17 1/2 x 23 in.); Ian Bennett, *History of American Painting*, no. 120, illus. p. 123 (as 17 x 23 in., credited to Sotheby); Cleveland, *Gund Collection of Western Art*, illus. p. 15; Los Angeles County Museum of Art, *American West*, no. 17, pl. 3 (as anonymous loan, 17 1/2 x 23 in.); Hassrick, *Way West*, p. 50

397. *Pawnee Indians Watching the Caravan. "War Ground."*

Pen and ink with sepia wash on paper

9 x 11 in. (22.75 x 28.0 cm.)

Signed and inscribed, l.l.: "AJM. [monogram]/Indians/ Pawnee Indians watching/ the Caravan/—'War Ground' "

Western Americana Collection, The Beinecke Rare Book and Manuscript Library, Yale University, New Haven, Connecticut (Coe No. V, 24–25)

EXHIBITIONS

"Gallery of Dudes," ACM, January 26–March 15, 1967; Yale University Art Gallery, New Haven, September 20, 1978–January 6, 1979

REFERENCES

Withington, no. 342; Sandweiss, p. 62

397A. *Indians Surprised at the Appearance of the Caravan*

Pen and ink with brown wash and touches of white on green card

6 7/8 x 8 3/8 in. (17.4 x 21.3 cm.)

(c. 1837)

Inscribed, u.l.: "60"; on mount, l.c.: "Indians surprised at the appearance of the/Caravan.—"

Whitney Gallery of Western Art, Buffalo Bill Historical Center, Cody, Wyoming 11.80; gift of the Joseph M. Roebling Estate

PROVENANCE

the artist; Sir William Drummond Stewart (c. 1839); Frank Nichols (sale: Chapman's, Edinburgh, June 16–17, 1871); Bonamy Mansell Power; willed to Edward Power (1900); by descent to Major G. H. Power, Great Yarmouth, England (sale: PB, May 6, 1966); Joseph M. Roebling

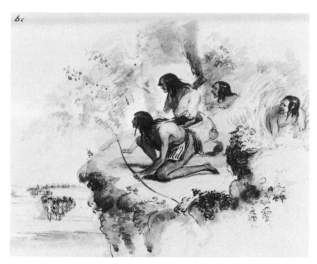

Catalogue number 397A.

EXHIBITIONS

Denver Art Museum, April 15–24, 1966; PB, April 29–May 6, 1966

REFERENCES

Murthly sale notices; PB sale 2436 (May 6, 1966), lot 6 (illus.); Knox, "83 Drawings From 1837 Trek," p. 28

397B. *Pawnee Indians Watching the Caravan*

Watercolor, heightened with white, on paper

10 7/16 x 9 7/16 in. (26.5 x 24.0 cm.)

Signed, l.l.: "AJM [monogram] iller"

(1858–1860)

Inscribed: "147"

The Walters Art Gallery, Baltimore, Maryland 37.1940.44

PROVENANCE

William T. Walters, Baltimore

REFERENCES

Davidson, *Life in America*, I, illus. p. 226; Hollmann, *Five Artists of the Old West*, illus. p. 71; Ross, pl. 44; Getlein, *Lure of the Great West*, illus. p. 66; Utley and Washburn, *American Heritage History of the Indian Wars*, illus. p. 164

397C. *Pawnee Indians Watching the Caravan*

Watercolor, gouache, and pen and ink over pencil on paper

11 11/16 x 9 1/2 in. (29.7 x 24.1 cm.)

Signed, l.l.: "AJM [monogram] iller Pt"

(1867)

Inscribed on mat, l.l.: "Nº. 31./Pawnee Indians,/ Watching the Caravan."

Public Archives of Canada, Ottawa, Ontario; gift of Mrs. J. B. Jardine (1946)

PROVENANCE

Alexander Brown, Liverpool, England (1867); by descent to Mrs. J. B. Jardine, Chesterknowes, Scotland

EXHIBITIONS

PAC museum, winter 1946–1947; Peale Museum, Baltimore, January 8–February 12, 1950; "Alfred Jacob Miller," ACM, February 13–March 26, 1972

REFERENCES

account book, March 26, May 8, August 10, 1867; Hunter, p. [15]; Brunet, no. 31; Bell, p. 136, illus. p. 137

397D. *Watching the Caravan*

Watercolor on paper

7 3/4 x 10 5/8 in. (19.7 x 27.0 cm.)

Signed, l.l.: "AJM [monogram]"

Inscribed, l.l.: "Watching the Caravan"

The Boatmen's National Bank of St. Louis, Missouri (May 26, 1947)

PROVENANCE

the artist; by descent to Louisa Whyte Norton; Old Print Shop, New York (1947)

EXHIBITIONS

BNB, May 4–29, 1964

REFERENCES

Cowdrey and Comstock, "Alfred Jacob Miller and the Farthest West," p. 1; BNB, *Catalog,* no. 37

398. *Hunting Elk*

Watercolor on paper

Sight: 5 3/4 x 5 1/8 in. (14.6 x 13.0 cm.)

Signed, l.l.: "AJM [monogram]"

Whitney Gallery of Western Art, Buffalo Bill Historical Center, Cody, Wyoming 37.64; gift of the W. R. Coe Foundation, Oyster Bay, New York

PROVENANCE

the artist; by descent to Louisa Whyte Norton; Old Print Shop, New York (1947); Edward Eberstadt and Sons, New York; John Howell-Books, San Francisco (1961)

EXHIBITIONS

High Museum of Art, Atlanta, November 1975–January 1976

REFERENCES

Old Print Shop ledger book (June 18, 1947), no. 8 (as *Shooting Elk,* 6 x 5 1/4 in., signed); Swingle, *Catalogue 33: Rare Books and Manuscripts,* no. 101 (as *Shooting Elk,* 6 1/8 x 5 1/4 in., monogrammed AJM); Donald A. Stevning, "Western Artist: His Role in History," *Brand Book II: San Diego Corral, the Westerners,* p. 56 (illus.)

398A. *Snake Indians Shooting Elk*

Watercolor, heightened with white, on paper

11 1/2 x 8 15/16 in. (29.2 x 22.7 cm.)

Signed, l.r.: "A. Miller"

(1858–1860)

Inscribed: "28"

The Walters Art Gallery, Baltimore, Maryland 37.1940.16

PROVENANCE

William T. Walters, Baltimore

EXHIBITIONS

"A. J. Miller Watercolors," Smithsonian, October 1956–November 1957; University of Pennsylvania Museum, Philadelphia, May 8–September 8, 1958

REFERENCES

Philadelphia, University of Pennsylvania Museum, *Noble Savage,* no. 41; Ross, pl. 16

399. *Sioux Indian in Pursuit of Enemy*

Pen and ink with gray wash, on pink card

8 3/8 x 7 in. (21.3 x 17.5 cm.)

(c. 1837)

Inscribed, u.l.: "31"

Eugene B. Adkins, Tulsa, Oklahoma (1967)

PROVENANCE

the artist; Sir William Drummond Stewart (c. 1839); Frank Nichols (sale: Chapman's, Edinburgh, June 16–17, 1871); Bonamy Mansell Power; willed to Edward Power (1900); by descent to Major G. H. Power, Great Yarmouth, England (sale: PB, May 6, 1966); Kennedy Galleries, New York (1966)

EXHIBITIONS

Denver Art Museum, April 15–24, 1966; PB, April 29–May 6, 1966

REFERENCES

Murthly sale notices; PB sale 2365 (May 6, 1966), lot 22; Knox, "83 Drawings From 1837 Trek," p. 28; *Kennedy Quarterly* 6, no. 2 (June 1966): no. 65 (illus.)

400. *Pawnee Supplying Camp*

Watercolor on paper

9 x 7 1/4 in. (22.9 x 18.4 cm.)

Signed, l.r.: "A. J. M."

Inscribed, l.c. of composition: "Pawnee/Supplying Camp"; l.l. of mount: "Pawnee supplying Camp"; l.r. of mount: "From Nature by A.J. Miller 1836 & 7"

Joslyn Art Museum, Omaha, Nebraska; InterNorth Art Foundation Collection 761

PROVENANCE

Mrs. Crawford Smith, Baltimore; M. Knoedler and Company, New York, #WCA 1368 (1951–1965)

EXHIBITIONS

Knoedler Galleries, New York, October 20–November 1, 1952, and "Far West," November 15–December 4, 1954, no. 8

REFERENCES

Knoedler Galleries, *Exhibition Featuring Paintings from Harold McCracken's Book Portrait of the Old West*, no. 14; Goetzmann and Porter, p. 67, illus. p. 87

400A. *A Pawnee Indian Shooting Antelope*

Watercolor on paper

10 11/16 x 13 3/8 in. (27.8 x 34.0 cm.)

(1858–1860)

Inscribed, l.r.: "15 [?]"

The Walters Art Gallery, Baltimore, Maryland 37.1940.68

PROVENANCE

William T. Walters, Baltimore

REFERENCES

Ross, pl. 68

401. *Returning from the Hunt*

Watercolor and gouache on paper

6 x 9 1/4 in. (15.3 x 23.5 cm.)

Signed, l.r.: "AJM [monogram]"

The Thomas Gilcrease Institute of American History and Art, Tulsa, Oklahoma 0236.1087

REFERENCES

Rough Draughts, no. 93

402. *Snake Indian, Returning with Game*

Pen and ink and watercolor on paper

9 1/2 x 13 1/4 in. (24.1 x 33.7 cm.)

Inscribed, l.l.: "Returning with Game"; u.l.: "93"

The Thomas Gilcrease Institute of American History and Art, Tulsa, Oklahoma 0236.1041

PROVENANCE

L. Vernon Miller; M. Knoedler and Company, New York, #CA 3223–25 (1949)

REFERENCES

Rough Draughts, no. 93

402A. *Indian Returning to Camp with Game*

Watercolor on paper

10 1/8 x 16 in. (25.7 x 40.6 cm.)

Signed, l.l.: "AJM [monogram] iller"

(1858–1860)

The Walters Art Gallery, Baltimore, Maryland 37.1940.118

PROVENANCE

William T. Walters, Baltimore

REFERENCES

Ross, pl. 118

403. *Looking out for Game*

Watercolor and gouache on paper

7 x 10 in. (17.8 x 25.4 cm.)

Inscribed, l.r.: "Looking out for Game."

The Thomas Gilcrease Institute of American History and Art, Tulsa, Oklahoma 0236.1106

PROVENANCE

[L. Vernon Miller; M. Knoedler and Company, New York, #CA 3223–21, as *Shoshone Looking out for Game* (1949)?]

REFERENCES

Rough Draughts, no. 105

403A. *Hunters in Search of Game*

Watercolor on paper

8 3/4 x 12 1/16 in. (22.2 x 30.6 cm.)

Signed, l.l.: "AJM [monogram] iller"

(1858–1860)

The Walters Art Gallery, Baltimore, Maryland 37.1940.124

PROVENANCE

William T. Walters, Baltimore

REFERENCES

Ross, pl. 124

404. *Going Home*

Oil on panel

7 x 11 in. (17.7 x 27.9 cm.)

The Thomas Gilcrease Institute of American History and Art, Tulsa, Oklahoma 0126.747

405. *Looking out for Game (Hunters in Search of Game)*

Watercolor and gouache on paper

4 x 6 in. (10.2 x 15.2 cm.)

The Thomas Gilcrease Institute of American History and Art, Tulsa, Oklahoma 0236.1090

REFERENCES
Rough Draughts, no. 105

406. *Shoshone Root Diggers*

Pen and ink and watercolor on paper

4 3/4 x 6 1/4 in. (12.1 x 15.9 cm.)

Joslyn Art Museum, Omaha, Nebraska; InterNorth Art
Foundation Collection 770

PROVENANCE

the artist; by descent to Mrs. Laurence R. Carton; M.
Knoedler and Company, New York, #CA 4311/WCA
2230 (1965)

406A. *Root-Diggers*

Watercolor on paper

8 7/8 x 12 3/16 in. (22.5 x 35.9 cm.)

Signed, l.c.: "AJM [monogram] iller"

(1858–1860)

The Walters Art Gallery, Baltimore, Maryland
37.1940.126

PROVENANCE

William T. Walters, Baltimore

REFERENCES

Ross, *Fur Hunters of the Far West,* illus. opp. p. 200;
Ross, pl. 126

406B. *Root Diggers, Platte River*

Watercolor and gouache on paper

5 3/4 x 9 in. (14.6 x 22.9 cm.)

The Thomas Gilcrease Institute of American History and
Art, Tulsa, Oklahoma 0236.1044

PROVENANCE

L. Vernon Miller; M. Knoedler and Company, New
York, #CA 3223–24 (1949)

REFERENCES

Rough Draughts, no. 112

406C. *Root Diggers*

Watercolor and gouache on paper (oval composition)

7 5/8 x 5 5/8 in. (19.4 x 14.4 cm.)

Joslyn Art Museum, Omaha, Nebraska; InterNorth Art
Foundation Collection 760

407. *Shoshone Camp Fording River*

Watercolor on paper

8 x 10 1/2 in. (20.4 x 16.7 cm.)

Inscribed, u.r.: "Shoshonee [*sic*]—Fording/a River"; r.c.:
"back figures—/smaller/Dark"; on mount, l.r.:
"Shoshonee Camp fording/River"; l.l.: "no. 116"; on
verso: "Carrie C. Miller/3 Oklahoma Terrace/Annapolis/
Maryland"

Joslyn Art Museum, Omaha, Nebraska; InterNorth Art
Foundation Collection 733

PROVENANCE

Carrie C. Miller, Annapolis; Porter Collection

EXHIBITIONS

Nelson, January 1939 (as *Shoshones Fording a River*);
"Western Frontier," SLAM, April 1-May 13, 1941 (as
Indians Fording a River); BBHC, May 15–September 15,
1959

REFERENCES

DeVoto, pl. XXXV; Neider, *Great West,* illus. p. 37;
BBHC, *Land of Buffalo Bill,* no. 62

407A. *Shoshonee* [sic] *Indians—Fording a River*

Watercolor on paper

9 1/2 x 12 3/8 in. (24.1 x 31.4 cm.)

Signed, l.r.: "AJM [monogram] iller"

(1858–1860)

The Walters Art Gallery, Baltimore, Maryland
37.1940.128

PROVENANCE

William T. Walters, Baltimore

EXHIBITIONS

[WCMFA, September 14–November 2, 1947?]

REFERENCES

[WCMFA, *American Indian and the West,* no. 72 (as
Fording the River)?]; Ross, pl. 128

408. *Shoshone Indian Hunters*

Watercolor with pen and ink on paper

5 1/8 x 5 in. (12.0 x 12.7 cm.)

Inscribed (formerly) on verso of mount: "Oklahoma
Terrace—/Annapolis—/Maryland—"

Stark Museum of Art, Orange, Texas 31.34/45

PROVENANCE

Carrie C. Miller, Annapolis; Edward Eberstadt and Sons,
New York

REFERENCES

Eberstadt catalogues 133 (1954), no. 644 (illus.), 139 (n.d.),
no. 86 (illus.), and 146 (1958), no. 123–37; Stark, p. 207

409. *Indians Fording a River, Oregon*

Pencil and brown wash on paper

6 x 9 9/16 in. (15.2 x 25.2 cm.)

Museum of Fine Arts, Boston, Massachusetts; M. and M. Karolik Collection 55.778

EXHIBITIONS

MFA, October 18, 1962–January 6, 1963; Los Angeles County Museum of Art, March 21–May 28, 1972 (and others); MFA, January 23–March 16, 1975; Denver Art Museum, April 19–June 1, 1975; Fine Arts Gallery of San Diego, July 2–August 17, 1975

REFERENCES

MFA, *Water Colors*, I, no. 551, fig. 120; Los Angeles County Museum of Art, *American West*, no. 13, pl. 30; MFA, *Frontier America*, no. 41 (illus.)

410. *Snake Indians: Fording a River*

Watercolor on paper

7 3/4 x 12 3/4 in. (19.7 x 32.4 cm.)

Signed, l.l.: "AJM [monogram] iller"

(1858–1860)

The Walters Art Gallery, Baltimore, Maryland 37.1940.144

PROVENANCE

William T. Walters, Baltimore

REFERENCES

Ross, pl. 144

410A. *[Sho-Shone Indians]*

Oil on wood panel

6 1/2 x 8 3/8 in. (16.5 x 21.3 cm.)

Bancroft Library, University of California, Berkeley 1963.2.1385

PROVENANCE

Robert B. Honeyman, Jr.

REFERENCES

Joseph Armstrong Baird, Jr., comp., *Catalogue of Original Paintings, Drawings and Watercolors in the Robert B. Honeyman, Jr., Collection*, no. 400

410B. *Indians Hunting Elk on Nebraska River*

Oil on paper

12 x 20 in. (30.5 x 50.3 cm.)

Signed, l.l.: "AJM [monogram]"

Inscribed on verso: "Hunting Elk on the Nebraska River"

The Thomas Gilcrease Institute of American History and Art, Tulsa, Oklahoma 0126.722

PROVENANCE

Victor D. Spark, New York; M. Knoedler and Company, New York, #A 4098, listed as 16 x 10 1/2 in. (1949)

411. *Indian Chief and His Squaw Fording River*

Pencil, pen and ink, wash, and gouache on paper

7 1/2 x 10 in. (19.1 x 25.4 cm.)

Signed, l.l.: "AJM [monogram]"

Inscribed, u.r.: "Indian Chief and his Squaw Fording River"

The Thomas Gilcrease Institute of American History and Art, Tulsa, Oklahoma 0236.1068

PROVENANCE

[Alfred J. Miller, Jr., Baltimore; M. Knoedler and Company, New York, #CA 3092 as *Indian Chief and Squaw* (1948)?]

REFERENCES

Rough Draughts, no. 163 or 106

411A. *Indian and His Squaw Fording a River*

Watercolor on paper

9 5/16 x 13 in. (23.6 x 33.0 cm.)

Signed, l.r.: "AJM [monogram] iller"

(1858–1860)

The Walters Art Gallery, Baltimore, Maryland 37.1940.131

PROVENANCE

William T. Walters, Baltimore

REFERENCES

Ross, pl. 131

411B. *Indian and His Squaw Crossing River*

Pencil, watercolor, and gouache on paper

6 1/2 x 9 1/2 in. (16.5 x 24.1 cm.)

Signed, l.l.: "AJM [monogram]"

The Thomas Gilcrease Institute of American History and Art, Tulsa, Oklahoma 0236.1020

PROVENANCE

[Alfred J. Miller, Jr., Baltimore; M. Knoedler and Company, New York, #CA 3026, as *Indians Crossing River* (1948)?]

REFERENCES

Rough Draughts, no. 106; McDermott, "A. J. Miller," p. 19 (illus. as *Shoshone Indians Crossing a River*)

412. *Indians Fording a River*

Watercolor on paper

Sight: 4 3/4 x 6 in. (12.1 x 15.2 cm.)

Whitney Gallery of Western Art, Buffalo Bill Historical Center, Cody, Wyoming 33.64; gift of the W. R. Coe Foundation, Oyster Bay, New York

PROVENANCE

the artist; by descent to Louisa Whyte Norton; Old Print Shop, New York (1947); Edward Eberstadt and Sons, New York; John Howell-Books, San Francisco (1961)

REFERENCES

Old Print Shop ledger book (June 18, 1947), no. 25 (as *Indian Squaw . . .* , 5 1/2 x 6 1/4 in.); Cowdrey and Comstock, "Alfred Jacob Miller and the Farthest West," fig. 5 (as *Indian Squaw . . . Etiquette of Riding with the Chief,* signed, 5 1/2 x 6 1/4 in.); Swingle, *Catalogue 33: Rare Books and Manuscripts,* no. 101 (as *Indian Squaw,* 5 3/8 x 6 5/8 in.)

412A. *Indian Warrior and His Squaw*

Watercolor, gouache, and pen and ink over pencil on paper

Sight: 8 7/8 x 11 5/8 in. (22.4 x 29.5 cm.)

Signed, l.r.: "AJM [monogram] iller"

(1867)

Inscribed on mat, l.r.: "N⁰. 5./Indian Warrior & his Squaw."

Public Archives of Canada, Ottawa, Ontario; gift of Mrs. J. B. Jardine (1946)

PROVENANCE

Alexander Brown, Liverpool, England (1867); by descent to Mrs. J.B. Jardine, Chesterknowes, Scotland

EXHIBITIONS

PAC museum, winter 1946–1947; Peale Museum, Baltimore, January 8–February 12, 1950; "Alfred Jacob Miller," ACM, February 13–March 26, 1972

REFERENCES

account book, March 26, May 8, August 10, 1867; Hunter, p. [15]; Brunet, no. 5; Bell, p. 30, illus. p. 31

413. *Indian Guide, Trying the Ford*

Pen and ink with gouache on paper

6 7/8 x 9 in. (17.5 x 22.9 cm.)

Signed, l.l.: "AJM [monogram]"

Inscribed, u.r.: "Indian Guide—trying the Ford"; (formerly) on mount: "No 94"

Stark Museum of Art, Orange, Texas 31.34/17

PROVENANCE

Edward Eberstadt and Sons, New York

REFERENCES

Eberstadt catalogue 146 (1958), no. 123–40 (illus.); Stark, p. 206

413A. *Guide Testing Big Sandie* [sic]

Watercolor and gouache on paper

6 1/2 x 10 in. (16.5 x 25.4 cm.)

The Thomas Gilcrease Institute of American History and Art, Tulsa, Oklahoma 0236.1105

PROVENANCE

[L. Vernon Miller; M. Knoedler and Company, New York, #CA 3223–12, as *Testing the Ford, Indian Guide* (1949)?]

413B. *Indian Guide, Trying the Ford*

Oil on canvas

20 x 23 in. (50.8 x 58.4 cm.)

Label on verso: "EE2, Charles Miller (1842–'92); Indian Guide Trying the Ford"

Stark Museum of Art, Orange, Texas 31.34/4

PROVENANCE

Charles Miller; Edward Eberstadt and Sons, New York

REFERENCES

Eberstadt catalogue 127 (1950), no. 279 (illus.); Brown, *Three Years in the Rocky Mountains,* no. 279 (illus.); Eberstadt catalogue 146 (1958), no. 123–40 (illus.); Stark, p. 206

414. *Indian Lodges near the Missouri*

Watercolor on paper

7 3/4 x 13 in. (19.7 x 33.0 cm.)

Signed, l.l.: "AJM [monogram]"

Inscribed, l.r.: "Indian Lodges near the Missouri"

The Boatmen's National Bank of St. Louis, Missouri (May 26, 1947)

PROVENANCE

the artist; by descent to Louisa Whyte Norton; Old Print Shop, New York (1947)

EXHIBITIONS

BNB, May 4–29, 1964

REFERENCES

Cowdrey and Comstock, "Alfred Jacob Miller and the Farthest West," p. 1; BNB, *Catalog,* no. 36

414A. *Indian Lodges*

Watercolor on paper

9 x 14 5/16 in. (22.9 x 36.4 cm.)

(1858–1860)

The Walters Art Gallery, Baltimore, Maryland 37.1940.94

PROVENANCE

William T. Walters, Baltimore

REFERENCES

Ross, pl. 94

414B. *Indian Village on the Missouri*

Watercolor, gouache, and pen and ink over pencil on paper

Sight: 8 5/8 x 14 1/8 in. (21.8 x 35.8 cm.)

Signed, l.c.: "AJM [monogram]"

(1867)

Inscribed on mat, l.r.: "Nº. 8./Indian Village./'On the Missouri' "

Public Archives of Canada, Ottawa, Ontario; gift of Mrs. J. B. Jardine (1946)

PROVENANCE

Alexander Brown, Liverpool, England (1867); by descent to Mrs. J. B. Jardine, Chesterknowes, Scotland

EXHIBITIONS

PAC museum, winter 1946–1947; Peale Museum, Baltimore, January 8–February 12, 1950; "Alfred Jacob Miller," ACM, February 13–March 26, 1972

REFERENCES

account book, March 26, May 8, August 10, 1867; Hunter, p. [15]; Brunet, no. 8; Bell, p. 42, illus. p. 43

415. *Interior of an Indian Lodge*

Watercolor on paper

5 15/16 x 4 15/16 (15.1 x 12.5 cm.)

Inscribed, u.l.: "54"; on mount, l.c.: "Interior of an Indian Lodge.—"

Western Americana Collection, The Beinecke Rare Book and Manuscript Library, Yale University, New Haven, Connecticut; gift of Frederick William Beinecke

PROVENANCE

the artist; Sir Williiam Drummond Stewart (c. 1839); Frank Nichols (sale: Chapman's, Edinburgh, June 16–17, 1871); Bonamy Mansell Power; willed to Edward Power (1900); by descent to Major G. H. Power, Great Yarmouth, England (sale: PB, May 6, 1966); bought by Edward Eberstadt and Sons for Frederick William Beinecke

EXHIBITIONS

Denver Art Museum, April 15–24, 1966; PB, April 29–May 6, 1966

REFERENCES

Murthly sale notices; PB sale 2436 (May 6, 1966), lot 56; Knox, "83 Drawings from 1837 Trek," p. 28

416. *Indian Lodge on the Upper Missouri*

Sepia, heightened with white, on brown paper

7 3/4 x 12 in. (19.7 x 30.5 cm.)

Signed, l.c.: "AJM [monogram]"

Inscribed, l.r.: "Indian Lodge on the Upper Missouri"

The Boatmen's National Bank of St. Louis, Missouri (May 26, 1947)

PROVENANCE

the artist; by descent to Louisa Whyte Norton; Old Print Shop, New York (1947)

EXHIBITIONS

BNB, May 4–29, 1964

REFERENCES

Cowdrey and Comstock, "Alfred Jacob Miller and the Farthest West," p. 1; BNB, *Catalog*, no. 51

416A. *Indian Lodge*

Watercolor on paper

7 7/8 x 11 7/8 in. (20.0 x 30.2 cm.)

Signed, l.l.: "AJM [monogram]"

(1858–1860)

The Walters Art Gallery, Baltimore, Maryland 37.1940.196

PROVENANCE

William T. Walters, Baltimore

EXHIBITIONS

WCMFA, September 14–November 2, 1947; "A. J. Miller Watercolors," Smithsonian, October 1956–November 1957

REFERENCES

WCMFA, *American Indian and the West*, no. 66 (as *Indian Council Lodge*); LaFarge, "Myths that Hide the American Indian," p. 16 (illus.); Clark, *Indian Legends from the Northern Rockies*, illus. fol. p. 294; Felton, *Edward Rose*, illus. fol. p. 48; Ross, pl. 196; Getlein, *Lure of the Great West*, illus. p. 71

416B. *Indian Lodge*

Watercolor, gouache, and pen and ink over pencil on paper

Sight: 7 3/4 x 11 7/8 in. (19.7 x 30.2 cm.)

Signed, l.r.: "AJM [monogram] iller Pᵗ"

(1867)

Inscribed on mat, l.r.: "Nᵒ. 23./Indian Lodge."

Public Archives of Canada, Ottawa, Ontario; gift of Mrs. J. B. Jardine (1946)

PROVENANCE

Alexander Brown, Liverpool, England (1867); by descent to Mrs. J. B. Jardine, Chesterknowes, Scotland

EXHIBITIONS

PAC museum, winter 1946–1947; Peale Museum, Baltimore, January 8–February 12, 1950; "Alfred Jacob Miller," ACM, February 13–March 26, 1972

REFERENCES

account book, March 26, May 8, August 10, 1867; Hunter, p. [15]; Brunet, no. 23; Bell, p. 104, illus. p. 105

417. *Indian Hospitality (Snake Indian and Free Trapper)*

Watercolor and gouache on paper

7 1/2 x 9 1/2 in. (19.1 x 24.1 cm.)

Inscribed, u.r.: "145"

The Thomas Gilcrease Institute of American History and Art, Tulsa, Oklahoma 0236.1030

REFERENCES

Rough Draughts, no. 51

417A. *Indian Hospitality—Conversing by Signs*

Pencil with brown, gray, and yellow washes, heightened with white, on paper

7 1/2 x 8 in. (19.2 x 19.7 cm.)

(c. 1837)

Inscribed, u.l.: "40"

The Dentzel Collection 1732

PROVENANCE

the artist; Sir William Drummond Stewart (c. 1839); Frank Nichols (sale: Chapman's, Edinburgh, June 16–17, 1871); Bonamy Mansell Power; willed to Edward Power (1900); by descent to Major G. H. Power, Great Yarmouth, England (sale: PB, May 6, 1966)

EXHIBITIONS

Denver Art Museum, April 15–24, 1966; PB, April 29–May 6, 1966; Los Angeles County Museum of Art, March 21–May 28, 1972; Seattle Art Museum, July 15–September 26, 1976

EXHIBITIONS

Murthly sale notices; PB sale 2436 (May 6, 1966), lot 10; Los Angeles County Museum of Art, *American West*, no. 9, pl. 27; Seattle Art Museum, *Lewis and Clark's America*, no. 61, illus. p. 31 (as *Indian and White Man Conversing in Sign Talk*)

417B. *Indian Hospitality*

Watercolor on paper

8 3/8 x 10 1/2 in. (21.3 x 26.7 cm.)

Signed, l.r.: "AJM [monogram] iller"

(1858–1860)

The Walters Art Gallery, Baltimore, Maryland 37.1940.143

PROVENANCE

William T. Walters, Baltimore

EXHIBITIONS

University of Minnesota Gallery, Minneapolis, June 13–August 18, 1978

REFERENCES

[Ruxton], *Life in the Far West*, illus. opp. p. 78; Ross, pl. 143; Minneapolis, University of Minnesota Gallery, *People of the Plains*, no. 44

418. *Indian Cabin on the Platte*

Pen and ink and wash on paper

6 7/8 x 6 in. (17.5 x 15.3 cm.)

Joslyn Art Museum, Omaha, Nebraska; InterNorth Art Foundation Collection 755

PROVENANCE

the artist; by descent to Louisa Whyte Norton; Old Print Shop, New York (1947); Porter Collection (1947)

REFERENCES

Old Print Shop ledger book (June 18, 1947), no. 50 (as 7 x 6 in.)

418A. *Indian Lodge*

Watercolor on paper

11 1/8 x 9 3/8 in. (28.3 x 23.8 cm.)

Signed, l.l.: "AJM. [monogram]"

(1858–1860)

The Walters Art Gallery, Baltimore, Maryland 37.1940.174

PROVENANCE

William T. Walters, Baltimore

REFERENCES

Randall, "Transformations and Imaginary Views by Alfred Jacob Miller," no. 6, illus. p. 49; Ross, pl. 174

419. *Visit to an Indian Encampment*

Pen and ink with gray wash on paper

7 3/4 x 11 7/8 in. (19.6 x 30.2 cm.)

(c. 1837)

Inscribed, u.l.: "72"

Private collection (March 1980)

PROVENANCE

the artist; Sir William Drummond Stewart (c. 1839); Frank Nichols (sale: Chapman's, Edinburgh, June 16–17, 1871); Bonamy Mansell Power; willed to Edward Power (1900); by descent to Major G. H. Power, Great Yarmouth, England (sale: PB, May 6, 1966); Chapellier Galleries, New York; Kennedy Galleries, New York; Alexander Gallery, New York

EXHIBITIONS

Denver Art Museum, April 15–24, 1966; PB, April 19–May 6, 1966; Kalamazoo Institute of Art, February 17–March 20, 1967

REFERENCES

Murthly sale notices; PB sale 2436 (May 6, 1966), lot 59; Knox, "83 Drawings from 1837 Trek," p. 28; *Kennedy Quarterly* 6, no. 2 (June 1966): no. 64 (as *Visit to a [Mandan?] Indian Encampment*), and 11, no. 4 (March 1972): no. 173 (illus. as *Visit to an Indian Encampment with Sir William Drummond Stewart*, 7 1/2 x 11 3/4 in.)

419A. *An Indian Camp*

Watercolor on paper

8 7/8 x 13 1/2 in. (22.5 x 34.3 cm.)

Signed, l.l.: "AJM [monogram] [?]"

(1858–1860)

The Walters Art Gallery, Baltimore, Maryland 37.1940.153

PROVENANCE

William T. Walters, Baltimore

REFERENCES

Ross, pl. 153

420. *Shoshone Caressing His Horse*

Watercolor with pen and ink on paper

7 1/8 x 10 in. (18.1 x 25.4 cm.)

Signed, l.l.: "AJM [monogram]"

Inscribed, l.l.: "Indian caressing his horse"; (formerly) on mount, l.r.: "Shoshone caressing his horse"

Stark Museum of Art, Orange, Texas 31.34/38

PROVENANCE

Edward Eberstadt and Sons, New York

REFERENCES

Eberstadt catalogues 131 (1953), no. 450 (illus.), 138 (1956), no. 437 (illus.), and 146 (1958), no. 123-31 (illus.); Stark, p. 207, illus. p. 65

420A. *A Shoshone Indian and His Pet Horse*

Oil on canvas

20 x 26 in. (50.8 x 66.0 cm.)

(c. 1845–1847)

The Peale Museum, Baltimore, Maryland; gift of the Misses Hough

PROVENANCE

Dr. Thomas Edmondson (1847); by descent to his granddaughters, the Misses Hough, Baltimore

EXHIBITIONS

Maryland Historical Society annual exhibition (1848), no. 290 (collection of Dr. Edmondson); Peale Museum, Baltimore, January 8–February 12, 1950

REFERENCES

account book, September 27, 1847 (as *Indian Caressing His Horse*, $30, for Dr. Edmondson); Hunter, p. [14], pl. IX; Ross, p. LV; Price, *Vincent Price Treasury of American Art*, illus. p. 78; Getlein, *Lure of the Great West*, illus. p. 64

420B. *Shoshonee* [sic] *Indian and His Pet Horse*

Watercolor on paper

9 1/16 x 12 in. (23.2 x 30.5 cm.)

Signed, l.l.: "AJM [monogram] iller"

(1858–1860)

Inscribed, l.r.: "42"

The Walters Art Gallery, Baltimore, Maryland 37.1940.62

PROVENANCE

William T. Walters, Baltimore

REFERENCES

Ross, pl. 62

420C. *Indian Village (Shoshone Indian Caressing His Horse)*

Oil on canvas (oval)

25 x 31 in. (63.5 x 78.8 cm.)

Unlocated

PROVENANCE

Newhouse Galleries, New York; Kennedy Galleries, New York; Clara Peck, New York (c. 1965–1970)

421. *Indian*

Oil

6 x 8 1/2 in. (15.2 x 21.6 cm.)

Signed, l.l.: "AJM"

Fenn Gallery, Santa Fe, New Mexico

422. *Pawnee Camp*

Watercolor on paper

7 1/8 x 9 3/4 in. (18.1 x 24.8 cm.)

Inscribed, u.r.: "No. 118"; l.c.: "Pawnee Indian Camp"

The Boatmen's National Bank of St. Louis, Missouri (May 26, 1947)

PROVENANCE

the artist; by descent to Louisa Whyte Norton; Old Print Shop, New York (1947)

EXHIBITIONS

BNB, May 4-29, 1964

REFERENCES

Cowdrey and Comstock, "Alfred Jacob Miller and the Farthest West," p. 1; BNB, *Catalog,* no. 53

422A. *Indian Encampment*

Watercolor on paper

8 5/16 x 13 in. (21.9 x 33.0 cm.)

(1858–1860)

The Walters Art Gallery, Baltimore, Maryland 37.1940.115

PROVENANCE

William T. Walters, Baltimore

REFERENCES

Goetzmann, *Exploration and Empire,* illus. p. 209; Ross, pl. 115

423. *Arapahos—Male and Female with Papoose*

Pencil, pen, and watercolor, heightened with white, on paper

7 1/4 x 9 15/16 in. (18.4 x 23.7 cm.)

Inscribed: "41"; u.l.: "Arapahos—male & female with papoose"

Private collection

PROVENANCE

the artist; by descent to Louisa Whyte Norton; Old Print Shop, New York (1947); private collection (1947)

REFERENCES

Old Print Shop ledger book (June 18, 1947), no. 21 (as *Two Indians and Horse,* 7 1/2 x 10 in.)

423A. *Arapahos*

Watercolor on paper

8 15/16 x 12 3/16 in. (22.7 x 30.9 cm.)

Signed, l.c.: "AJM [monogram] iller"

(1858–1860)

The Walters Art Gallery, Baltimore, Maryland 37.1940.74

PROVENANCE

William T. Walters, Baltimore

EXHIBITIONS

"A. J. Miller Watercolors," Smithsonian, October 1956–November 1957; University of Pennsylvania Museum, Philadelphia, 1958; University of Minnesota Gallery, Minneapolis, June 13–August 18, 1978

REFERENCES

Philadelphia, University of Pennsylvania Museum, *Noble Savage,* no. 45; Ross, p. XIV, pl. 74; Schomaekers, *Wilde Westen,* illus. p. 79; Getlein, *Lure of the Great West,* illus. p. 67; Randall, "Gallery for Alfred Jacob Miller," p. [839] (illus.); Minneapolis, University of Minnesota Art Gallery, *People of the Plains,* no. 42

424. *Indian Fort*

Brown wash on paper

5 3/16 x 7 1/16 in. (13.2 x 17.9 cm.)

Inscribed, l.r.: "Indian Fort"

The Boatmen's National Bank of St. Louis, Missouri (May 26, 1947)

PROVENANCE

the artist; by descent to Louisa Whyte Norton; Old Print Shop, New York (1947)

EXHIBITIONS

BNB, May 4-29, 1964

REFERENCES

Cowdrey and Comstock, "Alfred Jacob Miller and the Farthest West," p. 1; BNB, *Catalog,* no. 39

425. *Crow Encampment*

Watercolor on paper

8 1/2 x 11 in. (21.1 x 27.9 cm.)

Signed, l.l.: "AJM [monogram]"

The Thomas Gilcrease Institute of American History and Art, Tulsa, Oklahoma 0236.1065

PROVENANCE

[Alfred J. Miller, Jr., Baltimore; M. Knoedler and Company, New York, #CA 3088, as *Encampment of Indians,* or #CA 3091, as *Indian Encampment* (1948)?]

REFERENCES

Rough Draughts, no. 15; McDermott, "A. J. Miller," p. 24 (illus.)

425A. *Crow Encampment*

Watercolor on paper

9 3/4 x 13 3/4 in. (24.7 x 34.9 cm.)

(1858–1860)

The Walters Art Gallery, Baltimore, Maryland 37.1940.63

PROVENANCE

William T. Walters, Baltimore

EXHIBITIONS

"A. J. Miller Watercolors," Smithsonian, October 1956–November 1957; University of Pennsylvania Museum, Philadelphia, May 8–September 8, 1958

REFERENCES

Philadelphia, University of Pennsylvania Museum, *Noble Savage*, no. 47; Edward S. King, "Old West of A. J. Miller," *Bulletin of the Walters Art Gallery* 16, no. 8 (May 1964): illus. (as *Encampment of Crow Indian*); Ross, pl. 63

426. *Indian Family*

Pencil, watercolor, and gouache on paper

7 x 9 1/2 in. (17.8 x 24.1 cm.)

Signed, l.r.: "AJM [monogram]"

Inscribed on verso of mount: "63/Carrie C. Miller/3 Oklahoma Terrace/Annapolis, Maryland"

Joslyn Art Museum, Omaha, Nebraska; InterNorth Art Foundation Collection 749

PROVENANCE

Carrie C. Miller, Annapolis; Porter Collection; M. Knoedler and Company, New York

EXHIBITIONS

Nelson, January 1939; "Western Frontier," SLAM, April 1–May 13, 1941; BBHC, May 15–September 15, 1959

REFERENCES

BBHC, *Land of Buffalo Bill*, no. 78; Goetzmann and Porter, p. 67, illus. p. 83

426A. *Sioux Indian's Lodge*

Pencil, pen and ink, and watercolor on paper

5 1/4 x 8 1/4 in. (13.3 x 20.8 cm.)

(c. 1837)

Inscribed, u.l.: "25"; on mount, l.c.: "Sioux Indian's Lodge."

Whitney Gallery of Western Art, Buffalo Bill Historical Center, Cody, Wyoming 14.80; gift of the Joseph M. Roebling Estate

PROVENANCE

the artist; Sir William Drummond Stewart (c. 1839); Frank Nichols (sale: Chapman's, Edinburgh, June 16–17, 1871); Bonamy Mansell Power; willed to Edward Power

(1900); by descent to Major G. H. Power, Great Yarmouth, England (sale: PB, May 6, 1966); Joseph M. Roebling

EXHIBITIONS

Denver Art Museum, April 15–24, 1966; PB, April 29–May 6, 1966

REFERENCES

Murthly sale notices; PB sale 2436 (May 6, 1966), lot 21 (illus.); Knox, "83 Drawings From 1837 Trek," p. 28

426B. *Camp Scene (Sioux)*

Watercolor, heightened with white, on paper

9 5/16 x 12 1/4 in. (23.7 x 31.1 cm.)

Signed, l.r.: "Miller"

(1858–1860)

Inscribed, l.r.: "No. 35"

The Walters Art Gallery, Baltimore, Maryland 37.1940.64

PROVENANCE

William T. Walters, Baltimore

EXHIBITIONS

Baltimore Museum of Art, May 11–June 17, 1945

REFERENCES

Baltimore Museum of Art, *Two Hundred and Fifty Years of Painting in Maryland*, no. 127; Ross, pl. 64

426C. *Sioux Indians in the Mountains*

Oil on cardboard

10 11/16 x 13 13/16 in. (27.8 x 33.5 cm.)

Signed, l.r.: "A. J. Miller"

Inscribed on verso: "Miller Paris/No. 5"

The Walters Art Gallery, Baltimore, Maryland 37.1996; gift of C. Morgan Marshall (1945)

EXHIBITIONS

Cabildo, New Orleans, 1953

REFERENCES

New Orleans, Cabildo, *Louisiana Purchase* (1953), no. 158, illus. p. 85; WAG, *Catalogue of American Works of Art*, no. 32; Ross, pl. 202

426D. *Sioux Camp Scene*

Oil on canvas

14 x 20 in. (35.5 x 50.8 cm.)

The Thomas Gilcrease Institute of American History and Art, Tulsa, Oklahoma 0126.725

426E. *Sioux Camp*

Oil on canvas

17 1/2 x 23 in. (44.4 x 58.4 cm.)

Lyle S. Woodcock, St. Louis, Missouri

PROVENANCE
Kennedy Galleries, New York (c. 1950); Dr. Lester Bauer, Detroit (sale: PB, October 27, 1971); Robert E. Peters, Scottsdale; Kennedy Galleries, New York (1977)

EXHIBITIONS
PB, 1971; Phoenix Art Museum, February 8–March 9, 1975

REFERENCES
PB sale 3254 (October 27, 1971), lot 26; *Kennedy Quarterly* 13, no. 2 (June 1974): no. 77 (illus.); Phoenix Art Museum, *American West*, no. 2, illus. p. 9

427. *Indian with His Squaw and Child*

Pencil and watercolor, heightened with white, on paper

6 14/16 x 8 1/2 in. (17.4 x 21.6 cm.)

(c. 1837)

Inscribed: "73"

Unlocated

PROVENANCE
the artist; Sir William Drummond Stewart (c. 1839); Frank Nichols (sale: Chapman's, Edinburgh, June 16–17, 1871); Bonamy Mansell Power; willed to Edward Power (1900); by descent to Major G. H. Power, Great Yarmouth, England (sale: PB, May 6, 1966)

EXHIBITIONS
Denver Art Museum, April 15–24, 1966; PB, April 29–May 6, 1966

REFERENCES
Murthly sale notices; PB sale 2436 (May 6, 1966), lot 54; Knox, "83 Drawings from 1837 Trek," p. 28

428. *Encampment of Indians*

Oil on canvas on board

30 x 24 1/2 in. (76.2 x 62.2 cm.)

Signed and dated, l.r.: "A J Miller/1850"

The Thomas Gilcrease Institute of American History and Art, Tulsa, Oklahoma (1949) 0126.733

PROVENANCE
M. Knoedler and Company, New York

REFERENCES
Rough Draughts, no. 118; McDermott, "A. J. Miller," p. 16 (illus.); Fronval, *Fantastique épopée du Far West*, I, illus. p. 17; Rossi and Hunt, p. 325, illus. p. 124 (as *Indian Encampment*); "Alfred Jacob Miller," *American*

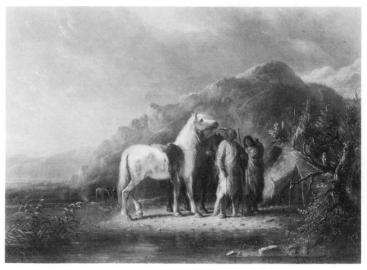

Catalogue number 426E.

Scene 14, no. 4 (1973): [12] (illus.); Krakel, *Adventures in Western Art*, p. 32 (as *Indian Encampment*)

428A. *Encampment of Indians*

Watercolor on paper

11 7/16 x 9 13/16 in. (29.1 x 24.9 cm.)

Signed, l.r.: "AJM [monogram] iller"

(1858–1860)

Inscribed: "91"

The Walters Art Gallery, Baltimore, Maryland 37.1940.34

PROVENANCE
William T. Walters, Baltimore

REFERENCES
Ross, pl. 34

429. *Building the Fire*

Watercolor on paper

Sight: 5 3/4 x 4 3/8 in. (14.6 x 11.1 cm.)

Whitney Gallery of Western Art, Buffalo Bill Historical Center, Cody, Wyoming 30.64; gift of the W. R. Coe Foundation, Oyster Bay, New York

PROVENANCE
the artist; by descent to Louisa Whyte Norton; Old Print Shop, New York (1947); Edward Eberstadt and Sons, New York; John Howell-Books, San Francisco (1961)

PROVENANCE
Old Print Shop ledger book (June 18, 1947), no. 34 (as *Camp Fire*, 6 x 4 3/4 in.); Swingle, *Catalogue 33: Rare Books and Manuscripts*, no. 101 (as *Camp Fire*, 6 x 4 7/8 in.)

430. *Snake Indian Camp*

Watercolor on paper

8 3/4 x 11 7/16 in. (22.2 x 29.0 cm.)

(1858–1860)

The Walters Art Gallery, Baltimore, Maryland
37.1940.160

PROVENANCE

William T. Walters, Baltimore

REFERENCES

Ross, *Fur Hunters of the Far West,* illus. opp. p. 184;
Ross, pl. 160

431. *Watering Horses, Oregon*

Watercolor on paper

5 x 8 1/4 in. (12.7 x 21.0 cm.)

Inscribed: "Oregon Indians Watering Horses"

Unlocated

PROVENANCE

the artist; by descent to Louisa Whyte Norton; Old Print
Shop, New York (1947); Peter Decker, New York (1947);
William J. Holliday, Indianapolis; Hammer Galleries,
New York (1959); J. William Middendorf (1961);
Kennedy Galleries, New York (1966); William J.
Williams, Cincinnati; Kennedy Galleries, New York
(1968); T. R. Potter, Clayton, Mo. (1968; now in Santa Fe)

REFERENCES

Old Print Shop ledger book (June 18, 1947), no. 23;
Cowdrey and Comstock, "Alfred Jacob Miller and the
Farthest West," fig. 3; *Kennedy Quarterly* 6, no. 2 (June
1966): no. 60 (illus. as *Mandan [?] Indian on Horseback*);
FARL 120–21D/(49205)

432. *Indian Village*

Watercolor on paper

8 1/8 x 11 3/8 in. (20.6 x 28.9 cm.)

The Boatmen's National Bank of St. Louis, Missouri
(May 26, 1947)

PROVENANCE

the artist; by descent to Louisa Whyte Norton; Old Print
Shop, New York (1947)

EXHIBITIONS

BNB, May 4–29, 1964

REFERENCES

Cowdrey and Comstock, "Alfred Jacob Miller and the
Farthest West," p. 1; BNB, *Catalog,* no. 34

433. *Indian Camp, Nebraska Territory*

Oil on canvas

13 5/8 x 9 1/8 in. (34.6 x 23.2 cm.)

Joslyn Art Museum, Omaha, Nebraska 1954.58

PROVENANCE

Victor D. Spark, New York; M. Knoedler and Company,
New York, #A 5064 (1952–1954)

EXHIBITIONS

JAM, May 12–July 4, 1954; Knoedler Galleries, New
York, October 20–November 1, 1952

REFERENCES

Knoedler Galleries, *Exhibition Featuring Paintings from
Harold McCracken's Book Portrait of the Old West,* no. 18;
JAM, *Life on the Prairie,* p. 5 (as *Indian Encampment,
Nebraska Territory*); George P. Tomko to Arthur J.
Phelan, Jr., September 12, 1977, collection of Arthur J.
Phelan, Jr.

434. *Indian Encampment at Sunset*

Oil on paper

4 15/16 x 6 7/8 in. (12.5 x 17.5 cm.)

Stark Museum of Art, Orange, Texas 31.34/39

PROVENANCE

Edward Eberstadt and Sons, New York

REFERENCES

Eberstadt catalogue 146 (1958), no. 123–16; Stark, p. 206

435. *Horse-Shoe Creek*

Pencil, watercolor, and gouache on paper

7 1/2 x 12 1/2 in. (19.1 x 31.8 cm.)

Signed, l.l.: "AJM [monogram]"

Inscribed, l.r.: "Horse-Shoe/Creek"; u.r.: "Scene on Horse
Shoe/Nebraska"

Joslyn Art Museum, Omaha, Nebraska; InterNorth Art
Foundation Collection 763

PROVENANCE

Porter Collection

EXHIBITIONS

Nelson, January 1939; BBHC, May 15–September 15,
1959

REFERENCES

BBHC, *Land of Buffalo Bill,* no. 2

435A. *River Scene—Watering Horses*

Watercolor on paper

8 13/16 x 13 1/16 in. (22.4 x 33.2 cm.)

(1858–1860)

The Walters Art Gallery, Baltimore, Maryland
37.1940.171

PROVENANCE

William T. Walters, Baltimore

REFERENCES

Ross, pl. 171

436. *Indian Women*

Pencil and ink with gray wash, heightened with white, on buff paper

8 9/16 x 11 5/16 in. (21.7 x 28.7 cm.)

(c. 1837)

Inscribed: "76"

Unlocated

PROVENANCE

the artist; Sir William Drummond Stewart
(c. 1839); Frank Nichols (sale: Chapman's, Edinburgh,
June 16–17, 1871); Bonamy Mansell Power; willed to
Edward Power (1900); by descent to Major G. H. Power,
Great Yarmouth, England (sale: PB, May 6, 1966)

EXHIBITIONS

Denver Art Museum, April 15–24, 1966; PB, April
29–May 6, 1966

REFERENCES

Murthly sale notices; PB sale 2436 (May 6, 1966), lot 16;
Knox, "83 Drawings from 1837 Trek," p. 28

437. *Indian Women—Shoshones*

Watercolor on paper

4 3/8 x 6 5/8 in. (11.1 x 16.9 cm.)

Signed, l.l.: "AJM [monogram] iller"

Inscribed on mount: "Indian women—Shoshonies [*sic*]";
on verso: "Carrie C. Miller/3 Oklahoma Terrace/
Annapolis, Maryland"

Joslyn Art Museum, Omaha, Nebraska; InterNorth Art
Foundation Collection 706

PROVENANCE

Carrie C. Miller, Annapolis; Porter Collection

EXHIBITIONS

"Western Frontier," SLAM, April 1–May 13, 1941;
BBHC, May 15–September 15, 1959

REFERENCES

BBHC, *Land of Buffalo Bill*, no. 35

437A. *Indians Watering Their Horses*

Pencil and gouache on paper

6 1/4 x 9 1/2 in. (15.9 x 24.1 cm.)

Inscribed (formerly) on verso of mount: "39—Carrie C.
Miller, 3 Oklahoma Terrace, Annapolis, Maryland/
Indians watering horses Oregon"

Stark Museum of Art, Orange, Texas 31.34/27

PROVENANCE

Carrie C. Miller, Annapolis; Edward Eberstadt and Sons,
New York

REFERENCES

Eberstadt catalogue 146 (1958), no. 123–42; Stark, p. 206

437B. *Indians Watering Their Horses*

Oil on wood panel

12 x 9 7/8 in. (30.5 x 25.1 cm.)

Philbrook Art Center, Tulsa, Oklahoma 60.11.4; gift of
Mr. and Mrs. Bailie W. Vinson, Tulsa, 1960

437C. *Indians Watering Horses*

Oil on panel

10 x 12 in. (25.4 x 30.5 cm.)

Joslyn Art Museum, Omaha, Nebraska 1963.614

PROVENANCE

Mrs. J. Douglas Freeman, Baltimore; M. Knoedler and
Co., New York #A 5511 (1965)

REFERENCES

George P. Tomko to Arthur J. Phelan, Jr., September 12,
1977, collection of Arthur J. Phelan, Jr.

438. *Scene on Big Sandy River*

Watercolor and gouache on paper

9 1/2 x 9 in. (24.1 x 22.8 cm.)

Signed, l.l.: "AJM [monogram]"

Inscribed, l.r.: "Scene on 'Big Sandy' River"

The Thomas Gilcrease Institute of American History and
Art, Tulsa, Oklahoma 0236.1062

PROVENANCE

the artist; by descent to Lloyd O. Miller

REFERENCES

Rough Draughts, no. 13; Stephen Decatur, "Alfred Jacob
Miller: His Early Indian Scenes and Portraits," *American
Collector* 8, no. 11 (December 1939): 7 (illus.); *American
Scene* 4, no. 3 (1962): front cover (illus.)

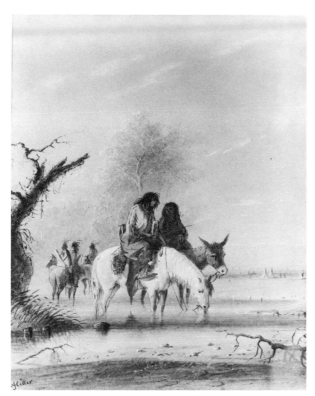

Catalogue number 438B.

438A. *Scene on "Big Sandy" River*

Watercolor, heightened with white, on paper

11 9/16 x 9 9/16 in. (29.9 x 24.3 cm.)

Signed, l.l.: "AJM [monogram] iller"

(1858–1860)

Inscribed, l.l.: "13"

The Walters Art Gallery, Baltimore, Maryland 37.1940.20

PROVENANCE

William T. Walters, Baltimore

REFERENCES

Ross, pl. 20

438B. [Indians watering their horses]

Watercolor and gouache on paper

9 3/8 x 7 7/8 in., approximately (23.8 x 20.0 cm.)

Signed, l.l.: "AJM [monogram] iller"

Bancroft Library, University of California, Berkeley 1963.2.1395

PROVENANCE

Robert B. Honeyman, Jr.

REFERENCES

Baird, *Catalogue of Original Paintings*, no. 399

439. *Females, Shoshone, Rocky Mountains*

Pencil and black wash, heightened with white, on beige paper

16 3/8 x 13 3/8 in. (41.6 x 34.0 cm.)

Signed, l.l.: "AJM [monogram]"

Inscribed, l.r.: "Females—Shoshone.—Rocky Mts"

Stark Museum of Art, Orange, Texas 31.34/32

PROVENANCE

Edward Eberstadt and Sons, New York

REFERENCES

[Old Print Shop ledger book (June 18, 1947), no. 5 (as 18 3/4 x 13 3/4 in., collection of Louisa Whyte Norton)?]; Eberstadt catalogues 133 (1954), no. 641 (illus. as *Shoshone Females Watering Their Horses, Rocky Mountains*), 139 (n.d.), no. 83 (as *Shoshone Females*), and 146 (1958), no. 123-38 (illus. as *Shoshone Females, Rocky Mountains*); Stark, p. 205

439A. *Shoshone Females Watering Horses, Rocky Mountains (The Halt)*

Oil on canvas (oval)

24 x 20 in. (60.9 x 50.8 cm.)

(c. 1850–1860)

The Newark Museum, Newark, New Jersey 61.444; gift of Mr. and Mrs. A. M. Adler, 1961

PROVENANCE

Henri Estate, Baltimore (1932); Hirschl & Adler Galleries, New York (1961)

EXHIBITIONS

Newark Museum, April 26–September 2, 1963

REFERENCES

Newark Museum, *Classical America: 1815–1845*, no. 262 (illus.)

439B. *Indian Girls Watering Horses*

Oil on canvas (oval)

30 x 25 in. (76.2 x 63.5 cm.)

Unlocated

PROVENANCE

American Art-Union, New York (1851–1852); J. A. Edgar, New York (1852)

EXHIBITIONS

American Art-Union Gallery, New York, December 15–17, 1852

REFERENCES

account book, January 2, 1851 (as *Watering Horses*), $85, for Art-Union; "Catalogue of Works of Art," *Bulletin of the American Art-Union* (December 1851): no. 100;

American Art-Union, *Catalogue of Pictures and Other Works of Art . . . to be Sold at Auction by David Austen, Jr.* (December 15–17, 1852), no. 101, cited in Cowdry, *American Academy of Fine Arts and American Art-Union,* I, p. 301 (as *Indian Girls,* sold to J. A. Edgar, New York), and II, p. 254

439C. *Watering Horses*

Unlocated

REFERENCES
account book, November 24, 1854, $65, for Dr. Keener

439D. *Watering Horses*

Unlocated

REFERENCES
account book, December 13, 1854, $60, for M. Wilson

439E. *Watering Horses (Indians Crossing a Stream) (Indian Girls Watering Horses)*

Oil on canvas (oval)

24 x 19 in. (60.9 x 48.2 cm.)

Signed and dated, l.r.: "Miller, 1855"

The Thomas Gilcrease Institute of American History and Art, Tulsa, Oklahoma 0127.728

PROVENANCE
Victor D. Spark, New York; M. Knoedler and Company, New York, #A 3961 (1948–1962)

REFERENCES
Rough Draughts, no. 13; *American Scene* 4, no. 3 (1962): back cover (illus.)

439F. *One Group Two Indian Girls Watering Horses*

Unlocated

REFERENCES
account book, February 12, 1857, $60, for J. Stricker Jenkins

439G. *Indian Girls Watering Horses (Eau Sucre River)*

Watercolor on paper

7 1/4 x 8 7/16 in. (18.4 x 21.4 cm.)

Signed, l.r.: "Miller"

(1858–1860)

The Walters Art Gallery, Baltimore, Maryland 37.1940.73

PROVENANCE
William T. Walters, Baltimore

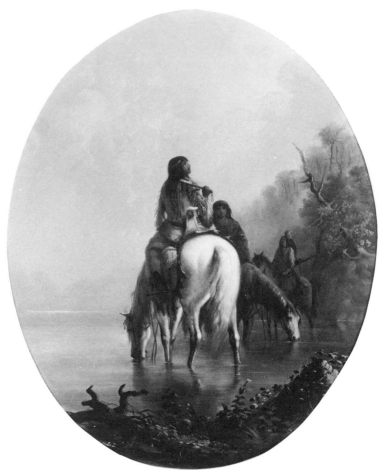

Catalogue number 439A.

REFERENCES
Ross, pl. 73

439H. *Indian Girls Watering Horses*

Watercolor and gouache on paper

6 1/2 x 8 in. (16.5 x 20.3 cm.)

Inscribed, u.r.: "Shoshonee [*sic*]—Indian/women.—"

The Thomas Gilcrease Institute of American History and Art, Tulsa, Oklahoma 0236.1116

440. *Medicine Circles near Platte River*

Watercolor on paper

14 x 20 1/4 in. (35.6 x 51.4 cm.)

Inscribed, l.r.: "Medicine Circles near the Platte"

The Thomas Gilcrease Institute of American History and Art, Tulsa, Oklahoma 0236.1043

PROVENANCE
the artist; by descent to L. Vernon Miller, Baltimore; M. Knoedler and Company, New York, #CA 3223–10 (1949)

REFERENCES
Rough Draughts, no. 104; DeVoto, pl. XX

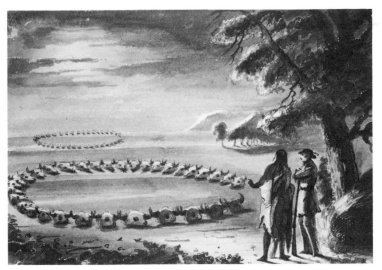

Catalogue number 440A.

440A. *An Indian Showing the "Medicine Circles" on the Platte*

Gray and red-brown washes on paper

7 3/16 x 10 7/16 in. (18.2 x 26.5 cm.)

(c. 1837)

Inscribed: "27"

Unlocated

PROVENANCE

the artist; Sir William Drummond Stewart (c. 1839); Frank Nichols (sale: Chapman's, Edinburgh, June 16–17, 1871); Bonamy Mansell Power; willed to Edward Power (1900); by descent to Major G. H. Power, Great Yarmouth, England (sale: PB, May 6, 1966)

EXHIBITIONS

Denver Art Museum, April 15–24, 1966; PB, April 29–May 6, 1966

REFERENCES

Murthly sale notices; PB sale 2436 (May 6, 1966), lot 18 (illus.); Knox, "83 Drawings from 1837 Trek," p. 28

440B. *Medicine Circles*

Watercolor on paper

9 1/16 x 12 1/4 in. (23.0 x 31.1 cm.)

(1858–1860)

The Walters Art Gallery, Baltimore, Maryland 37.1940.117

PROVENANCE

William T. Walters, Baltimore

EXHIBITIONS

"A. J. Miller Watercolors," Smithsonian, October 1956–November 1957; ACM, February 17–April 3, 1977;

BBHC, May 1–September 30, 1977; Glenbow-Alberta Institute, Calgary, October 15–November 27, 1977; JAM, December 20, 1977–January 29, 1978

REFERENCES

LaFarge, "Myths That Hide the American Indian," illus. p. 17; Baltimore, Peabody Institute, *Magic, Black and White* (1960); Clark, *Indian Legends from the Northern Rockies*, illus. fol. p. 294; Ross, pl. 117; ACM, *The Bison in Art*, p. 86 (illus.)

440C. *Medicine Circles*

Watercolor, gouache, and pen and ink over pencil on paper

Sight: 8 13/16 x 11 15/16 in. (22.4 x 30.2 cm.)

Signed, l.r.: "AJM [monogram] iller"

(1867)

Inscribed on mat, l.r.: "Nº. 16./Medicine Circles."

Public Archives of Canada, Ottawa, Ontario; gift of Mrs. J. B. Jardine (1946)

PROVENANCE

Alexander Brown, Liverpool, England (1867); by descent to Mrs. J. B. Jardine, Chesterknowes, Scotland

EXHIBITIONS

PAC museum, winter 1946–1947; Peale Museum, Baltimore, January 8–February 12, 1950; "Alfred Jacob Miller," ACM, February 13–March 26, 1972

REFERENCES

account book, March 26, May 8, August 10, 1867; Hunter, p. [15]; Brunet, no. 16; Bell, p. 76, illus. p. 77

441. *Sioux Setting out on an Expedition to Capture Wild Horses*

Watercolor on paper

12 x 7 3/4 in. (30.5 x 19.7 cm.)

Inscribed, l.r.: "Sioux Setting out on an Expedition to Capture Wild Horses"

The Boatmen's National Bank of St. Louis, Missouri (May 26, 1947)

PROVENANCE

the artist; by descent to Louisa Whyte Norton; Old Print Shop, New York (1947)

EXHIBITIONS

BNB, May 4–29, 1964

REFERENCES

Cowdrey and Comstock, "Alfred Jacob Miller and the Farthest West," p. 1; BNB, *Catalog,* no. 47

441A. *Expedition to Capture Wild Horses—Sioux*
Watercolor on paper
8 7/16 x 12 in. (21.4 x 30.5 cm.)
Signed, l.l.: "AJM [monogram]"
(1858–1860)
The Walters Art Gallery, Baltimore, Maryland
37.1940.169

PROVENANCE
William T. Walters, Baltimore

REFERENCES
Ross, pl. 169

442. *Shoshone Female Throwing the Lasso*
Pencil, watercolor, and gouache on paper
4 1/4 x 4 5/8 in. (10.8 x 11.8 cm.)
Joslyn Art Museum, Omaha, Nebraska; InterNorth Art
Foundation Collection 768

PROVENANCE
the artist; by descent to Mrs. Laurence R. Carton; M.
Knoedler and Company, New York, #CA 4314/WCA
2231 (1965)

442A. *Throwing the Lasso*
Pen and ink with gray wash on gray card
8 3/4 x 10 3/4 in. (22.2 x 27.3 cm.)
(c. 1837)
Inscribed, u.l.: "63"; on mount, l.c.: "Throwing the
lasso.—"
Joslyn Art Museum, Omaha, Nebraska; InterNorth Art
Foundation Collection 782

PROVENANCE
the artist; Sir William Drummond Stewart (c. 1839);
Frank Nichols (sale: Chapman's, Edinburgh, June 16–17,
1871); Bonamy Mansell Power; willed to Edward Power
(1900); by descent to Major G. H. Power, Great
Yarmouth, England (sale: PB, May 6, 1966)

EXHIBITIONS
Denver Art Museum, April 15–24, 1966; PB, April
29–May 6, 1966

REFERENCES
Murthly sale notices; PB sale 2436 (May 6, 1966), lot 32;
Knox, "83 Drawings From 1837 Trek," p. 28; Ross, pl.
204

442B. *Lassoing Horses*
Watercolor
Sight: 10 x 17 in. (25.4 x 43.2 cm.)

Signed: "AJM [monogram]"
Mrs. M. Bixler Leonard

PROVENANCE
Brantz Mayer, Baltimore

443. *Lassoing Wild Horses*
Pencil, pen and ink, watercolor, and gouache on paper
8 1/8 x 10 3/8 in. (20.7 x 26.4 cm.)
Signed, l.l.: "AJM. [monogram]"
Inscribed on mount: "Lassoing wild horses"; on verso:
"Property of Mrs. Joseph Whyte"
Joslyn Art Museum, Omaha, Nebraska; InterNorth Art
Foundation Collection 748

PROVENANCE
the artist; by descent to Mrs. Joseph Whyte; Porter
Collection; M. Knoedler and Company, New York

EXHIBITIONS
BBHC, May 15–September 15, 1959

REFERENCES
BBHC, *Land of Buffalo Bill*, no. 77; Ewers, *Artists of the
Old West*, illus p. 132 (as *Chasing Wild Horses*);
Goetzmann and Porter, p. 69

443A. *Capture of Wild Horses by Indians*
Watercolor on paper
8 11/16 x 12 15/16 in. (22.1 x 32.9 cm.)
Signed, l.l.: "AJM [monogram] iller"
(1858–1860)
Inscribed, l.r.: "Throwing the laso [?]"
The Walters Art Gallery, Baltimore, Maryland 37.1940.80

PROVENANCE
William T. Walters, Baltimore

REFERENCES
Roe, *Indian and the Horse*, illus. fol. p. 110; Felton,
Edward Rose, illus. fol. p. 48; Ross, pl. 80; Schomaekers,
Wilde Westen, illus. p. 176; *Sportsman's Wilderness*, illus.
p. 144

443B. *Wild Horses: Throwing the Lasso*
Watercolor, gouache, and pen and ink over pencil on
paper
Sight: 8 7/8 x 11 5/8 in. (22.8 x 29.4 cm.)
Signed, l.r.: "AJM [monogram] iller"
(1867)
Inscribed on mat, l.r.: "Nº. 7./Shoshonie [*sic*] Woman,/
'Throwing the Lasso' "

Public Archives of Canada, Ottawa, Ontario; gift of Mrs. J. B. Jardine (1946)

PROVENANCE
Alexander Brown, Liverpool, England (1867); by descent to Mrs. J. B. Jardine, Chesterknowes, Scotland

EXHIBITIONS
PAC museum, winter 1946–1947; Peale Museum, Baltimore, January 8–February 12, 1950; "Alfred Jacob Miller," ACM, February 13–March 26, 1972

REFERENCES
account book, March 26, May 8, August 10, 1867; Hunter, p. [15]; Brunet, no. 7; Bell, p. 34, illus. p. 35

443C. *Capture of Wild Horses by Indians*
Oil on panel
8 x 12 1/2 in. (20.3 x 31.7 cm.)
The Thomas Gilcrease Institute of American History and Art, Tulsa, Oklahoma 0126.745

PROVENANCE
Mrs. Eugenia R. Whyte, Baltimore; M. Knoedler and Company, New York, #A 3907 (1948)

REFERENCES
Krakel, *Adventures in Western Art,* p. 30 (as *Indians Capturing Wild Horses*)

443D. *Chasing Mustang (Chasing Wild Mustangs)*
Oil on canvas
27 x 34 in. (68.6 x 86.3 cm.)
Signed, l.l.: "AJM [monogram] iller"
The Thomas Gilcrease Institute of American History and Art, Tulsa, Oklahoma 0126.740

PROVENANCE
Joseph Katz, Baltimore; M. Knoedler and Company, New York, #CA 2826 (1947)

REFERENCES
Rough Draughts, no. 157; Krakel, *Adventures in Western Art,* p. 28

443E. *Wild Horse Hunt*
Oil on wood panel
9 x 13 1/2 in. (22.9 x 34.3 cm.)
Signed, l.l.: "AJM [monogram]"
Inscribed on verso: "Elizabeth Miller"
Unlocated

PROVENANCE
Post Road Antiques, Mamaroneck, N.Y.; Kennedy Galleries, New York (1968); Dr. MacAllen Reinhoff

(1968); Kennedy Galleries, New York (1968); Howard Garfinkle, Miami; Kennedy Galleries, New York; Howard Garfinkle, Miami (1974)

REFERENCES
Kennedy Quarterly 8, no. 2 (June 1968): no. 131 (illus.), and 11, no. 4 (March 1972): no. 159 (illus. as *Hunting Wild Horses*)

443F. *Lassoing Wild Horses*
Oil on canvas (oval composition)
28 1/2 x 35 5/8 in. (72.4 x 90.5 cm.)
Signed, l.l.: "A. J. Miller"
Stark Museum of Art, Orange, Texas 31.34/30

PROVENANCE
Edward Eberstadt and Sons, New York

REFERENCES
Eberstadt catalogue 146 (1958), no. 123–2 (illus.); Stark, pp. 18, 206, frontispiece

444. *Lassoing Wild Horses*
Unlocated

PROVENANCE
the artist; by descent to L. Vernon Miller

REFERENCES
DeVoto, pl. LIII

444A. *Shoshone Female—Catching a Horse*
Watercolor on paper
8 1/2 x 10 1/16 in. (21.6 x 25.6 cm.)
(1858–1860)
The Walters Art Gallery, Baltimore, Maryland 37.1940.137

PROVENANCE
William T. Walters, Baltimore

REFERENCES
Ross, pl. 137; Hillman, "Part Three: Bridging a Continent," illus. pp. 364–365; Holloway, *Lewis and Clark and the Crossing of North America,* illus. p. 122–123

444B. *Shoshonie* [sic] *Woman: Throwing the Lasso*
Watercolor, gouache, and pen and ink over pencil on paper
Sight: 8 11/16 x 11 7/16 in. (22.1 x 29.2 cm.)
Signed, l.l.: "AJM [monogram] iller"
(1867)
Inscribed on mat, l.r.: "Nº. 6./Wild Horses./'Throwing the Lasso.' "

Public Archives of Canada, Ottawa, Ontario; gift of Mrs. J. B. Jardine (1946)

PROVENANCE
Alexander Brown, Liverpool, England (1867); by descent to Mrs. J. B. Jardine, Chesterknowes, Scotland

EXHIBITIONS
PAC museum, winter 1946–1947; Peale Museum, Baltimore, January 8–February 12, 1950; "Alfred Jacob Miller," ACM, February 13–March 26, 1972

REFERENCES
account book, March 26, May 8, August 10, 1867; Hunter, p. [15]; Brunet, no. 6; Bell, p. 38, illus. p. 39

444C. *Shoshone Female Catching Wild Horses*

Watercolor on paper

6 1/2 x 7 in. (16.5 x 17.8 cm.)

Eugene B. Adkins, Tulsa, Oklahoma

EXHIBITIONS
Phoenix Art Museum, November 1971–January 1972

REFERENCES
Phoenix Art Museum, *Western Art from the Eugene B. Adkins Collection*, no. 51

444D. *Throwing the Lasso*

Watercolor on paper

6 1/8 x 5 1/8 in. (15.5 x 13.0 cm.)

Inscribed on mount: "Throwing the Lasso."

Western Americana Collection, The Beinecke Rare Book and Manuscript Library, Yale University, New Haven, Connecticut (Coe V, 26)

PROVENANCE
the artist; by descent to Louisa Whyte Norton; Old Print Shop, New York (1947); Edward Eberstadt and Sons, New York

EXHIBITIONS
Yale University Art Gallery, New Haven, September 20, 1978–January 6, 1979

REFERENCES
Old Print Shop ledger book (June 18, 1947), no. 22 (as *Indian Huntress Throwing the Lasso*, 5 x 6 1/4 in.); [Harry Shaw Newman Gallery] *Panorama* 3, no. 1 (August–September 1947): cover (illus.); Withington, no. 341; Sandweiss, p. 62

444E. *Shoshone Girl Catching Wild Horses*

Pen and ink, pencil, and gouache on blue paper

7 1/2 x 10 1/2 in. (19.1 x 26.7 cm.)

Signed, l.l.: "AJM [monogram]"

The Thomas Gilcrease Institute of American History and Art, Tulsa, Oklahoma 1336.1071

REFERENCES
Rough Draughts, no. 71

444F. *Hunting Wild Horses*

Oil on panel

13 1/2 x 19 in. (34.3 x 48.2 cm.)

Signed, l.r.: "AJM [monogram]"

Unlocated

PROVENANCE
Jim Fowler's Period Gallery West, Scottsdale, Ariz.; Kennedy Galleries, New York; Mrs. E. P. Moore, Washington, D.C.

445. *Indian Mourning over a Grave, Marked by a Buffalo Skull*

Pencil, pen and ink, and wash on paper

5 x 3 7/8 in. (12.7 x 9.9 cm.)

Inscribed, l.l.: "Indian mourning [illeg.] grave"; on mount: "Indian mourning over a grave/marked by a Buffalo Skull"

Joslyn Art Museum, Omaha, Nebraska; InterNorth Art Foundation Collection 707

PROVENANCE
Porter Collection

EXHIBITIONS
"Western Frontier," SLAM, April 1–May 13, 1941; BBHC, May 15–September 15, 1959

REFERENCES
BBHC, *Land of Buffalo Bill*, no. 36

446. *Sioux Indian at a Grave*

Watercolor on paper

10 3/8 x 8 3/16 in. (26.4 x 20.8 cm.)

Signed, l.r.: "AJM. [monogram]"

(1858–1860)

The Walters Art Gallery, Baltimore, Maryland 37.1940.191

PROVENANCE
William T. Walters, Baltimore

EXHIBITIONS
"A. J. Miller Watercolors," Smithsonian, October 1956–November 1957

REFERENCES
Ross, pl. 191

446A. *Sioux Indian at a Grave*

Watercolor on board

9 3/8 x 8 in. (24.8 x 20.3 cm.)

Signed, l.r.: "AJM [monogram]"

Unlocated

> PROVENANCE
>
> Rosequist Gallery, Tucson (sale: SPB, October 17, 1980)
>
> EXHIBITIONS
>
> SPB, October 11–16, 1980
>
> REFERENCES
>
> SPB sale 4435M (October 17, 1980), lot 20 (illus.)

446B. *Mourning at Skull-Marked Grave*

Oil on paper

4 13/16 x 5 in. (12.2 x 12.7 cm.)

Inscribed (formerly) on verso of mount: "Mourning at skull marked grave/Terrace/land"

Stark Museum of Art, Orange, Texas 31.34/18

> PROVENANCE
>
> Carrie C. Miller, Annapolis; Edward Eberstadt and Sons, New York
>
> REFERENCES
>
> Eberstadt catalogue 146 (1958), no. 123–18 (illus. as *Mourning at a Sioux Grave*); Stark, p. 207

446C. *Sioux Indian at a Grave*

Watercolor on paper

8 1/2 x 7 in. (21.6 x 17.8 cm.)

Signed, l.r.: "Miller"

Inscribed, l.c.: "Indian Grave"

The Thomas Gilcrease Institute of American History and Art, Tulsa, Oklahoma 0226.1086

> REFERENCES
>
> Rough Draughts, no. 104

447. *Group of Wild Horses Seen from an Eminence near the Sweet Water River*

Ink and watercolor, heightened with white, on paper

Sight: 7 1/2 x 13 1/2 in. (19.1 x 34.3 cm.)

Inscribed: "Group of Wild Horses seen from an Eminence near the 'Sweet Water' River"

Private collection

> PROVENANCE
>
> the artist; by descent to Louisa Whyte Norton; Old Print Shop, New York (1947); private collection (1947)
>
> REFERENCES
>
> Old Print Shop ledger book (June 18, 1947), no. 18

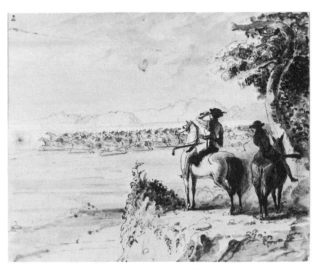

Catalogue number 447A.

447A. *Herd of Wild Horses*

Pen and ink with brown wash on paper

7 1/8 x 8 1/2 in. (18.1 x 21.5 cm.)

(c. 1837)

Inscribed, u.l.: "2"; on mount, l.c.: "Herd of Wild Horses."

Whitney Gallery of Western Art, Buffalo Bill Historical Center, Cody, Wyoming 12.80; gift of the Joseph M. Roebling Estate

> PROVENANCE
>
> the artist; Sir William Drummond Stewart (c. 1839); Frank Nichols (sale: Chapman's, Edinburgh, June 16–17, 1871); Bonamy Mansell Power; willed to Edward Power (1900); by descent to Major G. H. Power, Great Yarmouth, England (sale: PB, May 6, 1966); Joseph M. Roebling
>
> EXHIBITIONS
>
> Denver Art Museum, April 15–24, 1966; PB, April 29–May 6, 1966
>
> REFERENCES
>
> Murthly sale notices; PB sale 2436 (May 6, 1966), lot 31 (illus.); Knox, "83 Drawings From 1837 Trek," p. 28

448. *Stampede of Wild Horses*

Watercolor on paper

6 x 8 7/8 in. (15.3 x 22.6 cm.)

Inscribed, u.r.: "Stampede of Wild Horses"

The Boatmen's National Bank of St. Louis, Missouri (May 26, 1947)

> PROVENANCE
>
> the artist; by descent to Louisa Whyte Norton; Old Print Shop, New York (1947)

EXHIBITIONS
BNB, May 4–29, 1964

REFERENCES
Cowdrey and Comstock, "Alfred Jacob Miller and the Farthest West," p. 1; BNB, *Catalog*, no. 49

448A. *Stampede of Wild Horses*

Watercolor on paper

8 1/4 x 12 15/16 in. (21.0 x 32.9 cm.)

(1858–1860)

The Walters Art Gallery, Baltimore, Maryland 37.1940.92

PROVENANCE
William T. Walters, Baltimore

EXHIBITIONS
"A. J. Miller Watercolors," Smithsonian, October 1956–November 1957; Marion Koogler McNay Art Institute, San Antonio, 1960

REFERENCES
McNay, unpaginated; Ross, pl. 92

448B. *Stampede of Wild Horses*

Watercolor and gouache on paper

6 x 12 1/2 in. (15.3 x 31.7 cm.)

Signed, l.r.: "AJM [monogram]"

The Thomas Gilcrease Institute of American History and Art, Tulsa, Oklahoma 0226.1080

PROVENANCE
Alfred J. Miller, Jr., Baltimore; M. Knoedler and Company, New York, #CA 3076 (1948)

REFERENCES
Rough Draughts, no. 144; Donnie D. Good, "Mustangs," *American Scene* 12, no. 2 (1971): 7–8 (illus. as *Wild Horses*)

449. *Wild Horses*

Pen and ink and wash on paper

8 1/2 x 13 1/4 in. (21.5 x 33.7 cm.)

Signed, l.r.: "AJM [monogram]"

The Thomas Gilcrease Institute of American History and Art, Tulsa, Oklahoma 0236.1069

REFERENCES
DeVoto, pl. XXV (as *Wild Horses of the Sweetwater*)

449A. *Wild Horses*

Pen and ink with gray wash, heightened with white (oxidized), on blue card

8 1/2 x 13 3/4 in. (21.7 x 34.9 cm.)

(c. 1837)

Inscribed: "81"

Whitney Gallery of Western Art, Buffalo Bill Historical Center, Cody, Wyoming 5.73

PROVENANCE
the artist; Sir William Drummond Stewart (c. 1839); Frank Nichols (sale: Chapman's, Edinburgh, June 16–17, 1871); Bonamy Mansell Power; willed to Edward Power (1900); by descent to Major G. H. Power, Great Yarmouth, England (sale: PB, May 6, 1966)

EXHIBITIONS
Denver Art Museum, April 15–24, 1966; PB, April 29–May 6, 1966

REFERENCES
Murthly sale notices; PB sale 2436 (May 6, 1966), lot 33 (illus.); Knox, "83 Drawings from 1837 Trek," p. 28

449B. *Wild Horses*

Watercolor on paper

14 9/16 x 9 7/16 in. (37.0 x 24.0 cm.)

(1858–1860)

The Walters Art Gallery, Baltimore, Maryland 37.1940.176

PROVENANCE
William T. Walters, Baltimore

REFERENCES
Ross, *Fur Hunters of the Far West*, illus. opp. p. 152; Ross, pl. 176

450. *Indian Boy Shooting Prairie Dog*

Watercolor on paper

4 3/4 x 4 1/4 in. (12.1 x 10.8 cm.)

The Thomas Gilcrease Institute of American History and Art, Tulsa, Oklahoma 0226.1100

PROVENANCE
L. Vernon Miller; M. Knoedler and Company, New York, #CA 3223–6 (1949)

450A. *Snakes* [a young Indian poised to shoot his arrow]

Pen and ink and watercolor on paper

6 1/16 x 5 1/16 in. (15.4 x 12.9 cm.)

(c. 1837)

Inscribed: "36"

Unlocated

PROVENANCE
the artist; Sir William Drummond Stewart (c. 1839); Frank Nichols (sale: Chapman's, Edinburgh, June 16–17, 1871); Bonamy Mansell Power; willed to Edward Power

(1900); by descent to Major G. H. Power, Great
Yarmouth, England (sale: PB, May 6, 1966)

EXHIBITIONS
Denver Art Museum, April 15–24, 1966; PB, April
29–May 6, 1966

REFERENCES
Murthly sale notices; PB sale 2436 (May 6, 1966), lot 45;
Knox, "83 Drawings from 1837 Trek," p. 28

Catalogue number 450B.

450B. *Shooting the Prairie Dog*

Watercolor on paper

4 3/4 x 6 5/16 in. (12.0 x 16.0 cm.)

Signed, l.l.: "AJM [monogram]"

Inscribed on mount: "Shooting the Prairie Dog"

Western Americana Collection, The Beinecke Rare Book
and Manuscript Library, Yale University, New Haven,
Connecticut (Coe V, 26)

PROVENANCE
the artist; by descent to Louisa Whyte Norton; Old Print
Shop, New York (1947); Edward Eberstadt and Sons,
New York

EXHIBITIONS
"Gallery of Dudes," ACM, January 26–March 15, 1967

REFERENCES
Old Print Shop ledger book (June 18, 1947), no. 12 (as
Indian Lad Shooting Prairie Dogs, 7 1/4 x 6 in.);
Withington, no. 341

451. *Indian Babies*

Watercolor on paper

4 x 4 1/4 in. (10.2 x 10.8 cm.)

Signed, l.r.: "AJM [monogram] iller"

Bruce Wear, Tulsa, Oklahoma

452. *Louison Crevier*

Pencil, pen and ink, and watercolor, heightened with
white, on paper

8 1/2 x 6 5/8 in. (21.5 x 16.8 cm.)

(c. 1837)

Inscribed: "26"

Unlocated

PROVENANCE
the artist; Sir William Drummond Stewart (c. 1839);
Frank Nichols (sale: Chapman's, Edinburgh, June 16–17,
1871); Bonamy Mansell Power; willed to Edward Power
(1900); by descent to Major G. H. Power, Great
Yarmouth, England (sale: PB, May 6, 1966)

EXHIBITIONS
Denver Art Museum, April 15–24, 1966; PB, April
29–May 6, 1966

REFERENCES
Murthly sale notices; PB sale 2436 (May 6, 1966), lot 2
(illus.); Knox, "83 Drawings from 1837 Trek," p. 28

453. *Indian Runner*

Pencil, watercolor, and gouache on paper

6 5/8 x 8 5/8 in. (16.8 x 21.9 cm.)

Signed, l.r.: "AJM. [monogram]"

Joslyn Art Museum, Omaha, Nebraska; InterNorth Art
Foundation Collection 779

PROVENANCE
Miss Jane Miller; M. Knoedler and Company, New
York, #WCA 2736 (1965)

453A. *Antoine*

Pencil and watercolor on paper

7 5/8 x 7 1/8 in. (19.4 x 18.1 cm.)

(c. 1837)

Inscribed: "41"

Unlocated

Catalogue number 453A.

PROVENANCE

the artist; Sir William Drummond Stewart (c. 1839);
Frank Nichols (sale: Chapman's, Edinburgh, June 16–17,
1871); Bonamy Mansell Power; willed to Edward Power
(1900); by descent to Major G. H. Power, Great
Yarmouth, England (sale: PB, May 6, 1966)

EXHIBITIONS

Denver Art Museum, April 15–24, 1966; PB, April
29–May 6, 1966

REFERENCES

Murthly sale notices; PB sale 2436 (May 6, 1966), lot 1
(illus.); Knox, "83 Drawings from 1837 Trek," p. 28

453B. *Indian Runner*

Watercolor on paper

7 1/4 x 10 5/8 in. (18.5 x 27.0 cm.)

Signed, l.l.: "AJM [monogram] iller"

(1858–1860)

The Walters Art Gallery, Baltimore, Maryland
37.1940.103

PROVENANCE

William T. Walters, Baltimore

REFERENCES

Ross, pl. 103

454. *Snake Indian and His Dog*

Watercolor on paper

10 x 7 3/4 in. (25.4 x 19.7 cm.)

Signed, l.l.: "AJM [monogram]"

Inscribed, u.l.: "Indian of the Snake/Tribe."

The Thomas Gilcrease Institute of American History and
Art, Tulsa, Oklahoma 0236.1052

PROVENANCE

[L. Vernon Miller; M. Knoedler and Company, New
York, #CA 3223–17 as *Indian of the Snake Tribe* (1949)?]

REFERENCES

Rough Draughts, no. 75

454A. *Snake Indian and His Dog*

Watercolor, heightened with white, on paper

10 1/8 x 9 1/4 in. (25.7 x 23.5 cm.)

Signed, l.l.: "AJM [monogram] iller"

(1858–1860)

Inscribed, l.r.: "75"

The Walters Art Gallery, Baltimore, Maryland 37.1940.46

PROVENANCE

William T. Walters, Baltimore

REFERENCES

Ross, pl. 46

455. *Indians Testing Their Bows*

Pencil and oil on paper

7 1/2 x 10 1/2 in. (19.1 x 26.7 cm.)

Inscribed, u.r.: "Indians Testing their Bows"

The Thomas Gilcrease Institute of American History and
Art, Tulsa, Oklahoma 0236.1031

PROVENANCE

the artist; by descent to Mrs. Joseph Whyte (1947);
Edward Eberstadt and Sons, New York (1955)

EXHIBITIONS

Arizona Art Foundation; Roswell Museum; Palace of
Governors, Santa Fe; Santa Fe Museum

REFERENCES

Rough Draughts, no. 50; DeVoto, pl. XLIX; Eberstadt
catalogue 136 (1955), no. 418 (illus.); J. Hall Pleasants file
(1935), p. 92 (1502); FARL 120–24B

455A. *Trial of Skill—with the Bow and Arrow*

Pen and ink with gray and yellow washes on paper

7 3/8 x 10 1/4 in. (18.8 x 26.1 cm.)

(c. 1837)

Inscribed, u.l.: "22"

The Walters Art Gallery, Baltimore, Maryland 37.2438

PROVENANCE

the artist; Sir William Drummond Stewart (c. 1839);

Frank Nichols (sale: Chapman's, Edinburgh, June 16–17, 1871); Bonamy Mansell Power; willed to Edward Power (1900); by descent to Major G. H. Power, Great Yarmouth, England (sale: PB, May 6, 1966)

EXHIBITIONS
Denver Art Museum, April 15–24, 1966; PB, April 29–May 6, 1966

REFERENCES
Murthly sale notices; PB sale 2436 (May 6, 1966), lot 74 (illus.); Knox, "83 Drawings from 1837 Trek," p. 28; Ross, p. XXXIII, pl. 206

455B. *Indians Testing Their Bows*
Watercolor on paper
9 3/16 x 13 1/8 in. (23.4 x 33.3 cm.)
(1858–1860)
The Walters Art Gallery, Baltimore, Maryland
37.1940.189

PROVENANCE
William T. Walters, Baltimore

REFERENCES
Ross, pl. 189

456. *Indians Testing Their Bows*
Pencil, watercolor, and gouache on paper
7 1/4 x 10 3/4 in. (18.4 x 27.3 cm.)
Signed, l.l.: "AJM. [monogram]"
Inscribed, l.r.: "Indians testing their bows"
Joslyn Art Museum, Omaha, Nebraska; InterNorth Art Foundation Collection 737

PROVENANCE
Carrie C. Miller, Annapolis; Porter Collection; M. Knoedler and Company, New York

EXHIBITIONS
BBHC, May 15–September 15, 1959

REFERENCES
BBHC, *Land of Buffalo Bill*, no. 66; Goetzmann and Porter, p. 67, illus. p. 76

456A. *Snake Indians—Testing Bows*
Watercolor on paper
8 13/16 x 11 11/16 in. (22.4 x 29.7 cm.)
Signed, l c.: "Miller [?]"
(1858–1860)
The Walters Art Gallery, Baltimore, Maryland 37.1940.60

PROVENANCE
William T. Walters, Baltimore

EXHIBITIONS
"A. J. Miller Watercolors," Smithsonian, October 1956–November 1957

REFERENCES
Ross, pl. 60

457. *Indian Boys (Children of the Snake Tribe)*
Watercolor on paper embossed "LONDON SUPERFINE"
6 3/4 x 8 1/2 in. (17.2 x 21.6 cm.)
Inscribed, l.r.: "Children of the Snake Tribe"
The Boatmen's National Bank of St. Louis, Missouri (May 26, 1947)

PROVENANCE
the artist; by descent to Louisa Whyte Norton; Old Print Shop, New York (1947)

EXHIBITIONS
BNB, May 4–29, 1964

REFERENCES
Cowdrey and Comstock, "Alfred Jacob Miller and the Farthest West," p. 1; BNB, *Catalog*, no. 44 (as *Children of the Snake Tribe*)

Catalogue number 458.

458. *Snake Indian*
Pencil and watercolor on paper
5 1/2 x 4 1/2 in. (13.9 x 11.4 cm.)
(c. 1837)
Inscribed, u.l.: "38"; l.c.: "Snake Indian"; on mount, l.c.: "Snake-Indians."

Whitney Gallery of Western Art, Buffalo Bill Historical
Center, Cody, Wyoming 8.80; gift of the Joseph M.
Roebling Estate

PROVENANCE

the artist; Sir William Drummond Stewart (c. 1839);
Frank Nichols (sale: Chapman's, Edinburgh, June 16–17,
1871); Bonamy Mansell Power; willed to Edward Power
(1900); by descent to Major G. H. Power, Great
Yarmouth, England (sale: PB, May 6, 1966); Joseph M.
Roebling

EXHIBITIONS

Denver Art Museum, April 15–24, 1966; PB, April
29–May 6, 1966

REFERENCES

Murthly sale notices; PB sale 2436 (May 6, 1966), lot 43
(illus.); Knox, "83 Drawings from 1837 Trek," p. 28

459. *Giving Drink to a Thirsty Trapper*

Watercolor on paper

7 5/16 x 8 1/16 in. (18.5 x 20.5 cm.)

Signed, l.r : "AJM. [monogram]"

Inscribed, l.l.: "Giving drink to a thirsty trapper"

Western Americana Collection, The Beinecke Rare Book
and Manuscript Library, Yale University, New Haven,
Connecticut (Coe No. V, 24–25)

EXHIBITIONS

"Gallery of Dudes," ACM, January 26–March 15, 1967;
Yale University Art Gallery, New Haven, September 20,
1978–January 6, 1979

REFERENCES

Withington, no. 342; Sandweiss, p. 62, pl. 25

459A. *Receiving a Draught of Water from an Indian Girl*

Pencil and pen and ink with gray wash on paper

8 1/2 x 6 1/2 in. (21.5 x 16.6 cm.)

(c. 1837)

Inscribed, u.l.: "14"; u.r.: "Receiving a draught of water
from Indian Girl—"

Amon Carter Museum, Fort Worth, Texas 23.66

PROVENANCE

the artist; Sir William Drummond Stewart (c. 1839);
Frank Nichols (sale: Chapman's, Edinburgh, June 16-17,
1871); Bonamy Mansell Power; willed to Edward Power
(1900); by descent to Major G. H. Power, Great
Yarmouth, England (sale: PB, May 6, 1966)

EXHIBITIONS

Denver Art Museum, April 15–24, 1966; PB, April
29–May 6, 1966; Lakeview, April 19–June 2, 1968

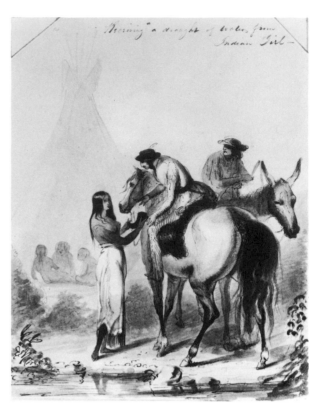

Catalogue number 459A.

REFERENCES

Murthly sale notices; PB sale 2436 (May 6, 1966), lot 14;
Knox, "83 Drawings from 1837 Trek," p. 28; Sprague,
Gallery of Dudes, illus. p. 24; Lakeview, *Westward the
Artist,* no. 86; ACM, *Catalogue of the Collection,* no. 117,
illus. p. 57

459B. *The Thirsty Trapper*

Oil on canvas

24 x 20 in. (61.0 x 50.8 cm.)

Signed and dated, l.r.: "A Miller/1850"

David Warner Foundation, Tuscaloosa, Alabama (1980)

PROVENANCE

American Art-Union, New York (1851–1852); Smith Van
Buren (1852); (sale: SPB, October 17, 1980)

EXHIBITIONS

American Art-Union Gallery, New York, December
15–17, 1852; SPB, October 11–16, 1980

REFERENCES

account book, January 2, 1851, as *Drink to Trapper,* $70,
for Art-Union; "Catalogue of Works of Art," *Bulletin of
the American Art-Union* (December 1851): no. 85;
American Art-Union, *Catalogue of Pictures and Other
Works of Art . . . to be Sold at Auction by David Austen,
Jr.* (December 15–17, 1852), no. 167 (as *Indian Girl
Giving Drink to a Trapper,* 20 x 24 in.), cited in Cowdry,

American Academy of Fine Arts and American Art-Union,
I, p. 301 (as *Indian Girl, Trapper,* sold to Smith Van
Buren), and II, p. 254; SPB sale 4435M (October 17,
1980), lot 19 (illus.)

459C. *Giving Drink to a Trapper*

Unlocated

> REFERENCES
> account book, January 15, 1854, $60, for W. C. Wilson

459D. *Giving Drink to a Trapper*

Unlocated

> REFERENCES
> account book, June 1, 1854, $65, for Dr. Keener

459E. *The Thirsty Trapper*

Watercolor, heightened with white, on paper
11 9/16 x 10 in. (29.4 x 25.4 cm.)
Signed, l.r.: "AJM [monogram] iller"
(1858–1860)
Inscribed, l.r.: "102"
The Walters Art Gallery, Baltimore, Maryland 37.1940.26

> PROVENANCE
> William T. Walters, Baltimore

> REFERENCES
> Ross, pl. 26

459F. *The Thirsty Trapper*

Oil on board
8 3/4 x 7 3/4 in. (22.2 x 19.7 cm.)
Signed, l.l.: "AJM [monogram]"
The Thomas Gilcrease Institute of American History and
Art, Tulsa, Oklahoma 0136.743

> REFERENCES
> Rough Draughts, no. 102; McDermott, "A. J. Miller,"
> p. 17 (illus. as *The Trapper's Bride*)

459G. *The Halt*

Oil on canvas (oval composition)
24 x 20 in. (61.0 x 50.8 cm.)
Sheldon Memorial Art Gallery, University of Nebraska,
Lincoln U–372; University Collection, gift of Norman
Hirschl

> REFERENCES
> "Accessions of American and Canadian Museums," *Art
> Quarterly* 25, no. 1 (Spring 1962): 81 (illus.)

460. *Indian Girl (Sioux) Riding with Full Equipment*

Watercolor and gouache on paper
6 1/2 x 8 1/2 in. (16.5 x 21.6 cm.)
Inscribed, u.r.: "Full Equipment of an/Indian Girl
(Sioux)"
The Thomas Gilcrease Institute of American History and
Art, Tulsa, Oklahoma 0226.1048

> REFERENCES
> Rough Draughts, no. 9

460A. *An Indian Girl (Sioux) on Horseback*

Watercolor on paper
8 5/16 x 12 1/16 in. (21.1 x 30.6 cm.)
(1858–1860)
The Walters Art Gallery, Baltimore, Maryland 37.1940.72

> PROVENANCE
> William T. Walters, Baltimore

> REFERENCES
> Ross, pl. 72

460B. *Sioux Maiden in Full Dress*

Watercolor on paper
10 x 14 in. (25.4 x 35.6 cm.)
S. L. M., Inc., Corning, Arkansas

> PROVENANCE
> [Porter Collection?]; private collection in Omaha; Martin
> Kodner, St. Louis

> REFERENCES
> Sam L. Manatt III, *SLM, Inc.,* unpaginated (illus.)

461. *Night Scene, Indians in a Storm*

Watercolor and gouache on paper
6 1/2 x 9 1/2 in. (16.5 x 24.1 cm.)
The Thomas Gilcrease Institute of American History and
Art, Tulsa, Oklahoma 0226.1101

> PROVENANCE
> L. Vernon Miller; M. Knoedler and Company, New
> York, #CA 3223-3 (1949)

> REFERENCES
> Rough Draughts, no. 86

461A. *Indians in a Storm: Night Scene*

Watercolor on paper

8 5/8 x 12 3/16 in. (21.9 x 31.0 cm.)

Signed, l.r.: "AJM [monogram] iller"

(1858–1860)

The Walters Art Gallery, Baltimore, Maryland 37.1940.83

PROVENANCE

William T. Walters, Batimore

REFERENCES

Randall, "Transformations and Imaginary Views by Alfred Jacob Miller," fig. 3; Ross, pl. 83

462. *Being Pursued*

Oil on paper

7 x 9 3/4 in. (17.8 x 24.8 cm.)

The Thomas Gilcrease Institute of American History and Art, Tulsa, Oklahoma 0236.1018

PROVENANCE

[Alfred J. Miller, Jr., Baltimore; M. Knoedler and Company, New York, #CA 3093, as *Indians on Horseback during Storm* (1948)?]

REFERENCES

Rough Draughts, no. 82

463. *Shoshone Girl Reclining on Buffalo Robe*

Watercolor on paper

7 3/4 x 10 1/4 in. (19.7 x 26.1 cm.)

The Thomas Gilcrease Institute of American History and Art, Tulsa, Oklahoma 0236.1047

PROVENANCE

L. Vernon Miller; M. Knoedler and Company, New York, #CA 3223-4, as *Shoshone Girl*, 11 x 8 1/8 in. (1949)

REFERENCES

Rough Draughts, no. 12

463A. *Snake Woman*

Pencil and watercolor on paper

5 1/8 x 6 in. (13.0 x 15.2 cm.)

(c. 1837)

Inscribed: "3"

Unlocated

PROVENANCE

the artist; Sir William Drummond Stewart (c. 1839); Frank Nichols (sale: Chapman's, Edinburgh, June 16–17, 1871); Bonamy Mansell Power; willed to Edward Power (1900); by descent to Major G. H. Power, Great Yarmouth, England (sale: PB, May 6, 1966)

EXHIBITIONS

Denver Art Museum, April 15–24, 1966; PB, April 29–May 6, 1966

REFERENCES

Murthly sale notices; PB sale 2436 (May 6, 1966), lot 47; Knox, "83 Drawings from 1837 Trek," p. 28

463B. *Indian Belle Reclining*

(1840)

Unlocated

PROVENANCE

Sir William Drummond Stewart (1840); Frank Nichols (sale: Chapman's, Edinburgh, June 16–17, 1871)

REFERENCES

AJM to Decatur H. Miller, December 25, 1840, cited in Warner, p. 169; Murthly sale notices

463C. *Indian Girl Reposing*

Watercolor on paper

7 1/2 x 11 7/8 in. (19.1 x 30.1 cm.)

(1858–1860)

Inscribed, l.l.: "12"

The Walters Art Gallery, Baltimore, Maryland 37.1940.71

PROVENANCE

William T. Walters, Baltimore

EXHIBITIONS

"A. J. Miller Watercolors," Smithsonian, October 1956–November 1957

REFERENCES

Ross, pl. 71

463D. *Snake Female Reposing*

Watercolor on paper

6 3/16 x 10 5/16 in. (15.8 x 26.2 cm.)

Signed, l.l.: "AJM [monogram]"

Inscribed, l.r.: "Snake Female Reposing"

The Boatmen's National Bank of St. Louis, Missouri (May 26, 1947)

PROVENANCE

the artist; by descent to Louisa Whyte Norton; Old Print Shop, New York (1947)

EXHIBITIONS

BNB, May 4–29, 1964

REFERENCES

Cowdrey and Comstock, "Alfred Jacob Miller and the Farthest West," p. 1; BNB, *Catalog*, no. 32

464. *[Two] Shoshone Indian Girls*

Watercolor and oil on paper

8 x 11 1/4 in. (20.3 x 28.5 cm.)

Signed, l.r.: "AJM. [monogram]"

Western Americana Collection, The Beinecke Rare Book and Manuscript Library, Yale University, New Haven, Connecticut (Coe V, 24–25)

EXHIBITIONS

"Gallery of Dudes," ACM, January 26–March 15, 1967; Yale University Art Gallery, New Haven, September 20, 1978–January 6, 1979

REFERENCES

Withington, no. 342; Sandweiss, p. 63 (as *Two Shoshone Girls*)

465. *Shoshone Girl with Dog*

Watercolor on paper

4 5/16 x 5 1/2 in. (11.0 x 14.0 cm.)

Signed, l.r.: "AJM [monogram]"

Inscribed on mount: "Shoshone Girl with Dog."

Western Americana Collection, The Beinecke Rare Book and Manuscript Library, Yale University, New Haven, Connecticut (Coe V, 26)

PROVENANCE

the artist; by descent to Louisa Whyte Norton; Old Print Shop, New York (1947); Edward Eberstadt and Sons, New York

EXHIBITIONS

"Gallery of Dudes," ACM, January 26–March 15, 1967

REFERENCES

Old Print Shop ledger book (June 18, 1947), no. 10 (as 5 3/4 x 4 1/2 in.); Withington, no. 341

466. *Dakota Mother Fondling a Papoose (Indian Woman with Papoose)*

Watercolor and gouache on paper

5 1/4 x 4 1/2 in. (13.4 x 11.5 cm.)

Signed, l.r.: "AJM [monogram]"

Inscribed on mat: "Indian Woman with Papoose"

The Thomas Gilcrease Institute of American History and Art, Tulsa, Oklahoma 0226.1082

PROVENANCE

the artist; by descent to Mrs. Laurence R. Carton; M. Knoedler and Company, #CA 4312/WCA 2056 (1957–1959)

REFERENCES

Rough Draughts, no. 154; Krakel, *Adventures in Western Art*, p. 336, n. 28 (as *Indian Woman with Papoose*)

466A. *Group of Indian Mother and Children*

Watercolor and gouache on paper

9 1/4 x 8 1/4 in. (23.5 x 21.0 cm.)

(1858–1860)

The Walters Art Gallery, Baltimore, Maryland 37.1940.21

PROVENANCE

William T. Walters, Baltimore

EXHIBITIONS

"A. J. Miller Watercolors," Smithsonian, October 1956–November 1957

REFERENCES

Ross, pl. 21

466B. *Dakota Squaw and Papoose*

Watercolor on paper

3 15/16 x 4 3/4 in. (10.0 x 12.0 cm.)

Inscribed, u.l.: "Dacotah"; on mount: "Dakota Squaw & Papoose"

Western Americana Collection, The Beinecke Rare Book and Manuscript Library, Yale University, New Haven, Connecticut (Coe V, 26)

PROVENANCE

the artist; by descent to Louisa Whyte Norton; Old Print Shop, New York (1947); Edward Eberstadt and Sons, New York

EXHIBITIONS

"Gallery of Dudes," ACM, January 26–March 15, 1967; Yale University Art Gallery, New Haven, September 20, 1978–January 6, 1979

REFERENCES

Old Print Shop ledger book (June 18, 1947), no. 42 (as *Dacotah, Mother and Papoose*, 5 x 4 1/2 in.); Withington, no. 341; Sandweiss, p. 62

467. *Sioux Women—Cut Rocks in the Distance*

Pencil, watercolor, and gouache on paper

5 5/8 x 5 in. (14.3 x 12.7 cm.)

Inscribed, u.r.: "Sioux [illeg.]/near Cut Rocks"

Joslyn Art Museum, Omaha, Nebraska; InterNorth Art Foundation Collection 710

PROVENANCE

Carrie C. Miller, Annapolis; Porter Collection

EXHIBITIONS

"Western Frontier," SLAM, April 1–May 13, 1941; BBHC, May 15–September 15, 1959

REFERENCES

BBHC, *Land of Buffalo Bill*, no. 39

467A. *Indian Women on Horseback in the Vicinity of the Cut Rocks*

Watercolor, heightened with white, on paper

9 3/8 x 8 3/8 in. (23.3 x 21.3 cm.)

(1858–1860)

Inscribed: "No. 4"

The Walters Art Gallery, Baltimore, Maryland 37.1940.9

PROVENANCE

William T. Walters, Baltimore

REFERENCES

Ross, pl. 9

467B. *Indian Woman "en grande tenue"*

Watercolor on paper

5 5/16 x 4 5/16 in. (13.5 x 11.0 cm.)

Inscribed on mount: "Indian Woman—'en grande tenue.'"

Western Americana Collection, The Beinecke Rare Book and Manuscript Library, Yale University, New Haven, Connecticut (Coe No. V, 26)

PROVENANCE

the artist; by descent to Louisa Whyte Norton; Old Print Shop, New York (1947); Edward Eberstadt and Sons, New York

EXHIBITIONS

"Gallery of Dudes," ACM, January 26–March 15, 1967

REFERENCES

Old Print Shop ledger book (June 18, 1947), no. 41 (as *Indian Women*, 4 1/2 x 5 1/2 in.); Withington, no. 341

468. *Indian Girl (Sioux) (Indian Girl Seated on a Log with Dog)*

Watercolor on paper

7 x 5 1/2 in. (17.8 x 14.0 cm.)

Signed, l.r.: "Miller"

The Thomas Gilcrease Institute of American History and Art, Tulsa, Oklahoma 0236.1058

PROVENANCE

Victor D. Spark, New York; M. Knoedler and Company, New York, #WCA 883 (c. 1948)

REFERENCES

Rough Draughts, no. 47; "Alfred Jacob Miller," *American Scene* 14, no. 4 (1973): [19] (illus.)

468A. *Indian Girl (Sioux)*

Watercolor and gouache on paper

9 1/4 x 7 1/2 in. (23.5 x 19.1 cm.)

Signed, l.l.: "AJM [monogram] iller"

(1858–1860)

Inscribed, l.r.: "47"

The Walters Art Gallery, Baltimore, Maryland 37.1940.22

PROVENANCE

William T. Walters, Baltimore

REFERENCES

Ross, pl. 22

468B. *Sioux Indian*

Watercolor on paper

5 1/8 x 6 1/8 in. (13.0 x 15.5 cm.)

Signed, l.l.: "AJM [monogram]"

Inscribed, l.r.: "Sioux"; on mount: "Sioux Indian"

Western Americana Collection, The Beinecke Rare Book and Manuscript Library, Yale University, New Haven, Connecticut (Coe No. V, 26)

PROVENANCE

the artist; by descent to Louisa Whyte Norton; Old Print Shop, New York (1947); Edward Eberstadt and Sons, New York

EXHIBITIONS

"Gallery of Dudes," ACM, January 26–March 15, 1967; Yale University Art Gallery, New Haven, September 20, 1978–January 6, 1979

REFERENCES

Old Print Shop ledger book (June 18, 1947), no. 9 (as *Sioux Indian Girl*, 6 1/2 x 5 1/2 in.); Withington, no. 341; Sandweiss, p. 62

469. *Indian Women, Snake Tribe, Oregon*

Watercolor on paper

7 7/8 x 10 in. (20.0 x 25.4 cm.)

Inscribed, u.r.: "Indian Women, Snake Tribe, Oregon"

The Boatmen's National Bank of St. Louis, Missouri (May 26, 1947)

PROVENANCE

the artist; by descent to Louisa Whyte Norton; Old Print Shop, New York (1947)

EXHIBITIONS

BNB, May 4–29, 1964

REFERENCES

Cowdrey and Comstock, "Alfred Jacob Miller and the Farthest West," p. 1; BNB, *Catalog*, no. 42 (as *Indian Woman, Snake Tribe*)

469A. *Indian Encampment on the Eau Sucre River*
Watercolor on paper
8 11/16 x 12 1/16 in. (22.7 x 30.7 cm.)
Signed, l.l.: "AJM [monogram] iller"
(1858–1860)
The Walters Art Gallery, Baltimore, Maryland
37.1940.136

PROVENANCE
William T. Walters, Baltimore

EXHIBITIONS
"A. J. Miller Watercolors," Smithsonian, October
1956–November 1957

REFERENCES
Ross, pl. 136

470. *Snake Girl Swinging*
Watercolor on paper
8 1/4 x 10 13/16 in. (21.0 x 27.5 cm.)
Signed, l.l.: "AJM. [monogram]"
Inscribed, u.r.: "Snake Indian Girl/[formerly: Swinging]"
Western Americana Collection, The Beinecke Rare Book
and Manuscript Library, Yale University, New Haven,
Connecticut (Coe V, 24–25)

EXHIBITIONS
"Gallery of Dudes," ACM, January 26–March 15, 1967;
Yale University Art Gallery, New Haven, September 20,
1978–January 6, 1979

REFERENCES
Withington, no. 342; Sandweiss, p. 62, pl. 24

470A. *Indian Girls Swinging*
Watercolor, heightened with white, on paper
10 15/16 x 9 1/2 in. (27.8 x 23.5 cm.)
Signed, l.l.: "AJM [monogram] iller"
(1858–1860)
Inscribed: "124"
The Walters Art Gallery, Baltimore, Maryland 37.1940.47

PROVENANCE
William T. Walters, Baltimore

REFERENCES
LaFarge, "Myths that Hide the American Indian," p. 16
(illus.); *Golden Book of America*, illus. p. 18; American
Heritage, ed., *American Heritage Book of Indians*, illus. p.
350; O'Meara, *Daughters of the Country*, illus. fol. p. 178;
Ross, pl. 47; Getlein, *Lure of the Great West*, illus. p. 80;
Capps, *Great Chiefs*, illus. p. 132

470B. *Indian Girls*
Watercolor, gouache, and pen and ink over pencil on
paper
Sight: 11 9/16 x 9 1/8 in. (29.4 x 23.1 cm.)
Signed, l.l.: "AJM [monogram] iller Pt"
(1867)
Inscribed on mat, l.l.: "Nº. 22./Indian Girls"
Public Archives of Canada, Ottawa, Ontario; gift of Mrs.
J. B. Jardine (1946)

PROVENANCE
Alexander Brown, Liverpool, England (1867); by descent
to Mrs. J. B. Jardine, Chesterknowes, Scotland

EXHIBITIONS
PAC museum, winter 1946–1947; Peale Museum,
Baltimore, January 8–February 12, 1950; "Alfred Jacob
Miller," ACM, February 13–March 26, 1972

REFERENCES
account book, March 26, May 8, August 10, 1867;
Hunter, p. [15]; Brunet, no. 22; Bell, p. 100, illus. p. 101

470C. *Indian Girl Swinging*
Unlocated

REFERENCES
account book, May 2, 1865, $65, for Col. Geo. D. Wise

470D. *Indian Girl Swinging*
Oil on canvas
17 x 14 in. (43.2 x 35.6 cm.)
Signed on tree trunk, left: "AJM [monogram] iller"
Eugene B. Adkins, Tulsa, Oklahoma

PROVENANCE
Berry-Hill Galleries, New York; Hammer Galleries, New
York (1961–1967); Berry-Hill Galleries, New York

EXHIBITIONS
Fine Arts Museum of New Mexico, Santa Fe, October
8–November 22, 1961; Phoenix Art Museum, November
1971–January 1972

REFERENCES
Santa Fe, Fine Arts Museum of New Mexico, *Artist in
the American West, 1800–1900*, no. 47 (illus.); Hammer
Galleries, *Works of Charles M. Russell and Other Western
Artists*, no. 35 (illus.); Phoenix Art Museum, *Western Art
from the Eugene B. Adkins Collection*, no. 48 (illus.)

470E. *Indian Maiden* [swinging]
35 3/4 x 29 in. (90.8 x 73.7 cm.)
Unlocated

PROVENANCE

Charles H. Linville, Baltimore (sale: Kende Galleries, New York, January 24, 1942)

EXHIBITIONS

Kende Galleries, New York, January 19–24, 1942

REFERENCES

Kende Galleries, *Collection of the Late Charles H. Linville, Baltimore*, no. 20

471. *Indian Girl with Papoose Fording a Stream*

Pencil, watercolor, and gouache on paper

9 1/2 x 7 7/8 in. (24.1 x 19.7 cm.)

Signed, l.r.: "AJM [monogram]"

Inscribed, u.r.: "Indian Girl with/papoose—fording/a stream"; l.c.: "27"

Joslyn Art Museum, Omaha, Nebraska; InterNorth Art Foundation Collection 679

PROVENANCE

Carrie C. Miller, Annapolis; Porter Collection; M. Knoedler and Company, New York

EXHIBITIONS

Nelson, January 1939 (as *Indian Girl with Papoose— Fording a Stream*); "Western Frontier," SLAM, April 1–May 13, 1941; BBHC, May 15–September 15, 1959

REFERENCES

BBHC, *Land of Buffalo Bill*, no. 8 (as *Indian Girl with Papoose Fording a Stream*); Goetzmann and Porter, p. 69

471A. *Indian Girl with Papoose Crossing a Stream*

Wash, heightened with white, on paper

11 3/4 x 9 1/2 in. (29.8 x 24.1 cm.)

Signed, l.r.: "A Miller."

(1858–1860)

Inscribed, l.r.: "27"

The Walters Art Gallery, Baltimore, Maryland 37.1940.14

PROVENANCE

William T. Walters, Baltimore

REFERENCES

Ross, pl. 14

471B. *Indian Woman with Papoose*

Unlocated

REFERENCES

account book, September 24, 1864, $45, for John Cassard

471C. *A Young Indian Mother Fording a Stream*

Watercolor, gouache, and pen and ink over pencil on paper

Sight: 11 13/16 x 9 1/2 in. (30.0 x 24.1 cm.)

Signed, l.r.: "AJM [monogram] iller. Pt."

(1867)

Inscribed on mat, l.r.: "N⁰. 19./A Young Indian Mother,/Fording a Stream."

Public Archives of Canada, Ottawa, Ontario; gift of Mrs. J. B. Jardine (1946)

PROVENANCE

Alexander Brown, Liverpool, England (1867); by descent to Mrs. J. B. Jardine, Chesterknowes, Scotland

EXHIBITIONS

PAC museum, winter 1946–1947; Peale Museum, Baltimore, January 8–February 12, 1950; "Alfred Jacob Miller," ACM, February 13–March 26, 1972

REFERENCES

account book, March 26, May 8, August 10, 1867; Hunter, p. [15]; Brunet, no. 19; Bell, p. 88, illus. p. 89

471D. *Indian Women Crossing Stream*

Oil on canvas

12 x 9 in. (30.5 x 22.9 cm.)

Signed, l.r.: "AJM [monogram]"

The Thomas Gilcrease Institute of American History and Art, Tulsa, Oklahoma 0126.741

PROVENANCE

Victor D. Spark, New York; M. Knoedler and Company, New York, #A 4032 (1948–1949)

REFERENCES

Rough Draughts, no. 27; McDermott, "A. J. Miller," p. 17 (illus.); Krakel, *Adventures in Western Art*, p. 32 (as *Indian Squaws Crossing a Stream*)

472. *Embroidering the War Costume*

Watercolor and gouache on paper

6 1/4 x 5 1/8 in. (15.9 x 13.0 cm.)

Signed, l.l.: "AJM [monogram]"

Inscribed, l.r.: "Embroidering the/War Costume"; u.l.: "77"

Joslyn Art Museum, Omaha, Nebraska; InterNorth Art Foundation Collection 705

PROVENANCE

Carrie C. Miller, Annapolis; Porter Collection; M. Knoedler and Company, New York

EXHIBITIONS
Nelson, January 1939; "Western Frontier," SLAM, April 1–May 13, 1941; BBHC, May 15–September 15, 1959

REFERENCES
DeVoto, pl. XXXVI; BBHC, *Land of Buffalo Bill*, no. 34; Goetzmann and Porter, p. 66, illus. p. 73

472A. *Indian Woman Making the War Dress*

Watercolor, heightened with white, on paper

10 1/16 x 9 in. (25.6 x 22.9 cm.)

Signed, l.r.: "AJM [monogram] iller"

(1858–1860)

The Walters Art Gallery, Baltimore, Maryland 37.1940.38

PROVENANCE
William T. Walters, Baltimore

REFERENCES
Ross, pl. 38

472B. *Indian Woman Making the War Dress*

Watercolor, gouache, and pen and ink over pencil on paper

Sight: 9 11/16 x 8 7/16 in. (24.6 x 20.8 cm.)

Signed, l.r.: "AJM [monogram]"

(1867)

Inscribed on mat, l.l.: "Nº. 9./Indian Woman./Making the War Dress."

Public Archives of Canada, Ottawa, Ontario; gift of Mrs. J. B. Jardine (1946)

PROVENANCE
Alexander Brown, Liverpool, England (1867); by descent to Mrs. J. B. Jardine, Chesterknowes, Scotland

EXHIBITIONS
PAC museum, winter 1946–1947; Peale Museum, Baltimore, January 8–February 12, 1950; "Alfred Jacob Miller," ACM, February 13–March 26, 1972

REFERENCES
account book, March 26, May 8, August 10, 1867; Hunter, p. [15]; Brunet, no. 9; Bell, p. 46, illus. p. 47

472C. *Nez Perces*

Watercolor on paper

4 15/16 x 5 7/8 in. (12.5 x 15.0 cm.)

Signed and inscribed, l.r.: "AJM [monogram]/Made from Nez Perces"; on mount: "Nez Perces"

Western Americana Collection, The Beinecke Rare Book and Manuscript Library, Yale University, New Haven, Connecticut (Coe V, 26)

PROVENANCE
the artist; by descent to Louisa Whyte Norton; Old Print Shop (1947); Edward Eberstadt and Sons, New York

REFERENCES
Old Print Shop ledger book (June 18, 1947), no. 11 (as *Nez Perces*, two seated Indians, 6 1/4 x 5 1/4 in.); Withington, no. 341

472D. *Making Moccasins*

Watercolor on paper

5 1/2 x 6 5/16 in. (14.0 x 16.0 cm.)

Inscribed on mount: "Making Moccasins"

Western Americana Collection, The Beinecke Rare Book and Manuscript Library, Yale University, New Haven, Connecticut (Coe No. V, 26)

PROVENANCE
the artist; by descent to Louisa Whyte Norton; Old Print Shop (1947); Edward Eberstadt and Sons, New York

EXHIBITIONS
"Gallery of Dudes," ACM, January 26–March 15, 1967; Yale University Art Gallery, New Haven, September 20, 1978–January 6, 1979

REFERENCES
Old Print Shop ledger book (June 18, 1947), no. 39 (as 6 1/2 x 6 in.); Withington, no. 341; Sandweiss, p. 62, pl. 26

473. *Indians' Toilet*

Watercolor on paper

9 x 8 1/2 in. (22.9 x 21.6 cm.)

Signed, l.r.: "AJM [monogram]"

The Thomas Gilcrease Institute of American History and Art, Tulsa, Oklahoma 0236.1119

PROVENANCE
the artist; by descent to Mrs. Laurence R. Carton; M. Knoedler and Company, New York, #CA–4306/WCA 2055 (1957–1959)

REFERENCES
Krakel, *Adventures in Western Art*, p. 336, n. 28 (as *Indian Girls Making Toilet*)

473A. *Female Indians Toilet*

Pen and ink with gray and brown washes, heightened with white, on buff paper

8 9/16 x 11 1/2 in. (21.7 x 29.2 cm.)

(c. 1837)

Inscribed: "58"

Unlocated

the artist; Sir William Drummond Stewart (c. 1839);
Frank Nichols (sale: Chapman's, Edinburgh, June 16–17,
1871); Bonamy Mansell Power; willed to Edward Power
(1900); by descent to Major G. H. Power, Great
Yarmouth, England (sale: PB, May 6, 1966)

EXHIBITIONS

Denver Art Museum, April 15–24, 1966; PB, April
29–May 6, 1966

REFERENCES

Murthly sale notices; PB sale 2436 (May 6, 1966), lot 17;
Knox, "83 Drawings from 1837 Trek," p. 28

473B. *Indian Toilet*

Watercolor on paper

10 1/4 x 9 1/4 in. (26.0 x 23.5 cm.)

Signed, l.r.: "AJM [monogram]"

(1858–1860)

The Walters Art Gallery, Baltimore, Maryland
37.1940.166

PROVENANCE

William T. Walters, Baltimore

REFERENCES

Ross, pl. 166

474. *Indian Women Swimming*

Watercolor and gouache on paper

7 1/4 x 11 in. (18.4 x 27.9 cm.)

Inscribed, u.l.: "Scene on the River—'Eau Sucre' "

The Thomas Gilcrease Institute of American History and
Art, Tulsa, Oklahoma 0236.1015

PROVENANCE

Alfred J. Miller, Jr., Baltimore; M. Knoedler and
Company, New York, #CA 3094, as *Indian Women in
Bathing* (1948)

REFERENCES

Rough Draughts, no. 67

474A. *Indian Women: Swimming*

Watercolor on paper

8 1/8 x 11 15/16 in. (20.7 x 30.3 cm.)

Signed, l.r.: "AJM [monogram]"

(1858–1860)

The Walters Art Gallery, Baltimore, Maryland
37.1940.194

PROVENANCE

William T. Walters, Baltimore

REFERENCES

DeVoto, pl. XXX (as *Indian Girls Swimming*);
Goetzmann, *Exploration and Empire*, illus. p. 209; Ross,
pl. 194

475. *Indian Women Waiting for the Caravan*

Watercolor and gouache on paper

7 1/2 x 10 in. (19.1 x 25.4 cm.)

Inscribed, u.l.: "Waiting for the Caravan."

The Thomas Gilcrease Institute of American History and
Art, Tulsa, Oklahoma 0236.1118

PROVENANCE

Alfred J. Miller, Jr., Baltimore; M. Knoedler and
Company, New York, #CA 3096, as *Indians Waiting for
Caravan* (1948)

475A. *Indian Women*

Pen and ink with gray wash, heightened with white, on
buff paper

9 x 11 in. (22.7 x 28.0 cm.)

(c. 1837)

Inscribed, u.l.: "66"

Eugene B. Adkins, Tulsa, Oklahoma (1967)

PROVENANCE

the artist; Sir William Drummond Stewart (c. 1839);
Frank Nichols (sale: Chapman's, Edinburgh, June 16–17,
1871); Bonamy Mansell Power; willed to Edward Power
(1900); by descent to Major G. H. Power, Great
Yarmouth, England (sale: PB, May 6, 1966); Kennedy
Galleries, New York (1966)

EXHIBITIONS

Denver Art Museum, April 15–24, 1966; PB, April
29–May 6, 1966

REFERENCES

Murthly sale notices; PB sale 2436 (May 6, 1966), lot 9;
Knox, "83 Drawings from 1837 Trek," p. 28; *Kennedy
Quarterly* 6, no. 2 (June 1966): no. 61 (illus. as *Shoshoni
Women in Camp*)

475B. *Indian Women*

Watercolor on paper

9 1/16 x 11 1/4 in. (23.0 x 28.6 cm.)

(1858–1860)

The Walters Art Gallery, Baltimore, Maryland
37.1940.188

PROVENANCE

William T. Walters, Baltimore

REFERENCES

Ross, pl. 188

476. *Indian Courtship*
Watercolor on paper
8 x 10 3/4 in. (20.3 x 27.3 cm.)
Signed, l.l.: "AJM [monogram]"
Inscribed, u.l.: "Indian Courtship/[formerly:] Present to the Bride"
Unlocated

PROVENANCE
Kennedy Galleries, Inc., New York (1976)

REFERENCES
Kennedy Quarterly 15, no. 1 (June 1976): no. 35 (illus. as *Bartering for a Bride*)

476A. *Indian Courtship*
Watercolor on paper
9 x 11 7/16 in. (22.9 x 29.1 cm.)
Signed, l.r.
(1858–1860)
The Walters Art Gallery, Baltimore, Maryland
37.1940.168

PROVENANCE
William T. Walters, Baltimore

EXHIBITIONS
"A. J. Miller Watercolors," Smithsonian, October 1956–November 1957

REFERENCES
Ross, pl. 168

477. *Sioux Indian Eloping with a Squaw*
Pen and ink with brown wash on paper
6 9/16 x 6 in. (16.7 x 15.2 cm.)
(c. 1837)
Inscribed: "12"
Unlocated

PROVENANCE
the artist; Sir William Drummond Stewart (c. 1839); Frank Nichols (sale: Chapman's, Edinburgh, June 16–17, 1871); Bonamy Mansell Power; willed to Edward Power (1900); by descent to Major G. H. Power, Great Yarmouth, England (sale: PB, May 6, 1966)

EXHIBITIONS
Denver Art Museum, April 15–24, 1966; PB, April 29–May 6, 1966

REFERENCES
Murthly sale notices; PB sale 2436 (May 6, 1966), lot 8; Knox, "83 Drawings from 1837 Trek," p. 28

478. *Shoshone Indian Carrying Home His Bride*
Watercolor on paper
6 1/2 x 6 1/2 in. (16.5 x 16.5 cm.)
Unlocated

PROVENANCE
the artist; by descent to Louisa Whyte Norton; Old Print Shop, New York (1947); Everett D. Graff, Winnetka, Ill. (1947)

REFERENCES
Old Print Shop ledger book (June 18, 1947), no. 6

479. *Indian Elopement*
Watercolor on paper
8 1/2 x 13 5/8 in. (21.6 x 34.7 cm.)
Signed, l.r.: "AJM [monogram]"
Inscribed, l.c.: "Indian Elopement"
Maryland Historical Society, Baltimore 54.151.1; gift of Mrs. Laurence R. Carton

PROVENANCE
the artist; by descent to Mrs. Laurence R. Carton

479A. *Indian Elopement*
Oil on canvas (oval composition)
30 1/4 x 36 1/4 in. (76.8 x 92.1 cm.)
Signed and dated, l.r.: "Miller 1852"
Whitney Gallery of Western Art, Buffalo Bill Historical Center, Cody, Wyoming 28.64

PROVENANCE
Kennedy Galleries, New York (1959–1962)

REFERENCES
Kennedy Quarterly 1, no. 1 (December 1959): no. 29 (illus.), and 3, no. 2 (October 1962): no. 104 (illus.); BBHC, *West of Buffalo Bill*, illus. p. [157] (as 28 x 36 in.); Peter H. Hassrick, "The Indian and American Art," *Connoisseur* 201, no. 807 (May 1979): 60, fig. E (incorrectly captioned *Blackfeet Burning Crow Range* by Charles M. Russell)

479B. *Indian Elopement*
Watercolor on paper
8 7/16 x 12 5/16 in. (21.4 x 31.3 cm.)
Signed, l.l.: "AJM [monogram] iller"
(1858–1860)
The Walters Art Gallery, Baltimore, Maryland 37.1940.86

PROVENANCE
William T. Walters, Baltimore

EXHIBITIONS

WCMFA, September 14–November 2, 1947

REFERENCES

WCMFA, *American Indian and the West*, no. 63 (as *Abduction*); Ross, pl. 86

480. *Indian Women Watching a Battle*

Watercolor on paper

7 3/8 x 8 in. (18.7 x 20.3 cm.)

The Boatmen's National Bank of St. Louis, Missouri (May 26, 1947)

PROVENANCE

the artist; by descent to Louisa Whyte Norton; Old Print Shop, New York (1947)

REFERENCES

Cowdrey and Comstock, "Alfred Jacob Miller and the Farthest West," p. 1

481. *Snake Indians Migrating*

Pen and ink, wash, and gouache on paper

9 1/8 x 12 1/8 in. (23.2 x 30.8 cm.)

Signed, l.r.: "AJM [monogram] iller"

Joslyn Art Museum, Omaha, Nebraska; InterNorth Art Foundation Collection 693

PROVENANCE

Carrie C. Miller, Annapolis; Porter Collection; M. Knoedler and Company, New York

EXHIBITIONS

Nelson, January 1939; "Western Frontier," SLAM, April 1–May 13, 1941; BBHC, May 15–September 15, 1959

REFERENCES

"America and the Future," p. 115 (illus. as *Pawnee Indians Migrating*); DeVoto, pl. XXXVIII; BBHC, *Land of Buffalo Bill*, no. 22

481A. *Pawnee Indians Migrating*

Watercolor on paper

9 7/16 x 12 3/16 in. (24.0 x 31.0 cm.)

(1858–1860)

The Walters Art Gallery, Baltimore, Maryland 37.1940.66

PROVENANCE

William T. Walters, Baltimore

EXHIBITIONS

[WCMFA, September 14–November 2, 1947?]; "A. J. Miller Watercolors," Smithsonian, October 1956–November 1957; University of Pennsylvania Museum, Philadelphia, May 8–September 8, 1958

REFERENCES

[WCMFA, *American Indian and the West*, no. 71 (as *Mounting Slope*)?]; Philadelphia, University of Pennsylvania Museum, *Noble Savage*, no. 46; Felton, *Edward Rose*, illus. fol. p. 48; Ross, pl. 66; Haines, *Buffalo*, illus. p. 107; Hillman, "Part Three: Bridging a Continent," illus. p. 385; Getlein, *Lure of the Great West*, illus. p. 74

481B. *Migration of the Pawnees*

Watercolor on paper embossed "[illeg.] Surface Drawing Boards"

5 3/4 x 9 3/8 in. (14.6 x 23.8 cm.)

The Boatmen's National Bank of St. Louis, Missouri (May 26, 1947)

PROVENANCE

the artist; by descent to Louisa Whyte Norton; Old Print Shop, New York (1947)

REFERENCES

Cowdrey and Comstock, "Alfred Jacob Miller and the Farthest West," p. 1

481C. *Migration of Pawnees*

Sepia on paper

12 3/16 x 6 7/8 in. (31.0 x 17.5 cm.)

Western Americana Collection, The Beinecke Rare Book and Manuscript Library, Yale University, New Haven, Connecticut (Coe No. V, 24–25)

EXHIBITIONS

"Gallery of Dudes," ACM, January 26–March 15, 1967

REFERENCES

Withington, no. 342; American Heritage, ed., *American Heritage Book of Indians*, illus, p. 351; Garraty, *American Nation*, illus. pp. 454–455

482. *Mrs. Allen*

Unlocated

REFERENCES

account book, August 16, 1847, $80, for William Heald

483. *Mrs. Appold*

Unlocated

REFERENCES

account book, January 5, 1848, $75, for Geo. Appold

484. *Daughter of Arnold*

Unlocated

REFERENCES

account book, July 10, 1851, $75, for Arnold

485. *Bishop Atkinson*

Unlocated

REFERENCES

Maryland Historical Society Annual Exhibition (1853), no. 40 (collection of the artist)

486. *Doctor Bailey*

Unlocated

REFERENCES

account book, April 23, 1851, $60

487. *Two Baltimore Children* (Jessie Slingluff Bailey and Joseph Cushing Bailey)

Oil on canvas

44 x 34 in. (111.8 x 86.4 cm.)

Signed, l.r.; "A. J. Miller"

(1858)

The Holyoke Museum at the Holyoke Public Library, Holyoke, Massachusetts; gift of the Herbert Frink estate (1973)

PROVENANCE

Lewis E. Bailey, Baltimore (1858); by descent to Jessie Slingluff Bailey, Joseph Cushing Bailey, and Herbert Bailey (1899); Robert B. Campbell Gallery, Boston (1948); Herbert Frink estate, Holyoke, Mass.

REFERENCES

account book, November 8, 1858 (as *Jessie and Curtis* [sic] *Bailey*, $150, for Lewis E. Bailey); J. Hall Pleasants file

488. *Freddy Baker*

Cabinet-size portrait: 10 x 10 in. (25.4 x 25.4 cm.)

Unlocated

REFERENCES

account book, November 20, 1868, $50, for Wm. S. G. Baker

489. *Wm. S. G. Baker*

25 x 30 in. (63.5 x 76.2 cm.)

Unlocated

REFERENCES

account book, April 16, 1865, $100

490. *Mrs. W. S. G. Baker*

25 x 30 in. (63.5 x 76.2 cm.)

Unlocated

REFERENCES

account book, January 1, 1866, $100, for W. S. G. Baker

491. *Cora Berkley*

Oil on canvas

35 3/4 x 28 3/4 in. (90.8 x 73.0 cm.)

Signed and dated, l.r.: "A J Miller 185 [1854]"

Maryland Historical Society, Baltimore 78.10.4

PROVENANCE

Edris Berkley (1854)

REFERENCES

account book, April 10, 1854, full length, $75, for E. Berkley

492. *Edris Berkley*

Oil on canvas

36 x 29 in. (91.4 x 73.7 cm.)

(1871)

Maryland Historical Society, Baltimore 77.35.1

REFERENCES

account book, May 20, 1871, $250

493. *Mrs. Edris Berkley (Virginia Enders)*

Oil on canvas

35 1/2 x 28 5/8 in. (90.2 x 72.7 cm.)

Signed: "AJM [monogram] iller"

(1854)

Maryland Historical Society, Baltimore 46.73.2

PROVENANCE

Edris Berkley (1854)

REFERENCES

account book, May 6, 1854, 3/4 length, $75, for
E. Berkley

494. *Henry J. Berkley*

Oil on canvas

36 x 29 in. (91.4 x 73.6 cm.)

Signed: "A. J. Miller"

(1866)

Maryland Historical Society, Baltimore 46.73.3

PROVENANCE

Edris Berkley (1866)

REFERENCES

account book, October 23, 1866, full length, $125, for
Edris Berkley; J. Hall Pleasants file

495. *Laura V. Berkley*

Oil on canvas

36 x 29 in. (91.4 x 73.6 cm.)

Signed: "A. J. Miller"

(1854)

Maryland Historical Society, Baltimore 78.10.3

PROVENANCE

Edris Berkley (1854)

REFERENCES

account book, April 6, 1854, full length, $75, for
E. Berkley

496. *Maidie Berkley*

Oil on canvas

35 7/8 x 28 3/4 in. (91.1 x 73.0 cm.)

(1871)

Maryland Historical Society, Baltimore 78.10.5

PROVENANCE

Edris Berkley (1871)

REFERENCES

account book, May 20, 1871, daughter of Edris Berkely,
$125

497. *Ruth Berkley*

Oil on canvas

36 x 29 in. (91.4 x 73.6 cm.)

Signed: "AJM [monogram]"

(1864)

Maryland Historical Society 77.71

PROVENANCE

Edris Berkley (1864)

REFERENCES

account book, May 31, 1864, $100, for E. Berkley

498–499. *Judge Jer^b Black and wife* [2 portraits]

Cabinet-size portraits: 14 x 17 in. (35.6 x 43.2 cm.)

Unlocated

REFERENCES

account book, October 6, 1868, $171.50 with frames

500. *Judge Jere^b Black* [copy of portrait of father]

30 x 23 1/2 in. (76.2 x 59.7 cm.)

Unlocated

REFERENCES

account book, October 15, 1866, $100, for Judge Jere.
Black, York, Pa.

501. *Mrs. Jere^b's Black's Mother*

Cabinet-size portrait: 13 x 16 in. (33.0 x 40.7 cm.)

Unlocated

REFERENCES

account book, February 19, 1868, $72 with frame, for
Judge Black, York, Pa.

502. *Child of R. Black*

Unlocated

REFERENCES

account book, November 7, 1849, $100, for R. Black,
New Orleans

503. *Jerome Bonaparte*

Unlocated

PROVENANCE

Edward Straus, Reisterstown, Md. (1969)

504. *Bosley*

Unlocated

REFERENCES

account book, September 18, 1855, $70, for G. M.
Bosley, near Govanstown

505. *Bradford*

Unlocated

REFERENCES

account book, January 24, 1846, $45, for A. W. Bradford

506. *Marchioness of Breadalbane*

Oil on canvas

Kit-cat-size

(1839–1840)

Unlocated

REFERENCES

Journal, p. 49

507. *Eliza, Marchioness of Breadalbane*

Oil on canvas

(c. 1840)

Unlocated

PROVENANCE

Sir William Drummond Stewart (c. 1840); Frank Nichols (sale: Chapman's, Edinburgh, June 16, 1871)

REFERENCES

AJM to D. H. Miller, December 25, 1840, cited in Warner, p. 168; "Sale of Pictures from Murthly Castle," *Scotsman*, June 17, 1871, p. 2, cols. 3–4

508. *Charles Breckinridge* [from photograph]

25 x 30 in. (63.5 x 76.2 cm.) (oval)

Unlocated

REFERENCES

account book, May 25, 1868, $132 with frame, for brother, Brevet Maj. Jos. J. Breckinridge, Lexington, Ky.

509. *Charles Breckinridge, with Dog*

Cabinet-size portrait: 14 x 17 in. (35.5 x 43.2 cm.)

Unlocated

REFERENCES

account book, February 1, 1870, $75, for Rev. Wm. Handy, Somerset County, Princess Anne, paid for by Joseph C. Breckinridge

510. *Maj. Josh C. Breckinridge*

25 x 30 in. (63.5 x 76.2 cm.)

Unlocated

REFERENCES

account book, November 19, 1868, $100 + $26.50 for frame, for Dr. Robert Breckinridge; Robert Breckinridge

to AJM, April 28, 1869, sending $126.50 for portrait of "my Joseph" and its frame

511. *Mrs. Josh. H. Breckinridge*

Cabinet-size portrait: 10 x 12 in. (25.4 x 30.5 cm.)

Unlocated

REFERENCES

account book, November 19, 1868, $50 + $8 for frame, for Josh Breckenridge

512. *R. C. Breckinridge* [copy]

Unlocated

REFERENCES

account book, April 3, 1861, $40.75 with box, for Wm. C. P. Breckinridge; William C. P. Breckinridge to AJM, July 2, 1861, enclosing $40.75

513. *Robert Breckinridge*

20 x 24 in. (50.8 x 60.9 cm.)

Unlocated

REFERENCES

account book, April 3, 1863 [begun as oval cabinet-size portrait]; account book, August 4, 1868, $75 + $2 for box, for Col. W. C. P. Breckinridge

514. *R. J. Breckenridge*

(c. 1845)

Unlocated

EXHIBITIONS

Cariss and Schultz's, Baltimore, 1845

REFERENCES

Baltimore, Maryland Historical Society, Dielman and Hayward files, unidentified newspaper clipping stating that Miller allowed the portrait to be engraved

515. *Rev. Robert Jefferson Breckinridge*
(1800–1871)

Oil on canvas

30 x 25 in. (76.2 x 63.5 cm.)

(1857)

The Museum of the Presbyterian Historical Society, Philadelphia, Pennsylvania

PROVENANCE

R. C. Breckinridge, New York (1857)

REFERENCES

account book, May 18, 1857, $50, for R. C. Breckinridge, New York

515A–D, 516, 516A–D. *Dr. and Mrs.*
Breckinridge

Unlocated

REFERENCES

R. Breckinridge to AJM, October 26, 1856, requesting
five copies of Jewett's portrait of his first wife, original
portrait of self, and four copies; account book, May 18,
1857, $425, for R. C. Breckinridge (one original of Rev.
R. J. Breckinridge, $50; nine copies of Mrs. and Dr.
Breckinridge, $360; one _____ of Mrs. Breckinridge, $15)

517. *Rev. Robert J. Breckinridge*

517A. Oil on canvas

Unlocated

PROVENANCE

Mr. John T. Vance, Washington, D.C.

REFERENCES

probably one of two copies in account book, August 20,
1857 (as Breckinridge, Rev. R. J., 4 copies—2 of himself
and 2 of Mrs. Breckinridge, for R. J. Breckinridge, $160)

518. *Mrs. Robert J. Breckinridge*

Oil on canvas

Unlocated

PROVENANCE

Mr. John T. Vance, Washington, D.C.

REFERENCES

probably one of two copies in account book, August 20,
1857 (as Breckinridge, Rev. R. J., 4 copies—2 of himself
and 2 of Mrs. Breckinridge, for R. J. Breckinridge, $160)

518A. *Mrs. Robert J. Breckinridge* [half length]

24 x 20 in. (60.9 x 50.8 cm.)

George Durrett, Baltimore

REFERENCES

probably one of two copies in account book, August 20,
1857 (as Breckinridge, Rev. R. J., 4 copies—2 of himself
and 2 of Mrs. Breckinridge, for R. J. Breckinridge, $160)

519. *Rev. Wm. C. P. Breckinridge*

Unlocated

REFERENCES

account book, August 1, 1860, with two portraits of late
wife, $212.50 with 5 frames

520. *Mrs. Wm. C. P. Breckinridge*

Oil on canvas

Unlocated

REFERENCES

one of two portraits listed in account book, August 1,
1860, with portrait of Rev. Wm. C. P. Breckinridge,
$212.50 with 5 frames

521. *Mrs. Wm. C. P. Breckinridge*

Oil on canvas

24 x 20 1/2 in. (60.9 x 52.1 cm.)

Signed in red, l.l.: "AJM [monogram]"

Norton Asner, Baltimore, Maryland

PROVENANCE

Lloyd O. Miller

EXHIBITIONS

Peale Museum, Baltimore, 1950

REFERENCES

one of two portraits listed in account book, August 1,
1860, with portrait of Rev. Wm. C. P. Breckinridge,
$212.50 with 5 frames; Decatur, "Alfred Jacob Miller," p.
7 (illus.); Hunter, p. [14]

522–523. *Col. Wm. C. P. Breckinridge and wife*
[two portraits]

20 x 24 in. (50.8 x 60.9 cm.)

Unlocated

REFERENCES

account book, August 4, 1868, $150 + $46 for two
frames

524–525. *Sam W. Briscoe* [two portraits]

20 x 24 in. (50.8 x 60.9 cm.)

Unlocated

REFERENCES

account book, April 23, 1864, $90, for Sam^l W. Briscoe

526. *Miss Burdick*

Unlocated

REFERENCES

account book, February 9, 1857, $40, for Wm.
Eichelberger [not paid for]

527. *Mrs. P. Cameron*

Small oval

Unlocated

REFERENCES

account book, October 6, 1854, $35, for L. Cameron

528. *Miss Augusta Cannon*
20 x 24 in. (50.8 x 60.9 cm.)
Unlocated

REFERENCES
account book, January 1, 1866, $75

529. *D. S. Carr*
Unlocated

REFERENCES
account book, March 30, 1846, $50

530. *Mrs. Carson*
Unlocated

REFERENCES
account book, March 12, 1854, $100, for Thomas Carson

531. *Jas. H. Carter* [head]
Unlocated

REFERENCES
account book, May 5, 1859, $75, for Mrs. J. H. Carter

532. *Lt. William Chapman* (1810–1887)
Oil on artist board
10 x 8 in. (25.4 x 20.3 cm.)
(c. 1836)
Society of the Cincinnati, Washington, D.C.

PROVENANCE
Mrs. William Chapman Elmore; Col. William McC.
Chapman, Pebble Beach, Calif.

REFERENCES
Antiques (January 1973): illus. p. [34]

533. *Mrs. William Chapman (Abby Ann Wheelock)* (1819–1871)
Oil on artist board
10 x 8 in. (25.4 x 20.3 cm.)
(c. 1836)
The Society of the Cincinnati, Washington, D.C.

PROVENANCE
Mrs. William Chapman Elmore; Col. William McC.
Chapman, Pebble Beach, Calif.

534–535. *Mr. and Mrs. Wm. Chesnut* [2 portraits]
Unlocated

REFERENCES
account book, March 17, 1852, $50 (Mr. Chesnut);
account book, March 16, 1852, $50 (Mrs. Chesnut)

536. *Mr. Chittenden*
Oil on canvas
25 x 30 in. (63.5 x 76.2 cm.)
(1837)
Unlocated

REFERENCES
Journal, p. 62

537. *Mat B. Clark*
Oval, 7 x 10 in., vignette (17.8 x 25.4 cm.)
Unlocated

REFERENCES
account book, November 24, 1857, $25, for Mathew B.
Clark

538. *Dr. Clendinen*
Unlocated

REFERENCES
account book, July 28, 1849, $50

539. *Mrs. Dr. Clendinen*
Unlocated

REFERENCES
account book, July 22, 1849, $50, for Dr. Clendinen

540. *Dr. Clendinen* [from daguerreotype]
Unlocated

REFERENCES
account book, July 7, 1852, $50, for W. H. Clendinen

541. *Doctor Clendinen, Junior*
Unlocated

REFERENCES
account book, March 12, 1849, $60, for Dr. Clendinen

542. *Mary Clendinen*
Unlocated

REFERENCES
account book, March 26, 1851, $40, for Isaiah Mankin

543. *Miss Zenobia Clendinen*

20 x 24 in. (50.8 x 60.9 cm.)

Unlocated

REFERENCES

account book, August 22, 1853, $35, for Mrs. Jane
Clendinen

544. *Anna Laetitia Coale* (1817–1856)

Oil on canvas (oval)

17 3/4 x 15 5/8 in. (45.1 x 39.7 cm.)

(c. 1840)

Maryland Historical Society, Baltimore XX.4.218

545. *Mrs. John Christian Brune (Anne Laetitia Coale)*

Oil on canvas

16 1/2 x 13 1/4 in. (41.9 x 33.7 cm.)

(c. 1840)

Mrs. Francis Jazewell Redwood, Baltimore

546. *Mary Abigail Willing Coale*

Oil on panel

29 1/4 x 24 in. (74.3 x 60.9 cm.)

Maryland Historical Society XX.4.219

547. *Mr. R. Cobb*

Cabinet-size portrait

Unlocated

REFERENCES

account book, November 10, 1853, $50, for Ruth A.
Cobb

548. *Mrs. R. Cobb*

Cabinet-size portrait

Unlocated

REFERENCES

account book, November 10, 1853, $50

549. *Mrs. Cobb* [copy]

Unlocated

REFERENCES

account book, April 13, 1858, $45

550. *Elizabeth Zantzinger Cockey*

Oil on canvas

38 x 32 in. (96.5 x 81.3 cm.)

(c. 1836)

Unlocated

PROVENANCE

Mrs. Malcolm Hathaway, Easton, Md. (1950)

REFERENCES

J. Hall Pleasants file (as "possibly a Miller of about
1836")

551. *Capt. Jno. Cockey* (1743–1808) [copy after an earlier painting]

25 x 30 in. (63.5 x 76.2 cm.)

Unlocated

PROVENANCE

William Sebastian Graff Baker (1868); estate of John Paul
Baker, Baltimore; Mrs. Edward Wroth, Merion, Pa. (1950)

REFERENCES

account book, January 16, 1868, $100, for Wm. S. G.
Baker, Baltimore County; J. Hall Pleasants file

552. *A. B. Coe* [post mortem]

Unlocated

REFERENCES

account book, March 12, 1849, $50

553. *Joseph Cox, Esq.* [copy]

Unlocated

REFERENCES

account book, February 2, 1846, $50, for Johns Hopkins

554. *Sketch of Miller's Schoolmaster, John D. Craig*

On paper

(1825)

Mrs. L. Vernon Miller, Sr.

EXHIBITIONS

Peale Museum, Baltimore, 1950

REFERENCES

Journal, p. 84; Hunter, fig. II

555. *Rich^d Cromwell*

Unlocated

REFERENCES

account book, January 2, 1846, $50

556. Mrs. Cromwell

Unlocated

REFERENCES

account book, April 2, 1846, $65, for R. Cromwell

557. Mr. Crothers [with hands]

Unlocated

REFERENCES

account book, February 13, 1858, $65, for Crothers

558. Cunningham [head]

Unlocated

REFERENCES

account book, April 10, 1853, $25 [possibly not finished]

559. Miss Alice Ann Dashiell

Unlocated

REFERENCES

account book, December 15, 1852, $75, for Mrs. Dashiell

560. Dr. N. Dashiell

Unlocated

REFERENCES

account book, May 24, 1850, $85

561. Mrs. Dashiell

Unlocated

REFERENCES

account book, March 25, 1850, $85, for Dr. Dashiell

561A. Mrs. Dashiell [copy]

Unlocated

REFERENCES

account book, February 12, 1852, $50

562. Charles Deford

Cabinet-size portrait

Unlocated

REFERENCES

account book, May 23, 1856, $45, for Wm. Deford

563. Wm. Deford

Unlocated

REFERENCES

account book, March 15, 1852, $45

564. Mrs. Wm. Deford

Oval

Unlocated

REFERENCES

account book, February 20, 1853, $45, for Wm. Deford

565. Mrs. M. A. Denny

Oval

Unlocated

REFERENCES

account book, August 3, 1854, $75, Talbot County

566. Mrs. Dickinson

Unlocated

REFERENCES

account book, March 25, 1848, $50, for Wm. Dickinson

567. Bill Dixon

Wash drawing on paper

6 7/8 x 6 in. (17.3 x 15.1 cm.)

Signed and dated, l.l.: "AJM [monogram] 1832"

Inscribed, l.r.: "Bill Dixon"; on mount, l.c.: "BOY, WHO WORKED IN STUDIO"; on mount, l.l.: "signed"; on mount, l.r.: "Our Contraband"; on verso: "SKETCH BY ALFRED J. MILLER PROPERTY OF/MRS JOSEPH WHYTE"

Maryland Historical Society, Baltimore 54.151.6; gift of Mrs. Laurence R. Carton

PROVENANCE

the artist; by descent to Mrs. Joseph Whyte; Mrs. Laurence R. Carton

568. Black Youth, William Dixon

Sketch on paper

5 13/16 x 4 1/2 in. (14.7 x 11.5 cm.)

Mrs. L. Vernon Miller, Sr.

REFERENCES

Journal, p. 124

569–569A. Dorsett [2 copies]

Unlocated

REFERENCES

account book, December 30, 1849, $100, for Dorsett of Davidsonville, Anne Arundel County

570–570A. Dorsett [2 copies]

Unlocated

REFERENCES
account book, April 9, 1850, $100, for Dorsett of Anne Arundel County

571. *Mr. Dorsett*

Unlocated

REFERENCES
account book, October 3, 1864, $50, for S. H. Dorsett, South River

572. *Dr. Frederick Dorsey* (1775–1858)

Oil on canvas

55 x 43 in. (140.9 x 109.2 cm.)

Signed and dated, l.l.: "A. J. Miller/Pinxt/1852"

Washington County Museum of Fine Arts, Hagerstown, Maryland

PROVENANCE
Dorsey, Hagerstown, Md. (1852); Washington County Medical Society, Hagerstown, Md.

REFERENCES
account book, September 14, 1852, $200; J. Hall Pleasants file

573. *Miss Dorsey* [from daguerreotype]

29 x 36 in. (73.2 x 91.4 cm.)

Unlocated

REFERENCES
account book, January 25, 1855, $122 with frame, for Miss S. Dorsey

574. *Lizzie Dorsey* (1834–1861)

Kit-cat-size portrait

Stencilled on verso of canvas: "12–16/S N Dodges/Artist & Painter/Supply Store/189 Chatamer of Oliver St./ N. York"

Unlocated

575. *Dr. Dudley*

Unlocated

REFEREENCES
account book, June 5, 1864, $77 with frame, for Wm. Warfield, Lexington, Ky.

576. *Mrs. Dr. Dulin*

Unlocated

REFERENCES
account book, December 13, 1849, $60, for Dr. Keener

577. *Mrs. Dr. Dunbar and son Mackie*

Unlocated

REFERENCES
account book, November 17, 1851, $100, for Mrs. Dunbar

578. *Robert Dunbar* [son of Dr. Dunbar]

Unlocated

REFERENCES
account book, March 12, 1851, $50, for Dr. Dunbar

579. *J. M. Duncan*

Unlocated

REFERENCES
account book, April 27, 1847, $85, for Wm. Heald

580. *Madame Durand*

Unlocated

REFERENCES
account book, August 22, 1853, $40, for Mme. Durand

581. *John Dushane, 1854*

Unlocated

REFERENCES
account book, April 8, 1855, $50

582. *John Dushane, 1855*

25 x 30 in. (63.5 x 76.2 cm.)

Unlocated

REFERENCES
account book, February 24, 1855, $50, for N. E. Berry

583. *Mrs. Dushane*

Unlocated

REFERENCES
account book, April 23, 1855, $50, for Dr. Austin for Mrs. Dushane

584. *Mr. Early*

Unlocated

REFERENCES
account book, May 5, 1848, $50

585. *Harriet Early* [daughter of J. D.]

Unlocated

REFERENCES
account book, May 30, 1852, $75, for H. Early

586. *Ed. Ellicott*

Unlocated

REFERENCES

account book, March 3, 1854, $40, for E. T. Ellicott

587. *Mrs. Ed. Ellicott*

Oval

Unlocated

REFERENCES

account book, February 6, 1854, $40, for E. T. Ellicott

588. *Mr. Philip Eubank*

Unlocated

REFERENCES

account book, June 6, 1854, $50, for T. P. Eubank, Montague PO, Essex County, Va.

589. *Mrs. T. Eubank*

Unlocated

REFERENCES

account book, September 7, 1854, $50, for Th. P. Eubank

590. *Ben F. Ferguson*

Unlocated

REFERENCES

account book, September 25, 1855, $100, for Col. Geo. P. Kane

591. *Miss Foster*

Unlocated

REFERENCES

account book, February 24, 1855, $65, for W. W. Foster, Maltby House

592. *William Frederick Frick* [attributed to Miller]

Oil on canvas

30 7/8 x 24 7/8 in. (78.5 x 63.2 cm.)

(c. 1830s)

Baltimore Museum of Art, Baltimore, Maryland

REFERENCES

Gold, "Alfred Jacob Miller," p. 26

593. *Jas. B. George*

Unlocated

REFERENCES

account book, July 10, 1853, $50, for Union Lodge

594. *J. Gephart* [Mr.]

Unlocated

REFERENCES

account book, November 12, 1855, $45

595. *Mrs. Gephart* [with hand]

Unlocated

REFERENCES

account book, November 12, 1855, $55, for J. Gephart

596. *Rosalie Gill and Martin Gillette Gill*

Oil on canvas

47 3/8 x 39 in. (120.3 x 99.1 cm.)

Signed and dated: "A J Miller/1841"

Maryland Historical Society, Baltimore 64.84.2

PROVENANCE

Mrs. M. Gillet [*sic*] Gill

EXHIBITIONS

Peale Museum, Baltimore, 1950

REFERENCES

Hunter, p. [14]

597–598. *George P. Gover* [2]

Unlocated

REFERENCES

account book, September 2, 1857, $150, for Gover

599. *Infant child of Girard Gover*

Unlocated

REFERENCES

account book, August 15, 1856, $75, for Girard Gover

600. *Mrs. Gover*

Unlocated

REFERENCES

account book, November 15, 1853, $75, for Philip Gover

601. *Robert Gover*

Unlocated

REFERENCES

account book, October 15, 1854, $35, for Gover

602. *T. H. Gover* [from daguerreotype]

Unlocated

REFERENCES

account book, September 2, 1853, $75, for G. Gover

603. *Miss Grafton*

Unlocated

REFERENCES

account book, September 18, 1856, $40, for Miss Isabell Grafton, Fayette Street

604. *Charles Grinnell*

Unlocated

REFERENCES

account book, February 9, 1857, $35

605. *Mrs. C. Grinnell*

12 x 16 in. (30.5 x 40.7 cm.)

Unlocated

REFERENCES

account book, December 19, 1856, $35

606. *Daughter of Mrs. Grinnell*

Cabinet-size portrait

Unlocated

REFERENCES

account book, March 1, 1851, $35, for Grinnell

607. *Infant of Mrs. Grinnell*

Cabinet-size portrait

Unlocated

REFERENCES

account book, October 26, 1853, $50

608. *Mrs. Gunn*

Unlocated

REFERENCES

account book, December 14, 1861, $50 [possibly not paid for]

609. *Geo. W. S. Hall*

Cabinet-size portrait

Unlocated

REFERENCES

account book, November 4, 1856, $35

610. *G. W. S. Hall*

Cabinet-size portrait: 20 x 24 in. (50.8 x 61.0 cm.)

Unlocated

REFERENCES

account book, June 28, 1857, $45

611. *G. W. S. Hall*

Vignette

Unlocated

REFERENCES

account book, June 28, 1857, $35

612. *Jas. Hall*

Cabinet-size portrait

Unlocated

REFERENCES

account book, April 15, 1856, $35

613. *Miss Hall*

12 x 15 in. (30.5 x 38.1 cm.)

Unlocated

REFERENCES

account book, January 24, 1858, $35, for Dr. Jas. Hall

614. *Mr. Wm. Wilmot Hall*

Cabinet-size portrait

Unlocated

REFERENCES

account book, March 16, 1869, $60, for Mrs. Mary C. Hall

615. *Dr. Hammond*

Cabinet-size portrait

Unlocated

REFERENCES

account book, November 10, 1855, $40 with frame

616. *Mrs. Dr. Hammond and Child*

Unlocated

REFERENCES

account book, August 15, 1855, $50, for Dr. Hammond

617. *Miss Kate Hammond*

Oval kit-cat-size portrait

Unlocated

REFERENCES

account book, September 14, 1854, $120 with frame, for Charles Hammond

618. *Mrs. Jesse Hare (Catherine H. Welch)*
(c. 1790–1872)

Oil on canvas (oval)

47 1/16 x 36 1/16 in. (119.4 x 91.6 cm.)

(1848)

Walters Art Gallery, Baltimore 37.2467; S. and A. P. Fund, April 1970

PROVENANCE

Decatur H. Miller (1848); by descent to Alfred J. Miller, Jr. (1968)

EXHIBITIONS

Peale Museum, Baltimore, 1950

REFERENCES

account book, September 1, 1848, $100, for D. H. Miller; J. Hall Pleasants file; Hunter, p. [14]; Gold, "Alfred Jacob Miller," p. 24 (illus.); Randall, "Gallery for Alfred Jacob Miller," p. 840, fig. 8

619. *Chapin Harris*

Cabinet-size portrait

Unlocated

REFERENCES

account book, March 23, 1850, $30

620. *Chapin B. Harris*

Pencil and charcoal on paper

9 5/16 x 7 3/8 in. (23.7 x 18.3 cm.)

Signed: "AJM [monogram]"

(c. 1850)

Maryland Historical Society, Baltimore 56.24.2d

621. *Anna Harrison* [daughter of Mr. Frederick Harrison]

Unlocated

REFERENCES

account book, March 19, 1858, full length, $80, for Frederick Harrison, York Road, Govanstown

622. *Mr. Ed^d. Harrison*

Unlocated

REFERENCES

account book, November 12, 1852, $72 with frame

623. *Dr. S. A. Harrison*

Unlocated

REFERENCES

account book, August 15, 1859, $150 for portrait and landscape

624. *Alice Heald* [daughter of Jno. Heald]

Unlocated

REFERENCES

account book, February 9, 1852, $75 [possibly not completed]

625. *Charles and Alice Heald* [two children]

Unlocated

REFERENCES

account book, January 29, 1856, $250, for Wm. Heald

626. *Ed^d Heald*

Unlocated

REFERENCES

account book, October 2, 1847, $75

626A. *Ed^d Heald* [copy]

Unlocated

REFERENCES

account book, October 2, 1847, $75

627. *Jacob Heald* (1798–1846)

Oil on canvas

30 x 25 in. (76.2 x 63.5 cm.)

(c. 1840)

Stencilled: "PREP BY DECHAUX—N.Y."

Mrs. Ruth Heald Lukens, Hibbing, Minnesota

628. *John Heald*

Unlocated

REFERENCES

account book, March 3, 1852, $60

629. *Mrs. Heald*

Unlocated

REFERENCES

account book, March 4, 1852, $60, for Jno. Heald

630. *Sarah Ann Heald (Mrs. William H. Heald)*
(1806–1845)

Oil on canvas

30 x 25 in. (76.2 x 63.5 cm.)

(c. 1840)

Stencilled: "PREP BY DECHAUX N Y"

Mrs. Ruth Heald Lukens, Hibbing, Minnesota

631. *Sarah Malvina Allen Heald (Mrs. Wm. Henry Heald) (1824–1854)*

Oil on canvas

30 x 20 in. (76.2 x 50.8 cm.)

(c. 1844)

The Walters Art Gallery, Baltimore 37.2511; gift of Mrs. William Newland Day, 1974

632. *William Heald* (1832–1837) [son of Jacob and Sarah Heald]

Oil on canvas

(c. 1837)

Unlocated

633. *William Henry Heald* (1819–1882)

Oil on canvas

30 x 25 in. (76.2 x 63.5 cm.)

(c. 1844)

The Walters Art Gallery, Baltimore 37.2509; gift of Mrs. William Newland Day, 1973

REFERENCES

Walters Art Gallery Forty-first Annual Report (1973), illus. p. 37; Randall, "Gallery for Alfred Jacob Miller," p. 840, fig. 9

634. *Wm. Heald*

Unlocated

REFERENCES

account book, June 3, 1847, $80

634A. *William Heald* [copy]

Oil on canvas

48 x 36 in. (21.9 x 91.4 cm.)

Don Anslew Gallery, Inc., Norfolk, Virginia

REFERENCES

account book, August 16, 1847, $100, for D. H. Miller

635. *William Heald*

Unlocated

REFERENCES

account book, February 9, 1848, $100, for D. H. Miller

636. *Our Heinrich, Fishing*

Sketch on paper (octagonal)

5 x 4 in. (12.7 x 10.2 cm.)

(c. 1847)

Mrs. L. Vernon Miller, Sr.

REFERENCES

Journal, p. 131

637. *Miss Henderson*

Wash on paper

7 1/2 x 6 in. (19.0 x 15.2 cm.)

(c. 1845)

Maryland Historical Society, Baltimore 54.24.3hh

638. *Miss Henderson*

Wash drawing

7 1/16 x 5 1/2 in. (17.9 x 14.0 cm.)

(c. 1846–1848)

Inscribed: "design for Miss Henderson"

Maryland Historical Society, Baltimore 56.24.3ww

639. *Mrs. Henderson*

Unlocated

REFERENCES

account book, February 20, 1847, $75, for H. Henderson

640. *Mrs. Henderson*

Unlocated

REFERENCES

account book, March 25, 1848, $50, for H. Henderson

641. *Miss Blanche Henderson*

Unlocated

REFERENCES

account book, April 5, 1848, $70, for H. Henderson

642. *Miss E. Henderson*

Unlocated

REFERENCES

account book, December 5, 1846, $70, for H. Henderson

643. *Master H. Henderson*

Unlocated

REFERENCES

account book, December 3, 1846, $70, for H. Henderson

644. *Henry Henderson*

Kit-cat-size portrait

Unlocated

REFERENCES

account book, February 1, 1847, $75

645. *Miss Mary Henderson*

Unlocated

REFERENCES

account book, May 1, 1847, $70, for H. Henderson

646. *Rebecca H. Henderson*

Unlocated

REFERENCES

account book, November 6, 1850, $40, for H. Henderson

647. *Johns Hopkins* (1795–1873)

Oil on canvas

30 x 25 in. (76.2 x 63.5 cm.)

Signed and dated on wall in background: "AJM/—1832"

Johns Hopkins University

PROVENANCE

Johns Hopkins

EXHIBITIONS

Peale Museum, Baltimore, 1950

REFERENCES

J. Hall Pleasants file; Hunter, p. [14]

648. *Mrs. Samuel Hopkins* (Hannah Janney) (1774–1846)

Oil on canvas

30 x 25 in. (76.2 x 63.5 cm.)

(1832)

Johns Hopkins University 26366; gift of Mrs. Francis White

PROVENANCE

Johns Hopkins

EXHIBITIONS

Peale Museum, Baltimore, 1950

REFERENCES

Mrs. Helen Hopkins Thorn, *Johns Hopkins, A Silhouette* (Baltimore, 1929), p. 29, illus.; J. Hall Pleasants file; Hunter, p. [14]

649. *Mrs. Hoppe*

Unlocated

REFERENCES

account book, October 9, 1848, $75, for Hoppe

650. *Jas. Hooper*

Unlocated

REFERENCES

account book, January 28, 1850, $75

651. *Miss E. Howell*

Unlocated

REFERENCES

account book, February 6, 1847, $60, for Dr. Edmondson

652. *Hutchins* [infant child]

Oval

Unlocated

REFERENCES

account book, November 8, 1852, for Mr. Luke Hutchins

653. *Daughter of John Jacobson*

Vignette

Unlocated

REFERENCES

account book, April 20, 1863, $50, for John Jacobson

654. *Daisy Jacobson* [daughter of Jno.]

Oval vignette: 20 x 24 in. (50.8 x 60.9 cm)

Unlocated

REFERENCES

account book, June 6, 1868, $75, for Jno. Jacobson

655. *Ed. Jenkins*

Oval

Unlocated

REFERENCES

account book, September 11, 1854, $75, for Edward Jenkins

656. *Mrs. Mark Jenkins*

Cabinet-size portrait

Unlocated

REFERENCES

account book, November 14, 1853, $50, for John T. Jenkins

657. *Daughter of Mark Jenkins*

Unlocated

REFERENCES

account book, May 30, 1854, $60, for Mark Jenkins

658. *Master Francis Mankin Jenks* (1846–1918)

Oil on canvas

36 x 29 in. (91.4 x 73.6 cm.)

(c. 1848)

Francis H. Jencks, Baltimore

PROVENANCE

F. H. Jenks (1848); by descent to the present owner

EXHIBITIONS

Peale Museum, Baltimore, 1950

REFERENCES

account book, November 24, 1848, $75, for F. H. Jenks; J. Hall Pleasants file; Hunter, p. [14]

659. *Mrs. Jenks*

Unlocated

REFERENCES

account book, November 16, 1848, $60, for H. H. Jenks

660. *Richard Johns*

Unlocated

REFERENCES

account book, February 21, 1852, $75

661. *Col. William Fell Johnson* [half length, 2 hands]

Oil on canvas

34 x 27 in. (86.3 x 68.6 cm.)

Private collection, Baltimore

REFERENCES

account book, September 10, 1851, $70

662. *J. C. Jones*

Pencil, heightened with white, on paper

Inscribed: "March 1850"

The Baltimore Museum of Art, *Scrapbook of Frank B. Mayer* (1850), 36.629

663. *Mrs. Kavanagh*

Kit-cat-size portrait

Unlocated

REFERENCES

account book, April 3, 1847, $85

664. *Children of George Kealhofer (Harry, Howard, and Frederick Augustus Kealhofer)*

Oil on canvas (oval)

28 1/2 x 34 1/2 in. (72.4 x 87.6 cm.)

(1855)

Washington County Museum of Fine Arts, Hagerstown, Maryland

PROVENANCE

George Kealhofer, Hagerstown (1855)

REFERENCES

account book, March 27, 1855, $150, for Geo. Keilhofer [*sic*]; J. Hall Pleasants file

665. *Kealhofer Children (Richard H. and William Kealhofer)*

Oil on canvas (oval)

(1855)

Washington County Museum of Fine Arts, Hagerstown, Maryland

PROVENANCE

George Kealhofer, Hagerstown (1855)

REFERENCES

account book, December 29, 1855, $100, for Geo. Keilhofer [*sic*]; J. Hall Pleasants file

666. *Miss Louisa Kealhofer*

Oil on canvas (oval)

28 1/4 x 23 3/4 in. (71.7 x 60.3 cm.)

(1856–1857)

Washington County Museum of Fine Arts, Hagerstown, Maryland

PROVENANCE

George Kealhofer, Hagerstown (1856–1857)

REFERENCES

account book, December 30, 1856, $50, for George Keilhofer [*sic*]; J. Hall Pleasants file

667–668. *Judge Thomas Kill [Kell]* [2 portraits]

Unlocated

REFERENCES

account book, February 5, 1846, $90, for [A. W. B.] Thos. Kell

669. *Mrs. Kennedy*

Unlocated

REFERENCES

account book, June 15, 1851, $30, for Kennedy

670. *Mrs. Krauth*

Kit-cat-size portrait

Unlocated

REFERENCES

account book, June 3, 1852, $75, for Jos. Reynolds

671. *Mrs. T. Newton Kurtz*

20 x 24 in. (50.8 x 60.9 cm.)

Unlocated

REFERENCES

account book, December 6, 1854, $40, for T. Newton Kurtz

672. *Miss Landstreet*

Cabinet-size portrait

Unlocated

REFERENCES

account book, March 5, 1854, $50, for Landstreet

673. *Josiah Lee*

Unlocated

REFERENCES

account book, July 5, 1852, $125, for Mrs. Josiah Lee

673A. *Josiah Lee* [post mortem]

Unlocated

REFERENCES

account book, October 13, 1856, $80, for Charles Lee

673B. *Josiah Lee* [copy]

Unlocated

REFERENCES

account book, April 15, 1857, $95 with frame, for Girard Gover

674. *Miss Lee*

Cabinet-size portrait

Unlocated

REFERENCES

account book, March 6, 1854, $30

675. *Alonzo Lilly*

Unlocated

REFERENCES

account book, December 20, 1856, $45

676. *Mrs. A. Lilly*

Unlocated

REFERENCES

account book, January 6, 1857, $45, for Alonzo Lilly

677. *Mr. Wilson Lloyd*

Unlocated

REFERENCES

account book, June 9, 1854, $40, for Mrs. W. Lloyd

678. *Robert Macklin* [son of Mrs. Eliz. Kelso Blackwood]

25 x 30 in. (63.5 x 76.2 cm.)

Unlocated

REFERENCES

account book, December 10, 1868, $100, for Mrs. Blackwood

679. *Dr. Clendinen Mankin*

Unlocated

REFERENCES

account book, February 15, 1849, $40, for I. Mankin

680. *H. Mankin*

Cabinet-size portrait

Unlocated

REFERENCES

account book, June 22, 1849, $40

681. *Henry Mankin and His Daughters*

Oil on canvas (oval)

36 7/8 x 48 1/8 in. (93.7 x 122.3 cm.)

(1848–1849)

The Baltimore Museum of Art, Baltimore, Maryland 16.1.1; gift of the Misses Mankin, 1916

PROVENANCE

Henry Mankin (1848)

EXHIBITIONS

Peale Museum, Baltimore, 1950

REFERENCES

account book, May 20, 1848, $250, paid August 20, 1848; J. Hall Pleasants file; Hunter, p. [14]

682. *Mrs. Henry Mankin and Maria Theresa Mankin*

Oil on canvas (oval)

37 x 48 1/4 in. (94.0 x 122.5 cm.)

(1847)

The Baltimore Museum of Art, Baltimore, Maryland

PROVENANCE

Henry Mankin (1847)

REFERENCES

account book, November 1, 1847, $180; J. Hall Pleasants file

683. *Mrs. Mankin*

Unlocated

REFERENCES

account book, May 17, 1847, $70, for I. Mankin

684. *Mr. Martin*

Cabinet-size portrait

Unlocated

REFERENCES

account book, December 10, 1853, $40

685. *Mrs. Martin*

Cabinet-size portrait

Unlocated

REFERENCES

account book, November 22, 1853, $40

686. *Mrs. Wm. Maxwell*

Unlocated

REFERENCES

account book, March 11, 1858, $45, for Wm. Maxwell

687. *Father of Lieutenant McConnell* [from daguerreotype]

Kit-cat-size portrait

Unlocated

REFERENCES

account book, December 26, 1854, $75, for Lieutenant McConnell

688. *Mrs. McDonald*

Cabinet-size portrait

Unlocated

REFERENCES

account book, October 15, 1855, $30

689. *Mrs. McEldowny*

Unlocated

REFERENCES

account book, June 1, 1848, $40, for McEldowny

690. *Mrs. McSherry*

Miniature

Unlocated

REFERENCES

account book, October 20, 1855, $25

691. *Lawson and Ed Mealey* [two children]

Unlocated

REFERENCES

account book, May 14, 1856, $115, for E. M. Mealey, Hagerstown

692. *Self-portrait* [Alfred Jacob Miller at age 17]

Oil on composition board

11 5/8 x 10 1/4 in. (29.5 x 25.7 cm.)

(c. 1827)

Maryland Historical Society, Baltimore 58.62.3

PROVENANCE

the artist; Alfred Jacob Miller, Jr.; Mrs. Laurence R. Carton

EXHIBITIONS

Peale Museum, Baltimore, 1950; Yale University Art Gallery, New Haven, September 20, 1978–January 6, 1979

REFERENCES

Hunter, p. [14]; Sandweiss, p. 62

693. *Self-portrait*

Oil on canvas (oval)

30 x 25 in. (76.2 x 63.5 cm.)

(c. 1850)

The Walters Art Gallery, Baltimore 37.2556; gift of Mrs. L. Vernon Miller, Sr., 1978

EXHIBITIONS

Peale Museum, Baltimore, 1950

REFERENCES

Hunter, p. [14]; Brunet, frontis.

694. *Self-portrait*

Oil on board

11 x 9 in. (28.0 x 22.8 cm.)

The Thomas Gilcrease Institute of American History and Art, Tulsa, Oklahoma 0126.721

the artist; by descent to his grand-nephew, Alfred J. Miller; Mrs. Eugenia Whyte, Baltimore; M. Knoedler and Company, New York, #WCA 1101 (1948)

REFERENCES
Decatur, "Alfred Jacob Miller," p. 6 (illus.); [Martin Wenger], "Miller Collection," *American Scene* 4, no. 3 (1962): [22] (illus.); "Alfred Jacob Miller," *American Scene* 14, no. 4 (1973): 13 (illus.); Warner, p. 199 (illus.)

695. *Columbus A. Miller*

Pencil on paper

Sight: 7 1/8 x 5 in. (18.1 x 12.7 cm.)

Dated and inscribed: "1832/C. A. Miller"

Mr. and Mrs. D. H. Miller

PROVENANCE
the artist; L. Vernon Miller, Sr.

696. *Decatur H. Miller*

Pencil on paper

7 1/2 x 5 in. (19.0 x 12.7 cm.)

Dated and inscribed: "1832 D. H. M."

Mr. and Mrs. D. H. Miller

PROVENANCE
the artist; L. Vernon Miller, Sr.

697. *Decatur Howard Miller* (1820–1890)

Oil on canvas (oval)

48 x 36 1/2 in. (121.9 x 92.7 cm.)

(c. 1855)

The Walters Art Gallery, Baltimore 37.2558; gift of Mrs. L. Vernon Miller, Sr., 1978

698. *Mrs. Eliza Miller*

On credit board

Unlocated

REFERENCES
account book, December 11, 1847, $100, for D. H. Miller

699. *Mrs. Decatur Howard Miller (Eliza Credilla Hare)* (1789–1861)

Oil on canvas (oval)

47 3/4 x 36 3/4 in. (121.3 x 93.3 cm.)

(c. 1850)

The Walters Art Gallery, Baltimore 37.2557; gift of Mrs. L. Vernon Miller, Sr., 1978

PROVENANCE
Decatur Howard Miller; by descent to L. Vernon Miller, Sr.

700. *George W. Miller* (1777–1836)

Oil on canvas (oval)

15 1/2 x 13 in. (39.4 x 33.0 cm.)

Maryland Historical Society, Baltimore 58.62.1

PROVENANCE
Mrs. Laurence R. Carton

EXHIBITIONS
Peale Museum, Baltimore, 1950

REFERENCES
Hunter, p. [14]

701. *Mrs. George W. Miller* (1780–1837)

Oil on canvas (oval)

15 1/2 x 13 in. (38.1 x 33.0 cm.)

Maryland Historical Society, Baltimore 58.62.2

PROVENANCE
Mrs. Laurence R. Carton

EXHIBITIONS
Peale Museum, Baltimore, 1950

REFERENCES
Hunter, p. [14]

702. *Mina Shelden Miller* (b. 1863)

Oil on canvas (oval)

Sight: 9 x 8 3/4 in. (22.8 x 22.2 cm.)

Signed: "AJM [monogram]"

Norton Asner, Baltimore, Maryland

703. *Jessie Dorsey Moore* (1834–1861)

Small oval

Marianne H. Moore, Ruxton

704. *Thomas Moore* (1779–1852) [lyricist poet of Ireland]

Charcoal, heightened with white, on tan paper

14 1/4 x 12 1/4 in. (36.2 x 31.1 cm.)

Signed and dated: "A. J. Miller 1838"

Schweitzer Gallery, New York

705. *Mrs. Morrison*

Unlocated

REFERENCES

account book, May 22, 1865, $75, for Rev^d Dr.
Morrison, Lexington, Ky.

706. *P. de Murguiondo*

25 x 30 in. (63.5 x 76.2 cm.)

Unlocated

REFERENCES

account book, March 15, 1865, $100

707. *Victor and Prudencio Murguiondo, with Dog*
[two children of P. de Murguiondo]

Unlocated

REFERENCES

account book, April 10, 1865, full length [not paid for]

708. *Mrs. Jane Murray* [aunt of Mrs.
Rutherford]

20 x 24 in. (50.8 x 60.9 cm.)

Unlocated

REFERENCES

account book, December 1, 1866, $93.50 with frame and
boxes, for Rev. E. H. Rutherford, Petersburg, Va.

709. *George Nelson*

Unlocated

REFERENCES

account book, April 4, 1846, $65

710. *Mrs. Geo. Nelson*

Unlocated

REFERENCES

account book, March 31, 1846, $75, for Geo. Nelson

711. *Rev. Charles Nisbit* (1736–1804) [copy of
an eighteenth-century portrait, oil on
metal, 9 1/2 x 8 in.]

Oil on canvas

30 1/4 x 25 1/4 in. (76.8 x 64.2 cm.)

(1854)

Dickinson College, Carlisle, Pennsylvania; gift of Judge
Nisbit, March 12, 1854

PROVENANCE

Judge Nisbit (1854)

REFERENCES

account book, March 12, 1854, for Judge Nisbit, $50

712. *Dr. Palmer*

Cabinet-size portrait

Unlocated

REFERENCES

account book, March 10, 1854, $30

713. *Mrs. J. Palmer*

Cabinet-size portrait

Unlocated

REFERENCES

account book, March 10, 1853, $25, for Dr. Jas. Palmer

714. *Miss May Patterson*

Unlocated

REFERENCES

account book, December 28, 1857, full length, $85, for
Henry Patterson

715. *Joseph Pearson* [post mortem]

Unlocated

REFERENCES

account book, October 15, 1860, $100, for Geo. R.
Vickers

716. *Mrs. R. W. Pendleton* [study for 1847
portrait]

Pen, ink, and watercolor on paper

7 7/8 x 5 7/8 in. (20.0 x 14.9 cm.)

(c. 1847)

Maryland Historical Society, Baltimore 56.24.3XX

716A. *Mrs. Pendleton*

Unlocated

REFERENCES

account book, July 5, 1847, $150, for R. W. Pendleton

717. *Two Pendleton Children*

Unlocated

REFERENCES

account book, February 5, 1846, $120, for R. W.
Pendleton; possibly exhibited at the Maryland Historical
Society annual exhibition (1849), no. 16 (as *Children at
Play*, collection of R. W. Pendleton)

718. *Mrs. Pickering*

Unlocated

REFERENCES

account book, December 24, 1846, $75, for Saml. Pickering

719. *Mrs. Pigman*

Unlocated

REFERENCES

account book, October 29, 1856, $50, for Mrs. Mary E. Pigman, 186 Franklin Street

720. *Mr. F. Posey*

Cabinet-size portrait

Unlocated

REFERENCES

account book, November 21, 1853, $35, for Fred J. Posey

721. *Mrs. Posey*

Cabinet-size portrait

Unlocated

REFERENCES

account book, November 18, 1853, $35

722. *Mrs. Col. Potter*

Unlocated

REFERENCES

account book, October 12, 1852, $60, for Col. Z. H. Potter

723. *Mr. E. Punderson*

Unlocated

REFERENCES

account book, December 14, 1853, $40, for E. M. Punderson

724. *Mrs. Punderson, 1852*

Unlocated

REFERENCES

account book, October 20, 1853, $40, for E. M. Punderson

725. *Two Punderson Children* [Laura and H_____]

48 x 36 in. (121.9 x 91.4 cm.)

Unlocated

REFERENCES

account book, December 13, 1856, $130, for E. M. Punderson

726. *Rhinehart*

Cabinet-size portrait: 7 x 10 in. (17.8 x 25.4 cm.)

Unlocated

REFERENCES

account book, February 2, 1858, $30, for W. T. Walters

727. *Alex^r Rieman*

Unlocated

REFERENCES

account book, October 1, 1849, $60

728. *Mrs. Rieman*

Unlocated

REFERENCES

account book, September 28, 1849, $60, for Alex. Rieman

729. *Henry Rieman*

Unlocated

REFERENCES

account book, December 14, 1861, $50, for Fred A. Hack

730. *Joseph Rieman*

Unlocated

REFERENCES

account book, December 10, 1849, $60, for Jos. Rieman

731. *Son of Wm. Rieman*

20 x 24 in. (50.8 x 60.9 cm.)

Unlocated

REFERENCES

account book, June 9, 1863, $60, for Wm. J. Rieman

732. *Mrs. Robinson*

Unlocated

REFERENCES

account book, March 6, 1846, $60, for Wm. Robinson

733. *Mrs. Rout*

Oval, 20 x 24 in. (50.8 x 60.9 cm.)

Unlocated

REFERENCES

account book, August 13, 1867, $75, Versailles, Ky.

734–739. *Saml. E. Schindel* [six portraits]

Four, 25 x 30 in. (63.5 x 76.2 cm.); two on one canvas, 29 x 36 in. (73.7 x 91.4 cm.)

Unlocated

REFERENCES
account book, October 25, 1856, $275, for Saml. E. Schindel, Hagerstown

740. *Infant of Mrs. Schindel*

Unlocated

REFERENCES
account book, November 1, 1858, $50, for Mrs. Schindel

741. *Mr. Seldon*

Kit-cat-size portrait

Unlocated

REFERENCES
account book, December 11, 1855, $97 with frame, for Miss Cassie Seldon, Lynchburg, Va.

742. *Daughter of Mrs. Sewell*

Unlocated

REFERENCES
account book, July 1, 1851, $70, for Richard Sewell

743. *Mrs. Shaw*

Pen and wash drawing on paper

5 7/8 x 8 3/8 in. (14.9 x 21.2 cm.)

Dated and inscribed: "1825/Mrs. Shaw"

Maryland Historical Society, Baltimore 56.24.2Z

744. *Moses Shepherd [Sheppard]* (1773–1857)

Oil on canvas

36 x 29 in. (91.4 x 73.7 cm.)

(1856)

Historical Society of Pennsylvania, Philadelphia

PROVENANCE
Moses Sheppard (1856)

REFERENCES
account book, September 15, 1856, $85 with frame

744A–B. *Shepherd [Sheppard]* [2 copies]

Unlocated

REFERENCES
account book, October 9, 1856, $150, for Moses Shepherd [sic]

745. *Harry Sindall*

29 x 36 in. (73.7 x 91.4 cm.)

Unlocated

REFERENCES
account book, January 1, 1857, $75, for S. Sindall

746. *Colonel Alexander Smith, Maryland Militia* (1790–1858)

Oil on canvas mounted on wood, in gold-colored frame

30 x 25 in. (76.2 x 63.5 cm.)

Signed on verso [prior to restoration]: "A. J. Miller"; label on verso of frame: "Painted 1833 by A. J. Miller"

(1833)

Private collection, Gibson Island, Maryland

PROVENANCE
Col. Alexander Smith (1833); by descent to the present owner

REFERENCES
account book of Alexander Smith, April 10, 1833, $75 paid to Alfred J. Miller for likenesses of himself and wife

747. *Mrs. Alexander Smith (Lydia Lloyd Murray)* (1805–1884)

Oil on canvas mounted on wood, in gold-colored frame

30 x 25 in. (76.2 x 63.5 cm.)

Signed on verso of canvas [prior to restoation]: "A. J. Miller"

(1833)

Private collection, Gibson Island, Maryland

PROVENANCE
Col. Alexander Smith (1833); by descent to the present owner

REFERENCES
account book of Alexander Smith, April 10, 1833, $75 paid to Alfred J. Miller for likenesses of himself and wife

748. *Mary Smith* [daughter of Richard]

Oval cabinet-size portrait

Unlocated

REFERENCES
account book, May 18, 1855, $40, for Richard Smith, Alexandria

749. *Mr. Rich^d Smith*

Oval

Unlocated

REFERENCES
account book, August 7, 1852, $60

750. *Mrs. Richards [?] S. Smith*
Oval
Unlocated

REFERENCES
account book, October 21, 1850, $60, for R. S. Smith

751. *Daughter of Wm. Prescott Smith*
Unlocated

REFERENCES
account book, September 26, 1857, $75, for Wm. Prescott Smith

752. *Miss Sothoron*
Unlocated

REFERENCES
account book, November 18, 1852, $75 with frame, for L. Hutchins

753. *Danl. Sprigg*
48 x 36 in. (121.9 x 91.4 cm.)
Unlocated

REFERENCES
account book, September 26, 1852, $100, for Daniel Sprigg

754. *Mrs. F. Stabler*
Unlocated

REFERENCES
account book, November 15, 1855, $45, for F. Stabler

755. *Col. Stansbury*
Cabinet-size portrait
Unlocated

REFERENCES
account book, November 25, 1849, $45, for John Stansbury

756. *Col. Stansbury [from daguerreotype]*
Unlocated

REFERENCES
account book, June 25, 1853, $60, for Carville Stansbury

757. *Mrs. Stansbury*
Unlocated

REFERENCES
account book, March 14, 1849, $60, for C. Stansbury

758. *Mrs. Stein*
Unlocated

REFERENCES
account book, July 10, 1853, $60, for Meyer Stein

759. *Wm. Stewart*
20 x 24 in. (50.8 x 60.9 cm.)
Unlocated

REFERENCES
account book, September 13, 1856, $50 with frame

760. *Dr. Stewart*
Unlocated

REFERENCES
account book, November 7, 1848, full length, $150

761. *J. H. Stimpson*
Unlocated

REFERENCES
account book, January 5, 1850, $75

762. *Samuel Stone* (1781–1860) [two hands]
Oil on wood panel
35 1/2 x 28 1/2 in. (90.2 x 72.4 cm.)
(1848)
Unlocated

PROVENANCE
Samuel Stone; by descent to his great-grandnephew, Harry S. Middendorf, Sr. (1967)

EXHIBITIONS
Baltimore Museum of Art, July 9–September 24, 1967; Metropolitan Museum of Art, New York, October 4–November 26, 1967

REFERENCES
account book, November 28, 1848, $80, for S. Stone; New York, Metropolitan Museum of Art, *American Paintings and Historical Prints from the Middendorf Collection*, no. 21 (illus.)

763. *John W. Stonehaker*
Unlocated

REFERENCES
account book, January 16, 1857, $35

764. John W. Stonehakers

Unlocated

REFERENCES

account book, December 13, 1856, $35, Hagerstown

765. Mrs. A. Hamilton Stump [copy from Sully]

Oval

Unlocated

PROVENANCE

Mrs. Fitzhugh Goldsborough (1941)

REFERENCES

account book, January 6, 1847, $65, for copy of Mrs. Stump's portrait from Sully; J. Hall Pleasants file

766. Mrs. Stump

Unlocated

REFERENCES

account book, October 1, 1848, $70, for Stump

767. Mrs. Stump, Sen^r.

Unlocated

REFERENCES

account book, October 1, 1848, $70

768. Mrs. Henry Sullivan

Unlocated

REFERENCES

account book, April 5, 1848, $75, for H. Sullivan

769. J. Sullivan

Cabinet-size portrait

Unlocated

REFERENCES

account book, November 9, 1848, $40, for Sullivan

770. J. Sullivan

Cabinet-size portrait

Unlocated

REFERENCES

account book, December 5, 1848, $40, for F. Sullivan

771–772. Jere Sullivan [two]

Unlocated

REFERENCES

account book, June 24, 1864, $80, for subject's nephew, P. H. Sullivan

773. J^n Sullivan

Cabinet-size portrait

Unlocated

REFERENCES

account book, January 3, 1849, $40, for H. Sullivan

774–775. J^n Sullivan [two portraits]

Cabinet-size portraits

Unlocated

REFERENCES

account book, February 15, 1849, $80, for H. Sullivan

776. P. H. Sullivan

Unlocated

REFERENCES

account book, June 26, 1849, $75

777. Father of P. H. Sullivan

12 x 14 in. (30.5 x 35.5 cm.)

Unlocated

REFERENCES

account book, June 24, 1864, $40, for P. H. Sullivan

778. Mrs. Sullivan

Cabinet-size portrait: 12 x 14 in. (30.5 x 35.5 cm.)

Unlocated

REFERENCES

account book, September 28, 1864, $40, for P. H. Sullivan

779. Col. Tagart

Unlocated

REFERENCES

account book, January 30, 1852, $95 with frame, for Col. Wm. Tagart

780. Dr. Theobold

Unlocated

REFERENCES

account book, December 8, 1846, $50

781. Son of Victor Thompson

Unlocated

REFERENCES

account book, December 11, 1855, $60, for Victor Thompson, Hagerstown

782. *Miss Towson*

Unlocated

REFERENCES

account book, May 30, 1855, $50 with frame, for Jacob Towson

783. *Wm. H. Trigo*

Unlocated

REFERENCES

account book, December 14, 1856, $40

784. *Mrs. Tyson*

Unlocated

REFERENCES

account book, November 23, 1846, $50

785. *Van Bibber*

Unlocated

REFERENCES

account book, November 22, 1852, $35, for Mrs. Van Bibber, Carroll Hall

786. *W^m C. Waite*

Oil on paper

9 3/16 x 7 1/16 in. (23.4 x 17.9 cm.)

Signed, l.r.: "AJM [monogram]"; label: "W^m C. Waite Esq. an old friend"

Mrs. L. Vernon Miller, Sr.

REFERENCES

Album I

787. *Ben^m Warfield*

25 x 30 in. (63.5 x 76.2 cm.)

Unlocated

REFERENCES

account book, November 14, 1866, $130 with frame, for subject's brother, Wm. Warfield, Esq., Lexington, Ky.

788. *Mr. W. Warfield and Ben Warfield* [five copies]

788A-D. Unlocated

REFERENCES

account book, April 15, 1857, $200, for Wm. Warfield

789. *Sister of Wm. Warfield* [copy]

Unlocated

REFERENCES

account book, June 2, 1870, $85, for Wm. Warfield, Lexington, Ky.

790. *Son of Wm. Warfield*

Oval cabinet-size portrait

Unlocated

REFERENCES

account book, April 3, 1863, $56.50 with frame, for Wm. Warfield, Lexington, Ky.

791. *Daughter of Wm. Warfield*

25 x 30 in. (63.5 x 76.2 cm.)

Unlocated

REFERENCES

account book, September 23, 1866, $135, for Wm. Warfield, Lexington, Ky.

792. *Mr. Way*

Cabinet-size portrait

Unlocated

REFERENCES

account book, April 20, 1849, $30

793. *Mrs. Andrew J. Way*

Oil on canvas (oval)

23 x 19 in. (58.4 x 48.3 cm.)

(1853)

Mrs. Bertha Giles, Seaford, Delaware

REFERENCES

account book, November 19, 1853, cabinet, $35

794. *Mr. Webb, Sen^r*

Unlocated

REFERENCES

account book, March 25, 1848, $50

795. *Katy Welsh* [daughter of Mrs. Jno. B.]

Vignette: 20 x 24 in. (50.8 x 60.9 cm.)

Unlocated

REFERENCES

account book, December 8, 1868, $60, for Mrs. Jno. B. Welsh, York, Pa.

796. *Miles White* (1792–1876)

(before 1846)

Mrs. Francis White, Baltimore, Maryland

Miles White, Guilford (1924)

J. Hall Pleasants file

797. *Nathaniel P. Willis, Esq.* [at age 25]

Sketch on paper

3 1/4 x 4 5/8 in. (8.3 x 11.8 cm.)

(1834)

Mrs. L. Vernon Miller, Sr.

REFERENCES

Journal, p. 14

798. *Wilson* [infant child]

Unlocated

REFERENCES

account book, January 28, 1850, $75, for H. Wilson

799. *Mary Wilson*

Mrs. William S. Hilles

EXHIBITIONS

Peale Museum, Baltimore, 1950

REFERENCES

account book, April 26, 1858, $50; Hunter, p. [14]

800. *Melville Wilson*

Cabinet-size portrait

Unlocated

REFERENCES

account book, April 24, 1855, $50, for Wm. C. Wilson

801. *Thos. Wilson* [copy]

Unlocated

REFERENCES

account book, April 20, 1846, $50, for Dr. Wilson

802. *William C. Wilson*

Oil on academy board (oval)

Kit-cat-size portrait: 15 1/2 x 12 1/4 in. (39.4 x 31.1 cm.)

(1854)

Unlocated

PROVENANCE

Mrs. William D. Poultney (1939)

REFERENCES

account book, November 24, 1854, $100; J. Hall Pleasants file

803. *William C. Wilson*

Oil on canvas

Cabinet-size portrait: 24 x 17 1/2 in. (60.9 x 44.4 cm.)

Paper label on original frame: "Looking Glass/Portrait . . ."

Mr. and Mrs. Hugh Bennett, Baltimore

PROVENANCE

by descent to the present owners

REFERENCES

account book, March 20, 1856, seated, full length, $50

804. *William Thomas Wilson*

Oil on canvas

Mrs. William S. Hilles

EXHIBITIONS

Peale Museum, Baltimore, 1950

REFERENCES

account book, April 26, 1858, $50; Hunter, p. [14]

805. *Miss Julia Winans (Mrs. George W. Whistler, Jr.)* (1825–1875)

Oil

(1847)

Unlocated

PROVENANCE

Ross Winans (1847); Miss Elise Celeste Hutton and Mrs. Harold A. Pritchard, Newport, R.I. (1941)

EXHIBITIONS

Peale Museum, Baltimore, 1950

REFERENCES

account book, December 28, 1847, $100, for Ross Winans; J. Hall Pleasants file; Hunter, p. [14]

806. *Mrs. Thomas DeKay Winans (Elise Celeste Revillon)* (1830–1861)

Oil on canvas

(1847)

Unlocated

PROVENANCE

Ross Winans (1847); Miss Elise Celeste Hutton and Mrs. Harold A. Pritchard, Newport, R.I. (1941)

EXHIBITIONS

Peale Museum, Baltimore, 1950

REFERENCES

account book, December 28, 1847, $100, for Ross Winans; J. Hall Pleasants file; Hunter, p. [14]

807. *Mr. Young*

Cabinet-size portrait

Unlocated

REFERENCES

account book, August 29, 1849, $37

808. *Mrs. Young*

29 x 36 in. (73.7 x 91.4 cm.)

Unlocated

REFERENCES

account book, January 12, 1858, $150, for Wm. T. Young

809. *Portrait of a Lady*

Oil on panel with bevelled edges

12 x 9 3/4 in. (30.4 x 23.8 cm.)

Stiles Colwill, Baltimore

PROVENANCE

Mrs. D. H. Miller

810. *Portrait of a Gentleman*

Oil on canvas (oval)

29 x 23 in. (73.7 x 58.4 cm.)

Harmsen's Western Americana, Denver, Colorado
(c. 1969)

PROVENANCE

Rosenstock Arts, Denver

811. *Portrait of an Unknown Gentleman*

Oil on canvas

30 x 25 in. (76.2 x 63.5 cm.)

J. W. Berry and Son, Baltimore

812. *Miller's Studio Boy*

Oil on canvas

23 13/16 x 19 7/8 in. (60.5 x 50.5 cm.)

Maryland Historical Society, Baltimore 56.75.3

813. *Sketch of a Man*

Ink on paper

Signed, l.r.: "A. J. Miller"

(c. 1845)

The Baltimore Museum of Art, *Scrapbook of Frank B. Mayer* (1850), 36.496

814. *Benjamin Franklin*

Oil on paper (oval)

13 x 8 in. (33.0 x 20.3 cm.)

Private collection, Baltimore

PROVENANCE

the artist; by descent to L. Vernon Miller, Sr.

814A. *Benjamin Franklin*

Oil on canvas (oval cut-out frame)

17 x 14 in. (43.2 x 35.5 cm.)

(c. 1847)

Stamp on verso: "PREPARED/BY/ED*wd* DECHAUX/NEW YORK; FROM W. A. WISONG/No 2 N. Liberty St./BALTIMORE"

Martin Kodner, St. Louis, Missouri

PROVENANCE

Ross Winans, Baltimore (1847); Mr. and Mrs. Arthur Clarke, Baltimore; Donald Webster, Chevy Chase, Md. (c. 1970); Hirschl & Adler Galleries, New York (1969–1977)

EXHIBITIONS

Engineers Club, Mt. Vernon Square, Baltimore

REFERENCES

account book, December 28, 1847, $40, for Ross Winans; advertisement for Hirschl & Adler Galleries, *Antiques* 97, no. 6 (June 1970): 848 (illus.); Randall, "Gallery for Alfred Jacob Miller," p. 840

815. *Washington Irving Being Presented to George Washington*

Oil on canvas

7 x 5 in. (17.8 x 12.7 cm.)

Signed, l.l.: "AJM. [monogram]"

S. L. M., Inc., Corning, Arkansas

PROVENANCE

the artist; Hugh Purviance King; by descent to Mrs. Francis K. Montgomery; Chapellier Galleries, New York; Museum Art Exchange, Boston (c. 1970); Martin Kodner, St. Louis; Kennedy Galleries, New York; Bernard and S. Dean Levy, New York (c. 1977)

REFERENCES

account book, cited in Randall, "Gallery for Alfred Jacob Miller," p. 840

816. *George Washington*

Oil on canvas (oval cut-out frame)

17 x 13 7/8 in. (43.2 x 35.2 cm.)

(c. 1847)

Stamp on verso: "PREPARED/BY/ED*wd* DECHAUX/NEW YORK; FROM W. A. WISONG/No 2 N. Liberty St./BALTIMORE"

Martin Kodner, St. Louis, Missouri

PROVENANCE

Ross Winans, Baltimore (1847); Mr. and Mrs. Arthur Clarke, Baltimore; Donald Webster, Chevy Chase, Md. (c. 1970); Hirschl & Adler Galleries, New York (1969–1977)

EXHIBITIONS

Engineers Club, Mt. Vernon Square, Baltimore

REFERENCES

account book, December 28, 1847, $40, for Ross Winans; advertisement for Hirschl & Adler Galleries, *Antiques* 97, no. 6 (June 1970): 848 (illus.); Randall, "Gallery for Alfred Jacob Miller," p. 840

817. *George Washington at Mount Vernon*

Oil on canvas

16 1/2 x 13 3/16 in. (40.2 x 33.5 cm.)

The Walters Art Gallery, Baltimore 37.2526; gift of Mrs. Frances W. Haussner, Baltimore, 1976

PROVENANCE

Mrs. Frances W. Haussner, Baltimore

REFERENCES

Walters Art Gallery Forty-fourth Annual Report (1976), illus. p. 46

818. *Daniel Webster at Marshfield*

Unlocated

EXHIBITIONS

Maryland Historical Society Annual Exhibition (1853), no. 183 (collection of Thos Cunningham)

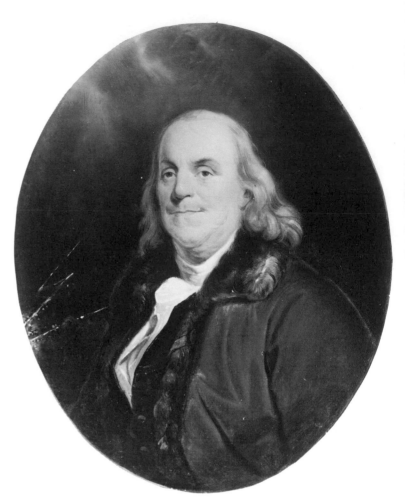

Catalogue number 814A.

819. *Sketch of George Washington's Tomb*

On paper

(summer 1832)

Unlocated

REFERENCES

Journal, p. 5

820. *View of the City of Baltimore*

Oil on canvas

60 x 42 in. (152 x 106.7 cm.)

Unlocated

REFERENCES

Journal, p. 54

821. *Baltimore View* [looking west from Laudenslager Hill]

Oil on paper

4 1/8 x 7 1/8 in. (upper right corner missing) (10.5 x 18.1 cm.)

Labeled: "Effect of Light. Autumnal Distant View of City of Balt—"

The L. Vernon Miller Family

PROVENANCE

the artist; by descent to the present owners

822. *Evening on the Brandywine*

Oil on canvas

26 7/8 x 43 3/8 in. (68.2 x 110.2 cm.)

Signed and dated, l.r.: "A Miller—/'73"

Unlocated

PROVENANCE

Gallery 21; Hirschl & Adler Galleries, New York (November 16–December, 1968); Gallery 21

823. *Gwynns Falls*

Ink, wash, and watercolor

6 1/4 x 9 7/8 in. (15.9 x 25.1 cm.)

Inscribed: "Gwins [*sic*] Falls"

The L. Vernon Miller Family

PROVENANCE

the artist; by descent to the present owners

824. *Hollingsworth Mill on Jones Falls (Hollingsworth-Timanus Mill)*

Watercolor on paper

11 5/8 x 18 3/8 in. (29.6 x 46.7 cm.)

Signed, l.r.: "AJM [monogram] iller"

(1830–1840)

Maryland Historical Society, Baltimore 44.58.1; gift of Alfred J. Miller

PROVENANCE

the artist; by descent to his great nephew, Alfred J. Miller

EXHIBITIONS

Baltimore Museum of Art, May 11–June 17, 1945

REFERENCES

Baltimore Museum of Art, *Two Hundred and Fifty Years of Painting in Maryland*, no. 131

825. *Landscape, View in Italy*

Unlocated

EXHIBITIONS

Boston Athenaeum (1839), no. 70 (collection of W. Hayward)

REFERENCES

Perkins and Gavin, *Boston Athenaeum Art Exhibition Index*, entry for "Miller"

826. *Temple of Vesta, Rome*

Watercolor on paper

7 3/4 x 11 in. (19.7 x 27.9 cm.)

Museum of Fine Arts, Boston, Massachusetts 50.3866

PROVENANCE

the artist; by descent to Louisa Whyte Norton; Old Print Shop, New York (1947)

EXHIBITIONS

MFA, October 18, 1962–January 6, 1963

REFERENCES

Old Print Shop ledger book (June 18, 1947), no. 59; MFA, *Water Colors*, I, no. 553

827. *View near Rome*

Unlocated

EXHIBITIONS

Maryland Historical Society Annual Exhibition (1856), no. 23 (collection of Dr. Edmondson)

828. *Lake of Killarney*
Watercolor on paper
4 3/4 x 6 3/4 in. (12.1 x 17.2 cm.)
Mrs. Hugh Montgomery, Lookout Mountain, Tennessee
PROVENANCE
the artist; by descent to the present owner

829. *View on the Shenandoah*
Unlocated
EXHIBITIONS
American Art-Union, New York, August 26, 1853, $60

830. *On the Shenandoah near Harper's Ferry*
Unlocated
PROVENANCE
the artist; Lloyd O. Miller
EXHIBITIONS
Peale Museum, Baltimore, January 1950
REFERENCES
Hunter, p. [15]

831. *Shenandoah Valley, Virginia*
Watercolor on paper
11 1/4 x 9 1/4 in. (28.6 x 23.5 cm.)
Signed, l.r.: "Miller Pt"
The Thomas Gilcrease Institute of American History and
Art, Tulsa, Oklahoma 0226.1115

832. *View from Staten Island*
Unlocated
EXHIBITIONS
Boston Athenaeum (1834), no. 67 (for sale)
REFERENCES
Perkins and Gavin, *Boston Athenaeum Art Exhibition
Index,* entry for "Miller"

833. *Ruins of an Old Bridge and Harbor*
Unlocated
EXHIBITIONS
Maryland Historical Society Annual Exhibition (1858),
no. 10 (estate of Dr. Edmondson)

834. *View on a Stream*
Watercolor on paper
13 1/4 x 19 1/2 in. (33.8 x 49.5 cm.)
Maryland Historical Society, Baltimore 45.15.1; gift of
Alfred J. Miller

PROVENANCE
the artist; by descent to his great-nephew, Alfred J.
Miller

835. Untitled [mountain scene: three figures
 standing on a rocky hillside in right
 foreground; lake in a valley and more
 mountains in the distance]
Oil on paper mounted on stiff backing
5 x 7 in. (12.8 x 17.9 cm.)
(painted at Murthly Castle, 1840–1841)
Maryland Historical Society, Baltimore 54.151.2; gift of
Mrs. Laurence R. Carton

836. *Camp on the River*
Watercolor and gouache on paper
11 x 9 in. (27.9 x 22.8 cm.)
Signed, l.c.: "AJM [monogram] iller"
The Thomas Gilcrease Institute of American History and
Art, Tulsa, Oklahoma 0236.1099

837. *Falls in the Mountains*
Oil on academy board
6 x 8 1/2 in. (15.2 x 21.6 cm.)
Kennedy Galleries, Inc., New York (neg. no. T 5664)
PROVENANCE
Mr. Bassin, Post Road Antiques, Mamaroneck, N.Y.

838. *Glacier*
Watercolor on paper
6 1/4 x 4 3/4 in. (15.9 x 12.1 cm.)
The Thomas Gilcrease Institute of American History and
Art, Tulsa, Oklahoma 0226.1102

839. *Lorraine—40 Acres—American Poplars*
Pencil, pen and ink, and wash on paper
11 1/4 x 8 1/2 in. (28.6 x 21.6 cm.)
Inscribed, l.r.: "American poplars/Lorraine/40 Acres"
The Thomas Gilcrease Institute of American History and
Art, Tulsa, Oklahoma 0226.1111

840. *Sea Coast*
Pen and ink, watercolor, and gouache on paper
6 1/2 x 10 in. (16.6 x 25.4 cm.)
Joslyn Art Museum, Omaha, Nebraska; InterNorth Art
Foundation Collection 754

PROVENANCE
Porter collection

EXHIBITIONS
Nelson, January 1939

841. *Second View—Swann Lake*

Brown wash on paper

6 1/8 x 9 1/8 in. (15.6 x 23.2 cm.)

Signed, l.l.: "AJM [monogram]"

Inscribed on mount: "2nd view—Swann Lake"; on verso of mount: "118/Carrie C. Miller/3 Oklahoma Terrace/ Annapolis, Maryland"

Joslyn Art Museum, Omaha, Nebraska; InterNorth Art Foundation Collection 756

PROVENANCE
Carrie C. Miller, Annapolis

842. *Snake Hill: Spring*

Watercolor on paper

8 1/4 x 9 1/4 in. (21.0 x 23.5 cm.)

Inscribed, u.c : "Snake Hill."; l.c.: "Spring."

Kennedy Galleries, Inc., New York (c. 1978; neg. no. T 5021)

PROVENANCE
Martin Kodner, St. Louis

REFERENCES
Kennedy Quarterly 16, no. 4 (June 1979): no. 162 (illus.)

843. *Snake Hill: Summer*

Watercolor on paper

8 1/4 x 9 1/4 in. (21.0 x 23.5 cm.)

Inscribed, u.c.: "Snake Hill."; l.c.: "Summer"

Kennedy Galleries, Inc., New York (c. 1978; neg. no. T 5022)

PROVENANCE
Martin Kodner, St. Louis

REFERENCES
Kennedy Quarterly 16, no. 4 (June 1979): no. 163 (illus.)

844. *Snake Hill: Autumn*

Watercolor on paper

8 1/4 x 9 1/4 in. (21.0 x 23.5 cm.)

Inscribed, u.c.: "Snake Hill."; l.c.: "Autumn."

Kennedy Galleries, Inc., New York (c. 1978; neg. no. T 5024)

PROVENANCE
Martin Kodner, St. Louis

REFERENCES
Kennedy Quarterly 16, no. 4 (June 1979): no. 164 (illus.)

845. *Snake Hill: Winter*

Watercolor on paper

8 1/4 x 9 1/4 in. (21.0 x 23.5 cm.)

Inscribed, u.c.: "Snake Hill."; l.c.: "Winter."

Kennedy Galleries, Inc., New York (c. 1978; neg. no. T 5023)

PROVENANCE
Martin Kodner, St. Louis

REFERENCES
Kennedy Quarterly 16, no. 4 (June 1979): no. 165 (illus.)

846. *Ruins* [after Cororanti [*sic*], actually Leonardo Coccorante]

Unlocated

REFERENCES
account book, January 2, 1846, $200, for J. S. McKim

847. *Danae* [after Correggio]

(1831)

Unlocated

PROVENANCE
Mr. Hoffman (1847); Maryland Historical Society (1853); Mrs. Oscar Coblentz, Baltimore (1950)

EXHIBITIONS
Pennsylvania Academy of the Fine Arts, Philadelphia (1847); Maryland Historical Society Annual Exhibition (1853), no. 230; Peale Museum, Baltimore, 1950

REFERENCES
Hunter, p. [14]

848. *Portrait of a Lady* [in the manner of J. B. Greuze]

Oil on wood

16 x 19 in. (40.7 x 48.2 cm.)

Unlocated

PROVENANCE
estate of Alfred J. Miller (1970)

849. Copy of portrait of Admiral Rodney's daughters by George Henry Harlowe [three heads]

Unlocated

REFERENCES
undated letter in the L. Vernon Miller family collection

850. *Rembrandt's Portrait of Himself* [copy of portrait of young Rembrandt in an oval format]

Oil on artist's board

8 1/4 x 6 3/4 in. (21.0 x 17.1 cm.)

Inscribed and signed on verso: "from Rembrandt/of himself/by A J Miller"

The Cloisters Children's Museum, Baltimore

PROVENANCE
Mr. and Mrs. Sumner Parker

851. *Rembrandt*

Unlocated

EXHIBITIONS
Boston Athenaeum (1835), no. 62 (for sale)

REFERENCES
Perkins and Gavin, *Boston Athenaeum Art Exhibition Index,* entry for "Miller"

852. Copy, head of Rembrandt

Unlocated

EXHIBITIONS
Maryland Historical Society Annual Exhibition (1858), no. 95 (estate of Dr. Edmondson)

REFERENCES
account book, October 1, 1849, $30, for Dr. Edmondson

853. *The Infant Samuel* [after Reynolds]

Unlocated

PROVENANCE
estate of Hugh Caperton (1933)

EXHIBITIONS
Maryland Historical Society Annual Exhibition (1849), no. 168 (collection of the artist)

REFERENCES
J. Halls Pleasants file

854. *Piety or Charity* [copy of work by Schidone in the possession of Joseph Bonaparte]

(before 1836)

Unlocated

EXHIBITIONS
Peale's Baltimore Museum, November 7, 1836

REFERENCES
Baltimore and Commerical Daily Advertiser, November 7, 1836

855. *Copy after Sully*

Unlocated

REFERENCES
account book, May 31, 1854, $35, for Jas. Coale

856. *Allegory of Alfonso d'Avalos* [copy from Titian]

Oil on canvas

45 x 42 in. (114.3 x 106.7 cm.)

(c. 1833)

Mr. George Durrett, Baltimore

PROVENANCE

Dr. Thomas Edmondson; Johns Hopkins; Johns Hopkins Hospital

EXHIBITIONS

Maryland Historical Society Annual Exhibition (1858), no. 60 (estate of Dr. Edmondson); Peale Museum, Baltimore, 1950

REFERENCES

J. Hall Pleasants file (as "painted for Johns Hopkins"); Hunter, p. [14]

857. *Christ Crowned with Thorns* [after Titian]

Oil on board

14 1/4 x 11 in. (36.2 x 27.9 cm.)

Inscribed, dated, and signed: "Sketch from Titian/Paris—1833/by Alfred J. Miller"

Unlocated

PROVENANCE

sale: SPB, September 18, 1980

REFERENCES

SPB sale no. 4416M (September 18, 1980), lot 107 (illus.)

858. Pair of copies of Van Dyck portraits

47 x 36 1/2 in. (119.4 x 92.7 cm.)

Maryland Historical Society, Baltimore; gift of Miss Harriet Miller

PROVENANCE

the artist; willed to his sister Harriet Miller

859. *Spanish Gentleman* [after Van Dyck]

(1850)

Maryland Historical Society

PROVENANCE

Dr. Thomas Edmondson (1856)

EXHIBITIONS

Maryland Historical Society Annual Exhibition (1856), no. 71 (collection of Dr. Edmondson)

REFERENCES

account book, February 13, 1850, $60

860. *Europa and the White Bull* [detail, after Paul Veronese]

Sketch in color

Unlocated

REFERENCES

AJM to sister Harriet, January 3, 1874, for Col. B. Mayer "to accept the sketch in color of 'Europa & The White Bull' from the original by Paul Veronese which he seemed to admire"

861. *Feast in the House of Levi* [detail, after Veronese]

Oil on canvas

13 3/4 x 10 3/4 in. (34.9 x 27.4 cm.)

Inscribed, signed, and dated: "Venice Academia Salle x AJM [monogram] 1831"

Private collection, Augusta, Georgia

862. *Jesus in the House of Simon the Pharisee* [detail, after Veronese]

Oil on canvas

13 3/4 x 9 3/4 in. (34.9 x 24.7 cm.)

Inscribed: "Copy of Veronese's Jesus in the House of Simon the Pharisee Louvre 183[?]" [actually at Versailles]

Private collection, Augusta, Georgia

863. *Webster at Marshfield*

Cabinet size

Unlocated

REFERENCES

account book, April 10, 1853, $30, for Cunningham

864. *Copy for Carroll Spence*

Unlocated

REFERENCES

account book, September 11, 1846, $30

865. *Copy of picture for W. W. Spence*

Unlocated

REFERENCES

account book, December 28, 1854, $50

866. *Copy of head of* [Guido Reni's *Beatrice Cenci*]

Unlocated

REFERENCES

account book, October 13, 1856, $50, for Chas. Lee

Religious Pictures

867. *Christ's Charge to Peter*

Unlocated, church in Scotland

REFERENCES

account book, February 5, 1846, $800, for Sir Wm.
Drummond Stewart; Early, *Alfred J. Miller*, p. 4

**868. *The Destruction of Sodom—Storm,
Earthquake, and Molten Fire***

Unlocated

EXHIBITIONS

Boston Athenaeum (1834), no. 86 (for sale)

REFERENCES

Perkins and Gavin, *Boston Athenaeum Art Exhibition
Index*, entry for "Miller"

869. *Jepthah's Vow*

Unlocated, church in Scotland

REFERENCES

account book, February 6, 1847, $968.88, for Sir Wm. D.
Stewart; Early, *Alfred J. Miller*, p. 4

870. *Judith and Hollofernes*

Oil on paper, mounted on masonite

10 x 7 in. (25.4 x 17.8 cm.)

Signed, l.r.: "AJM. [monogram]"

Washington County Museum of Fine Arts, Hagerstown,
Maryland

PROVENANCE

John Butler (1969)

**871. *Mary Magdalen Anointing the Feet of Our
Saviour***

Unlocated, church in Scotland

REFERENCES

Early, *Alfred J. Miller*, p. 4

872. *Prodigal Son*

Unlocated

EXHIBITIONS

Boston Athenaeum (1835), no. 24 (for sale)

REFERENCES

Perkins and Gavin, *Boston Athenaeum Art Exhibition
Index*, entry for "Miller"

873. *The Return of the Prodigal Son*

Pen and black ink and wash on paper (spliced at top)
with traces of brownish body-color

Sight: 14 x 11 in. (35.5 x 27.9 cm.)

Inscribed, l.r.: "Prodigal Son"

W. T. Hassett, Jr.

PROVENANCE

Hugh Purviance King; Mrs. Frances K. Montgomery;
Anslew Gallery

874. *Ruth and Boaz*

(c. 1845)

Unlocated

REFERENCES

National Academy of Design, New York (1845), no. 302;
Maryland Historical Society Annual Exhibition (1849),
no. 63 (collection of R. W. Pendleton)

875. *Religious Picture*

Oil on canvas

(c. December 1841–March 1842)

Unlocated

REFERENCES

AJM to D. H. Miller, December 25, 1841, and February
10, 1842, cited in Warner, pp. 188, 191

876. *Designs of Historical Scenes from Bible*

(c. February–March 1844)

Unlocated

REFERENCES

AJM to Sir Wm. Stewart, March 16, 1944, cited in
Warner, p. 193

877. *The Fountain*
Oil on artist's board
9 1/2 x 11 1/4 in. (24.1 x 28.6 cm.)
Signed and inscribed: "A J Miller Roma 1833"
Norton Asner, Baltimore, Maryland

PROVENANCE
Decatur H. Miller

878. *View of Tower* [of London]
Sketch
(c. November 22, 1841)
Unlocated

REFERENCES
AJM to D. H. Miller, November 22, 1841, cited in Warner, p. 187

879. *Sketch of Buffalo Chairs at Murthly*
(c. June 24, 1841)
Unlocated

REFERENCES
AJM to Theodore Miller, June 24, 1841, cited in Warner, p. 178

880. *View from Garden, Murthly Castle*
Watercolor on paper
5 x 7 5/8 in. (12.8 x 19.3 cm.)
Inscribed, l.l.: "Garden/[Summer house?]/Murthly Castle"; on mount, l.l.: "date on dormer window/1646"; on mount, l.r.: "Smoking hall/view from Garden—Murthly Castle/Scotland"
Maryland Historical Society, Baltimore 54.151.4; gift of Mrs. Laurence R. Carton

PROVENANCE
the artist; by descent to Mrs. Laurence R. Carton

881. *Rochalion* [sic] *—Shooting Villa near Murthly Castle*
Pen and ink with wash on paper
4 1/2 x 7 3/8 in. (11.5 x 18.7 cm.)
Inscribed on mount, l.l.: "Scotland"; on mount, l.r.: "Rochalion/Shooting Villa near Murthly Castle"
Maryland Historical Society, Baltimore 54.151.5; gift of Mrs. Laurence R. Carton

PROVENANCE
the artist; by descent to Mrs. Laurence R. Carton

882. *Bronte*
Pencil with ink wash on paper
5 1/8 x 9 1/2 in. (13.0 x 24.1 cm.)
Inscribed, l.r.: "Bronte/Mt [sic] St Bernard"
Maryland Historical Society, Baltimore 54.151.7; gift of Mrs. Laurence R. Carton

PROVENANCE
the artist; by descent to Mrs. Laurence R. Carton

883. *Pill*
Pencil with ink wash on paper
4 7/8 x 4 1/8 in. (12.5 x 10.4 cm.)
Inscribed, l.r.: "Pill"
Maryland Historical Society, Baltimore 54.151.8; gift of Mrs. Laurence R. Carton

PROVENANCE
the artist; by descent to Mrs. Laurence R. Carton

884. *Design for Ship Ravenel*
Unlocated

REFERENCES
account book, July 6, 1846, $10

885. *Kate Harbell*
Unlocated

EXHIBITIONS
Maryland Historical Society Annual Exhibition (1849), no. 266 (collection of the artist)

886. *Fruit*
Unlocated

EXHIBITIONS
Maryland Historical Society Annual Exhibition (1856), no. 102 (collection of the artist)

887. *Tomb of Cains Cestisos* [Caius Cestius]
Oil on canvas
8 x 11 1/2 in. (20.3 x 29.2 cm.)
Inscribed on verso: "Tomb of Cains Cestisos"
The Dentzel Collection 1034

888-1. Boy falling over stool with broken jug

Pencil, brown ink, white, and wash on brown paper

4 3/4 x 6 1/8 in. (12.1 x 15.5 cm.)

Signed, l.l.; "AJM. [monogram]"

Inscribed: "Let him who is sanguine, take heart, lest he miscarry."; label: "It's always so, whenever I am in a hurry."

888-2. Man seated on bench in prison cell with mouse [scene from the life of Jean-Henry Latude (1725–1805), who was imprisoned in various jails from 1749 to 1797]

Pencil, brown ink, black ink, and wash on white paper

7 9/16 x 5 3/4 in. (19.2 x 14.6 cm.)

Inscribed: "Latude in the Bastille making friends with a mouse"

888-3. Three boys, lying, sitting, and standing

Brown ink, black ink, pencil, and wash on brown paper

4 9/16 x 6 1/8 in. (11.6 x 15.5 cm.)

Signed, l.r.: "AJM [monogram]"

Inscribed: "News boys in winter—New York" "Jack, these printing offices keep up the steam all night through the grates, so all I have to do is to curl myself up & go to sleep—snug & warm."; label: "News boys in New York, Winter 3 o'clk a.m."

888-4. Men at table during a meal

Black ink, brown ink, white, wash, and pencil on brown paper

7 1/2 x 5 3/4 in. (19.1 x 14.6 cm.)

Signed, l.l.: "AJM. [monogram]"

Inscribed: "Joe (*loquitur*) 'Bob, will you have a sausage?, Bob–No! I'll be *dogged* if I do. ____, without they are home-made I am never quite certain of what they are composed,"

888-5. Men at table with drinking glasses and newspaper

Pencil, brown ink, black ink, wash, and white on brown paper

5 1/4 x 4 7/8 in. (13.3 x 12.4 cm.)

Label: "This Dutch gent, rearing [reading?] an account of an elopement expresses himself thus forcibly! 'If my wife runs away wit anoder man's wife, I shake him out of his breeches, if she be my fadder—mine Got!' "

888-6. Cupid with knife and bow

Pencil, black ink, crayon, watercolor, and wash on white paper

8 1/4 x 6 1/2 in. (21.0 x 16.5 cm.)

Label: "How many perils do environ, the boy who meddles with cold iron."

888-7. Woman and elderly man at a desk

Pencil, black ink, and wash on blue-gray paper

6 1/8 x 4 5/8 in. (15.5 x 11.7 cm.)

Label: "Pater familias (*loquitur*)—'Jane, I wonder what your mistress will want next?—It is impossible for me to keep a cent of money in my pocket.!!' "

888-8. Man and boy fishing from a boat

Black ink, white, and pencil on brown paper

6 5/16 x 10 3/8 in. (16.0 x 26.4 cm.)

Label: "Uncle H—fishing with 3 rods. Hawkins Point"

888-9. Gendarme pointing pistol at robed figure

Pencil, black ink, and wash on white paper

6 1/8 x 4 5/8 in. (15.5 x 11.7 cm.)

Label: "How to Lay a Ghost!"

888-10. Man watching another open oysters

Brown ink, black ink, white, and wash on brown paper

6 1/16 x 4 11/16 in. (15.3 x 12.6 cm.)

Label: "York River/'Its all very well to open that oyster Sam, but who is to swallow it?' "

888-11. Two women leading chickens

Brown ink, pencil, and wash on white paper

7 5/16 x 5 1/8 in. (18.6 x 13.0 cm.)

Label; "Feeding the chicks"

888-12. Three women, two seated, talking

Black ink, pencil, and wash on white paper

6 1/2 x 5 1/4 in. (16.5 x 13.3 cm.)

Label; "The latest Scandal. 'Ah ha!—Indeed!—indeed!! You don't say so?!!!' "

888-13. Girl selling flowers

Black ink, pencil, white, and wash on brown paper

5 3/4 x 4 1/2 in. (14.6 x 11.5 cm.)

Inscribed: "Flower girl—Roma"; label: "Volete bella fiore, Sigmore. Will you buy some fine flowers gentlemen?"

888-14. Men against lamp post with children

Black ink, brown ink, wash, and pencil on white paper

5 3/4 x 4 1/8 in. (14.6 x 10.5 cm.)

Label: "You must move on 'old bottle nose'—the city won't pay you anything for holding up the lamp post."

888-15. Two men restraining a third man

Black ink, pencil, and wash on brown paper

6 1/4 x 4 9/16 in. (15.8 x 11.6 cm.)

Label: "Loves labor lost—Shakespeare/Costard— 'Wellcome [sic] the sour cup of prosperity—affliction may one day smile again.' "

888-16. One man passing two other men on the street

Black ink, brown ink, wash, and pencil on brown paper

6 1/8 x 4 5/8 in. (15.5 x 11.7 cm.)

Signed, u.l. of label: "AJM [monogram]"

Label: "Charley!—When you see an old party like that, with his hat stuck over one eye, depend on it that he is a conceited, pig headed stubborn & unreasonable old chap."

888-17. Man reading newspaper while woman sets table for meal

Brown ink, black ink, pencil, wash, and white on brown paper

6 x 4 1/16 in. (15.3 x 10.3 cm.)

Label: "Mr. Fussaround is always in a hurry for his breakfast.—Madam thinks he must have the world on his shoulders."

888-18. Man chasing his hat in a street

Pencil, black ink, white, and wash on brown paper

5 1/16 x 4 3/4 in. (12.8 x 12.1 cm.)

Label: "Absurd state of affairs, the time to possess ye soul in patience."

888-19. Apothecarian reads a boy's note while a woman looks on

Black ink, pencil, and wash on brown paper

6 1/16 x 4 9/16 in. (15.4 x 11.6 cm.)

Label: "Please give the bara sumphin to fisick him 15 cents worth."

888-20. Man standing behind another seated reading newspaper

Black ink, brown ink, and wash on white paper

3 15/16 x 3 1/2 in. (10.0 x 8.9 cm.)

Label: "This Stupid fellow has been reading the paper for near two hours—I should like to choke him."

888-21. Two men in a bookshop [from James Boswell, *Life of Samuel Johnson*, 1791]

Black ink, wash, and pencil on white paper

5 3/4 x 4 1/16 in. (14.6 x 10.3 cm.)

Label: "Dr. Johnson & Davis, bookseller"

888-22. Woman and a milkman

White, black ink, and wash on brown paper

6 x 6 1/2 in. (15.3 x 16.5 cm.)

Inscribed: "Milk man of 1825"; label: "Recollections— Milk Man 1825"

888-23. Man running to help another falling down stairs

Black ink, wash, and white on brown paper

6 1/4 x 6 1/2 in. (15.9 x 16.5 cm.)

Label: "Tom (who is somewhat dissipated) falls from the top to the bottom of the stairs!, Jim (running to help)— 'Hope you hav'nt hurt yourself Tom?' Tom—'not much, this is the way I always come down stairs!' "

888-24. Seated man thrusting a crutch at another man standing [from Laurence Sterne, *Tristram Shandy*, 1767]

Brown ink, pencil, black ink, wash, and white on brown paper

6 1/4 x 4 7/8 in. (15.9 x 12.4 cm.)

Signed, l.l.: "AJM [monogram]"

Label: "Uncle Toby & Trim/Bless your honor cried Trim! advancing three steps,—does a man think of his Christian name when he goes upon an attack? or when he stands in a trench Trim? cried my Uncle Toby or when he enters a breach? said Trim pushing in between two chairs. or forcing the lines cried my uncle Toby?—rising up & pushing his crutch like a pike. Tristram Shandy"

888-25. Man speaking from a platform

Black ink, brown ink, wash, white, and pencil on brown paper

6 1/8 x 4 in. (15.5 x 10.2 cm.)

Inscribed: "A Sterling patriot"

Label: "My 'ke-ind' friends—only give me an office & I will take care of myself after that!"

888-26. Woman with tambourine

Black ink, brown ink, wash, and pencil on blue-gray paper

7 1/2 x 6 in. (19.1 x 15.3 cm.)

Signed, l.r.: "AJM [monogram] iller"

Label: "Italian Cantatrice & Ballerina"

888-27. Traveling man and crying boy [from Victor Hugo, *Les Misérables*, 1862]

Black ink, wash, and pencil on white paper

6 1/2 x 5 in. (16.5 x 12.7 cm.)

Signed, l.r.: "AJM [monogram]"

Inscribed, l.l.: "Les Miserables V. Hugo" [repeated slightly larger and darker: "Les Miserables"]; label: "Jean val Jean and the Savoyard Victor Hugo"

888-28. Four monks overlooking Rome

Black ink, pencil, wash, and watercolor on light brown paper

Dimensions not given

Signed, l.r.: "AJM [monogram]"

Inscribed: "Pincian Hill—Roma *Monks*"

888-29. Man speaking into tube in an office

Black ink, brown ink, pencil and wash on brown paper

8 1/2 x 7 1/8 in. (21.6 x 18.1 cm.)

Label: "The old clerk of the great criminal Lawyer, comes late—obfuscated by drink—the clerks chaff him,—he abuses Mr. Proviso. Jocular clerk—'Well.—Mr. Proviso is up in his room—tell him so up the tube, like a man.' Jolly Bacchus—'Misher Provishe-o, shir—I'm not going to be dictated by you—You're a hum'ug & an impos'er, shir an you know it.—I've more law in my lill'e finger, shir, than you have in—whole body shir.' "

888-30. Entertainer on stage with lions

Black ink, brown ink, wash, and white on brown paper

8 1/8 x 10 1/2 in. (20.6 x 26.6 cm.)

Label: "Herr Prussiwassin has just put his head into the Lions mouth who being in an ill humor, has nearly bitten it off—*he makes a speech*—'Bray not to be vrightened ladies & shentlemens, id is nothing.' Some of the audience are horrified, but a part *disappointed* not having what they *paid* to see."

888-31. Man sitting next to woman holding broom

Black ink, brown ink, wash, and white on brown paper

Signed, l.l: "AJM [monogram]"

Inscribed: "Fritz' Honey moon"; label: "Fritz (*loqr*) 'I'd vas youst so easy as a needle cood valk out mit a camel's eye as to get der behindt voud mit a voorman's.' "

888-32. Two men and a dog on the beach

Black and brown ink on beige paper

4 5/8 x 6 in. (11.7 x 15.3 cm.)

Signed, l.l.: "AJM [monogram]"

Inscribed: "Beach at Cape May"; label: "Consolation for the afflicted!—who cannot go to Cape May—viz—cant get away club, when there is a land breeze—two gangs of mosquitoes are laid on us!! the wide awake squad, reserved for the night!!!"

888-33. Man with bandaged head

Black ink, brown ink, white, pencil, and wash on blue paper

6 1/8 x 3 7/8 in. (15.5 x 9.8 cm.)

Label: "Oh! I dessay you want to know how that happened. Well, if you must know, the pavement flew up—&—Oh brother!"

888-34. Newspaper boy

Watercolor, ink, and pencil on brown paper

5 5/8 x 3 5/8 in. (14.3 x 9.2 cm.)

Inscribed: "Here's the Moo-ning Sun, who wants the Moo-ning Sun."; label: "5 o'clock a.m."

888-35. Man at a door

Black ink, pencil, and wash on brown paper

6 1/8 x 4 5/8 in. (15.5 x 11.7 cm.)

888-36. Children's bedroom at top of staircase

Black ink, brown ink, wash, and pencil on brown paper

6 1/8 x 4 5/8 in. (15.5 x 11.7 cm.)

Signed, l.l.: "AJM [monogram]"

Label: "Mother (calling from bottom of Stairs) 'What are you bellowing about Bill?' Bill—'Please, mother, Jim wants half the bed.' Bill—'Yes, mother, but he will have his half out of the middle and makes me sleep on both sides of him.' "

888-37. Woman seated holding small shoe

Black ink, wash, crayon, and pencil on brown paper (oval)

8 1/2 x 6 5/8 in. (21.6 x 16.8 cm.)

Signed, l.l.: "AJM [monogram]"

Inscribed: "Souvenir, The tiny Shoe"

888-38. Man, woman, and child standing outside building

Black ink, brown ink, wash, and watercolor

6 x 4 13/16 in. (15.3 x 12.2 cm.)

Label: "The hard Case"

888-39. Woman with child sitting on her bustle

Watercolor, black ink, brown ink, and wash on brown paper

6 x 4 7/8 in. (15.3 x 12.4 cm.)

Label: " 'Utile cum dulci' Found a good use for the pannier at last. What have you to say to this?, Mr. Grumbler?"

888-40. Two boys at a woman's window

Black ink, brown ink, wash, and white on brown paper

9 x 6 1/8 in. (22.8 x 15.6 cm.)

Signed, l.l.; "AJM [monogram]"

Inscribed: "Goodness, gracious!—what shall I do with this boy of mine? He picks up the lowest little beggar on the street to play with."

888-41. Two small girls waving to their father

Pencil, brown ink, black ink, and wash on white paper

9 1/8 x 6 1/8 in. (23.2 x 15.6 cm.)

Inscribed: "Good night, Papa"

888-42. Four boys attempting an exit

Brown ink, black ink, wash, and white on brown paper

6 3/16 x 4 5/8 in. (15.7 x 11.7 cm.)

Signed, l.r.: "AJM [monogram]"

Label: "Now, Buster, look where you plant your trotters, or I'll put a head on you—sure's you're born!!!—Mysteries of a Sugar Hogshead"

888-43. Two men seated in a drawing room, one with a crop

Black ink, brown ink, wash, and pencil on white paper

Dimensions not given

Inscribed: " 'Fox Hunters' Jockey Buckskin (loq.) 'We had a splendid run today Tom. Why didn't you come? Tom—couldn't go—Doctor says I've got the dyspepsy—now I don't [know] what that is but I suppose it's some d____d thing or another!!' "

888-44. Women reclining with leashed dog [from Laurence Sterne, *A Sentimental Journey,* 1768]

Brown ink, black ink, wash, and pencil

7 5/8 x 9 3/4 in. (19.4 x 24.7 cm.)

Signed, l.r.: "AJM [monogram]"

Inscribed: "Crazed Maria"; label: "Sterne's Sentimental Journey"

888-45. View of a mountain

Watercolor wash on paper

3 11/16 x 5 7/8 in. (9.3 x 14.9 cm.)

Label: "Virginia Scenery"

888-46. Man with rifle overlooking countryside

Black ink, brown ink, wash, and white pencil on brown paper

6 1/16 x 9 1/2 in. (15.3 x 24.1 cm.)

Inscribed: "Conscript leaving home for the 'Front' 1862"

888-47. Woman reading letter, small black boy looks on

Pencil, wash, white, brown ink, and black ink on pink paper

8 15/16 x 5 9/16 in. (22.7 x 14.1 cm.)

Inscribed: "A young *rebel's* letter to Jane. reads—'We will lick the yanks to Morrer if godlemity spares our lives.' "

888-48. An old woman, a younger woman and a girl

Watercolor, pencil, black ink wash, and white on white paper

7 1/8 x 5 in. (18.1 x 12.7 cm.)

Label: "Youth & old age"

888–49. A woman and child

Brown ink, black ink, and pencil on brown paper

7 1/4 x 5 1/4 in. (18.4 x 13.3 cm.)

Inscribed: "Just waked up"

888-50. Barn yard

Watercolor wash

3 11/16 x 6 9/16 in. (9.3 x 16.6 cm.)

Label: "Barn Yard/Hawkin's Point/Anne Arundle Co."

888-51. A horseman rides by a cottage and chapel

Pencil, black ink, wash, and white on brown paper

7 x 10 3/8 in. (17.8 x 26.3 cm.)

Label: "Effect of Lights"

888-52. Boys in a pond

Watercolor, gouache, and ink on paper

5 5/8 x 7 1/2 in. (14.3 x 19.1 cm.)

Label: "Boyhood/1827—Hawkins Point Farm."

888-53. Book seller with a child

Pencil, black ink, wash, and white on brown paper

7 5/8 x 5 5/8 in. (19.4 x 14.3 cm.)

Label: "Recollections 1830"

888-54. Rear of a colonial gentleman

Black ink, white, wash, and brown ink on blue-gray paper

8 1/16 x 6 in. (20.5 x 15.2 cm.)

Signed, l.r.: "AJM [monogram]"

Label: "Full length *likeness* of the author of Junius!!"

888-55. Rain upon a lake

Watercolor wash on paper

2 7/8 x 4 3/16 in. (7.3 x 10.6 cm.)

Label: "Effect of Rain Cloud."

888-56. Crying woman and two children

Black ink, white, and wash on blue-gray paper

6 1/4 x 5 3/8 in. (15.9 x 13.6 cm.)

Label: "Condemned prisoner's wife and children in the corridor of the prison"

888-57. Prisoner in a cell

Black ink, brown ink, and wash, and pencil on blue-gray paper

6 1/8 x 4 3/4 in. (15.6 x 12.1 cm.)

Signed, l.l.: "AJM [monogram]"

Label: "Condemned prisoner listening to preparations for his execution."

888-58. Man carrying child over bridge

Brown ink, black ink, white, wash, and pencil on blue-gray paper

6 1/4 x 4 3/4 in. (15.9 x 12.1 cm.)

Inscribed: "The Old 'Harry' "; label: "Coach & two to Mrs. Nisers. (Canton)—party crossing Harris' Creek 1825"

888-59. Three boys, two prepared to fight

Black ink, white, wash, and pencil on brown paper

4 7/8 x 4 1/2 in. (12.4 x 11.5 cm.)

Label: "Let us have some peace"

888-60. Black youth looking at fallen soldier [from John Hay, "Banty Tim," 1871]

Pencil, black ink, white, wash, and brown ink on brown paper

6 3/4 x 9 7/8 in. (17.1 x 25.1 cm.)

Signed, l.c.: "AJM [monogram]"

Inscribed: "That nigger, that Tim, was a crawlin to me through that fire proof gilt-edged Hell. John Hay"; label: "Banty Tim/Why blame your hearts, jest hear me!/ You know that ungodly day/ When our left struck Vicksbury Heights, how ripped/ And torn & tattered we lay./ When the rest retreated, I staid behind/ For reasons

sufficient for me./ With a rib staved in and a leg on a strike,/ I sprawled on that cursed glacee./ Lord! how the sun went for us,/ And bri'led & blistered & burned!/ How the rebels' bullets that wizzed round us/ When a cuss in his death grip turned!/ Till along toward dusk I seen a thing/ I couldn't believe for a spell;/ That nigger—that Tim was a crawlin to me/ Through that fire proof gilt edged hell!/ John Hay"

888-61. Virginia scenery
Watercolor wash on paper
3 1/2 x 5 5/8 in. (8.9 x 14.3 cm.)
Label: "Virginia Scenery"

888-62. Child on a wharf
Pencil, watercolor, crayon, black ink, and wash on brown paper [mounted]
5 5/8 x 4 5/8 in. (14.3 x 11.7 cm.)
Signed, l.l.: "AJM [monogram]"
Label: "Any body's child wharf rat!"

888-63. Two men in a hearth smoking
Watercolor, crayon, black ink, brown ink, and white on blue paper
4 5/8 x 6 1/4 in. (11.7 x 15.9 cm.)
Signed, l.l.: "AJM [monogram]"
Label: "Lady of the mansion gives strict orders that there is to be no drinking or smoking at her parties.—The law is evaded by the young gents in the last case with considerable discomfort & seats in the chimney."

888-64. View of a Falls
Pencil, brown ink, black ink, and wash on brown paper
6 7/16 x 9 1/16 in. (16.3 x 23.0 cm.)
Label: "From photo—Horse Shoe Fall from Goat Island"

888-65. Woman and child
Watercolor wash, black ink, pencil, and white on paper [round corners at top]
10 1/2 x 7 5/16 in. (26.7 x 18.6 cm.)
Signed, l.r.: "AJM [monogram]"
Label: "The Young Mother"

888-66. Burning of Stieff Silver Co. Factory
Watercolor and gouache on paper
4 x 7 15/16 in. (10.2 x 20.2 cm.)
(December 10, 1859)

Label: "Sketched at night/Burning of Stieff's Factory on Balto. St. Dec 10th 1859."

888-67. Men and horse cross a bridge [from Thomas Gray, "Elegy in a Country Churchyard," 1751]
Watercolor wash, pencil, and white on paper
4 3/4 x 6 5/16 in. (12.1 x 16.0 cm.)
Label: " 'The ploughman, homeward, treads his weary way.' Grays elegy."

888-68. Indian boy
Watercolor wash on paper
5 3/8 x 3 3/4 in. (13.6 x 9.5 cm.)
Label: "Bow Excercise 'Indian boy' "

888-69. Sunset over a field
Watercolor and gouache on paper
7 x 10 3/4 in. (17.8 x 27.3 cm.)
Label: "Study from nature/Sunset—Charles St. Avenue"

888-70. Two black men by a hearth, one holding foot
Black ink, white, pencil, and brown ink on blue-gray paper
6 1/16 x 4 13/16 in. (15.4 x 12.2 cm.)
Signed, l.l.: "AJM [monogram]"
Label: "Whose foot dat burning dar? Dick dat your's? no Golly! It my foot—Yah! Yah!"

888-71. George Washington with a woman and boy on the street
Black ink, brown ink, pencil, wash, and white on brown paper
6 3/16 x 5 13/16 in. (15.7 x 14.7 cm.)
Inscribed: "Gen. Washington giving a [illeg.] to W"; label: "Gen¹ Washington's interview with Washington Irving—Broadway, New York"

888-72. Two children leaning on a fence with a dog
Black ink, watercolor, wash, and pencil on paper
5 1/8 x 7 1/16 in. (13.0 x 18.0 cm.)
Label: " 'Waiting for the drafted father to come home'/ George's children"

888-73. Hampden Reservoir

Watercolor on paper

6 1/2 x 8 5/8 in. (16.5 x 21.9 cm.)

Label: "Hampden Reservoir near Bal^t"

888-74. Portrait of Wm. C. Waite

Oil on paper

9 3/16 x 7 1/16 in. (23.4 x 18.0 cm.)

Signed, l.r.: "AJM [monogram]"

Label: "Wm. C. Waite Esq. an old friend"

888-75. Two children, a cart, and a dog

Oil on canvas

7 1/2 x 6 15/16 in. (19.1 x 17.6 cm.)

Signed, l.r.: "AJM [monogram]"

Label: "Group children & dog"

888-76. Two lifeboats at sea amid storm

Brown ink, black ink, pencil, wash, and white on brown
paper

5 7/8 x 9 1/4 in. (14.9 x 23.5 cm.)

Signed, l.l.: "AJM [monogram]"

Label: "Wrecking of the English Turret Ship 'Captain'/
All this time the pinnace was being tossed heavily and
the men were frequently washed from its keel into the
mass of seething waters. The ship's second launch floated
towards them. Heard took hold of the commander &
said, 'Come Sir, let's jump!'—to which he replied—'Save
you own life man! I shall not forget you some day!' The
seaman jumped & with difficulty reached the launch—
and in a few minutes the pinnace was lost sight of. Sept.
1870"

888-77. Boy sleeping, with a dog

Watercolor, pencil, crayon, black ink, wash, and brown
ink on paper

Dimensions not given

Signed, l.l.: "AJM [monogram]"

Label: "Beggar boy & his dog"

888-78. Woman standing before seated man
 reading newspaper

Black ink, pencil, white, crayon, brown ink, and wash on
brown paper

9 3/16 x 7 3/4 in. (23.3 x 19.7 cm.)

Signed, l.r.: "AJM [monogram]"

Label: "Please have it all you way—Madam!"

888-79. Two monks and a serving girl [from a
 poem by Thomas Campbell]

Black ink, crayon, watercolor, wash, and white on paper

8 1/4 x 6 7/8 in. (21.0 x 17.5 cm.)

Inscribed: "When honest men confessed their sins, and
paid the church genteely. In Burgundy two Capuchins,
lived jovially and quite freely. 'The Friars of Dijon' ";
label: "Friars of Dijon from Poem by Tho^s Campbell"

888-80. Man and woman playing with a child

Black ink, pencil, crayon, watercolor, wash, and white on
brown paper

7 1/8 x 6 1/16 in. (18.1 x 15.4 cm.) [rounded top corners]

Label: "Mother's Pet"

888-81. Men fishing on a lake; cabin in
 background

Watercolor wash on paper

7 x 12 3/4 in. (17.8 x 32.4 cm.)

Label: "Virginia Scenery/Autumn"

888-82. Horse sale

Pencil, brown ink, black ink, white, and wash on brown
paper

8 7/16 x 12 1/4 in. (21.4 x 31.1 cm.)

Label: "Horse Market—Swan St. 1830"

888-83. Woman kneeling in church as a man
 looks on from behind a curtain [from
 Goethe, *Wilhelm Meister*, 1829]

Black ink, pencil, and brown ink on blue-gray paper

6 3/16 x 4 3/4 in. (15.7 x 12.1 cm.)

Label: "Mignon. He followed her on one occasion &
saw her kneeling down with a rosary in a corner of the
church & praying devoutly. Gothe's [*sic*]—Wilhelm
Meister & Mignon."

888-84. Boy squatting beside woman on chaise
 as group of figures looks on

Pencil, black ink, brown ink, wash, and white on brown
paper

5 3/4 x 5 1/2 in. (14.6 x 14.0 cm.)

Label: " 'It is the Madonna' Lorenzo Binoni by Giovanni
Ruffini"

888-85. Man leading woman on horse [from Sir Walter Scott, *St. Rowan's Well*, 1823]

Black ink, brown ink, white, wash, and pencil on brown paper

9 3/4 x 7 1/8 in. (24.7 x 18.1 cm.)

Inscribed: "Clara Mowbray & Tyrrel/Chap. IX—St. Rowan's Well";

Label: "Clara Mowbray and tyrrel, Scott's St. Rowan's Well Chapt IX

888-86. Boy and girl with market basket

Pencil, black ink, brown ink, white, and wash on brown paper

9 9/16 x 7 5/8 in. (24.3 x 19.4 cm.)

Signed, l.r.: "AJM [monogram]"

Label: "The way in which the market basket goes home."

888-87. Lake and mountain view

Pencil, black ink, brown ink, wash, and white on brown paper

6 1/8 x 9 9/16 in. (15.5 x 24.3 cm.)

Inscribed: "Swann Lake"; label: "Swann Lake"

888-88. Boy with yo-yo passing two other boys

Pencil, black ink, and white on brown paper

7 x 5 9/16 in. (17.8 x 14.1 cm.)

Label: "I say Jake, let's beat that feller & tear his fine clothes—he is what they calls a fernal 'ristocrat."

888-89. Girl kneeling over the arm of a chair

Black ink, brown ink, wash, and pencil on white paper

5 5/16 x 4 15/16 in. (13.5 x 12.5 cm.)

Label: "The old arm chair"

888-90. Child playing with cat

Brown ink, black ink, pencil, white and wash on brown paper

4 3/16 x 2 3/16 in. (10.6 x 5.5 cm.)

Signed, l.r.: "AJM [monogram]"

888-91. Two boys with raised sticks as man and dogs peer from window

Brown ink, black ink, wash, and white on blue-gray paper

6 1/4 x 4 11/16 in. (15.8 x 11.9 cm.)

Label: "Col^e The^o Anderson & his dogs/farm on Frederick Road"

888-92. Two men at a table with a cat [from James Boswell, *Life of Samuel Johnson*, 1791]

Pencil, pen and ink, and white watercolor on beige paper

7 1/2 x 6 3/4 in. (19.1 x 17.2 cm.)

Inscribed: "Dr. Johnson, Boswell & Hodge the cat"

888-93. Man cutting another's hair

Black ink, pencil, and wash on brown paper

6 1/16 x 4 11/16 in. (15.4 x 11.9 cm.)

Label: "Jack C. (practical joker) cuts Parson H^s hair—he now looks like a convict. Parson H. (putting his hand to his head) Bless me Mr. C, you have ruined my hair!!! It is monstruous! Jack C.—If you say another word Sir—I'll drop the whole concern. I hate ingratitude! [Recollections 1830]"

888-94. Roman peasant

Brown ink, black ink, and wash, white, and pencil on blue-gray paper

6 3/16 x 4 1/2 in. (15.7 x 11.5 cm.)

Signed, l.l: "AJM [monogram]"

Label: "A Noble Roman who disdains to labor as a machine"

888-95. Man lying on a floor

Black ink, white, pencil, and wash on blue-gray paper

6 1/16 x 4 5/8 in. (15.3 x 11.7 cm.)

Label: "Paradise. Up 'the Warehouse Stairs' 1825. This young gentleman has been trying to walk the 'slack wire,' result a cracked head—tried the 'tight' rope with same success. Moral—not competant to be a vagabond."

888-96. Scottish couple leaving church

Pencil, black ink, and wash on brown paper

6 1/4 x 4 11/16 in. (15.8 x 11.9 cm.)

Inscribed: "Coming from kirk"

Label: "Sandy—'A weel Jennie—how did ye like the sermon?' J. 'It was vira gude—muckle thanks till him.' Sandy—'and did ye understand what he said about St. Paul?' Jennie—'Ech Sir, Wad I hae the presumption!!' "

888-97. Portrait of a youth

Black ink, crayon, pencil, watercolor, and wash on white paper (oval)

7 1/8 x 5 1/8 in. (18.1 x 13.0 cm.)

888-98. Woman frightened by fireworks

Pencil, black ink, wash, and white on brown paper

6 1/8 x 4 5/8 in. (15.5 x 10.5 cm.)

Inscribed: "4th July 'The day we celebrate' "

888-99. Man addressing two other men from window [from James Boswell, *Life of Johnson*, 1791]

White, black ink, wash, and brown ink on blue-gray paper

6 3/16 x 4 15/16 in. (15.7 x 12.6 cm.)

Label: "Dr. Johnson, Beauclerk & Langton—at 3 o'clk. a.m.—Dr. J. 'What—is it you, you dogs? I'll have a frisk with you.' Roswell [*sic*]"

888-100. Guard crouching by prison cell door [from Sir Walter Scott, *Legend of Montrose*, 1819]

Black ink, brown ink, wash, and pencil on white lined paper

1 15/16 x 3 1/8 in. (5.0 x 7.9 cm.)

Label: "Major Dalgetty listening at the prisoner's door. Scot____"

888-101. Man being hit with book by another [from James Boswell, *Life of Johnson*, 1791]

Black ink, brown ink, wash, pencil, and white on blue-gray paper

5 15/16 x 5 5/16 in. (15.1 x 15.1 cm.)

Signed, l.l.: "AJM [monogram]"

Label: "Dr. Sam¹ Johnson knocking down Osborne (the bookseller) with a folio volume because he was impertinant."

888-102. Pocahontas and John Smith

Pencil, black ink, and watercolor wash on paper

4 7/8 x 3 3/8 in. (12.4 x 8.6 cm.)

Inscribed: "Pocahontas warning Capt. Smith"

888-103. Signal Tower on Federal Hill [Baltimore]

Black ink, brown ink, pencil, and watercolor wash on paper

2 1/8 x 3 3/8 in. (5.3 x 8.6 cm.)

Label: "Federal Hill"

888-104. Children with a firecracker

Pencil, black ink, white, and wash on brown paper

5 7/8 x 4 1/2 in. (14.9 x 11.4 cm.)

Label: " 'Young America'—on 4th July/The day we celebrate! 'Who's afraid!' "

888-105. Boy and woman in doorway

Black ink, brown ink, wash, and pencil on white paper

4 7/8 x 3 5/8 in. (12.3 x 9.2 cm.)

Label: "Nurse—Have caught Master Willie but where in the world, is Johnny? Street Sketch"

888-106. View of Federal Hill [Baltimore]

Brown ink, black ink, watercolor, wash, and pencil on paper

2 1/16 x 3 7/16 in. (5.2 x 8.7 cm.)

Label: "Federal Hill during the War"

888-107. Young boy with hoop and stick

Black ink, brown ink, watercolor wash, white crayon, and pencil on paper

Dimensions not given

Label: "The Spring time of Life"

888-108. Head of a Horse

Brown ink, black ink, pencil, and wash on white paper

5 7/8 x 4 15/16 in. (14.9 x 12.5 cm.)

888-109. Mother and son by fireplace

Black ink, brown ink, pencil, and wash on blue-gray paper

6 1/8 x 4 3/4 in. (15.6 x 12.0 cm.) Inscribed: "Mother, I don't think brother Tom's coat fits me very well in the back."

888-110. Amputee among a group of children

Pencil, black ink, and wash on light brown paper

5 5/16 x 3 3/4 in. (13.5 x 9.5 cm.)

Label: "Street Sketch/A Maimed Hero of the War"

888-111. Woman under an umbrella in a market

Black ink, pencil, and wash on brown paper

6 1/8 x 4 5/8 in. (15.6 x 11.7 cm.)

Label: "An old campaigner of the market"

888-112. People on a city car

Black ink, brown ink, wash, and white on blue-gray paper

5 7/8 x 4 1/4 in. (15.0 x 10.8 cm.)

Label: "Afflicted with 'Jim Jams' on City Car Conductor? Do you let spiders come in here with their great coats on?—Is the ear of a canary bird water proof &'would it do to make shoes?" [label dated on reverse "Dec 30/72"]

888-113a. Steamer in a storm

Black ink, pencil, watercolor, and wash on paper

4 x 5 3/4 in. (10.2 x 14.6 cm.)

Label: "Wreck of the steamer "Atlantic"

888-113b. Three men among others, one leaning against a tree, outside an ale house

Black ink, brown ink, pencil, and wash on blue-gray paper

6 1/4 x 9 7/16 in. (15.9 x 24.0 cm.)

Inscribed: "Oh, 'Rip Van Winkle,' exclaimed two or three. 'Oh to be sure!'—that's Rip Van Winkle leaning against the tree."

888-114. View of a mountain

Oil on paper

3 1/2 x 5 1/8 in. (8.9 x 13.0 cm.)

Signed, l.l. of mount: "AJM [monogram]"

Label: "Western Scenery"

ALBUM II: L. VERNON MILLER FAMILY ALBUM

889-1. Children outside a gate

Pencil, black ink, white, and wash on brown paper

5 13/16 x 4 3/4 in. (14.7 x 12.1 cm.)

Label: "from French School"

889-2. Room with prie-dieu and open door

Black ink, brown ink, pencil wash, and white on brown paper

5 9/16 x 4 1/2 in. (14.1 x 11.4 cm.)

Label: "French School"

889-3. Woman carrying jug through portal

Pencil, black ink, white, and wash on brown paper

5 9/16 x 4 7/16 in. (14.1 x 11.3 cm.)

Label: "French School/Effects of Light"

889-4. Woman holding a large cup or vase [after Reynolds]

Pencil, black ink, brown ink, and wash

6 1/8 x 5 3/8 in. (15.5 x 13.7 cm.)

Inscribed, u.r.: "Reynolds"; l.r.: "Kitty Fisher"

REFERENCES

"Kitty Fisher as Cleopatra"

889-5. Rembrandt

Pencil, crayon, pastel, and white on paper

4 3/16 x 3 1/2 in. (10.6 x 8.8 cm.)

Inscribed: "Rembrandt"

889-6. Group in corner of room

Black ink, pastel, white, wash, and crayon on paper

6 3/4 x 5 7/8 in. (17.1 x 14.9 cm.)

Label: "Rembrandt—Study of Effect/Louvre 1833"

889-7. Woman standing at top of several stairs

Black ink, brown ink, pencil, and wash on white paper

7 4/8 x 5 7/8 in. (20.0 x 13.6 cm.)

Inscribed: "Reynolds"

889-8. Rembrandt

Pencil, brown ink, black ink, white, and wash on paper

4 11/16 x 3 1/2 in. (11.9 x 8.9 cm.)

Inscribed: "Rembrandt"; label: "Rembrandt"

889-9. Man with sword [probably a copy from Della Vecchia]

Crayon, pencil, watercolor wash, black ink, brown ink, and white

3 7/8 x 4 1/2 in. (9.8 x 11.4 cm.)

Label: "Giorgione/Brigand"

889-10. View of man on rock formations and distant mountain

Black ink, crayon, pastel, and white on paper

5 3/8 x 7 5/8 in. (13.6 x 19.4 cm.)

Label: "Salvator Rosa"

889-11. Woman standing

Black ink, brown ink, wash, and pencil on white paper

5 7/8 x 5 in. (14.9 x 12.7 cm.)

Inscribed, u.r.: "Reynolds"

889-12. View of a boat on water with city in distance [after Ruysdael]

Pastel, crayon, pencil, wash, and black ink on paper

4 9/16 x 7 5/16 in. (11.6 x 18.6 cm.)

Label, l.r.: "Ruysdael"

889-13. Woman in a large hat [after Reynolds]

Black ink, pencil, and wash on white paper

5 5/8 x 4 7/16 in. (14.3 x 11.3 cm.) [rounded top corners]

Inscribed: "Reynolds"; label: "Kitty Fisher"

889-14. Figures grouped around one in bed [after Rembrandt]

Pencil, black ink, brown ink, and wash on white paper

3 7/8 x 5 9/16 in. (9.8 x 14.1 cm.)

Label: "Rembrandt"

889-15. Man standing by a bust [after Reynolds]

Pencil, black ink, brown ink, and wash on white paper

5 3/8 x 4 1/4 in. (13.7 x 10.8 cm.)

Label: "Sir J. Reynolds (1723–1792) portrait of himself"

889-16. Women in doorway [after Nicolas Maes]

Pencil, crayon, and pastel on paper

6 1/4 x 5 1/4 in. (15.9 x 13.3 cm.)

Label: "Maes/Flemish"

889-17. Christ at table [after Rembrandt]

Black ink, crayon, and pastel on paper

7 1/8 x 7 9/16 in. (18.1 x 19.2 cm.)

Label: "Rembrandt/Christ & his disciples"

889-18. Angel appearing to Abraham [after Rembrandt]

Crayon, and pastel on paper

6 1/2 x 5 3/8 in. (16.5 x 13.7 cm.)

Label: "Rembrandt/Abraham & the Angel"

889-19. Woman seated by open window [after Rembrandt]

Black ink, brown ink, watercolor, and wash on white paper

3 1/2 x 4 5/8 in. (8.9 x 11.7 cm.)

Label: "Study from Rembrandt/Louvre 1833"

889-20. Man seated by a window [after Rembrandt]

Black ink, brown ink, and watercolor

3 1/2 x 4 5/8 in. (8.9 x 11.7 cm.)

Label: "Study from Rembrandt/Louvre 1833"

889-21. View of mountains [perhaps after Calame]

Pencil, black ink, brown ink, watercolor, and wash on paper

9 3/16 x 6 13/16 in. (23.4 x 17.3 cm.)

Label: "Alps—French School"

889-22. Figure and a horse [after Wouvermans]

Black ink, brown ink, pencil, white, watercolor, and wash on white paper

4 3/4 x 3 1/8 in. (11.1 x 7.9 cm.)

Inscribed: "Wouvermans"

889-23. People arriving or leaving a house [after Wouvermans]

Black ink, brown ink, watercolor wash, and pencil on white paper

4 1/8 x 3 3/16 in. (10.5 x 8.1 cm.)

Inscribed: "Wouvermans"; label: "Wouvermans"

889-24. View of a falls and small lake

Pencil and black ink

4 15/16 x 7 3/4 in. (12.5 x 19.7 cm.)

Signed, l.l.: "AJM [monogram]"

Label: "Study from nature"

889-25. Young boy at water's edge

Pencil, black ink, and wash on white paper

6 1/2 x 5 in. (16.5 x 12.7 cm.)

Signed, l.l.: "AJM [monogram]"

Label: "Boy with a sea shell"

889-26. Woman leaning over fence

Black ink, brown ink, pencil, and wash on blue-gray paper

4 7/8 x 3 11/16 in. (12.4 x 9.4 cm.)

Signed, l.r.: "AJM [monogram]"

Label: "Dinner is ready"

889-27. Figure wading in water, fishing

Black ink, brown ink, wash, pencil, and white on brown paper

6 5/16 x 9 5/8 in. (16.0 x 24.5 cm.)

Label: "Study from nature"

889-28. View of mountains

Pencil, black ink, and wash on white paper

5 3/16 x 10 in. (13.2 x 25.4 cm.)

Label: "Blue Ridge Virginia Scenery"

889-29. View of a lake and mountains

Pencil, black ink, and watercolor wash on white paper

5 3/4 x 8 1/2 in. (14.6 x 21.6 cm.)

Signed: l.l. "AJM [monogram]"

Label: "Lake Scenery"

889-30. Rocks and trees

Pencil, black ink, white, and wash on paper

6 1/8 x 9 9/16 in. (15.5 x 24.3 cm.)

Signed, l.l.: "AJM [monogram]"

Label: "Bits for pictures"

889-31. Lake view with mountains

Pencil, black ink, watercolor, and wash on white paper

3 7/8 x 6 1/4 in. (9.8 x 15.9 cm.)

Signed, l.r.: "AJM [monogram]"

Label: "Lake Scene Rocky Mts."

889-32. Stream with a fallen tree

Brown ink, black ink, wash, and white on paper

5 3/4 x 9 5/8 in. (14.6 x 24.5 cm.)

Label: "Study from nature"

889-33. View of mountains

Black ink, pencil, brown ink, white, and wash on paper

5 1/2 x 10 in. (14.0 x 25.4 cm.)

Label: "from nature"

889-34. Small boat at shore

Pencil, watercolor, and wash on white paper

4 1/2 x 8 13/16 in. (11.5 x 22.4 cm.)

Inscribed: "Coast of England Scenery"; label: "Coast of England Scenery"

889-35. Boy looking over a wall

Pencil, black ink, and wash on white paper

Dimensions not given

Inscribed: "From Ed. Frére"

889-36. Steamer at night [after Turner]

Pencil, black ink, wash, and white on paper

4 3/4 x 6 in. (12.1 x 15.2 cm.)

Label: "from Turner/Gibraltar/Burial of Sir Daniel Wilkie" [actual title: "Peace—Burial at Sea," Tate Gallery]

889-37. Lighthouse

Pencil, black ink, and wash on white paper

7 x 5 5/8 in. (17.8 x 14.3 cm.)

Label: "Niagara"

889-38. Allegorical figure
Pencil on white paper
6 1/4 x 7 1/2 in. (15.9 x 19.1 cm.)
Signed, l.r.: "AJM [monogram]"
Inscribed: "Allegoric figure—Genius of Liberty"

889-39. Study of a young woman
Pencil, black ink, and white on brown paper
7 5/8 x 6 3/4 in. (19.4 x 17.1 cm.)
Label: "Pose for a Portrait"

889-40. Allegorical figure #2
Pencil on white paper
6 1/2 x 7 1/16 in. (16.5 x 18.0 cm.)
Signed, l.r.: "AJM [monogram]"
Inscribed: "Design for allegoric figure of history"

889-41. Back of a person's head [after Raphael]
Pencil on white paper
8 1/2 x 8 7/16 in. (21.6 x 21.5 cm.)
Inscribed: "Sketched at Rome 1833, Fire in 'Borgo' Raphael"

889-42. Boy playing a violin
Pencil, black ink, brown ink, and wash
4 1/4 x 2 15/16 in. (10.8 x 7.5 cm.)
Signed, l.c.: "AJM [monogram]"
Label: "Taking a lesson"

889-43. Two figures on a rock in a lake
Pencil, watercolor wash, and black ink
6 5/16 x 5 1/16 in. (16.1 x 12.9 cm.)
Signed, l.l.: "AJM [monogram]"
Label: "The Freshet"

889-44. Head of a bearded man
Black ink on white paper
6 5/16 x 5 3/8 in. (16.1 x 13.7 cm.)
Inscribed: "from Rembrandt"

889-45. [Three] children playing with a swing
Pencil and wash on white paper
5 15/16 x 7 1/8 in. (15.1 x 18.1 cm.)
Inscribed: "from English School"

889-46. Two figures outside a cottage
Pencil, black ink, and watercolor wash on paper
6 1/4 x 4 7/8 in. (15.9 x 12.4 cm.)
Label: "English cottage"

889-47. View of an estate
Pencil, brown ink, black ink, and wash on brown paper
6 5/16 x 9 11/16 in. (16.1 x 24.6 cm.)
Inscribed: "Carter's/formerly Water's"
Label: "Carters formerly Dr. Water's, near Franklin Road"

889-48. Figure by a large tree
Oil on paper
8 11/16 x 10 3/8 in. (22.1 x 26.4 cm.)
Label: "After French School"

889-49. View of stream and mountains
Pencil, black ink, and wash on paper
4 5/8 x 7 1/2 in. (11.7 x 19.1 cm.)
Label: "from nature"

889-50. Woman seated outdoors
Black ink, brown ink, pencil, and wash on white paper
5 13/16 x 4 7/8 in. (14.8 x 12.4 cm.) [corners clipped]
Signed, l.r.: "AJM [monogram]"
Inscribed: "The Visionary"

889-51. Guard on the Potomac
Brown ink, white, pencil, and wash on brown paper
Dimensions not given
Signed, l.r.: "AJM [monogram]"
Inscribed: "Winter Campaign Guard on the Potomac"

889-52. View of men fishing from a rock in a lake
Black ink, brown ink, pencil, wash, and white on brown paper
6 1/2 x 9 1/8 in. (16.5 x 23.2 cm.)
Label: "Lake of Killarney/from Dagge"

889-53. Barefoot girl
Pencil, brown ink, black ink, and wash on white paper
7 1/2 x 6 1/16 in. (19.1 x 15.4 cm.)
Signed, l.r.: "AJM [monogram]"

Label: "Scotch Lassie walks barefoot to church, washes her feet & then resumes stockings and shoes"

889-54. View of a Venetian church [actually a copy after Canaletto, *The Stonemason's Yard*, National Gallery, London]

Black ink and wash on white paper

4 x 5 1/2 in. (10.2 x 14.0 cm.)

Inscribed: "Ruysdael"; label: "Venice—from Ruysdael"

889-55. Organ grinder and woman with tambourine on street

Pencil and wash on white paper

7 5/8 x 6 5/8 in. (19.4 x 16.8 cm.)

Signed, l.r.: "AJM [monogram]"

Inscribed: "Street Sketch"

889-56. Organ grinder

Pencil and wash on white paper

7 1/2 x 6 1/8 in. (19.1 x 15.6 cm.)

Inscribed: "after Darley" [Felix O. Darley]

889-57. Boat on a river

Pencil, white, and watercolor wash on paper

5 1/16 x 9 1/8 in. (12.9 x 23.2 cm.)

Label: "River Scene"

889-58. Head of a girl

Brown ink, pencil, and wash on white paper

8 1/16 x 9 in. (20.5 x 22.9 cm.)

Inscribed: "Study for a head"

889-59. Small house among trees

Black ink, pencil, and wash on brown paper

5 3/8 x 7 in. (13.7 x 17.8 cm.)

Label: "Scene near Greenmount" [cemetery in Baltimore]

889-60. View of a bridge at Cumberland Gap

Black ink, brown ink, pencil, wash, and white on blue-gray paper

6 1/4 x 7 5/8 in. (15.9 x 19.4 cm.)

Inscribed: "Cumberland Gap"; label: "Cumberland Gap"

889-61. Bridge over river, with town and mountains in distance

Pencil, brown ink, wash, and white on blue-gray paper

6 1/4 x 7 3/4 in. (15.9 x 19.7 cm.)

Inscribed: "Cumberland, Md"; label: "Cumberland, Md"

889-62. Field with farm house and trees

Watercolor wash, and white on paper

5 13/16 x 10 3/16 in. (14.8 x 25.9 cm.)

Label: "Return to the Farm House, Missouri"

889-63. River view

Pencil, watercolor, wash, brown ink, and black ink on paper

3 3/8 x 6 3/4 in. (8.6 x 17.2 cm.)

Inscribed: "Susquehanna"; label: "Scene on the Susquehanna River"

889-64. View of water with mountains in background

Watercolor wash on paper

3 1/16 x 6 1/4 in. (7.8 x 15.9 cm.)

Label: "Sun set effect"

889-65. Savoyard playing hurdy-gurdy

Pencil, black ink, white, and wash on brown paper

8 x 5 7/8 in. (20.3 x 14.9 cm.)

Inscribed: "Savoyard"; label: "Paris 1834"

889-66. View of a mountain

Black ink, pencil, and wash on white paper

6 1/4 x 7 3/4 in. (15.9 x 19.7 cm.)

Label: "Mountain Scenery"

889-67. Sketch of a bearded man [probably after a photograph]

Black ink, pencil, brown ink, and wash on white paper

7 3/4 x 6 1/4 in. (19.7 x 15.9 cm.)

Inscribed: "Troyon—French artist" [Constant Troyon, 1810–1865]

889-68. Sketch of a bearded man [probably from a photograph]

Black ink, brown ink, pencil, and wash on white paper

7 3/4 x 6 1/4 in. (19.7 x 15.9 cm.)

Inscribed: "Messonier, artist" [J. L. E. Meissonier, 1815–1891]

889-69. Cow skull
Brown ink, pencil, and wash on white paper
6 x 6 1/4 in. (15.3 x 15.9 cm.)
Signed, l.r.: "AJM [monogram]"

889-70. Man posing alongside a cannon [after Reynolds]
Black ink, wash, and pencil on white paper
7 x 5 1/4 in. (17.8 x 13.3 cm.) [rounded top corners]
Label: "Sir. J. Reynolds" [Wilhelm, Count Schaumburg-Lippe, 1724–1777]

889-71. Cow lying on the ground
Pencil and wash on white paper
5 1/2 x 8 1/4 in. (14.0 x 21.0 cm.)
Dated, l.l.: "1850"
Inscribed: "Percy our pet calf at Lorraine B.C."

889-72. Mountain view
Pencil on white paper
4 x 6 1/4 in. (10.2 x 15.9 cm.)
Inscribed, l.c.: "O. G./orange"; center of composition: "D. P."
Label: "Virginia Scenery"

889-73. Figure on horse drinking from lake or stream
Brown ink, black ink, wash, white, and pencil on paper
3 3/8 x 5 3/16 in. (8.6 x 13.2 cm.)
Label: "Effect"

889-74. Horse standing in water
Black ink, watercolor wash, and pencil on brown paper
4 3/4 x 6 1/4 in. (12.1 x 15.9 cm.)

889-75. River view
Pencil and watercolor wash
2 3/4 x 4 3/4 in. (7.0 x 12.1 cm.)
Label: "Susquehanna"

889-76. View of Druid Hill Lake and building
Pencil, brown ink, black ink, and wash on white paper
4 1/16 x 5 1/4 in. (10.3 x 13.3 cm.)
Signed, l.r.: "AJM [monogram]"
Inscribed: "Druid Hill"; label: "Lake—Druid Hill Park" [Baltimore]

889-77. View of a mountain
Pencil, black ink, watercolor, and wash
3 11/16 x 6 1/4 in. (9.4 x 15.8 cm.)
Label: "Twilight"

889-78. Massacre of St. Bartholomew
Pencil, black ink, brown ink, and wash
5 x 7 in. (12.7 x 17.8 cm.)
Signed, l.l.: "AJM [monogram]"
Label: "Massacre of St. Bartholomew/Planned by Charles IX and his mother in order to exterpate the Huguenots—50,000 persons perished."

889-79. View of mountain falls
Pencil, black ink, brown ink, and wash
6 5/16 x 6 13/16 in. (16.1 x 17.8 cm.)
Label: "Mountain Torrent"

889-80. Fishing boat on a small island
Black ink, brown ink, wash, watercolor, and pencil on light brown paper
6 1/8 x 9 7/8 in. (15.6 x 25.1 cm.)
Label: "Coast Scene"

889-81. Country House
Pencil, black ink, and wash on white paper
5 1/2 x 8 5/16 in. (14.0 x 21.1 cm.)
Inscribed: "Trees & House in shadow cutting against sky."; u.r.: "roof light green/House/Door x Fence"
Label: "Country Seat of Reverdy Johnson/Balto. Co."

889-82. Mountain and lake scene
Pencil, brown ink, watercolor wash, and white on paper
5 1/2 x 9 7/8 in. (14.0 x 25.1 cm.)
Label: "Virginia Scenery"

889-83. View of a horse through a window
Pencil and wash on white paper
5 x 3 7/8 in. (12.7 x 9.8 cm.)
Inscribed: The words "Car Window" have noticeably been erased from the sketch. Label: "Car Window"

889-84. Boy wading into water
Pencil, brown ink, black ink, and wash on white paper
3 3/4 x 4 7/8 in. (9.5 x 12.4 cm.)

889-85. View of a mountain

Pencil, watercolor, brown ink, black ink, wash, and white on paper

6 5/8 x 9 9/16 in. (16.8 x 24.3 cm.)

Label: "Mountain Scenery"

889-86. Man and woman in a field

Black ink, brown ink, pencil, and wash on white paper

5 7/16 x 5 13/16 in. (13.8 x 14.7 cm.)

Label: "Harvest Field"

889-87. Bull grazing

Black ink, brown ink, pencil, and wash on white paper

7 5/8 x 10 1/8 in. (19.4 x 25.7 cm.)

Signed, l.l.: "AJM [monogram] iller"

Dated: "1848"

Inscribed: "Sketch at Lorraine/Young bull—Ranney"

889-88. Soldier semireclined with pipe and rifle

Black ink, pencil, brown ink, and wash on white paper

8 5/8 x 9 3/4 in. (21.9 x 24.8 cm.)

Signed, l.r.: "AJM [monogram]"

Inscribed: "Greek Brigand"

889-89. Lake and mountain view

Brown ink, black ink, pencil, and wash on light brown paper

5 11/16 x 9 5/8 in. (14.5 x 24.5 cm.)

Inscribed: "water *Carmine* & _____ siena,"; center of composition: "red"; label: "Virga Scenery"

889-90. Female figure, girthed with sword, reading a letter [scene from *As You Like It*]

Pencil, brown ink, and wash on light brown paper

12 3/8 x 9 5/16 in. (31.4 x 23.7 cm.)

Inscribed: "Rosalind [reading]/From the East and Western Ind [Indies]/no jewel is like Rosalind/Act III, *As You Like It*."

889-91. Boy seated in a chair

Black ink, brown ink, pencil, and wash

5 15/16 x 3 7/8 in. (15.1 x 9.8 cm.)

Signed, l.r.: "AJM [monogram]"

889-92. Figure of a woman leaning against a pedestal or ballustrade [after Reynolds]

Pencil, brown ink, and wash on white paper

5 5/8 x 4 7/16 in. (14.3 x 11.3 cm.) [rounded at top corners]

Inscribed: "Sir J. Reynolds"

889-93. Spired building on edge of lake

Pencil on white paper

6 x 7 11/16 in. (15.2 x 19.6 cm.)

Inscribed: "Virginia water—England" [near Egham]

889-94. Woman in wrap and bonnet

Pencil, brown ink, and wash on white paper

10 1/8 x 7 1/2 in. (25.7 x 19.1 cm.)

Inscribed: "Pose for a Portrait"

889-95. Mountain scene

Black ink, pencil, watercolor, wash, and white on white paper

3 x 5 5/8 in. (7.6 x 14.3 cm.)

889-96. Baltimore Cemetery gate

Black ink, brown ink, pencil, wash on white paper

4 x 5 3/8 in. (10.2 x 13.6 cm.)

Label: "Baltimore Cemetery Gay St."

889-97. St. Bernard dog, lying on ground

Pencil, black ink, and wash on white paper

5 1/8 x 9 1/8 in. (13.0 x 23.2 cm.)

Signed, l.c.: "AJM [monogram]"

Inscribed: "Sketched at Lorraine/Bronte/my St. Bernard"

889-98. View of Mt. Hope

Black ink, pencil, and wash on white paper

5 1/8 x 9 1/4 in. (13.0 x 23.5 cm.)

Inscribed: "Mount Hope"; label: "Mount Hope near Balt."

889-99. View of fisherman, lake, and distant house

Pencil, black ink, brown ink, and watercolor wash on paper

9 1/2 x 7 5/8 in. (24.1 x 19.4 cm.)

Signed, l.r.: "AJM [monogram]"

Label: "Mill Seat"

889-100. View of Mount de Sales, Baltimore
Brown ink, wash, and pencil on white paper
5 1/8 x 9 1/4 in. (13.0 x 23.5 cm.)
Inscribed: "Mount de Sales"

889-101. View of a falls and house
Black ink, brown ink, wash, and pencil on brown paper
6 1/4 x 9 5/8 in. (15.9 x 24.5 cm.)
Inscribed: "Mill *Seat*. Jones Falls"

889-102. View of hills with house in distance
Black ink, pencil, and wash on white paper
5 1/8 x 9 5/16 in. (13.0 x 23.6 cm.)
Inscribed: "Scene in Scotland"; label: "Scene in Scotland Perthshire"

889-103. Two children
Pencil, black ink, and wash on brown paper
6 5/16 x 5 1/4 in. (16.1 x 13.3 cm.)
Label: "Positions for children"

389-104. Small wooden cottage
Brown ink, black ink, wash, white, and pencil on paper
5 3/4 x 7 3/8 in. (14.6 x 18.7 cm.)
Label: "Cottage near Dr. Waters' Franklin Road"

889-105. Passemont stealing Sancho's mule [from M. de Cervantes, *Don Quixote*]
Pencil, black ink, brown ink, wash, watercolor, and white on paper
11 x 8 3/4 in. (28.0 x 22.2 cm.)
Inscribed: "Giles Passemont stealing Sancho's mule"; label: "Giles Passemont stealing Sancho's mule."

889-106. Portrait of a man with dog
Pencil, brown ink, black ink, and wash on brown paper
7 1/16 x 6 1/8 in. (18.0 x 15.6 cm.)

889-107. Sailboats beneath a lighthouse
Black ink, brown ink, pencil, watercolor, and wash on paper
4 1/16 x 6 1/4 in. (10.3 x 15.9 cm.)
Label: "English Coast"

889-108. Woman standing near a boat
Pencil, black ink, brown ink, and wash on brown paper
5 1/16 x 4 1/4 in. (12.9 x 10.8 cm.)
Inscribed: "She stood Lora long time, shivering with the cold dampness, looking at a delapidated boat on the rugged beach."

889-109. Man and woman with caged squirrel
Pencil, brown ink, black ink, and wash on white paper
5 5/8 x 4 in. (14.3 x 10.2 cm.)
Inscribed: "Squirrel dealer"

889-110. Sappho leaping into the sea
Watercolor, crayon, pencil, black ink, brown ink, and wash on paper
5 x 7 in. (12.7 x 17.8 cm.)
Inscribed in pencil, u.r.: "Sapppho", in ink, l.r.: "Sappho"; label: "Sappho leaping into the sea"

889-111. Sketch from "Hamlet"
Brown ink, black ink, pencil, and wash on white paper
5 x 6 3/4 in. (12.7 x 17.1 cm.)
Signed, l.r.: "AJM [monogram]"
Inscribed: "Hamlet—It will not speak, then I will follow it Hor⁰—Do not my lord!"

889-112. Sketch from "Hamlet"
Black ink, pencil, brown ink, and wash on white paper
4 7/8 x 6 1/16 in. (12.4 x 15.4 cm.)
Signed, l.r.: "AJM [monogram]"
Inscribed: "Hamlet Do you not come, your tardy son to chide"

889-113. Sketch from "Hamlet"
Black ink, brown ink, pencil, and wash on white paper
4 1/2 x 6 5/8 in. (11.5 x 16.8 cm.)
Signed, l.r.: "AJM [monogram]"
Inscribed: "Hamlet—Is this a prologue or a _____/ Opphelia [*sic*]—Tis brief my Lord."

889-114. Sketch from "Hamlet"
Black ink, pencil, brown ink, and wash on white paper
4 1/2 x 6 3/4 in. (11.5 x 17.2 cm.)
Signed, l.r.: "AJM [monogram]"
Inscribed: "Hamlet—What!—frightened with false fire?"

889-115. Boy being given food at woman's door

Black ink, brown ink, pencil, and wash on brown paper

8 3/4 x 5 5/8 in. (22.2 x 14.3 cm.)

Signed, l.r.: "AJM [monogram]"

Label: "Giving Alms"

889-116. Man riding toward house

Pencil, black ink, brown ink, wash, and white on brown paper

6 1/8 x 9 1/8 in. (15.6 x 23.2 cm.)

Signed, l.r.: "AJM [monogram]"

Inscribed: "Falls Road"; label: "Falls Road" [Baltimore]

889-117. Watercolor study

Watercolor and pencil on paper

5 7/8 x 9 11/16 in. (14.9 x 24.6 cm.)

Inscribed, l.c.: "mist in valley"; label: " 'Tenga Medusa' Effect—Turner"

889-118. Watercolor study

Watercolor, pencil, and wash on paper

7 1/4 x 9 3/4 in. (18.4 x 24.8 cm.)

Inscribed: "Wm. M. W. Turner, 'The Graiae' " [Italian Alps]

Label: "Wm. M. W. Turner"

889-119. Woman lifting infant to cell window

Pencil, black ink, brown ink, watercolor, and wash on paper

7 x 5 1/2 in. (17.8 x 14.0 cm.)

Inscribed: "Avan Moyden"; label: "Prison Window"

889-120. Waves in a rough sea

Pencil, white, and watercolor wash on paper

8 9/16 x 10 13/16 in. (21.8 x 27.5 cm.)

Inscribed: "Turner"; label: "Turner—Water in unrest"

889-121. Coastal view

Black ink, pencil, and wash on paper

4 1/2 x 5 3/4 in. (11.4 x 14.6 cm.)

Label: "Ruysdael Coast Scene"

889-122. Family at table [after Rembrandt]

Black ink, wash, watercolor, and pencil on paper

4 x 5 1/4 in. (10.2 x 13.3 cm.)

Inscribed: "Rembrandt"; label: "Rembrandt Sketch for Effect/Louvre 1833"

889-123. View of a mill, Falls Road, Baltimore

Black ink, brown ink, watercolor wash, pencil, and white on brown paper

6 3/4 x 9 13/16 in. (17.2 x 24.9 cm.)

Signed, l.l.: "AJM [monogram]"

Inscribed: "Falls Road"

889-124. View of reservoir, Hampden

Brown ink, pencil, black ink, white, and wash on brown paper

6 1/4 x 9 3/4 in. (15.9 x 24.8 cm.)

Signed, l.l.: "AJM [monogram]"

Label: "Hampden Reservoir"

ALBUM III: L. VERNON MILLER FAMILY ALBUM

890.

5 15/16 x 9 in. (15.1 x 22.8 cm.)

Signed and dated, u.r. corner of inside cover: "Alfred J Miller/Paris 1833"

Label on verso of cover: "à la palette de Rubens/St Martin/Rue de Seine, No 6 à Paris"

890-1. Color chart with interlocking bands of red, blue, and yellow

Watercolor

890-2a. Drawing of an Etruscan-style lamp

Pen and pencil

890-2b. Drawing of a chalet

Pencil

Inscribed: "Roman Lamp in my room Via Cap [uchin]/Rome 1834" [page torn]

890-3. Bands of tertiary colors: orange, purple, and green

Watercolor on paper, mounted in sketchbook

4 3/4 x 5 1/4 in. (12.1 x 13.3 cm.)

890-4. Eccolo Roma—"Behold Rome," [View of dome of Vatican as seen from an approaching coach]

Pen and ink washes, with pencil

Inscribed: "Eccolo Roma—Behold Rome"

890-5. God dividing light from darkness [after Raphael]

Pencil and ink washes

Inscribed: "1833 Loggia de Raffaele—Rome/God dividing Light from Darkness"

890-6. "Rival Lovers": a woman flanked by an older man and a young boy [copy of *La Jeune Courtisane* by Xavier Sigalon, 1787–1837]

Pencil

Inscribed: "Luxembourg June 6, 1833 Rival Lovers"

890-7. Two partially clad women seated on the ground

Pencil

Inscribed: "Luxembourg/1833"

890-8. Drawing of nude figures from Delacroix's *La barque de Dante*

Pencil

Inscribed in ink: "Luxembourg 1833"; "Eugene Delacroix *Dante's Inferno*"

890-9a. Drawing of woman from the back

890-9b. Drawing of Caesar Borgia after Raphael

Pencil and ink wash

Inscribed: "Louvre Caesar Borgio after Raffaele Palazzo Borgese"

890-10. Artists' models

Ink, wash, yellow watercolor, and pencil

Inscribed: "Artists models on the Pincian Steps/waiting for orders"

890-11. Drawing of a church

Pencil

Inscribed: "Church in Lyons—France—1833"

890-12a. Gates to Villa Borghese

890-12b. Copy of head after Caravaggio

Pencil and ink wash

Inscribed: "Villa Borgese [*sic*] Caravaggio"

890-13a. View of roof tops, Rome

Pencil

Inscribed: "On the Pincian"

890-13b. View of back of priest

Ink wash and pencil

Inscribed: "French clergy"

890-14a. Tower of San Marco

Pencil

Inscribed: "Torre di St. Marco Venice"

890-14b. Boys in park

Pencil and wash

Inscribed: "Garcons—Francais/Luxembourg"

890-15. Drawing of building with leaded windows

890-16a. Outline drawing of profile of a woman

890-16b. Drawing of a dead figure seen in diagonal perspective

Pencil

890-17. Drawing of a figure being carried on a litter [perhaps a dead Capuchin]

Pencil

890-18. Gondola

Ink with brown and blue washes

Inscribed: "Gondola/Venice"

890-19. Elgin Marbles, two figures and a horse

Pencil

Inscribed: "Elgin Marbles"

890-20. Perspective view of the harbor of Genoa

Pencil with ink washes

Inscribed: "Genoa"

890-21. Two heads, a bearded man and a young girl

Pencil with ink washes

Inscribed: [The identifications have been obliterated with an erasure]

890-22. Two heads of girls

Pencil and wash

890-23. Ophelia. She holds on to a bough and dips her foot in a brook

Pencil and wash

Inscribed: "Ophelia"

890-24a. Profile of a woman

890-24b. Young man and woman embracing

Pencil and wash

Inscribed: "Vacation finished"

890-25. Copy after Philip Veit's *Two Mary's at the Tomb*

4 5/8 x 6 in. (11.7 x 15.2 cm.)

Ink washes

Inscribed in ink: "Philip Veit"; in pencil: "Two Marys at the Tomb"

890-26. Girl looking in mirror

Pencil, watercolor, and wash

Inscribed: "Morning Toilet"

890-27. Sketch from St. Paul by Raphael

4 9/16 x 3 in. (11.6 x 7.6 cm.)

Pencil

Inscribed: "Sketch from St. Paul/by Raphaelle Rome 1833"

890-28. View of Florence

Pencil and wash

Inscribed: "Florence—Italy"

890-29a. Outside the walls of Rome

Watercolor and pencil

Inscribed: "Rome/Outside the Walls"

890-29b. *Rio Teveroni Environ of Rome*

Pencil and wash

890-30. Phrenological charts of J. C. Spurzheim

Pencil and ink

Inscribed: "Spurzheim"

890-31. Entrance to the Borghese Gardens

Ink, wash, and pencil

Inscribed in ink: "near the Pincian—Rome"; in pencil: "Entrance to the Borgese Gardens"

890-32. Profile of horse's head

Pencil on paper, mounted in sketchbook

4 15/16 x 3 3/4 in. (12.6 x 9.5 cm.)

Inscribed: "from nature"

890-33. Profile of a cow's head

Medium not given

3 1/2 x 3 3/4 in. (8.9 x 9.5 cm.)

Inscribed: "from nature"

890-34. Two children playing with a basket

Pencil

Inscribed: "children at play"

890-35a. Drawing of a woman in Renaissance dress

890-35b. Drawing of woman and child at the right of Guido Reni's *Massacre of the Innocents* in the Pinacoteca Nazionale, Bologna

Pencil and wash

Inscribed: "Bologna"

890-36a. Drawing of chimney stacks

890-36b. Drawing of a woman's head from a painting

Pencil and wash

Inscribed: "Chimney stacks/Venice"

890-37. Figures on horseback from the Elgin
 Marbles

Pencil and wash

Inscribed: "Elgin Marbles"

890-38a. Road to Villa Borghese

Ink wash and pencil

Inscribed: "Road to the Villa Borgese"

890-38b. Villa near the Pincian Gate

Ink wash and pencil

Inscribed: "Villa near the Pincian Gate"

890-39a. Detail of angel in P. F. Mola's *St. Peter
 freed from Prison*

890-39b. Detail of virgin in Caravaggio's
 Madonna de¹ Palafrenieri

Pencil

Inscribed: "Palazzo Borgese [*sic*] Caravaggio"

890-40. Detail of Raphael's *Fall of Jericho*

Pencil and wash

Inscribed: "Loggia de Raffaele Fall of Jericho Loggia de
Raffaele"

890-41. Two details from the Loggia de
 Raffaele

Pencil and wash

Inscribed: "Loggia de Raffaele Jacob's dream Jacob/from
Raffaele"

890-42. View of the Tiber

Pencil

890-43. Ponte Rotto Rome

Pencil and wash

Inscribed: "Ponte Rotto Rome"

890-44. Roman houses

Pencil

Inscribed: "View/Island of the Tiber/Pilate's House
Rome"

890-45. Roman aqueducts

Pencil, ink, and wash

Inscribed: "Campana of Rome Aqueducts"

890-45a. View of Villa Borghese

890-45b. Corridor

Pencil and wash

Inscribed: "Villa Borgese [*sic*]"

890-46a. Detail of a painting showing a man
 [actually a figure from Pieter Codde's
 Un corpo di guardia in the Borghese
 Gallery, Rome]

Pencil

Inscribed: "German School/Louvre"

890-46b. Study after Raphael's *St. Cecilia*

Ink, wash, and pencil

Inscribed: "St. Cecelia, Raffaelle Bologna"

890-47. Townscape

Pencil and wash

Inscribed: "Outside the walls of Rome"

890-48. Study of Decamps' *Le Passage du Gué*
 [*Le Passage du Gué* (1849) Musée des
 Beaux— Arts, Algiers]

Wash and pencil

3 1/4 x 4 1/2 in. (8.3 x 11.5 cm.)

Inscribed: "from De Camps"

890-49. Lot and his daughters from the Loggia
 de Raffaelle

Pencil and wash

Inscribed in pencil: "Lot and his daughters"; "Loggia de
Raffaelle"

890-50. Venetian window

Ink and pencil

Inscribed: "Venetian"

890-51. Color scale

Watercolors

Inscribed: "Prismatic Spectrum/colors of the Rainbow"

ALBUM IV: ROUGH SKETCHES
BY ALFRED JACOB MILLER

891.
Maryland Historical Society, Baltimore 56.24.3; gift of
Mr. Lloyd O. Miller

PROVENANCE
The artist; by descent to Lloyd O. Miller

891-1a. A striped cat is sitting in front of a fire.
It is a three-quarter view from the back
with its left side visible. One andiron
and the ends of some logs are visible in
the fire. On the back there is a rough
pencil sketch of a reclining figure.

Pencil with ink wash

5 1/8 x 4 1/8 in. (13.2 x 10.5 cm.)

Inscribed, l.c.: "Pill at the kitchen fire"

891-1b. A striped cat is lying down on the floor
and is viewed from the back. His right
side is visible and his head is turned so
that it is in right profile.

Pencil with ink wash

4 1/8 x 4 5/8 in. (10.4 x 11.8 cm.)

Inscribed, l.r. edge of image: "Lorraine"; l.c.: "Pill at
Lorraine"

891-2. A landscape that is dark in the
foreground and lighter in the distance.
There is a river with a large bridge over
it in the middle distance.

Ink wash

4 3/8 x 6 5/8 in. (11.2 x 16.5 cm.)

Inscribed, l.c.: "Effect—Sun—Rise"

891-3. Two children, a boy and a girl, are
sitting on the grass. The boy, wearing
red and white striped pants and a yellow
coat, is holding a basket. The girl, who
is wearing a red dress, is sitting to the
left of the boy and slightly behind him.
She has a hand on his arm and looks
over his shoulder.

Pen and ink with watercolor

6 3/8 x 5 5/8 in. (15.4 x 14.3 cm.)

Inscribed, l.r.: "Farmer's Children"

891-4. Two women are standing on a porch
and looking over a low masonry wall
toward a man who is riding away on a
horse at the left. On the back are several
pen-and-ink sketches: to the left is a
kneeling girl and a dog; in the center is
the head of a bearded man; to the right
is a man seated on a tree stump and
looking to the right at something that
has been cut off.

Pencil and pen and ink with ink wash

7 5/8 x 5 3/4 in. (19.5 x 14.8 cm.)

Inscribed, l.r.: "War draft"

891-5. A full-length front view of a boy seated
in an upholstered chair. He is well
dressed, wearing a coat, vest, and tie. His
left hand is in his pants pocket and his
other arm is resting on the arm of the
chair.

Pen and ink with ink wash

9 x 5 3/4 in. (23.1 x 14.7 cm.)

Inscribed, l.c.: "Pose for a boy"

891-6. A half-length figure shown turned to the
left. The person is wearing Renaissance
clothing with a plumed hat and a sword
that hangs from a strap that goes
diagonally from the shoulder to the
waist. The person is reading from a piece
of paper held out in the right hand.
[Shakespeare, *As You Like It*]

Pen and ink with ink wash

8 7/8 x 6 5/8 in. (22.7 x 16.8 cm.)

Inscribed, u.r.: "As you like it/Act III"; l.c.: "Pose—
reading "From the East to Western Ind/[He ____ vel?]
is like Rosalinde"

891-7. Three half-length portraits of men. The
man to the left is working on a palette.
The body of the man in the center is
turned to the left and is facing out. The
man on the right is also looking out at
the viewer and his body is facing slightly
to the right.

Pen and ink

6 1/2 x 9 7/8 in. (15.4 x 25.1 cm.)

Inscribed, u.r.: "Brower"; l.l.: "Van der Velde"; l.c.:
"Francis [Meiris?]/Elder"; l.r.: "Adrian Brower"

891-8a. A full-length drawing of a man seated in a chair to the left of a table. A bottle and a glass are on the table. The man has a rather sour look on his face as he raises a bell in his left hand.

Pencil and ink wash

5 3/4 x 4 1/2 in. (14.7 x 11.5 cm.)

Inscribed, l.r.: "out of spirits"

891-8b. A rough sketch of a woman standing outside in the wind. She is facing right and holds a torch up in her right hand. Her hair and clothing are being blown back by the wind.

Pencil and ink wash

4 1/8 x 3 1/2 in. (10.4 x 8.8 cm.)

Inscribed, u.r.: "Fisherman's wife"; l.c.: "After the storm/Fisherman's/wife"

891-9a. A view of a girl kneeling in the grass, seen from the back. She is wearing a straw hat and is watching a butterfly. Another girl, farther in the distance to the right, is also kneeling in the grass.

Ink wash

5 5/8 x 4 5/8 in. (14.3 x 11.8 cm.)

891-9b. A sketch of a little girl seated on the ground. Her legs are out to the left and she looks at the viewer straight on.

Pen and ink with ink wash

Dimensions not given

Inscribed, l.r.: "Pose for a girl"

891-10. A sketch of a full-length standing boy playing a drum. He is facing front and other figures are sitting in a circle behind him.

Pen and ink with ink wash

7 5/8 x 5 3/4 in. (19.4 x 14.7 cm.)

Inscribed, l.r.: "Morning Reville"

891-11. A view of a building at the edge of a stream. The house is on the left side of the image. Planks lead up to a second-story entrance and a figure is standing in the doorway. A red smokestack rises from the roof. Farther in the distance a house is in the center of the image. The sky is pink and some of the leaves on the trees are bright red.

Oil or gouache

7 1/4 x 5 1/2 in. (18.6 x 13.9 cm.)

891-12a. A sketch of a sitting dog, seen from the back.

Pen and ink with ink wash

4 x 2 3/8 in. (10.1 x 5.9 cm.)

Inscribed, l.c.: "sketch of a dog—from nature"

891-12b. A rough sketch of an older long-haired man sitting on the ground. A light is shining behind him and he seems to be writing.

Pen and ink with ink wash

3 7/8 x 3 1/4 in. (9.7 x 8.4 cm.)

Inscribed, l.r.: "Sterne's/Captive/Sterne's Captive"

891-13a. A half-length sketch of a man with his body turned to the left and his head to the right. He has thick, curly, dark hair and a hint of a moustache.

Pen and ink with ink wash

6 1/2 x 4 3/4 in. (15.1 x 12.1 cm.)

891-13b. A full-length, right-profile sketch of a man sitting in a straight-backed chair, reading a paper. He is wearing a wide-brimmed hat and a beard and moustache.

Pen and ink with ink wash

Dimensions not given

Inscribed, l.c.: "Jonathan must have/his newspaper"

891-14. A sketch of three girls who look wet and disheveled from having been caught in a downpour. Two of the girls are sitting down and holding out the hem of an apron with their fingertips. At the right, the rain is pouring down and a person is walking with an umbrella.

Pen and ink with ink wash

4 1/4 x 6 3/4 in. (10.8 x 17.1 cm.)

Inscribed in margin, below image: "Bonnet question/'O dear Fanny—the rain has/ruined my 'Sun Set'/Fanny—well My 'Snow Flake' has melted/& Susan's 'May Queen' is a perfect fright"

891-15a. A sketch of a man wearing a turban, sitting on the ground. His arms are raised and spread out. His feet are raised on a basket that has been knocked over and is spilling its contents. [Scene from *The Arabian Nights' Entertainments*]

Pen and ink with ink wash

3 3/4 x 5 1/8 in. (9.7 x 13.1 cm.)

Inscribed on upper edge: "it was not pleasant to watch/ them [illeg.]"; right of figure: "Alnaschar's/vision"; below figure: "Arcadis arabs [continues but is written over by second inscription] H[illeg.] in[illeg.] said of Game"; below image: "Alnaschar's Vision—Arabian Nights/ [illeg.]"

891-15b. A bust-length sketch of a man with dark, curly hair and a moustache. His head is turned to the left.

Ink wash with white

4 7/8 x 3 7/8 in. (12.3 x 9.9 cm.)

891-16a. A sketch of a young man sitting at the edge of a cliff by a dead tree. The sky is dark and lightning is indicated by jagged pencil lines.

Ink wash

4 3/4 x 4 1/4 in. (12.3 x 10.9 cm.)

Inscribed, l.c.: "The boy Schiller watching the/Lightening [*sic*]"

891-16b. A sketch of a woman looking out a window. She is seen from the chest up and has a finger up to her chin. She has curly brown hair.

Pen and ink with watercolor

5 5/8 x 4 1/4 in. (14.2 x 10.7 cm.)

Inscribed below window edge: "What keeps him, I wonder?"

891-17a. A rough sketch of a woman sitting on the ground and washing her feet.

Pen and ink

3 5/8 x 4 1/8 in. (9.1 x 10.4 cm.)

Inscribed, l.l.: "Scotch Lassie/Washing her feet"; l.r.: "Scotch Lassie"

891-17b. A sketch of a figure slumped on the ground with her head down. A cottage with a thatched roof is to the left. A man is walking off to the right with a gun over his shoulder.

Pencil with ink wash

4 x 5 in. (10.1 x 12.9 cm.)

Inscribed, u.r.: "arm arm it is—it is!/The cannon's openning [*sic*] roar"

891-18a. A waist-length sketch of a woman. Her body is turned to the left and she is looking out at the viewer. She has a shawl wrapped around her shoulders; she is holding the shawl with one hand.

Pen and ink with ink wash

5 1/2 x 4 3/4 in. (14.1 x 12.0 cm.)

891-18b. A full-length sketch of a boy seated in a chair. He has his right elbow on the chair rail and holds the side of his head with his right hand. A little girl is standing beside him and is resting her head on his right arm. Both children look very sad.

Pen and ink with ink wash and white gouache

5 1/2 x 4 1/2 in. (14.1 x 11.4 cm.)

891-19. A full-length sketch of a child seated on the ground. His position has his body above his feet, as if seated in a chair. The child is wearing a dress and is holding some beads in his lap with both hands. His feet are bare.

Pen and ink with ink wash and white

6 3/8 x 4 1/2 in. (16.1 x 11.3 cm.)

Inscribed, l.c.: "Sketch for Position of a child"

891-20. A three-quarter study of a woman in a wedding dress and veil. Her body is turned to the right and she looks out at the viewer. She is holding a closed fan in her right hand.

Pen and ink with ink wash

7 1/4 x 6 1/8 in. (18.5 x 15.6 cm.)

Inscribed, l.c.: "Position Three quarter length"

891-21a. A sketch of two boys on some steps. One boy is standing with one foot on the step and the other on the next step up. He is seen from the back and has both hands on the railing. The second boy is wearing a striped shirt and a cap over his curly hair.

Pen and ink with ink wash

4 5/8 x 4 1/8 in. (11.8 x 10.5 cm.)

Inscribed, u.r.: "Street sketch"

891-21b. A sketch of a man in a long coat, seen in right profile facing a curtsying woman. [from James Boswell, *The Life of Johnson*]

Pencil with ink wash

5 1/4 x 3 7/8 in. (13.3 x 9.7 cm.)

Inscribed, u.c.: "Dr Johnson & the actress"; upper edge of paper: "Dr Johnson & the actress/Boswell"; lower edge of image: "Dr Johnson and the actress/Boswell"; l.c.: "all the actresses know me/& dropped me a courtesy [curtsy?] as they/posed on stage"

891-22. A sketch of a girl leaning her back against the back of a chair. Her hands are in a fur muff and she has a stubborn, sour look on her face. Another person, an older woman, appears to be kneeling in the seat of the chair and is peering over the back of the chair at the girl.

Pencil and pen and ink with ink wash

7 3/8 x 4 3/4 in. (18.9 x 12.2 cm.)

891-23. A landscape with a yellow stucco villa with red tile roofs in the left foreground. Trees frame the picture. The view looks down toward a body of water and off toward some distant mountains. The sky is in pale shades of pink, yellow, and blue.

Watercolor

5 5/8 x 9 1/4 in. (14.4 x 23.3 cm.)

Inscribed, l.c.: "Italian Villa"

891-24. A full-length portrait study of a girl leaning on the back of a chair draped with a piece of fabric. Her lower left arm is across the top of the chair and her right elbow is on the back of the

chair. She is resting her chin on her right hand. She is standing on a tile floor and a faint landscape opens up behind her. Curtains are at the right.

Pen and ink with ink wash on paper embossed "BRISTOL/ BOARD"

7 3/4 x 6 1/8 in. (19.6 x 15.4 cm.)

Inscribed, l.r.: "Sketch for/Miss Henderson"

891-25a. Two beggars are shown in ragged clothes. The larger one, to the left, is seated on a fence rail. He is holding a walking stick and has his head bowed. The smaller one is standing to the right of the other and is holding out a hat.

Ink wash

5 5/8 x 4 5/8 in. (14.4 x 11.7 cm.)

Inscribed, l.r.: "street sketch"

891-25b. A young boy is running from right to left and is watching a balloon that is flying in the distance at the left.

Pencil with ink wash

6 x 4 1/4 in. (15.2 x 10.7 cm.)

Inscribed, l.r.: "Balloon"

891-26a. A full-length sketch of a man sitting at the end of a simple wooden bench. His legs are crossed at the knees and he has a book in his lap. He is holding a pen in his right hand.

Pen and ink with ink wash

5 1/8 x 4 1/2 in. (13.0 x 11.4 cm.)

891-26b. A philosopher-type man in classical robes and sandals is walking up a hill. He is carrying a lamp in his left hand.

Pen and ink with ink wash

5 1/8 x 4 1/4 in. (13.1 x 10.7 cm.)

Inscribed, u.r.: "Diogenes/looking for an [illeg.]/[illeg.] [honest man]"

891-27a. A small boy, sitting in a chair, is lifting the lid off a tea kettle on a table beside him. He is facing an older woman in another chair. The woman appears to be talking to the boy. [youth of James Watt]

Pen and ink with ink wash

5 3/4 x 4 1/8 in. (14.6 x 10.5 cm.)

Inscribed, l.c.: "Invention of Steam Engine/youth of James Watt"

891-27b. A little girl is sitting on the ground outside. She is wearing a cape that is clasped at her neck. Her knees are raised up and she is holding her hands around her left knee. Part of a tree is behind her and a stream is in front of her.

Pencil with ink wash

6 x 4 3/4 in. (15.4 x 12.2 cm.)

891-28. A sketch of some large rocks with a single tree growing up from them. The drawing is done on the back of an advertising flyer for the Ballad House Hotel in Richmond, Virginia.

Pen and ink with ink wash

5 x 8 7/8 in. (14.0 x 22.5 cm.)

Inscribed, l.l.: "Jefferson's Rock/Harper's ferry"

891-29a. A sketch of four people with baskets. The man drawn with the greatest clarity is in the center foreground. He is shown in right profile and has his left leg out in front of the right leg and bent at the knee.

Pen and ink with ink wash

4 5/8 x 4 1/4 in. (12.0 x 10.8 cm.)

891-29b. A little girl is sitting on a large cushion with a tassel at the corner. A doll is roughly sketched in, in front of her.

Pencil with ink wash

5 1/4 x 4 3/8 in. (13.2 x 11.0 cm.)

891-30. A drawing of an encounter between a young boy with a guitar strapped to his back and a man with a pack on his back. The boy is seen from the back and is to the right. The man has a walking stick and seems to be about to run over the boy. [from Victor Hugo, *Les Misérables*, 1862]

Pen and ink with ink wash

6 3/4 x 4 7/8 in. (17.1 x 12.3 cm.)

Inscribed, u.l.: "Jean Valjean"; u.r.: "Jean Valjean & the/ Savoyard"; l.c.: "Miserables of Victor Hugo"

891-31. A landscape with a windmill on some land that is slightly elevated from the surrounding marshy land. The sky is dramatic in its lighting.

Pen and ink with ink wash

4 3/8 x 6 5/8 in. (17.1 x 16.9 cm.)

891-32. A man is sitting in a chair in front of a fireplace. The fireplace has a pointed arch shape. The man is viewed from the side and behind. He is bent over and has his head buried in his hands. A walking stick, a pack, and a hat are beside him on the floor.

Pencil with ink wash

3 7/8 x 4 5/8 in. (8.6 x 11.8 cm.)

Inscribed, l.c.: "The Traveller/winter's night"

891-33. A woman is shown leaning on the corner of a stone pedestal on which a large urn has been placed. She is wearing a red wrap over a white dress. Her head is bowed in grief. A child is at the right, tugging on her wrap.

Watercolor

7 1/8 x 4 3/4 in. (18.1 x 12.2 cm.)

Inscribed below image, in margin: "Widowed Mother"

891-34. A sketch of a boy and a girl sitting on the ground. The boy, to the left, is slightly higher than the girl and is in full view. The girl is kneeling in left profile and is reaching up to put her arms around the boy's neck; she is looking out at the viewer. The boy has his arm around her back. On the back of the paper are pencil sketches of parts of crests.

Pencil with ink wash

7 1/4 x 4 3/4 in. (18.2 x 12.1 cm.)

891-35. A sketch for a portrait of a girl sitting in a landscape. She is in left profile and looks out at the viewer. In her left hand she is holding a piece of cloth with which she is playing with a kitten. The girl has curly brown hair.

Pencil with ink wash

7 1/8 x 5 5/8 in. (18.2 x 14.2 cm.)

Inscribed, l.c.: "Design for Miss Henderson"

891-36. A full-length sketch of a woman seated at the left end of a sofa. The sofa is red and a piece of blue fabric is draped over the arm. The woman is resting her arm on the arm of the sofa. She is wearing a white dress and is in full view.

Pen and ink with watercolor

7 7/8 x 6 in. (20.1 x 15.4 cm.)

Inscribed, l.r.: "Sketch for full length—Mrs/Pendleton"; l.c.: "Sketch for full length of Mrs Pendleton"

ALBUM V: SKETCHES OF VARIOUS SUBJECTS
BY ALFRED JACOB MILLER

892.

Maryland Historical Society, Baltimore 56.24.2; gift of Mr. Lloyd O. Miller

PROVENANCE

The artist; by descent to Lloyd O. Miller

892-1. Two men in a street, looking down and talking to a woman who is standing below them on some cellar steps. Only the upper part of the woman's body is visible. [from Sir Walter Scott, *The Antiquary*, 1816]

Ink wash

3 7/8 x 5 in. (9.8 x 12.8 cm.)

Inscribed, u.r.: "old buck"; label: "oldbuck & Mrs Machenchov/Mrs M—'Jude guide us'____ saw my body/the like o' that'/Oldbuck 'Yes you abominable woman, many/have seen the like of it & all will see/the like of it that have anything to so [do?]/with your trolloping sex'/Scotts Antiquary/page 5"

892-2. Two figures in a cart with two horses harnessed to it. They are standing in shallow water. A man in a rowboat is beside them and an object is being transferred between the boat and the cart.

Watercolor

3 7/8 x 5 3/4 in. (9.9 x 14.8 cm.)

Inscribed, l.l.: "[Marketing?]/Hawkins Point" [Anne Arundel County, Md.]

892-3. Sketch of a cat, seen from the right.

Pen and ink with ink wash

2 3/8 x 2 3/4 in. (6.2 x 7.1 cm.)

Signed, l.l.: "AJM [monogram]"

892-4. Title page

11 3/4 x 8 1/2 in. (19.9 x 21.5 cm.)

Inscribed in ink, center of page: "Rough sketches/by/ AJM [monogram] iller"; in pencil: "Lloyd O. Miller"

892-5. A boy in a chair, suspended in the air next to a cliff. He is using a pole to push himself away from the rocks.

Ink wash

4 7/8 x 3 in. (12.3 x 7.6 cm.)

Inscribed illegibly, l.l. and l.r.

892-6. An older man in armor, sitting by the side of the road. His plumed helmet is beside him. He has a large book on his lap and a sword in his hand. On the back is a rough sketch of a standing man with a book in one hand and a sword in the other. [scene from Sir Walter Scott, *Old Mortality*, 1816]

Watercolor

5 3/8 x 3 7/8 in. (13.8 x 9.7 cm.)

Inscribed, lower edge of image: "Balfour of Burley/ Scott"; on verso of image and on label: "Bible in one hand & sword in the/other contending with ever [*sic*] energy/of mankind, gasping for breath/& with the cold moisture running/down his face (old mortality)"

892-7. A woman, seated in a chair, is facing left. A girl is kneeling at her right side and has her face buried in the seated woman's lap.

Ink wash

4 x 4 3/4 in. (10.3 x 12.2 cm.)

Signed, l.l.: "AJM [monogram]"

Inscribed on verso: "consolation"; on label: "Always so, whenever I'm in a [illeg.]"

892-8. Three-quarter-length young man with a gun is shown in three-quarter view facing right. He is leaning against a tree.

Watercolor

8 7/8 x 6 1/4 in. (22.5 x 15.9 cm.)

892-9. Three-quarter-view, head-and-shoulders portrait of a young man with a bow tie.

Pencil and charcoal

9 x 7 in. (22.9 x 17.8 cm.)

Signed, l.l.: "AJM [monogram]"

Inscribed, l.c.: "Aged 17 yrs"; l.r.: "Chapin Harris"

892-10. Three-quarter-length portrait of a woman facing front. On the back is a perspective drawing of a table.

Pencil with ink wash

6 1/2 x 4 3/4 in. (16.5 x 12.3 cm.)

Inscribed, l.l. of image: "Sir Peter Lely Pinxt/attitude of the Duchesse of Portsmouth"; in margin, u.r.: "Perspec [sic] table on back"

892-11. Sketch of a striped cat, asleep next to a fireplace. On the mount is a rough sketch of a man.

Pencil with ink wash

4 1/2 x 4 in. (11.4 x 10.4 cm.)

Signed, l.l. of image: "AJM [monogram]"

Inscribed on mount, l.c.: "Favorite cat 'Pill' at Lorraine/near Franklin"

892-12. Sketch of a portrait by Lely. A woman in a low-cut dress in three-quarter length and turned to the left. On the back is a perspective drawing of an unidentifiable object.

Pencil with ink wash

8 3/8 x 6 1/8 in. (21.4 x 15.6 cm.)

Inscribed, u.r.: "Perpec [sic] of [Sgt.?] on back"; l.c.: "Sir Peter Lely/ Attitude of Cathe [sic] of Braganza/Queen of Charles 2"

892-13. Portrait sketch of a woman's head and upper torso. She is turned a little to the right.

Pencil with ink wash

5 3/8 x 4 1/8 in. (14.7 x 10.6 cm.)

Inscribed, l.c.: "Caroline of Brunswick"

892-14. Mountain scenery. The mountains in the background are craggy and snow covered. In the foreground are trees in a field and a figure on a donkey.

Watercolor

8 x 6 in. (20.4 x 15.3 cm.)

Label: "Swiss Scenery"

892-15. A landscape, roughly done.

Ink wash

2 5/8 x 6 in. (6.6 x 15.4 cm.)

Label: "Study for Effect"

892-16. Drawing of a woman draped in classical garb. She is shown standing in full length, facing front, and holding an open scroll.

Pencil

6 1/4 x 7 5/8 in. (15.8 x 19.5 cm.)

Signed, l.l. of image: "AJM [monogram]"

Inscribed, l.r.: "Allegoric figure of History"

892-17. Drawing of a man clinging to a broken mast that is sticking out of the water. On the back is a rough sketch of a chair in an interior.

Pencil

3 7/8 x 5 3/4 in. (9.8 x 14.6 cm.)

Label: "Survivor of the wreck"

892-18. Drawing of a full-length, standing woman, turned slightly to the right. Her arm is raised and her right hand is on an open book on a table. She seems to be talking.

Pencil

6 x 5 1/4 in. (15.3 x 13.5 cm.)

Signed, l.l. of image: "AJM [monogram]"

Inscribed, l.r.: "Truth"

892-19. A landscape.

Ink wash

2 3/4 x 6 1/8 in. (7.0 x 15.7 cm.)

Label: "study Effect of Light"

892-20. A landscape with a mountain in the background.

Watercolor

3 1/8 x 6 7/8 in. (7.9 x 15.1 cm.)

Label: "Effect of Light"

892-21. Four men, sitting in a tight circle in a sailboat.

Pen and ink with ink wash

5 5/8 x 5 in. (14.4 x 12.6 cm.)

Inscribed, l.r.: "Fou [*sic*] Castle yarn"

892-22. A man on his hands and knees, leaning over the edge of a dock. He has a stick in one hand and a basket beside him.

Pen and ink with ink wash

4 x 3 5/8 in. (10.1 x 9.3 cm.)

Label: "Wharf rat/a picker up of unconsidered trifles"

892-23. Mountain scenery. Craggy, snow-capped mountains are in the distance and a large lake is in the middle distance. In the foreground is a strip of grass-covered ground. A man and a mule are standing near the edge of the water.

Watercolor

6 7/8 x 5 7/8 in. (17.3 x 14.8 cm.)

Label: "Matterhorn/Switzerland"

892-24. An old woman in a mid-calf-length skirt, a shawl, and a straw hat. She is carrying a bucket and a basket. A roughly sketched outdoor market is behind her.

Pencil with ink wash

8 1/2 x 6 in. (21.6 x 15.2 cm.)

Inscribed, l.r.: "1825/Mrs Shaw"

892-25. A woman in classical garments; she is standing facing front, holding a staff in one hand and a sword in the other. A cannon and a drum are behind her.

Pencil

6 5/8 x 7 5/8 in. (16.9 x 19.3 cm.)

Inscribed, l.r.: "Allegoric figure of Liberty"

892-26. The head and shoulders of a man, turned slightly to the left. He has thick hair, a beard, and a moustache.

Ink wash

5 5/8 x 5 in. (14.3 x 12.8 cm.)

892-27. A half-length man, seen from the front with his head turned in left profile. His right hand is at his chin.

Ink wash

5 1/8 x 4 3/8 in. (13.1 x 11.1 cm.)

Label: "Chewing the cud of sweet/& bitter fancies"

892-28. A roughly done landscape.

Ink wash

2 5/8 x 4 7/8 in. (6.7 x 12.3 cm.)

Label: "Effect of Light"

892-29. A roughly done landscape.

Ink wash

2 3/4 x 6 1/4 in. (7.0 x 15.8 cm.)

Label: "Sketch for Effect"

892-30. A cabin in a field by a lake. Several trees are around. On the back is a watercolor sketch of a small red building by the shore.

Watercolor

3 3/8 x 5 1/4 in. (8.4 x 13.4 cm.)

Inscribed, l.l.: "View on other side"; l.r.: "Smiths Island Delaware"; on verso, u.l.: "2 umber dark/3 [mass?] of Ochre"; on verso, u.r.: "1 Pea green & subdued high [illeg.]/edges/sky and mountain blending into pale green"

892-31. Two men, about to fight with knives. The one on the left has on a butcher's apron and the one on the right appears to be the aggressor.

Pen and ink

4 x 4 5/8 in. (10.1 x 11.7 cm.)

Inscribed along lower edge: "Now! Come on Butcher if you want to fight"

892-32. Drawing of a woman with a fan, sitting in a chair in front of the fireplace.

Pencil and ink

5 1/2 x 3 3/4 in. (14.1 x 9.5 cm.)

892-33. Portrait sketch of a three-quarter-length seated woman, seen from the front. She has a dog to her left.

Pencil and ink

7 x 5 1/8 in. (17.3 x 13.1 cm.)

Inscribed, l.c.: "Elizabeth Countess of Chesterfield/Sir Peter Lely Pt"

892-34. A young woman in a white dress, seen in three-quarter length in left profile. A landscape is behind her.

Oil

4 3/8 x 3 3/8 in. (11.2 x 8.5 cm.)

Label: "In Maiden Meditation/Fancy free"; signed: "AJM [monogram]"

892-35. A girl kneeling by a tree and playing with a squirrel. Her body is in left profile and her head is turned out to the viewer.

Watercolor

5 3/4 x 4 3/4 in. (14.6 x 12.0 cm.)

Label: "Position for daughter of/H. Henderson"

892-36. A small man walking forward, cocking his head and holding his hands at his ears. He is wearing a hat and knee-length breeches.

Ink wash

8 x 6 3/8 in. (20.4 x 16.3 cm.)

Label: "Position for an infant"

892-37. A young girl, sitting on the floor with her right arm over a pillow. She is facing front.

Watercolor and ink

6 3/8 x 6 1/2 in. (16.3 x 16.5 cm.)

892-38. Fortifications on Federal Hill. The ground has been terraced in two tiers and there are cannons on both tiers. A man and a woman are in the foreground.

Watercolor on verso of printed invitation to party given by directors of Artists' Association of Baltimore

3 3/8 x 5 1/8 in. (8.7 x 13.0 cm.)

Label: "Fortification on Federal Hill—war of 1861–65—looking West"

892-39. Two figures in a hallway. They are seen from the back, looking out a window. On the back is a large boat in rough seas. [night before Battle of Waterloo]

Pencil with ink wash

4 x 5 3/4 in. (10.2 x 14.5 cm.)

Inscribed, l.c.: "First alarm at Brussels"

892-40. A building on the side of hill, overlooking a body of water in a valley.

Watercolor

3 3/4 x 6 1/4 in. (9.5 x 16.0 cm.)

Inscribed, l.l.: "Harper's Ferry"; Label: "Harper's ferry"

892-41. A small log cabin in a rural setting. A door and one window are on the long side. An addition with a chimney is at the right end. A water pump is in front of the cabin.

Medium not given

4 1/2 x 6 1/8 in. (11.5 x 15.5 cm.)

892–42. Two men in eighteenth-century dress, bowing to each other in front of a pair of double doors.

Pencil and ink

5 x 6 1/8 in. (12.9 x 15.5 cm.)

Label: "Old French regime/etiquette on entering a room"

892-43. A child in a blue dress and red-and-white socks. The child is in a landscape and holds a hoop and a stick.

Watercolor

6 1/2 x 4 7/8 in. (16.5 x 12.2 cm.)

892-44. A dog, sleeping on a wooden floor; it is seen from the rear and its head is not visible.

Pencil and ink

2 3/4 x 4 5/8 in. (6.8 x 11.8 cm.)

Label: "Dog asleep/from nature"

892-45. A landscape. The sun is low in the sky and the scene is hazy. A bridge is over a river in the middle distance.

Oil

3 1/2 x 5 1/8 in. (8.9 x 13.2 cm.)

Label: "Sketch for effect"

892-46. Sketch of the skyline of a city in a landscape; roughly done.

Ink wash

3 1/8 x 6 in. (7.9 x 15.4 cm.)

Label: "Distant Sun Lights"

892-47. Sketch of a landscape; there are some outlines of buildings.

Ink wash

3 3/8 x 6 in. (8.6 x 15.2 cm.)

Label: "Effect—Distant City"

892-48. A girl on her hands and knees in a field. She is holding her straw hat onto the ground in front of her and she is looking out at the viewer.

Watercolor

6 x 5 3/8 in. (15.3 x 13.6 cm.)

Signed, l.l.: "AJM [monogram]"
Label: "Capture of the Butterfly"

892-49. A figure in a kilt running through a landscape, carrying a burning torch in front of him. [from Sir Walter Scott, *Waverly,* 1814]

Ink wash

5 5/8 x 4 3/4 in. (14.4 x 11.9 cm.)

Inscribed, l.r.: "Feudal Levy/Scotch gillie/gathering the clans/ for the [pretender?]"

892-50. A girl sitting on a fence. She is holding a basket of flowers. On the back are some rough figure sketches.

Ink wash

7 1/4 x 5 1/2 in. (18.3 x 14.0 cm.)

Label: "Position for/length"

892-51. A woman in a red dress, a blue jacket, and an apron. She is standing in front of a wash tub, doing laundry.

Watercolor

7 x 4 7/8 in. (17.7 x 12.5 cm.)

Label: "Captain Molly/description opposite"

892-52. Missing.

892-53. A man, seated in a chair, with a bandaged foot on a stool in front of him. He has a crutch across his lap.

Ink wash

6 x 4 3/4 in. (15.2 x 12.2 cm.)

Label: "A touch of Gout"

ALBUM VI: BALTIMORE ALBUM

893.

Pen-and-wash sketches on paper

(1825–1870)

The Walters Art Gallery, Baltimore, Maryland; gift of Mr. and Mrs. J. William Middendorf II

PROVENANCE
the artist; by descent to L. Vernon Miller; Kennedy Galleries, New York; Mr. and Mrs. J. William Middendorf II

REFERENCES
WMAA, *Alfred Jacob Miller: Baltimore Sketches, 1825–1870,* text by Wendy J. Shadwell; John Canaday, "50 Drawings of Alfred Jacob Miller Placed on View at the Whitney Museum," *New York Times,* June 26, 1969, p. 38; "Reviews and Previews: Alfred Jacob Miller," *Art News* 70, no. 2 (April 1971): 18; Gold, "Alfred Jacob Miller," pp. 26, 28-29; Randall, "Gallery for Alfred Jacob Miller," p. 841

893-1. After the "Slap up" party of last night! Frank is somewhat indisposed to study.

6 7/8 x 5 1/8 in. (17.5 x 13.0 cm.)

Walters Art Gallery 37.2468.7; gift of Mr. and Mrs. J. William Middendorf II, New York City (December 1970)

893-2. " 'Ah Dan—Drunk as usual,—You've been fighting & received a pair of black eyes'—?—Oh you precious scamp! Dan— 'No, Sirree—Fella round the corner & most strodinary, would run right agin, me.' "

12 11/16 x 11 7/16 in. (32.2 x 29.1 cm.)

Walters Art Gallery 37.2510.1; gift of Mr. and Mrs. J. William Middendorf II, New York City (December 1973)

EXHIBITIONS
WAG, March 16–May 18, 1969; WMAA, June 17–July 20, 1969

893-3. Artist's studio. The Critic.

14 5/8 x 16 3/16 in. (39.7 x 41.1 cm.)

Walters Art Gallery 37.2519.7; gift of Mr. and Mrs. J. William Middendorf II, New York City (December 1974)

REFERENCES
Gold, "Alfred Jacob Miller," p. 28 (illus.)

893-4. Bibliomaniac with an "Elzivir" in hand!

5 x 4 in. (12.7 x 10.2 cm.)

Walters Art Gallery 37.2468.46; gift of Mr. and Mrs. J. William Middendorf II, New York City (December 1971)

893-5. "Bill—If you are coming,—why don't you come along?"

14 1/8 x 16 3/8 in. (35.9 x 41.6 cm.)

Signed, l.l.: "AJM [monogram]"

Walters Art Gallery 37.2510.16; gift of Mr. and Mrs. J. William Middendorf II, New York City (December 1973)

EXHIBITIONS

WAG, March 16–May 18, 1969; WMAA, June 17–July 20, 1969

893-6. Bob (from the city), visits his country cousin—"Come along cousin Bob and I will show you the *Hornet's nest!* and everything to make you *comfortable!* "

11 3/8 x 14 3/16 in. (28.8 x 36.1 cm.)

Walters Art Gallery 37.2519.1; gift of Mr. and Mrs. J. William Middendorf II, New York City (December 1974)

893-7. Bridge of Sighs. Tom Hood "Oh.—It was pitiful, near a whole city full, Friend, had she none." [from Thomas Hood (1799–1845), "The Bridge of Sighs," 1844]

6 1/2 x 5 1/2 in. (16.5 x 14.0 cm.)

Signed, l.l.: "AJM [monogram]"

Walters Art Gallery 37.2468.42; gift of Mr. and Mrs. J. William Middendorf II, New York City (December 1970)

893-8. "The bullets and the Gout/Have so knocked his hull about,/That he'll never more be fit for the sea."

11 3/4 x 13 1/8 in. (29.8 x 33.3 cm.)

Walters Art Gallery 37.2519.3; gift of Mr. and Mrs. J. William Middendorf II, New York City (December 1974)

893-9. "Capt"—Nor 'Nor'West—nothing off! Jack—"Aye, aye, Sir"

13 11/16 x 13 3/8 in. (34.7 x 34.0 cm.)

Signed, l.l.: "AJM [monogram]"

Walters Art Gallery 37.2510.13; gift of Mr. and Mrs. J. William Middendorf II, New York City (December 1973)

EXHIBITIONS

WAG, March 16–May 18, 1969; WMAA, June 17–July 20, 1969

893-10. "Carrie and the cats."

14 1/4 x 12 7/8 in. (36.2 x 32.7 cm.)

Walters Art Gallery 37.2510.19; gift of Mr. and Mrs. J. William Middendorf II, New York City (December 1973)

EXHIBITIONS

WAG, March 16–May 18, 1969; WMAA, June 17–July 20, 1969

893-11. Carrie. Toilet—at the broken mirror.

7 1/2 x 5 1/4 in. (19.1 x 13.3 cm.)

Walters Art Gallery 37.2468.38; gift of Mr. and Mrs. J. William Middendorf II, New York City (December 1970)

893-12. Clemence Newcome signing as a witness. Battle of Life—. C. Dickens. [from William M. Thackeray, *The Newcomes*, 1853–1855]

4 5/8 x 4 1/4 in. (11.7 x 10.8 cm.)

Walters Art Gallery 37.2468.49; gift of Mr. and Mrs. J. William Middendorf II, New York City (December 1970)

893-13. Differences in Opinion. Eldest Sister— "O you *charming* little creature!" Younger, ditto "O you *darling* pet!" Terrible boy from School. "Had my way—I'd wring its head off—noisy beast!"

Framed: 13 3/4 x 12 5/16 in. (34.9 x 31.3 cm.)

Signed, l.r.: "AJM [monogram]"

Walters Art Gallery 37.2510.10; gift of Mr. and Mrs. J. William Middendorf II, New York City (December 1973)

EXHIBITIONS

WAG, March 16–May 18, 1969; WMAA, June 17–July 20, 1969

893-14. "Dis Darkey's monsus fond of doing nuffin—Yah! Yah!"

Framed: 12 9/16 x 11 5/8 in. (31.9 x 29.5 cm.)

Walters Art Gallery 37.2510.6; gift of Mr. and Mrs. J. William Middendorf II, New York City (December 1973)

EXHIBITIONS

WAG, March 16–May 18, 1969; WMAA, June 17–July 20, 1969

893-15. A disposition to "pick-foul."

9 1/4 x 8 3/8 in. (23.5 x 21.2 cm.)

Signed, l.l.: "AJM [monogram]"

Walters Art Gallery 37.2468.28; gift of Mr. and Mrs. J. William Middendorf II, New York City (December 1970)

893-16. The Dreamer. Building Air-castles.

4 3/4 x 4 1/4 in. (12.1 x 10.8 cm.)

Walters Art Gallery 37.2468.48; gift of Mr. and Mrs. J. William Middendorf II, New York City (December 1971)

893-17. Fancy-Fairs—NixNax tenders a Ten dollar note for a Three dollar "Cigar Case" & gets no change!!!

12 x 13 1/8 in. (30.5 x 33.3 cm.)

Walters Art Gallery 37.2519.4; gift of Mr. and Mrs. J. William Middendorf II, New York City (December 1974)

893-18. Fashionable Intelligence. Bill Sykes stands up, out of the rain.

6 x 4 3/8 in. (15.2 x 11.1 cm.)

Walters Art Gallery 37.2468.12; gift of Mr. and Mrs. J. William Middendorf II, New York City (December 1970)

893-19. Gen Duff Green: as he appeared on the streets of Baltimore, 1870.

Framed: 13 1/16 x 11 9/16 in. (33.2 x 29.8 cm.)

Walters Art Gallery 37.2510.15; gift of Mr. and Mrs. J. William Middendorf II, New York City (December 1973)

EXHIBITIONS
WAG, March 16–May 18, 1969; WMAA, June 17–July 20, 1969

893-20. "Georgy!—See what a nice hoop I've bought for you!" "That's all very fine Father, but I want to go to *Sea.*"

5 7/8 x 3 3/4 in. (14.9 x 9.5 cm.)

Walters Art Gallery 37.2468.2; gift of Mr. and Mrs. J. William Middendorf II, New York City (December 1970)

893-21. Great deal of human nature in Man. What's out Jack? J. Why that Spooney Major Blowhard is promoted, curse that fellow.

5 3/4 x 4 1/2 in. (14.6 x 11.5 cm.)

Walters Art Gallery 37.2468.27; gift of Mr. and Mrs. J. William Middendorf II, New York City (December 1970)

893-22. Hang me!—If that is not one of the best stories I ever heard.

6 x 5 7/8 in. (15.2 x 14.9 cm.)

Walters Art Gallery 37.2468.45; gift of Mr. and Mrs. J. William Middendorf II, New York City (December 1971)

893-23. The Hard sum. The way how *not* to do it.

8 1/4 x 5 1/2 in. (21.0 x 14.0 cm.)

Walters Art Gallery 37.2468.37; gift of Mr. and Mrs. J. William Middendorf II, New York City (December 1970)

893-24. "Harry, dear. Only see what a nice silk I have bought. Only $6. a yard—Dog cheap!" Harry (pulling a long face)— " '*Dearest* of Dears'—You have always proved inexpressibly *dear* to me."

6 1/2 x 4 3/4 in. (16.5 x 12.1 cm.)

Walters Art Gallery 37.2468.8; gift of Mr. and Mrs. J. William Middendorf II, New York City (December 1970)

EXHIBITIONS
WMAA, June 17–July 20, 1969

REFERENCES
Canaday, "50 Drawings of Alfred Jacob Miller Placed on View at the Whitney Museum," p. 38 (illus.)

893-25. Haunts of the poor. Nurse (Sissy) makes an impromptu doll. Raborg St.

5 x 4 5/8 in. (12.7 x 11.8 cm.)

Walters Art Gallery 37.2468.41; gift of Mr. and Mrs. J. William Middendorf II, New York City (December 1970)

893-26. "Have you any soap-fot or Hicory ashes—or dom'd big Dog in the yard to bite a body?"

13 1/4 x 11 7/8 in. (33.7 x 30.2 cm.)

Walters Art Gallery 37.2510.18; gift of Mr. and Mrs. J. William Middendorf II, New York City (December 1973)

EXHIBITIONS
WAG, March 16–May 18, 1969; WMAA, June 17–July 20, 1969

893-27. Hawkins Point farm—Uncle H; "Susan, is supper ready?" Susan—"Yes Massa— all in 'caffus' tea!"

Framed: 13 x 11 3/16 in. (33.0 x 28.4 cm.)

Walters Art Gallery 37.2510.17; gift of Mr. and Mrs. J. William Middendorf II, New York City (December 1973)

EXHIBITIONS
WAG, March 16–May 18, 1969; WMAA, June 17–July 20, 1969

893-28. If there is one thing more than another, that I detest—it is getting my lessons!

6 x 6 3/4 in. (15.2 x 17.1 cm.)

Walters Art Gallery 37.2468.9; gift of Mr. and Mrs. J. William Middendorf II, New York City (December 1970)

893-29. Incident of a voyage to N. Orleans off Cape Hatteras in a storm. Capt [*loqr*]— "Mate? I say Mate!" Mate—"Aye, aye Sir" Capt—"Stand by, for a bit of dust."

11 7/8 x 13 5/16 in. (30.2 x 33.8 cm.)

Walters Art Gallery 37.2519.2; gift of Mr. and Mrs. J. William Middendorf II, New York City (December 1974)

893-30. Incident of the market house, Robinson [*loquitur*] "The Man's 'fraid of his own shadow" (The Market master has just given R. a lecture about his idleness.)

16 1/8 x 12 11/16 in. (41.0 x 32.3 cm.)

Walters Art Gallery 37.2510.5; gift of Mr. and Mrs. J. William Middendorf II, New York City (December 1973)

EXHIBITIONS
WAG, March 16–May 18, 1969; WMAA, June 17–July 20, 1969

REFERENCES
Randall, "Gallery for Alfred Jacob Miller," p. 842, fig. 13

893-31. Irish argument. Pat—How is this— Jimmy, my man? Jimmy—They till me, I forgot to tak out a loicense. Pat—But I say—they can't put you here for that. Jimmy—Ah, but you see I am here. Pat—But don't I till ye, they can't put ye here for that.

11 3/4 x 13 7/16 in. (29.8 x 34.1 cm.)

Walters Art Gallery 37.2519.6; gift of Mr. and Mrs. J. William Middendorf II, New York City (December 1974)

893-32. It's only his way, Sir. Extremely playful!

4 1/2 x 5 3/8 in. (11.4 x 13.6 cm.)

Walters Art Gallery 37.2468.13; gift of Mr. and Mrs. J. William Middendorf II, New York City (December 1970)

893-33. Jack C_____ & the Market house loafer, 1825

8 1/4 x 5 5/8 in. (21.4 x 14.3 cm.)

Walters Art Gallery 37.2468.47; gift of Mr. and Mrs. J. William Middendorf II, New York City (December 1970)

REFERENCES
Randall, "Gallery for Alfred Jacob Miller," p. 842, fig. 14

893-34. Jacques Strop receiving a bouquet [from Robert Lemaitre and Benjamin Antier, *L'Auberge des Andrets*]

8 1/8 x 5 7/8 in. (20.6 x 14.9 cm.)

Signed, l.r.: "AJM [monogram]"

Walters Art Gallery 37.2468.22; gift of Mr. and Mrs. J. William Middendorf II, New York City (December 1970)

893-35. The Lady Apothecary gets along very well, until a "new Style" Bonnet passes when she incontinently loses her head, picks up the wrong bottle & poisons the patient!

Framed: 12 7/8 x 11 1/2 in. (32.7 x 29.2 cm.)

Walters Art Gallery 37.2510.4; gift of Mr. and Mrs. J. William Middendorf II, New York City (December 1973)

EXHIBITIONS
WAG, March 16–May 18, 1969; WMAA, June 17–July 20, 1969

893-36. Like Sinbad, sooner or later, we have the dreadful "Old man of the Sea" on our backs, without power to throw him off.

5 3/4 x 4 3/8 in. (14.6 x 11.2 cm.)

Walters Art Gallery 37.2468.32; gift of Mr. and Mrs. J. William Middendorf II, New York City (December 1970)

893-37. Like to trade Grandpapa.

4 5/8 x 5 1/4 in. (11.7 x 13.3 cm.)

Walters Art Gallery 37.2468.10; gift of Mr. and Mrs. J. William Middendorf II, New York City (December 1970)

893-38. Long time ago; Our Contraband.

12 1/2 x 11 7/16 in. (31.8 x 29.0 cm.)

Walters Art Gallery 37.2510.11; gift of Mr. and Mrs. J. William Middendorf II, New York City (December 1973)

EXHIBITIONS
WAG, March 16–May 18, 1969; WMAA, June 17–July 20, 1969

893-39. "Look here Bub"—You must hold on to Horsey's head till I Mount.

5 1/2 x 4 5/8 in. (14.0 x 11.2 cm.)

Walters Art Gallery 37.2468.15; gift of Mr. and Mrs. J. William Middendorf II, New York City (December 1970)

893-40. The Love Letter. As Emma broke the seal,—Dolly's eyes by one of those strange accidents, for which there is no accounting, wandered to the glass again—Barnaby Rudge. [from Dickens' *Barnaby Rudge* (1841)]

6 3/4 x 5 3/4 in. (17.2 x 14.6 cm.)

Walters Art Gallery 37.2468.20; gift of Mr. and Mrs. J. William Middendorf II, New York City (December 1971)

893–41. The Marchioness [from Charles Dickens' *The Old Curiosity Shop* (1841)]

8 1/8 x 5 3/8 in. (20.7 x 13.7 cm.)

Signed, l.r.: "AJM. [monogram]"

Walters Art Gallery 37.2468.3; gift of Mr. and Mrs. J. William Middendorf II, New York City (December 1971)

REFERENCES
Walters Art Gallery Bulletin 29, no. 3 (December 1977)

893-42. Market house sketch 1825. Recollections conquered by *"wrestling with the Captain."*

7 1/2 x 5 3/4 in. (19.1 x 14.6 cm.)

Walters Art Gallery 37.2468.11; gift of Mr. and Mrs. J. William Middendorf II, New York City (December 1971)

893-43. Mischief Maker.

6 x 5 1/8 in. (15.2 x 13.0 cm.)

Walters Art Gallery 37.2468.39; gift of Mr. and Mrs. J. William Middendorf II, New York City (December 1970)

893-44. "My Papa smokes—so I smoke! Whatever he does, I will do & a little more—You bet!!"

Framed: 13 3/16 x 11 3/4 in. (33.5 x 29.8 cm.)

Signed, l.l.: "AJM. [monogram]"

Walters Art Gallery 37.2510.9; gift of Mr. and Mrs. J. William Middendorf II, New York City (December 1973)

EXHIBITIONS
WAG, March 16–May 18, 1969; WMAA, June 17–July 20, 1969

893-45. "Never am happy, except when *miserable!"*

6 5/8 x 5 in. (16.8 x 12.7 cm.)

Signed, l.r.: "AJM [monogram]"

Walters Art Gallery 37.2468.34; gift of Mr. and Mrs. J. William Middendorf II, New York City (December 1970)

893-46. Never go to France, without you learn the lingo/For if you do, you will repent of it by gingo.

7 3/8 x 5 7/8 in. (18.7 x 14.3 cm.)

Walters Art Gallery 37.2468 25; gift of Mr. and Mrs. J. William Middendorf II, New York City (December 1971)

893-47. "Now, Doctor,—do please tell me, *in plain terms* what is the matter?" "Why you see, my dear Madam, there is a concatenation of pyrosis, cardialgia & gastrodynia—we must resort to something that is analeptic, discutient and somnolific, or else we shall have malignant exanthemata, petechiar & peripneumony—Please recollect this."

15 5/16 x 12 9/16 in. (38.9 x 31.9 cm.)

Walters Art Gallery 37.2510.8; gift of Mr. and Mrs. J. William Middendorf II, New York City (December 1973)

EXHIBITIONS
WAG, March 16–May 18, 1969; WMAA, June 17–July 20, 1969

893-48. Now Johnny!—What in the world are you crying for? Why! I hit a Boy and he hit me back!

5 1/2 x 4 in. (14.0 x 10.2 cm.)

Walters Art Gallery 37.2468.29; gift of Mr. and Mrs. J. William Middendorf II, New York City (December 1970)

893-49. "Oh clo'—Oh clo' " "Look here my friend—What's the reason that you cannot say 'Old Clothes'?" "Sir—I can say Old Clothes as well as *you can*—but if you had to repeat it as often as I You would say Oh Clo' too."

5 7/8 x 4 1/2 in. (14.9 x 11.5 cm.)

Walters Art Gallery 37.2468.35; gift of Mr. and Mrs. J. William Middendorf II, New York City (December 1970)

893-50. Opera Martha. Oblivious top [fop?] (in a hurry) arrives safely at the Opera House—but has lost his ticket!—(great rush to the doors.)

5 x 4 5/8 in. (12.7 x 11.7 cm.)

Walters Art Gallery 37.2468.24; gift of Mr. and Mrs. J. William Middendorf II, New York City (December 1970)

893-51. Paris, Bohemian, Embryo Scheffer or Delacroix.

6 5/8 x 5 in. (16.8 x 12.7 cm.) (oval)

Walters Art Gallery 37.2468.23; gift of Mr. and Mrs. J. William Middendorf II, New York City (December 1970)

893-52. "Pat, Here is a shilling! Recollect that you owe me a sixpence." "God bless yer honor, and may ye live—till I pay ye!"

16 11/16 x 13 5/8 in. (42.4 x 34.6 cm.)

Walters Art Gallery 37.2510.20; gift of Mr. and Mrs. J. William Middendorf II, New York City (December 1973)

EXHIBITIONS
WAG, March 16–May 18, 1969; WMAA, June 17–July 20, 1969

REFERENCES
WMAA, *Alfred Jacob Miller*, illus. cover

893-53. "Pater Familias" is overcome by the heat of the weather.

12 7/16 x 11 13/16 in. (31.6 x 30.0 cm.)

Walters Art Gallery 37.2510.2; gift of Mr. and Mrs. J. William Middendorf II, New York City (December 1973)

EXHIBITIONS
WAG, March 16–May 18, 1969; WMAA, June 17–July 20, 1969

893-54. A penny's worth of Astronomy.

10 13/16 x 11 7/8 in. (27.5 x 30.2 cm.)

Walters Art Gallery 37.2519.5; gift of Mr. and Mrs. J. William Middendorf II, New York City (December 1974)

893-55. Play-mates.

7 1/8 x 5 3/4 in. (18.1 x 14.6 cm.)

Walters Art Gallery 37.2468.50; gift of Mr. and Mrs. J. William Middendorf II, New York City (December 1970)

893-56. "Pull-up Charley!—Don't you see what a glorious bite you have."

12 x 15 1/8 in. (30.5 x 38.4 cm.)

Walters Art Gallery 37.2510.12; gift of Mr. and Mrs. J. William Middendorf II, New York City (December 1973)

EXHIBITIONS
WAG, March 16–May 18, 1969; WMAA, June 17–July 20, 1969

893-57. Real Faith. "But what is the matter Judy?–you don't look well" "I is rather poorly,—tank God, Massa," she replied!

16 3/16 x 13 3/8 in. (41.1 x 34.0 cm.)

Walters Art Gallery 37.2510.7; gift of Mr. and Mrs. J. William Middendorf II, New York City (December 1973)

EXHIBITIONS
WAG, March 16–May 18, 1969; WMAA, June 17–July 20, 1969

893-58. The Real Master of the House. Everybody is brought into requisition when young Hopeful appears!— (Hopeful knows very well that mischief loving Bob "pokes fun at him").

13 1/4 x 14 11/16 in. (33.6 x 37.3 cm.)

Walters Art Gallery 37.2510.14; gift of Mr. and Mrs. J. William Middendorf II, New York City (December 1973)

EXHIBITIONS
WAG, March 16–May 18, 1969; WMAA, June 17–July 20, 1969

893-59. Recollections. Woolferz Cutter 1825.

8 1/8 x 4 5/8 in. (20.7 x 11.7 cm.)

Walters Art Gallery 37.2468.26; gift of Mr. and Mrs. J. William Middendorf II, New York City (December 1970)

893-60. Ringing the New Year in.

9 x 6 1/4 in. (22.7 x 15.9 cm.)

Walters Art Gallery 37.2553.1; gift of Mr. and Mrs. J. William Middendorf II, New York City (December 1977)

REFERENCES
Walters Art Gallery Forty-fifth Annual Report (1977), illus. cover

893-61. Rip van Winkle [from Washington Irving's *Sketchbook* (1819)]

4 1/2 x 6 1/2 in. (11.4 x 16.5 cm.)

Walters Art Gallery 37.2468.40; gift of Mr. and Mrs. J. William Middendorf II, New York City (December 1970)

893-62. Sairey Gamp and Betsy Prig. "No Betsy! drink wotever you do!" "Mrs. Harris, Betsy"—"Bother Mrs. Harris!" said Betsy Prig.—"I don't believe there's such a person." [from Dickens' *Martin Chuzzlewit* (1843); Betsy Prig is an old monthly nurse, Sarah Gamp, monthly nurse]

Dimensions not given

Walters Art Gallery 37.2468.30; gift of Mr. and Mrs. J. William Middendorf II, New York City (December 1970)

893-63. Sairey Gamp and Mr. Mould. [from Charles Dickens' *Martin Chuzzlewit* (1843)]

7 3/4 x 6 1/2 in. (19.7 x 16.5 cm.)

Walters Art Gallery 37.2468.6; gift of Mr. and Mrs. J. William Middendorf II, New York City (December 1970)

893-64. Scene from "Little Dorrit." Mr. Merdle stands in awe of his chief butler, & takes his tea behind the door, when that magnificent functionary appears. [from Charles Dickens' *Little Dorrit* (1855); Mr. Merdle is a banker who becomes insolvent and commits suicide]

5 7/8 x 9 1/4 in. (14.9 x 23.5 cm.)

Walters Art Gallery 37.2468.44; gift of Mr. and Mrs. J. William Middendorf II, New York City (December 1971)

REFERENCES
Randall, "Gallery for Alfred Jacob Miller," p. 843, fig. 15

893-65. School Room. Too late. "And then the whining School-boy, with his satchel, And shining morning face, creeping like snail, unwilling to School." "As You like it."

7 3/4 x 5 3/4 in. (19.7 x 14.6 cm.)

Signed, l.l.: "AJM. [monogram]"

Walters Art Gallery 37.2468.5; gift of Mr. and Mrs. J. William Middendorf II, New York City (December 1970)

893-66. Serenaders *under the wrong window!* Quaker gent—"My friends,—I think in thy song, I heard the expressions of 'Home Sweet Home' & that there was *no* place like *Home.*—Truly Friends I agree with Thee & now advise Thee to go Home."

13 7/16 x 16 1/4 in. (34.1 x 41.3 cm.)

Walters Art Gallery 37.2519.8; gift of Mr. and Mrs. J. William Middendorf II, New York City (December 1974)

893-67. "The Simple Fare of Everyday! The Toil of everyday applied."

13 7/16 x 11 9/16 in. (34.1 x 29.3 cm.)

Walters Art Gallery 37.2510.3; gift of Mr. and Mrs. J. William Middendorf II, New York City (December 1973)

EXHIBITIONS
WAG, March 16–May 18, 1969; WMAA, June 17–July 20, 1969

893-68. A Stickler for the letter of the Law.— "Carry me to prison" "Carry me did you say?" "Blur Nouns [?]" "I won't stir a ha'porth—Let's see you *carry me,* Ye bloody thafe of the woruld."

5 x 4 1/2 in. (12.7 x 11.4 cm.)

Signed, l.r.: "AJM. [monogram]"

Walters Art Gallery 37.2468.43; gift of Mr. and Mrs. J. William Middendorf II, New York City (December 1971)

893-69. Street Sketch. Boy Gallantry.

5 7/8 x 4 3/8 in. (14.9 x 11.1 cm.)

Signed, l.l.: "AJM. [monogram]"

Walters Art Gallery 37.2468.19; gift of Mr. and Mrs. J. William Middendorf II, New York City (December 1970)

893-70. Street sketch philosophy. Place me behind a good cigar & then let the world wag as it may.

4 5/8 x 4 in. (11.7 x 10.2 cm.)

Walters Art Gallery 37.2468.4; gift of Mr. and Mrs. J. William Middendorf II, New York City (December 1970)

893-71. Street Sketch. Washing Steps.

6 x 4 1/2 in. (15.2 x 11.4 cm.)

Walters Art Gallery 37.2468.18; gift of Mr. and Mrs. J. William Middendorf II, New York City (December 1970)

893-72. The Two Friends.

8 1/4 x 4 3/4 in. (21.0 x 12.1 cm.)

Walters Art Gallery 37.2468.21; gift of Mr. and Mrs. J. William Middendorf II, New York City (December 1970)

893-73. "Unsophisticated youth (loqr)—Frank— while I have been tickled almost to death with the farce, I notice that these fiddlers never move a muscle, but look as if they are to be hung immediately if not sooner."

13 3/8 x 15 7/16 in. (34.0 x 39.2 cm.)

Walters Art Gallery 37.2519.9; gift of Mr. and Mrs. J. William Middendorf II, New York City (December 1974)

REFERENCES
Walters Art Gallery Forty-second Annual Report (1974), illus. p. [38]

893-74. War. Going to front.

5 x 7 in. (12.7 x 17.8 cm.)

Signed, l.l.: "AJM. [monogram]"

Walters Art Gallery 37.2468.16; gift of Mr. and Mrs. J. William Middendorf II, New York City (December 1970)

893-75. "Well drat that cat! No getting a wink of sleep for the 'worriting' brute!"

4 5/8 x 4 3/4 in. (11.7 x 12.1 cm.)

Walters Art Gallery 37.2468.17; gift of Mr. and Mrs. J. William Middendorf II, New York City (December 1970)

893-76. "When nobody is present, Toby Hardcase peeps into his 'ugly cupboard'—"

4 5/8 x 4 in. (11.7 x 10.2 cm.)

Walters Art Gallery 37.2468.1; gift of Mr. and Mrs. J. William Middendorf II, New York City (December 1970)

893-77. Wonder where that Joe is?—he promised to take me to the concert.

3 7/8 x 3 5/8 in. (9.8 x 9.2 cm.)

Walters Art Gallery 37.2468.14; gift of Mr. and Mrs. J. William Middendorf II, New York City (December 1970)

893-78. Young America. "Sissy—I want my tea,—*The 'Old 'un'* is so mighty slow!— I'm tired of waiting for him."

4 7/8 x 4 3/8 in. (12.4 x 11.1 cm.)

Walters Art Gallery 37.2468.33; gift of Mr. and Mrs. J. William Middendorf II, New York City (December 1971)

ALBUM VII: RAVEL ALBUM

894.

(late 1850s)

The Walters Art Gallery, Baltimore, Maryland

PROVENANCE
the artist; Alfred Jacob Miller, Jr.; Norton Asner, Baltimore (1959)

REFERENCES
William R. Johnston, "Drawings of the Ravels by A. J. Miller in the Walters Art Gallery," typescript

894-1. *Gabriel Ravel as Godenski*

Watercolor on blotting paper

10 13/16 x 8 1/2 in. (27.5 x 21.6 cm.)

Walters Art Gallery; gift of Mr. and Mrs. D. Luke Hopkins

894-2. *Françoise Ravel as Roloff*

Watercolor on blotting paper

10 3/16 x 7 13/16 in. (25.9 x 19.8 cm.)

Walters Art Gallery; gift of Mrs. Alan Wurtzburger

894-3. *Jerome*

Pencil and watercolor on cream-colored paper

11 3/8 x 9 in. (28.9 x 22.8 cm.)

Walters Art Gallery; an anonymous gift

894-4. *Françoise Ravel as Jeannot*

Watercolor on cream-colored paper

10 7/16 x 8 1/4 in. (27.1 x 21.0 cm.)

Walters Art Gallery; gift of Mrs. Milton T. Edgerton, Jr.

894-5. *Françoise Ravel as the Conscript Recruit*

Watercolor on blotting paper

11 1/2 x 8 in. (29.2 x 20.3 cm.)

Walters Art Gallery; gift of Mr. and Mrs. D. Luke Hopkins

894-6. *Françoise Ravel as Roquinet*

Watercolor on cream-colored paper

9 x 6 5/8 in. (22.8 x 16.8 cm.)

Walters Art Gallery; gift of The H. Barksdale Brown Charitable Trust

894-7. *Françoise Ravel as Roquinet*

Watercolor on blotting paper

10 5/8 x 7 3/8 in. (27.0 x 18.7 cm.)

Walters Art Gallery; gift of The H. Barksdale Brown Charitable Trust

894-8. *Antoine Ravel as Robert Macaire*

Watercolor on blotting paper

11 x 8 3/16 in. (27.9 x 21.3 cm.)

Walters Art Gallery; gift of Mr. and Mrs. LeRoy E. Hoffberger

894-9. *Antoine Ravel as Robert Macaire*

Watercolor on cream-colored paper

8 7/8 x 6 3/8 in. (22.6 x 16.2 cm.)

Walters Art Gallery; gift of The Lisanelly Foundation

894-10. *Françoise Ravel as Bertrand*

Watercolor on blotting paper

10 1/2 x 8 3/8 in. (26.7 x 21.3 cm.)

Walters Art Gallery; gift of Mr. and Mrs. LeRoy E. Hoffberger

REFERENCES

Randall, "Gallery for Alfred Jacob Miller," p. 841, fig. 11

894-11. Untitled: Françoise Ravel as Bertrand [verso: Antoine Ravel as Bertrand]

Pencil on cream-colored paper

11 x 8 11/16 in. (27.9 x 22.1 cm.)

Walters Art Gallery; gift of Mr. and Mrs. LeRoy E. Hoffberger

894-12. Untitled: Françoise Ravel as Bertrand [verso: similar to recto]

Pencil on blue paper

11 x 7 15/16 in. (27.9 x 20.2 cm.)

Walters Art Gallery; gift of Mr. and Mrs. LeRoy E. Hoffberger

894-13. *Françoise Ravel as Bibi* [verso: study for *Antoine as Robert Macaire*]

Watercolor on cream-colored paper [verso: Pencil and pen on cream-colored paper]

10 3/4 x 8 5/8 in. (27.3 x 21.9 cm.)

Walters Art Gallery; gift of Mrs. Alan Wurtzburger

894–14. *Françoise Ravel as Bibi*

Watercolor on cream-colored paper

9 1/16 x 6 1/2 in. (23.0 x 16.5 cm.)

Walters Art Gallery; gift of Mrs. Alan Wurtzburger

894-15. *Monsta* [verso: unfinished drawing of a male figure pivoting on one leg]

Pencil on lined blue paper

8 3/4 x 7 7/8 in. (22.2 x 20.0 cm.)

Walters Art Gallery; an anonymous gift

894-16. *Antoine Ravel as the White Knight*

Watercolor washes on white paper

10 3/8 x 6 3/4 in. (26.4 x 17.2 cm.)

Walters Art Gallery; gift of Mr. and Mrs. Perry Bolton

894-17. *Gabriel Ravel as Babilas*

Watercolor on gray paper

9 1/8 x 6 5/16 in. (23.2 x 16.8 cm.)

Walters Art Gallery; gift of The Lisanelly Foundation

894-18. *Antoine Ravel as Bobadil*

Watercolor on white paper, varnished

8 15/16 x 6 3/8 in. (22.7 x 16.2 cm.)

Walters Art Gallery; an anonymous gift

894-19. *Antoine Ravel as Chevalier Grinaldo*

Gray wash on white paper

9 x 6 1/4 in. (22.8 x 15.9 cm.)

Walters Art Gallery; gift of The H. Barksdale Brown Charitable Trust

894-20. *Françoise Ravel as Starchington*

Watercolor on cream-colored paper, varnished

8 3/4 x 6 5/16 in. (22.2 x 16.0 cm.)

Walters Art Gallery; gift of Mr. and Mrs. D. Luke Hopkins

894-21. Untitled: sketch for *Françoise Ravel as Starchington* [verso: a related sketch]

Pencil on beige paper

11 15/16 x 9 1/4 in. (30.3 x 23.5 cm.)

Walters Art Gallery; gift of Mrs. Alan Wurtzburger

894-22. *Gabriel Ravel as Sawney Box* [verso: unfinished study for recto]

Pencil and watercolor on tan paper

10 1/2 x 7 1/2 in. (26.7 x 19.1 cm.)

Walters Art Gallery; gift of The H. Barksdale Brown Charitable Trust

894-23. *Gabriel Ravel as Sawney Box*

Watercolor on cream-colored paper, varnished

9 1/8 x 6 5/16 in. (23.2 x 16.0 cm.)

Walters Art Gallery; gift of E. Bruce Baetjer

894-24. *Françoise Ravel as Ventalaw*
Watercolor on cream-colored paper
10 3/4 x 8 7/16 in. (27.3 x 21.4 cm.)
Walters Art Gallery; gift of Mr. and Mrs. D. Luke Hopkins

894-25. Untitled: study for *Françoise Ravel as Ventalaw*
Pencil and white gouache on cream-colored paper
11 1/4 x 9 in. (28.6 x 22.9 cm.)
Walters Art Gallery; gift of Mr. and Mrs. D. Luke Hopkins

894-26. Untitled: similar to *Françoise Ravel as Ventalaw*
Watercolor, figure cut out and mounted on cream-colored paper
10 3/4 x 8 3/8 in. (27.3 x 21.3 cm.)
Walters Art Gallery; gift of Mr. and Mrs. D. Luke Hopkins

894-27. *Antoine Ravel as Courci*
Watercolor on white paper, varnished
9 1/16 x 6 7/8 in. (23.0 x 17.5 cm.)
Walters Art Gallery; gift of The Lisanelly Foundation

894-28. *Antoine Ravel as Courci*
Watercolor on cream-colored paper
10 9/16 x 8 in. (26.8 x 20.3 cm.)
Walters Art Gallery; gift of The Lisanelly Foundation

894-29. *Gabriel Ravel as Simon*
Watercolor on cream-colored paper, varnished
9 1/16 x 6 1/2 in. (23.0 x 16.5 cm.)
Walters Art Gallery; purchase

894-30. *Gabriel Ravel as Simon*
Watercolor on blotting paper
10 3/4 x 8 1/2 in. (27.3 x 21.6 cm.)
Walters Art Gallery; purchase

894-31. *Françoise Ravel as Vol-au-vent*
Watercolor on cream-colored paper
10 1/2 x 8 1/2 in. (26.7 x 21.6 cm.)
Walters Art Gallery; purchase

894-32. *Gabriel Ravel as the Clown*
Pencil and watercolor on cream-colored paper
10 3/4 x 8 1/2 in. (27.3 x 21.6 cm.)
Walters Art Gallery; gift of Mr. and Mrs. J. William Middendorf II

894-33. *Gabriel Ravel as the Clown*
Watercolor on white paper
9 x 6 3/8 in. (22.8 x 16.2 cm.)
Walters Art Gallery; purchase

894-34. *Françoise Ravel as the Harlequin*
Watercolor on blotting paper
10 x 7 3/16 in. (25.4 x 18.3 cm.)
Walters Art Gallery; gift of Mrs. Alan Wurtzburger

894-35. *Indian Girl*
Watercolor on blotting paper
11 7/8 x 9 1/2 in. (30.2 x 24.1 cm.)
Walters Art Gallery; gift of Mr. and Mrs. J. William Middendorf II

894-36. *Françoise Ravel as Lourdin*
Watercolor on cream-colored paper
9 x 6 1/2 in. (22.9 x 16.5 cm.)
Walters Art Gallery; gift of Mrs. Milton T. Edgerton, Jr.

894-37. *Jerome Ravel as Burge*
Watercolor
9 x 6 1/2 in. (22.9 x 16.5 cm.)
Walters Art Gallery; gift of The H. Barksdale Brown Charitable Trust

894-38. Joseph Jefferson as Asa Trenchard [from Tom Taylor's *Our American Cousin*]
Watercolor
10 15/16 x 9 1/8 in. (27.8 x 23.2 cm.)
Walters Art Gallery; gift of Mr. and Mrs. J. William Middendorf II

894-39. *Mrs. Keller as the Goddess of Liberty*
Watercolor
10 3/8 x 8 in. (26.4 x 20.3 cm.)
Walters Art Gallery; gift of Mr. and Mrs. J. William Middendorf II

894-40. *Mrs. Keller as the Goddess of Liberty*
Pencil
9 3/4 x 8 3/8 in. (24.7 x 21.3 cm.)
Walters Art Gallery; gift of Mr. and Mrs. J. William
Middendorf II

894-41. *William Evans Burton (1804–1860) as
Waddilove* [in *To Parents and
Guardians*]
Watercolor
9 x 6 5/16 in. (22.9 x 16.8 cm.)
Walters Art Gallery; an anonymous gift

894-42. *William Evans Burton (1804–1860) as
Waddilove* [in *To Parents and
Guardians*]
Watercolor
11 1/2 x 8 3/8 in. (29.2 x 21.3 cm.)
Walters Art Gallery; S. & A. P. Fund

894-43. *William Evans Burton (1804–1860) as
Waddilove* [in *To Parents and
Guardians*]
Watercolor
11 1/2 x 9 in. (29.2 x 22.9 cm.)
Walters Art Gallery; S. & A. P. Fund

894-44. Unidentified figure
Watercolor
7 x 4 3/4 in. (17.8 x 12.1 cm.)
Walters Art Gallery; gift of The Lisanelly Foundation

894-45. *Prince Charles Edward (disguised as a
Lady's maid to Flora McDonald),
escaping to Island of Sky, in an open boat*
[appendix to Boswell's *Johnson*]
Black pen and wash on blue-gray paper
5 9/16 x 6 3/4 in. (14.1 x 17.2 cm.)
Walters Art Gallery 37.2453.45; gift of The Lisanelly
Foundation, 1968

894-46. Untitled: study of a horsecart
Black and white washes on gray paper
8 3/16 x 8 1/2 in. (20.8 x 21.6 cm.)
Walters Art Gallery 37.2453.47; S. & A. P. Fund, 1968

894-47. Untitled: study of a horsecart
Black and white washes on gray paper
8 9/16 x 8 7/16 in. (21.7 x 21.4 cm.)
Walters Art Gallery 37.2453.46; S. & A. P. Fund, 1968

895. *Far O'er the Deep Blue Sea*

Lithographed sheet music cover

Sheet: 13 1/8 x 10 3/8 in. (33.3 x 26.3 cm.); composition: 7 1/2 x 9 1/2 in. (19.1 x 24.2 cm.)

(1834)

Inscription, l.l.: "Designed & Lith^d by A. J. Miller"; l.r.: "Pub^d by Geo. Willig"

Mr. George Durrett, Baltimore

REFERENCES

Levy, *Picture the Songs*, p. 40, illus. p. 41

896. *(Troubadour Song) The Warrior Braves the Sea and Foam*

Lithographed sheet music cover

Sheet: 12 5/8 x 9 5/8 in. (32.1 x 24.4 cm.); composition: 6 7/8 x 5 3/4 in. (17.5 x 14.6 cm.)

(1836)

Inscription, l.l.: "Des^d by A. Miller"

Lester S. Levy, Pikesville, Maryland

897. *Skeleton of the Mastodon Forming a Part of the Baltimore Museum in 1836* Lithograph on wove paper watermarked "ROCKVIL[LE]," from *A Brief Description of the Skeleton* (1836)

13 1/4 x 17 in. (33.5 x 43.2 cm.)

Signed on stone, l.l.: "Alfred J. Miller del."

(1836)

Maryland Historical Society, Baltimore

REFERENCES

Lois B. McCauley, *Maryland Historical Prints, 1752 to 1889*, p. 162 (illus.)

898. *Lost on the Prairie*

Chromolithograph published by H. Ward, Jr., 639 Broadway, New York

17 3/4 x 22 1/2 in. (45.1 x 57.1 cm.)

(c. 1851)

Joslyn Art Museum, Omaha, Nebraska 1955.12

REFERENCES

JAM, *Artists of the Western Frontier*, no. 68, illus. p. 15

899. *Scene in the Rocky Mountains of America*

Lithograph from Sir William Fraser, *The Red Book of Grandtully*, I

7 1/2 x 6 in. (19.1 x 15.2 cm.)

900. Untitled [Wind River Scene with Elk]

Chromolithograph from C. W. Webber, *The Hunter-Naturalist: Romance of Sporting; or, Wild Scenes and Wild Hunters* (Philadelphia: J. W. Bradley, [1851])

Approximately 4 7/8 x 7 1/2 in. (12.2 x 19.0 cm.)

Inscription, l.l.: "Chromo Lith^y of L. Rosenthal Phila"

Note: This print also appeared in two subsequent printings of Webber's *The Hunter-Naturalist*, both published by Lippincott, Grambo & Company in Philadelphia in 1852. The second of these subsequent printings carried the inscription "Miller Pinx't."

901. Untitled [Indians in a Storm: Night Scene]

Chromolithograph from C. W. Webber, *The Hunter-Naturalist: Romance of Sporting: or, Wild Scenes and Wild Hunters* (Philadelphia: J. W. Bradley, [1851])

Approximately 4 7/8 x 7 1/2 in. (12.2 x 19.0 cm.)

Inscription, l.r.: "Chromolithography of Rosenthal Phila"

Note: This print also appeared in two subsequent printings of Webber's *The Hunter-Naturalist*, both published by Lippincott, Grambo & Company in Philadelphia in 1852. The second of these subsequent printings carried the inscription "Miller Pinx't."

902. Untitled [Hunting the Bear]

Chromolithograph from C. W. Webber, *The Hunter-Naturalist: Romance of Sporting; or, Wild Scenes and Wild Hunters* (Philadelphia: J. W. Bradley, [1851])

Approximately 4 7/8 x 7 1/2 in. (12.2 x 19.0 cm.)

Inscription, l.l.: "Chromo Lith^y of L. Rosenthal Phila"

Note: This print also appeared in two subsequent printings of Webber's *The Hunter-Naturalist*, both published by Lippincott, Grambo & Company in Philadelphia in 1852. The second of these subsequent printings carried the inscription "Miller Pinx't."

903. Unititled [Hunting Buffalo, or Driving Herds of Buffalo over a Precipice]

Chromolithograph from C. W. Webber, *The Hunter-Naturalist: Romance of Sporting; or, Wild Scenes and Wild Hunters* (Philadelphia: J. W. Bradley, [1851])

Approximately 4 7/8 x 7 1/2 in. (12.2 x 19.0 cm.)

Inscription, l.l.: "Chromo Lith^y of L. Rosenthal Phil^a"

Note: This print also appeared in two subsequent printings of Webber's *The Hunter-Naturalist,* both published by Lippincott, Grambo & Company in Philadelphia in 1852. The second of these subsequent printings carried the inscription "Miller Pinxt."

904. Untitled [Wild Mustangs]

Chromolithograph from C. W. Webber, *The Hunter-Naturalist: Romance of Sporting; or, Wild Scenes and Wild Hunters* (Philadelphia: J. W. Bradley, [1851])

Approximately 4 7/8 x 7 1/2 in. (12.2 x 19.0 cm.)

Inscription, l.l.: "Chromo Lith^y of L. Rosenthal Phil^a"

Note: This print also appeared in two subsequent printings of Webber's *The Hunter-Naturalist,* both published by Lippincott, Grambo & Company in Philadelphia in 1852. The second of these subsequent printings carried the inscription "Miller Pinx't."

905. Untitled [Death of a Panther]

Steel engraving from C. W. Webber, *The Hunter-Naturalist: Romance of Sporting; or, Wild Scenes and Wild Hunters* (Philadelphia: J. W. Bradley, [1851])

Approximately 4 7/8 x 7 1/2 in. (12.2 x 19.0 cm.)

906. *Indian Caressing His Horse*

Chromolithograph from C. W. Webber, *The Hunter-Naturalist: Wild Scenes and Song-Birds* (New York: George P. Putnam & Company, 1854)

Approximately 4 7/8 x 7 1/2 in. (12.2 x 19.0 cm.)

Signed on stone, l.l.: "M Rosenthal"

Inscription, l.l.: "Miller pinx"; l.r.: "L N Rosenthal" "M Rosenthal Chromo Lith Phil^a" Note: This print also appeared in at least one subsequent printing of *Wild Scenes and Song-Birds,* published by Riker, Thorne & Company in 1854.

907. *Encampment of Indians*

Chromolithograph from C. W. Webber, *The Hunter-Naturalist: Wild Scenes and Song-Birds* (New York: George P. Putnam & Company, 1854)

Approximately 4 7/8 x 7 1/2 in. (12.2 x 19.0 cm.)

Inscription, l.l.: "Miller pinx"; l.r.: "L. N. Rosenthal's Chromo. Lith Phil^a"

Note: This print also appeared in at least one subsequent printing of *Wild Scenes and Song-Birds,* published by Riker, Thorne & Company in 1854.

908. *Toilet of the Indian Girls*

Chromolithograph from C. W. Webber, *The Hunter-Naturalist: Wild Scenes and Song-Birds* (New York: George P. Putnam & Company, 1854)

Approximately 4 7/8 x 7 1/2 in. (12.2 x 19.0 cm.)

Signed on stone, l.r.: "M Rosenthal"

Inscription, l.l.: "Miller pinx"; l.r.: "L. N. Rosenthal's Chromo Lith Phil^a"

Note: This print also appeared in at least one subsequent printing of *Wild Scenes and Song-Birds,* published by Riker, Thorne & Company in 1854.

909. *The Peaceful Valley*

Chromolithograph from C. W. Webber, *The Hunter-Naturalist: Wild Scenes and Song-Birds* (New York: George P. Putnam & Company, 1854)

Approximately 4 7/8 x 7 1/2 in. (12.2 x 19.0 cm.)

Signed on stone, l.l: "M Rosenthal"

Inscription, l.l.: "Miller pinx"; l.r: "L N Rosenthal's Chromo Lith Philad^a"

Note: This print also appeared in at least one subsequent printing of *Wild Scenes and Song-Birds,* published by Riker, Thorne & Company in 1854, and was titled *Antelope Chase.*

910. *Indian Girl Swinging*

Chromolithograph from C. W. Webber, *The Hunter-Naturalist: Wild Scenes and Song-Birds* (New York: George P. Putnam & Company, 1854)

Approximately 4 7/8 x 7 1/2 in. (12.2 x 19.0 cm.)

Signed on stone, l.l.: "M Rosenthal"

Inscription, l.l.: "Miller pinx"; l.r.: "L. N. Rosenthal's Chromo-Lith Phil^a"

Note: This print also appeared in at least one subsequent printing of *Wild Scenes and Song-Birds,* published by Riker, Thorne & Company in 1854.

910A. *Indian Girl Swinging* [wearing blouse]

Note: In the first edition of *Wild Scenes and Song-Birds* the Indian girl appeared bare-breasted, as she did in Miller's watercolors; in at least some later printings, she was covered by a blouse.

Appendix I

WARDER H. CADBURY

Alfred Jacob Miller's Chromolithographs

A<small>N INTERESTING FOOTNOTE</small> to the artistic career of Alfred Jacob Miller is his pioneering role in providing the original paintings used for illustrating books in color by the then new technology of chromolithography. The author who originated the project was Charles Wilkins Webber, a Kentucky-born journalist and traveler.

As a boy, Webber acquired an enthusiasm for hunting and fishing and the outdoor life. About 1838, at the age of nineteen, he spent several years on a tour of the Rocky Mountains and the troubled frontier of Texas, where he became acquainted with the leaders of the Texas Rangers. On his return to the East he studied medicine briefly, then theology, and, after 1844, engaged in editorial and literary pursuits. Somewhat later he was the leader of a proposed expedition to the Colorado and Gila rivers, which was aborted when the Comanches stole all the expedition's horses. He then became involved in a scheme to import camels for use by the army on the Western deserts, which also came to nothing.

Webber published two different and partly autobiographical books for which Miller provided the sketches to be copied as color-plate embellishments. Since each volume appeared in several subsequent reprintings, which lack the illustrations, the following bibliographical details may prove useful to the collector and connoisseur.

In his account book records for June and July 1851, Miller noted the sale of several Indian drawings to Webber in Philadelphia. In the late fall appeared Webber's handsome volume of 610 pages with the title *The Hunter-Naturalist: Romance of Sporting; or, Wild Scenes and Wild Hunters*. The title page also has a small profile portrait of both Webber and his wife and, beneath that, the name and address of the publisher, J. W. Bradley. The date of publication, 1851, does not appear on the title page but in the copyright notice on the reverse of the title page.

In his introduction, Webber wrote with enthusiasm about the illustrations "of the Wild Scenes of our own Indian Border Life . . . furnished from the noble and unequalled pencil of Alfred J. Miller, of Baltimore, who accompanied Sir William Drummond Stuart [*sic*] on his noted expedition among the Indian Tribes of the Plains, as Artist. . . . I say with perfect confidence that it remains yet for Art in this country to approach the amazing fidelity and spirit of these Drawings—and his glorious Portfolio is but yet just opened!"

This first edition has ten chromolithographic illustrations, including five plates of African game animals in addition to the five western scenes after Miller, all approximately 4 7/8 x 7 1/2 to 7 3/4 inches (12.2 x 19 to 19.7 cm.). They were specially printed by the Philadelphia firm of L. N. Rosenthal at the very time when the new techniques of making colored prints from stone were just beginning to flourish in America. Webber obviously thought his book had a special significance in publishing history, describing it proudly, if not quite accurately, as "this first experiment in a novel field." He went on to say that "the art of printing in colors, which is yet in embryo in Europe, has been left to us to develope in this country." It should be noted that, while this first edition printed the Rosenthal name under most of the color plates, it failed to add Miller's name as the original artist. The five chromolithographs after Miller are:

1. Untitled [Wind River Scene with Elk].
2. Untitled [Indians in a Storm: Night Scene].
3. Untitled [Hunting the Bear].

4. Untitled [Hunting Buffalo, or Driving Herds of Buffalo
over a Precipice].
5. Untitled [Wild Mustangs].

There is a sixth picture in the book after Miller, a steel engraving, untitled [Death of a Panther].

The following year, 1852, Webber decided to change publishers, with the confusing consequence that this same book reappeared in four different guises. The firm of J. W. Bradley, which had produced the first edition, now offered to the public *Wild Scenes and Wild Hunters of the World*. However, this edition had none of Miller's illustrations and only several of the colored prints of African animals "of less costly finish."

The new publisher of Webber's book was Lippincott, Grambo and Co. of Philadelphia, whose name and the date—1852—appear on the title page: *The Hunter-Naturalist: Romance of Sporting; or, Wild Scenes and Wild Hunters*. This edition does contain the five Miller illustrations but still omits mention of his name anywhere on the plate. A second printing by Lippincott, with the same title and date, finally gave credit to Miller by adding in type under each picture, "Miller Pinx't." A further change in format, which serves as a handy way to identify this especially desirable version of the book, was the addition of a black line border around the margin of the text on every page.

Why Webber changed publishers is not known, but it might have been the fact that Lippincott was more experienced in dealing with the many problems encountered in introducing chromolithographs as book illustrations. The firm had just been supervising, for the federal government, the production of the first volume of Henry Rowe Schoolcraft's history of Indian tribes, which contained forty-nine chromolithographs after sketches by Seth Eastman. However, both Lippincott and Eastman eventually were not satisfied with the quality of the chromolithographs, and their number was greatly reduced in subsequent volumes in the same series.

Perhaps Webber and his new publisher soon became equally disappointed with the production of the color plates after Miller. At any rate, a fourth printing for the year 1852, the third by Lippincott's, appeared with a slightly different title: *Romance of Natural History; or, Wild Scenes and Wild Hunters*. This edition lacks all the color plates, both the western scenes after Miller and the views of African animals. Instead, a steel engraving in black and white of Indian warriors on horseback after a sketch by Karl Bodmer was substituted as a frontispiece.

This same work was subsequently reprinted some half a dozen times at different dates by different publishers, including a translation into German. However, since all of these lack the color plates after Miller, their bibliographical minutiae are of no interest here.

Webber published a second work with chromolithographs after Miller. In May 1853, Miller noted in his financial records the sum of $140 for five drawings to the publisher George P. Putnam and Co. in New York. Early the following year appeared *The Hunter-Naturalist: Wild Scenes and Song-Birds*. Webber seemed undeterred in giving chromolithography another try, for the volume included fifteen additional color plates of birds from sketches that were the handiwork of his talented wife. (It is curious that, while the printed list of illustrations enumerates a total of twenty pictures in all, the title page erroneously advertises twenty-five colored lithographs.)

The chromos were again printed by the Philadelphia firm of L. N. Rosenthal, and in his introduction Webber had special praise for "the younger brother, M[ax] Rosenthall [*sic*]," who copied the drawings onto the different stones and who "has achieved an honorable place for himself in this new art." As a consequence, in this volume, although neither Miller nor Mrs. Webber is identified in print underneath the margin of each illustration, young Rosenthal has taken the liberty of adding—not always unobtrusively—his own signature within each picture in a manner suggesting that he was the original artist. The same book, with the same color plates, appeared for a second time in 1854, but with the firm of Riker, Thorne and Co. as publisher instead of Putnam's. This

time both Miller and Mrs. Webber are given credit on the title page as having produced the chromolithographs. Chromolithographs after Miller in *The Hunter-Naturalist: Wild Scenes and Song-Birds* are:

1. *Indian Caressing His Horse.*
2. *Encampment of Indians.*
3. *Toilet of the Indian Girls.*
4. *The Peaceful Valley* (titled *Antelope Chase* in later printings).
5. *Indian Girl Swinging.*

There were some changes in later printings of the chromolithographs in at least one instance, that of the *Indian Girl Swinging.* In the first edition, she appears, as in the Miller watercolor, bare-breasted. In at least some of the later printings, she has been provided with a blouse, probably in the name of nineteenth century modesty.

In his introduction, Webber noted that the illustrations of Indians from Miller's sketches depicted scenes from the camp life of the Delawares. They inspired him to make plans for yet another book in collaboration with the artist. "I propose to furnish among the Wild Scenes of a future and independent volume of this series," Webber wrote, "a full history of this noblest of the remaining Indian tribes of the continent."

A third book with illustrations after Miller never came to be. Webber's impulsive desire for excitement took him to Central America in 1855, and he was killed the following year while serving in the military forces of William Walker in Nicaragua.

A final edition of *Wild Scenes and Song-Birds* came out in 1858 with Leavitt and Allen at 379 Broadway identified as the publisher on the title page. This version of the book, however, has only one color plate, which serves as the frontispiece. In some copies it is a scene after Alfred Jacob Miller, while in others it is one of Mrs. Webber's bird pictures. Caveat emptor!

Appendix II

Alfred Jacob Miller: A Chronology

1810 Alfred Jacob Miller born in Baltimore, January 2

1832 With the assistance of Robert Gilmor, goes to Europe to study

1834 Returns to Baltimore and opens a studio over George Willig's shop
 Exhibits two paintings (cats. 832 and 868) at the Boston Athenaeum

1835 Exhibits three paintings (cats. 872, 41, and 851) at the Boston Athenaeum

1836 Exhibits *Piety or Charity* (after Schidone, cat. 854) at Peale's Baltimore Museum, Nov. 7
 Sails to New Orleans and opens a studio at 26 Chartres Street, over L. Chittenden's store

1837 Meets Captain William Drummond Stewart in the spring and agrees to accompany him to the Rocky Mountains
 as expedition artist
 Departs St. Louis in April en route to the mountains

 Attends the annual rendezvous near Horse Creek, a tributary of the Green River, in July
 Returns to New Orleans, probably in October, and begins making finished washes and paintings for Stewart

1838 Exhibits several Western paintings in Baltimore in the summer

 Stewart learns in the fall that his older brother has died and that he has inherited the family title and estates

1839 Exhibits eighteen Western paintings at the Apollo Gallery in New York City in May
 Moves back to Baltimore in the fall and begins work on the *Cavalcade* for Stewart
 Cavalcade is exhibited at the Apollo Gallery in October before being shipped to Murthly Castle
 Exhibits a landscape painting (cat. 825) at the Boston Athenaeum
 Is invited to Murthly Castle to paint several more pictures for Stewart

1840–41 Is in residence at Murthly, finishing more paintings for Stewart

1842 Leaves Murthly and goes to London to work on several religious paintings for Stewart
 Meets George Catlin
 Returns to Baltimore

1843 Declines, because of ill health, to accompany Stewart on his last expedition to the Rocky Mountains in the
 summer

1844 Exhibits three paintings at the National Academy of Design

1845 Exhibits two paintings at the NAD

1847 Exhibits *Danae* (after Correggio, cat. 847) at the Pennsylvania Academy of the Fine Arts

1848 Exhibits nine paintings (including cats. 7, 45, 103, 113, 135, 191D, 352D, and 420A) at the Maryland Historical
 Society

1849 Exhibits nine paintings (including cats. 717, 874, 847, 853, 855, and 8) at the MHS

1850 Exhibits three paintings at the MHS

1852 Exhibits three paintings (cats. 439B, 459B, and 160B) at the American Art-Union, December 15–17

1853 Exhibits three paintings (cats. 485, 818, and 847) at the MHS

1856 Exhibits three paintings (cats. 827, 859, and 886) at the MHS

1858 Exhibits three paintings (cats. 833, 852, and 13) at the MHS

1861 Exhibits one painting (cat. 14A) at the Pennsylvania Academy

1874 Exhibits one painting (cat. 147E) at the Grand Charity Art Exhibit, 5th Regiment Armory, Baltimore, in January
 Dies on June 26

MANUSCRIPTS

Amon Carter Foundation. Files. Fort Worth, Texas.

DeVoto, Bernard. Papers. Macgill James File. Stanford University Library, Palo Alto, California.

Duveen, Albert. Collection. Archives of American Art, Washington, D.C.

Dreer Collection. Paintings and Engravings in the Historical Society of Pennsylvania. Archives of American Art, Washington, D.C.

J. Hall Pleasants Studies in Maryland Painting. File. Maryland Historical Society, Baltimore.

Land Records of Baltimore County. Liber TK No. 323, folio 66. Copy in the Archives, Maryland Historical Society, Baltimore.

"Letters from Americans [to] R. S. P. Avery." Typescript in Library, Metropolitan Museum of Art, New York.

Mayer, Frank B. Papers. Library, Metropolitan Museum of Art, New York.

———. Papers. Baltimore Museum of Art.

Miller, Alfred Jacob. Account Book. Library, Walters Art Gallery, Baltimore.

———. Captions for paintings. Library, Walters Art Gallery, Baltimore.

———. Journal. In the collection of the L. Vernon Miller family, Baltimore.

———. "Rough Draughts for Notes to Indian Sketches." Manuscript. Library, Thomas Gilcrease Institute of American History and Art, Tulsa, Oklahoma.

———. Sketchbook albums. In the collections of the Miller family.

———. Various letters. In the collections of the Miller family.

———. Vertical file. National Museum of American Art, Washington, D.C.

Miller, George W. Will, Book 15, Folio 483, and Inventory, Book 45, Folio 392, 401, at Baltimore City Hall.

Murthly Muniments. G.D. 121. Scottish Record Office, H.M. General Register House, Edinburgh.

Ross, Marvin C., ed. "Artists' Letters to Alfred Jacob Miller." Typescript. Library, Walters Art Gallery, Baltimore.

Sublette, William. Papers. Missouri Historical Society, St. Louis.

NEWSPAPERS

American and Commercial Daily Advertiser. Baltimore. 1838.

Baltimore American. 1834.

Baltimore and Commercial Daily Advertiser. 1836.

Baltimore Monument. 1838.

Bee. New Orleans. 1836.

Federal Gazette and Baltimore Daily Advertiser. 1820.

Glasgow Herald. Glasgow, Scotland. 1871.

Jeffersonian Republican. Jefferson, Missouri. 1839.

Morning Herald. New York City. 1839.

New York Herald Tribune. 1951.

New-York Mirror. 1839.

New York Weekly Herald. 1839.

Perthshire Courier. Perth, Scotland. 1839.

Scotsman. Edinburgh. 1871.

Standard. London. 1839.

Sun. Baltimore. 1847, 1874, 1881, 1889.

BOOKS, CATALOGUES, THESES, AND DISSERTATIONS

Alter, Cecil. *Jim Bridger.* Norman: University of Oklahoma Press, 1962.

American Heritage, ed. *The American Heritage Book of Great Adventures of the Old West.* New York, 1969.

———. *The American Heritage Book of the Pioneer Spirit.* New York, 1959.

———. *The American Heritage Cookbook and Illustrated History of American Eating & Drinking.* New York, 1964.

———. *America on Parade: Stories from Our Country's Past.* Adapted for young readers by Irwin Shapiro. New York, 1958.

———. *Book of Indians.* Text by William Brandon. New York, 1961.

———. *Golden Book of America.* New York: Golden Press, 1957.

———. *Indians of the Plains.* New York, 1960.

———. *Trappers and Mountain Men.* Text by Evan Jones. New York, 1961.

———. *Treasury of American Heritage: A Selection from the First Five Years of the Magazine of History.* New York: Simon and Schuster, 1960.

_____. *Westward on the Oregon Trail*. New York, 1962.

Amherst [Massachusetts] College. Mead Art Gallery. *American Art at Amherst*. 1978.

_____. _____. *Cowboys, Indians, Trappers & Traders*. February 1–28, 1973.

[Anderson, William Marshall]. *Rocky Mountain Journals of William Marshall Anderson*. Edited by Dale Morgan and Eleanor Towles Harris. San Marino, Calif.: Huntington Library, 1967.

Appleton's Cyclopaedia of American Biography. 6 vols. New York: D. Appleton and Co., 1888.

Art in America, ed. *The Artist in America*. New York: W. W. Norton, 1967.

Athearn, Robert G. *American Heritage New Illustrated History of the United States*. New York: American Heritage, 1963.

Austin. University of Texas. Art Museum. *The Great American West*. Text by Margaret Blagg. 1980.

B. F. Stevens and Brown, London. *Coronation Catalogue* (1937).

Baird, Joseph Armstrong, Jr., comp. *Catalogue of Original Paintings, Drawings and Watercolors in the Robert B. Honeyman, Jr., Collection*. Berkeley, Calif.: Friends of the Bancroft Library, 1968.

_____, comp. *The West Remembered: Artists and Images 1837–1973; Selections from the Collection of Earl C. Adams*. San Francisco and San Marino: California Historical Society, 1973.

Baltimore. Maryland Historial Society. *Annual Exhibition, 1848–1850*.

Baltimore, Maryland. Museum of Art. *Two Hundred and Fifty Years of Painting in Maryland*. May 11–June 17, 1945.

_____. Peale Museum. *Alfred Jacob Miller: Artist of Baltimore and the West*. Introduction by Mae Reed Porter. Text by Wilbur Harvey Hunter, Jr. January 8–February 12, 1950.

_____. _____. *Rendezvous for Taste: Peale's Baltimore Museum, 1814–1830*. [1956].

_____. Walters Art Gallery. *Catalogue of American Works of Art*. 1956.

_____. _____. *Private Collections: A Culinary Treasure*. 1973.

Baudelaire, Charles. *Art in Paris, 1845–1862: Salons and Other Exhibitions*. Translated and edited by Jonathan Mayne. London: Phaidon Press, 1965.

Baur, John I. H. *American Painting in the Nineteenth Century*. New York: Praeger, 1953.

Beebe, Lucius, and Charles Clegg. *The American West: The Pictorial Epic of a Continent*. New York: E. P. Dutton, 1955.

Bell, Colonel William Gardner. *The Snake: A Noble and Various River*. Washington, D.C.: The Westerners, Potomac Corral, 1969.

Bennett, Ian. *History of American Painting*. London: Hamlyn, 1973.

Berry, Don *A Majority of Scoundrels*. New York: Harper and Bros., 1961.

Billington, Ray Allen. *The Far Western Frontier, 1830–1860*. New York: Harper and Bros., 1956.

Biltmore Galleries, Los Angeles. [Partial Catalogue of Western Collection]. May 1969.

Boatmen's National Bank, St. Louis, Missouri. *A Catalog of the Boatmen's Art Collection*. May 4–29, 1964

Boise [Idaho] Gallery of Art. *American Masters in the West: Selections from the Anschutz Collection*. April 26–June 16, 1974.

Born, Wolfgang. *American Landscape Painting*. Westport, Conn.: Greenwood Press, 1970.

Boston, Massachusetts. Museum of Fine Arts. *American Paintings: 1815–1865*. Exhibition circulated by the Museum of Fine Arts, Boston, 1957–1959.

_____. _____. *American Paintings in the Museum of Fine Arts, Boston*. 2 vols. Boston: Museum of Fine Arts, 1969.

_____. _____. *Frontier America: The Far West*. January 23–March 16, 1975.

_____. _____. *M. and M. Karolik Collection of American Paintings, 1815 to 1865*. Boston: Museum of Fine Arts, 1949.

_____. _____. *M. and M. Karolik Collection of American Water Colors and Drawings, 1800–1875* Boston: Museum of Fine Arts, 1962.

_____. _____. *Sport in American Art*. October 10–December 10, 1944.

Bragdon, Henry W., and Samuel P. McCutchen. *History of a Free People*. 5th ed. New York: Macmillan, 1964.

Branch, Edward Douglas. *Story of America in Pictures*. Chicago: Spencer Press, 1954.

Brookings, South Dakota. Memorial Art Center. *Art of South Dakota*. Text by Joseph Stuart. September 15–October 27, 1974.

Brown, David L. *Three Years in the Rocky Mountains*. New York: Edward Eberstadt and Sons, 1950 [reprinted from *Cincinnati Atlas*, 1845].

Brown, Dee. *The Westerners*. N.p., 1974.

Burr, David H. *A New Universal Atlas*. New York: H. Hall & Co., 1836.

Cambridge, Massachusetts. Harvard University. Fogg Art

Museum. *American Art at Harvard.* April 19–June 18, 1972.

Capps, Benjamin. *The Great Chiefs.* New York: Time-Life Books, 1975.

_____. *The Indians.* New York: Time-Life Books, 1973.

Catalogue of the Celebrated Dr. William H. Crim Collection of Genuine Antiques, To Be Sold by Order of the Orphans' Court of Baltimore City, by the Undersigned Executors of Ella G. Crim, Deceased, Widow of the Late Dr. Crim, in the Fourth Regiment Armory, Fayette Street, near Paca Street, Baltimore, Md. Beginning Wednesday, April 22d, 1903 . . . A. O. Kirkland, Auctioneer . . .

Catlin, George. *Catlin's North American Indian Portfolio; Hunting Scenes and Amusements . . .* London: G. Catlin, 1844.

_____. *Letters and Notes on the Manners, Customs, and Condition of the North American Indians.* 2 vols. New York: Dover Publications, 1973 reprint.

Chapellier Galleries, New York. *One Hundred American Selections Presented by the Chapellier Galleries on the Occasion of the Opening our Our Building at 22 East 80th Street, New York City.* 1966.

Chattanooga, Tenn. Hunter Museum of Art. *An American Collection.* Historical notes and commentary by Zane Probasco. 1978.

Cheyenne [Wyoming] Centennial Committee. *150 Years in Western Art.* July 1–August 15, 1967.

Chicago, Illinois. The Art Institute of Chicago. *The Hudson River School and the Early American Landscape Tradition.* Text by Frederick A. Sweet. February 15–March 25, 1945.

Christie's Review of the Year 1970/1971. London, 1971.

Clark, Carol. *Thomas Moran: Watercolors of the American West.* Austin: University of Texas Press, 1980.

Clark, Ella E. *Indian Legends from the Northern Rockies.* Norman: University of Oklahoma Press, 1966.

Clark, Thomas D. *Frontier America: The Story of the Westward Movement.* New York: Scribner's, 1959.

Cleveland, Ohio. *The Gund Collection of Western Art: A History and Pictorial Description of the American West.* 1973.

Cline, Gloria Griffin. *Exploring the Great Basin.* Norman: University of Oklahoma Press, 1963.

Clokey, Richard M. *William H. Ashley: Enterprise and Politics in the Trans-Mississippi West.* Norman: University of Oklahoma Press, 1980.

Cody, Wyoming. Buffalo Bill Historical Center. *Land of Buffalo Bill.* May 15–September 15, 1959.

_____. _____. *The West of Buffalo Bill: Frontier Art, Indian Crafts, Memorabilia from the Buffalo Bill Historical Center.* New York: Harry N. Abrams, [1974].

_____. _____. *The Mountain Man.* Text by William Goetzmann. May–September, 1978.

Columbia, South Carolina. Museum of Art. *Americana: A Painting Survey of the American Scene, from the Collection of the C. Thomas May, Jr. Family, Dallas, Texas.* January 29–March 14, 1976.

Colwill, Stiles T. "Painter of Baltimore's Elite and the Raw West." Master's thesis, George Washington University, 1975.

Connor, Daniel Ellis. *Joseph Reddeford Walker and the Arizona Adventure.* Norman: University of Oklahoma Press, 1956.

Cooke, Alistair. *Alistair Cooke's America.* New York: Alfred A. Knopf, 1974.

Cowdrey, Mary Bartlett. *American Academy of Fine Arts and American Art-Union.* 2 vols. New York: New-York Historical Society, 1953.

_____. *National Academy of Design Exhibition Record, 1826–1860.* 2 vols. New York: New-York Historical Society, 1943.

Crosby, Alexander L. *Old Greenwood: Pathfinder of the West.* Georgetown, Calif.: Talisman Press, 1967.

Davidson, Abraham A. *Story of American Painting.* New York: Harry N. Abrams, 1974.

Davidson, Marshall B. *American Heritage History of the Artists' America.* New York: American Heritage, 1973.

_____ *Life in America.* 2 vols. Boston: Houghton Mifflin, 1951.

Dawson's Book Shop, Los Angeles. *An Exhibition of Original Western Paintings, Water Colors & Prints.* October 15, 1952

_____. *The Northwest Coast.* Catalogue 361, n.d.

Denver [Colorado] Art Museum. *American Art from the Denver Art Museum Collection.* [1969].

_____. *Building the West.* October 15–November 21, 1955.

_____. *Colorado Collects Historic Western Art.* January 13–April 15, 1973.

DeVoto, Bernard A. *Across the Wide Missouri.* Boston: Houghton Mifflin, 1947.

Dorra, Henri. *The American Muse.* New York: Viking Press, 1961

Drago, Harry S. *Roads to Empire: The Dramatic Conquest of the American West.* New York: Dodd, Mead, and Co., 1968.

Dunlap, William. *A History of the Rise and Progress of the Arts of Design in the United States* 2 vols. Boston: C. E. Goodspeed, 1918.

Dykes, Jeff C. *Fifty Great Western Illustrators: A Bibliographic Checklist*. Flagstaff, Ariz.: Northland Press, 1975.

Early, Mrs. John D. [Maude G. Rieman]. *Alfred J. Miller, Artist*. Baltimore: privately published, [c. 1894].

Edward Eberstadt & Sons, New York. Catalogues 127 (1950), 128 (1951), 130 (1952), 131–132 (1953), 133–134 (1954), 136 (1955), 138 (1956), 139 (n.d.), 146 (1958).

Eiteljorg, Harrison. *Treasures of the American West: Selections from the Collection of Harrison Eiteljorg*. New York: Balance House, 1981.

Eliot, Alexander. *Three Hundred Years of American Painting*. New York: Time, Inc., 1957.

Elman, Robert. *Great American Shooting Prints*. New York: Alfred A. Knopf, 1972.

Ewers, John C. *Artists of the Old West*. Garden City, N. Y.: Doubleday, 1965.

Farmville, Virginia. Longwood [College] Fine Arts Center. *The American West: Selected Works from the Collection of Arthur J. Phelan, Jr.* Introduction by Carol Clark. February 19–March 15, 1979.

Favour, Alpheus H. *Old Bill Williams, Mountain Man*. Norman: University of Oklahoma Press, 1962.

Felton, Harold W. *Edward Rose: Negro Trail Blazer*. New York: Dodd, Mead and Co., 1967.

[Field, Matthew C.]. *Prairie and Mountain Sketches*. Collected by Clyde and Mae Reed Porter; edited by Kate L. Gregg and John Francis McDermott. Norman: University of Oklahoma Press, 1957.

Fifty American Masterpieces: 200 Years of Great Painting. New York: Shorewood Publishers, 1968.

Flexner, James Thomas. *That Wilder Image*. New York: Bonanza Books, 1962.

Flint [Michigan] Institute of Arts. *Artists of the Old West*. November 15–December 6, 1964.

Fort Worth, Texas. Amon Carter Museum. *Amerykánski Zachód: Wystawa zorganizowana Przez Muzeum sztuki zachodniej im.* Text by Ron Tyler and Peter H. Hassrick. Polska, 1974.

————. ————. *Art Works of the American West*. [Catalogue of a traveling exhibition held in Japan, April–May 1976.] Text by Ron Tyler.

————. ————. *The Bison in Art: A Graphic Chronicle of the American Bison*. Flagstaff, Ariz.: Northland Press, 1977. [February 17–April 3, 1977.]

————. ————. *Alfred Jacob Miller*. Text by Ronnie C. Tyler. 1972.

Franzwa, Gregory M. *The Oregon Trail Revisited*. St. Louis: Patrice Press, 1972.

Fraser, Sir William. *The Red Book of Grandtully*. 2 vols. Edinburgh: privately printed for Sir William Drummond Stewart, 1868.

Friedländer, Walter. *David to Delocroix*. Cambridge, Mass.: Harvard University Press, 1952.

Fronval, George. *Fantastique épopée du Far West*. 2 vols. Neuilly/s/Seine: S. A Dargaud, Editeur, 1969.

————. *La Veritable histoire des Indians Peaux-Rouges*. Paris: Fernand Nathan, 1973.

Garraty, John A. *American Nation: A History of the United States*. New York: Harper and Row and American Heritage, 1966.

Gerhards, Eva. *Blackfoot-Indianer*. Innsbruck, 1980.

Getlein, Frank. *The Lure of the Great West*. Waukesha, Wisc.: Country Beautiful, [1973].

Ghent, W. J. *Early Far West*. New York: Tudor Publishing Co., 1936.

Gibson's Guide and Directory of the State of Louisiana, and the Cities of New Orleans & Lafayette. New Orleans: John Gibson, 1838.

Gilbert, Bil. *The Trailblazers*. New York: Time-Life Books, 1973

Glanz, Dawn. "The Iconography of Westward Expansion in American Art, 1820 to 1870: Selected Topics." Ph.D. dissertation, University of North Carolina, 1978.

Glubok, Shirley. *Art of America from Jackson to Lincoln*. New York, 1973.

————. *Art of the Old West*. New York: Macmillan, 1971.

Goetzmann, William H. *Exploration and Empire: The Explorer and the Scientist in the Winning of the American West*. New York: Alfred A. Knopf, 1966.

————, and Joseph C. Porter. *The West as Romantic Horizon*. Artists' biographies by David C. Hunt. Omaha, Neb.: Center for Western Studies, Joslyn Art Museum/ The InterNorth Art Foundation, 1981 [Exhibition presented at Kennedy Galleries, New York, September 14–October 2, 1981.]

Golden Book of America. Adapted for young readers by Irwin Shapiro. New York: Golden Press, 1957.

Gottfried, Herbert Wilson. "Spatiality and the Frontier: Spatial Themes in Western American Painting and Literature." Ph.D. dissertation, Ohio University, 1974.

Government Services Savings and Loan, Inc., Bethesda, Maryland. *American West: Selected Works* [from the Collection of Arthur J. Phelan, Jr.]. March 29–June 2, 1978.

Grand Teton National Park, Wyoming. Jackson Lake Lodge. *First Painters of the West*. n.d.

Greenbie, Sydney. *Furs to Furrows: An Epic of Rugged Individualism*. Caldwell, Idaho: Caxton, 1939.

Gulf States Paper Corporation, Tuscaloosa, Alabama. *The*

Best of the West: The Recorders; the Warner Collection. Tuscaloosa, 1979.

Gussow, Alan. *Sense of Place: The Artist and the American Land.* 2 vols. New York: Saturday Review Press for Friends of the Earth, 1973.

Hafen, LeRoy R. *Broken Hand: The Life of Thomas Fitzpatrick, Mountain Man, Guide and Indian Agent.* Rev. ed. Denver: Old West Publishing Co., 1973.

————, ed. *The Mountain Men and the Fur Trade of the Far West.* 10 vols. Glendale, Calif.: Arthur H. Clark Co., 1965–1972.

————, and Carl Coke Rister. *Western America: The Exploration, Settlement and Development of the Region beyond the Mississippi.* New York: Prentice-Hall, 1941.

————, and Francis Young. *Fort Laramie and the Pageant of the West, 1834–1890.* Glendale, Calif.: Arthur H. Clark Co., 1938.

Hagerstown, Maryland. Washington County Museum of Fine Arts. *The American Indian and the West.* September 14–November 2, 1947.

Haines, Francis. *Appaloosa: The Spotted Horse in Art and History.* Austin: University of Texas Press, 1963.

————. *The Buffalo.* New York: Crowell, 1970.

Hammer Galleries, New York. *The Works of Charles M. Russell and Other Western Artists.* 1963.

Harmsen, Dorothy. *Harmsen's Western Americana.* Flagstaff, Ariz.: Northland Press, 1971.

Hartman, Gertrude. *America: Land of Freedom.* Boston: D. C. Heath, 1946.

Hassrick, Peter H. *The Way West: Art of Frontier America.* New York: Harry N. Abrams, 1977.

Hassrick, Royal B. *The Sioux: Life and Customs of a Warrior Society.* Norman: University of Oklahoma Press, 1964.

Hawgood, John A. *America's Western Frontiers: The Exploration and Settlement of the Trans-Mississippi West.* New York: Alfred A. Knopf, 1967.

Hawke, David. *Those Tremendous Mountains.* New York, 1980.

Haydon, Harold. *Great Art Treasures in American Museums.* Waukesha, Wis.: Country Beautiful, 1967.

————. *Great Art Treasures in America's Smaller Museums.* New York and Waukesha, Wis.: Putnam's and Country Beautiful, 1967.

Heiderstadt, Dorothy. *Painters of America.* New York: David McKay, 1970.

Helman, George S. *Washington Irving Esquire, Ambassador at Large from the New World to the Old.* New York: Alfred A. Knopf, 1925.

Hieb, David L. *Fort Laramie National Monument—Wyoming.* Washington, D.C.: National Park Service, 1954.

Hine, Robert V. *The American West: An Interpretive History.* Boston: Little, Brown and Co., 1973.

————, and Savoie Lottinville. *Soldier in the West: Letters of Theodore Talbot during His Services in California, Mexico, and Oregon, 1845–53.* Norman: University of Oklahoma Press, 1972.

Hirschl & Adler Galleries, New York. *Faces and Places: Changing Images of 19th Century America.* 1972–1973.

Hollmann, Clide. *Five Artists of the Old West.* New York: Hastings House, 1965.

Holloway, David. *Lewis and Clark and the Crossing of North America.* New York: Saturday Review Press, 1974.

Holme, Bryan, ed. *Pictures to Live With.* New York: Viking Press, 1959.

Honour, Hugh. *Romanticism.* London: Allen Lane, 1979.

Hoopes, Donelson F. *American Watercolor Painting.* New York: Watson-Guptill, 1977.

Horan, James D. *Great American West: A Pictorial History from Coronado to the Last Frontier.* New York: Crown Publishers, 1959; rev. and exp. ed., 1978.

Hubach, Robert R. *Early Midwestern Travel Narratives: An Annotated Bibliography, 1634–1850.* Detroit: Wayne State University Press, 1961.

Hunter, Wilbur Harvey, Jr. *Rendezvous for Taste: Peale's Baltimore Museum, 1814–1830.* Baltimore: Peale Museum, 1956.

Huntington, David. *Art and the Excited Spirit: America in the Romantic Period.* Ann Arbor: University of Michigan Museum of Art, 1972.

Huntsville [Alabama] Museum of Art. *Art of the American West.* September 8–November 26, 1978.

Huth, Hans. *Nature and the American.* Berkeley and Los Angeles: University of California Press, 1957.

Hyde, George E. *Life of George Bent, Written from His Letters.* Norman: University of Oklahoma Press, 1968.

Irving, Washington. *The Adventures of Captain Bonneville, U.S.A., in the Rocky Mountains and the Far West.* Edited by Edgeley W. Todd. Norman: University of Oklahoma Press, 1961.

————. *Astoria, or, Anecdotes of an Enterprise beyond the Rocky Mountains.* 2 vols. Philadelphia: Carey, Lea, and Blanchard, 1836.

————. *A Tour of the Prairies.* London: John Murray, 1835.

Jim Fowler's Period Gallery West, Scottsdale, Arizona. *Volume 2—1980 Edition.*

Josephy, Alvin M., Jr., ed. *American Heritage Book of Natural Wonders.* New York: American Heritage, 1963.

Kalamazoo [Michigan] Institute of Arts. *Western Art: Paintings and Sculpture of the West:* February 17–March 19, 1967.

Kansas City, Missouri. William Rockhill Nelson Gallery and Atkins Museum of Fine Arts. *The Last Frontier.* October 5–November 17, 1957.

Kelly, Charles, and Dale L. Morgan. *Old Greenwood: The Story of Caleb Greenwood.* Georgetown, Calif.: Talisman Press, 1965.

Kende Galleries, New York. *The Collection of the Late Charles H. Linville, Baltimore.* January 24, 1942.

Kennedy Galleries, Inc., New York. *The Kennedy Quarterly* 1–16 (December 1949–June 1979).

Kennerly, William C. *Persimmon Hill.* Norman: University of Oklahoma Press, 1949.

Knoedler Galleries, Inc., New York. *An Exhibition Featuring Paintings from Harold McCracken's Book Portrait of the Old West.* 1952.

Krakel, Dean Fenton. *Adventures in Western Art.* Kansas City, Mo.: Lowell Press, [1977].

LaFarge, Oliver. *The American Indian.* New York: Golden Press, 1960.

_____. *Pictorial History of the American Indian.* New York: Crown Publishers, 1956.

Lamar, Howard R., ed. *The Reader's Encyclopedia of the American West.* New York: Thomas Y. Crowell Co., 1977.

Lavender, David. *American Heritage History of the Great West.* New York: American Heritage, 1965.

[Leonard, Zenas]. *Zenas Leonard Fur Trader.* Edited by John C. Ewers. Norman: University of Oklahoma Press, 1959.

Levy, Lester S. *Picture the Songs.* Baltimore: Johns Hopkins University Press, 1976.

Life (Chicago), ed. *America's Arts and Skills.* New York: E. P. Dutton, 1957.

Look to the Mountain Top. Edited by Charles Jones. San Jose, Calif.: Gousha Publications, 1972.

Los Angeles County [California] Museum of Art. *The American West: Painters from Catlin to Russell.* Text by Larry Curry. March 21–May 28, 1972.

McCauley, Lois B. *Maryland Historical Prints, 1752 to 1889.* Baltimore: Maryland Historical Society, 1975.

McCracken, Harold. *Portrait of the Old West.* New York: McGraw-Hill, 1952.

McDermott, John Francis, ed. *The Frontier Re-examined.* Urbana: University of Illinois Press, 1967.

McKenney, Thomas L., and James Hall. *History of the Indian Tribes of North America, with Biographical Sketches and Anecdotes of the Principal Chiefs.* Philadelphia: Daniel Rice and James G. Clark, 1842.

Manatt, Sam L., III. *SLM, Inc.: A Private Collection of Western, Early American, European, Contemporary, Bronze and Indian Artifacts.* Corning, Ark., 1977.

Marsh, James B. *Four Years in the Rockies: or, The Adventures of Isaac P. Rose, of Shenago Township.* New Castle, Pa.: W. B. Thomas, 1884.

Mattes, Merrill J. *The Great Platte River Road.* Nebraska State Historical Society Publications 25. Lincoln, 1967.

_____. *Scotts Bluff National Monument, Nebraska.* National Park Service Historical Handbook Series No. 28. Washington, D.C., 1958.

Maximilian, Prince of Wied-Neuwied. *Voyage dans l'intérieur de l'Amérique du Nord . . .* Paris: Arthus Bertrand, 1840.

Maxwell Galleries Ltd., San Francisco. *American Art since 1850.* August 2–31, 1968.

[Mayer, Francis B.] *With Pen and Pencil on the Frontier in 1851.* Edited by Bertha L. Heilbron. St. Paul: Minnesota Historical Society, [1932]

Mendelowntz, Daniel M. *History of American Art.* New York: Holt, Rinehart and Winston, 1960.

Minneapolis. University of Minnesota Gallery. *People of the Plains.* June 13–August 18, 1978.

Montreal, Canada. Museum of Fine Arts. *The Painter and the New World.* June 9–July 30, 1967.

Nadeau, Remi. *Fort Laramie and the Sioux Indians.* Englewood Cliffs, N.J.: Prentice-Hall, 1967.

Neider, Charles, ed. *The Great West.* New York: Bonanza Books, 1958.

Newark [New Jersey] Museum. *Classical America: 1815–1845.* April 26–September 2, 1963.

New Haven, Connecticut. Yale University Art Gallery. *Pictures from an Expedition.* Text by Martha A. Sandweiss. September 20, 1978–January 6, 1979.

_____. Yale University Library. *A Catalogue of Manuscripts in the Collection of Western Americana Founded by William Robertson Coe, Yale University Library.* Compiled by Mary C. Withington. New Haven: Yale University Press, [1952].

New York. Metropolitan Museum of Art. *American Paintings and Historical Prints from the Middendorf Collection* October 4–November 26, 1967.

_____. Museum of Modern Art. *Romantic Painting in America.* Text by James Thrall Soby and Dorothy C. Miller. 1943.

_____. Whitney Museum of American Art. *Alfred Jacob Miller: Baltimore Sketches, 1825–1870.* June 17–July 20, 1969.

_____. _____. *American Painting: The Nineteenth Century.* April 22–May 23, 1954.

New York University. Institute of Economic Affairs. *Permanent Frontier.* Foreword by Babian Haig. New York, 1961.

Nicoll, Bruce Hilton, comp. *Nebraska, a Pictorial History.* Lincoln: University of Nebraska Press, 1975.

Nieman, Egbert W., and Elizabeth C. O'Daly. *Adventures for Readers: Book Two.* New York: Harcourt, Brace and World, 1963.

Nunis, Doyce Blackman, Jr. *Andrew Sublette, Rocky Mountain Prince.* Los Angeles: Dawson's Book Shop, 1960.

Oklahoma City, Oklahoma. National Cowboy Hall of Fame. *Inaugural Exhibition.* June 25–October 10, 1965.

Omaha, Nebraska. Joslyn Art Museum. *Angels and Urchins: Images of Children at the Joslyn.* Text by Hollister Sturges III with a contribution by Joseph C. Porter. November 15, 1980–January 4, 1981.

_____. _____. *Artist Explorers of the 1830's.* May 1–September 2, 1963.

_____. _____. *Artists of the Western Frontier.* July 3–October 17, 1976.

_____. _____. *Exploration in the West: Catlin, Bodmer, Miller.* [1967].

_____. _____. *Life on the Prairie: The Artist's Record.* May 12–July 4, 1954.

_____. _____. *The Way West: Artist Explorers of the Frontier.* [1978].

O'Meara, Walter. *Daughters of the Country: The Women of the Fur Traders and Mountain Men.* New York: Harcourt, Brace and World, 1968.

O'Neil, Paul. *The Rivermen.* New York: Time-Life Books, 1975.

Orange, Texas. Stark Museum of Art. *Stark Museum of Art: The Western Collection.* Text by Julie Schimmel with the assistance of Gilbert Tapley Vincent. 1978.

Ottawa. Public Archives of Canada. *Braves and Buffalo: Plains Indian Life in 1837.* Introduction by Michael Bell. Toronto: University of Toronto Press, 1973.

_____. _____. Picture Division. *Descriptive Catalogue of a Collection of Water-colour Drawings by Alfred Jacob Miller (1810–1874) in the Public Archives of Canada.* Introduction by Pierre Brunet. 1951.

Parke-Bernet Galleries, Inc., New York. *A Series of Watercolour Drawings by Alfred Jacob Miller, of Baltimore: Artist to Captain Stewart's Expedition to the Rockies in 1837.* (Sale 2436). May 6, 1966.

Parry, Ellwood. *The Image of the Indian and the Black Man in American Art, 1590–1900.* New York: George Braziller, 1974.

Peoria, Illinois. Lakeview Center for the Arts and Sciences. *Westward the Artist.* April 19–June 2, 1968.

Perkins, Robert F., Jr., and William J. Gavin III, comps. and eds. *Boston Athenaeum Art Exhibition Index, 1827–1874.* Boston: Library of the Boston Athenaeum, 1980.

Philadelphia. Pennsylvania Academy of the Fine Arts. *Annual Exhibition.* [1852, 1861].

Philadelphia. University of Pennsylvania Museum. *The Noble Savage: The American Indian in Art.* May 8–September 8, 1958.

Phillips, Paul Chrisler. *The Fur Trade.* 2 vols. Norman: University of Oklahoma Press, 1961.

Phoenix [Arizona] Art Museum. *American West: Selections from the Kennedy Galleries Collection.* Phoenix, 1975.

_____. *Beyond the Endless River: Western American Drawings and Watercolors of the Nineteenth Century.* Text by James K. Ballinger. January 12–February 18, 1979.

_____. *Western Art from the Eugene B. Adkins Collection.* November 1971–January 1972.

Planta, Edward. *The Stranger's New Guide in Paris.* Paris, 1827.

Platt, Rutherford. *Adventures in the Wilderness.* New York: American Heritage, 1963.

Polley, Robert L., ed. *Beauty of America in Great American Art.* Waukesha, Wis.: Country Beautiful, 1965.

Porter, Mae Reed, and Odessa Davenport. *Scotsman in Buckskin: Sir William Drummond Stewart and the Rocky Mountain Fur Trade.* New York: Hastings House, 1963.

Price, Vincent. *Vincent Price Treasury of American Art.* Waukesha, Wis.: Country Beautiful, 1972.

Quaife, Milo Milton, ed. *Kit Carson's Autobiography* Chicago: R. R. Donnelley & Sons Co., The Lakeside Press, Christmas, 1935.

Rasky, Frank. *The Taming of the Canadian West.* Toronto: McClelland and Stewart, 1967.

Reader's Digest. *Illustrated Guide to the Treasures of America.* Pleasantville, N.Y.: Reader's Digest Association, 1974.

_____. *The Story of the Great American West.* Pleasantville, N.Y.: Reader's Digest Association, 1977.

Roche, John Francis. *Frontier Nation: A History of the United States, 1763–1877.* Morristown, N.J.: Silver Burdett Co., 1964.

Roe, Frank G. *The Indian and the Horse.* Norman: University of Oklahoma Press, 1955.

Rorabacker, Albert J. *The American Buffalo in Transition.* St. Cloud, Minn.: North Star Press, 1970.

Ross, Alexander. *Fur Hunters of the Far West.* Norman: University of Oklahoma Press, 1956.

Ross, Marvin C., ed. *The West of Alfred Jacob Miller.* Norman: University of Oklahoma Press, 1951; rev. and enl. ed., 1968.

Rossi, Paul A., and David C. Hunt. *The Art of the Old West from the Gilcrease Institute.* New York: Alfred A. Knopf, 1971.

[Russell, Osborne]. *Osborne Russell's Journal of a Trapper.*

Edited by Aubrey L. Haines. Lincoln: University of Nebraska Press, Bison Books, 1965.

Ruth, Kent. *Great Day in the West.* Norman: University of Oklahoma Press, 1963.

Rutledge, Anna Wells, comp. *Cumulative Record of Exhibition Catalogues: The Pennsylvania Academy of the Fine Arts, 1807–1870; The Society of Artists, 1800–1814; The Artists' Fund Society, 1835–1845.* Philadelphia: American Philosophical Society, 1955.

[Ruxton, George Frederick]. *Life in the Far West.* Edited by LeRoy R. Hafen; foreword by Mae Reed Porter. Norman: University of Oklahoma Press, 1951.

_____. *Ruxton of the Rockies: Autobiographical Writings by the Author of Adventures in Mexico and the Rocky Mountains and Life in the Far West.* Collected by Clyde and Mae Reed Porter; edited by LeRoy R. Hafen. Norman: University of Oklahoma Press, 1950.

St. Louis, Missouri. City Art Museum. *Water Colors of the Western Frontier a Century Ago.* April 1–May 13, 1941.

_____. _____. *Westward the Way: The Character and Development of the Louisiana Territory as seen by Artists and Writers of the Nineteenth Century.* Edited by Perry T. Rathbone. [1954].

Saint Stephens Indian School. Wind River Reservation. Saint Stephens, Wyoming. *Wind River Rendezvous.* N.d.

Samuels, Peggy, and Harold Samuels. *Illustrated Biographical Encyclopedia of Artists of the American West.* Garden City, N.Y.: Doubleday, 1976.

San Antonio, Texas. Marion Koogler McNay Art Institute. *Go West, Young Man.* 1960.

Santa Ana, California. Charles W. Bowers Memorial Museum. *Painters of the West.* March 5–30, 1972.

Santa Fe, New Mexico. Fine Arts Museum of New Mexico. *The Artist in the American West, 1800–1900.* October 8–November 22, 1961.

Savelle, Max. *Short History of American Civilization.* New York: Dryden Press, 1957.

Scharf, J. Thomas. *History of Baltimore City and County.* Philadelphia: Louis H. Everts, 1881.

Schmitt, Martin F., and D. Alexander Brown. *Fighting Indians of the West.* New York: Scribner's, 1948.

Schomaekers, G[ünter]. *Der Wilde Westen.* Hessen: L. B. Ahnert Verlag, [1972].

Seattle [Washington] Art Museum. *Lewis and Clark's America: A Voyage of Discovery.* Text by Willis F. Woods. July 15–September 26, 1976.

Speck, Gordon. *Breeds and Halfbreeds.* New York: Clarkson N. Potter, 1969.

The Sportsman's Wilderness. Secaucus, N.J.: Ridge Press/Pound, 1974.

Sprague, Marshall. *A Gallery of Dudes.* Boston: Little, Brown and Co., 1967.

Stebbins, Theodore E., Jr. *American Master Drawings and Watercolors.* New York: Harper and Row, 1976.

Stegner, Wallace, ed. *The Letters of Bernard DeVoto.* Garden City, N.Y.: Doubleday and Co., 1975.

[Stewart, Sir William Drummond]. *Altowan: or, Incidents of Life and Adventure in the Rocky Mountains by an Amateur Traveler.* Edited by J. Watson Webb. 2 vols. New York: Harper and Bros., 1846.

_____. *Edward Warren . . .* 2 vols. London: G. Walker, 1854.

Stuart, Robert. *On the Oregon Trail: Robert Stuart's Journey of Discovery.* Norman: University of Oklahoma Press, 1953.

Sunder, John E. *Bill Sublette: Mountain Man.* Norman: University of Oklahoma Press, 1959.

Sweeney, J. Gray. "The Artist-Explorers of the American West, 1860–1880." Ph.D. dissertation, Indiana University, 1975.

Swift, Mary Grace. *Belles and Beaux on Their Toes: Dancing Stars in Young America.* Washington, D.C.: University Press of America, 1980.

Swingle, John, comp. *Catalogue 33: Rare Books and Manuscripts.* San Francisco: John Howell, 1961.

Thomas, Davis, and Karin Ronnefeldt, eds. *People of the First Man: Life among the Plains Indians in Their Final Days of Glory. The Firsthand Account of Prince Maximilian's Expedition up the Missouri River, 1833–34.* New York: E. P. Dutton and Co., 1976.

Thompson, Erwin N. *Whitman Mission National Historic Site.* National Park Service Historical Handbook Series No. 37. Washington, D.C.: 1964.

Todd, Lewis P., and Merle Curti. *The Rise of the American Nation.* New York: Harcourt, Brace and World, 1966.

Trenholm, Virginia C., and Maurine Carley. *The Shoshonis: Sentinels of the Rockies.* Norman: University of Oklahoma Press, 1964.

Truettner, William H. *The Natural Man Observed: A Study of Catlin's Indian Gallery.* Washington, D.C.: Smithsonian Institution Press, 1979.

Tuckerman, Henry T. *Book of the Artists.* New York, 1867; reprint, New York: James F. Carr, 1966.

Tulsa, Oklahoma. Philbrook Art Center. *American Art: The Philbrook Collection.* Catalogue notes by Linda M. Pinkerton. August 1–September 26, 1976.

200 Years: A Bicentennial Illustrated History of the United States. Washington, D.C.: U.S. News & World Report, 1973.

U.S. National Park Service. *Soldier and Brave.* Rev. ed.

Washington, D.C.: U.S. Department of the Interior, 1971.

Utley, Robert M., and Wilcomb E. Washburn. *American Heritage History of the Indian Wars*. New York: American Heritage, 1977.

Ver Steeg, Clarence L. *The Story of Our Country*. New York: Harper and Row, 1965.

Victor, Frances Fuller. *The River of the West: Life and Adventure in the Rocky Mountains and Oregon*. Hartford, Conn.: R. W. Bliss and Co., 1870.

Vigne, Godfrey G. *Six Months in America*. Philadelphia: Thomas T. Ash, 1833.

Warner, Robert Combs. *The Fort Laramie of Alfred Jacob Miller: A Catalogue of All the Known Illustrations of the First Fort Laramie*. University of Wyoming Publications 43, no. 2. Laramie, 1979.

Washington, D.C. Corcoran Gallery of Art. *American Processional: The Story of Our Country*. June 8–December 17, 1950.

———. Smithsonian Institution. National Collection of Fine Arts. *National Parks and the American Landscape*. Text by William H. Truettner and Robin Bolton-Smith. June 23–August 27, 1972.

Webber, Charles Wilkins. *The Hunter-Naturalist: Romance of Sporting; or, Wild Scenes and Wild Hunters*. Philadelphia: J. W. Bradley, 1851; Philadelphia: Lippincott, Grambo and Co., 1852.

———. *The Hunter-Naturalist: Wild Scenes and Song-Birds*. New York: George P. Putnam and Co., 1854; New York: Riker, Thorne and Co., 1854.

———. *Wild Scenes and Song Birds*. New York: Leavitt and Allen, 1858.

Wheeler, Keith. *The Chroniclers*. New York: Time-Life Books, 1976.

———. *The Scouts*. Alexandria, Va.: Time-Life Books, 1978.

White, Anne Terry, ed. *Indians and the Old West*. New York: Simon and Schuster, 1954.

Willard, John. *Adventure Trails in Montana*. Helena, 1964.

Williams, Hermann Warner, Jr. *Mirror to the American Past: A Survey of American Genre Painting, 1750–1900*. Greenwich, Conn.: New York Graphic Society, 1973.

Willis, Nathaniel P. *Pencillings by the Way*. 3 vols. London: John Macrone, 1835.

Wright, Nathalia, ed. *Letters of Horatio Greenough, American Sculptor*. Madison: University of Wisconsin Press, 1972.

ARTICLES

"Alfred Jacob Miller." *American Scene* 14, no. 4 (1973): 12–20.

"Alfred Jacob Miller—Indian Painter: 1810–1874." *Old Print Shop Portfolio* 3, no. 3 (November 1943): 68–69.

"America and the Future: West to the Rendezvous; an Artist Travels the Oregon Trail in 1837." *Fortune* 29, no. 1 (January 1944): 111–121.

Anderson, the Reverend William. "Sir William Drummond Stewart and the Chapel of St. Anthony the Eremite, Murthly." *Innes Review: Scottish Catholic Historical Studies* 15 (1964): 151–170.

Barsness, Larry. "The Bison in Art and History." *American West* 14, no. 2 (March–April 1977): 10–21.

Beetem, Robert N. "George Catlin in France: His Relationship to Delacroix and Baudelaire." *Art Quarterly* 24, no. 2 (Summer 1961): 129–145.

Brandon, William. "The Wild Freedom of the Mountain Men." *American Heritage* 6, no. 5 (August 1955): 4–9.

Bridger, Bobby. "Seekers of the Fleece, Part I." *Four Winds*, issue 5 (Winter-Spring 1981): 53–64; "Seekers of the Fleece, Part II." *Four Winds*, issue 6 (Summer-Autumn 1981): 53–72.

Brown, D. Alexander. "Jim Bridger—A Personality Profile." *American History Illustrated* 3, no. 4 (July 1968): 4–11, 44–47.

Canaday, John. "50 Drawings of Alfred Jacob Miller Placed on View at the Whitney Museum." *New York Times*, June 26, 1969, p. 38, col. 3.

Cole, Thomas. "Essay on American Scenery." In *American Art, 1700–1960: Sources and Documents*, by John W. McCoubrey. Englewood Cliffs, N.J.: Prentice-Hall, 1965.

Cowdrey, Mary Bartlett, and Helen Comstock. "Alfred Jacob Miller and the Farthest West." *Panorama* [Harry Shaw Newman Gallery, New York] 3, no. 1 (August-September 1947): 1–11.

Darling, Ernest F. "Rendezvous at Pierre's Hole Was One Wingding of a Fling." *Gilcrease Magazine of American History and Art* 3, no. 2 (April 1981): 22–27.

Decatur, Stephen. "Alfred Jacob Miller: His Early Indian Scenes and Portraits." *American Collector* 8, no. 11 (December 1939): 6–7

Dickson, Frank H. "Hard on the Heels of Lewis and Clark." *Montana: The Magazine of Western History* 26, no. 1 (January 1976): 14–25.

Edgerton, Samuel Y., Jr. "The Death of Jane McCrea: The Tragedy of an American *Tableau d'Histoire*." *Art Bulletin* 47, no. 4 (December 1965): 481–492.

Ewers, John C. "Deadlier Than the Male." *American Heritage* 16, no. 4 (June 1965): 10–13.

_____. "William Clark's Indian Museum in St. Louis, 1816-1838." In *A Cabinet of Curiosities: Five Episodes in the Evolution of American Museums*, ed. Whitfield J. Bell et al. Charlottesville: University of Virginia Press, 1967.

Fleming, E. McClung. "The American Image as Indian Princess, 1765-1783." *Winterthur Portfolio* 2 (1965): 65-81.

Forbes, M. H. "Election Scene, Catonsville, Baltimore County." *Corcoran Gallery of Art Bulletin* 13, no. 3 (October 1963): 15ff.

[Forrest, James T.]. "Each Painting Its Own Story." *American Scene* 2, no. 4 (Winter 1959-1960): 1-2.

Gold, Barbara. "Alfred Jacob Miller: 19th Century Artist." *Maryland* (Spring 1973): 24-29.

Good, Donnie D. "Mustangs." *American Scene* 12, no. 2 (1971), unpaginated.

Goosman, Mildred. "Collector's Choice: Old Gabe of Her Majesty's English Life Guards." *American West* 6, no. 6 (November 1969): 14-15.

Gray, William H. "Unpublished Journal of William H. Gray, from December, 1836, to October, 1837." *Whitman College Quarterly* 16, no. 2 (June 1913): 1-79.

Hafen, LeRoy R. "Etienne Provost, Mountain Man and Utah Pioneer." *Utah Historical Quarterly* 36, no. 2 (Spring 1968): 99-112.

Hassrick, Peter H. "The Indian and American Art." *Connoisseur* 201, no. 807 (May 1979): 60-66.

Hedgpeth, Don. "Emergence of Western Art." *Southwestern Art* 6, no. 4 (Winter 1977-1978): 4-16.

Hillman, Martin. "Part Three: Bridging a Continent." In *The New World. History of Discovery and Exploration.* London: Aldus Books/Jupiter Books, 1971.

"How the West was Won: Part I," *Life,* April 6, 1959, pp. 90-93.

Hunter, Wilbur Harvey, Jr. "A 'New' Painting by Alfred Jacob Miller." *Antiques* 101, no. 1 (January 1972): 221-225.

James, Macgill. "Noted Baltimore Artist Represented in Exhibit." *Baltimore Sun,* December 3, 1933.

Johnston, William R. "Alfred Jacob Miller—Would-be Illustrator." *Walters Art Gallery Bulletin* 30, no. 3 (December 1977): [2-3].

_____. "American Paintings in the Walters Art Gallery." *Antiques* 106, no. 5 (November 1974): 853-861.

_____. "Sketches by Alfred Jacob Miller." *Bulletin of the Walters Art Gallery* 21, no. 7 (April 1969): 3-4.

Josephy, Alvin M., Jr. "First 'Dude Ranch' Trip to the Untamed West," *American Heritage* 7, no. 2 (February 1956): 8-15.

King, Edward S. "The Old West of A. J. Miller." *Walters Art Gallery Bulletin* 16, no. 8 (May 1964), unpaginated.

Kingman, Eugene. "Painters of the Plains." *American Heritage* 6, no. 1 (December 1954): 32-42.

Knox, Sanka. "83 Drawings from 1837 Trek to Rockies Are Auctioned Here." *New York Times,* May 7, 1966, p. 28.

LaFarge, Oliver. "Myths that Hide the American Indian." *American Heritage* 7, no. 6 (October 1956): 4-19.

McDermott, John Francis. "A. J. Miller." *American Scene* 4, no. 3 (1962): 6-25.

Mattes, Merrill J. "The Jumping-Off Places on the Overland Trail." In *The Frontier Re-examined,* ed. John Francis McDermott. Urbana: University of Illinois Press, 1967.

Monaghan, Jay. "The Hunter and the Artist." *American West* 6, no. 6 (November 1969): 4-13.

_____. "The Whimsical Art of Alfred Miller." Chicago *Tribune,* November 19, 1950, graphic section, pp. 8, 14.

Murthly Castle estate sale notices: [Mr. Chapman's Sales advertisement], *Scotsman,* June 1, 1871, p. 8, col. 2; "Sale of Pictures from Murthly Castle," *Scotsman,* June 17, 1871, p. 2, col. 3-4; "Sale of Antique Furniture and Tapestry from Murthly Castle," *Scotsman,* June 19, 1871, p. 2, cols. 4-5.

"The Opening of the West." *Life,* July 4, 1949, pp. [40-47].

Pike, Donald G. "Images of an Era: The Mountain Man." *American West* 12, no. 5 (September 1975): 36-45.

_____. "The World of the Mountain Man." *American West* 12, no. 5 (September 1975): 28-35.

Randall, Richard H., Jr. "Don't Give Up the Ship." *Walters Art Gallery Bulletin* 22, no. 4 (January 1970): 2-3.

_____. "A Gallery for Alfred Jacob Miller." *Antiques* 106, no. 5 (November 1974): 836-843.

_____. "Transformations and Imaginary Views by Alfred Jacob Miller." *Baltimore Museum of Art Annual III, Part One,* 1968, pp. 43-49.

Ross, Marvin C. "A List of Portraits and Paintings from Alfred Jacob Miller's Account Book." *Maryland Historical Magazine* 48, no. 1 (March 1953): 27-36.

Russell, Carl P. "Wilderness Rendezvous Period of the American Fur Trade." *Oregon Historical Quarterly* 42 (March 1941): 1-47.

Seldis, Henry J. "Boom Interest in American Art." *Art in America* 47, no. 3 (Fall 1959): 60-63.

Stanley, J. M. "Portraits of North American Indians, with Sketches of Scenery, etc., Painted by J. M. Stanley." In *Smithsonian Miscellaneous Collections,* vol. 2. Washington, D.C., 1852.

Stegner, Wallace. "Historian by Serendipity." *American Heritage* 24, no. 5 (August 1973): 28-32, 92-96.

_____. "Ordeal by Handcart." *Colliers Magazine,* July 6, 1956.

Stevning, Donald A. "The Western Artist: His Role in History." *Brand Book II: The San Diego Corral, the Westerners.* 1971.

Vail, R. W. G. "The First Artist of the Oregon Trail." *New-York Historical Society Quarterly* 34, no. 1 (January 1950): 25–30.

Wasserman, Emily. "The Artist-Explorers." *Art in America* 60, no. 4 (July-August 1972): 48–57.

"Water Color Sketches of Indian Life a Century Ago Acquired by a Kansas Citizen." *Kansas City Star,* December 4, 1938, rotogravure section.

Wellman, Paul I. "An Artist Pictured the West He Visited a Century Ago." *Kansas City Star,* December 4, 1938.

[Wenger, Martin]. "Miller Collection." *American Scene* 4, no. 3 (1962): [23].

Young, Vernon. "The Emergence of American Painting." *Art International,* September 20, 1974, pp. 14–17.

The Garamond types of this catalogue were composed by
Typography Systems International, Inc. of Dallas, Texas.
The plates were printed by Hart Graphics in Austin, Texas;
while the text was printed and the books bound by
the Murray Printing Company of Westford, Massachusetts.
Design and production planning by Ink, Inc. of New York City.